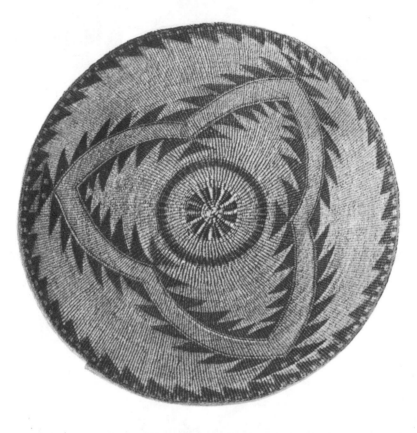

American Indian Basketry

by
Otis Tufton Mason

DOVER PUBLICATIONS, INC.
NEW YORK

Frontispiece

Plate 6. See page 33

KLAMATH INDIAN GAMBLING TRAY

In overlaid twined weaving, showing lines and squares dyed in Evernia

A sak-lotks′ p′a′-hla or flexible gambling tray of the Klamath Indians of Oregon. Both warp (pa-chĭs′) and weft (twach) are of cords of undyed twisted tule (p. 38), which are fully exposed only in the pale-brown stripe at the margin, where the ends of the warp are interlaced and bound with a strengthening cord of gray fiber from the nettle (p. 40). Every other stitch of the tray is covered with an overlaying material : the white is of reed (p. 33); the black (mok′-was) is of tule dyed in mud springs containing iron ; the canary yellow is of porcupine quills (smai′-am) dyed with wolf moss (p. 28), and the brown of the ring near the center of the tray is of undyed tule. Nettle cord was used in binding the strands of warp together at the beginning.

The main trefoil pattern is of unknown significance. The triangles upon it are bird-wing patterns (slas-al′-tĭs), while the triangles on the marginal design are arrow-head patterns (sa′-wal-sal′tĭs). The brown and black ring near the center is an op′-k′a, a name applied only to a ring of transversely alternating colours. A ring of uniform colour would be a smĕl-ō′-g′a.

Collection of Frederick V. Coville

Published in Canada by General Publishing Company, Ltd., 30 Lesmill Road, Don Mills, Toronto, Ontario.

Published in the United Kingdom by Constable and Company, Ltd., 10 Orange Street, London WC2H 7EG.

This Dover edition, first published in 1988, is an unabridged, slightly corrected republication in one volume of the work originally published in 1904 by Doubleday, Page & Company, New York, as a two-volume set, under the title *Indian Basketry: Studies in a Textile Art Without Machinery*. Some of the illustrations have been moved to different locations, and the original color plates have been converted to black and white.

Manufactured in the United States of America
Dover Publications, Inc., 31 E. 2nd Street, Mineola, NY 11501

Library of Congress Cataloging-in-Publication Data

Mason, Otis Tufton, 1838–1908.
 [Indian basketry]
 American Indian basketry / by Otis Tufton Mason.
 p. cm.
 Reprint. Originally published: Indian basketry. New York : Doubleday, Page, 1904.
 Bibliography: p.
 Includes index.
 ISBN 0-486-25777-0 (pbk.)
 1. Indians of North America—Basket making. I. Title.
E98.B3M44 1988 88-14977
746.41′2′08997—dc 19 CIP

INTRODUCTION

Adde et *bascuada* et mille escaria.
TERENCE, 12:46.
Barbara de pictis veni *bascuada* Britannis
Sed me jam mavult dicere Roma suum.
MARTIAL, XIV:99.

ABORIGINAL British or Pictish baskets and a thousand receptacles, says Terence, were carried to Rome by the successors of Julius Cæsar, and Martial adds that the word "basket" is Pictish,* though the Romans would have us believe it to have been indigenous.

Remnants of basketry are gathered from the Swiss lake-dwellings, made in several of the technical processes well known to the American Indians and to be described later.

In the second volume of Keller's Lake Dwellings (pls. 134–137) are startlingly interesting groups of such basketry. You have, first of all, the methods of treating the bark of trees and flax to form the fiber in various stages of preparation. Network and frame weaving are also there illustrated, but in this place attention is drawn only to the basketry. On his Plate 134 may be seen plain checkerwork and twined work in 2-strand and 3-strand varieties, also coiled work in the following varieties: (a) Foundation of two rods, sewing done with bark strips, so as to inclose both rods below, the stitches interlocking; (b) foundation of two rods, sewing inclosing them both, but only one of the rods underneath; the stitches interlock and split the upper portion of the one just below, as in many American baskets. The twined work of Robenhausen and Wangen is in a great number of varieties. There is solid, plain weaving; also openwork twined weaving, the body

*On the derivation of the word, however, consult the New English Dictionary and the Century Dictionary.

v

being stems of plants; borders are held together with twined weaving. In some specimens of openwork the warp of twined weaving is in pairs; but there are not shown in any of Keller's plates the types of twined work in which the warp plays any part for ornamentation; and in the remains, so far as examined, no attempts are made at embroidery, or overlaying, or any of the species of fine decoration, to be seen in the Alaskan or Californian weaving.*

In the Arabian Nights, the story of the lady who was murdered by her husband mentions a very large basket, by its size reminding one of the granary baskets of California, but it was evidently in coiled work, very much in the style of the Hopi plaques. The Caliph, Haroun Alraschid—

came to the bank of the river, and the fisherman, having thrown in his net, when he drew it out again brought up a trunk, close shut and very heavy. The Caliph made the vizier pay the man 100 sequins immediately and sent him away. Mesrour, by his master's orders, carried the trunk on his shoulders, and the Caliph, eager to know what it contained, returned to the palace with all speed. When the trunk was opened, they found in it a large basket made of palm-leaves, shut up, and the covering sewed with red thread. To satisfy the Caliph's impatience, they cut the thread with a knife and took out of the basket a package wrapped in a sorry piece of hanging and bound about with rope, in which, when untied, they found, to their amazement, the dead body of a young lady cut in small pieces.

The Ute Indians in ancient times used basketry for mortuary purposes, but by them made of the rarest material and with faultless workmanship, adorned with symbols of their religion. The dead was covered with a large carrying basket, and all around were laid with loving care the finest specimens of the craft. (See Plates 205–211.)

It is interesting to know that the first mention of baskets in the Bible is in connection with dreams. Joseph was a

* Ferdinand Keller, The Lake Dwellings of Switzerland and other parts of Europe, 2 vols., London, 1878.

prisoner in Egypt. He had interpreted the butler's dream
so favourably that Pharaoh's baker came also to him.

When the chief baker saw that the interpretation was good, he
said unto Joseph, I also was in my dream, and, behold, I had three
white baskets on my head; and in the uppermost basket [*sal*] there
was of all manner of baked meats [sweetmeats] for Pharaoh; and
the birds did eat them out of the basket upon my head. And
Joseph answered and said, This is the interpretation thereof:
The three baskets are three days; yet within three days shall
Pharaoh lift up thy head from off thee, and shall hang thee on a
tree; and the birds shall eat thy flesh from off thee.

It may in general be assumed that the baskets used by
the Israelites were not unlike those of the Egyptians. If the
ancient baskets of Egypt resembled the modern, those men-
tioned were of the coiled type, made from palm-leaf, resembling
thick bread-plaques of the Hopi pueblos of Arizona. They
were doubtless in use throughout North Africa long before
the days of Joseph.

Specimens of this type of ancient coiled basketry were dug
up by Randall-MacIver and Wilkin at El Armah, six miles
south of the site of Abydos, in middle Egypt. They are the
oldest that have yet been found in the world. El Armah
dates back to the earliest "new race," through the entire middle
period down to the late prehistoric in Egypt. Far up the Nile,
the type persists. It will be seen in abundance at Aden, and
it exists in much more elegant material in Hindustan. This
proves the persistence of a single type through six thousand
years. Long ago, caravans took it into the heart of Africa, and
the reader must not be surprised further on in discovering at
least a limited sphere of influence for it in America,
where the descendants of the Moors who invaded Spain
left it.

The Greek word for basket is kaneon, or kanastron, from
kanna, a reed, whence our cannister, through the Latin can-

istra. Or, to come closer to our theme, basketry was made long ago in the warmer countries of the Old World, as it is now in the New, from cane. In the time of Homer, this word was applied frequently to receptacles of clay, bronze, and gold. Doubtless, in earlier ages, the Greek women were nimble-fingered basketmakers, but the forms are not preserved.

Wherever civilisation has come in contact with the lower races, whether in Britain, Africa, Polynesia, or America, it has found the woman enjoying the most friendly acquaintance with textile plants and skilful in weaving their roots, stems, and leaves into basketry, matting, and other similar products without machinery. Basketry was wellnigh universal throughout the Western Hemisphere before the discovery, while at least one-half of the area was devoid of pottery.

Ancient cemeteries, mounds, caves, ruins, and lake dwellings gave evidence of the high antiquity of the art in both continents. The researches of Holmes and Willoughby on mound pottery; of Yarrow and Schumacher in southwestern California; of Cushing, Fewkes, and Hough in ancient pueblos; of Nordenskjöld and Pepper in the cliff dwellings of the Southwest; of George A. Dorsey, of the Field Columbian Museum, and many European explorers in Peru, demonstrate that no changes have taken place in this respect, either in the variety of the technical processes or the fineness of the workmanship. There is an unbroken genealogy of basket-making on the Continent, running back to the most ancient times.

For a time cheap patented ware made from veneering threatened to obliterate the ancient plicated basket, but at the same time the latter became exalted to a pastime and a fine art, and there were never so many genuine lovers of the handicraft as at present.

In the past few years a sympathetic spirit has been awakened in the United States to keep alive this charming aboriginal art and to preserve its precious relics. In every State in

the Union will be found rich collections, both in public and private museums. People of wealth vie with one another in owning them. It almost amounts to a disease, which might be called "canastromania." They resemble the "merchantman seeking goodly pearls, who, when he had found one pearl of great price, went and sold all that he had and bought it." The genuine enthusiasm kindled in the search, the pride of success in the acquisition, the care bestowed upon them, witness that the basket is a worthy object of study. The story is told of a distinguished collector who walked many weary miles to the shelter of a celebrated old weaver. He spent the day admiring her work, but still asking for something better. He knew that she had made finer pieces. At last flattery and gold won. She tore out the back of her hut, and there, hid from mortal eyes, was the basket that was to be burned at her death. Nothing could be more beautiful, and it will be her monument.

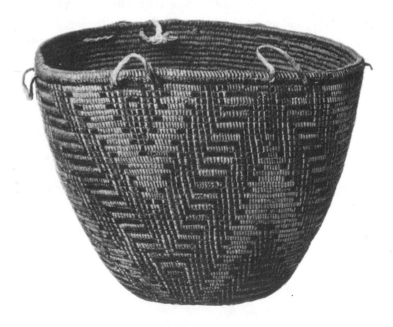

Plate 158. See page 346

COWLITZ (SALISHAN) PACKING BASKET AND KLIKITAT (SHAHAPTIAN)
BERRY BASKET

Both in imbricated decoration

Collected by Charles Wilkes and W. H. Holmes

CONTENTS

CHAPTER | PAGE

Introduction...................................... v

I. Definition of basketry......................... 3
 Kinds of woven basketry................... 6
 Kinds of coiled basketry................... 6
 Vocabulary of basketry.................... 10

II. Materials for basketry......................... 17
 Plants used in basketry (F. V. Coville)........ 19

III. Basket-making 44
 Harvesting materials 45
 Preparing materials....................... 47
 Processes of manufacture.................. 54
 Woven basketry....................... 56
 Coiled basketry 84
 Water-tight basketry................... 104
 Borders on basketry................... 105

IV. Ornamentation on basketry..................... 131
 Form and structure....................... 133
 Shapes of baskets as a whole............ 135
 Mosaic elements in decoration.......... 141
 Designs in decoration.................. 153
 Ornamentation through colour.............. 161

V. Symbolism 178

VI. Uses of basketry............................... 213
 In the carrying industry................... 217
 In defense and war....................... 222
 In dress and adornment................... 223
 In fine art and culture.................... 225
 In preparing and serving food.............. 228
 In gleaning and milling................... 230
 In house-building and furniture............ 238
 In mortuary customs..................... 239
 In relation to the potter's art............. 240
 As a receptacle.......................... 242
 In religion.............................. 244
 In social life............................ 247

CHAPTER PAGE

VI. Uses of basketry—Continued
 In trapping.............................. 248
 In carrying water....................... 249
 Alphabetical list of uses............... 252
VII. Ethnic varieties of basketry.............. 255
 List of basket-making tribes............ 260
 Eastern North America.................. 268
 The Alaskan region 296
 Athapascan coiled basketry......... 296
 Eskimo basketry.................... 301
 Aleutian basketry.................. 312
 Tlinkit basketry................... 317
 Haida basketry..................... 320
 The Fraser-Columbia region............. 336
 The California-Oregon region........... 363
 The Interior Basin region.............. 431
 Shoshonean and Pueblo basketry..... 432
 Athapascan basketry 461
 Middle and South America............... 481
VIII. Collectors and collections............... 501
 Preservation of baskets................ 503
IX. Bibliography 512
 Index.................................. 519

LIST OF ILLUSTRATIONS
PLATES

6. Klamath Indian gambling tray in overlaid twined weaving *Frontispiece*

ON OR FACING PAGE

1. New designs obtruding themselves among the old in coiled basketry................................. I
2. Pima basketry, showing new designs mixed with world-wide and old Indian designs.................... 2
3. Pomo treasure basket of the finest quality............ 26
4. Hazelnut (*Corylus californica*)...................... 26
5. Wolf moss (*Evernia vulpina*)....................... 28
7. Sitka spruce (*Picea sitchensis*)..................... 29
8. Three-leaf sumac (*Rhus trilobata*).................. 36
9. Tule (*Scirpus lacustris*)........................... 37
10. Giant cedar (*Thuja plicata*) 38
11. Klikitat imbricated basket showing use of cedar root.. 39
12. Pomo woman weaving a twined basket............... 54
13. Tlinkit woman weaving a twined wallet.............. 55
14. Checkerwork in cedar bark, showing variety of effects.. 58
15. Cigar-case in fine twilled weaving from Ecuador 59
16. Tray, olla ring, and peach basket................... 60
17. Mohave carrying basket in wrapped weaving.......... 61
18. Aleut women weaving grass wallets in twined work.. 68
19. Baskets in plain twined weaving, showing inside and outside effects—Pomo Indians, California......... 69
20. Baskets in twilled twine weaving.................... 72
21. Old twined jars for seeds and water................. 73
22. Twined baskets in tee or three-strand weave 76
23. Coiled baskets with split stitches................... 77
24. Basket in openwork coiling......................... 92
25. Treasure baskets in coiled weaving and decorated with shell money and quail plumes................. 92
26. Coiled basket with single-stem foundation........... 93
27. Water jar and trinket basket....................... 93
28. Rare old baskets.................................. 96

PLATES—*Continued*

FACING PAGE

29. Fine coiled basket with Bam Shi Bu, or three-rod foundation ... 97
30. Sacred plaques 102
31. Coiled sifter ... 103
32. Water-tight basket jars in twined and coiled weaving.. 104
33. Apache water jar 105
34. Three-strand border on Pomo basket, visible only on the outside .. 112
35. Old Salish imbricated baskets 113
36. Mission Indian coiled bowl 132
37. Tlinkit twined covered baskets 133
38. Gambling plaques from Tulare and Madera counties, California ... 136
39. Ceremonial baskets of the Navaho 137
40. Hats and mush-bowls in coiled ware 138
41. Bottle-neck coiled baskets 138
42. Ollas, or large water jars, of the Apache 139
43. Varied forms of imbricated baskets to suit the function .. 139
44. Twined work, with false embroidery 140
45. Precious old imbricated baskets 141
46. Fine coiled basket of the Washoes 142
47. Sacred plaque 143
48. Klamath old twined bowls 146
49. The finest old coiled Santa Barbara Mission basket jars with covers ... 147
50. Coiled basket bowls of the Pimas 154
51. Skokomish twined wallet with overlaying 155
52. Large Apache olla, designs in rectangles 156
53. Fine coiled bowls 157
54. Tulare and Mono coiled bowls 158
55. Imbricated coiled basket 159
56. Coiled baskets of the Maidu 160
57. Coiled baskets of the Maidu 160
58. Pima coiled bowl 160
59. Coiled bowls of the Pimas 161
60. Old coiled bowls of the Pimas 161
61. Coiled bowl of the Pimas 161
62. Mission Indian coiled bowls 164

PLATES—*Continued*

FACING PAGE

63. Basket bowls of the Pimas........................ 165
64. Chetimacha twilled basket........................ 166
65. Tlinkit modern baskets............................ 167
66. Oregon and California twined basketry.............. 170
67. Tlinkit twined covered jar........................ 171
68. Coiled baskets. Ornament by imbrication............ 176
69. Pomo feathered, or jewel basket.................... 177
70. Pomo feathered, or jewel basket.................... 178
71. Twined wallets of Tlinkit Indians with symbolism in false embroidery................................. 179
72. Twined wallets of Tlinkit Indians with symbolism in false embroidery................................. 190
73. Tlinkit covered twined basket...................... 191
74. Symbolism on Salish basketry...................... 194
75. Symbolism on Salish basketry...................... 195
76. Symbolism on Salish basketry...................... 196
77. Symbolism on Salish basketry...................... 197
78. Symbolism on Salish basketry...................... 198
79. Symbolism on Salish basketry...................... 199
80. Yuki feathered and jewelled basket 200
81. Gift basket of the Pomo Indians.................... 201
82. Symbolism on Washoe baskets...................... 208
83. Tulare bottle-neck treasure basket, showing mixed symbolism 208
84. Symbols on ancient Cliff-Dwellers' coiled basket........ 209
85. Oraibi wicker plaque.............................. 209
86. Aged Hupa basketmaker and burden-bearer, wearing fine hat... 218
87. Sandals of ancient Cliff-Dwellers.................. 219
88. Klamath twined sandal for walking over stony ground ... 224
89. Tulare and Kern coiled cup and jar................. 225
90. Coiled baskets of the Pomo 226
91. Klikitat imbricated water-tight baskets.............. 227
92. Hupa fish tray and mush bowl..................... 228
93. Hopi sacred coiled plaques........................ 229
94. Maidu woman cooking in baskets with hot stones 230
95. Basketwork of Amazon tribes 231
96. Harvesting and milling outfit for acorns............. 234

PLATES—*Continued*

FACING PAGE

97. Pomo twined baskets for harvesting, milling, and serving 235
98. Yokut mush bowl and complete mill.............. 236
99. Klamath Indian outfit for gathering seeds of the Wokas 236
100. Klamath Indian extracting Wokas seeds from the pods 236
101. Klamath Indian outfit for grinding Wokas seeds...... 237
102. Primitive Mohave storage basket.................. 237
103. Hopi basketry case for holding the bridal costume.... 237
104. Ancient mortuary baskets from cave in southeastern Utah .. 238
105. Ancient Peruvian lace work........................ 239
106. Relationship between basketry and pottery.......... 242
107. Twined basketry technic preserved by pottery........ 243
108. Tlinkit twined ammunition holder.................. 244
109. Tlinkit woman's twined work-basket................ 244
110. Decorated baskets in Hopi ceremony................ 245
111. Baskets used in Hupa woodpecker dance............ 245
112. Gift and also wedding baskets of the Pomo Indians.. 246
113. Pomo wedding or jewel baskets, adorned with feathers and shells 246
114. Pomo wedding or jewel baskets, adorned with shell beads and money............................... 247
115. Yokut gambling mat, with dice made of walnuts.... 247
116. Gambling mat and dice from Tulare County, California 248
117. Paiute pitcher and jug for holding and transporting water ... 249
118. Paiutes, of Nevada, carrying water and harvesting seeds 250
119. Algonkin checker and wicker basketry.............. 270
120. Caroline Masta, an Abénaki woman, making checker-work basket.................................... 271
121. Chippewa women making checker and wicker baskets.. 272
122. Twilled matting finished in one day by a Chippewa squaw 273
123. Hexagonal weaving, with twining, on a Mackenzie River snow-shoe..................................... 276
124. Coiled baskets made by Ojibwa Indians about Lake Superior 276
125. Eskimo coiled baskets of grass and sinew.......... 277
126. Openwork coiled basket of the Eskimo.............. 277
127. Coiled gambling basket of the Comanche Indians...... 278
128. Covered coiled baskets in pine straw.............. 279

PLATES—*Continued*

FACING PAGE

129. Coiled and twisted babiche in Dog Rib game-bags...... 280
130. Casts of potsherds showing twined weaving among ancient Mound-builders 281
131. Ojibwa twined wallet in open weaving............... 286
132. Twilled basketry of split cane, made by the Chetimachas 287
133. Fine old twilled baskets of the Chetimachas.......... 292
134. Twilled baskets of cane, made by Choctaw Indians.... 292
135. Twilled baskets of cane, made by Attakapas.......... 293
136. Types of twined and coiled basketwork in Alaska...... 293
137. Twined wallet in openwork, Eskimo................. 302
138. Twined wallet in openwork, Chukchis............... 303
139. Closely twined wallet from Kamchatka to compare with Eskimo work................................. 304
140. Coiled basketwork of Chukchis and Koryaks of Kamchatka .. 305
141. Eskimo basket, showing interlocking coiled work.... 310
142. Twined weaving in close and in openwork twined weaving 311
143. Detail of crossing warp strands in Aleut basket........ 312
144. Attu weaver working upward on soft warp suspended.. 313
145. Aleut Manual Training School; Mrs. Philaset teaching basket-weaving 318
146. Twined wallets, with false embroidery, Tlinkit Indians 319
147. Group of Tlinkit basket-weavers at work............. 324
148. Chilkat blanket done in twined weaving, the patterns set in.................................... 325
149. Old Haida wallets in twined weaving with braid on the borders 330
150. Haida basketmakers, showing upward weaving....... 331
151. Double basketry hats of the ancient Nutkas.......... 334
152. Twilled basket of the Quilleute Indians.............. 335
153. Nutka or Makah women making wrapped twine weaving 336
154. Varieties of technic practised by Salish women........ 336
155. Varieties of technic practised by Salish women........ 337
156. Coiled and imbricated baskets with covers........... 337
157. Coiled baskets imbricated and beaded............... 344
158. Cowlitz (Salishan) packing basket and Klikitat (Shahaptian) berry basket, both imbricated decoration.. x
159. Old Klikitat baskets, showing little imbrication...... 345

PLATES—*Continued*

FACING PAGE

160. Imbricated Klikitat baskets, highly decorated....... 348
161. Imbricated basket with open border 349
162. Twined and overlaid Quinaielt Salish baskets........ 356
163. Twined and imbricated work, showing detail.......... 357
164. Twined and overlaid carrying wallets of the Skokomish
 Salish Indians 358
165. Twined wallets of Clallam and Tillamuk Salish........ 358
166. Openwork twined wallets......................... 359
167. Women's hats in twined basketry, Nez Percé and Modoc
 compared 359
168. Wasco twined wallets, designs in wrapped weaving.... 362
169. Wasco twined wallets, called "Sally Bags".......... 363
170. Hupa granary baskets, twined and overlaid.......... 374
171. Shasta Indian basketmaker in the midst of her work .. 375
172. Baskets made from hazel stems.................... 376
173. Unfinished Pomo basket in Tee weave, showing technic 377
174. Three-strand twined baskets, Klamath Indians........ 394
175. Pit River twined baskets......................... 395
176. McCloud (Wintun) twined baskets 398
177. Twined basketry of the Hat Creek Indians, with designs
 in overlaying.................................. 398
178. Twined basketry of the Hat Creek Indians, with designs
 in overlaying.................................. 399
179. Washoe coiled basket bowls....................... 399
180. Fine coiled basket of the Washoes, design representing
 sunrise....................................... 400
181. Datsolalee, the Washoe basketmaker 401
182. Eastern Californian coiled baskets 402
183. Coiled bowls of the Panamint Shoshonean Indians 403
184. Tulare and Kern bowls........................... 410
185. Tejon bottle-neck and Yokut bowl, Fresno type 411
186. Yokut coiled basket bowl, with stepped designs radiating 412
187. Tulare coiled jar................................ 413
188. Coiled baskets of Kern and Tulare Counties for study
 in designs.................................... 414
189. Coiled baskets from Tulare County, showing char-
 acteristic patterns............................. 415
190. Group of coiled baskets, chiefly Tejon.............. 416
191. Coiled baskets, Kern and Tulare types, California...... 417
192. Coiled baskets, from Caliento Creek and Paiute
 Mountain, Cal. 418

PLATES—*Continued*

FACING PAGE

193. Bottle-neck coiled bowl, trimmed with feathers...... 419
194. Bottle-neck coiled bowl, with butterfly flight design.. 420
195. Apostle basket, flat top bottle-neck, California........ 421
196. Openwork coiled "Grasshopper" baskets 424
197. Mission Indian coiled bowl, showing charming shades of the material............................... 425
198. Mission Indian designs on basketry, original and borrowed 428
199. Mission Indian coiled bowl........................ 428
200. Detail of Mission Indian coiled bowl, coiling, decorating, bordering, and fastening off................... 429
201. Ancient coiled bowls in Peabody Museum............ 429
202. Ancient coiled baskets in Peabody Museum.......... 430
203. Rare old twined sack............................. 431
204. Water bottles in close and in open twined weaving.... 442
205. Coiled basketry of ancient basketmakers 443
206. Coiled basketry of ancient basketmakers 444
207. Coiled plaque of the ancient basketmakers 444
208. Coiled bowl of the ancient basketmakers 444
209. Coiled bowls of the ancient basketmakers 445
210. Food vessels of the ancient basketmakers 445
211. Hopper for mortar, ancient basketmakers'. 445
212. Sia ancient coiled baskets......................... 446
213. Old wicker and twined baskets from the Pueblo of Zuni 447
214. Old coiled baskets, Pueblos of Zuni and Sia........... 450
215. Hopi women making wicker and coiled basket trays.... 451
216. Hopi sacred coiled plaques in which the symbols are reduced to lowest terms....................... 454
217. Tewan Pueblo woman, on the Rio Grande, winnowing seeds ... 455
218. Old twined and coiled baskets from the Hopi Pueblo of Oraibi ... 456
219. Fragment of ancient wicker basket, Arizona.......... 457
220. Fragments of twilled and coiled basketry............ 458
221. Ancient wicker and coiled basketry from ruins in Arizona ... 459
222. Ancient coiled ware from ruins in Arizona............ 460
223. Ancient coiled and braided ware in mortuary uses...... 461
224. Coiled basketry of the Apache, showing borrowed designs 462
225. Apache coiled bowls.............................. 463
226. Coiled bowls of the White Mountain Apache.......... 466

PLATES—*Continued*

FACING PAGE

227. Mescalero coiled baskets........................... 467
228. Ceremonial baskets of the Navaho, Arizona.......... 470
229. Coiled basket of the Kohonino, showing method of finishing off...................................... 470
230. Havasupai coiled bowls............................ 471
231. Coiled baskets of the Chemehuevi, Arizona 471
232. Pima Indian carrying frame........................ 472
233. Old coiled bowl of the Pimas. Designs in complex fretwork .. 473
234. Coiled bowls of the Pimas, Arizona 478
235. Pima basketmaker at work in front of her dwelling.... 479
236. Covered plume basket, Tarahumara Indians.......... 482
237. Yaqui covered baskets in double twilled weaving...... 483
238. Indian basketmaker standing in front of her plant 486
239. Twilled basketry of the Arawak Indians............. 487
240. Different forms of carrying baskets of Brazilian tribes 488
241. Different forms of carrying baskets of Brazilian tribes 489
242. Ecuador, or Panama, hat of palm leaf in checker weaving .. 492
243. Ancient work-basket of Peruvian spinner in fine wool 493
244. Peruvian ancient carrying frame.................... 496
245. Fragment of ancient coiled basket, found in copper mine, Chile.................................... 497
246. Ancient coiled basket from copper mine in Chile....... 498
247. Ancient coiled baskets from copper mine in Chile..... 499
248. Modern coiled basket in openwork, Peru............ 500

TEXT FIGURES

PAGE

1. Mud shoes, Klamath Indians, California.............. 45
2. Coarse checkerwork................................. 56
3. Fine checkerwork................................... 56
4. Open checkerwork 57
5. Twilled work...................................... 57
6. Twilled work...................................... 57
7. Ancient twilled work, Alabama...................... 59
8. Ancient twilled work, Tennessee..................... 59
9. Twilled weaving, Cherokee Indians, North Carolina.... 61
10. Wicker basket, Zuñi, New Mexico................... 62

TEXT FIGURES—*Continued*

PAGE

11. Close wickerwork, Hopi Indians, Arizona............ 63
12. Twilled and wicker mat, Hopi Indians, Arizona........ 64
13. Wrapped weaving, Mohave Indians, Arizona.......... 66
14. Wrapped weaving, from mound in Ohio.............. 67
15. Plain twined weaving............................. 68
16. Openwork twined wallet, Aleutian Islands........... 70
17. Twined openwork, Aleutian Islands................. 71
18. Crossed warp, twined weave, Makah Indians, Washington 71
19. Diagonal twined weaving, Ute Indians, Utah........ 72
20. Diagonal twined basketry, Pomo Indians, California 72
21. Wrapped twined weaving.......................... 73
22. Wrapped twined weaving, Makah Indians, Washington 74
23. Detail of mixed twined weaving (outside)............ 75
24. Detail of mixed twined weaving (inside)............ 75
25. Variety in twined weaving (outside)................ 76
26. Variety in twined weaving (inside)................. 76
27. Tee or lattice-twined weaving, Pomo Indians, California 77
28. Three-strand braid and twined work (outside)........ 77
29. Three-strand braid and twined work (inside)........ 77
30. Basket-jar in three-strand twine, Hopi Indians, Arizona 79
31. Three-strand and plain twined weaving.............. 80
32. Three-strand braid, (a) outside, (b) inside.......... 80
33. Carrying-basket, three-strand braid, Klamath Indians,
 Oregon....................................... 81
34. Warp stems crossed in pairs....................... 83
35. Warp stems crossed in fours....................... 83
36. Sixteen stems woven in fours....................... 83
37. Warp stems crossed in fours and twined.............. 83
38. Six warp stems parallel............................ 84
39. Warp stems crossed in threes; held by wicker........ 84
40. Bone awl for coiled basketry...................... 85
41. Cross-sections of varieties in coiled basketry.......... 89
42. Carrying basket, Pima Indians, Arizona............ 90
43. Detail of interlocking stitches..................... 90
44. Foundation of three rods laid vertically, Mescalero
 Apache Indians................................ 91
45. Detail of figure 44................................ 92
46. Detail of single-rod coil in basketry................. 92
47. Foundation of two rods, vertical................... 94

TEXT FIGURES—*Continued*

PAGE

48. Rod and welt foundation........................... 95
49. Water-jar in coiled basketry, Wolpi, Arizona.......... 95
50. Foundation of three rods, stitches catching rod underneath. .. 97
51. Foundation of splints............................... 98
52. Imbricated work detail, called Klikitat.............. 98
53. Imbricated coiled work, called Klikitat.............. 99
54. Imbricated basketry detail, Thompson River........ 99
55. Overlaying in coiled work.......................... 101
56. Foundation of straws in coiled work................ 101
57. Coil with open sewing, inclosing parts of foundation.. 102
58. Foundation of grass or shredded materials.......... 102
59. Fuegian coiled basket, and details.................. 103
60. Coiled border on checker weaving.................. 107
61. Weft and warp fastened down with twine, (a) front, (b) back..................................... 108
62. Three-strand warp border in wickerwork 109
63. Border made by weaving warp rods in pairs.......... 109
64. Single-strand coiled border, Moravian Settlement, North Carolina..................................... 110
65. Braided border from warp.......................... 110
66. Twined wallet, Quinaielt Indians, Washington........ 112
67. Single-strand twined border, Pomo Indians.......... 112
68. Three-strand twined border........................ 113
69. Border of Hupa twined basket...................... 113
70. Wrapped warp border, Zuñi, New Mexico............ 114
71. Border of Paiute twined basket..................... 114
72. Three-strand warp border, Pomo Indians............ 115
73. Two-strand twine, onlaid for border, Tlinkit Indians.. 116
74. Three-strand braid woven in for border, Tlinkit Indians 118
75. Border of braid, onlaid, Tlinkit Indians.............. 118
76. Border of turned-down warp with two-strand twine, Tlinkit Indians............................... 119
77. Border of four-strand braid, turned-down warp, Tlinkit Indians..................................... 120
78. Border of four-strand braid onlaid, warp turned down, Tlinkit Indians................................ 120
79. Border inclosing hoop, Tlinkit Indians.............. 121
80. Border of three-strand braid, Tlinkit Indians........ 121

TEXT FIGURES—*Continued*

PAGE

81. Mixed 'twined work, Haida Indians, British Columbia 123
82. Simple coil border, Paiute Indians, Utah............ 124
83. Simple wrapped border............................ 124
84. Three-strand coiled border, Hopi, Arizona.......... 125
85. Detail of figure 84............................... 125
86. Single-strand plaited border...................... 126
87. Single-strand plaited border, Havasupai Indians,
 Arizona..................................... 126
88. Plain coiled border on bark vessel................ 127
89. Coil-and-knot border on bark vessel 127
90. Plain coiled border on bark vessel..:............. 129
91. Coil-and-knot border on bark vessel.............. 129
92. Checker ornament in two colours.................. 144
93. Amazonian basket decorations in checker.......... 144
94. Twilled work in two colours...................... 145
95. Diaper twilled work in two colours................ 146
96. Diagonal twilled ornament, British Guiana........ 146
97. Human figures in twined weaving, ancient Peru.... 148
98. Design on coiled bowl, Tulare Indians............. 149
99. Detail of figure 98 150
100. Pima carrying frame, southern Arizona............ 153
101. Wrapping weft fillets with darker ones............. 171
102. Beading on twined work, Klamath Indians.......... 172
103. Beading on coiled work, Clallam Indians, Washington 173
104. Overlaid twined weaving......................... 174
105. Breast-band for hauling, Zuñi, New Mexico 219
106. Carrying frame, Papago Indians, Mexico............ 220
107. Twined cradle, Hupa Indians..................... 221
108. Stick armour twined together, California........... 222
109. Ceremonial basket, Hupa Indians, California........ 246
110. Ash log for making splints, Menomini Indians........ 271
111. Wooden mallet for loosening splints............... 272
112. Basketmaker's knife of native workmanship........ 272
113. Coil of basket strips............................ 273
114. Finished wicker basket........................... 274
115. Coiled basketry, Hopewell Mound, Ohio............ 280
116. Coiled basketry, Hopewell Mound, Ohio............ 280
117. Wickerwork from cave in Kentucky................ 281

TEXT FIGURES—*Continued*

		PAGE
118.	Charred fabric from mound	282
119.	Charred fabric from mound	282
120.	Twined fish trap, Virginia Indians	284
121.	Twined weave from ancient pottery, Tennessee	287
122.	Twined weave from ancient pottery, Tennessee	287
123.	Detail of twilled basketry border, Choctaw Indians, Louisiana	290
124.	Border of twilled basketry, Choctaw Indians, Louisiana	290
125.	Twilled basket, Arikara Indians	293
126.	Ancient twilled matting, Petit Anse Island, Louisiana	295
127.	Coiled work-basket, Tinné Indians, Alaska	297
128.	Coiled work-basket, Tinné Indians	298
129.	Coiled work-basket, Tinné Indians	299
130.	Coiled work-basket, Tinné Indians	300
131.	Detail of coiled basket	301
132.	Tobacco basket, Hupa Indians, California	302
133.	Detail of Eskimo twined wallet	303
134.	Coiled basket, Eskimo Indians, Alaska	306
135.	Bottom of figure 134	307
136.	Detail of Eskimo coiled basket	308
137.	Twined basket wallet, Tlinkit Indians, Alaska	321
138.	False embroidery, Tlinkit Indians, Alaska	322
139.	Detail of false embroidery	323
140.	Carrying wallet, Tlinkit Indians, Alaska	324
141.	Twined and wicker weave, Tlinkit Indians, Alaska	325
142.	Wallet, Chilkat Indians, southeastern Alaska	326
143.	Hat in fine twined weaving, Haida Indians, British Columbia	327
144.	Detail of figure 143	327
145.	Twined openwork basket, Haida Indians	328
146.	Detail of figure 145	328
147.	Unfinished basket, Haida Indians	329
148.	Virginia Indian woman weaving a basket	330
149.	Detail of wrapped basket, Clallam Indians	332
150.	Wrapped twined basket, Makah Indians, Cape Flattery	333
151.	Bottom of Makah basket	334
152.	Detail of Nutka hat	335
153.	Cross-section of Nutka hat	335
154.	Checkerwork basket, Bilhula Indians, British Columbia	338

TEXT FIGURES—*Continued*

PAGE

155. Coiled and imbricated basket...................... 344
156. Imbricated basket, Yakima Indians, Washington.... 351
157. Imbricated basket, Cowlitz Indians................ 352
158. Twilled basketwork, Clallam Indians, Washington.. 353
159. Water-tight basket, Clallam Indians, Washington.... 355
160. Detail of figure 159.............................. 356
161. Twined wallet, Nez Percé Indians, Idaho........... 360
162. Detail of figure 161.............................. 361
163. Linguistic map of California...................... 366
164. Old feathered baskets from Oregon................. 372
165. Tiny coiled basket, Pomo Indians.................. 390
166. Tiny coiled basket, Pomo Indians.................. 390
167. Coiled basket, Hoochnom Indians, California........ 391
168. Detail of figure 167.............................. 392
169. Twined basket bowl, Klamath Indians, Oregon...... 393
170. Detail of figure 169.............................. 395
171. Carrying basket, McCloud River Indians, California.. 397
172. Grasshopper basket, Wikchumni Indians, California.. 421
173. Detail of figure 172.............................. 422
174. Coiled bowl, Coahuilla Indians, California.......... 426
175. Inside view of figure 174......................... 427
176. Square inch of figure 174......................... 428
177. Coiled bowl, Coahuilla Indians, California.......... 429
178. Twined basket, Diegueños Indians, California....... 430
179. Woman's hat, Ute Indians, Utah................... 434
180. Harvesting fan, Paiute Indians, Utah.............. 435
181. Harvesting fans, Paiute Indians, Utah............. 436
182. Gathering basket, Paiute Indians, Utah............ 437
183. Bottom of figure 182............................. 438
184. Border of figure 182............................. 438
185. Carrying basket, Paiute Indians, Utah............. 439
186. Roasting tray, Paiute Indians, Utah............... 440
187. Coiled jar, Paiute Indians, Utah.................. 441
188. Square inch of figure 187......................... 442
189. Coiled basket jar, Zuñi Indians, New Mexico........ 451
190. Coarse wickerwork, Hopi Indians, Arizona.......... 455
191. Ancient basketry gaming wheel, Pueblo Indians..... 458
192. Coiled bowl, Coyotero Indians, Arizona............ 464
193. Basket jar, Apache Indians....................... 465

TEXT FIGURES—*Continued*

		PAGE
194.	Coiled basket bowl, Apache Indians	466
195.	Coiled plaque, Navaho Indians	467
196.	Sacred basket tray, Navaho Indians	468
197.	Border of figure 196	469
198.	Gourd in coiled network, Pima Indians, Arizona	473
199.	Coiled bowl, Pima Indians	475
200.	Coiled bowl, Pima Indians	476
201.	Coiled bowl, Pima Indians	477
202.	Coiled bowl, Pima Indians	478
203.	Coiled granary, Pima Indians	479
204.	Carrying net, Araucanian Indians	490
205.	Carrying net, Chiriqui, Colombia	491
206.	Detail of figure 205	492
207.	Ancient Peruvian work-basket	497
208.	Detail of figure 207	498
209.	Detail of a Peruvian basket	498
210.	Detail of a Peruvian basket	498
211.	Detail of a Peruvian basket	498
212.	Ancient coiled basket from Chile	499

Plate 1. See page 8

New Designs Obtruding Themselves Among the Old in Coiled Basketry

Photograph from A. C. Vroman

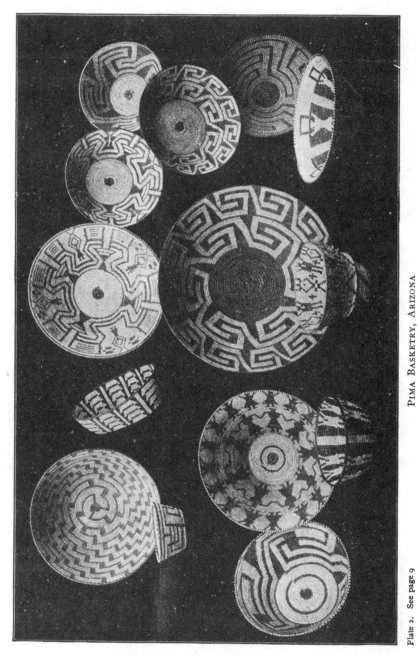

PIMA BASKETRY, ARIZONA

Showing new designs mixed with world-wide and old Indian designs

Collection of J. W. Benham

Plate 2. See page 9

INDIAN BASKETRY

Studies in a Textile Art Without Machinery

CHAPTER I

DEFINITION OF BASKETRY

A place for everything.—FRANKLIN.

BASKETRY is the mother of all loom work and bead-work. In that elaboration of industries through which they pass from naturism to artificialism, from hand-work to machine work, from human power to beast power, wind power, water power, steam or fire power, and electric power, the loom is no exception. The first and most versatile shuttles were women's fingers. Machinery has added speed. But there are many niceties of technic to which the machine device can not yet aspire.

Over and above the sympathetic spirit engendered and the kind encouragement given to exquisite and most worthy artists by the collection of basketry, the study is a very important one from the side of culture. It is the alpha of an art in which billions of capital are invested, millions of human beings are employed, whose materials and products are transported to earth's remotest limits, whose textures are sought by every tribe of mankind. It is from this last point of view that the present work is written.

The praises of men who invented the cotton-gin, the power loom, and the tapestry loom will be repeated, and monuments erected to memorialise those who harnessed the forces of nature to do their bidding. Here a good word is said for the earlier, more primitive women who made the others possible.

3

It is true that pride in the ownership of an exquisite piece of work may be joined with frigid indifference toward the maker. It is to be hoped that with admiration of American basketry may be coupled a humane feeling for Indian women themselves, who have made so much genuine pleasure possible.

American basketry, ancient and modern, may be studied under the following subdivisions:

I. Definition of the art, its materials, tools, processes, and products.

II. Materials for basketry, with lists of plants, animals, and minerals, including the Indian name, common names, and scientific names.

III. Basket-making or construction.
Harvesting materials, with account of tools and apparatus.
Preparing materials, including the tools and processes, peeling, splitting, making splints, shredding, soaking, cleaning, yarning or twisting, twining, braiding, gauging, and colouring (dyeing).
Processes of manufacture—tools, apparatus, and patterns.
Braiding, checkerwork, wicker, twilled, wrapped woof, twined, and coiled, and checks, decussations, meshes, and stitches. Women at work.

IV. Ornamentation on basketry.
1. Forms and structure in baskets.
2. Mosaic elements in decoration.
3. Design in technic and colour.

V. Symbolism, also absence of, and meanings.

VI. Uses of basketry.

VII. Ethnic varieties and culture provinces, ancient and modern. Indian names.

VIII. Collections, public and private.

IX. Bibliography.

For convenience, American basketry may be compared in the following-named regions:—

1. Eastern region: Canada, Eastern States, Southern States, Western States.

2. Alaskan region: Interior Alaska, Arctic Alaska, Aleutian Chain, southeastern Alaska, Queen Charlotte Archipelago.

3. Fraser-Columbia region: Fraser drainage, Columbia drainage.

4. Oregon-California region: Southern Oregon, California.

5. Interior Basin region: Between Rocky Mountains and the Sierras.

6. Middle and South American region: Mexico, Central America, eastern and western South America.

These regions must be regarded only as convenient divisions for reference. The last named is a measure of ignorance, rather, for it could easily be divided into half a dozen regions. Again, before the balance of savagery had been violently disturbed by the discovery of the hemisphere, there were migrations of native blood and speech and arts. Basketry further on will be witness to many of these.

Basketry is differentiated from network by the fact that the meshes of the latter are not formed by decussations, but by knots; and from loom products, not only by the material, which is usually less rigid, but by the workmanship, which is done by machinery. Needlework is approached in coiled basketry, and beadwork borrows from all weaves. No wide gulf separates the different varieties of textiles, however, beginning with such coarse products as brush fences and fish weirs and ending with the finest lace needlework.

In form, basketry varies through the following classes of objects:

1. Flat mats or wallets, generally flexible.

2. Plaques or food plates, which are slightly concave. These occur in quality ranging from that of the coarsest sieve to that of the sacred meal tray.

3. Bowls for mush and other foods and for ceremonial purposes, hemispherical in general outline.

4. Pots for cooking, with cylindrical sides and rounded or flat bottoms. These vary into cones, truncated cones, and trough-shaped baskets.

5. Jars and fanciful shapes, in which the mouth is constricted, frequently very small, and now and then supplied with cover. They are spindle-shaped, pyriform, napiform, and, indeed, imitate fruits known to the natives. The influence of civilisation in giving modern shapes to basketry has not always been beneficial to this class of forms.

W. H. Holmes, writing of the transition from service to decoration, speaks of form in and on basketry as (1) functional and essential only, (2) functional and esthetic combined, and (3) as suprafunctional and wholly esthetic.

There are two distinct types of technic in basketry, namely, (1) hand-*woven* basketry, which is built on a warp foundation, and (2) sewed or *coiled* basketry, which is built on a foundation of rods, splints, or straws.

Kinds of Woven Basketry

A. Checkerwork: The warp and the weft having the same width, thickness, and pliability.

B. Diagonal, or twilled basketry: Two or more weft strands over two or more warp strands.

C. Wickerwork: Inflexible warp; slender, flexible weft.

D. Wrapped weft, or single weft wrapped: The weft strand is wrapped, or makes a bight about the warp at each decussation, as in the Mohave *Kiho*.

E. Twined or wattled basketry: Weft of two or more elements.

Kinds of Coiled Basketry

A. Coiled work without foundation.

B. Simple interlocking coils.

C. Single-rod foundation.

D. Two-rod foundation.

E. Rod-and-welt foundation.

F. Two-rod and splint foundation

G. Three-rod foundation.

H. Splint foundation.

I. Grass-coil foundation.

K. Fuegian coiled basketry (See p. 103.)

These will be described at length in the proper places.

In basket-making there are several characteristics to be observed which will enable one to classify the objects and to refer them to their several tribal manufacturers. These characteristics are the material, the framework, the methods of weaving, the coiling or sewing, the border, the decoration, the use, etc.

The tool almost universally employed in the manufacture of coiled ware is a bone awl or pricker. Of the manipulation of the material previous to the weaving little is known.

In some of the technical drawings accompanying this work the actual size of the specimens is indicated by a series of inch marks in the margin. The inches on the standard line are shown by spaces between dots. In order to indicate exactly the manner of weaving, a rectangle, usually an inch in dimension, is taken from a portion of the surface wherein all the methods of manipulation occur. This part is enlarged sufficiently to make the structure comprehensible. This plan enables one to show form and ornamentation in the whole figure, as well as the method of treatment in the enlarged inch.

The writer is indebted to a large number of friends in various parts of the United States, especially on the Pacific slope, who have given him access to their valuable collections, furnished information, and sent photographs. Especial thanks are due to F. V. Coville for writing the chapter on plants, to William H. Holmes for advice in matters of ornamentation, and to C. Hart Merriam for privilege of studying the precious collection made by him. Many friends who have generously given their special knowledge and supplied photographs and illustrations will be mentioned in the proper place. At the same time he would express his admiration of their zeal and generosity, through which the Sibylline leaves of an almost lost chapter in human industrial history has been rescued from oblivion.

With a few exceptions, the makers of baskets are women.

In the division of labour belonging to the lowest stages of culture the industrial arts were fostered by women, the military and aggressive arts by men. It is a well-known rule in these first stages of progress that, with few exceptions, the user of an implement or utensil was the maker of it. There are people on the earth among whom the men are the basketmakers. Indeed, for ceremonial purposes, our own Indian priests or medicine men are frequently the makers of their own basket drums, etc.

As soon as the products of this art entered into the world's commerce, and uncanny machinery was necessary for the manufacture, the art of basket-weaving passed from the hands of its foster mothers and became man's work, but in the Western Hemisphere almost exclusively the basketmakers have been women.

It is a matter of profound regret that already over much of the United States the art has degenerated, or at least has been modified. In methods, forms, and colours truly, old things have passed away, and, behold, all things have become new. But proof is forthcoming that the contrary is true in some places. The Hyde Expedition and other associations have made determined efforts to resist the demoralising influences of trade.

This process of extinction has gone on with differing rapidity in the several areas. Nothing ancient in mechanical processes, in form, and in design can be predicated of the basketry sold at summer resorts. The trees are felled by the white man and the trunks divided into ribbons by his latest machinery. The Indian woman uses a steel gauge to regulate the width of her weft, steel awls for sewing. Even in western ware the demand and influence of mercenary motives drown the cry of the ancient spirit in the lowly artist. Plate 1 will show the conflict for preëminence between the old and the new. Dogs and horses are mingled with designs older than the Discovery. (See also Plates 42, 168.)

But it is not alone the unrefined public who eliminate the delightful classic from the decoration of basketry; men and women with the most exalted motives have for centuries substituted European and Asiatic forms for aboriginal in basketry. Plate 2 is worthy of notice in this regard. Eliminate the human figures altogether as realistic and as without standing in an art whose designs are preëminently symbolical. The other figures are divided into two series, those bearing some suggestion of ancient patterns and those covered with classical fretwork as the underlying motive, which then runs wild with savage freehand. (See also Plates 50, 58, 233.)

The reason for the genuine unspoiled art of the tribes in northwestern California is given by Carl Purdy. The Franciscan fathers who built the missions in the central and southern portions of the State never penetrated those wilds; the traders of the Hudson's Bay Company, whose presence and traffic changed the arts of other Indians so profoundly, did not come so far south, and Mexican soldiers were driven out of the country. It was not until settlers in the middle of the last century began to maltreat the Indians that bloody conflicts arose which resulted in their present status, but, fortunately, those pioneers had no interest in baskets, and probably did not notice them. There are in possession of old families in the eastern States baskets sent home by the Forty-niners that now are worth their weight in gold. The forms and designs on these are similar to many still made. This indicates that the art has kept its old-time purity.

It must be distinctly understood that many basket-making Indians are not now in their priscan homes. Besides the migration occasioned by the ordinary motives operating on the minds of the savages, the rapid intrusion of white settlers and the strong arm of the Government have hastened such movements. For our purposes, these compulsory migrations must be noted, specially in the case of basketmakers. For example, on the Round Valley reservations in northern Cali-

fornia are the Concow (Pujunan); and from the eastern side of the Sacramento Valley, the Nomelakki and Wailaki (Copehan), Little Lakes (Kulanapan), Ukie (Yukian), and Pit Rivers (Palaihnihan), belonging to five absolutely different linguistic families. Now, in a collection of baskets from Round Valley, one must not be surprised to find shapes, uses, decorations, and names for the same form or part or design extremely varied and mixed.

The author is aware that he has come far short of doing justice to his theme. Omissions will be noticed, and it is feared that some references of work to the wrong band or tribe have been made. This is unavoidable in a great museum. It is only in such rare collections as have been gathered with one's own hands that errors can be avoided.

Vocabulary of Basketry

So much is said and written on the subject of Indian basketry that a vocabulary is desirable. On some terms all are even now agreed. All things considered, words in common use should be adopted. There are, as before mentioned, two absolutely different kinds of technic employed, dividing basketry into *woven* and *coiled*. The former leads to the loom, the latter to the needle. It is not correct to speak of warp and weft in the latter—only in the former; the parts of coiled basketry are the *foundation* and the *sewing*. The following terms and definitions are suggested, not arbitrarily, but subject always to amendment and common consent. Words from Indian languages are purposely omitted. A few of them, however, ought to be retained, such as "tee," for the Pomo twined weaving:

Basket.—A vessel or receptacle in textile material; a technic product resembling this.

Basketry.—A general term including (1) basket-making, the process or art; (2) basketwork, the technic or stitches, any textile motive resembling work in baskets; (3) basket-ware, a collection of finished products.

Beading.—A strip of bark or a splint run in and out through the spaces in woven or among the stitches in coiled basketry.

Braidwork.—Fabric in which three or more elements are braided, as in some three-strand twined basketry. See *False braid.* Preferred to the word plaited. There may be flat, round, or square braid. The term sennit is also allowable.

Button-hole stitch.—A series of half stitches, as in Fuegian coiled basketry.

Check.—Where warp and weft cross.

Checkerwork.—Basketwork in which the warp and weft are equally flexible, and the checks are square, or at least rectangular.

Chevron.—V-shaped ornament, in which two or more coloured lines meet at an angle; for example, the device on the sleeve of a non-commissioned officer. (See *Herringbone* and *Zigzag.*)

Chinking.—Soft materials between hard stems in the foundation of coiled basketry.

Coil.—An element in basketry ornamentation. The varieties are plain coil, reversed coil, loop coil, continuous loop coil.

Coiled basketry.—Type of basketwork in which a foundation of hard or soft material, arranged in a spiral, is held together by means of over-and-over sewing.

Crossed warp.—Type of basketwork in which two sets of warp cross each other at an angle—for interlacing weft, for seizing or wrapping (Makah), or for twined weaving, common in Attu wallets.

Decussations.—Crossing of warp at acute angles.

Diagonal weaving.—Passing weft over two or more warp elements, but not the same in adjoining rows. Used here chiefly of twined weaving, to distinguish it from twilled weaving with single weft element; also running the weft at an angle, as in matting.

Diaper.—A surface decoration which shows a pattern by the relief or direction of warp and weft.

Designs.—Figures and patterns used in the ornamentation of basketry. Must not be confounded with *Symbol.*

Embroidery.—Ornamentation added after the basket is finished. (See *False embroidery.*)

Faggoting.—Same as *Hemstitch.*

False braid.—An appearance of braidwork on the margin of a basket made with a single splint in ball stitch or "racking-seizing."

False embroidery.—An appearance of embroidery made on Tlinkit and other twined ware by wrapping the strands on the outside with coloured material in the process of weaving.

Fiber.—A flexible substance composed of filaments such as cedar bark, wild hemp, etc.

Frap.—To bind one element about another.

Fret.—The Greek ornament occurring in endless variety on basketry.

Furcate.—Said of stitches in coiled sewing intentionally and symmetrically split—bifurcate, trifurcate, etc.

Fylfot.—Ornament imitating a Greek cross with arms extended at right angles, all in the same direction; called also Swastika.

Gorrita.—The shallow basket bowl of the Pimas and other southwestern tribes.

Hemstitch.—Drawing warps together in groups of two or more and holding them by twined weavings. Seen in Aleutian openwork wallets. Called also *faggoting.*

Herringbone.—Basketry designs in which chevron patterns are in parallel series.

Herringbone border.—On coiled basketry, a finish in which with a single splint the appearance of 3-ply braid is given. (See *False braid.*)

Hitched weft.—Basketwork in which the weft makes a half hitch about each warp element. In coiled work it would be hitched sewing, same as button-hole stitch.

Hurdle.—A coarse form of basketwork in brush and trees for hunting and fishing purposes.

Imbricated ornament.—Coiled basketry in which a strip of soft material is folded back and forth over the stitches, overlapping like shingles on a roof or the folds in knife plaiting. Klikitat and Fraser River basketry are imbricated.

Impacted.—Driven close together, as the weft or stitches in basketry.

Inset.—A pattern worked separately into a basket. The Chilkat blankets are thus woven.

Interlacing.—The crossing and intertwining of parts, as in woven baskets and borders.

Knife plaiting.—See *Imbricated ornament.*

Lattice weaving.—Basketwork in which a frame of rods crossing at right angles is held together by wrapping the intersections with a single splint or ribbon, as in Makah basketry, or by a twined weft, as in the Pomo Tee weaving.

Multiple coil.—The foundation of coiled basketry made up of filaments, grass stems, or splints.

Muskemoot.—Loucheux netted bags of babiche. Coiled work without foundation.

Meander.—Crossed frets in basketry ornament.

Oblique weaving.—Chiefly in matting, where the weaving begins at one corner. Also oblique weft. Charming beadwork is thus made.

Osier.—Basket materials prepared from small stems of willow or similar plants. Shoots of dogwood (*Cornus stolonifera*) are called red osier.

Overlaying.—Laying a split straw or other coloured material on a tough weft splint or sewing-material in basket-making, to take the place of coloured bark. If the two are not twisted on each other, the figure does not show inside the basket.

Padding.—Soft material in the foundation of coiled basketry, helping to make the structure water-tight. (See *Chinking.*)

Pentacle.—In basket ornament, a 5-pointed star, whose lines inclose a pentagon.

Pierced warp.—The form of weaving in cattail and other

soft material when the weft strings pass through the warp. The warp stems are strung on the weft strings.

Ply.—Warp is two-ply when one of its filaments stands in front of the other. Used in weaving double baskets, or to bring the glossy side of the strands or splints outward, both on the right side and the wrong side.

Radial warp.—The arrangement of warp elements or spokes in the bottom of a cylindrical basket. They may be (1) crossed, (2) cut away, or (3) inserted. Radial patterns or designs are such as proceed from the central portion of a bowl-shaped basket outward to the border.

Scrollwork.—Imitation of art scroll on basketry. It is usually angular.

Sewing.—The joining of parts with an awl and splint. Coiled basketry is sewed, not woven.

Shoots.—The young and pliable growth of plants in the first year. Rough shoots, prepared shoots, and split shoots are used.

Shreds.—Irregular strips of plants used in foundations of coiled baskets.

Spiral.—Term applied in basket-making and decoration (1) To the whorled coil, wound about a center and receding, as in Hopi plaques, *flat spiral;* (2) to the helical coil, winding on a cylinder, *cylindrical spiral,* as in coiled jars; (3) to the conical coil, rising in a cone, *conical spiral.*

Splint.—In basketry, a long strip of split wood, uniform in width and thickness, for weaving or sewing materials. Often the term is more loosely applied to the split pieces that make up the foundation of coiled work.

Spoke.—Term sometimes applied to each of the elements in radiating basket warp.

Stalk.—The stems of reeds, grass, cattails, etc., for basket materials.

Stitches.—The separate elements in sewing coiled basketry. They may be close or open, whole or split (furcate), and interlocked.

Strand.—One of the elements of the warp or weft in basketry, which may be two-strand, three-strand, etc., when two or more are used.

Strip.—A narrow ribbon of leaf or other thin basket material answers in function to the harder splints.

String.—Two or more small yarns twisted together. The warp of twined wallets is of strings.

Symbol.—The meaning of a design on a basket. Care must be exercised in the use of this word. Only the maker of the design knows the symbol or meaning.

Tessellate.—Inlaid, as in checkered mosaic. The checks and stitches as well as the designs in baskets have a tessellate appearance.

Twine.—To bend something around another object. In basketry, to make twined ware in any of its varieties, plain, twilled, wrapped, latticed, three-strand, etc.

Warp.—The elements of woven basketry on which the fabric is built up; may be single or multiple, one-ply, two-ply or more, and laid parallel, decussated, latticed, radiated, zigzag, etc.; also a single one of these. (See *Spoke.*)

Wattling.—Coarse fence or fish weir in wicker or twined basketry.

Weft.—The filling of woven basketry, same as woof.

Weftage.—The texture of woven basketry.

Whip or *whipstitch.*—To sew with an overcast stitch, with long wrapping stitches. The sewing of coiled basketry may be so called. Borders of baskets are often whipped on.

Wickerwork.—Weaving in which the warp is rigid and the weft flexible.

Wind.—To wrap one element about another. Same as *Frap.* In Thompson River wallets, the twined weft is wound or frapped with corn husk.

Wrapped weft.—Basketwork in which the plain or twined weft is wrapped with soft decorative material.

Waterproofing.—Resin of the pine and mesquite for covering and lining basket jars, rendering them waterproof.

Woof.—See *Weft.*

Yarn.—Fibers twisted together, as in receptacles made from native hemp.

Zigzag.—A broken line of equal angular portions applied to structure or decoration in basketry.

CHAPTER II

MATERIALS FOR BASKETRY

Man is one world, and hath another to attend him.
—EMERSON.

IN the manufacture of their baskets, the Indians have ransacked the three kingdoms of nature—mineral, animal, and vegetal. For the first named, Cushing has shown how the Havasupai Indians line the inside of a basket with clay in order to render it fireproof. A great many of the paints or dyes with which the baskets are coloured are drawn from the mineral kingdom. In the decoration of basketry, beautiful stones and the mineral shells of mollusks are employed, either whole or cut into beads and pendants. (See Plate 3.)

Besides the beautiful shells, teeth, wings of insects, and other hard animal substances used for added ornaments, softer parts enter into the very texture of basketwork. In a few localities, the tribes have relied on them largely. It will be seen that wool of goat, sheep, and llama are treated in precisely the same manner as splints of wood. The undressed skins of smaller mammals, notably the rabbit, are cut into strings and twisted; and dressed hides into babiche to serve as weft in woven baskets and bags. Sinew thread was employed in making coiled basketry about the Great Lakes and farther north. But the most serviceable animal substance for basketry was the feather, its plume for decoration and its quill for hard work as well as ornament. Porcupine quills were likewise split and worked into coiled basketry, in addition to their embellishment of birch-bark utensils. The multitude of uses for feathers in this art will be described later.

The chief dependence, however, of the basketmaker is upon the vegetal kingdom. Nearly all parts of plants have been

17

used by one tribe or another for this purpose—roots, stems, bark, leaves, fruits, seeds, and gums. It would seem as though, in each area for purposes intended, the vegetal kingdom had been thoroughly explored and exhausted above ground and under ground. Is it not marvellous to think that unlettered savages should know so much botany? Mr. Chesnut, in his Plants Used by Indians of Mendocino County, California, calls attention to the fact that, in our advanced state, we are yet behind these savages, not having caught up with them in the discovery and uses of some of their best textile materials.

How did the savages find out that the roots of certain plants hid away under the earth were the best possible material for this function? And, for another use, the stem of a plant had to be found, perhaps miles away, so that, in the make-up of a single example, leagues would have to be travelled and much discrimination used. Unless the utmost care is exercised, the fact will be overlooked that often three or four kinds of wood will be used in the monotonous work of the weft. One is best for the bottom, another is light and tough for the body, a third is best for the flexible top. This, in addition to the employment of half a dozen others for designs, for warp or foundation, or for decorative purposes.

Among the basketmaker's materials must not be forgotten the demand for water-tight vessels. Besides the widely spread faculty of securing this result by texture, there were present in certain areas natural substances suitable for waterproofing, such as the gum of the pinyon (*Pinus edulis*), the resin of various pines, and even the mineral asphalt.

The making of canteens and other water vessels, in lieu of pottery, in this way was most prevalent among the Shoshonean tribes of the Interior Basin and the migratory Apache farther south. Barrows* calls attention to Humboldt's Essay on New Spain,† in which the Indians around Santa Barbara are

* The Ethnobotany of the Coahuilla Indians of Southern California, Chicago, 1900, p. 41.

† Vol. II, p. 297.

spoken of as "presenting the Spaniards with vases very curiously wrought of stalks of rushes," and covered "within with a very thin layer of asphaltum that renders them impenetrable to water."

The author is greatly indebted to Mr. Frederick V. Coville, Botanist of the Department of Agriculture, for the identification of plants used in basketry by the Indians of America north of Mexico. This list contains those that have been certainly identified. There are other plants alleged to be used in basketry, but of which no scientific determination has been made as yet. A complete discussion of this part of the subject would demand that, for each tribe making baskets, there should be a list of the plants employed by them, and for each plant used a list of the tribes by whom it is used. Such a discussion requires a long and tedious investigation by a number of talented workers coöperating. It is hoped that the chapter here given by Mr. Coville will be a starting-point for a complete study of Indian phytotechny.

PLANTS USED IN BASKETRY

BY FREDERICK V. COVILLE

While some of the materials used by American Indian tribes in their basketry have long been known, by far the larger number had not been identified with precision prior to the beginning of the past decade. Most students of Indian plants had been satisfied with casual names applied by themselves or given to them by botanists after the examination of fragmentary specimens. Since the year 1890, a few botanists, notably Mr. V. K. Chesnut, of the Department of Agriculture, have turned their attention to the plants used by the aborigines and have made new records with definite identifications of the plants concerned, covering, among other subjects of Indian activity, that of basketry. When, therefore, after Professor Mason's invitation to prepare a chapter on the subject, the compilation of existing records was begun, it was

found that the earlier publications contained much that was indefinite, considerable that was incorrect, and a little that was both correct and exact. The notable exception to the general rule was the publication of Dr. Edward Palmer, whose work as a botanical collector in the western United States and Mexico extended from the late sixties of the last century to the present time. Under the circumstances, it was determined to admit only such matter as was capable of verification, based, first, on the writer's own observation; second, on published records that seemed to come under the last of the categories mentioned above; and, third, on the collections of the United States National Museum. A few unverified statements have been admitted for the purpose of bringing them to the attention of those who may be in a position to verify them. In the case of statements which did not originate with the writer, a parenthetic reference indicates the source of the information and, if published, the year of its publication. The work as here presented is recognised as by no means complete, but it is offered as a substantial basis for future investigation.

Acer circinatum. Vine Maple.
<p style="text-align:center">Läl'shtl (Quinaielt).</p>

Fresh twigs split into flat strips are employed by the Quinaielt Indians of the State of Washington in the construction of coarse twilled baskets for household use. (H. S. Conard, notes.)

Acer macrophyllum. Oregon Maple.
<p style="text-align:center">Päl-gun'-shi (Yuki).</p>

The Indians of Mendocino County, California, particularly the Concows, who now occupy a reservation there, use the white inner bark, preferably gathered in spring, in making baskets (V. K. Chesnut, 1902). From its inner bark, the Indians of the Pacific slope make baskets so closely woven as to hold water (J. T. Rothrock, 1867).

Adiantum pedatum. Maidenhair Fern.

The slender, black or dark brown, shining stems, after splitting, are used by the Indians of Mendocino County, California, in the ornamentation of some of their baskets, particularly those worn as hats (V. K. Chesnut, 1902). The Hupa Indians of Humboldt County, California, and other nearby tribes, use the stems in the same way. The practice extends also to the Snohomish Indians of western Washington (C. M. Buchanan, letter) and to the Tlinkit Indians of southern Alaska (G. T. Emmons, 1903).

Agave deserti. Desert Agave.

In the coiled basket bowls of the Coahuilla Indians of southern California, the cleaned fiber from the leaves is used to form the first few turns of the coil, which is then continued with grass stems. Evidently the grass is not sufficiently flexible to make these first turns without breaking, but the Agave fiber answers the purpose admirably (Cat. Nos. 207580 and 207581, U.S.N.M.). Some of the basket hats of the Diegueño Indians of San Diego County, California, are woven from cords made of the cleaned and twisted fiber, and from their great strength must be almost indestructible by any ordinary wear (Cat. No. 19751, U.S.N.M.).

Alnus oregana. Red Alder.

Among the Hupa Indians of northern California, the roots are sometimes used as weft at the beginning of a basket and in a round between the bottom and the sides (P. E. Goddard, notes). Various species of alder have been used by the American aborigines to produce an orange or red-brown dye, and, among a few tribes, these are known to be used for dyeing basket materials. Among the Tlinkit Indians of the south Alaskan coast, dye-pots were formerly made from the wood of this species, and the colour secured in this way was often heightened by adding pieces of the bark itself (G. T. Emmons, 1903).

Alnus rhombifolia. White Alder.

Among the Hupa, Yuki, and other Indians of northern California, a basket dye is obtained from the bark of this alder by infusion in water, or sometimes the bark is chewed and the material to be dyed is drawn through the mouth.

Amaranthus palmeri. Amaranth.

Ko'-mo (Hopi).

This is the source of a pink to purple dye used in the coiled and wicker plaques of the Hopi Indians of northern Arizona (W. Hough, notes). The identification is by C. F. Millspaugh.

Amelanchier alnifolia. Serviceberry.

Ĭ-ta'-gë (Apache).
Chak (Klamath).

The small, straight, peeled branches of this and other species of Amelanchier are used by the Apaches of the White Mountain Indian Reservation, Arizona, to form the uprights in their large carrying-baskets, a use for which the very tough wood is well adapted. The Klamath Indians of Oregon often weave a stout branch, peeled or not peeled, into the rims of their large coarse baskets to stiffen and strengthen them.

Apocynum cannabinum. Indian Hemp.

The well-known Indian hemp, including a number of plant forms once referred to *Apocynum cannabinum*, but now treated as belonging to several species, occurs from the Atlantic to the Pacific coast, and was and still is widely used by the aborigines in the making of many kinds of cordage articles. It is commonly cited as an Indian basket material, and, although it has not been possible to secure a verifiable record of its use in a basket, it is altogether probable that some of the strings and cords so frequently used in beginning a basket, or in making the carrying-loops, are twisted from the inner bark of this plant.

Artemisia ludoviciana. Wormwood.

Hang-al (Coahuilla).

In that portion of the Colorado Desert of California known as the Cabeson Valley the Coahuilla Indians make from the stems of this plant the large granary baskets in which they store seeds and other dried vegetable foods (D. P. Barrow, 1900). The plant was identified by W. L. Jepson.

Arundinaria tecta. Cane.

The split outer portion of the stems of the cane was the favourite basket material of the Southern Indians, including the Choctaws, Chickasaws, Cherokees, Creeks, Seminoles, and other tribes from Texas and Arkansas to the Carolinas, and it is still in use among the remnants of these peoples. The handsome baskets of the Chetimacha and Attakapa Indians of Louisiana are made from split cane.

Berberis nervosa. Oregon Grape.

Among the Hupa Indians of northern California a yellow dye is obtained by steeping the twigs and bark of one of the species of evergreen barberry, or Oregon grape (Mary H. Manning, letter). Leaves of squaw - grass (*Xerophyllum tenax*) dyed with this are sometimes used in the yellow patterns occasionally seen in the Hupa hat baskets. The same material and dye are used in the huckleberry and other baskets of the Quinaielt (H. S. Conard, notes), Snohomish (C. M. Buchanan, letter), and Klikitat Indians of western Washington. The particular species used has been definitely identified in one instance as *Berberis nervosa*. Another species, *B. aquifolium*, is undoubtedly used also.

Betula populifolia. White Birch.

The soft wood of this tree is still employed in the northeastern United States and Canada by the descendants of the Algonkin and Iroquois in the making of baskets (V. Havard, 1890). These baskets are thoroughly modernised, and

doubtless give little idea of the aboriginal methods of using this material.

Bromus sitchensis. Brome-grass.

The split stems are sometimes used by the Tlinkit Indians of the south Alaskan coast as an overlaying material for the white patterns of spruceroot baskets. (G. T. Emmons, notes.)

Butneria occidentalis. Calycanthus.

Sai ka-le' (Pomo).

Both the wood and the bark from young shoots of this shrub are used in basketry by the Indians of Mendocino County, California. (V. K. Chesnut, 1902.)

Calamagrostis langsdorffii. Bluejoint.

Chu'-kan shark ki-kark-tush' (Tlinkit).

The split stem is sometimes used for overlaying material in the spruceroot baskets of the Tlinkit Indians of the south Alaskan coast. (G. T. Emmons, notes.)

Carex barbarae. Sedge.

Ka-hum' (Pomo).

The long, tough, woody, interior portion of the rootstocks of this sedge is used to form the white sewing-strands in the fine coiled baskets of the Pomo Indians of northern California. Among the neighbouring Wailakis the roots of another unidentified species of Carex are used in the same way, and the leaves are made into hats and crude, somewhat flexible baskets. (V. K. Chesnut, 1902.)

Carthamus tinctorius. False Saffron.

A-sap-zran'-ĭ (Hopi, from the Spanish).

This plant, introduced by the Spanish, produces a bright-yellow dye, used in basketry by the Hopi Indians of northern Arizona. (W. Hough, notes; Cat. Nos. 11,724 and 11,726, U.S.N.M.)

Ceanothus integerrimus. California Lilac.

Hi'-bi (Concow).

The long, flexible shoots are used in basket-making by the Concows of northern California. (V. K. Chesnut, 1902.)

Cercis occidentalis. Redbud.

Ché-e (Yuki).

The wood of the branches, with or without the bark, is used in basketry by many California tribes, notably by the Round Valley Indians of northern California (V. K. Chesnut, 1902). Among the Nishinam Indians of Bear Valley, Placer County, the willow foundations in certain coiled baskets are sewed together with a thread of redbud wood (Stephen Powers, 1877). The dark-red patterns in the baskets of the Pit River Indians and the Tulare Indians are formed from split branches with the bark left on.

Ceropteris triangularis. Goldenback.

This little fern, known usually as *Gymnogramma triangularis*, has a black stipe or stem which is sometimes used by the Round Valley Indians (V. K. Chesnut, 1902) and the Hupa Indians (Mary H. Manning, letter) of northern California as a substitute for maidenhair stems, when these are not available, in black basket patterns.

Chrysothamnus laricinus. Rabbitbrush.

Ma'-i-bi (Hopi).

The branches are sometimes used by the Hopi Indians of northeastern Arizona for the weft of their finer wicker plaques. (W. Hough, notes.)

Chrysothamnus moquianus. Rabbitbrush.

Ha'-no shi'-va-pi (Hopi).

The twigs are used at Oraibi, Arizona, to form the weft in the wicker plaques of the Hopi Indians (W. Hough, notes). The identification of the plant (U. S. Nat. Herb. 274,057) is by

E. L. Greene, the species being one closely related to the widely distributed *Chrysothamnus* [*Bigelovia*] *graveolens.*

Cinna latifolia. Wood Reed-grass.

Among the grasses employed by the Tlinkit Indians of the south Alaskan coast for the white patterns in their spruceroot baskets this species is the commonest. The part used is the stem, from which sections are split to be applied as an overlay on the spruceroot strands. (G. T. Emmons, notes.)

Cladium mariscus. Cladium.

From the tough interior portion of the rootstock is derived the surface material of the handsome coiled baskets, commonly called Tulare baskets, made by tribes on the lower Sierra Nevada from Fresno River to Kern River, California (C. Hart Merriam, 1903). Imperfect specimens of the plant, secured from the Indians by Dr. Merriam, have been identified by Miss Alice Eastwood as *Cladium mariscus.*

Corylus californica. Hazelnut.

Ol mam (Yuki).

The shoots of the hazelnut are used by many of the Indian tribes from northern California to Washington, west of the Cascade Mountains, in the making of baskets, especially as radials or uprights (Mary H. Manning, letter). The burden-basket, baby-basket, and salmon-plate of the Hupas are made entirely of the shoots of hazelnut. (P. E. Goddard, notes.) (See Plate 4.)

Covillea tridentata. Creosote Bush.

A gum-lac found upon the branches of this desert bush has a wide application among the southwestern Indians as a cement, and among the Cocopas of northern Lower California it is used for pitching baskets (E. Palmer). The gum, which occurs in conspicuous nodules of a reddish-amber color, is not a direct exudation from the plant, but is deposited by a minute scale insect, *Carteria larreae.*

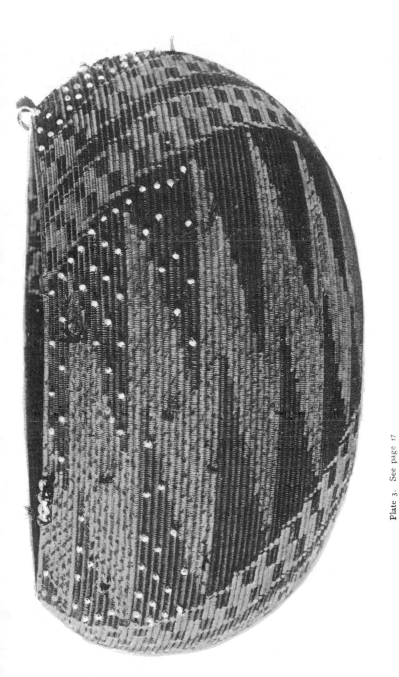

Plate 3. See page 17

POMO TREASURE BASKET OF THE FINEST QUALITY

With added decorations of bits of feathers, quail plumes, shell money, and beads

Collected by J. W. Hudson

Plate 4. See page 26

HAZELNUT (CORYLUS CALIFORNICA)

The main figure is a fruiting branch. Above at the left are two staminate catkins, with a pistillate flowering bud at their base, accompanied by a sectional view of a catkin scale and stamens, enlarged six times. To the right above are a terminal bud and a nut. Underneath the main figure are views of catkin scales and stamens, from front and back, six times natural size, and at the right a terminal cluster of pistillate flowers, enlarged three times. Except in the cases noted, the figures are of natural size.

Dasylirion wheeleri. Sotol.

The leaves, split into strands about a quarter of an inch wide and the coarse marginal teeth removed, are used among the Pima Indians of southern Arizona in coarse twilled baskets. (Cat. No. 218,027, U.S.N.M.)

Delphinium scaposum. Larkspur.

So-ro'-si (Hopi).

The flowers are the source of a light-blue dye used by the Hopi Indians of northern Arizona in their coiled and wicker plaques. (W. Hough, notes.)

Deschampsia caespitosa. Tufted Hair-grass.

Kût-kûk-kli'-tc shark (Tlinkit).

This is one of the grasses the split stems of which are used among the Tlinkit Indians of the south Alaskan coast to form the white patterns on their spruceroot baskets. (G. T. Emmons, notes.)

Dondia suffrutescens. Sea-blite.

The Coahuilla Indians of the Colorado Desert in southern California blacken the stems of their basketry rush (*Juncus acutus*) by steeping them for several hours in a decoction of this plant (E. Palmer, 1878). The identification of the species is by W. L. Jepson.

Elymus mollis. Beach Rye.

The split stems of this grass are sometimes used for the white patterns in the spruceroot baskets of the Tlinkit Indians on the south Alaskan coast. This material is employed only for coarse work, and when other grasses better adapted for the purpose are not available. (G. T. Emmons, notes.)

Epicampes rigens. Epicampes.

In the region of the Mohave and Colorado deserts of southeastern California the Panamint, Coahuilla (D. P. Barrows, 1900), and other tribes use this grass for the packing of

their coiled baskets. The part used, at least in the better baskets, is that portion of the stem above the uppermost joint, which sometimes reaches a length of 45 centimeters (18 inches).

Equisetum palustre. Horsetail.

Dabts (Snohomish).
Hin-mûn-ĭ' (Tlinkit).

The rootstocks of this plant, which sometimes reach a diameter of 1.5 centimeters (⅗ inch) and a length of 20 centimeters (8 inches) between the joints, were used in the early days, though rarely now, in the patterns on spruceroot Tlinkit baskets of the south Alaskan coast, particularly among the Hoonah and Yakutat branches of the tribe. Strips are split from the surface of the rootstock and used as an overlaying material. The colour is a rich, very dark purple, which appears as a black. (G. T. Emmons, notes.) A similar use was made of the plant, in their cedar-root baskets, by the Snohomish Indians of Puget Sound, Washington (C. M. Buchanan, notes).

Equisetum robustum. Scouring Rush.

The coal-black surface of the rootstock is sometimes used by the Cowlitz Indians of southwestern Washington as a substitute for the rootstock of *Equisetum palustre* in the black overlay patterns on cedar-root baskets.

Evernia vulpina. Wolf Moss.

Se'-ho-lĭ (Tlinkit).
Swä'-u-sam (Klamath).

This yellow tree-lichen was widely used as a dye by the Indians of the timbered area of the western United States. The Klamath Indians of Oregon, as well as the Hupas of northern California (Mary H. Manning, letter), use this dye in their baskets, the colouring matter being extracted by boiling. In the case of the Hupas the dye is applied to Xerophyllum leaves, but the Klamaths use it only for the porcupine quills

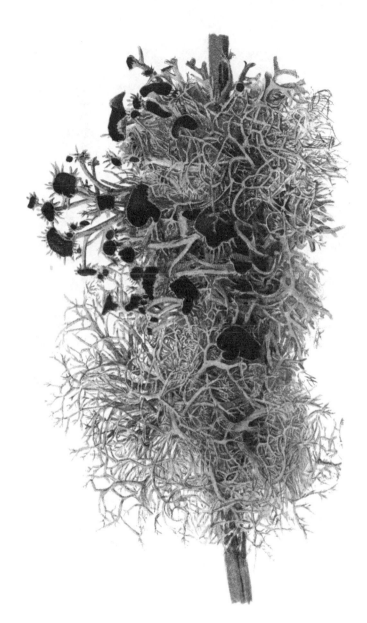

Plate 5. See page 29

WOLF MOSS (EVERNIA VULPINA)

Used by Klamath, Hupa, and other tribes to produce a bright yellow dye

The lichens are shown as growing on a dead branch, their usual habitat. The plant at the right is in fruit, the shallow cups (apothecia) containing the brown spore-bearing surfaces.

Drawing by Frederick A. Walpole

Plate 7. See page 33

SITKA SPRUCE (PICEA SITCHENSIS)

From the slender roots the north Pacific tribes make thousands of baskets

Fig. *a*, twig with staminate catkins. Fig. *b*, pistillate catkins. Fig. *c*, cones approaching maturity. Fig. *d*, mature cone. Fig. *e*, inner view of a cone scale showing the position of the two-winged seeds. Fig. *f*, seeds. With the exception of fig. *e*, which is enlarged one and one-third times, the figures are reproduced eight-ninths their natural size.

Drawing by Frederick A. Walpole

which form the beautiful canary-yellow patterns of their twisted tule baskets. The Tlinkit Indians of the south Alaskan coast also use the dye in their spruceroot baskets, the lichen being secured by them not on the coast, but from the interior (G. T. Emmons, notes). (See Plate 5.)

Fraxinus nigra. Black Ash.

The remnants of the Six Nations in New York, Pennsylvania, and adjacent portions of Canada make extensive use of ash, presumably black ash, in their modern splint-basket industry. (T. Donaldson, 1894.)

Helianthus petiolaris. Sunflower.

A-ka′-u-shi (Hopi).

The seeds are used by the Hopi Indians of northern Arizona to make a blue dye for use in both coiled and wicker plaques (W. Hough, notes). The colour produced in the coiled plaques, on sewing-material of *Yucca glauca*, is of a dark, almost prussian, blue shade, when the sewing-strands are applied with their broken inner surface outward, but of a much lighter shade when the epidermal surface is outward (Cat. No. 128,708, U.S.N.M.).

Hicoria ovata. Hickory.

The wood of some unidentified species of hickory, probably *Hicoria ovata*, is employed among the remnants of the Six Nations in New York, Pennsylvania, and adjacent portions of Canada in the manufacture of modern splint baskets (T. Donaldson, 1894). The inner bark of a hickory is used by the North Carolina Cherokees for yellow patterns in their baskets (Cat. No. 63,077, U.S.N.M.).

Hilaria jamesii. Galleta.

Ta′-ka-shu (Hopi).

The stems of this grass, roughly stripped of leaves and seeds, are used for the filling in of the coiled plaques of the Hopi Indians of northern Arizona (W. Hough, 1898). In the first

few turns of the spiral, which are too short to be made of the grass stems, the packing is of shredded leaves of *Yucca glauca* (Cat. No. 128,467, U.S.N.M.).

Juglans nigra. Black Walnut.

The Cherokee Indians of North Carolina use the split inner bark to make black patterns in their baskets. (Cat. No. 63,077, U.S.N.M.)

Juncus acutus. Rush.

The Coahuilla Indians of the Colorado Desert, southern California, use the stems to make patterns in their coiled basket bowls. The material, as gathered in a marsh at Palm Springs, is immersed for several days in the muddy water of the spring to render it flexible, and is then dyed a dark olivaceous or almost black colour with the juice of a sea-blite. (E. Palmer, notes.) (See *Dondia suffrutescens*.)

Juncus balticus Rush.
Tsin-a′-u (Klamath).
Kloh-tso′-sĕ (Apache).

The stems of this rush, which is commonly known as wire-grass, are often used by Indian children to make small baskets. The practice has been noted among the Klamaths of Oregon and the White Mountain Apaches of the Arizona plateau.

Juncus effusus. Rush.
Lal′-ûm (Yuki).

The stems of this rush, or wire-grass, are used among the Round Valley Indians of Mendocino County, California, to make temporary baskets, particularly in teaching the Indian girls the art of basketry. (V. K. Chesnut, 1902.)

Juncus textilis. Basket Rush.

The Luiseño Indians of southern California use the split stems of this rush as the sewing-material of their coiled baskets (C. Hart Merriam, notes). The varying natural colours of the stem at different heights produce a very attractive effect.

The herbarium specimens collected by D. P. Barrows, as illustrating the rush found by him, in use among the Coahuilla Indians of southern California in 1901, prove to be *Juncus textilis*. The stems, split in three strips, were used as a surface material of coiled baskets.

Juniperus occidentalis. Western Juniper.

K'ä'-hlo (Klamath).

Strips of wood split from the branches of this tree are sometimes used by the Klamath Indians of Oregon in coarse sieve baskets.

Larix laricina. Tamarack.

The Tinné Indians of the Upper Yukon River in Alaska and Yukon Territory use the roots of tamarack for their coiled basket kettles (Strachan Jones, 1866). There is doubt about the identity of the tree, because the true tamarack, *Larix laricina*, and the lodge-pole pine, *Pinus murrayana*, to which the name tamarack is often applied, both grow in the region.

Libocedrus decurrens. Post Cedar.

Wu'-lu-ansh (Klamath).

The split wood of this tree is occasionally woven into rough V-shaped pack-baskets by the Klamath Indians of Oregon.

Lonicera interrupta. Honeysuckle.

Hai-wat' (Yuki).

The long flexible stems are used to a slight extent among the Round Valley Indians of California in the coiled "one-stick" baskets, in which the foundation consists of a single stem. (V. K. Chesnut, 1902, and notes.)

Martynia louisiana. Devil Horns.

Ta-g'at'-ē (Apache).

This plant, which is often known in books as the unicorn plant, has a large green pod with a slender terminal projection. At maturity the green outer layer becomes dry and falls off,

the remaining interior portion of the projection splitting into two parts or horns which are exceedingly tough and black, and sometimes reach a length of 35 centimeters (13 inches). Moistened and split, they are used extensively to make black patterns in the baskets of various Indian tribes, notably the Apaches, in the desert region of Arizona, southern Nevada, and southeastern California.

Neowashingtonia filamentosa. Desert Palm.

In parts of the Colorado Desert of southeastern California the Coahuilla Indians use strips split from the leaves of this palm as a surface material of their coiled baskets. (C. Hart Merriam, 1903.)

Nymphaea polysepala. Wokas.

Wo′-kas (Klamath).

In the baskets of twisted tule, made by the Klamath Indians of Oregon, overlay patterns in black, also made of tule, are frequent. Ordinarily, this colour is produced by immersing the tule stems in the black mud of springs containing iron, and it is frequently intensified by the addition of broken seed-shells of wokas. The same result is secured by prolonged soaking of the tule in an iron kettle with water and wokas hulls, tannate of iron being formed. The hulls contain about twenty per cent. of tannin.

Panicularia nervata. Manna Grass.

Ki′-ka shark (Tlinkit).

Among the Tlinkit Indians of the south Alaskan coast, strips split from the internodes of this grass are sometimes used as an overlay for the white patterns in spruceroot baskets. This species is the most highly esteemed of the various grasses used for this purpose. (G. T. Emmons, 1903, and notes.)

Parosela emoryi. Parosela.

The Coahuilla Indians, of the Colorado Desert, in south-eastern California, give a yellowish-brown colour to the rush

(*Juncus acutus*) they use in basket-making by steeping it in water with the branches of this plant. (E. Palmer, 1878.)

Philadelphus gordonianus. Syringa.

Hân'lĭ (Yuki).

The pithy stems of this shrub, which is locally known as arrowwood, are employed by the Indians of Mendocino County, California, in the manufacture of baskets for carrying babies, a use to which the stems, on account of their lightness, are well adapted. (V. K. Chesnut, 1902.)

Phragmites phragmites. Reed.

Tkap (Klamath).

The white patterns in the twisted-tule baskets of the Klamath and Modoc Indians of Oregon are made from this reed. The part used is the shining surface layer of the stem, taken from less thrifty plants, particularly those which have produced no flower cluster. (See Plate 6.)

Phyllospadix torreyi. Phyllospadix.

Lŭk'-o-stap (Quinaielt).

The narrow flat leaves of this marine plant are occasionally used by the Quinaielt Indians of western Washington for black patterns in small flexible baskets overlaid with Xerophyllum leaves. The naturally dark colour is accentuated by burying the leaves in black mud. (H. S. Conard, notes.)

Picea sitchensis. Sitka Spruce.

Sit (Tlinkit).

The roots of this tree, boiled and split, are the basis material of the baskets manufactured by the Tlinkit Indians of Yakutat Bay, Alaska (F. Funston, 1896). The same use prevails among the Tlinkits of the Alexander Archipelago, notably those of Sitka, Juneau, and Douglas. The Quinaielt Indians (H. S. Conard, notes) and the Indians of Neah Bay, Washington, and doubtless other tribes also, use the split roots for their coarse burden-baskets. (See Plate 7.)

Pinus edulis. Arizona Nut Pine.

O-bĕ′ (Apache).

The Apaches of the White Mountain district, Arizona, use the resin of this tree, often called pinyon, as a pitching material for their water-baskets.

Pinus lambertiana. Sugar Pine.

Slender strands split from the root of the sugar pine, woven about uprights of California hazel, are the foundation material of the acorn-soup baskets of the Hupa Indians, northern California. To make them split more easily, the roots are steamed by burying them in sand and building a fire over them. (Mary H. Manning, letter.)

Pinus monophylla. Nevada Nut Pine.

The Panamint Indians of southeastern California use the pitch of this tree to make their water-baskets impervious to water.

Pinus ponderosa. Yellow Pine.

The split wood of the root is one of the materials used by the Hupa Indians of northwestern California for the principal part of the weft in closely woven baskets. (P. E. Goddard, notes.)

Pinus sabiniana. Digger Pine.

Pol′-kûm ol (Yuki).

The Little Lake Indians of Mendocino County, California, use the split roots to make their large V-shaped baskets for carrying acorns. The root is warmed in hot damp ashes, and the strands are split off before cooling (V. K. Chesnut, 1902). A similar use extends northward among the Hupa and other California coast Indians as far as Klamath River (V. Havard, 1890).

Populus trichocarpa. Balm of Gilead.

In northwestern California the Hupa Indians sometimes used the root to fasten the ribs of their baskets at the begin-

ning and to form a round at the base of the sides of the basket.
(P. E. Goddard, notes.)

Prunus emarginata. Bitter Cherry.

Some of the Indians of the Fraser River watershed in
British Columbia use the thin tough outer bark of a sub-
species of this tree, *villosa*, as an overlay for patterns in their
narrow-bottomed quadrangular baskets. The patterns are
either of their natural colour, chestnut brown, or black from
the dyeing of the bark in mud or iron-water.

Pseudotsuga mucronata. Red Fir.

According to J. W. Hudson, the Pomo Indians of Men-
docino County, California, use the roots of this tree in the
manufacture of some of their fine baskets.

Pteridium aquilinum. Bracken.

Bĭs (Calpella).

A form of the common bracken occurring in the western
United States is occasionally employed as a basket material
among the Indians of Mendocino County, California (V. K.
Chesnut, 1902). It is the material of the black designs in
the coiled baskets of the Tulares and various other California
tribes in the lower western slopes of the Sierra Nevada (C.
Hart Merriam, 1903). The part used is the two flat strips of
black hard-celled tissue in the rootstock.

Quercus alba. White Oak.

Splints from the wood of a white oak, presumably this
species, are still used by the Cherokee Indians of North Carolina
as the material for certain of their baskets. (Cat. No. 63,073,
U.S.N.M.)

Quercus lobata. California White Oak.

The Concow Indians of Mendocino County, California,
sometimes blacken their basket strands of redbud (*Cercis
occidentalis*), on which the bark is still attached, by soaking

them in water containing the bark of this oak and scraps of rusty iron. (V. K. Chesnut, 1902.)

Rhus diversiloba. Poison Oak.

Kats'-te (Wailaki).
Mà-tyu'-ya"-ha (Pomo).

The slender stems are occasionally used for horizontal withes in some of the baskets of the Mendocino County Indians of California (V. K. Chesnut, 1902), while the juice, which turns black rapidly on exposure to air, is the source, according to J. W. Hudson, of a dye sometimes used to stain the purest black strands of the Pomo basketry.

Rhus trilobata. Threeleaf Sumac.

Si'-i-bi (Hopi).
Chĭl-chĭn' (Navaho).
Tselh kan'-ĭ (Apache).

Among the desert Indians the slender branches of this bush are used extensively, perhaps more extensively than any other plant except willow, in the manufacture of their baskets. For warp the peeled branches are used. For weft and for the sewing-material of coiled baskets the branch is usually split into three strips and the bark and brittle tissue next the pith removed, leaving a flat, tough strand. The use of the threeleaf sumac has been noted among the Apache, Panamint, Paiute, Navaho (W. Matthews, 1886), Hopi (W. Hough, 1898), and Coahuilla (D. P. Barrows, 1900) Indians. (See Plate 8.)

Salix. Willow.

Branches from various undetermined species of willow were widely used among the western Indians, probably more generally than any other plant, particularly in the various forms of coarser baskets. Among the tribes in which travellers have recorded the manufacture of willow baskets, in addition to those given below under the identified species of willow, are the Mission, Mohave, Coahuilla, Cocopa, Yuma, and Coconino Indians of Arizona and southern California; the

Plate 8. See page 36

Threeleaf Sumac (Rhus Trilobata)

The main figure is a branch in leaf and fruit. Above at
the left is a single fruit enlarged one and a half times, and at
the right a section of the same twice the natural size. At the
left below is a flowering twig, and to the right are four views
of flowers, enlarged four times, the two at the left showing
the two forms of flowers, one without stamens.

Drawing by Frederick A. Walpole

Plate 9. See page 38

TULE (SCIRPUS LACUSTRIS)

Stems used by Oregon and California tribes for weaving, and the bright red roots form patterns in basketry

Fig. *a*, rootstock, roots, sheathing base of the stem, summit of the stem, and inflorescence. Figs. *b* and *c*, flowers, from within, showing the scale behind. In *c*, the stigmas are mature, but the stamens not yet fully developed; in *b*, the stigmas have withered, the ovary enlarged, and the stamens matured. Fig. *d*, a scale, viewed from the back. Fig. *e*, a mature nutlet with its barbed bristles. Fig. *f*, a cross section of the nutlet. Fig. *a* is half natural size, figs. *b* and *c* five times enlarged, and figs. *d* to *f* ten times enlarged.

Drawing by Frederick A. Walpole

Zuñi of New Mexico; the Hupa, Yurok, Modoc, Chimariko, Gualala, Nishinam, and Yokut of northern and middle California, and the Tinné of the Yukon Valley, Alaska. The split roots of willow are sometimes used for the weft in beginning the hat baskets of the Hupa Indians (P. E. Goddard, notes).

Salix argophylla. Willow.

Bam ka-le' (Pomo).

The Pomo Indians near Ukiah, California, consider this their best willow for the manufacture of coarse baskets. (V. K. Chesnut, 1902.)

Salix geyeriana. Willow.

Yas (Klamath).

Among the Klamath and Modoc Indians of Oregon this is the principal willow used in their coarser basketry, for pack-baskets, sieves, seed-beaters, and, in primitive times, plates. The shoots are the part employed, usually peeled and seldom split.

Salix lasiandra. Willow.

A willow, which is referable to *Salix lasiandra* in its broad sense, is used to some extent by the Panamint Indians of Inyo County, California, in their twined baskets, and by the Apaches of the White Mountain Reservation, Arizona.

Sambucus mexicana. Elder.

The Coahuilla Indians of San Diego County, California, give a deep black colour to strands of the three-leaf sumac, used as a sewing-material of their coiled baskets, by soaking them for about a week in an infusion of the berry-stems of this elder. (D. P. Barrows, 1900.)

Savastana odorata. Holy-grass.

The Indians of the northeastern United States and adjacent parts of Canada, such as the Penobscots of Maine (V. Havard, 1890) and the•Abenakis of Ontario (Cat. No. 206,394,

U.S.N.M.), use the long sweet-scented leaves of this grass in some of their baskets.

Scirpus lacustris. Tule.

Ma'-ĭ (Klamath).

The principal basket material of the Klamath and Modoc Indians of Oregon is the tule, a plant widely used by the tribes of the Pacific coast States in the manufacture of mats. Narrow strips from the surface of the stem are twisted into long threads and these used for their finer twined baskets, giving a great variety of green and brown shades or, when dyed, a black. For coarser baskets whole or split stems are commonly employed, without twisting. The very slender roots of the tule, which occur in great abundance on the stout rootstocks, are used, without any other preparation than drying, to make patterns of a maroon colour in the twisted-tule baskets. (See plate 9.)

Scirpus maritimus. Bulrush.

Tsu-ish (Pomo).

The Pomo Indians of California use for the brown and black patterns of their fine coiled baskets a fiber extracted from the rootstock of this bulrush. Structurally the fiber is the same as that described under *Carex barbarae.* The identification is by Miss Alice Eastwood. A similar material, blackened by burying in wet ashes (C. Hart Merriam, 1903), is sometimes used for black patterns in the fine coiled baskets of the Panamint Indians of Inyo County, California.

Smilax californica. Greenbriar.

The long and exceedingly strong stems, brought from the watershed of the Sacramento River, are sometimes employed by the Indians of Mendocino County, California, in their basketry. (V. K. Chesnut, 1902.)

Thelesperma gracile. Thelesperma.

O-ha'-u-shi (Hopi).

A decoction of the whole plant was formerly used to give a red-brown colour to the stems of rabbitbrush (*Chrysothamnus*

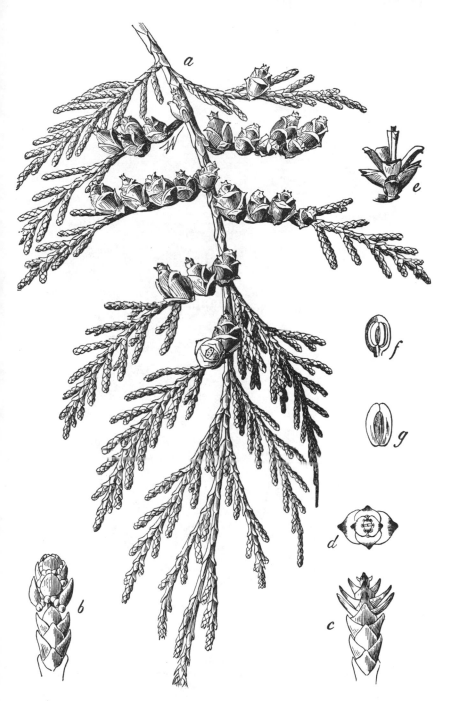

Plate 10. See page 39 GIANT CEDAR (THUJA PLICATA)

The large figure is a branch in its natural pendent position, with full-sized but not yet opened cones. Below at the left is the apex of a twig with staminate flowers, at the right a pistillate flowering twig, and above it an end view of the same, five times enlarged. Above at the right is a mature and opened cone, one and a fourth times enlarged, and below a cone scale, from within, showing the seeds natural size, and still lower a single seed twice enlarged.

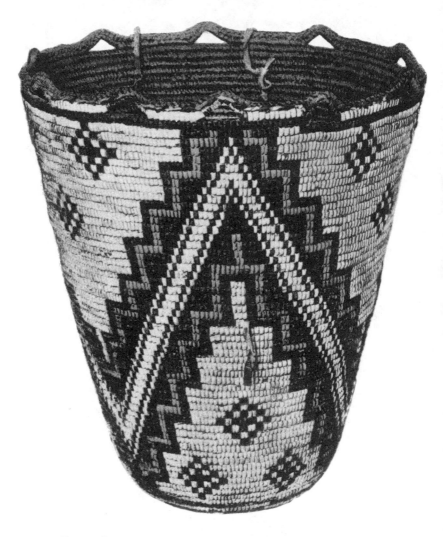

Plate 11. See page 52

KLIKITAT IMBRICATED BASKET

Showing use of cedar root, xerophyllum, cherry, and cedar bark in decoration

Collection of Mrs. R. S. Shackelford

moquianus) for the patterns in the wicker plaques of the Hopi Indians of northern Arizona. (W. Hough, 1898; Cat. No. 128,708, U.S.N.M.)

Thuja plicata. Giant Cedar.

The split twigs of this tree are employed as weft, with a spruceroot warp, in the strong coarse baskets used by the Quinaielt Indians of Washington for carrying firewood (H. S. Conard, notes). The split roots are the common sewing-materials for the strong, water-tight huckleberry baskets of certain tribes of the Northwest Coast from northern Oregon to British America, including the Klikitat, Cowlitz, Puyallup, Tulalip, Snoqualmie, Skagit, and Fraser River Indians. The Indians of Neah Bay, Washington, and of Vancouver Island, British Columbia, use the split brown inner bark as the warp of their finely woven but artificially dyed flexible baskets. The Nisqualli Indians of Puget Sound, and doubtless many other tribes of the Northwest Coast, employ the same material in coarser strands in making rough burden-baskets, frequently in conjunction with a warp of split branches from the same tree. (See Plate 10.)

Tsuga heterophylla. Western Hemlock.
Y'ghûn (Tlinkit).

The bark of this tree was formerly used by the Tlinkit Indians of southern Alaska in the preparation of certain dyes for the grass strands used in the overlay of spruceroot baskets. Black was sometimes produced by boiling the straw in the black mud of sulphur springs with salt water and hemlock bark, with the addition, after the introduction of iron, of pieces or scrapings of that metal. A greenish shade of blue was produced by boiling hemlock bark with oxide of copper scraped from old pieces of metal or from copper ore. (G. T. Emmons, 1903.)

Tsuga mertensiana. Black Hemlock.

The Indians of Neah Bay, Washington, sometimes use split hemlock roots in their coarse openwork quadrangular

V-shaped burden-baskets. The tree was described by a Neah Bay Indian as having cones 2½ inches long, in which case the species would be the black hemlock instead of the Western hemlock (*Tsuga heterophylla*), which is the commoner of the two at low elevations in that vicinity.

Tumion californicum. California Nutmeg.

K'o'-bi (Pomo).

The split roots of this tree are sometimes used by the Pomo Indians of Mendocino County, California, in the manufacture of their finer baskets. (V. K. Chesnut, 1902.)

Typha latifolia. Cattail.

Po'-pas (Klamath).

Twisted strands made of slender ribbons split from the sheathed portions of the leaves are used by the Klamath Indians of Oregon in their smaller flexible baskets, either to form the body of the basket or to make an ornamental band. The colour is a lusterless, slightly ashy white.

Ulmus americana. Elm.

The Sioux Indians of the northern plains region used the inner bark of the elm to make a coarse basket. (V. Havard, 1890.)

Urtica breweri. Nettle.

Slĕdsh (Klamath).

The Klamath Indians of Oregon make from the fiber of the inner bark of this nettle very strong cords which are frequently employed to bind together the warp strands at the beginning of a basket or to bind the interlaced ends of the warp at the finished margin.

Vaccinium membranaceum. Blueberry.

Ka-na-ta' (Tlinkit).

The boiled juice of some species of blueberry, probably *Vaccinium membranaceum*, is used as a purple dye in spruce-root baskets by the Tlinkit Indians of the south Alaskan coast. (G. T. Emmons, 1903.)

Vitis californica. Grape.

Shi-ĭn' (Pomo)

Among the Hupa Indians of northern California the root is sometimes used to fasten the ribs of a basket at its beginning, and to make a round at the outer edge of the basket's bottom, while in fine hats grape root sometimes makes up the whole weft (P. E. Goddard, notes). Portions of the woody stem are used by the Pomos of Mendocino County, California, as a sewing-strand for attaching the rims to their pack-baskets. The grape strands completely cover the stout withe that forms the basis for the rim, making it more durable and at the same time thickening it so as to give a good means of firmly grasping the basket. (V. K. Chesnut, 1902, and notes.)

Woodwardia spinulosa. Giant Chain Fern.

The Hupa Indians of northern California use a portion of this fern, either white or dyed orange brown with alder bark, in the patterns of their hat baskets (Mary H. Manning, letter). The parts employed are two slender flat strands, very flexible and leathery when moist, which are extracted from the stalk of the frond.

Xerophyllum tenax. Xerophyllum.

The long, tough, minutely serrated, grass-like, lustrous leaves of this plant, often called squaw-grass, are very commonly used by the Indians of the Northwest Coast as an overlaying material to make the white patterns of their baskets. Occasionally it is dyed. The base of the leaf for an inch or more often has a natural faint purple colour which is used to good effect. The use of the material extends from the Pit River, Shasta, and Hupa Indians, in northern California, northward through most of the tribes west of the Cascade Range to the Neah Bay and Vancouver Island Indians of the Straits of Fuca. These last two use Xerophyllum leaves, cut to a uniform width by a gauged knife-edge, as the weft of their gaudily dyed flexible baskets.

Yucca arborescens. Tree Yucca.

In California the slender roots are used for red figures in baskets of the Kern Valley and Newooah Indians of the southern Sierra Nevada (C. Hart Merriam, 1903), and those of the Panamint Indians of Inyo County.

Yucca arkansana. Yucca.

The leaves are used in the basketry of the Kiowa Indians of Oklahoma. (J. Mooney, notes.)

Yucca baccata. Banana Yucca.

The Mescalero Apaches of southern New Mexico and adjacent parts of Texas, in the region between the Rio Grande and Pecos rivers, use the split leaves of this plant for the main portion of their baskets, and its roots for the red patterns (Cat. Nos. 204,646 to 204,653, U.S.N.M.). It is probable, I am informed by Mr. Vernon Bailey, that they use also in the same way the leaves and roots of *Yucca macrocarpa*, an arborescent species growing at lower elevations in the same region.

Yucca filamentosa. Silk grass.

The leaves of this plant were formerly in use among the Indians of North Carolina as a basket material. (J. Lawton, 1714.)

Yucca glauca. Plains Yucca.

Mo'-hu (Hopi).

This plant is used in the basketry of the Hopi Indians (W. Hough, 1902) of northern Arizona. In some of the coarser twilled baskets the warp and weft are made up of the narrow unsplit leaves thinned by the removal of a strip from the back (Cat. No. 213,254, U.S.N.M.). In the coiled plaques the sewing-material consists of narrow strips split from the leaves. The outer surface of the leaves gives various shades of green and greenish-yellow or, in the case of the young leaves, white, or they are dyed in several colours. The dyed strips are often applied with the inner, broken surface outward.

This surface takes the dye more readily and gives a deeper shade. For the use of the shredded leaves as a packing material in the first few turns of the spiral, see *Hilaria jamesii*.

Zea mays. Maize.

Some of the Indian tribes of the Columbia Plains, in Oregon, Washington, and Idaho, including the Yakimas, Warm Springs, Umatillas, and Nez Percés, use narrow strips from the husks of maize, or Indian corn, as an overlay for the white patterns in their trinket-bags.

CHAPTER III

BASKET-MAKING

The sallow knows the basketmaker's thumb.—EMERSON

UNDER the head of basket-making are included all the activities in and fostered by construction, namely:

1. *Harvesting materials.*—This embraces intimate acquaintance with the places where just the right substances abound, knowledge of the times when each element is ripe, methods of growing, harvesting, and conveying involved, as well as the tools and apparatus used in gathering. In their rough state much of the materials would be as unfit for the use as quarry clay would be for the potter or crude ore for the metallurgist.

2. *Preparing materials.*—Frequently the raw materials are stored away at the time of harvesting until required for manufacture. Nature makes the rules for gathering in her own good time. But this might be the busy season, whereas this art may go on in different seasons. When the time comes for their use, special manipulations are necessary, such as peeling, splitting, making splints, yarning or twisting, twining, braiding, soaking, gauging, colouring. These should each be noted carefully and described for the several basket areas.

3. *Processes of manufacture.*—The materials being ready, the maker seats herself in the midst and begins the technical operations that should be minutely watched, and photographed, if possible. Collections should also be made of tools, apparatus, and patterns.

Each of these will be examined with minute care, especially the third. If this art is to be imitated and become a stimulus in technical instruction, it is of the utmost importance that the substances be correctly known, that the manipulations of

materials be familiar, and, above all, that the course of each element in the warp and weft, the foundation, and sewing be understood. Care has been taken to draw correctly the figures used in illustration. They are all in the basketry of the Indians, and, more than that, they are the beginnings of more refined processes and structures.

HARVESTING MATERIALS

Since the materials used in basketry are derived from different parts of a great variety of plants, the gathering of them involves many industries. The harvesting of basket

FIG. 1.
MUD-SHOES, CALIFORNIA.
Klamath Indians.
Cat. No. 24109, U.S.N.M. Collected by L. S. Dyar.

material is no exception to the rule that every human activity begins with a natural process slightly modified. The birds are in a sense the original basketmakers, and it is known that some very expert Indian tribes take the grasses and the stems of plants as they find them. They know nothing of drying or manipulating. Improvement grows out of study into the nature of substances, until with some tribes the obtaining of raw materials involves quite as much sagacity, toil, and travel as the making of the basket.

For procuring the roots, the apparatus of digging is neces-

sary. To be sure, the hand was the first hoe and the strong arm draws the root from its hiding-place, but our Indians had gotten beyond that. The northern Indians, especially those of the Columbia River in western Canada, use quite elaborate forms of this device. It is wonderful to think of the sagacity developed in savage minds by the quest for underground substances and the proper discrimination of the places where the best examples abound. From the farthest north, in the neighbourhood of Point Barrow, to the southern portions of South America, roots form substantial materials in basket-making, both twined and coiled. It is not enough to say simply that roots of plants were the materials of the baskets, but it is well known that the savage women knew in each section what plant furnished the toughest and most pliable roots, the localities in which this kind of root reached its best, the plants that yielded brown, red, and black coloured splints, which produced unrivalled effects, though the portion above ground gave no sign of the treasures held or the time of year when it was proper to obtain these substances, and the processes by which they could be extracted and saved most economically. Incidental to this quest of material, of course, was that of carrying, so that here in the very beginning of our art a host of useful human activities are engendered. The Klamath invented a peculiar kind of mud-shoe to wear when wading about in shallow marshes after roots for their industrial arts. (See fig. 1.)

The stems of plants, grass, rushes, and woody species are to be found in the basketry of almost every portion of the Western Hemisphere. The young and tough shoots of a single year's growth are choice materials for some purposes, and were eagerly sought. In those regions where spinous plants yielded the materials, a sort of gathering-knife was employed resembling a miniature sickle with a wooden handle. There is a time of year when they are in the best condition for the basket woman's craft. There are certain parts of the stems

which are useful in this direction, while others are valueless. In woody species the outer layer next to the bark has the toughness of leather, while a little way inward the wood is almost as brittle as glass. Furthermore, the stems of plants vary greatly in colour—different parts of the same stem vary much in this respect.

Now, the student would be surprised to find in the East, in the West, in the North, and in the South that there is very little more for the savage woman to learn. Distinguished botanists will say that instead of trying to teach the Indians the use of new plants, the best way to search for new materials to introduce into modern textile arts can be learned from these savage artisans. The leaves of plants are used in basketry, especially in the South. In the extreme North, among the Eskimo and Athapascan tribes, no leaves are suitable for basketry. Among the Aleutian Islanders, stems and leaves of grass come into play. Down the Pacific coast of the continent, in southeastern Alaska, British Columbia, and the coast States of the Union, leaves, either in their natural colours or dyed, are employed with great effect in many types of ornamentation, as will be seen further on. The range of usefulness, either for texture or ornament, is well known to the basketmaker. In Mexico and tropical America this division of the subject has been developed most. Little mechanism is necessary in this part of the world. A sharpened stick for the root-gatherer and a flint knife and mussel-shell for the stem-harvester complete the outfit. Nimble fingers aided with the teeth were the most useful apparatus.

In her textile gleaning, the savage woman has not been slow to avail herself of the metal appliances introduced by the whites. You will now see her afield with pick and knife of steel, gathering the old-time substances.

PREPARING MATERIALS

As is well known, every industry may be divided, either in savagery or in civilisation, into four parts: First, that which

is associated with taking the gifts of nature, called in this particular instance harvesting; second, the transformation of this material into proper form for special trades; third, the manufacture of useful and ornamental objects; and, finally, the activities of consumption and enjoyment, by which the things may take their places as servants to supply the wants and desires of mankind.

The preparation of materials for basketry consists in splitting and separating the desirable from the undesirable portions; in removing the bark; in taking the soft and spongy matter from the fibrous portion, like soaking and hackling in flax; in making ribbon-like splints of uniform width and thickness; in shredding, as in cedar bark; in twisting, twining, and braiding; in gauging, and colouring.

The apparatus for this intermediate work must have been in aboriginal times very simple, a stone knife and shell for scraping supplementing the work of the fingers and the teeth. The quality of the finished workmanship depends largely upon this secondary process. In those regions of very uniform moisture the plants used were of quick growth and pliable, and it would be easy, even without metal tools, to secure fine splints and other elements in the manufacture; but in those localities where the raw substances were more brittle, fine work would be difficult, and, indeed, was impossible until quite recently. It is a question, therefore, whether anciently some of the modern processes in basketry were known at all. Certainly there was no such delicate basketry made in Canada by the untaught aborigines as can now be procured from their descendants; but in the old graves of California and the adjoining areas wonderful pieces of delicate workmanship are brought from ancient pre-Columbian tombs.

It must not be forgotten that colouring matters were in ancient times among the prepared materials of basketry. Nature furnishes opportunities for diversity of colour in the substances themselves. The Indian also knew how to change

or modify the natural colour of different materials by burying them in mud. The juices of the plants and the mineral substances in the mud combined to produce darker shades of the same colour or an entirely different one. But the savage women had gone further, for they well knew that certain plants were useful as dyes. In point of fact, the best dyestuffs of each area had been exhaustively exploited. A list of these for each area would include a large number of useful plants. As in gathering materials the simplest processes involved slight artificiality, so in this intermediary art the most primitive basketmakers modified little their raw materials. They did not store them away for the convenient season, and, save that they soaked them before using, practiced none of the refining processes necessary to the highest results.

In each of the culture areas of America the methods of preparing materials were peculiar.

Dr. Walter J. Hoffman* described, in 1895, the aboriginal process of preparing material for wicker baskets among the Menomini Indians (Algonquian family) on Lake Michigan. See figs. 110 to 114 in this book.

A small log of wood, 3 or 4 inches in diameter and as long as it is possible to procure one without knots, furnishes the splints. (Hoffman's fig. 37.) These logs are cut when the rings of annual growth are most easily ruptured. The log is beaten with a wooden mallet. The example shown in Hoffman's illustration (fig. 38) is of modern type, made with steel tools, but the ancient Indian, no doubt, had a much rougher but quite as efficient implement. The strips thus loosened are torn off one by one as long as the material is sufficiently flexible for basket-making. The next process is the shaping of these splints for the desired work—splitting them, shaving them down thin and smooth, and finishing them for the hand of the weaver.

* Fourteenth Annual Report of the Bureau of Ethnology, Part I, Figs. 37-41.

The basketmaker's awl of bone, the old aboriginal imple-
ment, may be seen at work in many camps; but the knife
with which the pre-Columbian woman cut her basket material
has utterly disappeared from use. Now, among the Algonkin,
the knife of steel has vastly improved their art, and it raises a
question whether in the pristine condition of savagery some
forms of basketry were as good as they are at present. This
query applies only to work done in hard wood.

The knife now in use among the Indians for this and other
wood-working purposes is an interesting survival from the
remote past in Europe. It is now active in the farrier's shop
for paring the frog of the horse's foot prior to putting on the
shoe; but two or three centuries ago, under the name of man's
knife,* it found its way through the entire English and French
area of North America.

A curved blade of steel is inserted or laid in a groove on
the side of the handle, made fast by wrapping with strong
twine. The groove is shouldered so as to take the pressure.
The blade is detachable for the purpose of grinding it. It
will be seen that if held in the right hand the operator cuts
toward himself. This is the ancient method of whittling
practiced by the peoples on the western shores of the Pacific
Ocean, the Ainos, Japanese, etc. (Hoffman's fig. 39.)

A bundle of splints is shown in fig. 40 of Hoffman's paper
of different widths ready for the hand of the basketmaker,
and in fig. 41 (Hoffman) is a coarse-finished product showing
the method of setting up the warp and applying the weft in
wicker basketry of the Menomini.

It is not known that the ancient Menomini used any dyes
whatever on their baskets. In their modern ware they pro-
cure these substances through traders.

The sweet grass (*Savastana odorata*), of which large quan-

* The Man's Knife among the North American Indians: A study in the
Collections of the U. S. National Museum, by Otis Tufton Mason, Report of
the U. S. National Museum, 1897, pp. 725–745, 17 figs.

tities of baskets are manufactured, was dried in the shade to hold its colour. Further, it was rolled into bunches and sewed with sinew, as the Eskimo do in making their coiled baskets. Very old specimens of such ware are preserved in collections. But in the ware now in the market, twine and braid of this material are prepared beforehand in large quantities for the future use of the weaver and frequently by different hands.

Farther south in the Eastern basket area the canes for twilled basketry needed no knife for the splitting. A slight blow would crush the stalk, the spongy matter adhering to the inside was scraped away, and the splints were ready for the dyer or the weaver, if they were not to be coloured.

The following information concerning natural sources of colour for basketry and other objects among the Cherokee Indians comes from Miss Harriet C. Wilkie, of Raleigh, North Carolina. The petals of the iris rubbed on a slightly rough surface are said to yield a rich and lasting purple. The blossoms and tender green tops and leaves of the common sneeze weed (*Helenium autumnale*) made into a tea yield a beautiful and fadeless yellow. Long boiling dulls this to a yellowish olive. The common broom-sedge (*Andropogon scoparius*), winter dried, yields another yellow, less pure and brilliant, also much affected by continued boiling. The colour is known as burnt orange and works beautifully in basketry.

In central Alaska the Athapascan tribes use both spruce and willow for their coiled basket jars and trinket material. Much care is bestowed in splitting the roots and stems in order to procure uniform sewing-material. In the U. S. National Museum the specimens all show care in this regard. The Alaskan Eskimo on Bering Sea also manufacture coiled basketry as well as twined, but it is from dried grass, and shows very little care in the preparation. Crossing over to the Aleutian chain, the care bestowed on materials is different.

When Attu weavers want the grass to be white, it is cut in November, the whole stalk (wild rye), and hung points down

out of doors to dry. If grass is to be yellow, the common colour, it is cut in the middle of July, and the two youngest blades that are full-grown are then taken out and split into three pieces, the middle one being thrown away. The other pieces are then tied in bunches about two inches in diameter and hung up to dry out of doors (points down). If the grass is to be cured green it is prepared as when it is wanted to be yellow, but the first two weeks of the curing is carried on in the shade of the dense growth of grass and weeds that is found in the villages. After that it is taken out and dried in the house. Under no circumstances is the sun allowed to shine on any of the grass in the process of curing, which takes about a month or more.

Beautiful coiled basketry is made by the Chilcotin, Harrison Lake, Lower Thompson Indians in British Columbia, Salish on the coast, as well as Klikitat and Tulalip in Washington. Only women and girls occupy themselves with this work. The baskets are made from the small, trailing roots of the cedar (*Thuja plicata*). These are dug up with an ordinary root-digger, and pieces of the desired length and of about the thickness of a finger are cut off. These are buried in the ground to keep them fresh. When required, they are taken out and peeled or scraped with a sharp stone or knife. They are then hung up until dry enough for use. Next they are split into long strips by inserting and pressing forward the point of the awl used in basket-making, made from the long bone of a deer. The pieces which have the desired width and thickness throughout their entire length are used for stitching purposes, while others which split irregularly, or are too short or too thin to be used for that purpose, are put together in bundles to form the foundation of the coils. In the sewing, these foundations are kept continuous and of uniform thickness by adding fresh pieces as required. (See Plate 11.)

In other basketry, thin, pliable strips of cedar, sap or

other wood, in pairs, having both smooth sides out, are used for foundation instead of the bunches of split roots. These are stitched in the same manner, but are neither so strong nor so durable, nor are they water-tight.*

The Upper Fraser and the Lytton bands sometimes use *Elymus triticoides* instead of *Xerophyllum*. The bark used is that of *Prunus demissa*, which is either left its natural light reddish-brown colour or is dyed by burying it in damp earth. By thus keeping it under ground for a short time it assumes a dark-brown colour; if kept longer it becomes quite black. (Teit.)

The Makah Indians make a red colour by mixing vermilion with chewed salmon eggs; black colour is a combination of bituminous coal and the same carrier; cedar bark is coloured black by soaking in mud, and red by means of alder bark, chewed. (Swan.)

The Twana Indians, on Skokomish Reservation, Washington, now use a steel-bladed knife and an awl of the same material in basket-making. Formerly they employed a pointed stick or bone for their imbricated ware and for pressing home the weft of twined basketry; but in large measure their fingers are their tools. (Myron Eells.) The same remark applies to basketmakers in all the culture areas. Fingers and teeth are still in vogue and can not be dispensed with. The metal awl, however, quite displaces that of bone, and it is not surprising to find scissors of the best make added to the steel-bladed knife, especially for clipping off the projecting ends of materials.

Hazel stalks are gathered by Oregon tribes in best form on ground that has been burned over, the young ones springing up straight and strong from the rich soil. The peeled stems are used without splitting, and generally without dyeing: now and then a few are stained in mud and charcoal (See Plate 172).

* James Teit, The Thompson Indians of British Columbia, Memoirs of the American Museum of Natural History, II, Pt. 4, 1900, pp. 163-392.

(Mrs. Harriet K. McArthur.) The fine white grass, like ivory in smoothness and tint, in fine Shasta and Rogue River baskets, is obtained at great elevations, their excursions leading them to the summer snow-line of Mount Shasta.

PROCESSES OF MANUFACTURE

As you gaze on the Indian basketmaker at work, herself frequently unkempt, her garments the coarsest, her house and surroundings suggestive of anything but beauty, you are amazed. You look about you, as in a cabinet shop or atelier, for models, drawings, patterns, pretty bits of colour effect. There are none. Her patterns are in her soul, in her memory and imagination, in the mountains, watercourses, lakes, and forests, and in those tribal tales and myths which dominate the actions of every hour. She hears suggestions from another world. Her tools are more disappointing still, for of these there are few—a rude knife, a pointed bone, that is all. Her modelling-block is herself. Her plastic body is the repository of forms. Over her knee she moulds depressions in her ware, and her lap is equal to all emergencies for convex effects. She herself is the creator of forms in her art.

The Tlinkit in weaving, says Emmons, sits with the knees drawn up to the chin, the feet close to the body, the shoulders bent over, the arms around the knees, the hands in front. Sometimes one knee is dropped a little to the side, and, in the case of old women, they often recline on one hip, with the legs drawn up, the elbows resting on a pillow or blanket doubled up.

In all types of weave the working strands are constantly dampened by dipping the fingers into a basket or cup of water close at hand, or, in the case of embroidery, by drawing the section of grass stem through the lips. The material is kept in a plaque-like workbasket called tarlth ("spread out," from its flat bottom and low, flaring sides). Besides the shell or metal knife there is generally a rude awl, consisting of a spike of goat or deer horn, a bear's claw, or a piece of bone

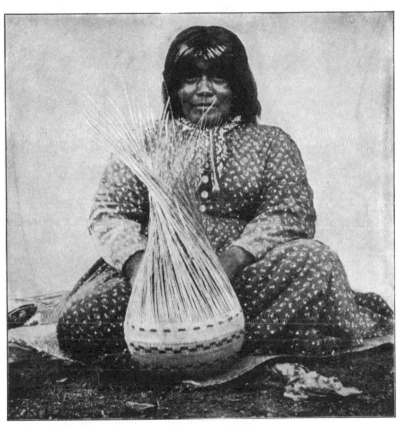

Plate 12.　See page 55

POMO WOMAN WEAVING A TWINED BASKET, CALIFORNIA

Photograph by H. W. Henshaw

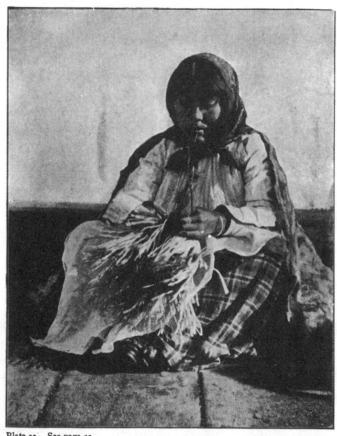

Plate 13. See page 55

TLINKIT WOMAN WEAVING A TWINED WALLET, SOUTH-
EASTERN ALASKA

Photograph from G. T. Emmons

rubbed down to a tapering point, and a large incisor of the brown bear or the tooth of the killer whale. These constitute all of the tools and accessories used in basketry. I am indebted to Lieutenant Emmons for this information.

Plate 12 represents a Pomo Indian basketmaker. In front of her is an unfinished water-tight basket jar in plain twined weaving. The warp elements are willow rods dressed down to uniform thickness; the weft is of carex root and ceris stems split, the patterns being made in the latter. (Photographed by H. W. Henshaw.)

Plate 13 represents a Tlinkit woman of Sitka, Alaska, making a twined basket. All the native surroundings are absent—the environment, as men are wont to say—but the artist's mind and skilful fingers remain. She has four elements to handle simultaneously—warp, two wefts, and decorative material. The mouth, therefore, is brought into requisition, as may be seen. The operation consists in twining with finely divided spruceroot and wrapping each outside splint with coloured straw. The work resembles embroidery when finished, and is, in this work, called false embroidery.

There seems to be always an affectionate fellow-feeling between the skilful hand of the artisan and the materials which it fashions. The more tractable the latter, the more deft the former. That is not always true in culture. The best endowment does not always yield the best results. But the statement holds good in our art with few exceptions. Where the finest grasses grow, and the toughest roots and stems, they set up a school of mutual refinement between the woman and her work. It needs only a few miles eastward or northward to change the garden into a desert and correspondingly to degenerate the artist. It would be unjust to her ingenious mind to overlook the fact that she has been utterly cast down by the failure of one kind of material. She is not long in finding out new substances and new technic processes for each environment.

WOVEN BASKETRY

The various processes of manufacture will now be definitely explained. In technic, as already said (page 6), basketry is either hand-woven or sewed. The hand-woven basketry is

further divisible into (A) *Checkerwork*, (B) *Twilled work*, (C) *Wickerwork*, (D) *Wrapped work*, and (E) *Twined work*, in several varieties. The sewed work goes by the name of coiled basketry, and is classed both by the foundation and the fastening. In addition to these technical methods on the body, special ones are to be found in the border.

FIG. 2.
COARSE CHECKERWORK.

A. *Checkerwork.*—This occurs especially in the bottoms of many North Pacific coast examples, and also in the work of eastern Canadian tribes (fig. 2); in matting its use is well nigh universal.

In this ware the warp and the weft have the same thickness and pliability. It is impossible, therefore, in looking at the bottoms of the cedar-bark baskets and the matting of British Columbia (fig. 3) or Eastern Canada, to

FIG. 3.
FINE CHECKERWORK.

tell which is warp and which is weft. In very many examples the warp and weft of a checker bottom are turned up at right

angles to form the warp of the sides, which may be wicker or twined work. A great deal of bark matting is made in this same checkerwork, but the patterns run obliquely to the axis of the fabric, giving the appearance of diagonal weaving. The fine hats of Ecuador are especially noticeable in this deceptive appearance, which is caused by the weaver's beginning the work at the center. Perhaps, though there is no positive information on this subject, the North Pacific coast women proceed in the same manner to give a tiled effect to the surface of their matting. When warp and

FIG. 4.
OPEN CHECKERWORK.

weft are fine yarn or threads the result is the simplest form of cloth in cotton, linen, piña fiber, or wool. The cheap fabrics of commerce are of this species of weaving. In art

FIG. 5.
TWILLED WORK.

FIG. 6.
TWILLED WORK.

and industry latticework frequently shows the bars intertwined as in checker basketry (fig. 4).

From this results a most stable figure, the elasticity of

the material and the friction of the surfaces holding the fabric together. (See figs. 4, 5, 6.)

The pleasing effects that may be produced in checker are shown in Plate 14. At the bottom is coarse work. At the end of seven rows the warp strips of bark are held firmly in place by a row of twined weaving and then split into four, each sixth one being left whole for artificial effects. At proper intervals broader strips of weft are introduced. In the chapter on ornamentation attention will be called to the variety in this mass of unity by the individual characteristics of each square in the weaving.

B. *Twilled work.*—This is seen especially in those parts of the world where cane abounds. In America it is quite common in British Columbia, Washington, southern United States, Mexico, and Central America, and of excellent workmanship in Peru, Guiana, and Ecuador. The fundamental technic of diagonal basketry is in passing each element of the weft over two or more warp elements, thus producing either diagonal or twilled, or, in the best samples, an endless variety of diaper patterns. (See figs. 5 and 6.)

The example shown in Plate 15 represents a cigar-case made by the women of Ecuador, who weave the celebrated Panama hats, the texture being fine twilled work. The ornamentation should be studied carefully, for it consists of twined weaving, in which both warp and weft strands are brought together in pairs and one twined about the other. There is no attempt at anything but plain over-two weaving elsewhere in this specimen. To the student of technology it is charming to read in this connection from Ure's Dictionary* the laboured description of twilled loom-work with its hundreds of parts in the climax of a series of inventions initiated with savage women's fingers.

Twill, or *tweel*. A diagonal appearance given to a fabric by causing the weft threads to pass over one warp thread, and

* Article Weaving, fourth edition, London, 1853.

Plate 14. See page 58

CHECKERWORK IN CEDAR BARK, SHOWING VARIETY OF EFFECTS

Collections of U. S. National Museum

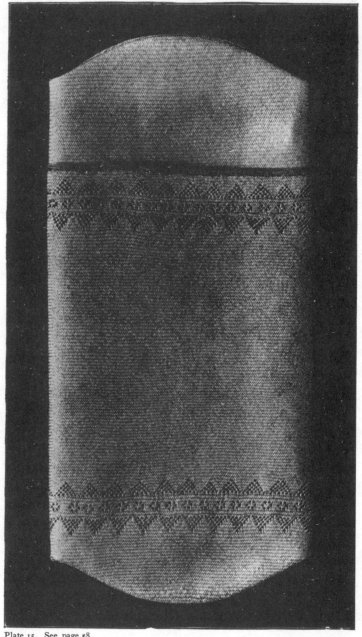

Plate 15. See page 58

CIGAR CASE IN FINE TWILLED WEAVING, FROM ECUADOR
Collection of Robert Fletcher

then under two, and so on, instead of taking the warp threads
in regular succession, one down, one up. The next weft thread
takes a set oblique to the former, throwing up one of the two
deposed by the preceding. In some twills it is one in three, or

FIG. 7.
ANCIENT TWILLED WORK.
Pressed on pottery of Alabama. After W. H. Holmes.

one in four. The Latin *trilix*, a certain pattern in weaving,
became *drillich* in German, and hence our word *drill*. *Twill*
is derived from *zwillich*, which answers to the Latin *bilix*, and

FIG. 8.
ANCIENT TWILLED WORK.
Pressed on pottery of Tennessee. After W. H. Holmes.

the Greek *dimitos*. The latter survives in *dimity*. See also
samite, derived from Greek *hexamiton*, six-thread.

The French *touaille* has also been suggested as the etymo-
logical source of the word.

The fabrics thus woven are very numerous—satin, blanket,
merino, bombazine, kerseymere, etc. When the threads cross

each other alternately in regular order it is called *plain weaving*; but in *twill* the same thread of weft is *flushed*, or separated from the warp, while passing over a number of warp threads, and then passes under a warp thread.　(See Plate 16.)

The points where the threads of the warp cross form diagonal lines, parallel with each other, across the face of the cloth.　In *blanket twill* every third thread is crossed.　In some fabrics 4, 5, 6, 7, or 8 threads are crossed.　In *full satin twill* there is an interval of 15 threads, the warp (*organzine silk*) being floated over 15 threads of the woof (*tram*), giving the glossy appearance.

Twills require heddles equal in number to the threads that are included in the intervals between the intersections.　This disposition of the warps in the heddles is termed *mounting the loom*, and the heddles are termed *leaves*.　A twill takes its name from the number of leaves employed, as a three-leaf twill, a five-leaf twill, etc.

Twills are used for the display of colour, for strength, variety, thickness, or durability.

On a fragment of ancient pottery from Alabama, Holmes also discovered marks of basketry in twilled weaving, as shown in fig. 7.

It will be noticed that material of cattail or split cane was used.　The effect shown in the figure was produced by passing each weft strand over three warp strands and under one on the side exhibited.　On the other side of the texture, no doubt, the process was reversed, the warp strands passing over three and under one.　In such work there was opportunity to use double warp and weft, the strips of cane laid together so as to expose two bright surfaces.

In order to vary the texture of twilled work, the inhabitants of the Mississippi Valley knew how to use for warp and weft substances of different widths.　On a fragment of ancient pottery from Pope County, Tennessee, Holmes found impressions of basketry.　Fig. 8 shows how these ancient weavers

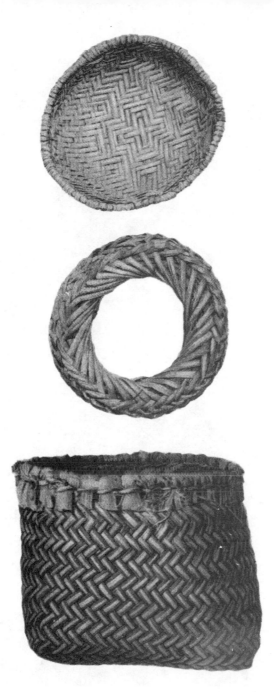

Plate 16. See page 60

TRAY, OLLA RING, AND PEACH BASKET

These baskets are quickly twilled from Yucca leaves and bear the brunt of domestic use.
On the trays, peaches, hominy, etc., are dried, or the family meal is served. Peaches are
carried from the orchards in the deeper basket, or it may contain odds and ends of food
about the house. The water vases are protected from knocks on the stone floor by the wicker
ring.

Collected by V. Mindeleff and W. Hough

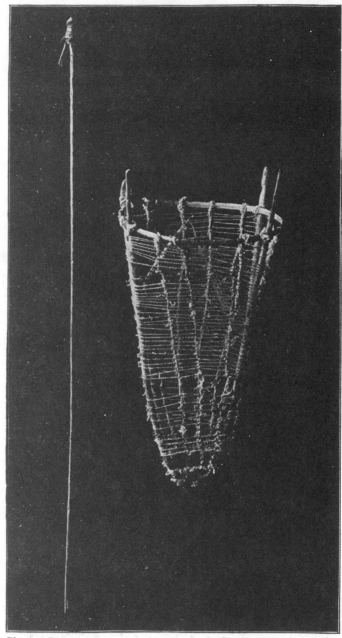

Plate 17. See page 67

MOHAVE CARRYING BASKET, IN WRAPPED WEAVING,
LOWER COLORADO RIVER

Collection of Field Columbian Museum

utilised wide fiber of bast or split cane for the warp, and string
for the weft, passing in their work over two each time. For
the uses of woven fabrics on making pottery, and the interest-
ing way in which the history of lost arts have been preserved,
see Chapter VII.

Excellent variety was also produced in this kind of weaving
by means of colour. Almost any textile plant when split has

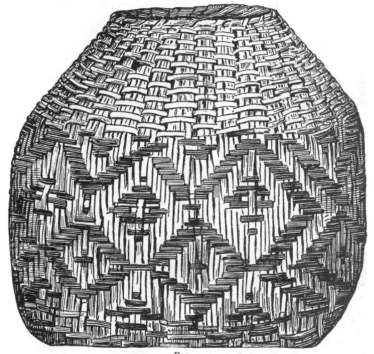

FIG. 9.
TWILLED WEAVING.
Cherokee Indians, North Carolina.

two colours, that of the outer, or bark surface, and that of the
interior woody surface or pith. Also the different plants used
in diagonal basketry have great variety of colour. By the
skilful manipulation of the two sides of a splint, by using
plants of different species, or with dyed elements, geometric
patterns, frets, labyrinths, and other designs in straight line
are possible. (See fig. 9.)

Examples from the saltpeter caves, and modern pieces
from the Cherokee, both in matting and basketry, are double.
By this means both the inside and the outside of the texture
expose the glossy silicious surface of the cane. By changing
the number of warp splints or a stem over which the weft

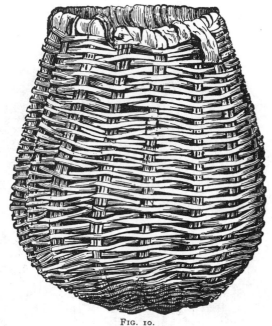

Fig. 10.
WICKER BASKET.
Zuñi, New Mexico.
Cat. No. 40291, U.S.N.M. Collected by J. W. Powell.

passes, it will be seen in the figure here given that great variety
of diaper or damask effect may be produced.

C. *Wickerwork.*—The name is from the Anglo-Saxon
wican, to bend. Common in eastern Canada, it is little known
on the Pacific coast and in the Interior Basin, excepting in one
or two pueblos, but is seen abundantly in southern Mexico and
Central America. It consists of a wide or a thick and inflexible
warp and a slender, flexible weft (fig. 10). The weaving is
plain, and differs from checkerwork only in the fact that one of

the elements is rigid. The effect on the surface is a series of ridges. It is possible also to produce diagonal effects in this type of weaving.

Wickerwork must have been a very early and primitive form of textile. Weirs for stopping fish are made of brush, and wattled fences for game-drivers are set up in the same manner. A great deal of the coarse basketry in use for packing and transporting is made in this fashion. The Zuñi Indians make gathering-baskets of little twigs after the same technic, the inflexible warp being made up of a small number of twigs of the same plant laid side by side. The transition from checker to wicker in some examples is easy. The moment one element, either warp or weft, is a little more rigid than the other, the intersections would naturally assume a wicker form.

Fio. 11.
CLOSE WICKERWORK.
Hopi Indians, Arizona.

The finest specimens in America are the very pretty Hopi plaques made of *Chrysothamnus moquianus* and *C. laricinus*. Short stems are dyed in various colours for weft, the ends worked into the warp, and the whole driven tightly home, so as to hide the ends of the warp and even the manner of weaving. (See fig. 11.)

Various patterns are effected on the surface—geometric figures, clouds, mythical animals and persons, and symbols connected with worship. Wickerwork has pleasing effects combined with diagonal and other work. Fig. 12 is a square Hopi plaque, having twilled weaving in the middle and a band of wicker outside of this, the whole finished with rough, coiled sewing on the border.

It has passed into modern industry through the cultivation of osiers, rattan, and such plants for market-baskets, covers for glass bottles, and in ribbed cloth, wherein a flexible weft is worked on a rigid warp. Also, good examples are now pro-

FIG. 12.
TWILLED AND WICKER MAT.
Hopi Indians, Arizona.
After W. H. Holmes.

duced by the Algonkin tribes of New England and eastern Canada.

For commercial purposes, wicker baskets precisely like those of the Abenaki Indians are thus made.

The white-oak timber is brought to the yard in sticks running from 6 to 40 inches in diameter and from 4 to 18 feet long. It is first sawed into convenient lengths, then split with a maul and wedges into fourths or sixteenths. The bark is then stripped off with a drawing-knife. The next process is cutting it into bolts at what is called the splitting-horse, to be shaved down with a drawing-knife into perfectly smooth, even bolts of the width and length desired. These are then placed in the steam-box and steamed for a half-hour or so, which makes

the splints more pliable. They are taken thence to the splint knife, which is arranged so that one person, by changing the position of the knife, can make splints of any desired thickness, from that of paper to that of a three-fourths-inch hoop.

The oyster-baskets and most small baskets have the bottom splints laid one across another and are plainly woven in checker.

But the round-bottomed baskets, used for grain and truck, are made by taking from ten to eighteen ribs and laying them across each other at the middle, in radiating form, and weaving around with a narrow thin splint until the desired size for the bottom is reached, when the splints are turned up and set in other baskets, about a dozen in a series, for twenty-four hours.

They are then woven around with a fine splint and placed on a revolving drum or form and filled up the required height and set in the sun to dry for six hours. They are then shaken hard by striking the bottom on the floor, which causes the splints to settle tightly together, prepared for the rim. They next proceed to fasten the handles to the sides and put the rims or hoops on by fitting them into the notches made in the handles, and binding them tightly with fine splints. Styles are made by using different-shaped drums and variously coloured splints, the latter being made by dipping the splints before weaving into dyes.

The most curiously made baskets are those for charcoal and eelpots.

The charcoal-baskets are shaped like a tray and are carried on the head by the coal-carriers.

The eelpots are used as traps for catching eels. The wood is prepared for them in the same manner, and they are made on a form about forty inches long and in the shape of a bottle without the bottom, and have a funnel arrangement at either end, which is detachable.

D. *Wrapped work.*—Wrapped basketry consists of flexible or rigid warp and flexible weft. Examples of this technic are

to be seen in America at the present time among the Indians of southern Arizona for their carrying-frames. (See fig. 13.)

The warp extends from the rigid hoop, which forms the top, to the bottom, where the elements are made fast. Firmness is given to the structure by means of two bowed rods crossing at right angles at the bottom and securely lashed at the top.

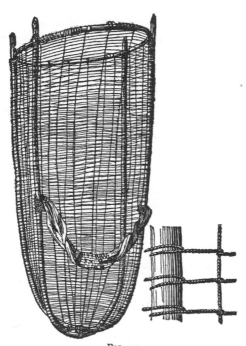

FIG. 13.
WRAPPED WEAVING.
Mohave Indians, Arizona.
Cat. No. 24145, U.S.N.M. Collected by Edward Palmer.

The weft, usually of twine, is attached to one of the corner or frame pieces at the bottom and is wrapped once around each warp element. This process continues in a coil until the top of the basket is reached. In some of its features this method resembles coiled work, but as a regular warp is employed and no needle is used in the coiling it belongs more to the woven series. In the Merriam collection are shallow trays of coiled work in which the spiral foundation is held in place by means of radiating strings wrapped thus. On the wrong side a cord runs under the stitches. Hudson mentions the same among the Pomos for holding roof-poles in place. The wrapping is very close where the rafters come to a point. As they widen, the weft comes to be farther apart, being quite open on the outer margin. This method of weaving was employed by the ancient Peruvians and by the Mound Builders

of the Mississippi Valley. Markings of wrapped weaving pressed on ancient pottery taken from a mound in Ohio are to be seen in the Third Report of the Bureau of Ethnology. (See fig. 14.)

This style of weaving had not a wide distribution in America and is used at the present day in a restricted region. When the warp and the weft are of the same twine or material and the decussations are drawn tight, the joint resembles the first half of a square knot. The Mincopies of the Andaman Islands construct a carrying-basket in the same technic. Specimens of their work were collected and presented to the United States National Museum by Dr. W. L. Abbott.* These baskets

FIG. 14.
WRAPPED WEAVING, FROM MOUND IN OHIO.
After W. H. Holmes.

resemble most closely the Mohave specimens, only they are smaller and more attractive. The Mincopies and their neighbours far and near have the incomparable rattan for warp and weft, which combines the strength and flexibility of copper wire. The distribution of this wrapped weaving has not been studied. Plate 17 is a carrying-basket in wrapped weaving from the Mohave Indians, photographed from the original now in the Field Columbian Museum, Chicago.

E. *Twined work.*—This is found in ancient mounds of the Mississippi Valley, in bagging of the Rocky Mountains, down the Pacific Coast from the island of Attu, the most westerly of the Aleutian chain, to the borders of Chile, and here and there on the Atlantic slope of South America. Indeed, it is found among savages throughout the world. It is the most elegant and intricate of all in the woven or plicated series. Twined work has a set of warp rods or rigid elements as in wickerwork,

* Smithsonian Report, 1901, pp. 475–492, pl. 11.

but the weft elements are commonly administered in pairs, though in three-strand twining and in braid twining three weft elements are employed. In passing from warp to warp these elements are twisted in half-turns on each other so as to form a two-strand or three-strand twine or braid, and usually so deftly as to keep the smooth, glossy side of the weft outward.

The position of the weaver at her task on twinedwork, in

FIG. 15.
PLAIN TWINED WEAVING.

Plate 18, shows the transition between the humble posture of the primitive basketmaker and her successor later on seated at a loom. The name of the weaver in the lower figure is Elizabeth Propokoffono. Her home is on the island of Atka, far out in the Aleutian chain. The Tlinkit weaver sits on the ground in the old-fashioned way, because her warp is rigid and self-supporting; Elizabeth, however, is working in soft grass, both for warp and weft. For this reason the former is suspended, and she is working from below upward. The Haida Indians on Queen Charlotte Archipelago south of her, as will be seen later on, weave in the same manner, the warp resting on a disk fastened to the top of a stake. Enough of modern technical appliances are mingled with this thoroughly aboriginal process to mark a sharp contrast between the woman's fingers and her beautiful basket on the one hand, and her loom-woven clothing, her flatiron, and the iron hinges on her door on the other hand.

The upper figure shows a woman from Attu Island, also weaving a grass wallet in twined work, in front of her underground home or barabara. It is most interesting to observe that her warp is supported from a stick in the top of the house, and is mounted precisely as one shown in Plate 1, of Holmes's

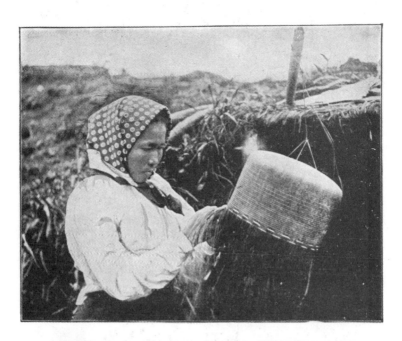

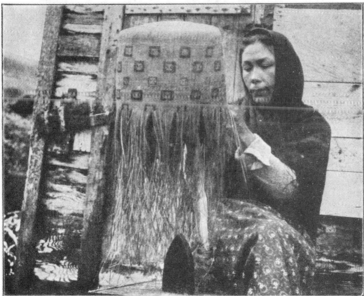

Plate 18. See page 68

ALEUT WOMEN WEAVING GRASS WALLETS IN TWINED WORK

Compare Figs. 147, 148

Photographed by C. Gadsden Porcher

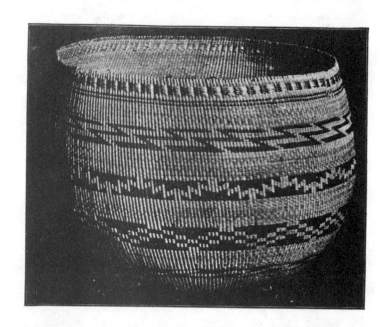

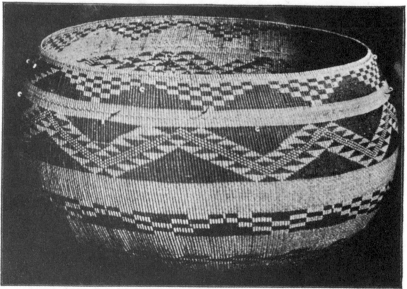

Plate 19. See page 69

BASKETS IN PLAIN TWINED WEAVING, SHOWING INSIDE AND OUTSIDE
EFFECTS, POMO INDIANS, CALIFORNIA

Collection of C. P. Wilcomb

Prehistoric Textile Art, taken from Hariot,* and illustrating industries of the eastern Indians at the period of discovery.

According to the relation of the weft elements to one another and to the warp, different structures in twined weaving result as follows:

1. Plain twined weaving over single warps.

2. Diagonal twined weaving, or twill, over two or more warps.

3. Wrapped twined weaving, or bird-cage twine, in which one weft element remains rigid and the other is wrapped about the crossings.

4. Lattice-twined, tee or Hudson stitch, twined work around vertical warps crossed by horizontal warp element.

5. Three-strand twined weaving and braiding in several styles.

1. *Plain twined weaving.*—Plain twined weaving is a refined sort of wattling or crating. The ancient engineers, who built obstructions in streams to aid in catching or impounding fish, drove a row of sticks into the bottom of the stream, a few inches apart. Vines and brush were woven upon these upright sticks which served for a warp. In passing each stake, the two vines or pieces of brush made a half-turn on each other. This is a very primitive mode of weaving. Plain twined basketry is made on exactly the same plan. There is a set of warp elements which may be reeds, or splints, or string, arranged radially on the bottom and parallel on the body. The weft consists of two strips of root or other flexible material, and these are twisted as in forming a two-strand rope passing over a warp stem at each half-turn. (See fig. 15.) Many wastebaskets are woven on this plan.

Plate 19 shows two bowls in plain twined weaving, called Bamtush by the Pomos, which are excellent examples of the possibilities and limitations of this style. They are in the collection of C. P. Wilcomb, of San Francisco. The upper figure,

* Thirteenth Annual Report of the Bureau of Ethnology, 1896, Plate 1.

10 inches in diameter, is from Cloverdale, Russian River, Sonoma County; the lower from Potter Valley, in Mendocino County. The warp is of willow rods, the weft of carex root and splints of cercis. A small space at the bottom is in three-ply braid, and the narrow band near the top, with wide twists, is plain twined work over more than one warp stem. (See Plates 34, 44, 71, 72.)

In this connection must not be overlooked a variety of twined weaving in which the warp plays an important part. It is a transition between the plain twine and the next type, the halves of the double warp standing for the independent warp stems of the diagonal weave. If the weft be administered in openwork with the rows from a fourth to a half an inch apart, and the warp elements be flexible under the strain of weaving, they will assume a zigzag shape.

FIG. 16.
OPENWORK TWINED WALLET.
Aleutian Islands.
Cat. No. 14978, U.S.N.M. Collected by W. H. Dall.

Pleasing varieties of this type of twined weaving will be found in the Aleutian Islands. (See fig. 16.) It resembles hemstitching. The Aleuts frequently use for their warp stems of wild rye or other grasses, in which the straws are split, or a pair used, and the two halves pass upward in zigzag form.

Each half of a warp is caught alternately with the other half of the same straw and with half of the adjoining straw, making a series of triangular instead of rectangular spaces. (See fig. 17.)

A still further variation is given to plain twined ware by crossing the warps. In the bamboo basketry of eastern Asia these crossed warps are also interlaced or held together by a horizontal strip of bamboo passing in and out in ordinary weaving. In such examples the interstices are triangular, but in the twined example here described the weaving passes across between the points where the warps intersect each other,

Fig. 17.
TWINED OPENWORK.
Aleutian Islands. (Enlarged.)

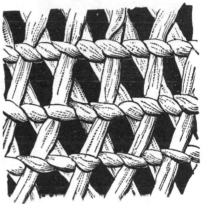

Fig. 18.
CROSSED WARP, TWINED WEAVE.
Makah Indians, Washington.

leaving hexagonal interstices. (See fig. 18 and Plate 166.) This combination of plain twined weft and crossed warp has not a wide distribution in America, but examples are to be seen in southeastern Alaska and among relics found in Peruvian graves.

2. *Diagonal twined weaving.*—In diagonal twined weaving the twisting of the weft filaments is precisely the same as in plain twined weaving. The difference of the texture is caused by the manner in which the weft crosses the warps. This style abounds among the Ute Indians and the Apache, who dip the bottles made in this fashion into pitch and thus produce a

water-tight vessel, the open meshes receiving the pitch more freely. The technic of the diagonal weaving consists in passing over two or more warp elements at each turn, just as in weaving

FIG. 19
DIAGONAL TWINED WEAVING.
Ute Indians, Utah.

with a single element. But the warp of the diagonal twined weaving never passes over or under more than one weft as it does in twilled weaving. There must be an odd number of warps, for in the next round the same pairs are not included in the half-turns. The ridges on the outside, therefore, are not vertical as in plain weaving, but pass diagonally over the surface, whence the name. (See Plate 20 and figs. 19 and 20.)

Plate 20 will make clear the difference between plain twined weaving and diagonal twined or twilled work. The figures are of the burden basket, the granary, and the mush bowls of the

Pomo Indians, in Lake, Sonoma, and Mendocino counties, California, in the collection of C. P. Wilcomb. Especial attention is here drawn to the infinitely greater possibilities of decoration in the twilled work. The foregoing plate shows that the ornamentation of plain twined basketry is confined chiefly to bands, but here the artist revels in the cycloid, which widens and becomes

FIG. 20.
DIAGONAL TWINED BASKETRY.
Pomo Indians, California.
Collection of C. P. Wilcomb.

more intricate as it ascends. It rivals in complexity the best coiled work of the Pomos, and should be compared with Plates 29 and 56.

3. *Wrapped twined weaving.*—In wrapped twined weaving

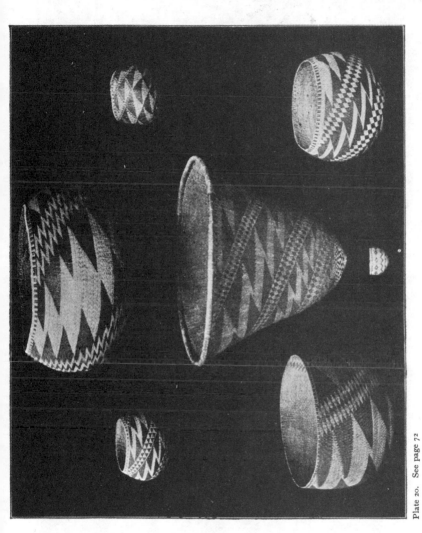

Plate 20. See page 72

BASKETS IN TWILLED TWINE WEAVING, SHOWING IMPROVED CAPABILITIES FOR ORNAMENT,
POMO INDIANS, CALIFORNIA

Collection of C. P. Wilcom>

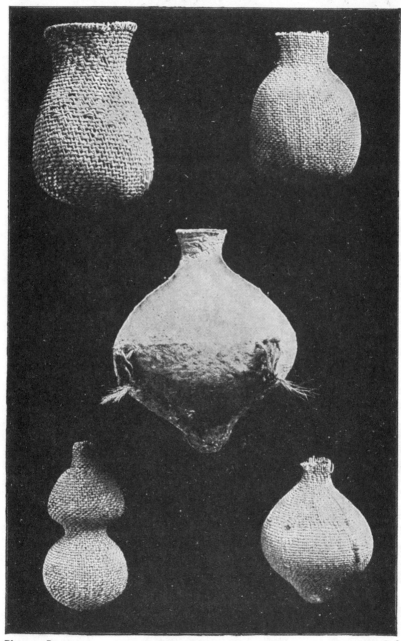

Plate 21. See page 75

1 2
3
4 5

OLD TWINED JARS FOR SEEDS AND WATER. UTES OF UTAH

Collections of U. S. National Museum

one element of the twine passes along horizontally across the the warp stems, usually on the inside of the basket, forming a lattice. The binding element of splint, or strip of bark, or string, is wrapped around the crossings of the horizontal element with the vertical warp. (See fig. 21.)

On the outside of the basket the turns of the wrapping are oblique; on the inside they are vertical. It will be seen on examining this figure that one row inclines to the right, the one above it to the left, and so on alternately. This was occasioned by the weaver's passing from side to side of the square carrying-basket, and not all the way round, as usual. The work is similar to that in an old-fashioned bird-cage, where the upright and horizontal wires are held in place by a wrapping of finer soft wire. The typical e x a m p l e of this wrapped or bird-cage twine is to be seen among the Makah Indians of the Wakashan family l i v i n g a b o u t Neah Bay, Washington,

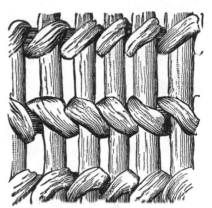

FIG. 21.
WRAPPED TWINED WEAVING.

and in the soft hats of Salish and Shahaptian. (See fig. 22.)

In this type the warp and the horizontal strip behind the warp are both in soft material. The wrapping is done with a tough straw-coloured grass. When the weaving is beaten home tight, the surface is not unlike that of a fine tiled roof, the stitches overlying each other with perfect regularity. Such a simple style of fastening warp and weft together would seem to have occurred to tribes of savages in many parts of the world. Strange to relate, however, excepting in Washington and the ocean side of Vancouver Island, the process is not known. The exception to this statement is to be found in a few sporadic cases where, perhaps, Nutka and Makah women

had married into adjoining tribes. A few of the Salish women make similar ware, and it will be seen in basket hats of the Nez Percé Indians. A small collection of this ware came to the Museum through the Wilkes Exploring Expedition, but the ornamentation is decidedly Skokomish.

Figs. 23 and 24 show the detail of mixed twined weaving, diagonal twined weaving, and wrapped twined weaving, inside and outside view. The facility with which the basketmaker combines these weaves in the same texture gives her complete control over her material in the matter of ornamentation.

FIG. 22.
WRAPPED TWINED WEAVING.
Makah Indians, Washington.

The colouring of the two sides of the splints of cercis shows, in the figures, the difference between the outside and the inside of the basket. Another element of technic, not mentioned hitherto, is made apparent here in the requirements of these three different styles of workmanship controlling the space somewhat of the warp rods. Perhaps in no other tribe than the Pomo is there such free use of any number of textile methods on the same piece of workmanship to secure different results.

It is possible to combine the several methods of twined weaving and, calling in the aid of colour, to produce good effects even in unpromising materials. Figs. 25 and 26 show back and front of a square from a Ute basket jar. The first two rows are plain twined work, then there come three rows of plain twined work also, though it does not look like it. It incloses warp stems in pairs, and the back and front are alike. It changes to diagonal merely by alternating warps. Below these three rows are diagonal twine, wrapped twine, or Makah

weave, combined with diagonal. Plate 21 contains five figures, all in diagonal twined weaving. They were made by the Ute Indians and collected long ago by Major J. W. Powell. They represent first of all the different results of the same technical

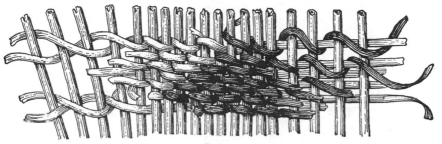

FIG. 23
DETAIL OF MIXED TWINED WEAVING.
(Outside.)

process in varied materials. The specimens are all woven precisely alike. Fig. 1 has a coarse, inflexible warp. Fig. 2 has a finer warp, and hence the twists may be driven closer home. Fig. 4 shows the adaptation of modern shape in facili-

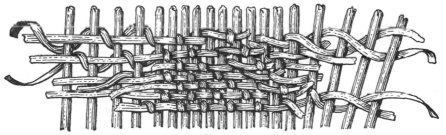

FIG. 24.
DETAIL OF MIXED TWINED WEAVING.
(Inside.)

tating the carrying. In fig. 5 a fine weft assumes a diagonal shape in being twisted, while fig. 3 is the last word in the story of the water-jar.

4. *Lattice twined weaving.*—The lattice twined weaving, so far as the collections of the National Museum show, is confined to the Pomo Indians, of the Kulanapan family, residing

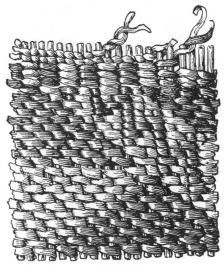

FIG. 25.
VARIETY IN TWINED WEAVING.
(Outside.)
American Anthropologist, III, 1901, fig. 18.

on Russian River, California. It is so called because it has a vertical and a horizontal warp resembling latticework. Dr. J. W. Hudson calls this technic Tee. This is a short and convenient word, and may be used for a specific name. The tee-twined weaving consists of four elements, (a) the upright warp of rods, (b) a horizontal warp crossing these at right angles, and (c, d) a regular plain twined weaving of two elements, holding the warps firmly together. (See fig. 27.)

In all these examples in the National Museum the horizontal or extra warp is on the exterior of the basket. On the outside the tee basket does not resemble the ordinary twined work, but on the inside it is indistinguishable. Baskets made in this fashion are very rigid and strong, and frequently the hoppers of mills for grinding acorns, and also water-tight jars, are thus constructed. The ornamentation is confined to narrow bands, the artist being restricted by the technic.

Plate 22 shows two

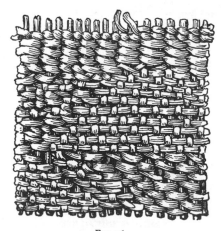

FIG. 26.
VARIETY IN TWINED WEAVING.
(Inside.)
American Anthropologist, III, 1901, fig. 21.

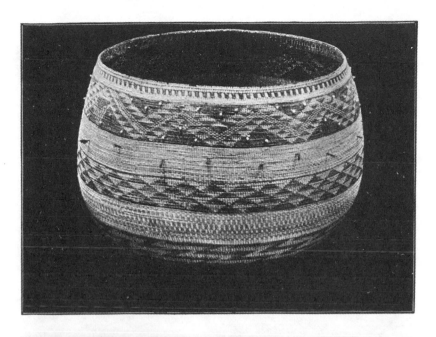

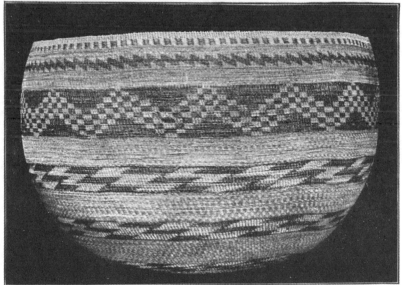

Plate 22. See page 76

TWINED BASKETS IN TEE OR THREE-STRAND WEAVE. INSIDE
AND OUTSIDE DIFFERENT

Collection of C. P. Wilcomb

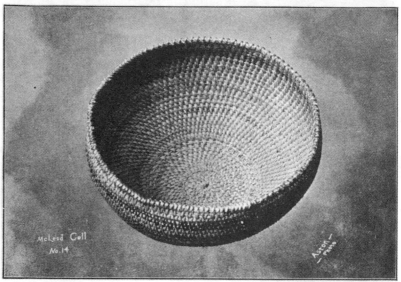

Plate 23. See page 85

COILED BASKET WITH SPLIT STITCHES, MU-WA TRIBE, CALAVERAS CO., CAL.

Collection of E. L. McLeod

examples of tee weaving. The upper one, 19 inches in diameter, is made from Pinole rancheria, Mendocino County, California. The lower one is from Lake County, and both are in the collec-

tion of C. P. Wilcomb. The warp is in stems of the willow, the dull - coloured material of the weft is the root of sedge, the brown and very white colours are in the stem of cercis—the former colour being outside bark, the latter of wood next to the bark. (See also Plate 173.)

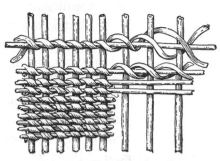

FIG. 27.
TEE OR LATTICE-TWINED WEAVING.
Pomo Indians, California.
American Anthropologist, III, 1901, fig. 22.

The technic of these two baskets is as follows: Beginning at the upper edge there is no special border, the ends of the warp stems being cut off; two or three rows of plain twined weaving are at the top; just below will be seen three or four

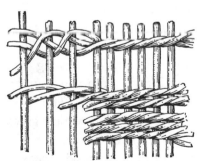

FIG. 28.
THREE-STRAND BRAID AND TWINED
WORK. (Outside.)
American Anthropologist, III, 1901, fig. 23.

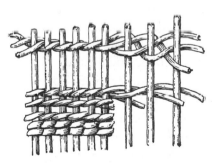

FIG. 29.
THREE-STRAND BRAID AND TWINED
WORK. (Inside.)
American Anthropologist, III, 1901, fig. 24.

rows of alternating brown and white rectangles; these are also in plain twined weaving, although the twists pass over two or three warp stems instead of one; after that twined tee-weaving follows over the entire surface. With an ordinary hand-glass

the two sets of warp, vertical and horizontal, can be made out, and also the way in which the weft of thin splints is administered. The limitations of ornament to the narrow bands with triangles and parallelograms for the elements are clearly seen. On the plain bands a form of ornament will be noted, in which splints of cercis unite with those of sedge root to form an alternation of wood colour and very white. In the coloured bands the effects are produced by exposing now the outside or bark of the cercis, now the inside or wood colour of these splints artificially.

5. *Three-strand twined weaving.*—Three-strand twined weaving is the use of three weft splints and other kinds of weft elements instead of two, and there are four ways of administering the weft:

(*a*) Three-strand twine.

(*b*) Three-strand braid.

(*c*) Three-strand, false embroidery, Tlinkit.

(*d*) Frapped twine, Thompson River.

It will be seen in studying these four methods that they are partly structural and partly ornamental, especially the last two. Inasmuch however, as the Indian woman makes her ornamental work a part of her industrial work, the four methods may be studied here. Very little was known among the American aborigines concerning additional ornaments given to the textile after the foundation was woven. The part which furnishes strength to the fabric and that which gives decoration were in technic one and the same process.

(*a*) *Three-strand twine.*—In this technic the basket-weaver holds in her hand three weft elements of any of the kinds mentioned. In twisting these three, each one of the strands, as it passes inward, is carried behind the warp stem adjoining, so that in a whole revolution the three weft elements have in turn passed behind three warp elements. After that the process is repeated. By referring to the lower halves of figs. 28 and 29, the outside and the inside of this technic will be

made plain. On the outside there is the appearance of a
three-strand string laid along the warp stems, while on the
inside the texture looks like a plain twined weaving. The
reason for this is apparent, since in every third revolution one
element passes behind the warp and two remain in front.
Three-strand twined work is seldom used over the entire sur-

FIG. 30.
BASKET-JAR IN THREE-STRAND TWINE.
Hopi Indians, Arizona.
Collected by J. W. Powell.

face of a basket. In fig. 30 will be seen the drawing of a very old
piece of twined work from the ancient Hopi or Moki Pueblo.
The bottom of this old basket jar and a portion of the body,
as will be seen are covered with plain twine weft. The
shoulder and neck and two bands of the body are in three-
strand twined weaving. A small portion of the inside, shown
in the top of the illustration, presents the appearance of

small two-strand twined work. In fig. 31 is shown a square inch from the surface of this jar, enlarged to make plain the appearance of the two types of technic. The upper portion of

the figure has all the appearance of t w i l l e d and twined work in two-strand weft. The three-strand work shown in this figure is a Ute motive. The U. S. National Museum collections represent at least seven different styles of basketry technic attributed to the Hopi people of Tusayan, and philologists have come to the conclusion that the Hopi are a very mixed people.

FIG. 31.
THREE-STRAND AND PLAIN TWINED
WEAVING.

(b) *Three-strand braid.*—In three-strand braid the weft elements are held in the hand in the same fashion, but instead of being twined simply they are plaited or braided, and as

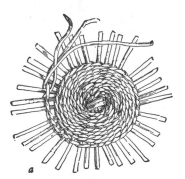
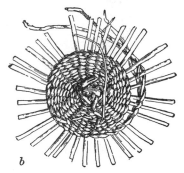

FIG. 32.
THREE-STRAND BRAID.
a, outside, *b,* inside.

each element passes under one and over the other of the remaining two elements it is carried behind a warp stem. This process is better understood by examining the upper part

of fig. 32, *a* and *b*. On the surface, when the work is driven home, it is impossible to discriminate between three-strand twine and three-strand braid. The three-strand braid is found at the starting of all Pomo twined baskets, no matter how the rest is built up.

Fig. 33 is a conical carrying-basket of the Klamath Indians of Oregon, collected by L. S. Dyar. It is made of coarse stems

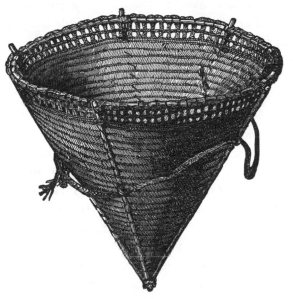

FIG. 33.
CARRYING-BASKET, THREE-STRAND BRAID.
Klamath Indians, Oregon.
Cat. No. 24,104, U.S.N.M. After W. H. Holmes.

of rushes. The warp begins with a few stems brought together to a point at the bottom and as the specimen widens out fresh warp stems are added. These are securely joined together by a continuous coil of weft, which is a three-strand braid. At the beginning these turns of the coil touch one another, but as the work progresses and the basket widens the distance from one row to the next increases until they are nearly an inch apart at the top. The braiding is done from the outside, two of the stems always showing there and only one on the

inside, resembling common twined weaving. This is the only specimen in the Museum in which the whole surface is braided. In many twined baskets of the Pomo an inch or so at the bottom is thus woven. The top is finished off in the following manner: Three warp-ends are braided together for at least 2 inches, turned down, and cut off. The hook-shaped ends are held in place by a row of common twined weaving at the top. Just below this and close to the ends is a row of three-strand braid. Another row of the same kind is made half-way between the upper edge of the solid weaving and the border. A hoop of wood is held in place on the inside by a wrapping of coarse twine. The appearance of three-strand braid in the drawing on the inside of the basket is given by the strands of twined weaving and the ends of the warp bent over. The basket is strengthened on the outside by five vertical rods, and the carrying-string is in three-strand braid, precisely as in the body and margin of the basket. Height 22 inches, diameter 23 inches. In the collection of Dr. C. Hart Merriam are two closely woven Klamath baskets in the same technic (see Plate 174). Styles (c) and (d) belong rather to ornamentation, and will be described under that heading.

Something should be said in this connection about the manner of laying the foundation for weaving baskets. In many of the specimens illustrated in this book it will be seen that very little tasteful care has been bestowed upon this part of the work. The Eskimos, for instance, do not know how, seemingly, but use a piece of rawhide, and it is said that the Indians of British Columbia formerly inserted a piece of board or wood at the bottom of their coiled baskets and sewed the coils around an edge of it, but there is method in much of the basket-weaving in this point, as will be seen on examining the plates. Miss Mary White, in her "More Baskets and How to Make Them," has worked this subject out very carefully.*

* How to Make Baskets, New York, 1902; also, More Baskets and How to Make Them, New York, 1903.

Figs. 34 to 39, inclusive, show the result of her studies.

Fig. 34 is the simplest form of starting the bottom of a basket. Four warp stems are arranged in pairs and crossed

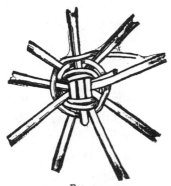

FIG. 34.
WARP STEMS CROSSED IN PAIRS.
After Mary White.

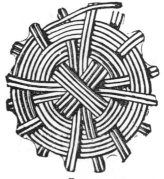

FIG. 35.
WARP STEMS CROSSED IN FOURS.
After Mary White.

at the center. A strip of wood or a flexible stem is wound twice around the intersection. The figure also shows how additional warp stems may be introduced into this pattern,

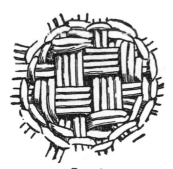

FIG. 36.
SIXTEEN STEMS WOVEN IN FOURS.
After Mary White.

FIG. 37.
WARP STEMS CROSSED IN FOURS
AND TWINED.
After Mary White.

being thrust between the regular stems. Once they are held firmly in place by two or three rows of common basket weaving, additional warp stems are added, and they are bent out radially as a foundation for the work.

Fig. 35 shows how a start may be made with 16 warp stems crossing in groups of four at the center. Two sets begin at once to divide and radiate, and after they are held together by three rows of weft the other eight are spread out in the same way. The drawing illustrates exactly the manner in which this is done.

FIG. 38.
SIX WARP STEMS PARALLEL.
After Mary White.

· Fig. 36 shows another method of beginning with 16 warp stems, plaiting them into checker pattern at first, then afterward spreading them out radially.

Fig. 37 brings us into the Hopi Indian type of twined weaving. Here four stems in one direction cross the same number at right angles and are held in place by a row of twined weaving, additional warp stems being inserted at the corners, which spread out radially.

Fig. 38 is a Hopi application of coiled sewing to the beginning of the basket. In Fig. 39 the warp stems are woven together in wickerwork in two sets; the first vertical, the second horizontal. As soon as they are in place and held together the work proceeds as in ordinary weaving.

FIG. 39.
WARP STEMS CROSSED IN THREES; HELD BY WICKER.
After Mary White.

COILED BASKETRY

Coiled basketry is produced by an over-and-over sewing with some kind of flexible material, each stitch interlocking with the one immediately underneath it. The exception to this is to be seen on Salish, Maidu, and other baskets, in which the passing stitch is driven through the wood of the one underneath and splits it.

In the coiled basketry of British Columbia, as well as here and there farther south, this splitting of stitches, so clumsy looking when done without plan, is turned into an element of beauty. The top of every stitch is carefully bifurcated or trifurcated, so that to the uninitiated the sewing appears to have been done vertically instead of horizontally. This type of work may be called furcate coil. (See Plate 23 and figs. 51 and 55.)

The specimen (Plate 23) is a remarkable old piece of Mu-wa work, from Calaveras County, California. Diameter, 6½ inches; depth, 4 inches; colours, dark wood, with line of brown around top. This is one of the finest exhibitions of furcated stitches. It resembles common Ute basketry of the two-stem variety, and in the sewing the stitches are not driven home tight, but left as wide apart as possible. On the inside of the basket it is plain coiled sewing, showing the foundation rod clearly between the stitches. Passing the awl-point between the stitches on the inside, it is carefully pushed through so as to divide the sewing-splint of the previous coil exactly in the middle. This gives the appearance of embroidery stitches from the center of the bottom to the outer margin. This specimen of furcated stitching is in the collection of Edward L. McLeod. Doctor Merriam secured an example from a Mu-wa squaw in Calaveras County, California, on the western slope of the Sierra. Those familiar with the coiled basket-making taught in the industrial schools will compare this

FIG. 40.
BONE AWL FOR
COILED BASKETRY.
Collected by Edward
Palmer.

work with their own, in which the coloured raffia is hidden in the foundation for a space of wrapping and comes out at the point where the double stitch is to be made.

The transition from lace work and coiled basketry is interesting. In the netted bags of pita fiber, common throughout middle America, in the muskemoots or Indian bags of fine caribou-skin thong from the Mackenzie River district, as well as in the lace-like netting of the Mohave carrying-frames and Peruvian textiles, the sewing and interlocking constitute the whole texture, the woman doing her work over a short cylinder or spreader of wood or bone, which she moves along as she works. When the plain sewing changes to half hitches, or stitches in which the moving part of the filament or twine is wrapped or served one or more times about itself, there is the rude beginning of point-lace work. This is seen in basketry and soft wallets of the Mackenzie River tribes, the Hopewell mound relics in Ohio, here and there in California, and especially among the Fuegians, as well as in many pieces from various parts of the Old World. (See figs. 59 and 115.)

The sewing-materials vary with the region. In the Aleutian Islands it is of delicate straw; in the adjacent region it is spruce root; in British Columbia it is cedar or spruce root; in the more diversified styles of the Pacific States every available material has been used—stripped leaf, grass stems, rushes, split root, broad fillets, and twine, the effect of each being well marked. The gathering and preparation of these materials for use have already been described in the first portion of this paper. It is understood that, as in woven basketry, the grasses, roots, and splits of wood are soaked in water and kept as pliable as possible until the work is done.

In all coiled basketry, properly so called, there is a foundation more or less rigid, inclosed within stitches, the only implement being an awl of some kind. Fig. 40 shows the metatarsal of an antelope sharpened in the middle and harder portion of the column, the joint serving for a grip for the hand.

It was the universal prehistoric sewing-implement of savage women, and persists to our day.

In every living tribe of basketmakers these awls are among the commonest of woman's tools, most serviceable in sewing garments as well. They are dug up in mounds, found in caves, and are rarely absent from the work-baskets of mummies in the arid regions.*

Frank H. Cushing was of the opinion that the bone awl was far better for fine basketwork than any implement of steel; the point, being a little rounded, would find its way between the stitches of the coil underneath, and not force itself through them. The iron awl, being hard and sharp, breaks the texture and gives a very rough and clumsy appearance to the surface, as will be seen in fig. 51.

Coiled basketry in point of size presents the greatest extremes. There are specimens delicately made that will pass through a lady's finger-ring, and others as large as a flour-barrel; some specimens have stitching-material one-half inch wide, as in the Pima granaries, and in others the root material is shredded so fine that nearly 100 stitches are made within an inch of space. In form the coiled ware may be perfectly flat, as in a table-mat, or built up into the most exquisite jar-shape. In design the upright stitches lend themselves to the greatest variety of intricate patterns.

Coiled basketry may be divided into ten varieties, based on structural characteristics.

The foundation of the coil may be (1) a single element, either splint, or stem, or rod; (2) a stem or other single element, with a thin welt laid on top of it; (3) two or more stems one over another; (4) two stems or other elements laid side by side, with or without a welt; (5) three stems in triangular position; (6) a bundle of splints or small stems; (7) a bundle of grass or small shreds.

The stitches pass around the foundation, in progress (1) in-

* Smithsonian Report, 1882, p. 724, fig. 3.

terlocking with and sometimes splitting stitches, but not inclosing the foundation underneath; (2) under one rod of the coil beneath, however many there may be; (3) under a welt of the coil beneath; (4) through splints or other foundation, in some cases systematically splitting the sewing-material underneath. With these explanations it is possible to make the following ten varieties of coiled basketry, matting, or bagging:

A. Coiled work without foundation.

B. Simple interlocking coils.

C. Single-rod foundation.

D. Two-rod foundation.

E. Rod-and-welt foundation.

F. Two-rod and splint foundation.

G. Three-rod foundation.

H. Splint foundation.

I. Grass-coil foundation.

K. Fuegian coiled basketry (see p. 103).

These will now be taken up systematically and illustrated. (See fig. 41.)

A. *Coiled work without foundation.*—Specimens of this class have been already mentioned. The sewing-material is babiche or fine rawhide thong in the cold north, or string of some sort farther south. In the Mackenzie Basin will be found the former, and in the tropical and subtropical areas the latter. If a plain, spiral spring be coiled or hooked into one underneath, the simplest form of the open coiled work will result. An improvement of this is effected when the moving thread, in passing upward, after interlocking, is twined one or more times about its standing part. (See figs. 41 A and 100.)

The technical process just mentioned is practised among the Athapascan tribes of the Mackenzie River drainage. It is doubtful whether anciently the predecessors of these Indian women did such fine work in rawhide. The steel-bladed knife made slender babiche possible, and the thrift brought about

by the Hudson Bay Company made it desirable. But it will
be seen that the Mound Builders had the weave and could
produce texture in flax even more delicate than the muske-
moots or hunting-bags of the northern tribes.

Fig. 42 represents a carrying-frame and net of the Pima and
other tribes on our Mexican border. It is supported by a rude
framework of sticks. The network is of agave twine, and is

FIG. 41.
CROSS-SECTIONS OF VARIETIES IN COILED BASKETRY.

made of interlocking coils, looking as all coiled basketry would
if the foundation were removed.

Further on, illustrations will be given showing the wide
extent of this technical process of coiled basketry without foun-
dation. Examples in the United States National Museum come
from as far south as Paraguay and even the Strait of Magellan.
It is in common use as far north as northern Mexico. Both
the possession of different material and the demands of a
tropical life have occasioned the employment of this particular
technic in articles of common use about the household. Its

FIG. 42.
CARRYING-BASKET.
Pima Indians, Arizona.
Cat. No. 126,680, U.S.N.M. Collected by
Edward Palmer.

relation to coiled basketry and beadwork is shown by the fact that women, in making the fabric, use a needle to carry the thread or string around through the row of work preceding. A small rod or mesh-gauge is used to secure uniformity in the size of the meshes.

B. *Simple interlocking coils*.—Coiled work in which there may be any sort of foundation, but the stitches merely interlock without catching under the rods or splints or grass beneath. This form easily passes into those in which the stitch takes one or more elements of the foundation, but in a thorough ethnological study small differences cannot be overlooked (see fig. 41 B).

Fig. 43 represents this style of workmanship on a coiled basket in grass stems from Alaska, collected by Lucien M. Turner. The straws for sewing merely interlock without gathering the grass roll.

In the imbricated basketwork of British Columbia and Washington, the sewing is done with splints of cedar root, and the stitches interlock. Two quite distinct styles of foundation

FIG. 43
DETAIL OF INTERLOCKING
STITCHES.

are used, namely, bunches of splints taken from the more brittle and rough interior of the cedar root, and two flat strips of the smooth layer on the outside of the root. The surface of the one will be rugose, of the other flat and smooth (see figs. 52, 53, and 54 and Plates 156–161).

Figs. 44 and 45 represent a type of coiled work in vogue among the Mescalero Apaches. As has been said previously,

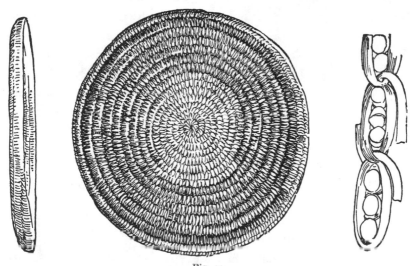

Fig. 44.
FOUNDATION OF THREE RODS LAID VERTICALLY.
Mescalero Apache Indians.

the Apache Indians, who live in the arid regions of Arizona, made the foundations of their coiled basketry of hard rods. In various tribes these rods are arranged in a foundation after different patterns. It will be seen by examining the drawing here given that three rods form the basis of the coil. They are laid one on another in a vertical row, the stitches simply interlocking so that the greatest economy of work is effected. It is not known that any other tribe in America practises this peculiar arrangement of the foundation rods. This specimen (Cat. No. 211,941, in the United States National Museum) was collected by F. M. Covert.

Plate 24 shows a style of coiled weaving called openwork. This specimen, in the collection of C. E. Rumsey, Riverside, California, is termed a grasshopper basket, but it belongs to a

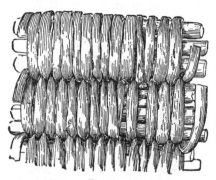

type of technic that has a very wide distribution, and probably has nothing to do with holding live insects. The foundation is a bundle of shredded material or grass. The sewing is a splint of hard wood. This is wrapped a certain n u m b e r of times around the foundation and then caught under the sewing of the coil underneath, the

Fig. 45.
DETAIL OF FIG 44.

stitches interlocking. Perhaps a few bits of the foundation are caught also in the stitch. After two stitches are made in this way, the wrapping continues. It is possible, by counting this last as well as the number of stitches, to reproduce beautiful patterns on the surface. The orna- mentation a l s o m a y b e varied by the use of differ- ent coloured splints. This s p e c i m e n is from the W i k c h u m n i (Mariposan) Indians of middle California, but examples are in the Na- tional Museum collected from Norway, Porto Rico, and Peru (see Plates 224 and 248).

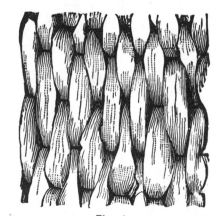

Fig. 46.
DETAIL OF SINGLE-ROD COIL IN BASKETRY.

C. *Single-rod foundation.*—In rattan basketry and Pacific coast ware, called, by Dr. J. W. Hudson, Tsai, in the Pomo language, the foundation is a single stem, uniform in diameter.

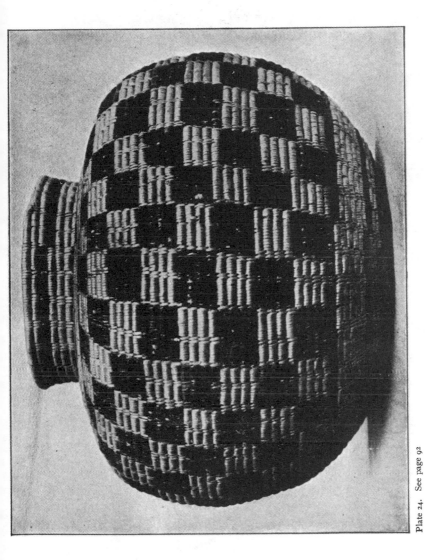

Plate 24. See page 92

BASKET IN OPENWORK COILING, ONLY A FEW STITCHES CATCH THE COIL UNDERNEATH

Collection of C. E. Rumsey

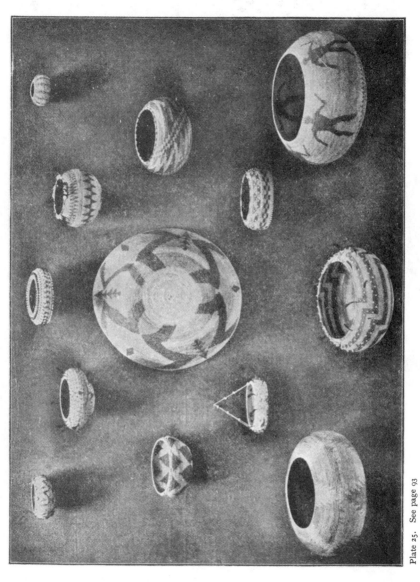

Plate 25. See page 93

Treasure Baskets in Coiled Weaving, and Decorated with Shell Money and
Quail Plumes. Pomo Indians, California

Collection of C. P. Wilcomb

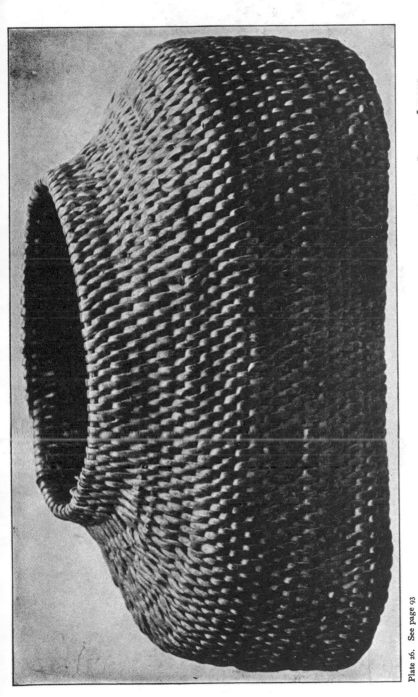

Plate 26. See page 93

COILED BASKET WITH SINGLE-STEM FOUNDATION. FROM ALASKAN ESKIMO, BUT MADE BY INDIANS INLAND

Collection of P. H. Ray, U. S. National Museum

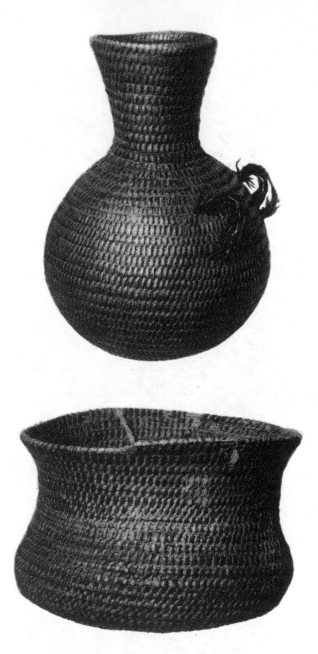

Plate 27. See page 95

WATER JAR AND TRINKET BASKET

Like the Utes, the Hopi use the efficient and unbreakable *wikozro* for long journeys over
the arid region. Hanging from the rafters of the dwelling, one often sees the deep bowl-like
basket, with flaring rim, bought from the Havasupai of Cataract Canyon.

In it are kept beads, feathers, and other trinkets used in ceremonies.

Collected by J. Stevenson and V. Mindeleff

The stitch passes around the stem in progress and is caught under the one of the preceding coil, as in fig. 41 C. In a collection of Siamese basketry in the United States National Museum the specimens are all made after this fashion. The foundation is the stem of the plant in its natural state; the sewing is with splints of the same material, having the glistening surface outward. As this is somewhat unyielding, it is difficult to crowd the stitches together, and so the foundation is visible between. California is not far behind the East in the quality of material, willow for the basis of the coil, and plants in a variety of colours for the sewing The Siamese coiled basketry has little of design on its surface, but the American basketmaker may fix whatever her imagination may suggest. The effect of the plain stitching is pleasing to the eye by reason of the regular broken surface. In America, single-rod basketry is widely spread. Along the Pacific coast it is found in northern Alaska and as far south as the border of Mexico. The Pomo Indians use it in some of their finest work. The roots of plants and soft stems of willow, rush, and the like are used for the sewing, and, being soaked thoroughly, can be crowded together so as to entirely conceal the foundation (see fig. 46)

Plate 25 represents a collection of Pomo treasure-baskets, all in single-rod foundation, called Tsai by Dr. Hudson and bam tsha or bam tshai by Carl Purdy. These specimens are in the collection of C. P. Wilcomb; the foundation is of willow rod, the sewing-material of sedge root, the design in the cercis splints, the decoration with shells, beads, and partridge plumes. The method of sewing is on all of these baskets the same as shown in fig. 41 C.

Plate 26, Cat. No. 89,801, U.S.N.M., is from Point Barrow, Alaska, and was collected by Captain P. H. Ray, United States Army. The material is shoots and roots of willow, and the specimen was secured from Eskimo people living at the extreme northern point of Alaska. It had evidently been procured, however, from Indians near by. On the bottom, small rods are

used for the foundation, and the sewing is in straight lines backward and forward until this portion is finished. Here the foundation-rods are somewhat larger and the sewing-splints wider. Comparing this specimen, then, with a great many others from the same area, the uniformity in size of the foundation - rod is noticeable. It will also be noted that the stitches are not driven home closely, a feature which occurred over and over again in coiled basketry between Point Barrow and the Republic of Mexico.

D. *Two-rod foundation.*—One rod in this style lies on top of the other; the stitches pass over two rods in progress and under the upper one of the pair below, so that each stitch incloses three stems in a vertical series (fig. 47). A little attention given to fig. 41 D will demonstrate that the alternate rod, or the upper rod, in each pair will be inclosed in two series of stitches, while the other or lower rod will pass along freely in the middle of one series of stitches and show on the outer side.

Fig. 47
FOUNDATION OF TWO RODS,
VERTICAL.

Examples of this two-rod foundation are to be seen among the Athapascan tribes of Alaska, among the Pomo Indians of the Pacific coast, and among the Apache of Arizona. An interesting or specialised variety of this type is seen among the Mescaleros of New Mexico, who use the two-rod foundation, but instead of passing the stitch around the upper rod of the coil below, simply interlock the stitches so that neither one of the two rods is inclosed twice. This Apache ware is sewed with yucca fiber and the brown root of the same plant, producing a brilliant effect, and the result of the special technic is a flat surface like that of pottery. The United States National

Museum possesses a single piece
of precisely the same technic
from the kindred of the Apache
on the Lower Yukon (see figs.
44 and 45).

E. *Rod-and-welt foundation.*
—In this kind of basketry the
single-rod foundation is over-
laid by a splint or strip of tough
fiber, sometimes the same as
that with which the sewing is
done; at others, a strip of leaf

Fig. 48.
ROD-AND-WELT FOUNDATION.

or bast. The stitches pass over the rod and strip that
are on top, down under the welt only of the coil below,
the stitches interlocking. The strip of tough fiber between
the two rods which serves for a welt has a double purpose—
strengthening the fabric and chinking the space between
the rods (fig. 48). This style of coil work is seen on old
Zuñi basket-jars and
on California ex-
amples. This type of
foundation passes
easily into forms C, D,
E, and F. In fact,
it is impossible to dis-
tinguish between them
without marring the
specimen (see fig. 41).

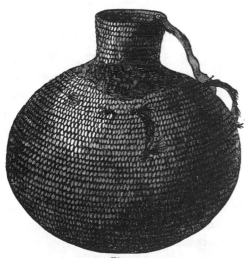

Fig. 49.
WATER-JAR IN COILED BASKETRY.
Wolpi, Arizona.
Cat. No. 42,128, U.S.N.M. Collected by
James Stevenson.

The specimens
shown on Plate 27 are
a water-bottle and a
gathering-basket of
the Utes—that is, they
are of Ute motive.
Such pieces, however,

are often seen among other tribes and in some of the recent pueblos. By looking carefully at the surface of the pictures, it will be seen that there may be two rods, the upper much smaller than the other; or on the top of the principal rod will be a splint or two of material. The foundation of such basketry is not uniform in composition, but in motive they are all the same. The strength of the basket is in the principal rod. The joint is made stronger by having between the stitches of two coils an additional rod or smaller piece. There are no wide gaps separating any two styles of weaving, and it will be easily seen that this Ute type passes readily into other forms. Cat. Nos. 84,596 (upper figure), 42,126 (lower figure), U. S. N. M.

F. *Two-rod and splint foundation.*—In this style the foundation is made thicker and stronger by laying two rods side by side and a splint or welt on top to make the joint perfectly tight. The surface will be corrugated. Tribes practising this style of coiling generally have fine material, and some of the best ware is so made up. It passes easily, as one might guess, into the Lillooet style, in which the two elements of the foundation are thin and flat. Fig. 49 is a water-jar from the Wolpi pueblo, one of the Hopi group, collected long ago by James Stevenson. It is Cat. No. 42,129, U.S.N.M., and was first figured in the Second Annual Report of the Bureau of Ethnology (see fig. 41 F).

Plate 28 represents two fine old coiled baskets from the pueblo of Sia, on the Rio Grande River, New Mexico. In addition to the structure, which consists of two rods and a splint above sewed with willow splints, the stitches interlocking and catching in the welt below, the ornamentation a stepped design, suggestive of pueblo architecture on the upper figure and spirals made up of coloured rectangles on the lower figure, needs to be merely pointed out. The characteristic sought to be illustrated here in this connection is the false braid made on

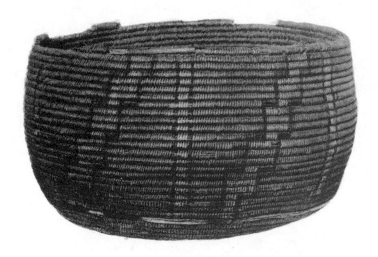

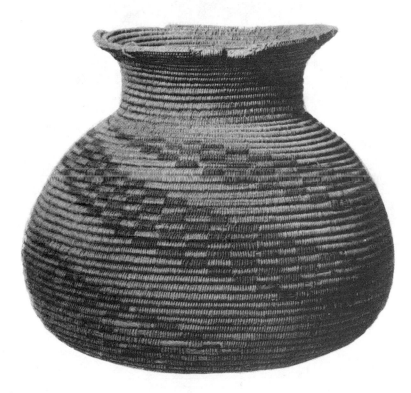

Plate 28. See page 96

RARE OLD BASKETS

Among the treasures of the Southwest are these examples of woman's skill in the olden time. Some of these baskets are hundreds of years old, and have survived in the caves and cliffs, or in the secret rooms of the pueblo folk, deep in the house cluster.

Collected by James Stevenson

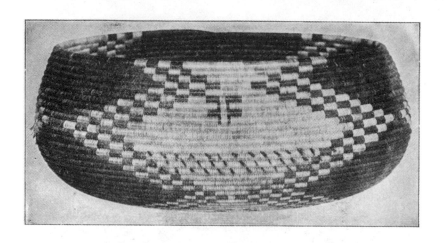

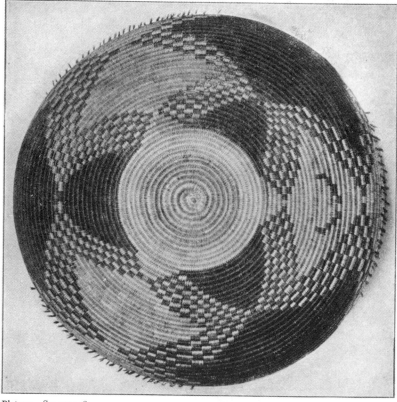

Plate 29. See page 98

FINE COILED BASKET WITH BAM SHI BU, OR THREE-ROD, FOUNDATION,
POMO INDIANS, CALIFORNIA

Collection of C. P. Wilcomb

the surface produced by sewing a single splint in a figure-of-eight weaving, shown in the plate. The modern Indians of this pueblo do not make basketry of this character, and it is altogether reasonable to think that in the olden times these pieces came into the possession of these people by traffic from Shoshonean tribes near by. Cat. No. 134,213, U. S. N. M. Collected by James Stevenson.

G. *Three-rod foundation.*—This is the type of foundation called by Carl Purdy Bam shi bu, from bam, sticks, and sibbu, three. Among the Pomo and other tribes in the western part of the United States the most delicate pieces of basketry are in this style. Dr. Hudson calls them "the jewels of c o i l e d basketry." The surfaces are beautifully corrugated, and patterns of the most intricate c h a r a c t e r can be wrought on them. The technic is as follows: Three or four small willow stems of uniform thickness serve for the foundation, as shown in fig. 50;

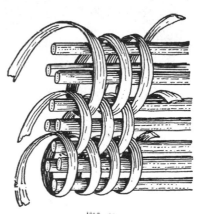

FIG. 50.

FOUNDATION OF THREE RODS, STITCHES CATCHING ROD UNDERNEATH.

also in cross-section in fig. 41 G. The sewing, which may be in splints of willow, black or white carex root, or cercis stem, passes around the three stems constituting the coil, under the upper one of the bundle below, the stitches interlocking. In some examples this upper rod is replaced by a thin strip of material serving for a welt (see fig. 41 F). In the California area the materials for basketry are of the finest quality. The willow stems and carex root are susceptible of division into delicate filaments. Sewing done with these is most compact, and when the stitches are pressed closely together the foundation does not appear. On the surface of the Bam shi bu bas-

ketry the Pomo weaver adds pretty bits of bird feathers and delicate pieces of shell. The basket represents the wealth of

FIG. 51.
FOUNDATION OF SPLINTS.

the maker, and the gift of one of these to a friend is considered to be the highest compliment.

Plate 29 is a beautiful example of Bam shi bu coiled basketry, having a foundation of three bams, or shoots of Hind's willow (*Salix sessilifolia*). The sewing of the lighter portions is in carefully prepared roots of a sedge, Kahum (*Carex barbarae*), while the designs are in the roots of a bulrush, Tsuwish (*Scirpus maritimus*). Red feathers of the California woodpecker are scattered over the surface. This faultless specimen, now in the collection of C. P. Wilcomb, was made in the year 1896 by Squaw Mary, a noted basketmaker,

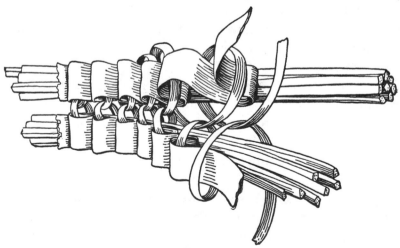

FIG. 52.
IMBRICATED WORK DETAIL, CALLED KLIKITAT.
Showing method of concealing coil stitches.

wife of Ned Dunson (Indian), then living at Santa Rosa Creek, Sonoma County, California. She belonged to the Tsar walo division of the Pomos. Diameter of the basket, 8⅜ inches. Collected by J. P. Stanley.

H. *Splint foundation.*—In basketry of this type the foundation c o n s i s t s of a number of longer or shorter splints massed together and sewed, the stitches passing under one or more of the splints in the coil beneath (fig. 51). In the Pomo language it is called Chilo, but it has no standing in that

FIG. 53.
IMBRICATED COIL-WORK, CALLED KLIKITAT.

tribe. In the Great Interior Basin, where the pliant material of the California tribes is wanting, only the outer and younger portion of the stem will do for sewing. The interior parts in

FIG. 54.
IMBRICATED BASKETRY DETAIL.
Thompson River.
After James Teit.

such examples are made up into the foundation. All such ware is rude, and the sewing frequently passes through instead of around the stitches below. In the Klikitat basketry the pieces of spruce or cedar root not used for sewing-material are a l s o worked into the foundation (see fig. 41 H).

In a small area on Fraser River, in southwestern Canada, on the upper waters of the Columbia, and in many Salishan tribes of northwestern Washington, basketry, called imbricated, is made. The foundation, as said, is in cedar or spruce-

root, while the sewing is done with the outer and tough portion of the root; the stitches pass over the upper bundle of splints and are locked with those underneath. On the outside of these baskets is a form of technic which also constitutes the ornamentation. It is not something added, or overlaid, or sewed on, but is a part of the texture effected in the progress of the manufacture (see fig. 52).

The method of adding this ornamentation in strips of cherry bark, cedar bast, and grass stems, dyed with Oregon grape, is unique, and on this account I have applied the term "imbricated" to the style of weave here shown. (See fig. 53.)

The strip of coloured bark or grass is laid down and caught under a passing stitch; before another stitch is taken, this one is bent forward to cover the last stitch, doubled on itself so as to be underneath the next stitch, and so with each one it is bent backward and forward so that the sewing is entirely concealed, forming a sort of "knife-plaiting."

In some of the finer old baskets in the National Museum, collected over sixty years ago, the entire surface is covered with work of this kind, the strips not being over an eighth of an inch wide. James Teit describes and illustrates this type of weaving among the Thompson River Indians of British Columbia, who are Salishan. The body of the basket is in the root of *Thuja plicata*, and the ornamentation in strips of *Elymus triticoides* and *Prunus demissa*. (See fig. 54.)

Imbrication is one of the most restricted of technical processes. Eells says that some women in every tribe on Puget Sound could produce the stitch, and he names the Puyallups, Twanas, Snohomish, Clallam, Makah, Skagit, Cowlitz, Chehalis, Niskwalli, and Squaxin. It doubtless originated here. It is the native art of the Klikitats, Yakimas, and Spokans. The Thompson and Fraser River Indians have long known the art. (See Plates 68, 74–79, 156–167.)

Fig. 55 is a square inch from the bottom of a Fraser River imbricated coiled basket. It illustrates several important

features in the basketmaker's art. In the first place, the Indians of this area did not know how to make a beginning of the bottom of a rectangular basket with coiled work, so a block was inserted or foundation strips were l a i d parallel and w e r e w h i p p e d together after t h e manner of coiled work. This figure also shows how the splitting of stitches before mentioned in sewing may have at first been a c c i d e n t a l, the basketmaker h a v i n g in mind only the purpose of p l a c i n g the stitches

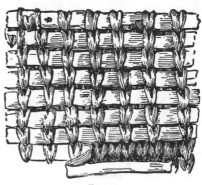

FIG. 55.
OVERLAYING IN COILED WORK.

in vertical rows. From this unintentional furcation of the stitches comes the purposeful splitting, the forked stitches being made alike and uniform. Thus, out of a careless habit has come one of the beautiful ornamentations in coiled basketry. A third purpose in this figure is to show, perhaps, the initial step in imbricated work. Indeed, this form of overlaying is seen on many examples of it. A straw of squaw-grass (*Xerophyllum tenax*) is inclosed under a s t i t c h ; it is then turned back; a second stitch is made and the strip of grass laid over it. Thus, over the surface there is an alternation of exposed and concealed stitches by means of this material. This is elsewhere called "beading."

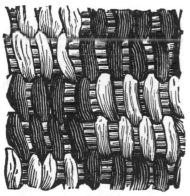

FIG. 56.
FOUNDATION OF STRAWS IN COILED WORK.

I. *Grass-coil foundation.*—The foundation is a bunch of

grass or rush stems, or small midribs from palm leaves, or shredded yucca. The effect in all such ware is good, for the

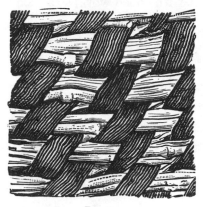

FIG. 57.
COIL WITH OPEN SEWING INCLOS-
ING PARTS OF FOUNDATION.

reason that the maker has perfect control of her material. Excellent examples of this kind are to be seen in the southwestern portions of the United States, among the Pueblos and Missions, and in northern Africa. The sewing may be done with split stems of hard wood, willow, rhus, and the like, or, as in the case of the Mission baskets in southern California, of the stems of rushes (*Juncus acutus*) or stiff grass (*Epicampes rigens*). (See fig. 56, and the cross-section given in fig. 41 I.) In the larger granary baskets of the southwest a bundle of straws furnishes the foundation, while the sewing is done with broad strips of tough bark, as in fig. 57.

Plate 30 shows specimens of Hopi coiled plaques on shredded foundation made up of the harder parts of the yucca split and rolled into a bundle. The sewing is with the tough, leafy portion, and passes simply under the coil in preparation, the stitches interlocking. Between the refined type of coiled

FIG. 58.
FOUNDATION OF GRASS OR
SHREDDED MATERIALS.

work of this class and the old-fashioned straw beehive or the Mohave granary is a long distance. These thick Hopi plaques have their nearest resemblance in the Moorish basketry of

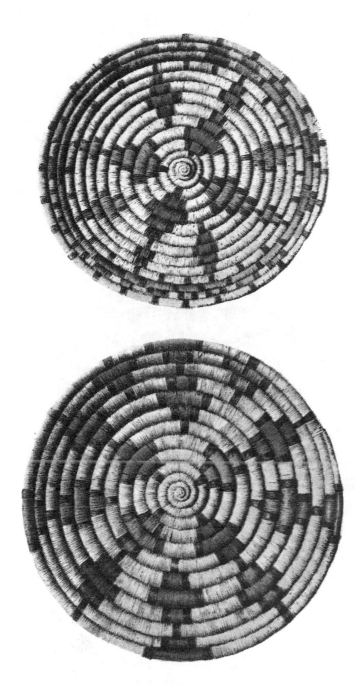

Plate 30. See page 102

SACRED PLAQUES

These are the brightest baskets produced in America, and on them the Hopi women lavish their skill in decoration and knowledge of symbolism. They are carried as shields in the women's ceremonies.

Collected by James Mooney

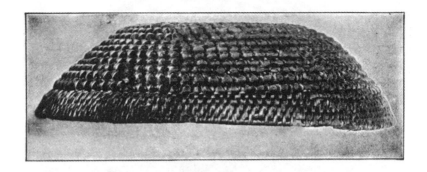

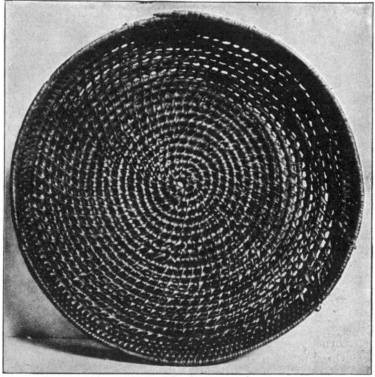

Plate 31. See page 103

COILED SIFTER, IN WHICH EACH STITCH MAKES A TURN ABOUT ITSELF
BETWEEN RODS. CAVE IN UTAH

Collection of Am. Mus. of Nat. Hist., N. Y.

North Africa, and leave the question on the mind whether from long contact the Hopi themselves may not have gotten a suggestion therefrom. These specimens are Cat. Nos. 166,856 and 166,858 in the United States National Museum, and were collected by James Mooney. (See also fig. 58.)

K. *Fuegian coiled basketry.*—In this ware the foundation is slight, consisting of one or more rushes; the sewing is in

FIG. 59.
FUEGIAN COILED BASKET, AND DETAILS.

buttonhole stitch or half hitches, with rush stems interlocking. The resemblance of this to Asiatic types on the Pacific is most striking. (See fig. 59.)

Plate 31 is one of the most interesting specimens of basketry found in America, because in its structure it practically imitates the specimens just illustrated from the Strait of Magellan. It is described by George H. Pepper in Guide Leaflet No. 6 of the American Museum of Natural History. It is called a "sifter," and was found among the relics of the ancient basketmakers of southeastern Utah. The outer rows of coiling belong to the single-stick variety. On the

rest of the surface the binding material in passing around the foundation rods makes a whole turn on itself between them. The basket is 9½ inches in diameter and 2 inches deep.

WATER-TIGHT BASKETRY

Basketry is rendered water-tight by closeness of texture and by daubing with pitch or asphaltum. Both twined and coiled ware are useful for the latter purpose. It is said of the mother of Moses that she "took for him an ark [a boat-shaped basket] of bulrushes and daubed it with slime and with pitch and put the child therein, and she laid it in the flags by the river's brink." (Exodus ii, 3.) Now, the Egyptians and other Hamites of our day make coiled basketry of type fig. 41 I—that is, with a foundation of shredded material sewed with finely split palm leaf. The foundation is quite thick, so that the ware is strikingly like the Hopi plaques of the Middle Mesa. There is no reason for believing that the ancient ware differed from the modern. In the Interior Basin, also, baskets are used for pottery by tribes that are not sedentary. (See Plate 32.)

Major J. W. Powell, during his topographical and geological survey of the valley of the Colorado River of the West, in company with Professor A. H. Thompson, made a collection of water-tight basketwork from the Paiute Indians (Shoshonean family) in southern Utah, and additions have been made by Dr. Walter Hough and others. Both coiled and twined work are found in great varieties. Plate 32 represents the varieties of these water-tight carrying-jugs or bottles. Fig. 1 of the plate, Cat. No. 11,882, is a Tsai a wats in twined weaving, the pattern being twilled work. Lugs on the side support the broad, soft, buckskin band. The pitch is evenly laid on, just revealing the texture beneath. Height, 7½ inches.

Fig. 2, Cat. No. 10,760, is a globose jar in coiled weaving, carelessly done on a splint foundation, as among the Utes.

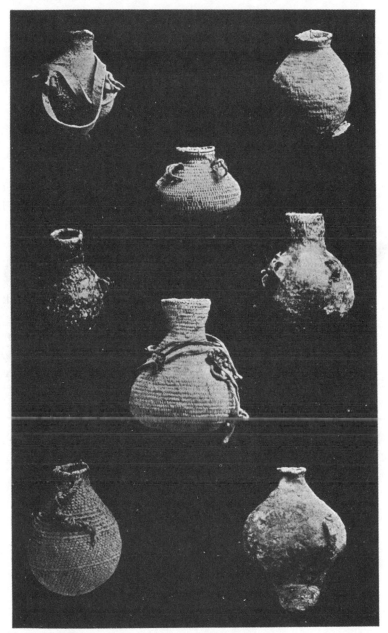

Plate 32. See page 104

WATER-TIGHT BASKET JARS IN TWINED AND COILED WEAVING

Collections of U. S. National Museum

1 2
3
4 5
6
7 8

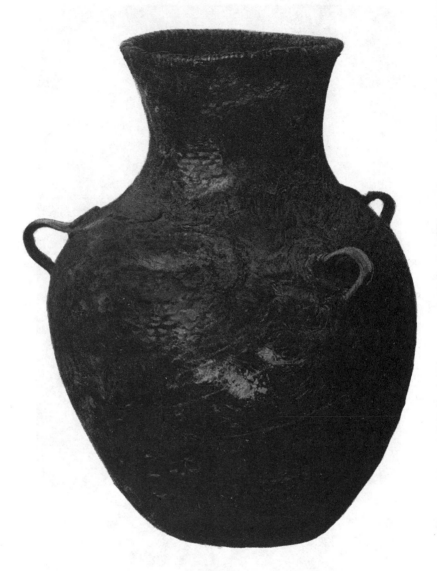

Plate 33. See page 105

Apache Water Jar

The Apache have never found any vessel to supersede their ancient tōs, which is indestructible, and imparts a sweet taste to the water from the pine gum used in pitching it.

Collected by Walter Hough

Height, 7½ inches. There are no lugs on the outside, so this piece would be a pitcher rather than a canteen.

Fig. 3, Cat. No. 10,758, is a Tsai a wats of squat form in single-rod coiled weaving, with three lugs at equal distances around the shoulder for carrying. Height, 4¾ inches.

Figs. 4 and 5, Cat. Nos. 213,101–2, in the United States National Museum, are small canteens, collected from the Havasupai Indians, in Cataract Canyon, by Dr. Walter Hough. They are precisely the same in structure as the foregoing, though the Havasupai are of the Yuman family, while the Utes are Shoshonean. Height, 7½ inches and 8½ inches.

Fig. 6, Cat. No. 211,020, U.S.N.M., is a Paiute water-jar for carrying, from the collection of Captain Carr, United States Army. The foundation is of splints, and the pitch is carefully restricted to the inside. Horsehair lugs support the headband of old leather. Height, 9 inches.

Fig. 7, Cat. No. 11,880, U.S.N.M., is an excellent specimen of twined work in twill, with single rows of three-ply twine, and the neck in openwork. In many examples like the one here shown the melted pitch or asphaltum is poured inside and whirled around until the surface is covered. Height, 9 inches. The rope handle gives the appearance of a pitcher.

Fig. 8, Cat. No. 10,759, U.S.N.M., is pear-shaped, and has wooden lugs upon the sides for the carrying-bands. It is twined and twilled weaving and thoroughly overloaded with pitch. The rounded bottom serves to keep the bottle erect. Height, 8½ inches.

Plate 33 is a water-jar of the White Mountain Apaches, Cat. No. 213,278, U.S.N.M., collected by Dr. Walter Hough. It is made in diagonal twined weaving and covered with pitch. Three lugs of wood attached to the sides are for the purpose of suspension and carrying. The height is 12 inches.

BORDERS ON BASKETRY

Having studied the structural processes on the body of these textiles, it will now be in order to note how the work is

finished off. A glance at a lady's workbasket or a waste-paper basket shows how important such an examination must be. Both in woven and in twined ware many beautiful specimens will be seen whose edges differ not in the slightest degree from other portions of the basket. Indeed, the Tlinkit, the Pomo, and the Mission weavers all frequently affect the plain border on their ware, and certain kinds of plaques of the Hopi Indians, said to be the workmanship of unmarried women, leave the foundation exposed, and the work is suddenly brought to an end.

Another fact will surprise the student, namely, that technically the border is often in quite another class of weave. This grows, as will be seen, out of the exigencies of the case. A checker weaving, with the edges left open all around, would be a clumsy affair. Coiled work lends a hand in putting a finish on woven work; the latter, or an imitation of it, on the contrary, becomes an embellishment of the former. The drawings and the plates will explain more clearly than words the structure of borders. The motive in this inquiry should be to learn the steps or evolutionary processes through which the ingenious savage woman's mind has passed in this series of inventions to discover, if possible, a little truth about the relationship and communication among tribes in olden times, and to learn some new manipulations in an art now becoming popular. It is like the breaking out of an old hereditary complaint in the tips of the fingers. The borders will be studied in the following order: The finishing off in checkerwork, in wickerwork, in twilled work, in twined work, and in coiled work.

The first and simplest method of making borders is illustrated in examples collected among the Abenaki Indians of Canada belonging to the Algonquian family. The baskets are made of splints from the ash, formerly worked out with aboriginal tools (see fig. 60), but nowadays made by machinery. The foundation of the borders consists of three narrow

hoops. Every alternate warp splint is cut off flush; the others are bent down over the middle hoop and pushed under the upper row of weaving, having first been pointed. Outside and inside of this middle hoop, and clasping the bends in the warp splints, are the other two hoops, the whole being bound securely together by a coiled sewing in splint. The specimen here figured is Cat. No. 206,390, U.S.N.M., made by Caroline Masta. Diameter, 5¼ inches; height, 3 inches.

The border of twilled work, when the weaving is finished, resembles closely the interlacing of a series of crossed warps. In matting made in this way the ends of the warp and of the weft are bent backward on one another and forced under the texture. In one example a twilled mat is finished out with wicker weaving, both sets of elements being straightened out for warp. (See fig. 12.) The margin is then finished off as if the whole mass had been in wicker weaving. The examples

FIG. 60.
COILED BORDER ON CHECKER WEAVING
Cat. No. 206,390, U.S.N.M.

here shown was made recently by an Indian woman in the Zuñi pueblo, western New Mexico. (See fig. 61.) The material is stripped leaves of yucca, from which coarse mats, basket bowls, and trays are made. The mat is woven square, and a hoop of wood is provided for the border. The mat is forced down into it, the ends of the warp and weft cut off about an inch above the hoop. They are then bent down on the outside in groups of fours and held in place with one row of twined weaving, as shown in the accompanying drawing, giving both front and back view. The basket is the gift of Mr. G. B. Haggett. Diameter, 11 inches. Cat. No. 215,488, U.S.N.M.

In the simplest forms of wickerwork the ends of the warp

are all cut off in uniform lengths and each bent down by the side of the next warp, or behind one warp and down beside the second warp, or is woven behind and in front of the other warp stems with greater or less intricacy, forming a rope pattern on the outside. So much of wicker basketry as originated with the Indians is very simple in the matter of finishing.

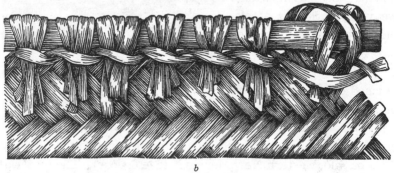

FIG. 61.
WEFT AND WARP FASTENED DOWN WITH TWINE.
(a, front; b, back.)
Cat. No. 215,488, U.S.N.M.

Cat. No. 215,487 shows how this sort of work is done. The basket is the work of the Zuñi Indians, New Mexico, and is the gift of Mr. G. B. Haggett. Diameter, 9½ inches. (See fig. 62.)

This variation of this type may be seen in the next figure. The warp stems are in pairs, and are bent in this case to the left at right angles and woven out and in among the next three

or four sets, returning to the starting-point. It is not alto-
gether certain that this style of finishing the border was in-
vented by the Indians, but they have adopted it. This draw-

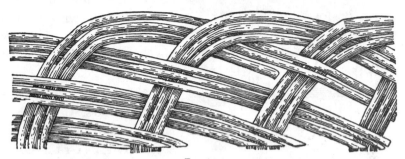

FIG. 62.
THREE-STRAND WARP BORDER IN WICKERWORK.

ing is made from specimens in the collection of G. Wharton
James. (See fig. 63.)

In the next example the handle is a stiff splint of hickory,
circular in shape. The wide hoop border shown in the drawing

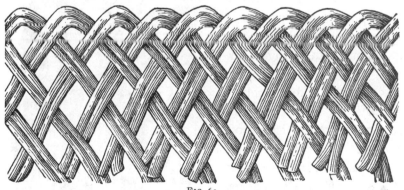

FIG. 63.
BORDER MADE BY WEAVING WARP RODS IN PAIRS.
Collected by G. Wharton James.

and the circular hoop are the framework from which the weave
begins. All the smaller warp elements focus at the junction
of these two. The widening is effected by the introduction of
fresh warp elements as the work proceeds; the weft makes

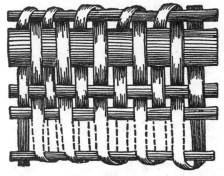

FIG. 64.

SINGLE-STRAND COILED BORDER.

Moravian Settlement, North Carolina.

Cat. No. 214,558, U.S.N.M. Collected by Carolyn G. Benjamin.

only a short excursion at the beginning around one or two warp stems, the hoop increasing in length as the work widens and additional warp elements are inserted. This specimen is Cat. No. 214,558, U.S.N.M., and was collected by Mrs. C. G. Benjamin from the Moravian Settlement, North Carolina. Diameter, 5¾ inches. (See fig. 64.)

The term "twined basketry" is applied to every variety whose warp elements are held together by twined weaving. The warp is either soft filament, or hardwood splints, or roots. The weft likewise may be yarn of flax, wool, or other very pliable material, or it may be rigid splints from roots, or tough young wood, such as osier, redbud, sumac, or the like. Such a variety of material will demand in the finishing off various kinds of borders. Lieutenant Emmons speaks of the border of the basket as its life, and says that, while a rent in the side or bottom of a wallet may be sewed with fresh root, the breaking of the edge suggests at once to the woman

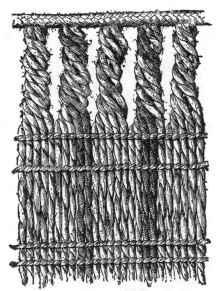

FIG. 65.

BRAIDED BORDER FROM WARP.

After W. H. Holmes.

the gathering of materials for a new basket. The great variety of borders in this type of weaving can be best understood by studying specimens. It will be interesting to begin this by comparing examples from two widely separated areas, namely, the caves of Kentucky and the distant islands of the Aleutian Chain, both in soft warp. (See Plate 143.)

Holmes* describes bags made from fiber found in a cave eight miles from Mammoth Cave, Kentucky. The largest is 34 inches across and 15 inches deep. The warp is of two-strand twine; an ornamental variety is given by introducing two larger cords of a different color at stated intervals. These warps are held in place by regular twined weaving at distances varying from a quarter of an inch to an inch apart. At the top, where the twined work finishes, the warp cords are brought together in groups of five and twisted into a rope for a short distance. They are then gathered into a continuous braid; the ends of those plaited in are cut off when the ends of a new set are taken up. This very elaborate form of border will also be found later on in Washington. (See fig. 65.)

The methods of finishing borders on twined work among the Salishan tribes are shown in the accompanying figure. The Quinaielt wallet (Cat. No. 127,843, U.S.N.M., collected by Charles Willoughby) has several noteworthy characteristics. The twined weft is vertical, woven over a frail warp. At the upper margin are outside strengthening rows of close-twined work. Finally, the two ends of each vertical weft element are brought together as one, bent backward behind the two preceding ones, then forward under a row of twined weaving, serving to hold them in place, the loose end showing on the inside. (See fig. 66.)

Turning now to twined weaving on hard foundation, it will be a matter of surprise that the Pomo Indians, who make some of the finest twined basketry in the world, take no pains

* Thirteenth Annual Report of the Bureau of Ethnology, 1896, p. 34, fig. 8.

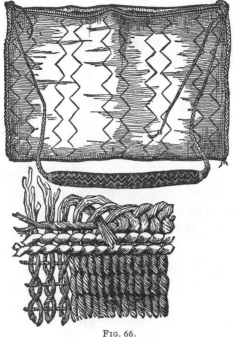

FIG. 66.
TWINED WALLET.
Quinaielt Indians, Washington.
Cat. No. 127,843. Collected by Charles Willoughby.

in finishing off the upper margin of many pieces. Cat. No. 165,659, U.S. N.M., is a basket of the Pomo Indians collected for the Bureau of Ethnology by H. W. Henshaw. Diameter, 11 inches. (See fig. 67 and Plate 19.)

The weaving is done when the material is wet and soft, and in drying the weft shrinks and binds itself to the warp, so that the basket actually wears out before it unravels. Granary baskets, mill-hoppers, mush-bowls, and other varieties in common use have this sort of margin. In the drawing here shown the weft is supposed to be untwisted, and the whole is enlarged in order to exhibit the texture. When complete, the warp is driven close together, and the little sticks of alder or willow forming the warp are left protruding.

In the following illustration the same principle obtains of making little or no change in the finishing, but the technic is three-

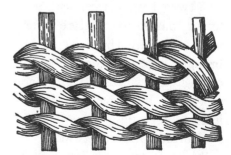

FIG. 67.
SINGLE-STRAND TWINED BORDER.
Pomo Indians.
Cat. No. 165,659, U.S.N.M. Collected by
H. W Henshaw.

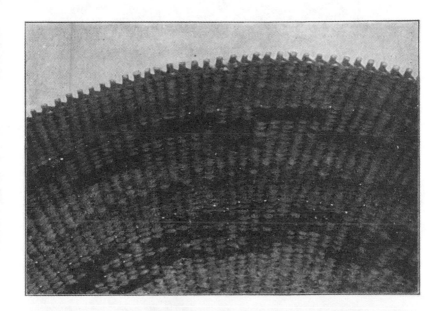

Plate 34. See page 113

THREE-STRAND BORDER ON POMO BASKET, VISIBLE ONLY ON THE OUTSIDE

Collections of U. S. National Museum

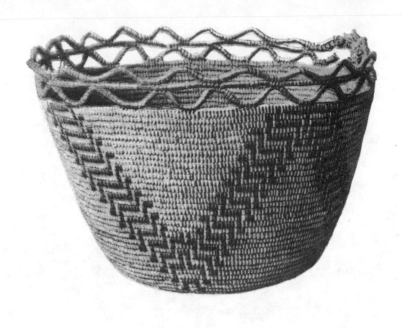

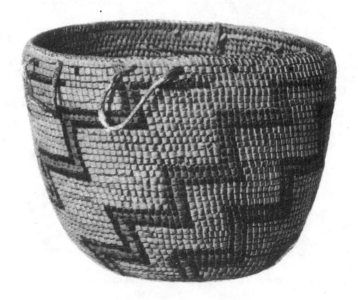

Plate 35. See page 124

OLD SALISH IMBRICATED BASKETS

Showing plain and sinuous coiled borders, Washington coast tribe type

Collected by J. H. Wilbur and Wilkes Exploring Expedition

strand instead of two-strand. The figure represents a section of a meal - bowl of the Ceyal Pomo, Cat. No. 203,287, U.S.N.M., which was collected by Dr. J. W. Hudson. (See fig. 68.)

Plate 34 makes evident the difference between the plain twined border and the three-strand border. In the upper figure the inside of the basket is exhibited and the effect is that of common two-strand twine, but in the lower figure the three-strand twine

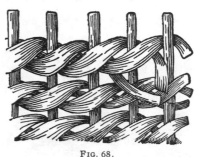

FIG. 68.
THREE-STRAND TWINED BORDER.
Cat. No. 203,287, U.S.N.M. Collected by
J. W. Hudson.

appears in a single row of weaving on the upper border. The cutting off of the margin is also shown. It is to be understood that the trimming of the ends of the warp stems is not done

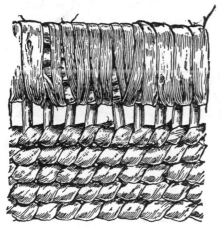

FIG. 69.
BORDER OF HUPA TWINED BASKET.

until all the weaving is entirely finished.

The Hupa Indians in some cases finish the borders of twined work by bending down the ends of the warp and wrapping or seizing them with splints of willow or other tough material. An inch of the border in a basket of the Ray collection in the United States National Museum is shown. (See fig. 69 and Plate 170.)

Another example of this woven and coiled work is shown. The basket (Cat. No. 68,491, U.S.N.M.) is the work of the Zuñi Indians of New Mexico. It will be seen that the last

row of weaving at the top is three-strand. The warp rods
or stems extend a little way upward, then bend sharply to the
left. They are then cut so that there will be always three of
them included. The coil or seizing of splints holds them all
firmly in place. The top
of the basket measures $4\frac{1}{4}$
inches in diameter. (See
fig. 70.)

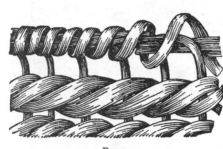

FIG 70.
WRAPPED WARP BORDER.
Zuñi, New Mexico.
Cat. No. 68,491, U.S.N.M. Collected by
Frank H. Cushing.

The McCloud River
Indians in Shasta County,
California, cut off the
warp flush and finish the
border with what looks
like plain twined
weaving on the edge,
but a regular half-knot
is tied between each pair of warp stems.

Fig. 71 shows a border of Paiute Indian twined basket, in
which the warp rods or stems are bent to the left at right angles
and cut off after passing two or more stems, the object being

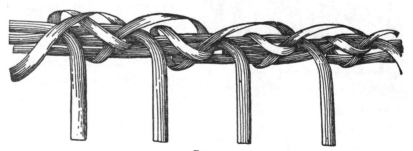

FIG. 71.
BORDER OF PAIUTE TWINED BASKET.

to have at least three ends in a bunch forming the foundation
of the border. The uniting material is a long splint of willow
or rhus, passing to the left, up and around the foundation in
front of the standing part, and under the upper foundation
stem backward, forward to begin another series. It is in fact

an application of the half-stitch or button-hole stitch. When these are drawn tight they form an effective border which on the upper margin has all the appearance of a four-ply braid. The basket itself is an example of twined weaving in twilled style, and shaped something like an immense strawberry.

This same process of imitating braid on the border of a basket by the ingenious wrapping of a single splint becomes much more complex in coiled basketry, as will be seen later in many figures.

The figure (Cat. No. 203,253, U.S.N.M.) shows a combination of the work just described and the twined work border

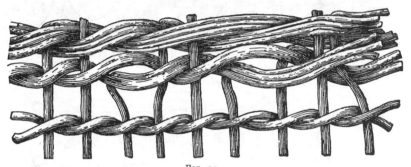

FIG. 72
THREE-STRAND WARP BORDER.
Pomo Indians.
Cat. No. 203,253. Collected by J. W. Hudson.

formed by bending down the warp. The specimen is from the Pomo Indians. Collected by J. W. Hudson. Diameter, 14 inches; height, 10 inches. (Fig. 72.)

By far the greatest variety in the treatment of borders in twined basketry will be found among the Tlinkit Indians, southeastern Alaska, and the Haida Indians, on the Queen Charlotte Islands. Neither of these great families use coiled work, and they employ little of other types of weaving than the twined. The Tlinkits are more ornamental and use coloured grasses in their false embroidery, while the Haidas never employ such decorations, but excel in plain and diagonal twined work and in three-strand weaving. Lieutenant G. T.

Emmons, United States Navy,* has studied these people closely for many years, and the information regarding the borders of these tribes is derived from him.

According to this authority, fully nine-tenths of all the baskets used by the Tlinkits are of the open, cylindrical type, in which the border is called upon to sustain more than its proportion of the wear in use. Some tribes have always used

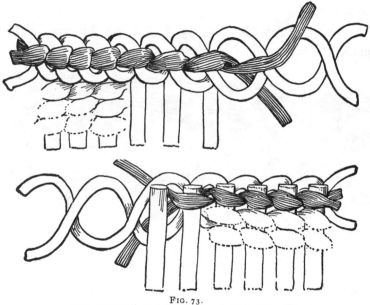

FIG. 73.
TWO-STRAND TWINE, ONLAID FOR BORDER.
Tlinkit Indians.

certain trimmings, plaitings, or braidings to the exclusion of others, and the work of different periods within tribal limits shows marked preferences. Two principal methods are employed in the finish of the border edge, (1) by trimming off the warp ends flush with the last spiral of weave (see Plate 44); and (2) by turning the warp over and fastening it down to the standing part by twined weaving or braiding. The first

* Basketry of the Tlingit Indians, Memoirs of the American Museum of Natural History, III, Pt. 3, 1903, pp. 229–277.

system is always used with covered baskets and generally with double baskets, where the two borders give protection to each other, with hats and mats, and generally with all types of baskets made for the tourist trade. The second method is employed in all open baskets made for use and in the finer varieties with double warp. When extreme nicety is required, the inner strand or layer of the double warp is cut off two lines of weave below the top, so that, when the outer strand is turned down on the standing half, the thickness of the border is not increased beyond that of the regular walls. But whether the warp is cut off flush or turned over, the last few spirals of weave are generally strengthened by additional twining, braiding, sennit, or embroidery. There are a few examples in the collection of the National Museum in which the turned reverted ends of warp stems are braided among themselves.

This braided warp is held together by rows of twined weaving.

1. The crudest border, or really want of border, consists in cutting off the ends of the warp even with the last spiral of two-strand weft. This is universally practised with the covered work-basket, and is often the finish of the smaller double basket. (See fig. 67.)

2. Border with the warp ends cut off flush, the one or more rows of three-strand twined woof around the edge adding strength to this part. (See fig. 68.)

3. In the third type of border a two-strand twine is laid vertically against the outside of the warp stems and held in place by another two-strand twine passing through the vertical twine and around the back of the warp stems. The vertical twine appears only on the outside of the basket. The horizontal twine is seen on the outside and the inside alike. (See fig. 73.)

4. In the fourth type of border a two-strand twine is ornamented on the outside with false embroidery, precisely as on the body. In some cases a narrow band of this style of weaving occurs at the upper margin and is decorative as well as useful.

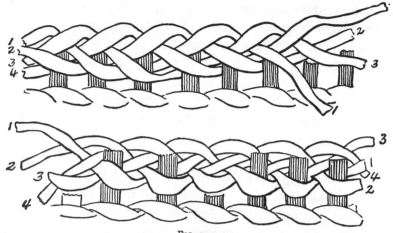

FIG. 74.
THREE-STRAND BRAID WOVEN IN FOR BORDER.
Tlinkit Indians.

5. The Haida and the Tlinkit truncated cone-like hat of root is finished at the border by cutting off the warp ends flush and weaving a common three-strand or four-strand braid around the warp, so that one part goes inside and the other two or three parts remain on the outside. This shows a rope-like ridge on the outside around the edge. (See fig. 74.)

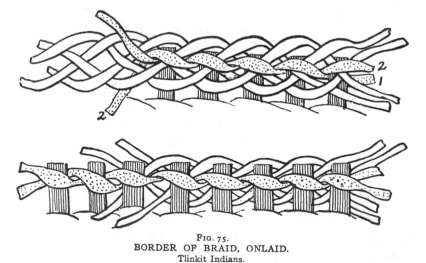

FIG. 75.
BORDER OF BRAID, ONLAID.
Tlinkit Indians.

6. Another style consists in sewing a braid or sennit on the outside of the warp by means of a two-strand twine passing through the first and around the second. These two styles of finishing hat-borders are in use by the Haida in basketry, and may have been borrowed from them. (See fig. 75.)

7. In all open baskets made for use where strength is of primary importance the warp ends are doubled over on the standing part of the next warp splint in the direction of the

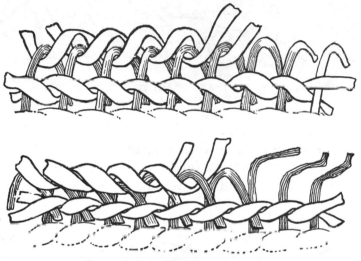

FIG. 76.
BORDER OF TURNED-DOWN WARP WITH TWO-STRAND TWINE.
Tlinkit Indians.

weave—that is, to the right—and twined down to it with the weft. This finish is found on the oldest pieces of Yakutat work. It is often strengthened by the overlaid embroidery in straw or root around the last few spirals of weave. A number of technical processes employed when the warp is cut off flush will be found also on the borders of specimens in which the warp is turned down.

8. With the turning down of the warp strands the three-strand woof twining is sometimes used in the place of the two-strand.

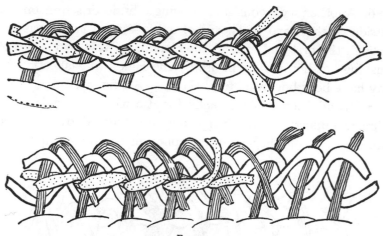

FIG. 77.
BORDER OF FOUR-STRAND BRAID, TURNED-DOWN WARP.
Tlinkit Indians.

9.. A later finish, and one generally found on the shallow, basin-like basket used as a work basket in weaving and as a berry screener, consists of a turning down of the warp ends as described, and, in addition, weaving a two-strand twining

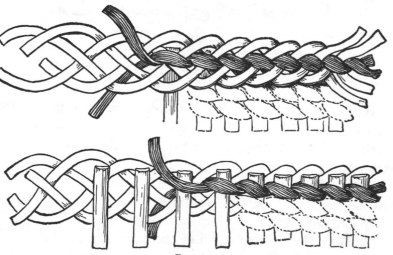

FIG. 78.
BORDER OF FOUR-STRAND BRAID ONLAID, WARP TURNED DOWN.
Tlinkit Indians.

over the bights, forming a rope-like twist over the outer edge, and thoroughly protecting the more exposed parts of the

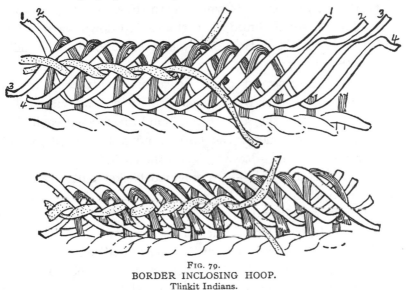

FIG. 79.
BORDER INCLOSING HOOP.
Tlinkit Indians.

warp. This character of finish occurs more among the Sitka, Hoonah, and Hootz ah tar tribes. The Chilkat never used it,

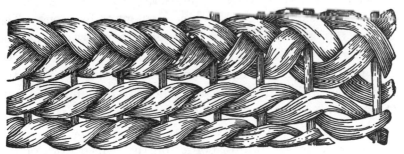

FIG. 80.
BORDER OF THREE-STRAND BRAID.
Tlinkit Indians.

and the Yakutat only in the case of the basketworker's basket. It is certainly of more recent date, although not of to-day. (See fig. 76.)

10. The most elaborate finish, peculiar to the Chilkat, used

to a degree by the Hooach, seldom found among the Sitka and Hootz ah tar, and practically unknown to the Yakutat, consists in two extra woof strands which, with the original, go to form a regular flat sennit braided on the turned-down warp. This finish is also found on the finest and most elaborate ceremonial hats. (See fig. 77.)

11. The four-strand braid or sennit is attached to the outside of the border by a two-strand twined weaving. The middle strands of the four-strand braid are crossed each time behind the outer one of the two-strand weft (fig. 78), which also grasp the turned-down warp on the back.

12. The border of the oval covered basket differs radically from that of all others. Here the top of the body is rolled over on the outside and twined down all around, and sometimes this roll incloses a thick spruce hoop, which adds considerably to the strength and stiffness of the border. (See fig. 79.)

In all instances where the warp ends are turned over, the ends of the woof splints in finishing off the border are twisted and run through the bights of the two or three last warp strands.

Fig. 80 shows a border of a basket hat from the Tlinkit Indians, Alaska, also collected by Lieutenant Emmons. The border represents two rows of regular twined weaving, the finishing in three-strand braid (fig. 74). It will be noticed that in crossing each warp rod one of the three members of the braid passes behind the warp, the other two remaining in front. On the inner side, therefore, the appearance will be that of the ordinary twined work. Cat. No. 168,263, U.S.N.M.

Fig. 81 shows a form of border on the twined work of the Haida Indians in Queen Charlotte Islands, British Columbia, in which the warp stems are cut off flush. In this example four splints, or two rows of twined work, are combined into a braid, as will be seen in fig. 73, the two rows of twining becoming one row of braid. As the braiding proceeds, the weft splint on the inside is hooked over the end of the warp stem. In the

drawing are shown also the plain-twined weaving and diagonal or twilled work by means of which figures are wrought on the surface of the hat.

In coiled basketry many specimens, often among the finest, as will be seen in the accompanying drawings, have in their borders the same structure as on the rest of the body. For each special type of coiled work there will be a variety of

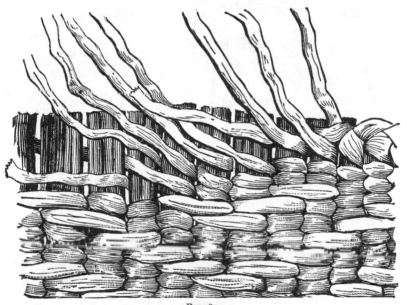

FIG. 81.
MIXED TWINED WORK.
Haida Indians, British Columbia.
Cat. No. 89,033, U.S.N.M. Collected by James G. Swan.

border. Frequently the coiled netting, of which hammocks and other weaves without foundation are examples, is finished off by simply stopping the work. The same would be true in all the varieties of foundation mentioned in the previous sections. In the present example the foundation consists of three rods or stems, not set in triangular fashion, as in the best Pomo coiled work, but in a vertical series. This makes the rows much wider and economises the sewing. But the

varieties of this type are as numerous as the tribes of Indians practising coiled weaving. (See fig. 82.)

Fig. 83 illustrates the same statement already made with reference to the so-called grasshopper basket (Plate 24). The drawing shows how, with a splint foundation, the sewing-material interlocks with the stitches underneath, taking up at the same time one or more splints.

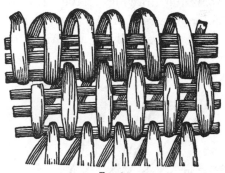

FIG. 82.
SIMPLE COIL BORDER.
Paiute Indians, Utah.
Cat. No. 14,688, U.S.N.M. Collected by
J. W. Powell.

In Plate 23, illustrating bifurcated stitches on a basket in the McLeod collection, will be seen the simplest departure from the ordinary coiled sewing on the border. The stitches pass forward one space, through and backward a space, making a herring-bone effect on the upper edge of the basket.

Plate 35, upper figure, illustrates a simple type of border-work. The foundation is a bundle of splinters wrapped with splints of spruceroot and sewed on here and there in regular order to the coil underneath, being bent between the stitches so as to form a regular sinuous line. On the next round the

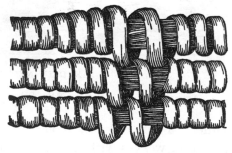

FIG. 83.
SIMPLE WRAPPED BORDER.

row is straight, wrapped like the first, and is sewed to the top of the sinuous coil underneath. On the top of all is another row, the bends not being so high, the lower portion being sewed to the joint of the other two. The border forms a

series of lenticular openings, with a bar across the long diameter. This method of ornamentation is not confined to one area, an Eskimo specimen from Davis Inlet, northern Labrador, collected by Lucien Turner, being made on substantially the same plan.

Fig. 84 is the border of a coiled basket, collected among the Hopi Indians by Victor Mindeleff, Cat. No. 84,596, U.S.N.M. It will be seen that the foundation of the coiled work on the body of the basket consists of three rods on the same perpen-

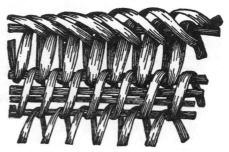

FIG. 84.
THREE-STRAND COILED BORDER.
Hopi, Arizona.

dicular plane. The stitch passes over the three; catches under one of the previous coils, the stitches interlocking. In finishing off this work a single rod is used for the margin or border. It is sewed to the upper rod of the previous foundation in plain coiled work; but while this process is going on a series of three

FIG. 85.
DETAIL OF FIG. 84.

splints are twined around both the foundation and the stitches of the border. When the whole is drawn tight it gives the appearance of a very elaborate double-braided work, looked at from the outside, and a continuous twined or rope-work on the upper margin. In order to make the style more compre-

hensible, a drawing from the border of Cat. No. 204,833 is introduced (fig. 85), in which the elements of the border twine are in different colours. The two examples just shown illustrate what was previously said about using twined work

Fig. 86.
SINGLE-STRAND PLAITED BORDER.

for the borders of coiled weave, and the opposite among the Tlinkits.

Fig. 86 represents the border of a coiled basket of the Sia Indians, of New Mexico, Cat. No. 134,213, U.S.N.M., collected by Mrs. Matilda C. Stevenson. A hoop is used for the founda-

Fig. 87.
SINGLE-STRAND PLAITED BORDER.
Havasupai Indians, Arizona.
Cat. No. 213,259. Collected by Walter Hough.

tion of the border, and it is first made fast to the regular sewing underneath by means of a simple coiled splint on the outside of this. The ornamental border consists of an ordinary figure-of-eight wrapping, as in winding up a kite-string, going from left to right. A splint passes under the foundation rod toward

the front, and then forward five stitches over, behind, and under, back three stitches and under. The same process repeated gives the form of a braid on the outside. Finally, by the manipulation of a single pliable splint, effects are pro-

FIG. 88.
PLAIN COILED BORDER ON BARK VESSEL.
Cat. No. 217,750, U.S.N.M. Collected by I. C. Russell.

duced on the border which resemble three-ply or four-ply braid.

Fig. 87 shows the detail of border on a Havasupai (Yuman) basket, Cat. No. 213,259, U.S.N.M., collected by Dr. Walter

FIG. 89.
COIL AND KNOT BORDER ON BARK VESSEL.
Cat. No. 217,744, U.S.N.M. Collected by I. C. Russell.

Hough. It will be seen that two rows are used in the foundation of the border. The strip, or splint, passes under the upper backward, then around in front forward, and under both, then backward to repeat the process by a sort of figure-eight movement, passing from left to right. When the work

is done and driven home it has the appearance of regular plaiting. Fig. *b* shows both top- and side-view of the completed work.

The application of borderwork to other forms of receptacles may be studied here, since the processes are quite akin. In a large area of North America, bark of trees, with some leather, was so easily worked that very little trouble was taken in weaving baskets.

Fig. 88 represents the border of a birch-bark tray formed over a rod of willow, a very simple and effective but quite ornamental method of attachment. Five holes are bored or cut through the bark near the upper border. Two holes are then made half an inch from the border, and these series are repeated all the way around. The sewing passes around the rod and through the hole in a simple coil, but the effect of the shallow and the deep stitching is quite pleasing. The sewing is done with tough splints from the root of the spruce. The specimen here figured is from the Upper Yukon River, Cat. No. 217,750, U.S.N.M., collected by I. C. Russell.

Fig. 89 is the border of a birch-bark tray from the Tinné Indians, Central Alaska, collected by I. C. Russell, Cat. No. 217,744, U.S.N.M. Three slits were cut through the bark near the margin; after an interval of some distance three others, and so on around the entire border. A willow rod serves for the strengthening element, and the spruceroot is attached by a series of half-hitches or button-hole stitches. On the inside the effect is a combination of coiled and twined weaving, and on the outside only the vertical stitches of the coil are seen.

Fig. 90 represents a border of a Yukon River, Alaska, birch tray. It consists of the alternate use of plain coil around a strengthening rod and three stitches, passing down and under a rod on the inside, crossing the standing part to the right through an opening or slit cut in the bark, and up to the beginning. There are three of these half-hitches, as they

might be called, and then five wraps around the upper rod. From this point the process is renewed.

Fig. 91 is a border of birch-bark tray from the Upper Yukon River, collected by I. C. Russell. On the upper edge

FIG. 90.
PLAIN COILED BORDER ON BARK VESSEL.

a rod is used for strengthening. It is attached to the margin of bark by means of splint of spruceroot. The drawing shows the front and back of the method of holding the root and bark together. From the back the splint passes

FIG. 91.
COIL AND KNOT BORDER ON BARK VESSEL.
Cat. No. 217,247, U.S.N.M. Collected by I. C. Russell.

from the hole in the bark obliquely over the rod, down, forward through the bark, backward and behind the standing part, over the rod, down and through the same hole, to start another knot. Practically, then, it is a series of single knots, as is shown in the upper openwork drawing. The Indians

who make these birch baskets are called Tinné, or Déné. They live in Central Alaska and belong to the Athapascan family. The specimen is Cat. No. 217,247, U.S.N.M.

The ordinary checker and other woven mats are fastened off in the same manner as the baskets.

An interesting and intricate border is made by the Chilkat Indians on their ceremonial blankets. It consists of a number of long strings of mountain goat's wool and cedar bast held together by a few rows of twined weaving at the middle. This is then doubled and sewed to the margin, the ends forming the fringe. (See Plate 148.)

CHAPTER IV

ORNAMENTATION ON BASKETRY

There's magic in the web of it:
A sibyl that had numbered in the world
The sun to make two hundred compasses,
In her prophetic fury sewed the work.
—OTHELLO, III. 4.

ORNAMENTATION in and on basketry is to be studied with
three teachers or guides—the technician, the artist, and the
folklorist. With the first-named are learned the varied mate-
rials as to colour and texture, the technical elements and their
forms, and the methods of assembling them. The artist will
show how these elements, on the one hand, open possibilities
for esthetic effects, and how, on the other hand, the stitches
and decussations handicap attempts at free-hand drawing.
The folklorist examines the pictography, the totemism, the
lore and mythology of the ornamentation, with a view of put-
ting the student into intellectual and spiritual relationship
with the basketmaker. Without her, basket-making would be
merely a trade or calling, and the art student would be utterly
helpless in detecting the alphabet of design. This phase of the
subject will be elaborated in the chapter on symbolism.

Great help in this investigation would be derived from a
visit to the humble artist to watch the processes through which
the fine effects have been elaborated. To this inquiry special
attention will here be given. It should be added in passing
that in producing her effects the basketmaker must be fully
equipped for her work before the first stitch or check is at-
tempted. The painter, the potter, and the sculptor may add
finishing touches or make corrections after the work is done,

but the basketmaker is like the musician—every detail in the production must be attended to correctly at the time. There is no chance to go back and remedy defects. Decoration on basketry is studied under the following heads:

A. Form and structure.

B. Ornamentation through colour.

Form and colour may be studied (1) on the basket as a whole; (2) on the minutest structural elements; and (3) in the designs upon the surface. These will be taken up in order and treated in their relation to the sense of the beautiful, present in the humble Indian woman's mind as well as in those more refined. Growth, progress from pure naturalism to greater and greater artificiality, may be observed here quite as marked as in other activities. To illustrate what is here said by way of introduction, Plate 36 represents a coiled basket of the Mission Indians in the collection of G. Wharton James. The noteworthy characteristics of this basket-bowl are the effects produced by variety in designs and colour in shades, as well as by symmetry of outline. The sharp contrast seen in the designs are due not to modern dyes, but to a skilful use of Nature's colours. Under the descriptions of materials, attention was called to the variety of natural pigmentation in the stems and roots of the plants used in the construction of the Mission work. The center of the specimen is in rectangles, the colours of which alternate between white and dark brown. The center zone is made up in straw-colour, white, and black; the third or outer zone in natural shades of the stem—white, brown, and black—with here and there spots of brown introduced into the straw-coloured sewing. The outer edge is in brown and white. Anciently, the Mission baskets were not nearly so gaudy-looking, but among the frequent transformations in artistic forms and colours this example illustrates progress in the adoption of really beautiful motives of a high order.

The elaboration of decoration in form first, and then of colour, will now be taken up more minutely. The esthetic

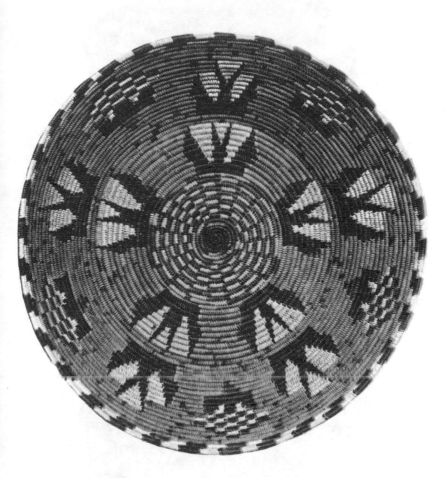

Plate 36. See page 132

MISSION INDIAN COILED BOWL

This is the climax of colour and shade effects produced by skilful use of natural materials,
the stems of rushes. The black colour is from sea-blite

Collection of G. Wharton James

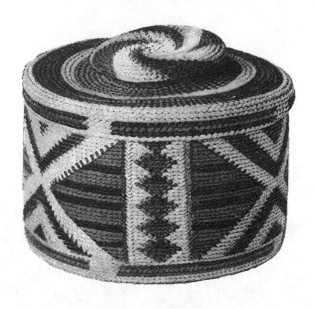

Plate 37. See page 135

TLINKIT TWINED COVERED BASKETS

A study in form, colour, and symbolism. The rhomboid figures are salmon berries

Collected by J. B. White

side of this part of the subject is so well explained by Holmes,* that it is here necessary only to make plain the technical elements and processes involved in ornamentation.

As on Pueblo pottery, so on basketry, some patterns are merely likenesses of things, and that is all. A step in advance of this is the portraiture of some particular and sacred natural feature, mountain, body of water, trait, etc. Pictography is one grade higher, and, beginning with attempts at figuring animals and plants entire, runs the whole gamut of transformation, ending with conventional metonymies, synecdoches, and geometric patterns of the classic type.

FORM AND STRUCTURE

Form in basketry is decided at the outset, not by the desire to create something artistic, but to produce a useful receptacle. There is scarcely a basket so rude, however, that a sense of symmetry and other artistic qualities did not enter into its composition, both as to its general outline and the management of its details. These varied forms are decided in reality by:

(a) Function, which is discussed in the chapter on uses, from the purely industrial point of view.

(b) Materials, shown in the chapter on manufacture as to their variety and quality, but here considered as suggesting and restricting form.

(c) Imitation of natural objects and of forms of utensils in other materials.

(d) Physiological limitations. Both in the making of the basket and in using it the Indian woman had ever in view the convenience of her own body. The curves of the basket itself, the length and the width, the proportion of all its parts, as well as convenience of holding, transporting, and utilising, all had reference to the woman's physical frame.

(e) Esthetic purpose. The desire to produce something beautiful in itself without any regard to other motives.

* Sixth Annual Report of the Bureau of Ethnology, Washington, 1889, pp. 189–252.

If there be any beauty in work belonging to the first step, it is purely *adventitious;* the weaver did not effect it purposely. In the next higher grade there are no separate elements of beauty, but the utilitarian features are dominated by taste purposely. A third class of esthetic forms, one step higher, enhances the beauty of the basket, but does not diminish its serviceability. It seems a pity to waste so much prolonged work and lovely design and colour on a mere berry-picking basket or a pot for cooking with hot stones, but who will say nay? Finally, usefulness is ignored or sacrificed to pure estheticism. (See Plates 11, 23, 45, 70, and 71.)

When the very lowly and practical functions of a great deal of this ware are considered, one has a striking example of the way in which the sense of beauty may coexist with forlorn poverty and surroundings, as may also be seen by comparing the most skilful basketmaker with her workshop. This thought must not be carried too far, however, in understanding the culture status of the woman, since all artists are busy practically with uncleanly materials and do not wear their best attire in the studio. On the same practical side, also, the love of beauty for its own sake may not be the entire motive in the artist's mind; her natural ambition and pride of achievement in technical skill, and perhaps envy, have much to do with preëminent success—quite as much with her as with artists at the other end of civilisation. The same discrimination is made by art critics in the highest walks of culture. The singer or musician who renders a technically difficult piece may be stimulated quite as much by pride of performance as by the overpowering influence of esthetic feeling. It is difficult to sound the depths of the Indian woman's motives, but in the matter of shape, as will be seen, her masterpieces are fine models of symmetry and grace. Quite every plate in this work will illustrate in some way or another what will be said respecting the ornamentation of Indian basketry in the six geographic areas. In each one of the phases under

which shape as a decorative element is studied there will be found a response in the different parts of the hemisphere.

The study of form and structure in the ornamentation of basketry will be now considered under the heads named: First, the shape of the basket as a whole; second, the minute structural elements out of which all designs on basketry are formed; and third, the designs on the surface of the basket and their combination into symbols or composite ornamentations. (See Plate 37.)

SHAPES OF BASKETS AS A WHOLE

The shapes of basketry have relation to the forms of solid geometry. The cube, the cone, the cylinder, the sphere, are the bases of all simple and complicated varieties. In softer material basketry approaches matting. The products are then flat or pliable, although the process of manufacture is the same. Among the eastern tribes of the United States the Algonkin and Iroquois baskets are all cylindrical or rectangular in outline. The same is true of the tribes in the southern United States, although the greater flexibility of the reed cane invites the basket-weaver to a wider diversity. In the Interior Basin and everywhere else the wild flax and other fibrous plants abounded, the sack, rectangular in outline, prevailed, but in the western portions of Canada east of the Rocky Mountains the prevalence of birch bark occasioned a variety of solid forms. The Indians of the Interior Basin also employ the cylinder largely. The same is true of the Eskimo, of Alaska, while the Aleutian Islanders, especially in the outer islands, having the flexible wild grass to work with, return to the form of the bag or satchel. The cylinder and the rectangle prevail among the Haida and Tlinkit, while the soft wallet, rectangular in outline, was more common farther south. The Salish and other tribes of Indians, of Columbia and Washington, diversified in their tribal and linguistic elements, produced many forms of baskets. Those in touch with the

Hudson's Bay Company were very quick to imitate the shapes of packages used by them. In this region, also, since the boiling with hot stones was a prevalent method of cooking, the basket-pot, somewhat cylindrical in motive yet more in the form of a truncated cone, was seen in every house. What is said about the diversity of form among the Salish tribes is true all along the Pacific coast of the United States. Here also are to be found conical baskets in great abundance, since the people were partly vegetarians or diggers. The carrying-basket is a prominent feature in collections from this area. From these simple geometric forms were developed dishes, jars, bottles, packing-cases, and so on, in unlimited numbers, combining the cylinder, the cone, and the rectangle. In many of these the jar-shaped necks of pottery are imitated, in which the elements of the sphere and the spheroid are used.

In giving to basketry the forms just indicated the Indian woman has always in mind the elements of the beautiful as well as of the useful. It is considered a reproach to violate the rules of bilateral symmetry or proportion in form. A superficial view of a large collection of baskets from any portion of America would strike the most careless observer as the fruits of thoughtful and painstaking labour on esthetic lines. These forms are often said to be mere imitations of something the savage woman has seen in Nature or in other arts. Imitation is indeed one of the elements in this problem, but it is an entire misconception of the underlying plan to suppose that the skilful weaver is a slave to natural patterns. Indeed, it might also be averred that she is less subservient to such things than are artisans of much higher grade. On entering the workshops of civilisation one sees the walls loaded with designs and models after which to work, but rarely would the observer see an Indian woman looking to any other source than her own imagination for the model of her basket; strictly speaking, she never makes two alike. A close observation of the weaver at her work demonstrates the fact that the eye,

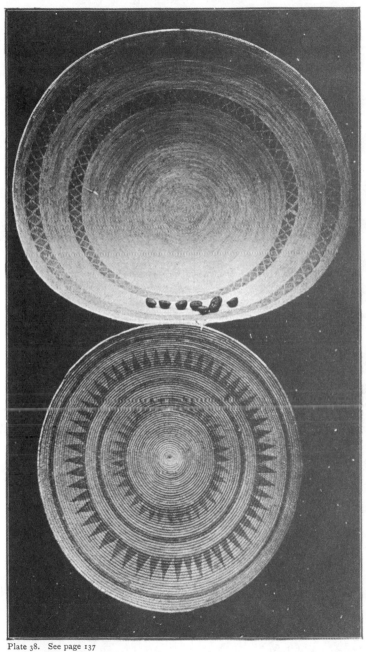

Plate 38. See page 137

GAMBLING PLAQUES FROM TULARE AND MADERA COUNTIES, CALIFORNIA

Collection of E. L. McLeod

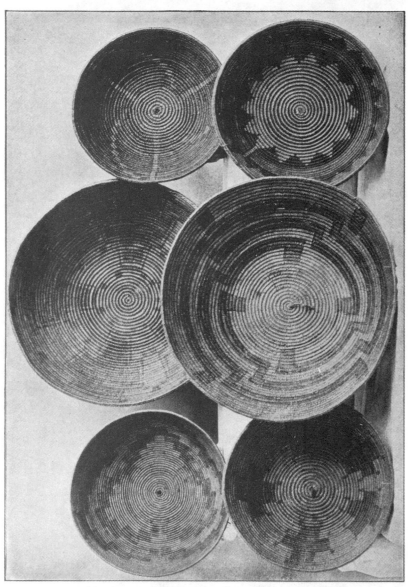

Plate 39. See page 137 Ceremonial Baskets of the Navaho, Arizona, Showing Shallow Dish Forms

Fred Harvey Collection

the hand, the curves of the body, the angles of the lower limbs, all contribute their share to giving beautiful forms to basketry. The following illustrations will show the gradations of general outline through which basketry passes, the maker keeping always in mind the sense of pleasure to be awakened or gratified.

They are as follows: *a*, flat forms; *b*, dish forms; *c*, bowl forms; *d*, jar forms; and *e*, miscellaneous forms.

(*a*) The simplest of these is the flat tray, mat, wallet, sail, gambling-plaque, and more. They assume endless varieties of outline, and through the stimulus of trade all sorts of shapes result, table-mats of standard patterns in Sitka and Vancouver Island, rectangular wallets in Washington, Idaho, and Montana, but especially the gambling-plaques of California.

Plate 38 shows two flat plaques of this form, the upper one from the Tule River country, Tulare County, California, the lower one from Madera County, both in the collection of E. L. McLeod, of Bakersfield, California. The coiling, if well done, would produce the circular outline. The Indian woman who constructed the plaque made the stitches under the spell of this art motive. A number of additional examples of artistic forms in flat basketry will be found in Plates 6 and 61.*

(*b*) Use coöperates with beauty in deepening the basket into a shallow plate as among the Hopi (Moki) for the sacred meal in their prayer ceremonials, but more attractive still are the so-called Navaho ceremonial baskets. (See Plate 39.) These beautiful objects have attracted much attention also through their association with Navaho ceremonies. They are called ghost drums, wedding baskets, and various other names, all associated with the Navaho religion. The dish-baskets shown in the plate are in the collection of Fred Harvey. The same form exists along the Pacific States wherever meal or other vegetal diet is eaten. They are the common dish in

* W. H. Holmes, Report of the United States National Museum, 1900, Plate XLI.

which the mush is served throughout the acorn-bearing parts
of California. It is an excellent example of adaptation to
use, consistent at the same time with correct esthetic expres-
sion. Doing her best in producing the proper form, the
basketmaker was not hampered by the fear of lessening utility.
Figures of similar shapes will be seen in Plates 93 and 216.

(c) Deepening the plate gives the bowl an unlimited
number of forms and emancipates the basketmaker. All
through the southwestern United States the olla is the pre-
vailing form. It is a segment cut from a sphere, marvellous
in symmetry when the production of a master hand. Depart-
ing from this simple outline, varieties are produced by flatten-
ing the bottom and straightening the body until the truncated
cone and regular cylinder are reached. The quality of the
material used may have a little to do with the general outline,
but it is charming to see how easily the savage woman over-
comes the obstinacy of Nature and persuades reluctant wood
to do the work of grass and soft fibers. Cylindrical forms
are in favour with the Aleuts, with the Haidas of Queen Char-
lotte Islands, with the Tlinkits of southeastern Alaska, and
some tribes in Washington and Oregon. In the eastern parts
of Canada and the United States cylindrical forms are mixed
with rectangular. The baskets shown in Plate 40 are in the
collection of E. L. McLeod, of Bakersfield, California. These
are all from Kern County, and include hats as well as domestic
forms. It will be noticed that some of the examples have
straight conical bodies and others are curved outward, but
none are incurved. As models for modern basketry these
shapes can not be improved upon, since they are grounded
in the structure of the human body itself. Reference will be
again made to the baskets in this plate when the elementary
forms are studied that go to make up the designs. The photo-
graph does but half justice to the basketry from this region,
which adds to the beauty of outline and variety of design the
charms of tints and colours in varied materials.

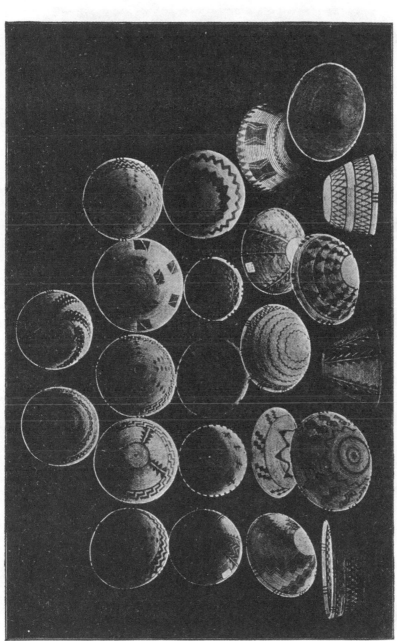

Plate 40. See page 138

HATS AND MUSH BOWLS IN COILED WARE, FROM KERN COUNTY, CALIFORNIA, TO SHOW METHODS OF DEEPENING THE FORM

Collection of E. L. McLeod

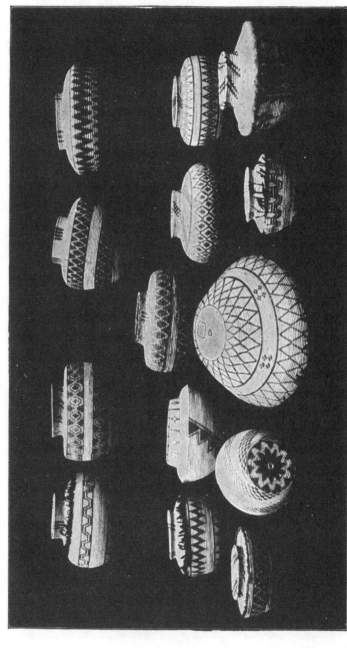

Plate 41. See page 139

BOTTLE-NECK COILED BASKETS, KERN COUNTY, CALIFORNIA,
SHOWING POTTERY MOTIVES

Collection of E. L. McLeod

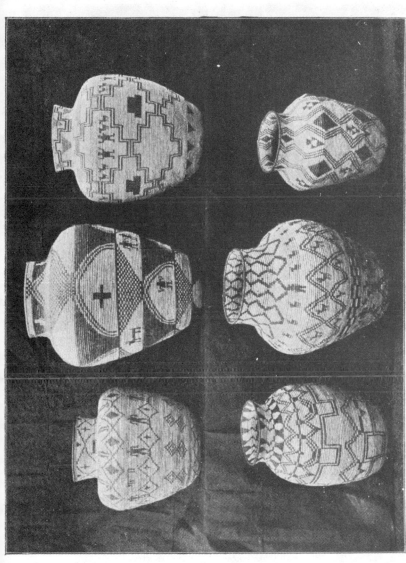

Plate 42. See page 139 Ollas, or Large Water Jars, of the Apache, Arizona, with
Mixed Designs

Collection of J. W. Benham

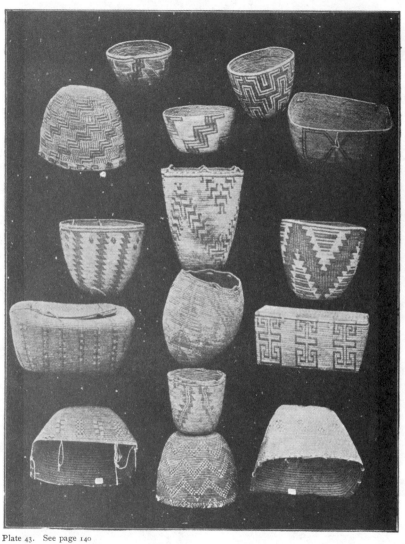

Plate 43. See page 140

VARIED FORMS OF IMBRICATED BASKETS, TO SUIT THE FUNCTION,
BRITISH COLUMBIA AND WASHINGTON

Collection of E. L. McLeod

(d) Baskets with constricted borders go by the general name of bottlenecks. If a motif be sought outside the desire of the Indian artist to have it thus, there is a style of old Pueblo pottery at hand which stands preëminent in the southwestern United States.* After the body of the vessel or basket is built up to the required height the work is drawn into the form of a jar or bottle. Attention has already been called to the fact that no pottery existed formerly on the west coast of North America. The few exceptions to this rule only intensify this absence. The place of pottery is taken by basketry, even for cooking. There is no limit to the pine trees yielding gum which will render basketry water-tight. The bottle-shaped basket soon appears and is installed as Aquarius of the Utes, the Apache, and other tribes, and also as a seed vessel. No sooner was its office fixed than it began to dress up in artistic form, and the inimitable bottleneck of the Panamint and other tribes in the Inyo-Kern and Tulare area appeared. The Apaches are having the last word at this point in the adoption of correct esthetic forms purely European. Plate 41 shows a group of Kern County bottlenecks in the collection of E. L. McLeod. Plate 42 illustrates a number of Apache ollas in the collection of J. W. Benham, of New York City.

That these pretty jar-shapes have little significance so far as tribes are concerned is shown by the fact that they occur all the way from Point Barrow in Alaska to southern California.

(e) This class includes all odd forms whatever. They are frequently made in imitation of objects that struck the Indian woman's fancy. The very best examples of this are the imbricated baskets of the Fraser-Columbia drainage. A good collection of them tells the whole story accurately, starting from the conical forms, with foundation of splints and bottoms in shape of a watch-spring to be found on the Klikitat and the Thomp-

* J. W. Fewkes, Seventeenth Annual Report of the Bureau of Ethnology, 1898, Plates 130, 131, 143.

son River and ending below and above the Fraser mouth with
flat and uniform foundation and straight lines in the bottom,
the last shapes in the series being nothing more than imitations
of Hudson Bay Company's packages, trunks, cradles, and so
on. These bizarre shapes are not confined to the mere imita-
tion of white men's devices. The demands of ceremony and
religion required special forms of basketry (see Plates 43,
157–172).

Finally, ornamentation in the form of the basket as a whole
has kept pace with the multiplication of uses. The first con-
tact of the Indians with the whites created new desires in their
minds. Furthermore, it was not long before they discovered
their best interests to lie in the direction of service to their
conquerors. The supply of new wants and responses to the
demands just mentioned would necessarily break in upon the
ancient régime. Not at first, however, did the new object
respond to the best workmanship. Plate 44 represents a part
of the outfit of a Tlinkit Indian in the service of the Russians.
Among his other accoutrements there must be a receptacle for
ammunition. This must conform to those already in use.
The result is the three forms shown in the plate. First, a
small jar-shaped holder with a basketry cap-like cover; second,
a bullet-holder, in which the one basket fits exactly over
another; third, a combination in which the cover is attached
to the basket by means of a running-string. All of these
forms are shown in the plate. While drawing attention to
these designs it will be well to examine their characteristics.
The cover of No. 2 is plain twined weaving of the old-fashioned
sort. The attractiveness of the work is in its regularity, both
of vertical lines and horizontal weaving. The under portion
of this double basket is covered over with false embroidery
designs. No. 1 is an evident departure from ancient shapes,
and the surface is covered with poor work in embroidery. No.
3 is more worthy of scrutiny. On the outer basket, or cover,
plain weaving and embroidery alternate in single lines and

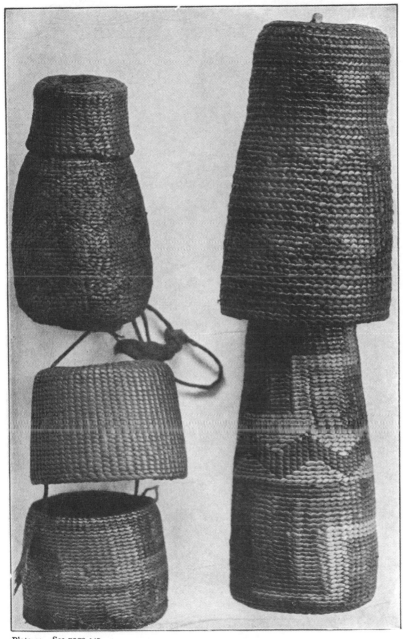

Plate 44. See page 140

TWINED WORK WITH FALSE EMBROIDERY, COPYING EUROPEAN DESIGNS,
TLINKIT INDIANS, ALASKA

Collection of L. H. Brittin

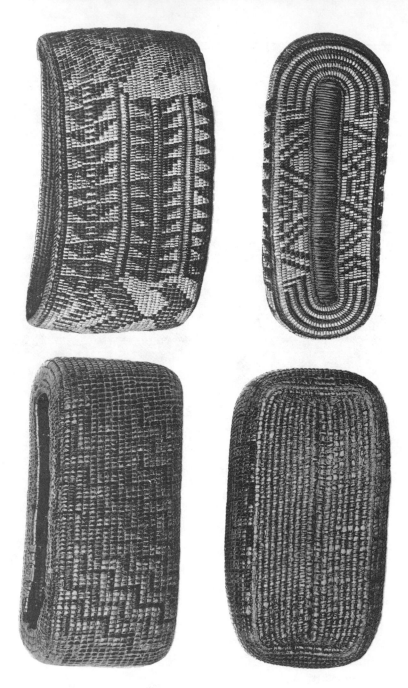

Plate 45. See page 141

PRECIOUS OLD IMBRICATED BASKETS

Showing the mosaic or tessellated nature of basketry designs

Collected by J. J. McLean and Wilkes Exploring Expedition

narrow bands. The lower or inside basket has its surface enveloped in embroidered weaving of excellent character, and is wrought in three colours. The specimen is in the collection of L. H. Brittin, of Edgewater, New Jersey.

MOSAIC ELEMENTS IN DECORATION

The composition of the basket—its molecular elements, so to speak—is guided largely by the materials. In cross-section they are in their coarsest forms round, then half-round, resulting from splitting whole stems. The finer sorts arise from further subdivision of stems, being roundish on the outside and flat within; or flat on both surfaces, as in the Canadian ash splints and the flat foundations of Fraser River baskets; or ribbon-like, as in basketry made of palm leaves; or thread-like, as in the coiled basketry of the Pomo, sewed with split sedge root as fine as packthread. These various kinds and grades of materials in their tractability are dependent on climate, latitude, and phytogeography in the first place, and finally upon the maker's grade of culture, on the form and function she had in mind, as well as on the higher forms of fine art, social rivalry, and mythology (see Plate 45).

In ultimate structure, basketry is free-hand mosaic or, in finest materials, like pen-drawings or beadwork, the surface being composed of any number of small parts—technically decussations, stitches, or meshes, practically separate from one another so far as the effect on the eye is concerned. These mosaic parts are with some materials quite flat on the outer surface, as in the best matting and bags, while in others they stand out on account of the coarseness and rigidity of the wood. The object of mosaic ordinarily is to produce a flat surface for pavements or floors. The term "mosaic," here used as a simile, applies to such as is seen in mural decoration, where projections and depressions are wrought into artistic designs. In much basketry the separation of the stitches and exposure of a warp beneath having another colour have precisely the

same effect. In many examples the stems and roots are thoroughly soaked and rendered plastic and then pressed home, the parts being forced together, in which case the little elements become spindle-formed or hexagonal. Mosaic effects in basketry may be—(a) Tessellate, as in checker or twilled weaving; (b) concentric, as in wicker and twined weaving; and (c) radiate in all coiled weaving. These must be kept in mind.

Unity in variety, the underlying principle of all esthetic composition, finds its first step illustrated in the making up of a basket. The perfection of an Indian basket in its artistic technic is monotony, or monotechny, if such a word existed. In looking at a clumsy bit of work done by a child, or a beginner, one is aware of painstaking effort to make all the checks or stitches alike, ending in failure. In the most elegant pieces the victory is won, unity is achieved. With her mouth for a vise and for other purposes, with a flint knife and educated fingers, the patient and skilful artist formerly brought all her filaments to uniform thickness. At present, scissors, awls, knives, and gauges (all of metal) aid her immensely in her task. The eyes and hands coöperating, in some instances through a hundred thousand efforts, produce elements of astonishing uniformity. This unity is of a very high order; for in many examples, coupled with a monotony of elements absolutely under control of the artist, there is at the same time a charming variation in width and length of parts in harmony with, and made necessary by, the widening and narrowing of the basket. This unity in a myriad of details is the more noteworthy in a basketmaker's art, in common with that of all other textile workers, because the individual elements are not lost or destroyed in the operations. The exceptions to this are rare, as in a few California specimens, where the coiled sewing is entirely obscured by overlaying of feathers. Usually the perfection of the stitch is the aim of the worker.

Plate 46 is a rare coiled basket made by a Washoe woman named Datsolalee. It is in the collection of A. Cohn, Carson

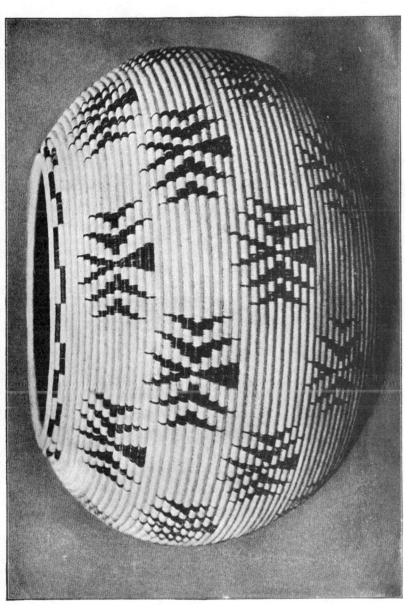

Plate 46.　See page 142　　Fine Coiled Basket of the Washoes, Nevada.　Designs of Birds Migrating

Collection of A. Cohn

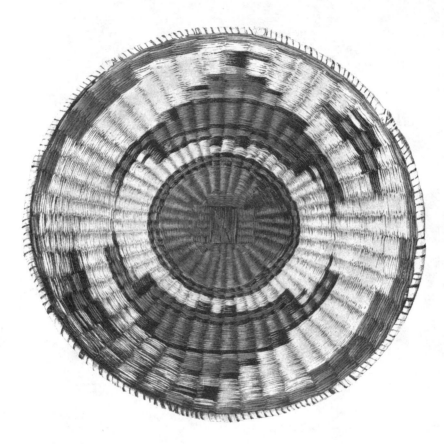

Plate 47. See page 146

SACRED PLAQUE

The town of Oraibi produces only wicker plaques. These are strikingly decorative and bright coloured. There is a greater range of designs in this pueblo than in the pueblos to the East, where coiled baskets are made. The design represents the birds of the five regions.

Collected by J. W. Benham

City, Nevada. The piece measures 8½ inches high, is 12 inches wide, and 6 inches wide at the opening. The stitches number more than fifty thousand, being thirty to the inch. The body colour is a rich light gold, and the figures are in red and black. It weighs 16 ounces, and is valued at many hundreds of dollars. The figures on the basket represent birds migrating or flying away, the motto being, "When the birds leave their nests and fly away, we shall move." The shape of this piece and the quality of the sentiment in the markings are excelled only by the inimitable quality of the work on the surface. It is difficult to conceive of a more perfectly uniform piece of handiwork than this.

In pottery all vestiges of coiling and moulds are commonly obliterated. In a very few examples of ancient ware there seems to have been an aim to perfect the coiling and render its detail monotonous and artistic, but in the many thousands of other examples the potter has erased the marks of the fingers, the paddle, and the mould. On the other hand, the whole development of the art of basketry has been an effort to perfect the individual stitch, or mesh, or check, if necessary to make any number of thousands of them exactly alike over the entire surface of a large receptacle, or to study the greatest possible number of variations that may be given in form to these primary elements consistent with the unity of the whole effect. The Eskimo near the mouth of the Yukon must have only lately acquired the art of basket-making. With coarse hay for the foundation and sinew for thread, they produce the clumsiest excuses for basketry, ugly in form, slovenly in stitching, and utterly devoid of designs on the surface, while the Aleuts, close by, have unique elementary forms and work with surprising uniformity. With the monotony of the mosaic elements in any basket, one must not fall into the error of thinking that there is not the greatest variety of fundamental shapes in the things to be monotonised. They vary in outline and relief in position with reference to the horizon—

that is, the rim of the basket, in relative proportion of the whole and its parts.

In checkerwork, the basketry tiles, one might call them,

FIG. 92.
CHECKER ORNAMENT IN TWO
COLOURS.
After W. H. Holmes.

keeping in mind the use of the word mosaic, are squares or rectangles in close or open work. The mosaic of checkerwork pleases by its uniformity, and yet many baskets made by hand with tools not over refined have in them enough of variety to relieve them from the dull monotony in machine products. Flexibility in materials, as between hard-wood splints and those of cedar bark and palm leaf, offers all the chance the weaver needs to play tricks in reliefs. The eye is never

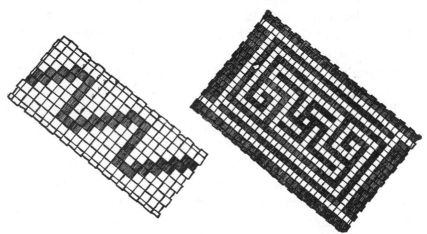

FIG. 93.
AMAZONIAN BASKET DECORATIONS IN CHECKER.
After F. H. Cushing.

wearied in rambling up and down among these crooked paths. There is possibility of variety even in checkerwork, through changing the width of warp and weft elements.

Oblong rectangles there mingle with tiny or larger squares in tessellated surfaces (see Plate 14 and figs. 96 and 97).

What is here said concerning the esthetic effects produced in the plainest kind of checkerwork by simple alternation of the colours is illustrated by fig. 92, after Holmes in the Sixth Annual Report of the Bureau of Ethnology, already quoted.

Fig. 93, from a drawing after Frank H. Cushing, is a more interesting illustration from the Amazon region. The surface of the basket is mosaic in two colours, made up of little square blocks, and by their alternation not only sloping and vertical patterns are produced, but the most intricate labyrinth of fret-work. There is no limit to the possibilities any more than there is to the Italian workman making a tessellated pavement with marble blocks in white and black.

As soon as the weaver steps outside of her monotonous checkerwork into the province of wicker, or especially twilled weaving, the possibilities of ornamentation are infinitely mul-tiplied. In plain weave, wicker ele-ments are sigmoid or spindle-shaped; on twilled weaving, they are oblong rectangles. Passing into the most in-tricate damask effects in modern linen weaving, in which materials of one colour only have to be used, it will be seen how greatly varied this sort of ornamentation may be made. The elements of wickerwork mosaic are horizontal, but twilled weaving in single elements may be both vertical and horizontal in the same piece. The three accompanying figures are

FIG. 94.
TWILLED WORK IN TWO COLOURS.
After W. H. Holmes.

from Holmes, and show better than words the possibilities of the little squares and rectangles for decoration. In fig. 94, in two colours, the white work is under two and over one; the

weft over one, two, or three and under one; the result being a
series of sloping designs of great beauty. Fig. 95 in precisely
the same materials shows how, by
varying the count, the pattern is
changed. Fig. 96 is interesting be-
cause it exhibits a widespread type
of mat-weaving farthest away from
loom work. The woman begins at
the corner to weave. All the little
blocks are rectangles; all stop at
the same angle, and the result is a
perfect Greek fret in two colours (see
Plate 47).

FIG. 95.
DIAPER TWILLED WORK IN
TWO COLOURS.
After W. H. Holmes.

In twined weaving the effect of
the single rows is funicular one way
and corrugated the other. If the
reader will notice any number of twined baskets in plain
twined weave, it will at once become apparent that it has

FIG. 96.
DIAGONAL TWILLED ORNAMENT.
British Guiana.
After W. H. Holmes.

its limitations. The Pomo make only bands in it to represent
the skin of a snake or some such motive. The Haida and

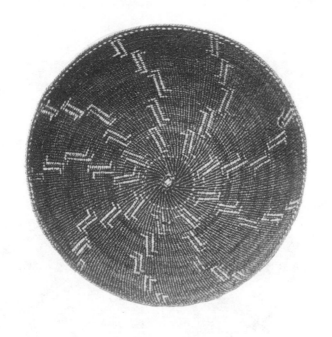

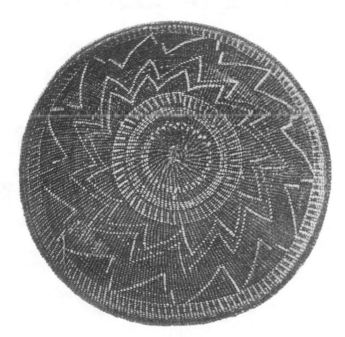

Plate 48. See page 147

KLAMATH OLD TWINED BOWLS

In which the designs are in the natural colour of the materials, the body being dyed with mud

Collected by George Gibbs

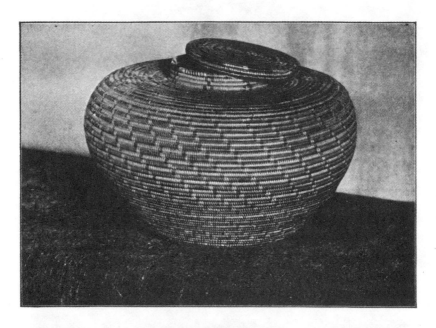

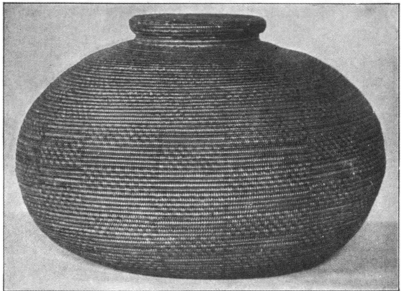

Plate 49. See page 152

THE FINEST OLD COILED SANTA BARBARA MISSION BASKET
JARS WITH COVERS

Collection of the Misses Eaton

Tlinkit vary the ribbed effect with decorative overlaying or three-strand weft. With the diagonal twined work the case is entirely different. The boldest of spiral designs covering an immense surface are wrought in weaving in twilled fashion. Nothing can excel the Pomo, Pit River, and other northern California carrying-baskets in attractiveness of decoration. In openwork twining, where the warp has a chance to show its versatility, as in mound-builders' ware, but especially in Aleutian wallets, the pleasing effects in a single colour are without end. For examples of the great variety in twined work decoration see Plates 19, 21, and 48.

Plate 48, illustrating twined decoration in its elements, is a representation of food-bowls of the Klamath Indians of southern Oregon. These old specimens were among the first received at the United States National Museum, and were collected by George Gibbs, Cat. No. 7,568, U.S.N.M. The resources of ornamentation used by the Klamath Indians are fine stems and rods for the fiber, different colours in the wood, and superadded elements for decoration. Much of their work is done in soft material, and in the type of overlaying used by them the ends are fastened off carelessly on the inside of the structure so as to give a rough appearance.

Further illustrations of Klamath ornamentation, as well as that of their kindred, the Modocs, will be found in Plates 167, 174.

One of the prettiest and boldest attempts at securing effects in twined weave in the United States National Museum is from the vast cemetery of Ancon in Peru. The illustration (fig. 97) shows the decorative belt on a small work-basket made from rushes. One might be deceived into thinking that the motive came from the Yokut Indians of California (figs. 98 and 99), but a glance at the texture reveals a different method of achieving the same result. The warp is double, consisting of two straws side by side as in the Aleut wallets. At the bottom are three rows of plain twined weaving, each twist inclosing two

warps. Follow these pairs up to the top of the basket, and note that the two rows of twined weaving—one dark, the other light—also inclose pairs, but not the same pairs, between the single twinings. Here seven human figures are woven in black on a brown ground. The pairs are holding in their hands between them a rhomboid object, reminding one of an Iroquois wampum belt in which two warriors are shown as bearing the sacred pipe. The weaving on this space is twilled mixed with twined, the latter being subservient to the former. The warp elements no longer are worked in pairs, but singly. The

FIG. 97
HUMAN FIGURES IN TWINED WEAVING.
Ancient Peru.
After W. H. Holmes.

twined weaving on them is twilled on the brown body surface and vertical across the black rectangles, making the double warp conform to the twined weaving below everywhere save on the feet. All this is finger work, and deserves a prize for its maker both for the plan and the size of the molecules.

Coiled basketry, on the contrary, is made up of radial elements only, which are the stitches, some being long and thin, others short and wide. The esthetic effects depend on the

quality of the material. The very coarsest ware of the Utes and the Klondike nations has little beauty of texture, while that of the Alaskan Tinné or the California Washoe, Panamint, or Pomo is faultless. In finer coiled work, when the stitches barely interlock, they appear to stand one over another from

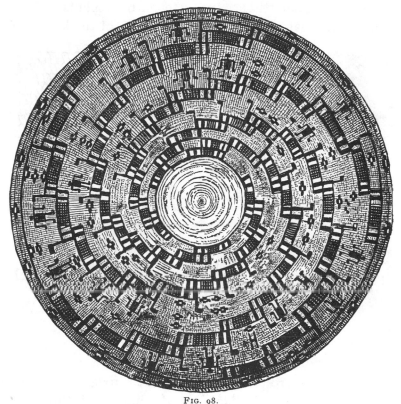

FIG. 98.
DESIGN ON COILED BOWL.
Tulare Indians.
Cat. No. 19,691, U.S.N.M. Collected by Stephen Powers.

row to row; but when the stitches pass underneath one of the rods at least of the foundation below, there is an alternation of stitches with open spaces on the surface resembling twilled weaving, each one being wedged between two, over and under. It is impossible to trace any ornamentation in coiled work among the eastern Indians of North America, through lack of

material. The Arctic Alaskan coiled basketry also is lacking in colour features. It is not until the Salish tribes of British Columbia are reached that attempts are made to produce beautiful effects in the primitive coiled elements of ornamentation. The resources of the artist are fourfold.

(1) Her regular stitches are in tough root splints coiled in such manner that the smooth outer surface of the last year's

FIG. 99.
DETAIL OF FIG. 98.
After W. H. Holmes.

growth is exposed to view. Seldom will the rough inner splints which constitute the foundation come into sight through or between the stitches. Indeed, there is a type of weaving in this area in which smooth, thin strips of wood are laid together in pairs so that when the warp is exposed it is the bright outer surface that is seen. The Salish woman is not backward in making most of her opportunities with the dull brown colour of the cedar in that she has learned to practice uniformity in the stitches themselves.

(2) Mention has already been made of splitting stitches in

the sewing of these savage women. It is done in such a careful manner that it becomes an element of beauty, otherwise it would become a contribution to ugliness. Examples of this work will be seen in Plate 24.

(3) Another resource of ornamentation in the elementary American work of coiled basketry has been well used by the Salish Indians—that is the so-called beading, which consists in running a strip of bright grass in and out among the coiled stitches at regular intervals. Many examples of brown cedar sewing with bright golden-coloured straws for the beading are in the United States National Museum. This arrests the radial effect of the coil stitches and substitutes the concentric or parallel motif.

(4) The last elementary resource referred to among the Salish tribe is imbrication, which will be more minutely described in the section devoted to colour in ornamentation. The sewing on such specimens is entirely obliterated and the surface reconstructed in yellow, red, brown, and wood colour, the effect being tessellate mosaic.

Among the California tribes, these coiled elements, being much smaller in size than those in the baskets of the Salish tribes, afforded opportunity for different artistic effects. An inspection of the work done by Pomo, Maidu, and other tribes of northern California shown in many plates and figures will prove this.

Fig. 98 is from the surface of a beautiful coiled basket of the Tulare Indians, Tulare County, California. It gives an opportunity of studying the elementary stitches on the best of coiled work. These Indians have at their command four colours, that of the root or wood with which the body of the basket is sewed; black filaments taken from the root of a peculiar sedge; where the redbud or cercis is available, the outer bark is a rich brown and the inner side quite white; in addition, there is a bright reddish root, *Yucca arborescens*.

The stitches are, of course, hexagonal in form, but the press-

ing of the wood together gives them quite an oval outline, and they naturally, in the course of sewing, incline toward the right. With these colours and oval elements, to which the artist is bound to restrict herself, the attempt is here made to produce a step-formed cycloid. In the spaces between each two designs is the figure of a man. It is interesting to note how, under such narrow restrictions, so good effects can be produced.

In southern California, among the Tulare and other neighbouring tribes, as well as among the Apache and Navaho, most pretentious figures are attempted in coiled elements. Fig. 99, after Holmes in the Sixth Annual Report of the Bureau of Ethnology (fig. 339), furnishes a good example of what is here mentioned, but the furthest departure from old-fashioned types is exhibited in the work of the Apaches, who attempt all sorts of animal forms in coiled work, and the Pima tribes, who lose themselves in labyrinths and frets.

The basket from which this elementary rectangle is taken will be found illustrated on Plate 30 in Report of the United States National Museum for 1884.*

Plate 49 shows two covered jars in exquisite coiled work, brought from Santa Barbara, California, by William Alden Gale, of Boston, between 1810 and 1835, and owned by the Misses Eaton. The upper basket is 11 inches high and 5 inches wide; the lower, 15½ inches wide and 10 inches high. They are introduced here for the purpose of calling attention to their combination of esthetic qualities. One does not know which to admire most, their forms, the fineness of the stitches, the simple but effective designs, or the charming effect of colour both in the patterns and in the mosaic work. Covers on baskets from this area are rare and may not be ancient. It is just suggested that their motif came from the old preserve jars common in ships' outfits a hundred years ago.

* See also Stephen Powers in Contributions to North American Ethnology, III, 1877, p. 256.

In fig. 100 the ornamentation has all the features of lace-work; indeed, it might be called the beginning of lace. The detailed drawing above the figure shows, however, that the example is simply a piece of coiled basketry from which the foundation rows have been carefully withdrawn and only the sewing remains. In the long stitches between, the thread has been simply wrapped twice around the standing part instead of once. It is within the weaver's power to make this change at any moment from single wrap to double w r a p, the result being a figured surface, as in the lower drawing. This sort of ornamentation has rare existence north of the present boundaries of Mexico, but may be found all t h r o u g h tropical America. The example here shown was procured from the Pima Indians of the Piman family in Arizona and Mexico, but

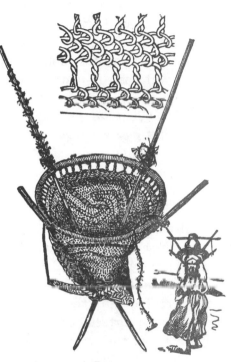

FIG. 100.
PIMA CARRYING-FRAME.
Southern Arizona.
Cat. No. 76,033. Collected by Edward Palmer.

beautiful examples were collected by W J McGee among the Papagos, their kindred.

DESIGNS IN DECORATIONS

The fundamental checks, decussations, stitches, and meshes of which the mosaic of basketry is made up are used, associated

or not with colour, in forming designs or patterns on the sur-
face. Compare the severely plain Haida cylinder wallet with
the exquisitely decorated hat from the same tribe. Both are
in the colour of the spruceroot, but the latter resembles fine
lacework on account of the delicate pattern covering its sur-
face. All Indian tribes know how to give variety to unity by
simply making up various technical compositions that add no
new procèsses. These compositions are aggregations of sim-
ple forms which are the alphabet of the Indian woman's most
intricate patterns. It matters not how complicated the whole
design may be, it is composed of the following simple parts:

(a) *Lines in ornaments.*
(b) *Squares or rectangles.*
(c) *Rhomboidal figures.*
(d) *Triangles.*
(e) *Polygonal elements.*
(f) *Complex patterns.*

It may be well to devote a little more space to the considera-
tion of these. Many seemingly incomprehensible patterns
become clear when resolved. At the same time, the secret of
their pleasure-giving quality is revealed. Just as a subtle
pleasure creeps into the mind in scrutinising the uniform
stitches on the surface of the Washoe basket (Plate 46), so, in
a higher sense, the orderly recurring of the same geometric
shape over and over in an intricate design adds to the enjoy-
ment of the whole. These elements are not exact, however,
being hand-made and bounded by lines produced by the curved
forms in most basketry. The artistic effect is thus heightened.

(a) *Lines in ornament.*—It may not have occurred to the
reader to observe how scrupulous almost every Indian basket-
maker is to relieve the monotony of her work by a simple line
of some other kind of weaving. It would be safe to say that
no basket is without them. In the entire Hudson collection in
the National Museum thère is not a twined basket whose tex-
ture is not improved in more than one place by a line in a differ-

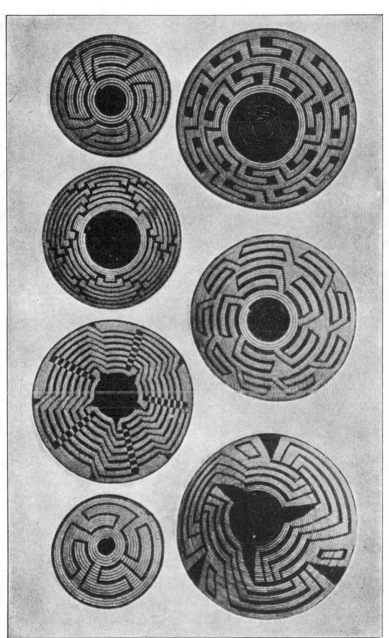

Plate 50. See page 155 COILED BASKET BOWLS OF THE PIMAS, ARIZONA, SHOWING THE
CAPABILITIES OF WANDERING LINES
Collection of F. M. Covert

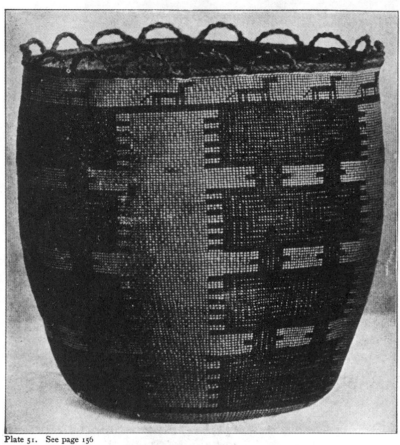

Plate 51. See page 156

SKOKOMISH TWINED WALLET WITH OVERLAYING, WASHINGTON, SHOWING
CLEVER USE OF RECTANGLES ONLY

Fred Harvey Collection

ent style of technic. These lines may run in almost any direction, and, as in the Haida hat, be worked into geometric figures.

Plate 50 is a collection of Pima basket-bowls from southern Arizona, belonging to F. M. Covert, of New York City. It shows how many different effects are produced in the same tribe by the mere administration of lines wandering about. In some of the figures shown it will be seen how easy it is for a row of stitches to become double and then to add or to make additional rows at the ends or on the sides, to separate lines or to give to a line any sort of curved effect. This is especially noticeable in fig. 3. The line may pass by further additions into rectangles, triangles, or geometric figures. The Indians of the southwestern portion of the United States have exhausted the situation in this matter of meandering lines.

(b) *Squares or rectangles.*—The next simplest form upon which the basket artist may venture is the square or rectangle, which may be a band of two or more rows interrupted by vertical spaces, perhaps in another colour. It is a matter of counting the same number over and over as the work progresses, and is one of the first steps in arithmetic. In a Pomo gift basket the square patterns on the bottom are the mats on the floor, and so the simplest of weaving motives lends itself to symbolism. In the plainest forms of work the checkers or squares are oriented at right angles to the horizon or border of the specimen. Variety is effected by the position of the squares and their relation one to another and to other decorative elements. A delightful effect is produced on matting, especially where the squares or checkers are oblique to the borders. Such work is to be seen in America, but was much more common in the islands of the Pacific.

The rectangle gives a wider scope still to variety in artistic effects. Bands of rectangles are to be seen around basketry, and more complicated forms are made up of them or have them in their composition. A departure from the rectangle, but in the same line of workmanship, is the parallelogram. Such

work is easily produced in the diagonal or twilled weaving. An excellent example of an intricate design made up of rectangles in various positions and relations one to another is shown in the old Skokomish wallet from Washington in the collection of Fred Harvey (see Plate 51). The decorations on this wallet consist of vertical collections of geometric figures, one hanging from another, in suits of four. Each one of the designs which go to make up the whole decoration in its simplest elements is a rectangle. The projections from the sides of these are the same, and the wolves around the upper border are simply a collection of the same elementary design—the head, the neck, the body, the legs, the tail, each one is the same. On the larger rectangles are nests of geometric figures of the same class, one inclosed in the other by widening lines. The entire effect on the surface is produced by the clever use of a single element.

In many examples, when the rectangular figure is set obliquely, the pattern of the basket appears to have a rhomboidal form. The types of weaving have much to do with the administration of the rectangle, whether it be radial or concentric. In diagonal weaving the long axis is horizontal, but in coiled work the long, slender rectangles are perpendicular. In loose coiling the figures become rhomboidal on account of the longer slope of the stitch. Twined work produces an infinite number of rhombs in rows having ragged edges. In the style of weaving produced by the Makah, the separate elements are rectangular on the inside, but they form a charming patchwork of rhombs on the outside. The rectangle, aside from colour, which will be studied later, lends itself to ornament by its relief, its proportions, and its position. The relief depends on the material, which may be soft inner bark or bast, or pliant leaves. On the other hand, it may be soft fillets of ash and stems of willow or coarse brushes, as in the fish weir. When the projecting elements are intractable, the possibilities of plain geometric ornamentation are limited in the extreme,

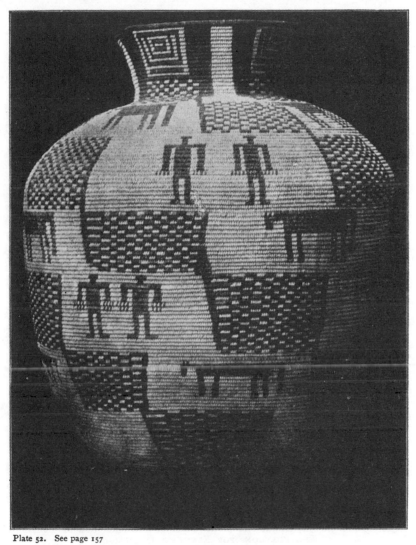

Plate 52. See page 157

LARGE APACHE OLLA, ARIZONA, DESIGNS IN RECTANGLES

Collection of F. S. Plimpton

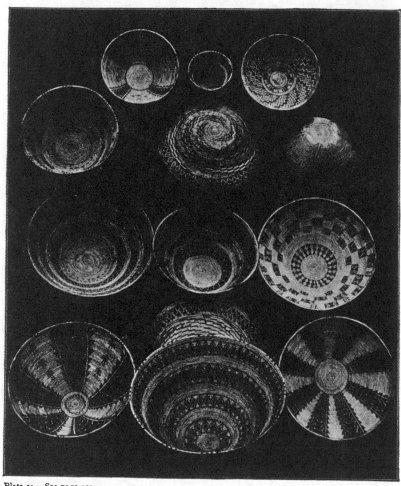

Plate 53. See page 157

FINE COILED BOWLS, KERN, INYO, AND TULARE, SHOWING USE OF DIAMONDS
AND POLYGONS FOR ELEMENTS IN DESIGNS

Collection of C. P. Wilcomb

but with fibers highly flexible and well-soaked materials the field of the decorator becomes greatly enlarged.

Plate 52, a large bottle-shaped granary of the San Carlos Apache Indians, belonging to the fine collection of F. S. Plimpton, of San Diego, California, shows what is meant by proportion. Upon the surface of this coiled basket will be found stepped patterns rising in a cycloid from the bottom to the neck and even to the rim of the specimen. Each one of these spaces is covered with black and white rectangles, or as near as rectangular forms can be made on a globular surface governed in length and width by the widening or narrowing of the specimen. In the spaces between these patterns so made up are men and horses, but even these have square heads, bodies, legs, and feet. The fingers on the men are in proper shape. An amusing departure is manifest in the effort to give a little shape to the tails and ears of the horses.

(c) *Rhomboidal figures.*—With the parallelogram or rhomb, the surface of the basket has a tessellated or mosaic appearance. These figures also may be oriented with reference to the borders, but the patterns become oblique, and more pleasing diaper effects are caused when the figures are not oriented with reference to the horizon or border. Plate 53 shows a number of beautiful bowls in the collection of C. P. Wilcomb, from Kern, Inyo, and Tulare counties, California. They are introduced here for the purpose of showing how, on many of them, diamond-shaped patterns have been worked into basketry with excellent effect. Associated with these geometric forms, polygons are also the elements of cycloids covering almost the entire surface. Radiating from the bottom, triangular spokes proceed to the outer margin, and these are decorated with diamond patterns and irregular polygons. The human form and other typical patterns are united with those now under consideration. The majority of the decoration, however, is in the simple elementary geometric shape here considered.

(d) *Triangles.*—On the surface of basketry the triangle, as an element of design in mosaic, does not occur in the single stitch or check, but it is found in openwork basketry, as among the Aleuts, where the warp is bent backward and forward or crossed. By the combination of elementary parts triangular effects in a great variety are obtained. In this technic a triangle is not a three-sided figure with straight outline, but a pyramid made by piling up rectangles, vertical or radial in coiled basketry, horizontal or concentric in woven basketry. The base of the triangle may be straight, but the sides are notched and stepped as in the beadwork.

A great many symbolical designs of arrowheads, mountains, and other artificial and natural objects which suggest the three-sided form, are produced on both coiled and woven basketry, the base of the triangle being at the top, at the bottom, or on either side of the figure. The conical or the globular basket lends itself most cheerfully to this element in design. On cylindrical, and especially on vertical vasi-formed basketry, for ornamental effects the triangle easily passes into curved figures of infinite variety. After the foundation of the figure is laid on a certain round of weaving or coiling, it is possible on the next round to widen or narrow above either end of this line. In some examples a sweeping cycloid, beginning at the base, narrows and curves to the right or left, terminating with the outer border. The Filipino hat-makers are exceedingly fond of creating a series of these triangle cycloids in different colours, some of them turning to the right, others to the left. The California basketmaker also produces flame-like effects with elongated triangles. There seems to be no end to the versatility of this figure on globular basketry.

Plate 54 represents two of the finest bowls in the collection of F. S. Plimpton. The upper figure is a Tulare, and shows in its bands of decoration in brown and black how the rhomb and triangle coöperate to produce regular and pleasing decoration. The lower figure is a so-called Mono, made by a Nim

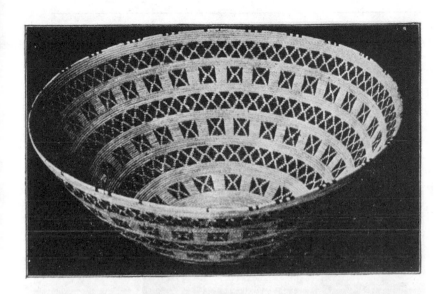

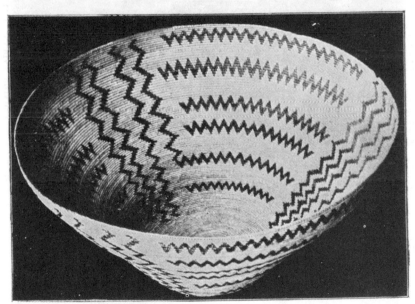

Plate 54. See page 158

TULARE AND MONO COILED BOWLS, CALIFORNIA
Collection of F. S. Plimpton

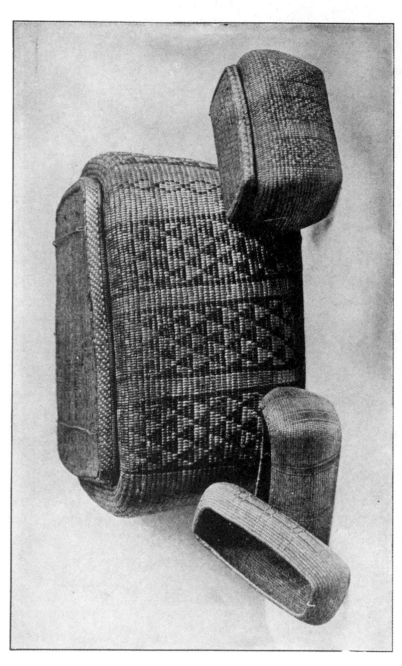

Plate 55. See page 159 IMBRICATED COILED BASKET, USING DARK AND LIGHT TRIANGLES IN DESIGNS, MAIDU INDIANS, CALIFORNIA

Fred Harvey Collection

Shoshonean woman, and is a still better illustration of the use of narrow parallelograms, combined in lines concentric and radial, to give expression to phenomena such as lightning.

Plate 55 is an imbricated box from the Fraser River country in British Columbia. Excepting the parallel bands, the front and body of the basket are covered with white and dark-brown triangles, no other elementary geometric figure being introduced. Each triangle is an example of the limitations before mentioned, which practically cut the basketmaker off from free-hand drawing. The geometricians say that a circle is a polygon with an infinite number of sides. With them, all curved lines resolve themselves into the rectilinear. The basketmaker does not stop there, but resolves rectilinear forms into still minuter rectilinear forms of another class. The mosaic elements on the basket are most regular squares of imbrication. There is for her no other way to make a triangle. This specimen is in the collection of Fred Harvey.

(e) *Polygonal elements.*—What has been said of the triangle is also true of polygonal figures—that is, of those having more than four sides. These figures may be produced in the texture of baskets in openwork. They are also brought about by uniting different forms of checks or stitches in the same piece of work. On the hats of the Haida Indians and on twined work of the Pacific coast excellent diaper patterns are woven. In closely packed basketry the individual stitches assume the form of the hexagon, after the manner of the bee's cell. On matting, wallets, bags—that is, on flat surfaces—all of the geometric figures before mentioned having straight borders occur. In many rhombs the ends are cut off by boundary lines of bands and turned into hexagons.

However, as soon as basketry begins to assume curved outlines, borders that would be straight on a flat surface are bent in one or more directions. The effect of this, both in the single mosaic element and in the larger designs, is to change the figure from a hard outline to one that is far more graceful.

In a coiled basket the foundation coil is curved horizontally, but the stitches cross these at right angles. In a coiled bowl with globose bottom there are three sets of curves with different radii—the horizontal curve of the foundation, the curve of the pattern, and the vertical curves of the stitches. The shapes of polygons that may be worked on the surface of basketry are legion. The designs which may be made out of these are even more numerous. It will be possible to illustrate only a limited number of them, but the reader may be pleased to turn from plate to plate in the decorations on the surface of basketry in the various chapters to see how versatile the Indian woman's mind was in making the best of her limitations. Being confined to angular elements, having no opportunity to introduce the curve except so far as the body of the basket itself made straight lines curved, it became necessary to rack her ingenious brain to satisfy her cravings for expression of the beautiful with straight lines only (see Plates 56–59).

(f) *Complex patterns.*—The most striking artistic effects in basketry are realised when the simple lines, bands, and geometric figures are united and modified to suit the weaver's fancy, to fit the general shape of the object, and oftentimes to correct a miscalculation on the part of the maker. The effect of lines is changed by breaking, curving, setting at different angles, widening, and colouring. Geometric figures become subsidiary to and are lost in mythological compositions, but they are the organic parts of the whole design.

Plate 60 will illustrate what is said about the production of intricate designs by combining two or more of the separate elements in the foregoing paragraphs. In every one of the bowls shown in this plate a circular form in basketwork is attained by using material of the same colour in the coiling at the bottom. From these central beginnings designs in triangles, squares, rectangles, and polygons are built up into labyrinthian decoration for the whole surface. In the middle figure of the bottom row five patterns radiate from the central

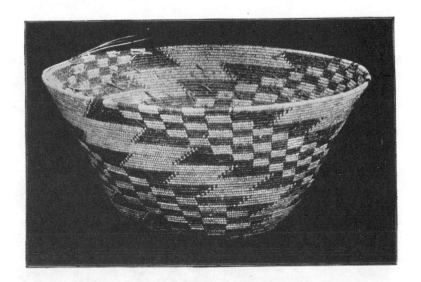

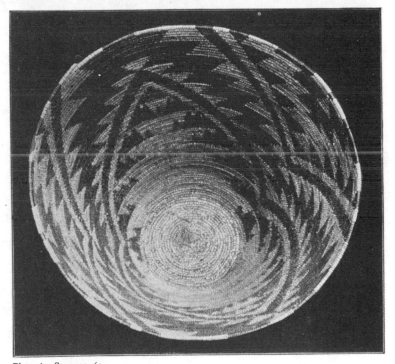

Plate 56. See page 160

COILED BASKETS OF THE MAIDU, CALIFORNIA. DESIGNS MADE UP OF
SIMPLE GEOMETRIC FIGURES

Collections of U. S. National Museum

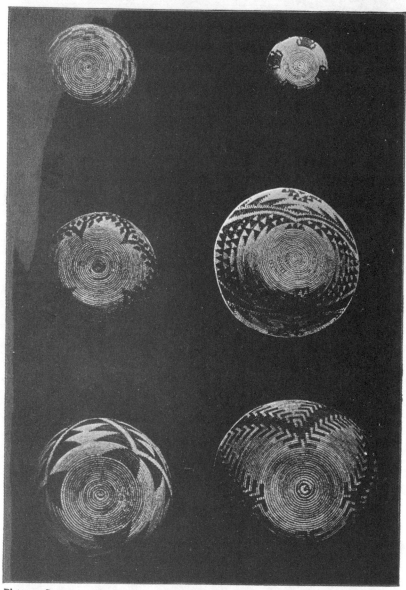

Plate 57. See page 160

COILED BASKETS OF THE MAIDU, CALIFORNIA. DESIGNS IN
GEOMETRIC FIGURES

Collections of U. S. National Museum

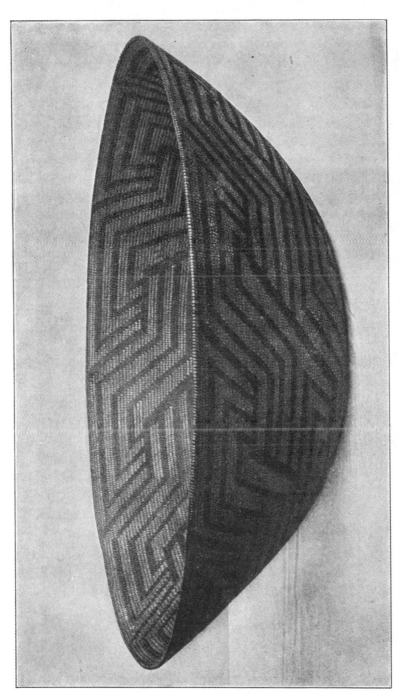

Plate 58. See page 160 PIMA COILED BOWL, ARIZONA. EXTRAORDINARY USE OF PARALLELS IN DESIGNS
Collection of C. E. Rumsey

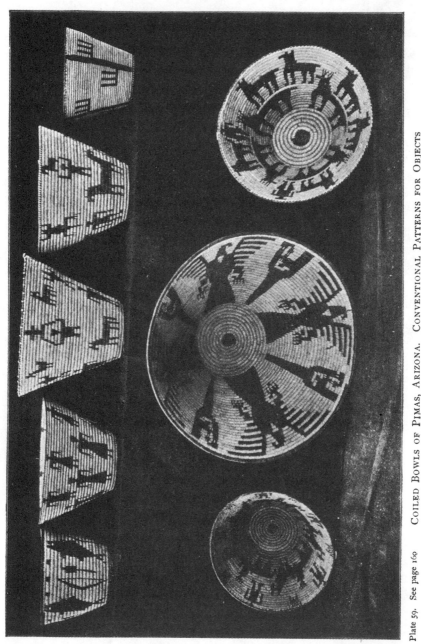

Plate 59. See page 160 Coiled Bowls of Pimas, Arizona. Conventional Patterns for Objects
with Curved Outlines

Collection of J. W. Benham

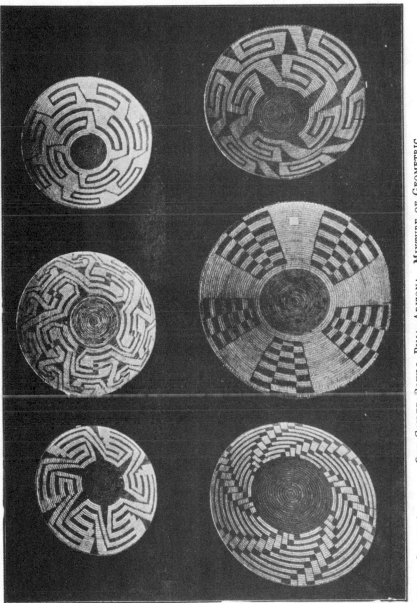

Plate 60. See page 160 OLD COILED BOWLS, PIMA, ARIZONA. MIXTURE OF GEOMETRIC
ELEMENTS IN COMPLEX DESIGNS

Collection of J. W. Benham

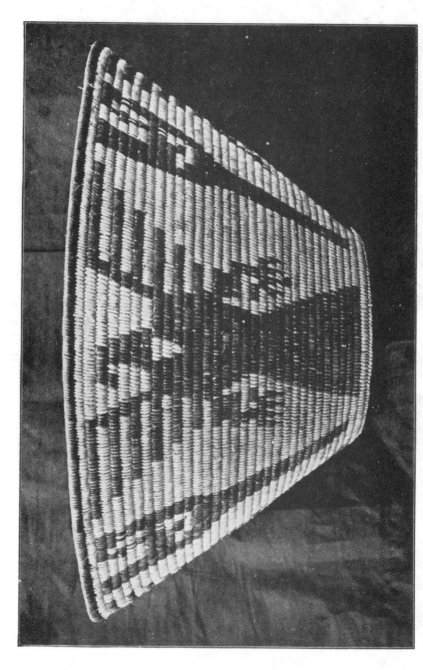

Plate 61. See page 161 Coiled Bowl of the Pimas, Arizona. Enlargement of Eagle on Plate 59

Collection of J. W. Benham

circle, each one of which is made up of three groups of rectangular figures in black and white. Specimens are in the collection of J. W. Benham.

Plate 61 will interest the student as an example of bold design, being the American eagle, with expanded wings. It will surprise him to note how, with the use of straight-line figures before mentioned, some little life is given to the neck and to the talons of the bird by the fine markings of stitches, which lend themselves somewhat to curved effects. It can not be said, however, that this treatment is a success.

ORNAMENTATION THROUGH COLOUR

Quite as much as form, the colours in basketry are an element of beauty. As in basket forms the sense of pleasure is awakened by the mass, by the minute elements, and by the shape of patterns or designs, so it is with colours. One does not know which to admire the most—the subdued shades of the natural materials, the pretty effects of the infinite variety of hues in the stitches, or the combinations of patterns in ornamentation through colours furnished by Nature's laboratory, which the importunate Indian women of America have secured in their tireless quest. The gamut of shades runs from pure white through the yellows and browns to sooty black, and age only ripens the effects. The peculiar golden shade of an old piece from California will set the connoisseur's face aglow. No doubt a part of this admiration springs from association of ideas such as age, rareness, the seeming disparity between the maker and her art, and, maybe, the pride of ownership. When it is remembered that for utilitarian purposes merely not one speck of this artistic colouring is needed, and further noted that great fatigue and search and critical judgment are necessary in order to assemble materials for a single basket, surely no one will withhold admiration from the creator of coloured ornamentation in basketry.

One can scarcely begin to appreciate her struggles and triumphs until the effort is made to reproduce her results.

Ornamentation by means of colour is effected in basketry through the following processes, already hinted at in the chapter on basket-making:

(a) By employing materials which are of different colours by nature. This has been partly described in the foregoing sections.

(b) By the use of dyed materials.

(c) By overlaying the weft and warp with thin strips of pretty materials before weaving, or by wrapping strips about them in various ways.

(d) By embroidering on the texture during the process of manufacture, called false embroidery.

(e) By covering the texture with plaiting, called imbrication.

(f) By adding feathers, shells, beads, and other ornamental objects.

In the making of designs on basketry, dyeing, overlaying, false embroidery, and imbrication are merely artificial methods of repeating and heightening the decorative effects already shown to be possible through use of materials in their native colours. No new designs are added, symbolical or otherwise. The effect of new forms in elementary technic has already been mentioned. But the artist obtains an immense advantage in the number of colours as well as the richness of shades and harmonies. After all, excepting in California, there are only a few colours in tough fibers to select from in any area. If it were not for pretty grasses, which have brilliancy of colour but little tenacity, and the bright dyes in mineral and vegetal substances which have no value as textiles, the esthetic power of basketry would be greatly curtailed. There are two or three small linguistic families of Indians in California that seem to have gathered unto themselves every kind of basket decoration. As in the island of Crete, the culture of the

ancient peoples about the eastern Mediterranean seemed to have assembled, so in the Pomo and Mariposan tribes of Indians the composite art reached its climax of decoration. Is it not marvellous that here, hundreds of years ago, perhaps, broke out the first basketry epidemic; not as now resulting in a fever to own them merely, but manifesting itself in a passion for making them. In the chapter on uses it will be seen that this passion was intimately related to the most sacred feelings that dwelt in the soul of the maker, namely, those associated with the spirit world. It is also true that the natural materials for other forms of art expression were lacking or not courted.

(a) *In natural materials.*—Colour in basketry is effected, first, by the materials from which the structure is made up. In the Aleutian Islands the ware is in the colour of the wild grass stalks, unripe and ripe; farther south the spruce-root decides the shade, and in British Columbia cedar root and bast and bark give a brown or white appearance to the ware. In eastern Canada, ash splints are white and brown; so are the baskets made therefrom, but the cane of the southern States has a glossy yellow-green surface, and that predominates in Cherokee and Choctaw ware.

Among the bewildering varieties of baskets between British Columbia and Mexico the foundation colours will be decided by that of the Indian hemp, spruce and cedar root, bulrushes, cattail stems, shoots of willow and rhus, roots of sedges and agave, roots of yucca, and so on.

In this connection it must not be overlooked that these same materials are not lacking in responsiveness to the severest esthetic demands of the artist. The Abenaki woman knows that last year's growth of black ash is almost as white as snow, while the rings of growth farther in are brown. She therefore makes warp of one and weft of the other, or bands of them alternately, much to the embellishment of the surface. The commonest fisherwoman on the coast of British Columbia will show you that cedar root has three colours—that of the woody

portion, the brown of the outer bark, and the newest wood nearest to the bark. She also knows how to overlay with grasses. The California cercis, or redbud, has a pretty reddish-brown bark, but the wood inside is pure white. Remarkable suggestiveness to a wide-awake mind exists in the yucca leaf of the Southwest, which may be used in basketry, whole or split. The outside is mottled green in a number of shades, while the inside is white. The leaf of the yucca (*Yucca arborescens*) is green, the root a reddish brown.

Holmes calls attention to the possibilities of esthetic effects in a single colour shown in a work-basket from the ancient cemetery of Ancon, Peru, produced through variety in the management of diagonal weaving. There will be found on all these work-baskets (1) ordinary diagonal weaving, over and under two or three or more; (2) bands of greater or less width formed by laying a piece of wood or cane between warp and weft and then continuing the weaving on the other side; (3) the forming of hinges and ridges by twining in each weft element about two or three warps before continuing the weaving. The herring-bone effects are produced by leaving in front alternately warp and weft in the padded bands. If the number of rows of common diagonal weaving is even, a herring-bone effect is seen; if odd, the checks in the two rows will be parallel. In Mexico and Central America the valuable yuccas give colour to all textiles, as do the palm leaves in South America. (See figs. 207–209.)

It is said that the Japanese, in sawing up logs, will keep the planks bound together until the workman is ready to use them, and when the carpenter places them in a ceiling or a piece of furniture he is careful to have the ends abut on each other as they were together in nature. The grain, in such case, fits and produces odd but pleasing forms. In the same way the basketmaker, by showing discretion and taste with roots or stems of different shades, succeeds in producing cloud effects upon the basket or mat. So nature comes in to the assistance of the Indian woman in her elementary steps. She

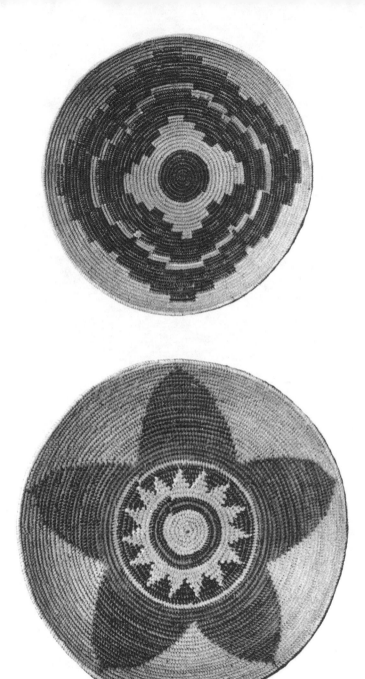

Plate 62. See page 165

MISSION INDIAN COILED BOWLS

Into which modern colours have intruded, and designs of keystones, star, and sun, through
outside suggestions

Collection of G. Wharton James

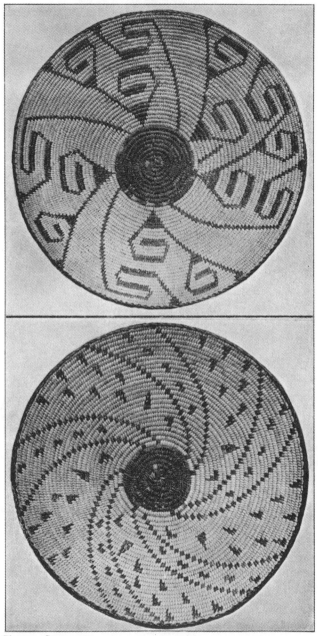

Plate 63. See page 167

BASKET BOWLS OF THE PIMAS, ARIZONA. DESIGNS IN
NATURAL COLOURS

Collected for the Bureau of Ethnology, by Frank Russell

does not start out with the design in her mind which she will produce in colour, but by using the coloured elements she is able to get her effect with less forethought. Indeed, it can be seen that in such a way the earliest thoughts of beauty might have been awakened.

Plate 62 shows two coiled Mission baskets in the collection of G. Wharton James; the upper one is 10 inches and the lower one 11¾ inches in diameter. They are made of rush, but the interesting feature for which they are introduced here is the design—the upper figure might be called the keystone pattern, the body of the bowl having two zones of patterns in brown and black material, each one made up of wedge-shaped figures, narrow on the inside and widening outward. These patterns are in four parts, each one surmounted by a middle piece extending two rows beyond the next pair and each pair of the series ending two rows nearer to the center. They are of equal width. A narrow wedge separates the four groups. Between the zones is a band of white preserving the outline of the border. The lower figure is a five-pointed star, the border of the segments being curved as in the orange-peel pattern. The central figure might be called a sun design, which, though it be modern, shows the adaptability of the Indian mind to invasion by suggestion.

A second step in colour resources, without going away from the natural and necessary structural elements, is in the use of different materials. Very few areas in the Western Hemisphere are so poor in resources as to have only one good basketry plant. On the Great Lakes, ash, hemp, and sweet grass are white, brown, and green; in the Southwest, rhus is white and martynia is black; in California, willow is woody white; cercis is red outside and snow-white inside, and at least one sedge has black root, and the yucca a red one. Most dainty effects are secured in coiled basketry by sewing with strips from quills of flickers and other highly coloured birds. Not to pursue the statement too far, it is only in

Alaska and the Strait of Magellan that the body of our textile does not contain varied material.

The moment a savage woman has in hand these variegated substances, her fancy is emancipated. Warp may be of one plant and weft of another, either in plain checker or in twilled weaving. Wickerwork is not entirely irresponsive to the opportunity. In twined weaving the two strands of the weft may differ in colour, so that the result will be the mottled line. If the warp stems be odd in number, then on the next round the colours on vertical lines will not match. With these simple resources the basketmaker may play an unlimited number of melodies. An excellent example of lines in simple and two-colour effects from southeastern Alaska is shown in coloured Plate 67.

But the ambitious artist is not satisfied with flecked lines and mottled surfaces, and broad bands in one colour. Her bands are divided into rectangles, triangles, and rhomboidal elements. The zones of element are widened and the geometric patterns composing them are multiplied and variegated. Those who have large collections may have noticed how the several styles of technic behave in this regard. Checkerwork is little restrained, so also are wicker and twilled ornamentation; but in twined and coiled ware the case is entirely different. Plain twine and the Pomo tee work venture little beyond the banded ornament. The same is true of most coil types; but the twilled or diagonal-twined work and the three-rod coil leap over the parallels and spread themselves out in bewildering cycloids of coloured patterns, or, keeping to the angular elements, the weaver covers a large surface with fretwork in endless variety. All of this is wrought into the structure of the basket in the substantial everyday materials, which possess tenacity and colour as well. Quite a number of tribes in the southwestern United States use no superadded material or dyes whatever, and yet the tribes of the Piman family excel all others in the endless variety of fretwork on their basketry,

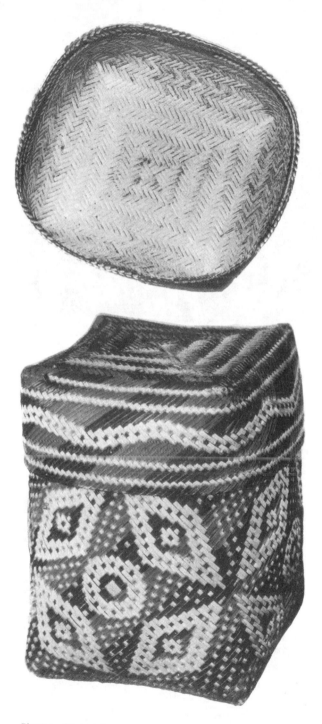

Plate 64. See page 167

CHETIMACHA TWILLED BASKET

To show artistic effects in mosaic, colour, and patterns

Collected by C. E. Whitney

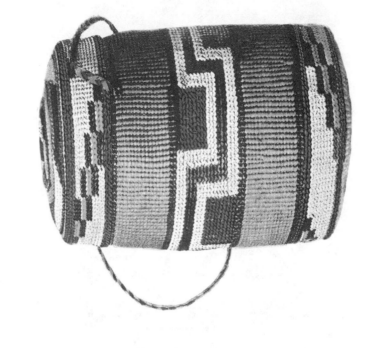

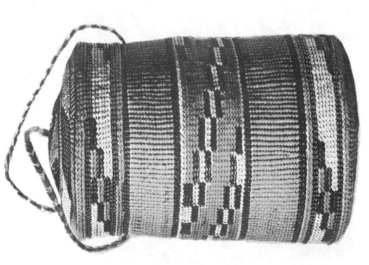

Plate 65. See page 168

TLINKIT MODERN BASKETS

The dinner pail in twined basketry, but preserving ancient patterns

Collected by G. T. Emmons

produced with splints in wood colour and the undyed splints from the pod of the cat's claw, or *Martynia louisiana*. (See Plate 63.)

(b) *By dyeing.*—The colours of natural textile materials were still further diversified with dyes and paints, the latter either stamped, stencilled, or applied freehand. At the present time, the cheap and obtrusive dyes and paints of the trades supplant the aboriginal and more attractive substances. The latter have also become more difficult to procure as civilisation has preëmpted the ground.

The artificial colouration of basketry material was known to the American savages in pre-Columbian times. For mineral dyes they used earth colours, burying the splints in different soils, where they acquired permanent shades. Vegetable dyes were known from Alaska southward everywhere. The substances used were such as have the power of directly fixing themselves within the texture of the basket material. It is true and also interesting to note that certain of the processes of the Indians in dyeing their basketry materials were, all unconsciously to them, foreshadowings of the later and more complicated processes in which a mordant is employed to fix the dyestuff in the materials. The Indian had no appreciation of how the causes were produced. They discovered the fact, but their theories would lead into dreamy myths in which the personeity of the dyestuff would be the prominent characteristic.

Plate 64 shows twilled basket No. 76,778, U.S.N.M., from the New Orleans Centennial Commission. It is a basket of the Chetimacha Indians of Louisiana made in split cane in the natural colour and dyed. The union of textile effects and the three colours—orange, black, and straw colour—are most pleasing, the motive being ellipses and rhombs, made by the use of small squares and rectangles. The upper portion on the figure also shows how a diaper effect may be produced on the surface by the lights and shades of the uncoloured material.

It is useless to tarry about the eastern basketmakers in

search of native dyes. There is no doubt of their having possessed them. The porcupine quill workers about the Great Lakes and all the way to the Arctic circle are still adepts in the art. In the National Museum are little wallets of bladder from Anderson River, Canada, each one filled with porcupine quills dyed in a separate colour.

The basket-weavers of Yakutat Bay, in southeastern Alaska, colour with dye from the willow their splints of spruceroot from which they weave their twined basketry. They scrape the roots of willow and make a decoction in a wooden tub, in which they soak the spruceroot splints. Their neighbours of the same linguistic family had a more extensive laboratory in colour. For more than a hundred years they were in contact with the Russians and from them obtained good dyestuffs and knowledge of processes. Many an old piece of their basket ware, although it has stood hard use in all the years, and in spite of all, has grown more beautiful with age.

Plate 65 shows two covered baskets of the Tlinkit Indians, in twined work, which are inserted here for the purpose of exhibiting the influence of modern traffic. Cæsar, in his Commentaries, speaks of the Belgians as being the most manly of all the Gallic tribes, because merchants less frequently went among them and sold them the things that tended toward effeminating their minds. The Mercatores have also been among the tribes of the Northwest. On the right-hand basket even the bands that would show some little survival of the ancient wood colour have been dyed, while the red, yellow, black, and white shades are in aniline. The form of these baskets is also borrowed from civilisation, and the handles in braided ware are not aboriginal. Cat. Nos. 168,267 and 168,268.

The wood of the alder, when freshly cut, says Swan,* is soft and white and easily worked, but a short exposure to

* The Indians of Cape Flattery, Washington, 1870, p. 43.

the air hardens and turns it to a red colour. The bark, chewed and spit into a dish, forms a bright-red dye pigment of a permanent colour, which is used for dyeing cedar bark or grass. Governor Dagget, writing of the Indian women on the Hupa reservation in northwestern California, uses almost precisely the same language with reference to making a dye-pot of their mouths. The processes of weaving there are in twined work, and suggest connection with the Washington State tribes.

The Navaho Indians, according to Washington Matthews, employ native dyes of yellow, reddish, and black. In their blankets they have also wool of three different natural colours, white, rusty black, and gray. The black dye is made from the twigs and leaves of aromatic sumac (*Rhus trilobata*). They put into a pot of water leaves and branches of the sumac. The water is allowed to boil five or six hours. Ocher is reduced to a fine powder and slowly roasted over a fire until it assumes a light-brown colour. It is then combined with an equal quantity of Piñon gum (*Pinus edulis*), and again the mixture is placed upon the fire and stirred. The gum melts and the mass assumes a mushy consistency. As the roasting progresses the mass is reduced to a fine black powder. When it has cooled it is thrown into the decoction of sumac, with which it forms a rich, blue-black fluid. This is essentially an ink, the tannic acid of the sumac combining with the iron of the ferric oxide in the roasted ocher. The whole is enriched by the carbon of the calcined gum.

Reddish dye is made from the bark of the *Alnus tenuifolia* and the bark and root of *Cercocarpus parvifolius*, the mordant being fine juniper ashes. These dyes are now applied by the Navaho. The so-called Navaho blankets are in three colours.

For yellow, the flowering tops of *Chrysothamnus graveolens* are boiled about six hours, until a decoction of deep yellow is produced. The dyer then heats over the fire some native

alunogen (native alum) until it is reduced to a pasty consistency. This she adds to the decoction and puts the whole in the dye to boil. From time to time a portion is inspected, until it is seen to have assumed the proper colour. The tint produced is nearly lemon yellow.

Julian Scott makes the statement that the Coconinos or Havasupais in northwestern Arizona use only black in the ornamentation of their basketry, while the Apaches and Walapais use black and red also.

(c) *By overlaying.*—This process of ornamentation consists in laying a strip of pretty grass, dyed or in the natural colour, on the outside of one or both the strands in woven or coiled weaving. It is virtually furnishing a dull-brown strip of root with a bright-coloured bark. By this ingenious combination beauty and strength coöperate in the result. The weaver has it always in her power to twist the strands so as to hide this bark side or bring it into view. The Hupa Indians especially, but also many other tribes in northern California and northward, do the weft of their beautiful twined weaving in sombre materials. The men are most adept in lining the backs of their bows with sinew shredded and mixed in glue. In a similar way, as if one had suggested the other, they line the back of the weft strands with bright straw. It is not glued, since the weaving would hold it in place. When the Hupa reveals the straw side of the strand at every half-turn, she covers the surface of her basket with straw colour which turns to gold with age. The overlaying of only one of the two weft strands gives a freckled effect on the surface. In some of the tribes the pattern does not show on the inside.

This will be a good place in which to mention a kind of overlaying common in countries where the cane abounds. The outside of the stem is glossy and may be dyed. The inside is spongy and unattractive. By laying two strips together, so that the smooth surface may be outward, there would be really a double fabric with two glossy surfaces. The

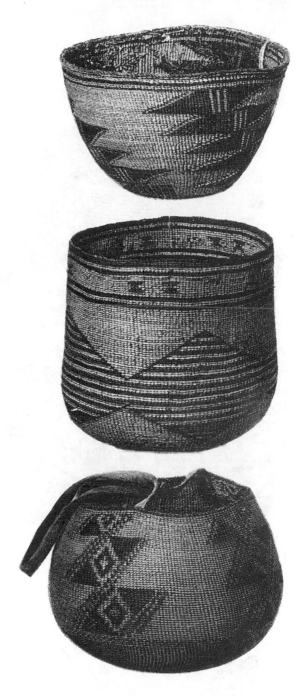

Plate 66. See page 171

 OREGON AND CALIFORNIA TWINED BASKETRY

To show how decoration is produced by overlaying the dull foundation with bright materials

Collected by Mrs. Benjamin and Livingston Stone

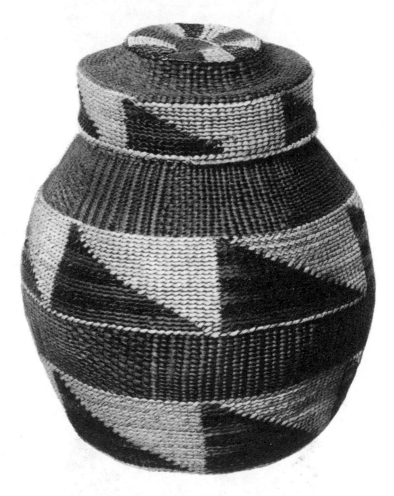

Plate 67. See page 174

TLINKIT TWINED COVERED JAR

The form is a relic of old Russian occupation; charming designs in varied weaving of
foundation and in false embroidery

Collected by J. J. McLean

southern Indians also frequently passed only one of the pair of splints over or under weaving.

Fig. 101 shows a style of wrapping done in Mexico City.* The illustration is from a hand wallet. The body of the checker weaving is in hard, flattened straws of varying shades. Each warp straw is wrapped with two fillets of thin material in darker colour so as to leave small squares on the surface set diagonally. When the plain weft is run among the warp elements, the surface of the fabric is covered with larger and smaller squares in white set in triangles of darker material. The white squares run diagonally across the surface. There are endless variations produced by this wrapping added to the body of the fabric.

Fig. 101.

WRAPPING WEFT FILLETS WITH DARKER ONES.

After W. H. Holmes.

This overlaying must not be confounded with the many tricks which cunning women play with the strands of the regular twined weaving, which are frequently of brilliant straws of squaw-grass and other pretty materials. (See Plates 146, 164, 170, 177, and 178.)

Plate 66 represents twined basketry of the Klamath River Indians of various types, and is here introduced for the purpose of showing how the tough weaving material may be overlaid with basketry and other coloured filaments so as to conceal the foundation both outside and inside. It has been shown in the chapter on processes, however, that the exposure of the overlaying material need not occur on the inside. These specimens are Cat. Nos. 204,258, collected by Mrs. Carolyn G.

* The Indians of Cape Flattery, Washington, 1870, p. 43.

Benjamin; and Nos. 19,286 and 19,282, collected by Livingston Stone.

Akin to the "beading," so common in the Fraser River coiled basketry to be mentioned, is an ornamental effect produced in twined work by the onlaying of coloured straws in regular geometrical designs and catching the angle under the strand of the weft. Holmes* figures an example of this from the Klamath Indians in northeastern California—a rare process in North American basketry. (See fig. 102.) It

reminds o n e o f the stamps for printing tapa cloth used in the Polynesian area.

FIG. 102.
BEADING ON TWINED WORK.
Klamath Indians.
After W. H. Holmes.

Beading is the insertion of narrow strips of pretty grass or other material into the sewing of coiled baskets, passing it under one, over the next, and so on. Plain beading produces a broken line of dark and light colour alternating, and shifts the direction of the elemental figure from vertical to horizontal. If several rows are made, figures are produced by the process of twilled weaving. The basketmaker may pass her filament over and under as many stitches as she chooses; she may make the element of any row immediately over those of the preceding row, or they may alternate. The Fraser River Salish are adept in this on many of their imbricated baskets. Especially on the ware whose coils have flat foundations is beading effective. (See fig. 103.)

(d) *False embroidery.*—This is a method of ornamentation

* W. H. Holmes, Sixth Annual Report of the Bureau of Ethnology, 1888, p, 227, fig. 330.

in which the outer surface of a twined basket is covered wholly or in part with designs, but they do not show on the inside. The Tlinkits excel in this, calling it uh tah yark tu twage (outside lifted up and put around). It has the appearance of being sewed on after the weaving is done. The process is described on the next page, and many figures in this work show examples of it. Plates 71 and 74, in colour, demonstrate more plainly how effective false embroidery may be made. The body of all Tlinkit and Haida ware is in dull-brown shade of

FIG. 103.
BEADING ON COILED WORK.
Clallam Indians, Washington.
Cat. No. 23,512, U.S.N.M. Collected by J. G. Swan.

spruceroot. The saving feature which lends itself cheerfully to ornamentation is the pliability and even fiber of the young roots. Nothing can be more pleasing to the eye than a fine old Haida hat, its surface covered with intricate patterns. The Tlinkit false embroidery in subdued colours, yellow, red, and black, contrasts harmoniously with the cinnamon-brown spruceroot. Also the restful manner in which this work changes the slope of the elements in the weaving should not be overlooked. The twined weaving is made up of a series of little

mosaic elements lying down one upon another like a row of
bricks that have fallen. The incline of the stitches in false
embroidery is in the opposite direction. In Plate 67, charming
effects are produced by alternating the plain weaving and the
embroidery. (Emmons.)

The twined false embroidery might be classed technically
with three - strand twined weaving. (See figs. 29, 31, and
104.) The warp is in normal position. The weaver selects
three strands for weft, two of spruceroot and one of brightly
coloured grass. They all have their places in the weaving,
but the third, or deco-
rative element, instead
of taking its turn to pass
behind the warp, re-
mains on the outside
and makes a wrap about
the strand that happens
to be there. The wrap-
ping may pass, also,
over two by skipping
every alternate twist of
the warp. The Thomp-
son Indians vary the
mode of wrapping by
passing a strip of corn husk or other soft material entirely
around the twining each time, showing the figure on the inside.

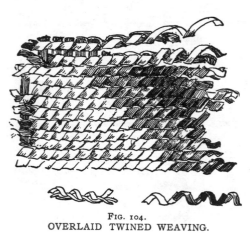

FIG. 104.
OVERLAID TWINED WEAVING.

(e) *Imbrication.*—This term, derived from the Latin imbrex,
a tile, is applied to a style of decoration used in Washington
and British Columbia by the Klikitat and many of the Salish
tribes, and most closely allied in technic with the feather-work
on basketry farther south. Leaves of *Xerophyllum tenax*,
strips of wild cherry bark or of the inner bark of the cedar, in
natural colour or dyed black, are laid over the sewing of the
coiled work. The juice of the Oregon grape is used to produce
a bright yellow dye. The separate elements of the imbrica-

tion are squares or rectangles, varying in size with the fineness of the workmanship. But the mosaic effect is most striking, and designs of intricate character are successfully expressed in it. The Salish tribes about the Fraser mouth have learned to widen the coils by using thin strips of wood, often half an inch wide, as foundation of the coil. This increases the size of the imbrications and of the patterns. (See page 99 and Plate 68, also Plates 11, 43, 45, and 55.)

Ornamentation in Thompson River basketry is produced by imbrication and by beading (for detail drawing see figs. 52 and 53 and Plate 102). Imbrication is done by bringing the piece of grass over the outside of the last stitch and forward, then doubling it back and catching the double end with the next stitch. The outsides of Klikitat, Cowlitz, and Thompson baskets are completely covered in this manner, so that the whipped cedar splints can be seen only from the inside. Lillooet baskets have the lower part of the body plain, while the Chilcotin baskets have a separate band in the middle of the body. The grass used is that called Nho'itlexin. It is long, very smooth, and of a glossy yellow-white colour (*Xerophyllum tenax*). To make it whiter, diatomaceous earth is sometimes spread over it and it is then beaten with a flat stick on a mat or skin. The grass is seldom dyed, as the colours are said to fade soon. (Teit.)

(*f*) *Featherwork, beads, etc.*—The California baskets adorned with feathers are called jewels. They no longer serve vulgar uses. The beautiful productions covered with styles of ornamentation before described have often the marks of fire, the stain of berries, the smell of fish about, proclaiming that they were not above combining the beautiful with the useful. The feather baskets sacrifice use to beauty.

The tribes of eastern America have not employed feathers in basketwork in recent times. The nearest approach to it is the porcupine-quill work of the Indians in Canada and the United States. The quills are dyed and set on the surface

of birch baskets by thrusting the sharp ends into the bark. The old historians tell of gorgeous feather robes made doubtless in the Indian fashion of twined weaving, which is akin to basketry. The Eskimo, Aleut, Haida, and Tlinkit do not ornament baskets with feathers, but they do apply in dainty fashion to some of them worsted, hair, and furs. Neither do the tribes of the Fraser-Columbia area. It is the California tribes chiefly that have developed the art, of which they practice two styles. In the one, tiny bits of coloured feather are sewed by their shafts into coiled basketry just to give a hazy effect to the surface. Plate 3 is an excellent example of this. It will be observed that the elaborate pattern in black is not obscured in the least by the feather. In the other process the feathers are laid one upon another so thickly that the surface of the basket is hidden. The addition of so much extraneous matter thickens the foundation and coarsens the work. As previously remarked, the best examples of coiled sewing are not to be found in the feathered baskets.

Plate 69 is a coloured illustration of a feathered basket of the Pomo Indians from Sonoma County, California, in the collection of C. P. Wilcomb. It is examples such as these that technically are called jewels. The foundation is a three-rod coil, the sewing is with split sedge root (*Carex barbarae*), and the stems of the feathers are caught under the stitches. The feathers on this rare specimen are as follows:

Red—Woodpecker (*Melanerpes formicivorus*).
Green—Mallard duck (*Anas boschas*).
Orange—Oriole (*Icterus bullockii*).
Yellow—Meadow lark (*Sturnella neglecta*).
Black—Quail (*Lophortyx californicus*).
White wampum (Kaya)—Disks of *Saxidomus nuttallii*.
Red wampum (po)—Disks of *magnetite*.
Pendants of abalone, *Haliotis* sp.
Long diameter—9 inches.
Coloured plate kindly furnished by C. P. Wilcomb.

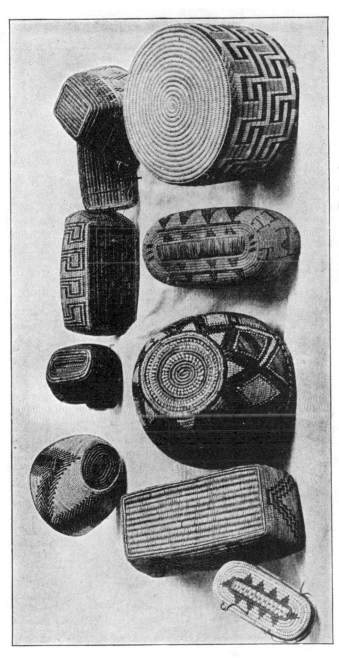

Plate 68. See page 175 COILED BASKETS OF THOMPSON, FRASER, AND LUMMI INDIANS, B. C. ORNAMENT BY IMBRICATION

Collection of Miss Anne M. Lang

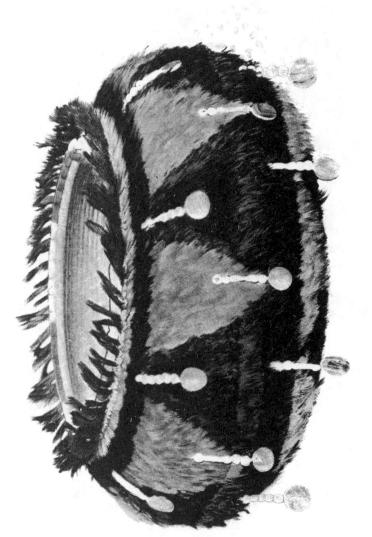

Plate 69. See page 176

POMO FEATHERED, OR JEWEL BASKET

In which the woodpecker, the mallard duck, the oriole, the quail, and the haliotis have
furnished the decoration

Collection of C. P. Wilcomb

Plate 70 is a feathered jewel basket of the Upper Lakes, who are Pomo Indians, in Lake County, California. The stitches are of the coiled work over three rods and interlocked beneath. The yellow feathers are from the breast of Jushil, the meadow lark (*Sturnella neglecta*); the red ones are the throat and scalp feathers of Katatch, the woodpecker (*Melanerpes formicivorus*); and the black feathers at the top are from the crest of Chikaka, the quail (*Lophortyx californicus*). In recent forms, pretty feathers of the peacock and other showy birds gotten in trade are used. The perforated disks are money from the clam-shell, Kaya (*Saxidomus nuttallii*); and the iridescent pendants are cut from Tem, or the hailotis shell, which is quite abundant on the Pacific coast.

The following list of plants used in colouring has been identified by Frederick V. Coville, Botanist of the Department of Agriculture:

Alnus rhombifolia—White alder.
Amaranthus palmeri—Amaranth.
Berberis nervosa—Oregon grape.
Carthamus tinctorius—False saffron.
Covilloa tridontata—Creosote bush.
Delphinium scaposum—Larkspur.
Dondia suffrutescens—Sea-blite.
Evernia vulpina—Wolf moss.
Helianthus petiolaris—Sunflower.
Parosela emoryi—Parosela.
Quercus lobata—California white oak.
Rhus diversiloba—Poison oak.
Sambucus mexicana—Elder.
Thelesperma gracile—Thelesperma.
Vaccinium membranaceum—Blueberry.

CHAPTER V

SYMBOLISM

All the high and low
Of my wild life in these wild stems I snare;
The jagged lightning and the star I show;
The spider and the trailing snake are there.

—ANNA BALL

ALL industry leads to fine art, and all savage arts begin at the foot of the ladder and end "beyond the bourne of sunset." In this apotheosis, basketry is the rival of stone working, wood carving, skin dressing, and pottery. The merely useful basket has some beauty, but the exalted specimen of handiwork is the acme of intelligent discrimination in the materials as well as of hand skill and taste, and leads up to the choicest textile productions. Its maker must be botanist, colourist, weaver, designer, and poet, all in one. But could the windows of her mind be thrown open wide, there would be seen, in addition to all these, the mystic love of her tribe alive and active. In the old days of unsophisticated savagery, no doubt, there was everywhere in America the overseeing and guiding presence of the mythic in the practical. Its relics are still to be found on fragments of pottery especially, and there is no reason to doubt that it reigned in other departments of activity. The old-time basketmakers were under its spell everywhere. It would be an interesting study, though it can not be pursued here, to find out how far the various peoples of Europe, in settling down upon the lands of the savages, had by their ethnic traits and beliefs gradually eliminated or modified those of the aborigines in the matter of symbolism.

Besides the unmodified artistic motives in the designs on basketry, there still survives in the Pacific coast area a sym-

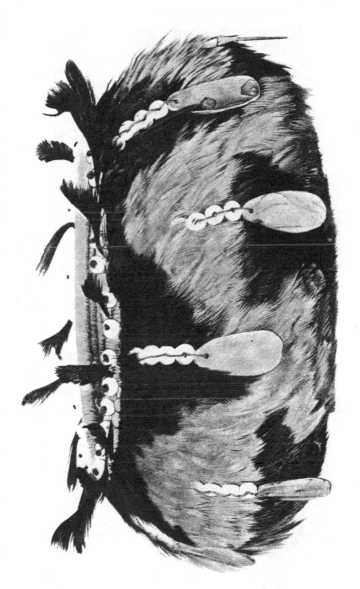

Plate 70. See page 17=

Pomo Feathered, or Jewel Basket

The ornamentation is from the woodpecker, the meadow lark, the quail, the clam, and haliotis

Collection of C. P. Wilcomb

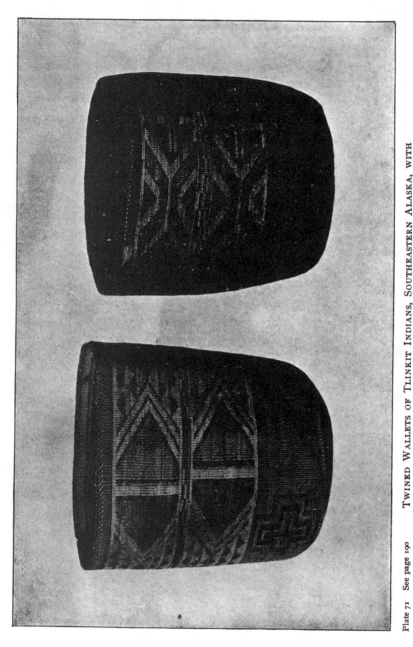

Plate 71 See page 190

TWINED WALLETS OF TLINKIT INDIANS, SOUTHEASTERN ALASKA, WITH
SYMBOLISM IN FALSE EMBROIDERY

Collections of U. S. National Museum

bolism more or less connected with Indian cosmogony. The maker is a sorcerer. In such tribes as the Hopi this idealism in design is still alive and active. Among the Algonkin Indians of the Atlantic States the thought seems to have escaped entirely from the design, and the Indian woman making her baskets at the seaside resort, at the springs, or at Niagara Falls has no more idea of putting a thought into the colours and patterns which she weaves than if such a thing never existed. The designs are changed to suit the whims of the buyers. Idealism is buried in commercialism. Tracing the motive around the Arctic region, there still is found no pattern in basketry until southern Alaska is reached. In the birch-bark ware of middle Alaska and Canada, and in the rawhide-parfleche receptacles of the Sioux and other Plains tribes, the mythical conception is reawakened. The Ojibwa about the Great Lakes preserve all sorts of ancient patterns in porcupine-quill work on birch bark, while the Sioux, the Arapahos, and Kiowas paint upon their parfleche cases the totemic symbolism of their tribes.* It is well to keep in mind these other symbolic representations in speaking of basketry, since they raise questions of origins and relationships. Boas is inclined to refer the designs on Salishan basketry to the tribes inland across the Cascade Mountains.

The Haida Indians of Queen Charlotte Archipelago make wallets and hats of spruceroot, now and then weaving in a band of black, but the ware is extremely plain. Its decoration depends upon the various types of weaving employed and painted symbols. But the Tlinkits on the mainland and islands of southeastern Alaska, on the other hand, cover the surface of their baskets, made precisely similar to those of the Haidas, with symbolism connected with their daily life. It has been thought that anciently the Tlinkits made baskets like the Haida without coloured ornaments, and that the designs on

* A. L. Kroeber, The Arapaho, Bulletin of the American Museum of Natural History, XVII, 1902, pp. 1–150.

the baskets have no mythological significance. The Chilkats, however, who are akin to the Tlinkits and live on the mainland, cover the surface of their fringed robes with their totemic symbolism in most subtle fashion. The technical process on these blankets is precisely the same as that on the baskets, only the blankets are made in soft wool while the baskets are in hard material. Coming farther southward, the land of the imbricated basket is reached. The symbolism on this ware has been worked out by Livingston Farrand.* Further on, these designs will be taken up with greater detail. As the inscriptions on Assyrian slabs have preserved the thoughts and lore of Mesopotamia and the hieroglyphics of Egypt held secure for millenniums the story of the oldest of empires, so in a much humbler fashion the myths and stories of these Indians have been in the olden times symbolised on their basketry. As there is no Rosetta stone nor alphabet of design for their decipherment, all the more diligent must the present seeker be to save the evanescent records. The basket is frequently made for no other end than to record the legend.

The Salish tribes of Washington and Oregon, and tribes of California, Arizona, and New Mexico, all place some kind of designs on their basketry. Whether it has a symbolical significance or not has to be determined in each case by inquiry. Looking at the whole field as revealed in collections and publications, the following classes of objects and phenomena sought to be represented seem to be complete:

1. Natural phenomena, such as lightning, sunrise, clouds, and sky.

2. Natural features of objects, such as mountains, lakes, shores, and rivers.

3. Plant phenomena, including splints of the plant used to make the design.

4. Animals and parts of animals. There is no end to this species of design, from the attempt to represent the entire animal

* Basketry Designs of the Salish Indians, Memoirs of the American Museum of Natural History, II, 1900, Pt. 5, pp. 393–399.

alive and in motion, to the few stitches which stand for a part of
the creature, perhaps a wing, a fin, an eye, or a tooth, to show what
the animal might be.

5. Human beings, either full or in part.

6. Devices used by the Indians in their occupations, arrow-
heads especially.

7. Ideas connected with the Indian thought and life; for ex-
ample, such as the opening in a Navaho basket.

8. Mythical personages connected with sorcery and witchcraft.

9. Their gods and heavenly beings.

In thinking of symbolism, the sign or form on the basket
and the thing signified must be kept separate in the mind.
The sign may be at the beginning pictorial, and pass down
through changes and abbreviations to a mere outline that has
no suggestion in it, or a simple geometric figure common in the
technic may become a mythic being by making here and there
a significant addition through suggestion.

When it is remembered that the Indian represents in a
general way the childhood of the race, one has but to revert
to that period of life to recall how a spot of ink or a meaningless
form was transformed into a picture of something real or ideal.
A fundamental geometric figure on basketry may in similar
fashion, by the addition of a line or two, become almost any
design, the visible home of any symbol.

In this work, devoted more particularly to the technical
side of basketry, the manner of realising the symbol is still
important. However, it is not so much sought to teach that
a certain design represents a butterfly as to see how the woman
put the form into the texture of her basket.

The sculptor, the painter, the carver, and the potter are
more realistic than the basketmaker, since the making of
portraiture and pictures is easily within their reach. Yet
nothing is more common among them all than abbreviation and
synecdoche. Not only are they under the spell of symbolism,
but the symbol is curtailed to the lowest terms. A fin stands
for a whale, incisor teeth for a beaver, the beak for a bird, and

often the image is completely obliterated in the symbol. Now, the basketmaker is still more handicapped by her technical limitations, and driven to symbolism if she did not largely invent it. For pictorial effects on the surface, the maker is hampered by the limitations of weaving and sewing. It will be found, therefore, that her temptations are to pass more quickly to the symbolic stage of representation. It is well to remember, also, that just as on the baskets themselves the symbolism, starting with pictures, has in some tribes been reduced to its lowest terms, so in the basketmaker's mouth the legends have become faded into concrete words and then into meaningless terms, yet the thought is there. Of a certain form on a basket plaque the Hopi woman would say it is the bird that carries messages to the rain god; another tribe would call it a bird; a third name it wings, and finally it becomes an empty geometric design. Again, the student himself passes through a process of initiations as the subject is exploited.

It is said that Pompey declared, when he had drawn aside the veil of the Holy of Holies, at Jerusalem, "The Jews worship nothing." With some such feeling the collector of baskets begins his quest. The first impression is that no set patterns were in the maker's mind. She had a sense of the beautiful and loves to give her fancy free rein. Indeed, the reticent and suspicious basketmaker helps the delusion. A little later the discovery is made that the patterns stand for things, but still for general notions. It is only after long familiarity and systematic converse with old basketmakers that the veteran collector learns that the belief that these patterns stand for mountains, lakes, rivers, men and women, deer or other mammals, flying birds or bird tracks, fishes, insects, flowers, plants, heavenly bodies, or articles of use and worship merely is but a fraction of the truth. They are concrete, standing not for all or any, but for one, and underneath them is charming folk-lore. Mrs. Shackelford tells of a certain intricate pattern on a Washington basket that it represents

ripples, but on patient inquiry it was found to mean the subtle movements in the under waters of a certain lake upon a special occasion. To appreciate symbolism fully, one must know the sign, hear the story, and then study the skies, the landscape, and the social environment.

It is too early to attempt to discover an alphabet in this primitive art, for each tribe adapts old and new standard forms to its own concept myths. The artist alone, in every case, can interpret them. This existence of concrete stories in art form is not confined to basketry. Dr. Boas is authority for saying that the intricate totem post and composite painting of the North Pacific coast can be interpreted only by the carver. The attempt to find a clue to the mystery of their composition is hopeless, for none exists. As soon as the perfection of monotony or uniformity has been reached in the technic to form the basis of real art, there ensues a variety no less thorough and diversified in the ornamentation for symbolising the same idea. The rule in the Indian woman's mind seems to be reduced to a formula like this: "The minimum of variety in the technic; the maximum of variety in the symbolic." Or, in other phrase, variety of symbolic expression in the unity of the real art. One looks carefully at a set of drawings like those of Emmons, Farrand, Fewkes, or Dixon, and turns to a familiar collection to find the same symbols. They are not there; or, rather, they are hiding there. It is a question whether there be two baskets alike in design among any tribe. This is the real charm of savage handwork as compared with the rather dull uniformity of machine products. All the tribes of the West that have preserved their symbolisms have at the same time made the most of their liberty to modify the original.

The subject of symbolism may be studied from several points of view, the technic, the elaborative or historic, and the ethic. Beginning with the technic as the easiest, symbolism is wrought in checker, twill, wicker, twine, and coil.

Looking at a coarse piece of matting made up of monotonous squares, it is not easy to see how the story of creation or tribal preservation could be wrought into them. But with finer elements and the introduction of colour, a part of the difficulty vanishes. In point of fact, however, there is little evidence that sentiment was wrought into checker, or even into twilled weaving. There is no essential difficulty in the way. Mosaic in stone or other hard material is made up of little blocks, chiefly squares, and both the twined and the coiled basketry surfaces contain innumerable designs made up in small squares in black or other colour.

Symbolism may be studied in its elaboration or historic development. The history of a symbol on basketry is the same as that of a design on pottery or a painting on hide. Perhaps, since the technical demands are more exacting, the progressive appearance of the ideal is more rapid and the hiding of the original more complete. A moment's thought makes it clear that one is dealing simply with a universal law of mental development. The basketry of any one tribe will show what is meant. On a single Hopi plaque it is not rare to see side by side the complete figure of a bird or butterfly with outspread wings and near by an abbreviated cross which means the same thing. (See Plate 47.)

Another specimen constructed by the same hands will have the cross but not the birds. By and by enough examples are brought into comparison to show the process of fading out through which the realistic becomes only a skeleton. There is a celebrated Japanese painting showing seven stages in the life of a beautiful girl. As she passes into womanhood, through all its years, behind the real face the pretty child is seen, and even the skull that lies among the flowers shows to the beholder, after a moment's gaze, the lovely girlish face. In the last relic of symbol on basketry, to the trained eye of mythology the same transition takes place. The comparison of an ordinary lot of California basketry, their zigzag lines, arrow-

heads, mountains, and crossing paths, with such treasures as are in the Merriam collection, each gathered from the hand of the maker, together with the song of the soul whose melody is written there also, makes plain what is here set forth.

Professor Farrand calls attention wisely to the fact that in the reduction of symbols to their lowest terms very dissimilar forms have converged until the same figure does duty for many objects, the technical exigency or strain predominating. This has led to differences of opinion among native connoisseurs, and frequently confusion to the ethnologist. The same observation would be true in working the other way. It is only in most recent times that psychologists have appreciated the power of suggestion in helping one to determined action.

Recently a package of beautifully marked shells was sent to the National Museum as the probable origin of designs in savage art. Nothing could be farther from the truth Form does not come to the savage artist's mind in that way. Whether the symbol arise by contraction or expansion, the artist is the creator of new forms, working always within the school of her materials and tools.

Wicker basketry in its worst state is positively ugly. In the eastern part of North America no attempt is made to put a legend upon it, but in New Mexico and Arizona it is found in two forms side by side, one as plain as undressed stems can be made, and the other at the topmost point of pictorial representation. In Oraibi, the most western of the Hopi (Moki) towns, are made the pretty little wicker plaques called Katchinas. The finding of fragments of these in ancient ruins by Dr. Fewkes is good proof that they have long been made by the Hopi. Farther on, the designs themselves will be examined. They are mentioned here rather to show that where there is a will with the human species, of whatever colour, there is a way. Examples of Katchinas are shown in Plates

85 and 93. The Hopi wicker plaques are made up of short stems of *Chrysothamnus* that have been previously smoothed and dyed in as many colours as are needed. The work resembles closely that in porcupine quills. Figures do not show effectively on the back, for the reason that a single stem often passes over only one warp element. Symbols of complex pattern are also frequently finished out with the brush. In many of the intricate symbols on the Katchinas the narrow limitations of the material and the curve of texture that can go in one direction only put the artist to her wits' end for conventionalisms. She does not mind, but goes ahead. True, a rainbow must be upside down; the sky goddess must have rectangular eyes and mouth. There is no perspective, the round must be flat, and even those features that are out of sight must be brought to view. Never mind; the ideal wins and the plaque is finished.

With twined work the case is different. All its varieties are capable in themselves of expressing ideas even in one colour, but as soon as overlaying, embroidery, and the use of different hues are added there is practically no end to the possibilities. In this connection the reader may be reminded again that designs must not be confounded with symbols. The former are apparent and constant and extremely limited; the latter ideal and as varied as an Indian woman's fancy. But in the chapter on ornamentation it was seen how varied in different hands and materials twined patterns might be made. Twined ware is, if anything, at the start the coarsest of all, for what could be ruder than the wattling of a fish weir or the wall of a granary? Taking the geographic areas in turn, it is not until southeastern Alaska is reached that an attempt to tell a story in twined decoration occurs. Even there, the symbol exists more in the false embroidery on the surface than in the twined work. In point of fact, however, whether studied with Emmons for southeastern Alaska, with Farrand on Salish ware, or with Dixon in northern California

tribes, it is not in twined work that the most exalted and idealised symbolism has been wrought.

Coiled ware also has such a variety of technical treatment, with the whole colour scheme of nature to select from, that in practice there is no limit to the form and combination of designs or of symbolism. In these the weaver secretes her thoughts. You must ask her what they mean. Rarely is one of her symbols widespread. In the next tribe the sign will stand for quite something else. It is well to observe here that a vast deal of coiled basketry has no symbol or design on it whatever.

Ethnic symbolism.—Recurring to the six ethnic areas which, for convenience, have been adopted in this publication, basketry has lost all trace of symbolism among the Indians of eastern North America. It cannot be for a moment supposed that they have none, for with Algonquian, Siouan, Kiowan, the substitutes for basketry, rawhide receptacles, as well as moccasins, cradles, and objects in three dimensions, are covered with idealism in painting and embroidery.

To understand the richness of this survival of aboriginal symbolism, the student will receive his principal aid at hand in the researches of A. L. Kroeber among the Arapaho.* Four hundred and fifty-eight distinct symbols are given in figures covering Indian ideas from common objects to spiritual beings. All the closing pages of the above-named paper (pp. 138–150) must be examined carefully in order to comprehend both the sign and the thing signified, the thought and the overthought, the text and the symbolic context in Arapaho embroideries, paintings, and three-dimension designs. The closing paragraph will give the gist of Dr. Kroeber's study:

* Symbolism of the Arapaho Indians, Bulletin of the American Museum of Natural History, XIII, 1900, pp. 69–86; Decorative Symbolism of the Arapaho, American Anthropologist N. S., III, 1901, pp. 308–336; The Arapaho, Bulletin of the American Museum of Natural History, XVIII, 1902, pp. 1–150.

The closeness of connection between this Arapaho decorative symbolism and the religious life of the Indians can not well be overestimated by a white man. Apart from the existence of a great amount of decorative symbolism on ceremonial objects not described in this chapter, it should be borne in mind that the making of what have been called tribal ornaments is regularly accompanied by religious ceremonies; that some styles of patterns found on tent ornaments and parfleches are very old and sacred, because originating from mythic beings; that a considerable number of objects are decorated according to dreams and visions; and, finally, that all symbolism, even when decorative and unconnected with any ceremony, tends to be to the Indian a matter of a serious and religious nature.

Mrs. Sidney Bradford, of Avery Island, Louisiana, discovers the following symbols on the twilled basketry of the Chetimachas, an almost extinct tribe in her State. (See Plate 133.)

1. Nesh-tu-wa-ki: Alligator intestine, a sinuous line.
2. Cous-pi-se-on: Muscadine rind. A row of squaws.
3. Chish-nish: Worm track, fretted sinuous line.
4. Can-ops-to-man: Things over again, fretted line.
5. Marx-narx: Perch fish. A row of open diamonds.
6. Cars-ox-oxun: Something around, little squares in other squares.
7. Wash-ti-ka-ni: Beef eye. A row of wheels.
8. Arx-tan-tini: A big mark. A row of black dentales marks.
9. Ops-tong-kani: Crosses. Rows of little X marks between.
10. Another worm track: Row of ellipses or rhombs.
11. Kark-mark-ta: Bottom of basket, four triangles forming square.
12. Kop-kop-ni: To catch something. A row of diamonds.
13. Another worm track: Chevroned bans.
14. Acon-wa-ash: Beam earring. Row of arrowhead forms.
15. Nak-ka-ki-li: Turtle neck. Row of loops or festoons.
16. Chek-ka-ni: Black hind-eye. Drum-shaped pattern.
17. Tchu-tchu: Big crop basket. Surface covered with checker pattern.

The Eskimo, also, and the Aleuts perpetuate no thought or myth in basketry symbols. The etchings of the former on

ivory are also modern, and were learned from outside teachers. It is not in these that the idea is to be sought. Not for a moment is it to be thought, however, that there is no symbolism existing. All the life is wrapped up in hunting. The long, dark winter, the return of the sun with the innumerable retinue of life in the air and in the waters, gives the key-note. It is in the drama of hunting and the masks worn in dances that symbolism is embodied.

On the Pacific coast from Alaska to the peninsula of California and in the Interior Basin the tribes have been left to their own devices through the centuries, and it is here that survivals of symbolism are to be sought. They will be found in one place full of life and ancient spirituality; in another, stung by civilisation, they are as torpid as the spiders that are placed in their nests by the mud wasps.

The name Tlinkit applies to a number of basket-making tribes in southeastern Alaska. In their charming archipelago they have developed a unique scheme of symbolism growing out of their mode of life. This has been thoroughly studied by Lieutenant G. T. Emmons, United States Navy, in his collections in the American Museum of Natural History, New York, and the identifications here made are on his authority.* They cover a wide range of meanings. Supplementary to this basket symbolism—or, rather, preëminent over it—are the Chilkat blankets and the endless variety of carvings in stone, horn, and wood, and the symbolic paintings on all sorts of surfaces. The following identifications are from specimens in the United States National Museum:

Ars suckhar ha yar ku: Spirit voice, or shadow of a tree.
Kah thluckt yar: Water drops.
Kisht: The crossing.
Klake da kheet see tee: Single tying around.
Klaok shar yar kee kee: Head of the salmon berry cut in half.

* Basketry of the Tlingit Indians, Memoirs of the American Museum of Natural History, III, 1903, pp. 229–277.

Ku Klate ar ku wu: The Arctic tern's tail.
Kuk thla ku: Flaking of the flesh of fish.
Shon tche kulth kah katch ul tee: Tattooing on the back of the hand of an old person.
Shuh tuck ou hu: Shark's tooth.
Shar dar yar ar kee: Work on Shaman's hat.
Thlul k yar nee: The leaves of the fireweed.
Ut tu wark ee: An eye.
Ut kheet see tee: Tying around.
Yehlh ku wu: Raven's tail.

Plate 71 shows specimens of twined wallets made of spruce roots, for carrying berries and other articles of food on the back. The left-hand figure in this plate is Catalogue No. 20,704 in the National Museum, and was collected by James G. Swan, at Sitka, Alaska. It is an excellent specimen of twined weaving, with what is here called false embroidery. The figures on the surface, determined by Lieutenant Emmons, are as follows: The two wide bands contain the following ornaments: The large five-sided figures in the middle are the "Shark's tooth"; the chevron pattern covering the shark's tooth means the "Flaking of flesh of fish into narrow strips"; the small triangular figures are the "Salmon berry cut in halves," but in this arrangement also called "Water drops"; the narrow middle band is rendered "Single tying around"; below the ornamental bands the cross-shaped figure represents the "Raven's tail."

The right hand figure in this plate is also a berry basket. The two wider bands have the same design, having a bar in the middle with its ends bifurcated, known by the Tlinkit as "The crossing." The triangles in these bands stand for "The salmon berry cut in halves." The middle band is "Tying around." The vertical designs at the bottom represent "An eye" on one side, and on the other side "Shark's tooth." The five-sided figure with a reëntrant angle stands for "The Arctic tern's tail." Cat. No. 21,560, U.S.N.M., collected by J. B. White.

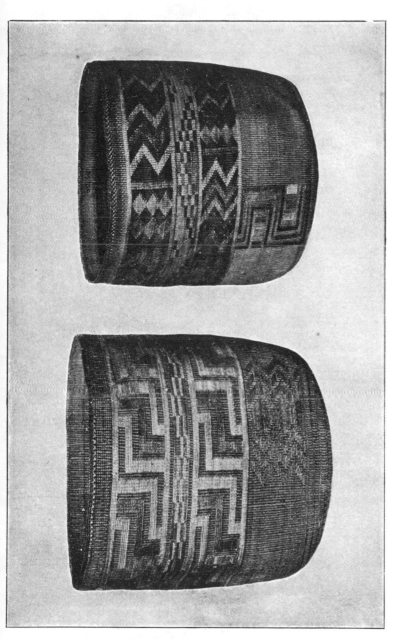

Plate 72.　See page 191　Twined Wallets of Tlinkit Indians, Southeastern Alaska, with Symbolism in False Embroidery

Collections of U. S. National Museum

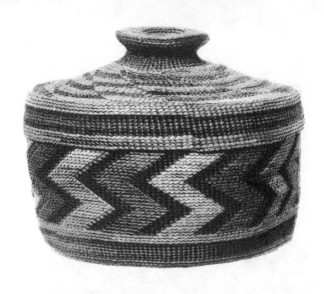

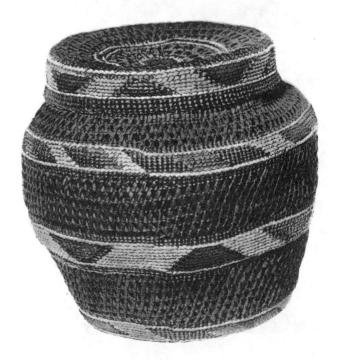

Plate 73. See page 191

Tlinkit Covered Twined Baskets

Showing ancient and modern form, texture, and ornamentation. The latter under recent
influences
Collected by F. M. Ring and G. T. Emmons

The right-hand figure in Plate 72, Cat. No. 20,704A, in the National Museum, collected by J. G. Swan, is a cylindrical basket in twined weaving. The upper part of the body of this basket is divided into three bands worked in straw, natural colour, and dyed red and brown. The symbols in the upper and lower band are (1) the "Spirit voice, or the shadow of a tree," in zigzag lines; (2) vertical rows of rhombs, which indicate the eye; the middle band, made up of sinuous lines on rectangular figures is called "Tying around." The allusion may be either to the fact that this figure constitutes an encircling band, or to the sinuous pattern itself. On the lower part of the body the fretted pattern, with three rectangles inclosed in the bents like the bars on an epaulette, stands for "The tattooing on the back of the hand of an old person."

Plate 37 represents two small, beautiful baskets with rattles in the tops made by the Tlinkit Indians of southeastern Alaska. Both of them are covered over the entire surface with false embroidery in three colours. The small patterns on the baskets portray the salmon berry and the triangular figures stand for shark's teeth. These are fine old specimens collected in 1875 by Dr. J. B. White, United States Army. Cat. No. 21,562.

Plate 73. The bottom figure is a covered basket of the Tlinkit Indians, Cat. No. 168,282, collected by Lieutenant Emmons. The warp is crossed, and the weaving is in twined work ornamented with false embroidery. The upper band and the one across the middle of the body represent "The salmon berry cut in half," while the band on the shoulder and the one at the bottom stand for "The leaves of the fireweed."

The upper covered jar on the same plate illustrates the combination of false embroidery and the use of two colours in the material out of which the specimen is woven. This specimen is Cat. No. 9,112, U.S.N.M., and was collected in Alaska by Lieutenant F. M. Ring, United States Army.

The Haida Indians on Queen Charlotte Islands are near

to the Tlinkit in arts, but weave no symbols into their basketry. They paint various designs on their ceremonial hats, and have no end of richest symbolism on their canoes and carved in wood and slate. They also now engrave on silver and keep alive the poetry of their ancient art.

The following story, collected for Lieutenant Emmons by a friend, proves that the basket is not altogether out of touch with their world of myth:

Once upon a time there were two Haida Indian orphan girls living on Queen Charlotte Islands, British Columbia. After being punished by their stepmother for eating up a store of deer tallow, they resolved to run away. They wandered about in the forest a long time, and were eventually rescued by the "seek quan ni" (Black Bear tribe), one of whom married the girls. Years afterward, these girls determined to visit the scenes of their sad childhood. For their journey back from the forest to places of human habitations their good totem spirit directed them to weave two baskets apiece large enough to fit over the end of the thumb. These they were directed to fill with crumbs of various kinds of cured meats and deer tallow. As in the miracle of the five loaves and two fishes which sufficed for a multitude, the contents of these tiny baskets furnished food for the two women on their journey of many moons. Arrived at the entrance of their father's house, their baskets suddenly became very large—so large, in fact, that it required the strength of many slaves to take them into the house. The women found their stepmother still alive. They offered her the various meats and tallow which they had brought from their forest home. More and yet more food they pressed upon her, until the unhappy woman died of overeating.

Professor Farrand selected, happily, the most versatile of all the North American families of Indians for his studies, the Salishan. Among these, the Lillooet and Thompson baskets, of British Columbia, supply the flat and round types of im-

bricated coiled work, and the Quinaielt, on Puget Sound, the overlaid twined weaving. The Klikitat ware is not included, but a comparison of its symbols with the Salish would be profitable. The line of development in symbolism among the Salish tribes has been from the pictorial to the geometric. Professor Farrand finds that the use of animal designs is by no means predominant. This was seen to be true on the Tlinkits also, while the Chilkat blanket shows the dissected and distorted motives described by Boas.*

The list of symbols on the baskets of the lower Thompson Indians is given by Mr. James Teit. It is made up of:

1. Arrowhead pattern (tataza, arrowhead).
2. Root pattern (múla, a variety of root).
3. Butterfly pattern (nkíkaẋeni, butterfly).
4. Star pattern (nkokucên, star).
5. Packing-strap pattern (tsupîn, packing-strap).
6. Zigzag pattern (skolotz, crooked).
7. Box pattern (luka, grave box).
8. Eagle pattern (haláu, eagle).

Each of these words is compounded with the suffix "aist," pattern; but the lower Thompson also have symbols for snake or snakeskin, snake or snake tracks, rattlesnake tail, grouse or bird tracks, bear foot or bear tracks, bird or geese flying, fly, beaver, deer, horse, man, hand, tooth, leaf, shells (dentalia), stone hammer, comb, necklace, net, root-digger handle, leggings, canoe, trail, stream, lake, mount, air, lightning, and the same is true of other Salishan tribes.

Plates 74 to 79 reproduce Professor Farrand's figures, and the descriptions are from his monograph.† These illustrations, being most of them in a difficult technical process, called imbrication, furnish excellent studies in mosaic pictographs.

* The Decorative Art of the Indians of the North Pacific Coast, Bulletin of the American Museum of Natural History, IX, 1897, pp. 123–176.

† Basketry Designs of the Salish Indians, Memoirs of the American Museum of Natural History, II, 1900, pp. 393–399.

The elements are all little squares in different colours, varying from one-eighth to one-quarter inch in dimensions. Much charity is needed in detecting the thing in the symbol. The shark's mouth, with its horrid teeth, is rather intensified by the angularity of the design, but most of the things represented are hidden in the symbol.

Plate 74, fig. 1, shows a coiled and imbricated berry basket of the Lillooet Indians, British Columbia. It has a pyramidal form, flat foundation in the coils, and the decoration is in two segments or bands. The designs are flies, arrow-heads, and half circles (?). The lower stripes are clusters of flies. Height, $10\frac{1}{2}$ inches; 1 inch $= 7\frac{1}{2}$ stitches, $4\frac{1}{2}$ coils. Compare Cat. No. 213,535, U.S.N.M.

Plate 74, fig. 2, shows a twined and overlaid basket of the Quinaielt Indians, Washington. Its design represents flounders. Height, $5\frac{1}{2}$ inches; 1 inch $= 8$ twists, 12 rows of weaving.

Plate 74, fig. 3, shows a coiled and imbricated basket of the Lillooet Indians, British Columbia, with structural elements the same as in fig. 1. Its design is a head, with mouth, teeth, and hair along the back of the head. The stripes below are arrow-heads. Height, 11 inches; 1 inch $= 7\frac{1}{2}$ stitches, 4 coils.

Plate 74, fig. 4, represents the end of Plate 75, fig. 6, Lillooet. The design is said to typify flies. Compare example 216,422, U.S.N.M.

Plate 74, fig. 5, shows a coiled and imbricated basket of the Lillooet Indians, British Columbia. The two segments are preserved in the design as in figs. 1 and 3. The structural features are also the same. The design is a head, with open mouth; below are arrow-heads. Compare fig. 3.

Plate 74, fig. 6, represents a coiled and imbricated basket of the Lower Thompson Indians, British Columbia. Special attention is called to the ridged surface caused by a bundle of splints. On this plate are shown the two radically different methods of laying the foundation for the coil. The two

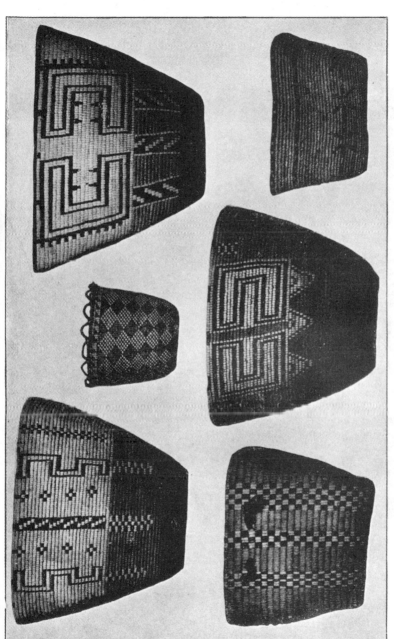

Plate 74. See page 194 Symbolism on Salish Basketry, British Columbia, After Livingston
Farrand

Collections of Am. Mus. of Nat. His., N. Y.

1 2 3
4 5 6

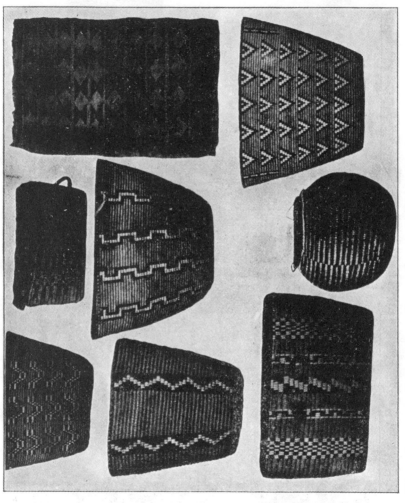

Plate 75. See page 195 Symbolism on Salish Basketry, British Columbia,
After Livingston Farrand

Collections of Am. Mus. of Nat. History, N. Y.

1 2 3
4 5
6 7 8

narrow black and white stripes on the upper portion are made
by beading, and represent earth lines. The lower figures are
grouse tracks. Height, 6 inches; 1 inch=6½ stitches, 5 coils.

Plate 75, fig. 1, represents a coiled and imbricated cooking-
basket of the Lower Thompson Indians, British Columbia,
with a design of flying geese. The foundation of the coil is of
splints; the distinctive characteristic is that the ornamentation
covers the whole surface and is not divided into bands. Height,
9 inches; 1 inch=6½ stitches, 4½ coils.

Plate 75, fig. 2, shows a coiled and imbricated covered
basket or trunk of the Lower Thompson Indians, British
Columbia, while the design is of a rattlesnake's rattle. Height,
5 inches; 1 inch=6 stitches, 3½ coils.

Plate 75, fig. 3, represents a wrapped-twined bag of the
Yakima (Shahaptian family) Indians, Washington. The
National Museum has many bags from Shahaptian tribes
showing Farrand's symbols. The design is of flying birds.
Height, 22 inches; 1 inch=7 stitches, 9 rows.

Plate 75, fig. 4, shows a coiled and imbricated basket of
the Lower Thompson Indians, British Columbia. Its design
is a snake trail or track Height, 9½ inches; 1 inch—6½
stitches, 3½ coils.

Plate 75, fig. 5, shows a coiled and imbricated basket of
the Lower Thompson Indians, British Columbia. The design
indicates a snake trail. In technical elements this example is
Thompson, but the crenelated form of design is widespread
and has many interpretations. Compare Plate 74, fig. 1;
also Merriam's butterfly design, page 332. Height, 13 inches;
1 inch=6½ stitches, 3½ coils.

Plate 75, fig. 6, represents a coiled and imbricated basket
of the Lillooet Indians, British Columbia. The shape and
flat foundation are Lillooet, but the solid design over the
whole surface is not so. The design shows flies, snake tracks,
and arrow-heads (side view). Height, 10¼ inches; 1 inch=5½
stitches, 2 coils.

Plate 75, fig. 7, is a coiled and imbricated globular basket of the Lower Thompson Indians, British Columbia. The design represents a snake coiled around the basket, and exists on baskets in other Salishan tribes. The vertical line interrupting the coils shows the limitation of this style of weaving, made up of a continuous spiral, and not of a series of rings. Height, 7½ inches; 1 inch = 8 stitches, 4½ coils.

Plate 75, fig. 8, is a coiled and imbricated basket of the Lower Thompson Indians, British Columbia. This beautiful example is true to type in all except the angular design. The designs represent butterflies' wings. Height, 14 inches; 1 inch = 6 stitches, 3½ coils.

Plate 76, fig. 1, is a coiled and imbricated basket of the Lillooet Indians, British Columbia, the upper design representing intestines; the vertical stripes in the lower segment are flies. Height, 11 inches; 1 inch = 7 stitches, 4 coils.

Plate 76, fig. 2, is a coiled and imbricated basket of the Lillooet Indians, British Columbia, with a design representing a net; the interspaces show deer shot by arrow, deer, man, dogs, flies. The flat coil in the bottom, the absence of angles, the design over the surface are noteworthy in the basketry of the Lillooet Indians. Height, 13½ inches; 1 inch = 6 stitches, 3½ coils.

Plate 76, fig. 3, is a coiled and imbricated basket of the Lillooet Indians, British Columbia, with a design representing a man with feather in his hair, bow and two arrows, and at either end a notched ladder (?). The lower segment is beaded. Height, 8¾ inches; 1 inch = 8 stitches, 5½ coils.

Plate 76, fig. 4, shows a typical coiled and imbricated basket of the Lower Thompson Indians, British Columbia. The design is a plant with fern-like leaf, end view. Height, 8½ inches; 1 inch = 7½ stitches, 3½ coils.

Plate 76, fig. 5, shows a coiled and imbricated basket of the Lillooet Indians, British Columbia, having a design representing arrow-heads and flies. In technic this example

Plate 76. See page 196 Symbolism on Salish Basketry, British Columbia, After Livingston
Farrand

Collections of Am. Mus. of Nat. History, N. Y.

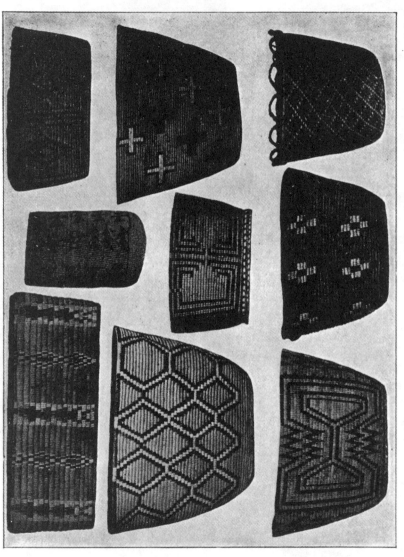

Plate 77. See page 197

SYMBOLISM ON SALISH BASKETRY, BRITISH COLUMBIA, AFTER
LIVINGSTON FARRAND

Collections of Am. Mus. of Nat. History, N. Y.

1	2	3
4	5	6
7	8	9

represents the older forms. Height, 11 inches; 1 inch=7 stitches, 4 coils.

Plate 77, fig. 1, shows a coiled and imbricated basket trunk of the Lillooet Indians, British Columbia. The structure and form are decidedly Hudson's Bay Company in motive. The design represents arrow-heads of different shapes. Height, 9 inches; 1 inch=5½ stitches, 3½ coils.

Plate 77, fig. 2, shows a bag in twined weaving, with wrapped ornament, of the Wasco Indians (Chinookan family), Washington, with designs representing flying birds, men, and sturgeon. Height, 8½ inches; 1 inch=8 twists, 12 rows.

Plate 77, fig. 3, is a coiled and imbricated basket trunk of the Lower Thompson Indians, British Columbia; design, arrow-heads. This specimen shows the intrusion of Hudson's Bay Company forms into the upper country. Height, 6½ inches; 1 inch=7 stitches, 4 coils.

Plate 77, fig. 4, represents a coiled and imbricated basket of the Lower Thompson Indians, British Columbia, with a design showing a packing-strap or tump line, possibly a net. This is a good type in technic, form, and decorations. (See also figs. 6, 7, and 8.) Height, 11½ inches; 1 inch=6½ stitches, 4 coils.

Plate 77, fig. 5, is a coiled and imbricated packing-basket of the Lower Thompson Indians, British Columbia, with a design representing grave or burial boxes. This is an interesting hybrid, with Thompson stitch and decoration on a Coast box, having even the added foot. Height, 6¾ inches; 1 inch= 7 stitches, 4½ coils.

Plate 77, fig. 6, is a coiled and imbricated basket of the Lower Thompson Indians, British Columbia. The design indicates crossing trails, possibly stars. Height, 14 inches; 1 inch=6½ stitches, 4 coils.

Plate 77, fig. 7, is a coiled and imbricated basket of the Lower Thompson Indians, British Columbia. Legend, stone hammer, side view. Compare example 217,438, U.S.N.M.

Plate 77, fig. 8, is a coiled and imbricated basket of the Lower Thompson Indians, British Columbia. Height, 9 inches; 1 inch $=7\frac{1}{2}$ stitches, $3\frac{1}{2}$ coils.

Plate 77, fig. 9, shows a twined and overlaid basket of the Quinaielt Indians, Washington, with a design representing a fish net. Height, $7\frac{1}{2}$ inches; 1 inch $=5$ twists, 8 rows of weaving.

Plate 78, fig. 1, shows a twined and wrapped wallet of the Upper Thompson Indians, British Columbia, with a design representing lakes, lakes connected by streams, ducks flying toward the lakes, and animal footprints. Figs. 1–4 are akin to the Shahaptian work in Washington, with the exception that the decorative filaments are wrapped about both elements of the twine. Height, 21 inches; 1 inch $=9$ twists, 13 rows of weaving.

Plate 78, fig. 2, is a reverse of the preceding, having a design of arrow-heads and crossing trails.

Plate 78, fig. 3, is a twined and wrapped wallet of the Upper Thompson Indians, with a design showing three rows of lodges. Height, 23 inches; 1 inch $=5\frac{1}{2}$ twists, 8 rows of weaving.

Plate 78, fig. 4, is the reverse of No. 3, and has a design showing household utensils.

Plate 78, fig. 5, is a twined and overlaid wallet of the Quinaielt Indians, Washington, having a design representing a mountain chain. Height, 8 inches; 1 inch $=6$ twists, 8 rows of weaving.

Plate 78, fig. 6, shows a twined and overlaid basket of the Quinaielt Indians, Washington. Its design is called a mountain chain. Height, 10 inches; 1 inch $=5$ twists, $7\frac{1}{2}$ rows of weaving.

Plate 79, fig. 1, is a coiled and imbricated basket of the Lower Thompson Indians, British Columbia. The design is said to represent mountains, with lakes in the valleys. Height, $14\frac{1}{2}$ inches; 1 inch $=6\frac{1}{2}$ stitches, $3\frac{1}{2}$ coils.

Plate 79, fig. 2, is a twined and overlaid basket of the

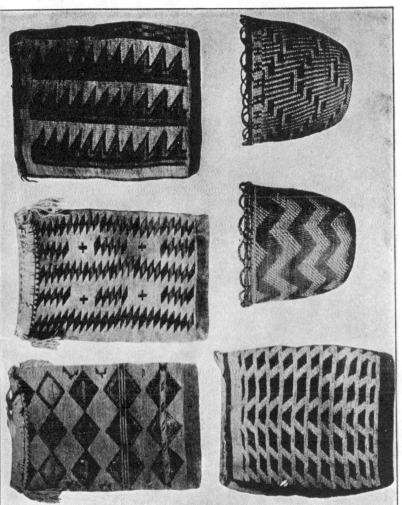

1 2 3
4 5 6

Plate 78. See page 198 SYMBOLISM ON SALISH BASKETRY, BRITISH COLUMBIA, AFTER
LIVINGSTON FARRAND

Collections of Am. Mus. of Nat. History, N. Y.

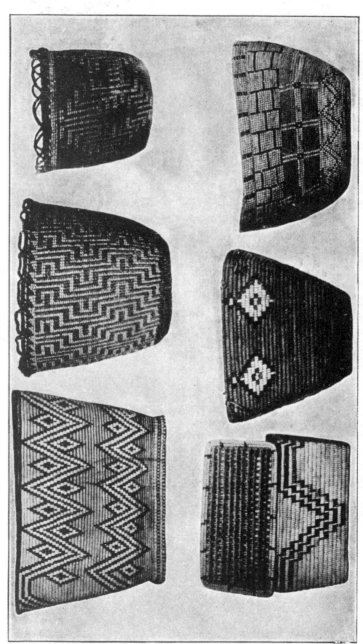

1 2 3
4 5 6

Plate 79. See page 198 Symbolism on Salish Basketry, British Columbia, After Livingston Farrand

Collections of Am. Mus. of Nat. History, N. Y.

Quinaielt Indians, Washington, with a design representing waves or ripples on the water. Height, 10 inches; 1 inch = 5½ twists, 9 rows.

Plate 79, fig. 3, shows a twined and overlaid basket of the Quinaielt Indians, Washington, with an unknown design. It is widespread, however, and resembles a cluster of marsh plants. Resembles motives in northern California. Height, 6¼ inches; 1 inch = 7 twists, 10 rows.

Plate 79, Fig. 4, is a coiled and imbricated basket of the Lillooet Indians, Washington, with a design representing lightning. Compare Plate 75, figs. 1 and 2, where it stands for flying geese. Height, 5 inches; 1 inch = 8 stitches, 3½ coils.

Plate 79, fig. 5, is a coiled and imbricated ware of the Lillooet Indians, British Columbia. The design is said to be of meaning unknown revealed in a dream. Height, 10 inches; 1 inch = 5 stitches, 3½ coils.

Plate 79, fig. 6, is a coiled and imbricated basket of the Chilcotin Indians, British Columbia, with an unexplained design. This rare piece is noteworthy for having three or four bands of segments of independent designs. It shows in its technic little influence of foreign culture. Height, 8½ inches; 1 inch = 6½ stitches, 7 coils.

For the northern California and southern Oregon tribes the guide to the study of symbolism is Roland B. Dixon,* who divides basketry into three types (see fig. 163):

I. *Northwestern type* includes the area occupied by the Hupa (Athapascan), Karok (Quoratean), Yurok (Weitspekan). The technic is twined work overlaid.

II. *Northeastern type* comprises Modoc and Klamath (Lutuamian), Shasta (Sastean), Pit River (Palaihnihan), Yana (Yanan), Wintun (Copehan), and Maidu (Pujunan). The technic is twined and coiled.

* Basketry Designs of the Indians of Northern California, Bulletin of the American Museum of Natural History, XVII, 1902, pp. 1-32.

III. *Pomo type.*—This versatile people of the Kulanapan family in its technic is cosmopolitan, using both twined and coiled ware in every variety. The Yukian and the Costanoan tribes are left unclassed.

Three groups of symbols are distinguished by Dixon— animal designs, plant designs, and representations of natural or artificial objects. For the Pomo symbols he relies upon Carl Purdy, collector of material from that people in the American Museum, New York. For the northeastern group, Doctor Dixon has made exhaustive personal observations and illustrated the symbols in Plates i-xvi of his monograph.

The following story applies to a beautiful piece of basket-work from the Yuki Indians, now in Round Valley Agency, Covelo, California. They are associated with the Wailakis, who are Copehan, but the Yuki themselves form a separate family. Cat. No. 131,108, in the U.S.N.M., Plate 80, is called a sun basket, of Yuki manufacture, collected by N. J. Purçell, and in order to complete its history it is necessary to know what the Yukis believe to be the origin of the world. "In the beginning there was no land; all was water. Darkness prevailed everywhere. Over this chaos of dark waters hovered 'On-coye-to,' who appeared in the form of a beautiful white feather, hence the love of the Yukis for feathers. In time the spirit became weary of his incessant flight through the murky space and lighted down upon the face of the water. Where he came in contact with the water there was a whirl-pool that spun his body round and round. So rapid became the motion that a heavy foam gathered about him. This became more dense and expanded in width and length. It gathered up the passing bubbles until it was a huge floating island. On the bosom of this rested the snowy form of On-coye-to. As he lay upon this island after an almost endless flight through the dark space, the idea of a permanent resting-place came into his mind. So he made the land and divided it from the water. From the form of a feather he

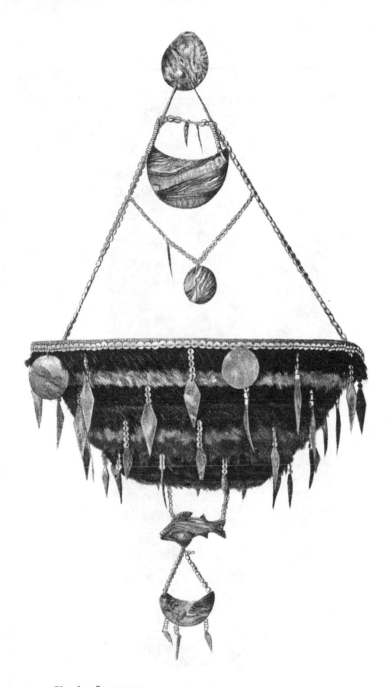

Plate 80. See page 200

YUKI FEATHERED AND JEWELLED BASKET

In which Oncoyeto stole the sun and brought it to his people

Collected by N. J. Purcell

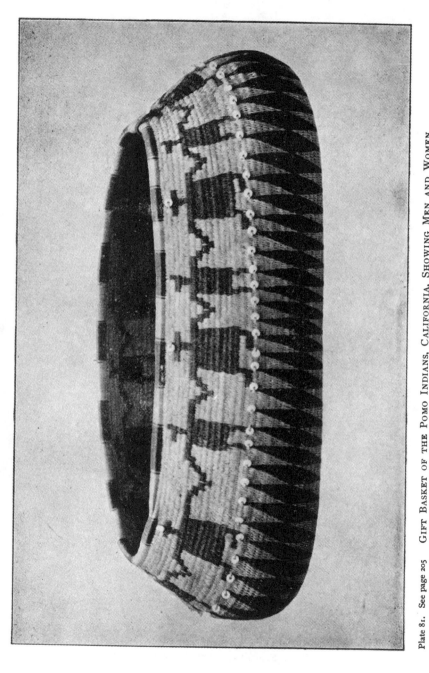

Plate 81. See page 205 GIFT BASKET OF THE POMO INDIANS, CALIFORNIA, SHOWING MEN AND WOMEN
CELEBRATING THE FOOD-FALLING OR ACORN HARVEST

Collections of U. S. National Museum

assumed that of a man and rested upon the land. Still there was no light, and the spirit was troubled. On-coye-to saw far off in the firmament a star, po-ko-lil-ey, and resolved to visit it and learn how it emitted its sparkling light. After a long journey he arrived and found a large and beautifully lighted world, inhabited by a numerous, hospitable people. Still, he saw not whence came the light. He was allowed free access to all the habitations save one, 'the sweat house.' This was guarded night and day, and was accessible only to sick persons. Finally a great hunt was planned, and as the time drew near all was prepared for the occasion. But On-coye-to feigned sickness, that he might investigate the sweat house. When the morning arrived for the hunt he was too ill to accompany the hunters. A council was held to determine whether this stranger should be admitted to the sweat house, which is even now a sacred place with the Yuki tribe, and it was decided to give him the benefit of this house of medicine, religion, gambling, and many other practices. A few old men were left to administer to his wants and to see that all went well. As he entered the sweat house he was almost blinded by the light that flashed upon him. As he became accustomed to it, he looked around him and discovered its origin. Hanging high over his head, in several baskets, were as many beautiful suns. Having found the fountain of light, he waited patiently until the old men were all asleep, then climbed cautiously to what seemed the brightest of the suns, took down the basket which held it, slipped from the sweat house, and made his way rapidly back toward his own world. He was hotly pursued by the indignant warriors, but he arrived safely after many adventures. He hung the sun in its basket far in the east, then surveyed it. It did not light up to suit him, and he moved it a little higher. Still it did not suit him, so he continued to move it on and on, and is moving it to the present day." Thus the Indian accounts for the moving of the sun, and thinks not that the earth moves.

The basket here shown is believed to be a copy of the same in which the sun was stolen from the other world and brought to this. On the bottom is a piece of polished abalone shell, cut round to represent the sun. Below this is suspended a new moon, then a fish, and all around the sides hang pieces of the same shell, which the Yuki say represent the stars. (N. J. Purcell.)

As before mentioned, Doctor Dixon relies on Mr. Purdy for the symbolism on the Pomo basketry. The collection was made in 1900, and the names of designs given. Since that time more information has come to Mr. Purdy, and some of the terms are changed. The United States National Museum has the collection of Doctor J. W. Hudson for comparison, made some years earlier. The interpretations of the symbols by the two men are quite as interesting a study in the psychology of the collectors as of the Indian basket women. From Doctor Hudson's manuscript, accompanying his collection, the following notes on symbolism are taken. The underlying thought in his mind is that each separate social group of the Pomo has peculiar types of basketry known by the key-note in the ornamentation, which is the totem of that group.

Both in painting and in feather decoration, the following colours have a significance with the Pomo:

Red: bravery; pride. (Personified by the woodpecker.)
Yellow: amatory; success; gaiety; fidelity. (Lark.)
Blue: demoniac cunning; perfidy. (Jay.)
Green: astuteness; discretion; watchfulness. (Duck.)
Black: conjugal love; beauty. (Quail.)
White: riches; generosity. (Wampum.)

The following interpretations of signs were given by Dr. Hudson in connection with his collection of basketry secured by the United States National Museum:

Baiyakan (Baiyak, net mesh). Same as Mr. Purdy's. The design is an alternation of dark and light squares between two boundary lines.

Bishekamak, deer's hoofs or trail made by those animals in the mud. Very rare pattern, once common to the Taco (Yukian) of Potter Valley. Consists of two right-angled triangles joining so as to represent the track of a deer's hoof.

Bishemao, deer's loins, the mottles on the buck's rump when struggling out of the slime of Clear Lake at the creation. Parallel lines with the inclosed space filled with dark and light parallelograms.

Bisheo, deer's teeth, seen by the primal Indians when that animal called to them for help as he struggled in the mud. A row of little squares with open spaces between.

Danokakea, Mountain Waters tribe, totem of a tribe once living six miles north of Upper Lake, in the mountains at the headwaters of McClure Creek, and a close affinity and neighbour of the Pomo of Potter Valley. A band of equilateral triangles in two colours alternating.

Ka wi na ote, or *Ka wi na mi yak*, turtle neck. A charm of halved turtle backs strung one above the other, indicated by three equilateral triangles, one resting on another.

Katsha, arrowheads often represented on the basket as strung together and worn as necklaces.

Katshak, arrowhead. A row of equilateral triangles bounded by two lines and touching by their bases, or having the apex of each one touching the middle of the base of the other.

Kawinateedi, turtle backs which were seen floating on the waves of Clear Lake. A series of rhombs adjoining one another.

Kea, quail plume. Totem of the confederated tribes of Lake County, California, especially those living in the valleys around Clear Lake. This excludes the Napo, Kabe napo, rock village; and Kura napo, water-lily village, who had no recognised totems. The Yokaia also claimed the Kea totem, being close kin to Lake tribes, though living across the range. L-shape and Z-shape designs in colour. Most common of Pomo symbols.

Misakalak, blacksnake, a totem recognised as belonging to the Shokowa of Shokowa Valley, around Hopland. Represents a snake trail. Two parallel lines near together with a sinuous pattern between.

Na wa kai, a totem consisting of a series of ponds connected by a slough. Though this tribe is totally extinct, yet the pattern is often seen in the Yokaia village, and called Beketch, or man's spit. This is a row of squares made up of dots.

Poma, red earth. Named from the mound of siliceous earth in Potter Valley, whence all Pomos sprang, and from which, to this day, their ceremonial yeast or sacrament is dug to be mixed with their bread and eaten. The totem of a Potter Valley tribe. Pomo —red (stone) mine or quarry, where argillite or magnetite is mined for wampum. A row of triangles in red splints.

Shakobiya, grasshopper elbows, or the spines on the tarsi. Trail noted in mud. It consists of a line of right-angled triangles joined at their bases.

Shakokamak, grasshopper tracks made in the mud at creation. Parallel rows of dots in fours.

Tsi yo tsi yo, up and down, the word *Ka* being understood. "Waves" rolling back from the shores of Clear Lake, releasing the new-born creatures. Three zigzag lines parallel and oblique. Certain Lake County Pomo tribes use the term tsi yo tsi yo, signifying waves, or the marriage of the east wind to the waters of Clear Lake, representing it by a series of dotted parallelograms in stepped pattern.

Carl Purdy's vocabulary of Pomo symbols on basketry is as follows:

Baiyakan (Baiyak, net), band of rectangles, called meshes; also, snake.

Bishe mao, or *mia*, backbone or ribs of a deer. Rectangles or rhombs in échelon.

Butterfly pattern, Long Valley Indian (Copehan).

Chi kakh, quail.

Dalan, halved. (Yokaia, dilan.)

Dan, opening. (Compare the path in Navaho baskets.)

Itchi cu we; len we is naked, or bare and naked; itci tcu we, bare of design—*i. e.*, not ornamented.

Ka pok poko, short design, rhomb or rectangle in the middle.

Ka tio tio, waves (Ka, water, and tio tio, rippling); or Kahio or Kalio (?).

Kailakama, crow foot (kai, crow, and akama, foot).

Kalcha misit, arrow points. (Yokaia.)

Kalen le lan, white mark in the middle.

Katcha, arrowhead.

Katcha, arrow; Katcha da lan, arrow halved; Katchi mi set (or misit), arrow points.

Kawina ritcha, turtle neck.
Kèyá, quail tip.
Kèya, tip or top.
Lelan (lilan), in the middle.
Mato, large; Kalcha mato, arrowhead large.
Mi sit, point; or miset (?). Upper Lake Pomo.
M sa kalle, spiral, or snake; name of a certain spotted snake.
Pau shna, acorn top (Pau, corn, and shna, head).
Sakalle (Yokaia for snake).
Siot sio, zigzag, waves.
Tchikaka ke-ya, quail tip (Tchikaka, quail; ke-ya, top knot).
Una leu, crossing.
Utcha, neck.

Mr. Purdy's interpretations of Pomo symbols will be found in Dr. Dixon's paper before quoted. If the reader have a collection of Pomo baskets, an examination of the symbols on them in comparison with the Dixon plates will demonstrate what liberties the basket-weaver took with her designs. Maybe, it were better to say, what struggles she made to realise a design or symbol under general and special limitations.

POMO (KULANAPAN) DESIGNS, DIXON'S PLATES

Arrow point. (Plates 29, 30, 33, 36.)
Buckeye tree. (Plates 27, 34.)
Crossing tracks. (Plates 28, 29, 34, 36.)
Crow's track. (Plates 34, 35.)
Grasshopper leg. (Plate 27.)
Leaf. (Plate 27.)
Meshes in fish net. (Plates 30, 31, 33, 34, 35.)
Quail tip. (Plates 27, 28, 29, 36.)
Red mountains. (Plates 27, 30, 31, 33, 34, 35.)
Spotted fawn skin. (Plate 27.)
Unknown designs. (Plate 32.)
Zigzag. (Plates 28, 29, 30, 32, 33, 35, 36.)

To illustrate the technic of symbolism, Plate 81, Catalogue No. 203,398, collected by Dr. J. W. Hudson, is presented. It shows a gift basket of the Pomo Indians, made by a Yokaian

woman whose name is Keshbim, who worked upon it seven months. The pattern is a pictograph of a feast, the bottom of the basket being tule mats (bitsan) interspersed on the assembly hall floor, not shown in the figure. The band of rhomboid figures around the bottom is the roof of the dance lodge with its rafters crossed and interlaced, and the dancers, male and female, are celebrating the Ma a ca ka (food-falling) harvest (acorns). The Pomos have four seasons in their year, beginning on the first full moon (tha na bu sa da, thumb moon) in July, and Sa ha nim, smoke floating time, has four moons; Ma a ca ka has three moons, beginning with Ba too da, index moon. Kat sa na, green earth, has three moons, and Kat sa mi, green-things time, has three moons. This basket, under the old régime, would have been presented to some friend during the feast, demanding a very handsome return, for no one appreciated a fine piece of work like a Pomo woman. The foundation is of willow rods. The sewing is not done with linen thread, as one would suppose, but with roots split so fine that in some places the sewing shows sixty stitches to the inch.

Dr. Dixon has made careful personal investigations concerning the symbolism on the basketry of California tribes east of the Sacramento River.* The following designs with their tribal assignments may be found in Dr. Dixon's plates:

WINTUN (COPEHAN) DESIGNS

Arrow points. (Plate 23.)	Flying geese. (Plate 23.)
Bear's foot. (Plate 23.)	Leaves strung. (Plate 24.)
Bent elbow. (Plate 23.)	Pulled around. (Plate 24.)
Cross Waves. (Plate 24.)	Rattlesnake. (Plate 23.)
Deer excrement. (Plate 24.)	Striped. (Plate 24.)
Empty spool. (Plate 24.)	Water snake. (Plate 23.)
Fish tail. (Plate 23.)	Wolf's eye. (Plate 23.)

* Basketry Designs of the Indians of Northern California, Bulletin of the American Museum of Natural History, XVII, pp. 1–32, 37 plates.

Moquelumnan Designs

Eye. (Plate 26.) Quail tip. (Plate 26.)

Pit River (Palaihnihan) Designs

Arrow point. (Plate 22.) Skunk's nose. (Plate 22.)
Lizard. (Plate 23.)

Maidu (Pujunan) Designs

Deer excrement. (Plate 25.) Rattlesnake. (Plate 25.)
Earthworm. (Plate 25.) Water snake. (Plate 25.)

Nozi (Yanan) Designs

Wolf's eye. (Plate 25.) House. (Plate 25.)

Dr. Dixon's conclusions are of interest. Designs are subject to much variation, chiefly through different arrangements of elementary and constant forms in the pattern. If there are two or more types for the same element, they are never found together. Designs are essentially the same on coiled and twined basketry, but most of the Maidu baskets are coiled, and there is suggestion of acculturation from the Pit Rivers. Function and form of the basket have something to do with symbols, certain designs being restricted to plaques, others to soup bowls, and so on. The spiral line is a favourite in massing symbols. Some of the patterns are found everywhere in the Maidu area, others are quite restricted. In most cases (and this is the universal testimony) the intent of the design is not clear from mere inspection, but must be explained before it can be understood. The author's summary of Maidu symbols is the very large variety and number, the frequency of animal designs, the unusual predominance of plant designs, the number in which the realism is obscured, the tendency to spiral and zigzag patterns, and the well-nigh universal practise of putting but a single design on a basket.

Plate 82, fig. 1, is a Washoe basket 8½ inches high, 12 inches wide, and 6 inches across the opening. There are thirty stitches to the inch. Colours, red, black, and brown. Weight, 16 ounces. The legend is named "Migrating," or "When the birds leave their nests and fly away we shall move." The lower left-hand basket, fig. 2, is 7 inches high, 11½ inches across, and 6 inches over the opening, with thirty stitches to the inch. The body is light-gold colour, and the ornamentations are in red and black. Weight, 15 ounces. The legend is, "Rays of the sun ascending." An attempt to imitate the radial appearance of the light at sunrise. The lower right-hand basket, fig. 3, is 7 inches high, 6 inches across the opening, and 11½ inches in diameter, with thirty stitches to the inch. The body is light-gold colour, and the decorations are in red and black. Attention is invited to the intricate combination of squares and triangles, stepped patterns, and rhombs to form the total design on the surface. These symbols relate to the different ranks or degrees in the chieftaincy of the tribe which they are entitled to receive by inheritance. This information is based on the studies of A. Cohn, of Carson City, Nevada.

Plate 83 is a Tulare bottleneck, collected on Tule River, Tulare County, California, and is in the collection of C. P. Wilcomb. The material and sewing are similar to those in other Tulare baskets. The ornamentation deserves especial attention. The bands of rhombs on the body and the part on the upper border, which resembles the shaftment and feather of an arrow, are common to the region. On the middle of the body, however, is a band of ornamentation which resembles the Egyptian ankh. It is useless to speculate on the origin of this symbol, since the Indians in this part of California have been in touch with the Latin-American race for centuries. In this Inyo-Kern-Tulare subarea, Dr. C. Hart Merriam finds the crenelated design to be associated in symbolism with the spasmodic flight of the butterfly as it flits among the flowers (see

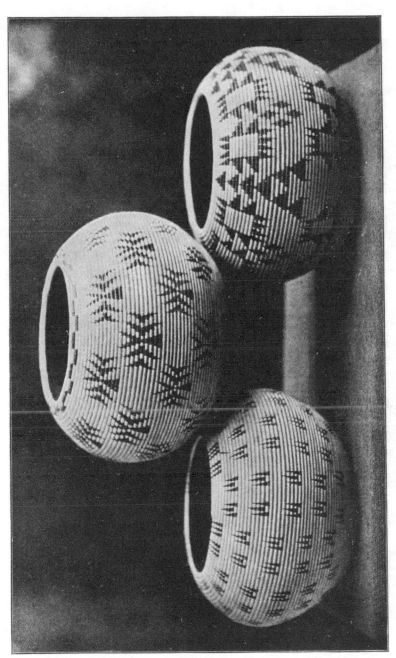

Plate 82. See page 208 Symbolism on Washoe Baskets, Nevada. Designs Mean Rising Sun,
Migrating Birds, and Inheritance

Collection of A. Cohn

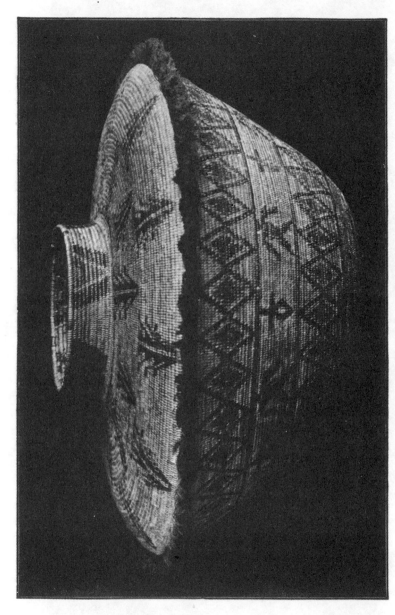

Plate 83. See page 208 TULARE BOTTLE-NECK TREASURE BASKET, SHOWING MIXED SYMBOLISM

Collections of C. P. Wilcomb

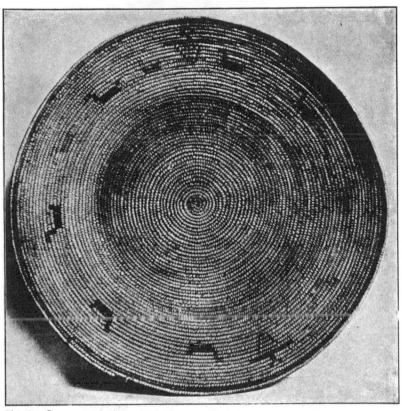

Plate 84. See page 209

SYMBOLS ON ANCIENT CLIFF-DWELLERS' COILED BASKET,
UTAH. BUTTERFLY AND DUCK DESIGNS

Collections of Am. Mus. of Nat. History, N. Y.

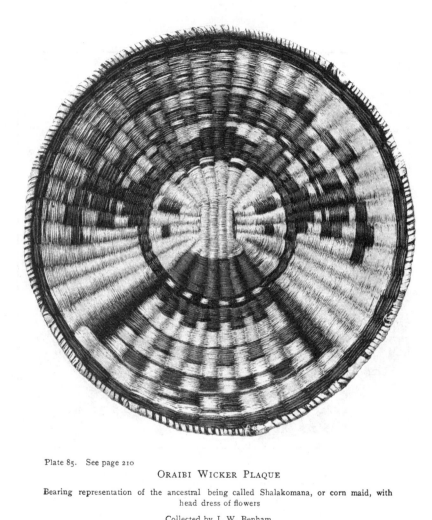

Plate 85. See page 210

ORAIBI WICKER PLAQUE

Bearing representation of the ancestral being called Shalakomana, or corn maid, with head dress of flowers

Collected by J. W. Benham

Plates 41, 188, 192, 194), and calls attention to the dispersion of the symbol as far north as southeastern Alaska. Miss DuBois calls attention to an interesting series of basket symbols representing the harvest dance, bought by her at Campo, a little border village of the Missions. In the *American Anthropologist* for January–March, 1903, a Pima conventional symbol, T-shaped, stands for the drinking festivals, marking the saguaro cactus harvest at the beginning of the year.

Designs were found by Dr. George H. Pepper* on the ancient basketry from the caves of southeastern Utah. He refers them to symbols as they are now understood among living tribes, but recognises that such forms do not stand for the same object always, even in the same tribe. The designs given are the butterfly of the Maidu, water-fowls, mountain, and sun. A glance at the beautiful workmanship and at the designs on Dr. Pepper's specimens at once places them not in the Ute or Shoshonean family, but with the exquisite basket-making tribes westward in California. They have the three-rod foundation. The upper one is 17½ inches in diameter and 5 inches deep.

The basket having the butterfly design was found over the body of an infant, and this led the finder to the conviction that the forms had some mythic significance. These specimens, and many more, belonging to the Wetherill, the McLeod, and Graham collections, are now in the American Museum of Natural History, New York (see Plate 84).

The Pueblos, called Hopi in northeastern Arizona, were visited by the Spaniards in the early part of the sixteenth century. Having no gold to tempt the avarice of the conquerors, they were let alone. On their coiled and wicker baskets, used in their religious ceremonies, are shown the personages and phenomena most intimately associated with their

* The Ancient Basketmakers of Southeastern Utah, Guide Leaflet No. 6 of the American Museum of Natural History.

cult. I am indebted to Dr. J. Walter Fewkes for the inter-
pretation of their symbolism.

The basket shown in Plate 85 is peculiar to the Hopi village
of Oraibi; has a picture of the Corn Maiden (Shalakomana or
Palahikomana). The head bears the representation of a tablet
which is symbolic of the rain-clouds. The colours represent
the rain-clouds of the four cardinal points: Yellow, the North;
blue, the West; red, the South; white, the East. Usually in
representations of this maiden, the Hopi hair-puffs are repre-
sented. A design on the forehead stands for an ear of corn,
which is one of the symbolic marks of this maiden. There
ought to be represented in the middle of the forehead, depen-
dent from this ear of corn, a fragment of Haliotis shell. This
is for the rainbow. The two eyes appear as bands, and should
be of different colours, the left green or blue, the right red.
The two bands below the eyes are meant for facial markings,
which are generally triangular in shape. Green and red
stripes on the chin represent the rainbow. On paintings, the
bow is curved the other way, but the restrictions of basket-
making require the curve to be downward. The blanket on
the body is a garment made of feathers, the individual feathers
being represented by blue and red bands. This is the earth
goddess, or corn goddess. Interesting descriptions of the
ceremony in which she is engaged will be found in Dr. Fewkes's
interesting paper* on the Minor Hopi Festivals. On Plate 24,
opposite page 494 of his article, is illustrated the Palahiko-
mana dance. She is shown as the central figure. The head-
dress, body garment, and embroidered blanket are represented
in full. The head-dress is decked with feather plumes, and
altogether the appearance is more striking. The basket
weaver has done her best where her pictorial ability gave out,
at least, to indicate the presence of even the clan markings
on the face, which in the drawings picture the human hand.

The top figure, Plate 93, shows the birds of the four car-

* American Anthropologist, N. S., IV, 1902, pp. 482–511.

dinal points, two very much enlarged and two smaller. The stripes on the border are the tail-feathers of the larger birds. The limitations of the basketmaker are well shown in the specimen, in that all perspective is neglected and every part of the body brought to the same plane; the feet are turned around so as to show the toes.

The lower figure in the same plate represents one bird, the head on the upper margin having rain-cloud appendages, the beak being represented by an extension on the right-hand side. The wider symbolic colours are abbreviated in every part. The bend in the knee is shown by the rectangular spaces representing the leg (see Plate 93).

The basket shown in Plate 47 was made at the Hopi village of Oraibi. The symbols on this basket represent the sky birds of the four cardinal points, two of which are larger, two smaller, apparently made so for want of room. The central figure represents the heart of the sky with geometrical rain-cloud figures. The sky god has a number of names.

In the upper figure (see Plate 216), the designs have gotten past the pictorial stage, and the meaning could be known only by consulting the maker of the basket. It is doubtful whether she did any more than what she saw her mother do. It might be possible, if a large series were had, to follow this symbol outward to the known pictorial form.

The lower figure in this plate represents the four birds of the cardinal points. The standard colours of the cardinal points are not all in the design, because the basket itself is yellow, which deprived the workwoman of the privilege of representing the North. The symbol is very highly conventionalised.

The figures on both examples, Plate 30, denote rainclouds.

The same types of symbolism, occasioned by the climate, the physical features and productions of the arid region, will

be found at Zuñi and among the Rio Grande Pueblos.* Symbolism on the basketry of Middle and South America has not been worked out.

In closing this meager chapter, the author calls attention to the fact that symbolism, or giving sensuous representation to spiritual ideas, is wider than basketry or any other class of useful objects. In order to reach substantial results, the subject must be taken up comparatively. For such a profound study many of the plates in this work will aid substantially.

* F. H. Cushing, A Study of Pueblo Pottery, Fourth Annual Report of the Bureau of Ethnology, Washington, 1887, pp. 467–521.

For a fuller explanation of the rich symbolism surviving in the Pueblo region the reader must consult the papers of J. W. Fewkes, to be found illustrated in the American Anthropologist, N. S., V, 1899–1903, and in the reports of the Bureau of Ethnology.

A Study of Textile Art in Its Relation to the Development of Form and Ornament, Sixth Annual Report of the Bureau of Ethnology, Washington, 1889, pp. 189–252; also, Prehistoric Textile Art of Eastern United States, Thirteenth Annual Report of the Bureau of Ethnology, Washington, 1896, pp. 3–45.

CHAPTER VI

Uses of Basketry

Blessed shall be thy basket and thy store.
—Deuteronomy, XXVIII: 5.

Nature has provided members of the animal kingdom with receptacles which are a part of their anatomy. The camel has its water cells, the ruminant animals have their extra stomach for the storage of grasses, the squirrel carries nuts in the pouch in the side of its cheek, and certain insects are provided with various means for transporting food to a distance. It remained for the human race to invent appliances to accomplish similar results, and basketry forms one of the principal means adapted to such needs. There is practically no limit to the uses to which basketwork weaving has been put. The enumeration of these uses in detail will show what a prominent place the receptacle has had for holding water, food, and other precious objects, for gathering the materials connected with industry, and for transporting them. Basketry also enters into the house, the furniture, the clothing, the armour, the domestic economy, the family life, and the religion of the American tribes.

There are a multitude of secondary uses of baskets which will be mentioned in the proper place. Certainly they have done as much as any other industry to develop, in the intellectual life of savage women, both a knowledge of the resources of nature and a taste for esthetic products. It will also be found that there is no gulf between basketry, beadwork, lacework, and loomwork. There are times when the basket-weaver suspends her work and, with the use of her

213

fingers alone, imitates the products of most complicated weaving frames. The highest steps in basket-making will be the first steps in the great mechanical art which now costs so many millions of dollars and employs so many human beings.

Before the coming of the European, basketry supplied nearly every domestic necessity of the Indians, from an infant's cradle to the richly decorated funerary jars burned with the dead. The wealth of a family was counted in the number and beauty of its baskets, and the highest virtue of woman was her ability to produce them. Some domestic vessels were named for the particular service they performed; as bi-ti-bo-um' (dishes), or Ká-dem (water-giver) among the Pomos; but the majority were known by their weave or shape. Vessels of the Tee weave, says Hudson, bore the brunt of culinary usage, as pots, pails, roasters, etc. There were two varieties of sifters; the coarse pshu-kan' separating the crumbs for nut cake, etc., and the ma-a-po'-i, or finer sifter (a conoid utensil), which, slightly tilted and struck sharply within by the finger tips, spills the chaff over the outer margin.

The great value of her work reflected upon the maker herself. It was the most expert woman in basketry, says Miss Jennie C. Carr, who brought the highest price, namely, two strings of shell-money.

Of old basketry some examples are clean, while others are soiled and dilapidated. The former had the good fortune to fall into careful hands half a century ago, when they were new, and have with the years merely faded down to their indescribable shades. The other precious old pieces have been

> Dipped in baths of hissing tears
> And battered by the shocks of doom.

The study of structure in basketry, as in other activities, leads to investigations concerning functions and use. Among

the least favoured tribes in this regard there is a similarity to
the lower forms of animal life where the same structure per-
forms a number of processes. It is also common to see, among
the plainer sorts of people and the uneducated, one utensil
used for many purposes. So with the little-advanced tribes of
Indians there will be one technical process in basket-making
and very small variety of forms for many uses, but when the
more advanced and skilful tribes are reached, there is a
differentiation of function and along with it corresponding
differences in structure and technical processes even in
the same piece.

In the study of function there are two inquiries of equal
value, namely, (1) the geographic distribution of functions
together with the particular types of basketry that are used
to perform these offices from place to place, and (2) tribal
origins and purposes in order to connect function with
ethnological and geographical studies. In each one of
the six areas into which the Western Hemisphere has
been divided, the uses to which baskets are put will be
decided by the animals, plants, and minerals that are
indispensable to the happiness of the people, and the
forms and characteristics of the baskets will depend
upon the plants that are to be had for making them. On
the seashore there must be clam baskets and fish baskets.
In the interior there will be berry baskets; and in those
regions where no pottery is to be found, cooking baskets,
in which food is boiled by means of hot stones, are
among the commonest objects in sight. From the other
point of view a more subtle question arises, whether
ethnology has anything to do with basket materials or
things to be carried in them. In tracing the history
of invention during its primitive stages it will at once
be recognised that the art of basket-making was greatly
stimulated by the multiplication of ends to be served;
that the inventive faculty, having such a versatile and

accommodating material, found scope for its own enlarge-
ment and improvement. In the end it becomes apparent
that the art and the artist have set themselves one to the
other "like perfect music unto perfect words." The
basket adapts itself to the woman's life. It is not
easy to pin any special structure upon a definite tribe,
however, since women were captured or ran away mayhap
into other tribes. A quiet system of pedagogy was going
on all the time in basketry, as well as in other activities. The
uses of basketry will be given in further detail, the topics
arranged in alphabetic order.

An interesting phase of the struggle between use and beauty
is to be seen in the compromises which they make for space
on the same basket. The jewel, the cremation *chef d'œuvre*,
or the precious gift to a friend, may be covered with designs,
having the most beautiful on the bottom, or where the maker's
fancy led her. On the other hand, the piece for common use
is the despair of the artist; it is bereft of ornament. Among
the Tlinkit of southeastern Alaska, while the covered trinket-
baskets are decorated to the ground, the cylindrical food-
baskets are plain near the bottom, and in many examples half
the way up the body. This compromise in decoration is more
apparent in the heavy coiled work of the British Columbia
tribes. Boxes for show, cradles, and such examples are
surrendered to the decorator, while the berry baskets
and cooking pots have their adornments chiefly on the
upper portion of the body. This fact limits the motives
in the design. On old pieces it is melancholy to see
how the hard wear of years has invaded the sacred
precincts of art and destroyed even the symbols of
religion. On the California basketry, art was predominant.
The spirals descend nearly to the bottoms of the mush
bowls and the carrying baskets, but a glance reveals at the
point of strain a patch of ordinary strong weaving or a
protective covering.

As previously mentioned, baskets are receptacles of some kind or other. They do not of themselves usually perform work, but are used for holding the materials and apparatus of work. The art of basketry, however—that is, the plication or working of somewhat rigid materials—easily passed out of the mere making of receptacles into the construction of all sorts of objects needed in daily life.

The uses of basketry are either industrial or ideal. Industrially, they are connected, first, with the whole range of obtaining food or nourishment and the other natural materials upon which all history depends.

With the secondary industries, called manufactures, with transportation, and with consumption or enjoyment, one has but to take a stroll along the crowded dock, as in a great seaport or the busy warehouse of any modern city, to become familiar with the infinite number of ways in which the basket lends its services to the comfort of the human race.

All of these functions, so intricate and diversified in civilisation, are represented in savagery by much more simple occupations, from which, however, the basket is never absent.

Beyond the drudgeries of life lie its beatitudes, and here the basket is also present. In fine art, in social functions, in birth, in lore, in custom, and even in burial it is not absent.

A detailed description of the way in which these functions are performed by basketry, with abundant illustrations, will show just what is meant in these declarations.

IN THE CARRYING INDUSTRY

Carrying in baskets was done by the Americans on the head, on the back with head-band or breast-strap, and in the hands; about the home the basket was scarcely ever absent. It was the strongest of all Indian fabrics, easily made into any shape convenient to the load or the carrier, and it was lightness

itself. In a hemisphere almost devoid of pack-animals, where woman was the ubiquitous beast of burden, is it any wonder that she invented the most economical of devices for holding and transporting? Since nothing grows where it is wanted, an attempt to enumerate the things transported in baskets would be to list every natural material that contributed to the Indian's happiness. Mineral, vegetal, and animal substances are all in there. Clay from the quarry, water from the spring, stones for working, firewood, edible roots, fruits, and seeds, textile materials, fish, flesh, and fowl are a part of the freight ever on the move throughout the culture areas.

The carrying basket did not lose its multitudinous functions for women with the departure of savagery. One has only to look into market-houses and stores, walk along the streets, or visit farms in the country to be convinced of this.

They are borne on the head, shoulder, hips, or knees; they are hung to the body in every possible fashion, and carried by two or more persons with the hands—all for loading ships, cars, or wagons. They are used also as panniers on the backs of animals, and smaller and better specimens are used by the interminable procession of children and buyers and travellers.

The transportation basket did not cease as a stimulus to invention, with its holding things and spurring the maker to do her best in its composition. It waked up her mind in other directions. Her feet had to be fitly shod to gather materials; thus sandals were often made in basketwork. Her clothing required adjustments to new occupations and exposures in the new activities made possible by the art. Even the baskets of other functions were perfected and new functions were created by the carrying art.

In the Report of the United States National Museum for 1894 * a large number of illustrations are devoted to showing

* O. T. Mason, Report of the United States National Museum, 1894, pp. 237–593, pls. 1–25, figs. 1–257.

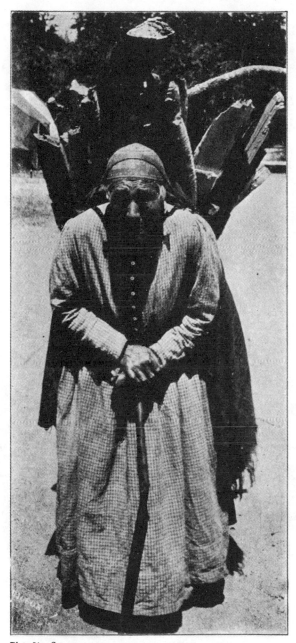

Plate 86. See page 219

AGED HUPA BASKETMAKER AND BURDEN BEARER,
WEARING FINE HAT

Photographed by A. W. Ericson, Arcata, Cal.

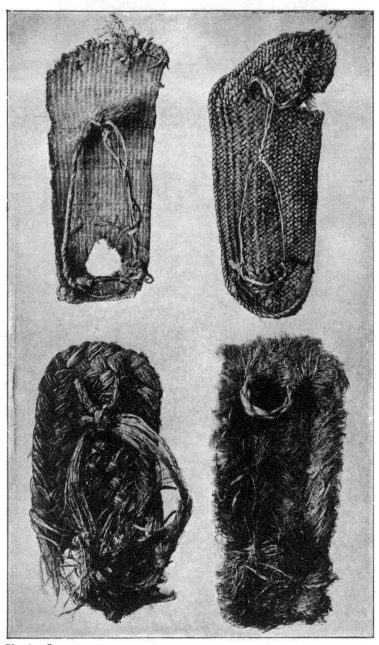

Plate 87. See page 223

SANDALS OF ANCIENT CLIFF-DWELLERS, COLORADO, SHOWING STYLES OF
WEAVING

Collections of U. S. National Museum

the variety of ways in which baskets may become vehicles among the aborigines of our hemisphere.

Edwin Bryant describes the moving of a Sioux camp, near Fort Laramie, in 1846.* The tent-poles were fastened to the sides of the ponies for *travaux*. Crosspieces were lashed to these, and small children were confined in cages, made from willows in the form of crates for crockery, having doors on the sides.

The Moki, or Hopi, Indians of to-day, in addition to the woven head-ring and the ordinary head-straps for carrying loads, have in use a breast-band of yucca fiber for dragging loads over the ground. (See figs. 105 and 106.) The Papago women fit a lacework frame to the back in carrying loads for long journeys. (See fig. 106.)

The Apaches make a special pannier in twined work, one of which will fit the human back, and two may be used on a donkey.

The Totonacs, of Vera Cruz, make soft carrying bags in twined weaving.

Plate 86, from a photograph by A. W. Ericson, represents a Hupa Indian woman using the carrying basket for firewood. On her head she wears one of the beautiful little conical basket caps of this tribe, common in collections. A band of leather passes across her forehead, and the load of wood is supported on her back. There is no other function of basketry so universally widespread as this.

FIG. 105.
BREAST BAND FOR HAULING.
Zuñi, New Mexico.
Cat. No. 70,962, U.S.N.M.
Collected by James Stevenson.

According to Muhlenpfordt, the Pimas and Maricopas make a basket boat, which they call "cora," woven so tight as to be waterproof without the aid of pitch or other

* Rocky Mountain Adventures, p. 110.

application. And upon the same parallel of latitude, along the Gulf of Mexico, the Indians used to cross the rivers on floats of cane woven together and called "cajen." Bundles of cane were laid together sidewise, and over them others, the whole being woven together.*

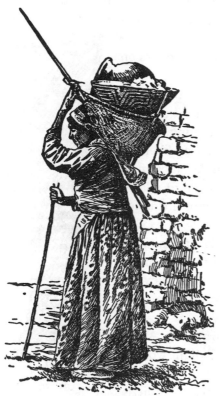

FIG. 106.
CARRYING FRAME.
Papago Indians, Mexico.
After W J McGee.

Formerly mats were used by the Makah as canoe sails, but at present they are employed for wrapping up blankets, for protecting the cargoes in canoes, and for sale to the whites, who use them as lining of rooms, or as floor coverings (James G. Swan). Besides the endless carrying of things among the Indians, called transportation, there is, it must not be forgotten, a large amount of passenger movement. The cradle, or, more correctly, the papoose basket, was the beginning of devices for carrying persons. Except a little riding by people of note on the backs of men in the Andes, only infants were passengers in aboriginal days throughout America.

For the infant there were three zones of going about in the Western Hemisphere—the Arctic, the Temperate, and the Tropical; speaking technically, the zone of the fur hood,

* Du Pratz, History of Louisiana, London, 1763, II, pp. 228–229. Dumont also mentions rafts of poles and canes.

the zone of the carrying frame, and the zone of free motion. The Atlantic province tribes made use of flat boards, or racks; the Eskimo mother carried her babe safely ensconced in her ample hood of fur. The cradles of southeastern Alaska and the mainland near by were troughs, but most of the Pacific tribes made their papoose frames of basketry, and it is to

these that attention is invited. In nearly all of them the feet and head are left free.* The Hupa Indians, on the Hupa Reservation, in northwestern California, belong to the Athapascan family in Alaska and northwestern Canada, and that may account for the resemblance of their cradles in form to those of birch bark made by the tribes of that n o r t h e r n region. Structurally, they are in plain twined weaving, with here and there a row of wrapped twine and false braid. In passing, it may be noted that these Hupa babies are not strapped on a board, as among the

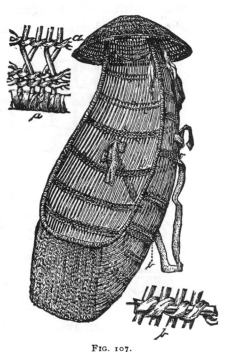

FIG. 107.
TWINED CRADLE.
Hupa Indians.
Cat. No. 126,519, U.S.N.M. Collected by
P. S. Ray, U. S. A.

eastern tribes, nor are their heads bandaged, as are those of the tribes along the coast of British Columbia.† (See fig. 107.)

* O. T. Mason, Primitive Travel and Transportation. Report of the United States National Museum, 1894, p. 521.

† See Report of the United States National Museum, 1887, p. 178, fig. 11.

In Defense and War

Basket armour of the tribes on the Pacific coast is made of narrow slats of wood, recalling those in the bottoms of some of the Lillooet Indian baskets in British Columbia. The slats are associated with straight rods of hard wood. These are woven with cords in regular twined weaving. The twine is finely spun and laid on so as to produce an ornamental

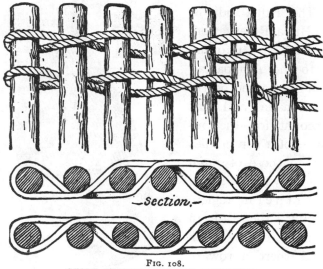

FIG. 108.
STICK ARMOUR TWINED TOGETHER.
California.
After W. Hough.

effect upon the surface. This basket ornament has been found in caves of the Aleutian Islands, also among the Tlinkit Indians of the Pacific coast as far south as the Hupa Indians of the coast of California. In some specimens wicker weaving takes the place of twined weaving.*

An examination of Hough's Plates 7, 8, 9, 10, 11, 13, 14, and 15 will show how the weft of twine in basketry is trans-

* Walter Hough, Primitive American Armour. Report of the United States National Museum, 1893, pp. 625–651.

ferred to slat armour, worn anciently by the Tlinkit, Aleut, Takoo, Shasta, Hupa, and Klamath Indians.

Fig. 108, reproduced here, illustrates one in which the twined basketry was applied to this sort of armour.

The Massawomekes, on the Chesapeake Bay, had similar basket shields or armour. Smith * speaks of them as made of small round sticks woven "betwixt strings of thin hempe and silke grass," but so firmly that no arrow could possibly pierce them. Comparing this description with the figure above leaves no doubt of the similarity of the defense on both sides of the continent.

In Dress and Adornment

Basketry, laying aside its chief function of holding something, is even now used extensively among many tribes in dress and adornment of the person. It was mentioned in the section on carrying that the exigencies of going about stimulated the inventive faculty not only in the basket industry, but in other crafts accessory to travel. The foremost of these companion arts is that of sandal or shoe maker. It is true that boots of hide and moccasins of tawed skin are the commonest supply of this want, but there is a vast portion of America where the sandal holds sway. They are made of tough fiber and woven in wicker, checker, twill, twined in a number of fashions. Some of the Cliff Dwellers' sandals are studies in weaving three and even four ply. Many of them are figured in my paper on Primitive Travel and Transportation.* (See Plate 87.)

But, far more than the feet, the head claims the basket-weaver's art the world over. In America the basket hat clings to the Pacific slope. As soon as the Indian area is reached in southeastern Alaska, the hat reaches its acme. It is made not only for comfort, to save the eyes of the hunter

* John Smith, History of Virginia, Richmond, 1819, p. 185.

† Otis T. Mason, Primitive Travel and Transportation, Report of the United States National Museum, 1894, pp. 237–593.

from the glare, and to act as an umbrella, but the handy weaver, having first scoured the earth for the most delicate spruceroot, exhausts her artistic skill in its composition. The Tlinkit woman and the Haida woman solve the problem differently. Given the task to make the most elegant hat that can be done in spruceroot, the Haida artist relies upon her delicate fingers to get the result. Twined weaving is her technic, but plain and twill and three-ply are so happily blended that she discards colour. The Tlinkit, just a whit less refined in touch, or maybe not having such perfect material, resorts to colour. The designs are not always wrought, but are frequently painted, while beard of seal, abalone shell, and beads exhaust the possibilities of decoration. These hats are made for men as well as women. Indeed, the finest are doubtless made for men to wear on the chase, with the conviction that a hunter must not only do his best but wear his best.

The use of the basket in clothing reaches its climax in the California hats. In a description of the costume worn by Hupa Indians in northern California, a large collection of designs on their basket hats is shown in Plates 3, 4, and 5 in the Ray collection, from the Hupa Reservation,* and on Plate 6 of the same paper will be shown the relation of basketry to footgear. (See Plate 88 for Klamath sandal.)

Excepting the headgear and the footgear, the American Indian in places needed protection from rain and cold. The robes made from the tender skins of rabbits and other small animals, by cutting them into strips and making them into blankets, by twined weaving, were widely diffused in North America from Virginia to the Pacific. Wherever the tough cedar bark abounded, soft capes and robes were made therefrom by the same women who made the baskets. The rain cloaks of middle America, if they are not of oriental origin, are knotted, and do not belong to basketry. Other basketry dress

* Smithsonian Report, 1886, pp. 205–238.

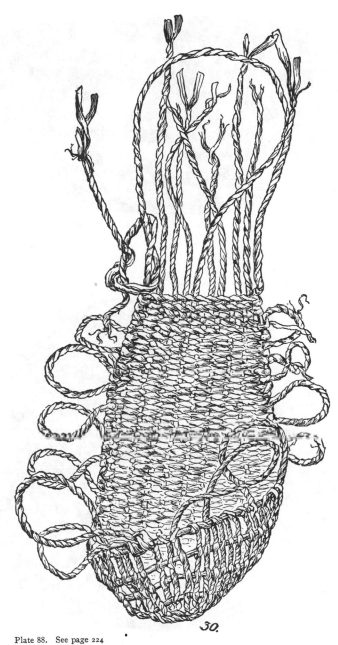

30.

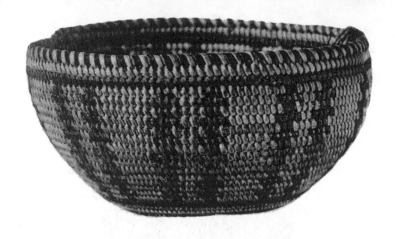

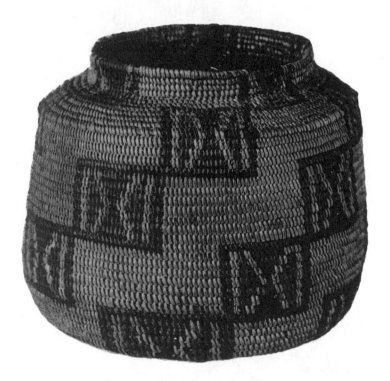

Plate 89. See page 225

TULARE AND KERN COILED CUP AND JAR

Collection of Mrs. E. Greble

was chiefly ornamental. Leggings reaching to the knees, made up by well-known processes, are to be found. A great deal of ceremonial regalia, even that from buckskin, is put together by basketmaker's processes.

In Fine Art and Culture

Basketry has been most useful as the patron of fine art and culture. Like all other human activities, it passes from the homely useful to the useless beautiful, and in so doing combines the two qualities whose union was long ago said to be the acme of excellence. The best art critics will say that in many of her productions the American Indian woman had, by obeying the voices within, attained a high degree of excellence. The practice of this superb work, and the admiration of it, elevated her; her abject state is not her fault.

There is no doubt that in the centuries of sorrow the Indian men have suffered more than women, since all their old occupations in which they excelled have been destroyed, and hope with them; but the pride of excellence remained with the woman, who easily surpassed the whites in the work she was allowed to continue. That thousands of children are now being taught her art is witness of this.

Plate 89 shows two coiled baskets from Tulare and Kern counties, California, specimens of the combined art of three or four well-known basket-making stocks, who have united at this point—the Shoshonean, from the east, the Mission Indians, from the south, and the makers of coiled basketry, from the north. In the upper figure the basket bowl is in open sewing over a grass foundation, with ornamentation in plain, vertical stripes. Every item of form, colour, and design in this specimen has in it the true element of art.

The lower basket is jar-shaped, in closer weaving and more uniform in texture, but its design is especially attractive. The base is a rectangular outline, but the pattern is made up of hour-glass form flanked by two triangles. The body colour

is that of the material, the hour-glass is black, and the triangles in reddish brown. Especial attention is called to this figure. It occurs many times in the basketry in the Merriam collection. It is also seen in McLeod's specimens from the Kern County tribe. The symbolism is not known, nor is there any attempt at imitation of natural objects in these figures, which are natural size in the plate.

Plate 90 shows the resources of the western California tribes of Mendocino County for heightening the beauty of ordinary coiled basketry. The abalone shell, having been ground away from the back, the nacreous surface becomes one of the most beautiful natural objects. The beadlike ornamentation around the edges is the money of the tribes, the feathers are the crests of the partridge, and forming the body of the basket the plumage of various species of birds is sewed on in bands. These objects, of course, have no other value than to show the taste and skill of the maker, and they are chiefly employed in making presents to friends, who are expected to give something quite as good in return.

Emulation in esthetic ideals and technical skill, a potent factor in education and refinement, found unrestrained opportunity in basketry. It is doubtful whether pottery excelled this art in the demand for scrupulous care in every movement. Many of the best pieces in California ware are marked with the monogram of the maker; and these special marks are often at the bottom of a piece, as if the artist with consciousness of excellence had felt the Horatian thrill when the poet wrote: *Sublimi feriam sidera vertice.*

A sense of beauty in detail was the motive which led the basketmaker to search the fields and dig into the earth for fibre. It educated her mind and sharpened her judgment. In order to secure the plume of the quail, the crest of the woodpecker, the shoulder tips of the blackbird, the mottled feathers of the duck, and more, the woman must catch her birds. So she becomes an inventor, more dangerous than the

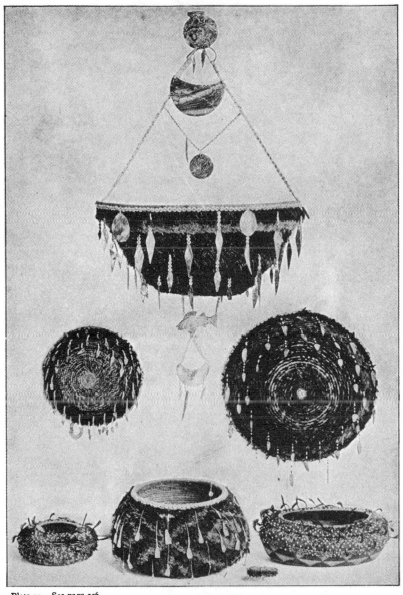

Plate 90. See page 226

COILED BASKETS OF THE POMO, CALIFORNIA, CALLED FEATHERED JEWELS
Collections of U. S. National Museum

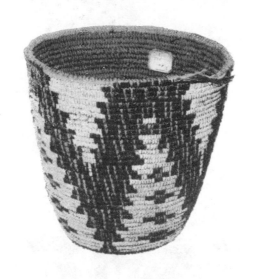

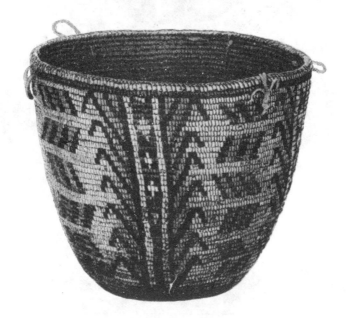

Plate 91. See page 228

KLIKITAT IMBRICATED WATERTIGHT BASKETS

Representing geese migrating, and a swamp plant

Collected by Mrs. Levi Ankeny

owl, more skilful than the hawk, more subtle than the serpent. At first the inventions were crude enough, but effective in damming the waters and barricading the air. Ministering to these called forth a new grade of artificialities; culture grew by what it fed upon until it is not possible to comprehend in one grasp the multitude of materials, the variety of technical methods, the shapes, the designs and their meanings, involved in what one forlorn woman had to master in order to graduate in her art.

Dr. Washington Matthews* figures the so-called Navaho basket plaque as a drum, and says that the art of basket-making is little cultivated among them to-day, because it was neglected through the development of blanket-weaving. The material is the twigs of the aromatic sumac. The work is done in coiled weaving. The foundation is in roots of the same material, and in starting the basket the butt of the rod is placed in the center, the tip toward the periphery all the way to the end of the work. Around the middle is a band in red, and branching from this band outward and inward are triangles in black. The band is not continuous, but at one point is intersected by a narrow line of a coloured wood. At first this seemed to be an imitation of the Pueblo "line of life" on pottery, but the Navaho line is put there to assist in the orientation of the basket in the medicine lodge when the light is dim. In playing their game, the butts and tips of the Navaho give preference to the butt-end of the gambling stick, associating the idea with that of the position of the warp in the coiled basket. When the basket is finished the butt of the first twig and the tip of the last twig in the outer edge must be on a line with this radial opening. When the basket is used in ceremony this line must lie east and west. The stick for this drum is made from the leaves of the yucca bent together, wrapped, and sewed. The dull, ghostly sound accords well with the other portions of their ceremonies.

* American Anthropologist, VII, 1894, pp. 202–208.

In Preparing and Serving Food

The basket is closely connected with the Indian kitchen and dining-room, if these terms be allowed. After the purveyor has gleaned from the waters, the air, the range, or the field, with appropriate devices, and the patient carrier has emptied her baskets at the tent side, and forsooth the miller has put through their exercises quite another series, the cook and caterer take up the burden. She is generally the selfsame woman who made the baskets and performed the forenamed drudgeries. But she is prepared for this task as well. There is, first of all, the mixing bowl or basket, about the shape of the bread trays in millions of kitchens. The coiled method suits the purpose, especially in their manufacture, since to be solid and water-tight is desirable, and weight is not an objection; yet there are tribes that make excellent mixing-bowls in twined work. (See Plates 50, 53, 92, 93.)

It must not be supposed that basketry cooking-pots are placed over a fire, as might be one of metal. Great preparation and skill are necessary to success. The basket must be substantial and water-tight; the proper kinds of stones must be selected and cleaned. After heating to a high degree, they must be dipped into water to reduce the heat. A red-hot stone would spoil the broth, sure enough. Tongs of wood of a certain species, and bent just so, must be made ready, and paddles for incessant stirring.*

Plate 91 shows two of the best examples of Klikitat imbricated basketry. The foundation is seen in the basket exposed, consisting of a bundle of rude splints of cedar root; the sewing is with prepared splints of the same material, and in both figures it will be seen that no ornamentation ever occurs on the inside of this type. The method of laying on the outer ornamentation has already been explained in the earlier part of this paper.

* For illustrations of cooking with hot stones see W. H. Holmes, Report of the United States National Museum, 1900, pp. 170–173, pls. 9–15.

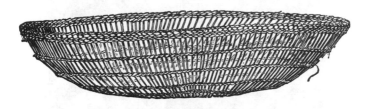

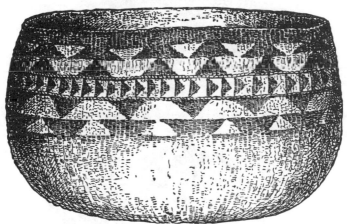

Plate 92. See page 229

HUPA FISH TRAY AND MUSH BOWL, CALIFORNIA
Collections of U. S. National Museum

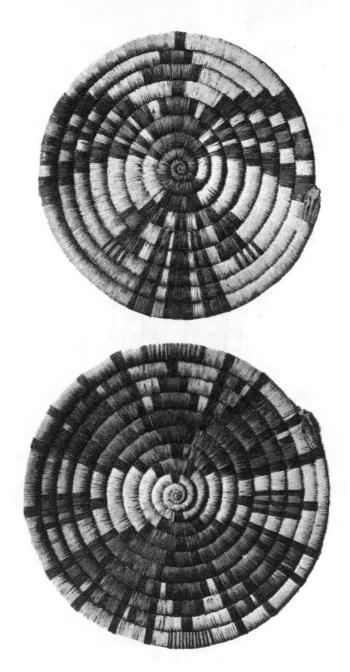

Plate 93. See page 229

Hopi Sacred Coiled Plaques

The great bird man and four winged creatures, either birds or butterflies, form the decorations

Collected by Mrs. M. C. Stevenson

The designs are made up of rectangular figures in the grass colour for the body, with yellow material dyed with Oregon grape, cherry bark, and cedar bark. The designs represent in the upper figure geese migrating; the lower, some species of swamp plant.

The border of the lower figure is in false braid, laid on the upper row of sewing. The stains on the lower basket show that it has been used in gathering berries for a long time; the upper one has not yet seen use. Both of them, however, are vessels for gathering and cooking food.

This cooking with hot stones is mentioned by many older writers, which proves that it was not an innovation with the discovery of America. After the cooking of the food, the next thing was the serving of it, for which purpose there were a number of forms in basketry for holding the fish or mush and for the individual eater.

Plate 92 represents a collection of baskets used for preparing and serving food. The lower figure is a cooking basket in which either mush or fish can be prepared to eat by means of hot stones. Spoons are made from the horns of the Rocky Mountain sheep or goats, and may be used for the individual eater. The upper basket is for draining food or for holding fish or some hot substance and allowing the water to drain off. The other figure shows the method of twined weaving and introducing a new splint into the texture.

Plate 93 shows two of the meal trays of the Hopi Indians in northern Arizona. When the coils are left open, as in these examples, they are said to have been made by an unmarried woman. The base or foundation of the coil is the shreds of yucca stems, and the sewing is done with the rib-like strips of the leaves. The colors used in dyeing are those employed also by the weavers in the same region, but of recent years common cheap dyes have taken the place of the native colours. The mythology of the figures in the plaques is explained on page 210.

Plate 94 takes the student to Calaveras County, California.
A Digger, or Maidu woman, descendant of the stock to which
the owner of the famous Calaveras skull belonged, is cooking
her acorn mush by means of hot stones. The process is
described by Holmes,* the entire apparatus consisting of a
series of baskets for pots and kettles, an ingenious spoon of
sapling for lifting the stones from the mush, and sticks for
handling them in the fire.

In Gleaning and Milling

Gleaning or harvesting, storing away, and milling, what
a vast number of men are nowadays employed in them.
Women are not absent from them altogether in the United
States, and nothing is more common in the Eastern Hemi-
sphere than to see harvest fields and all activities associated
with root and seed gathering thronged with them. The in-
dustry was almost solely hers in America. Baskets are named
for their part in these crafts. There are picking baskets, root
baskets, berry baskets, and so on to the list of acorns, fruits,
seeds, and roots without end. Carrying baskets are univer-
sal, but there are a great many of them used by this set of
workwomen, and it will be found that special varieties have
been devised for these pursuits.

Also, as every other important invention calls for a host of
subsidiary devices, there must be wands for beating off seeds,
sieves for separating grain from chaff, fans for the same pur-
pose, roasting trays in which the raw material is parched before
grinding. Brooms are made from basket fiber, hoppers for
the top of the millstone also, and the open, generous bowls
to hold meal. All this is before the cooking processes are
reached. If the meal is not to be used up at once, all thrifty
tribes had learned to store up vegetable supplies against the
day of need. The granary basket was the rival of the pit and

* William H. Holmes, Report of the United States National Museum
for 1900, Washington, 1902, p. 173, pl. 15.

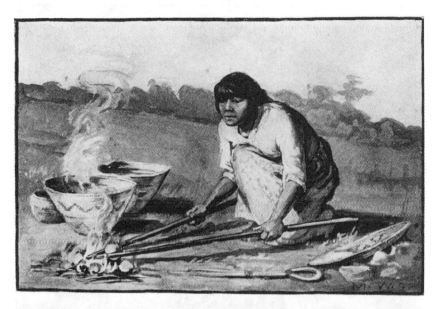

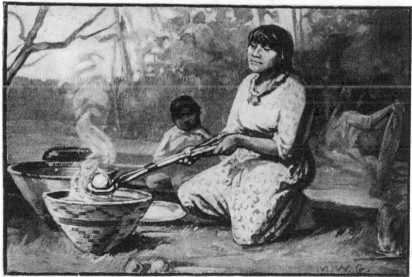

Plate 94. See page 230

MAIDU WOMAN COOKING IN BASKETS WITH HOT STONES
After William H. Holmes

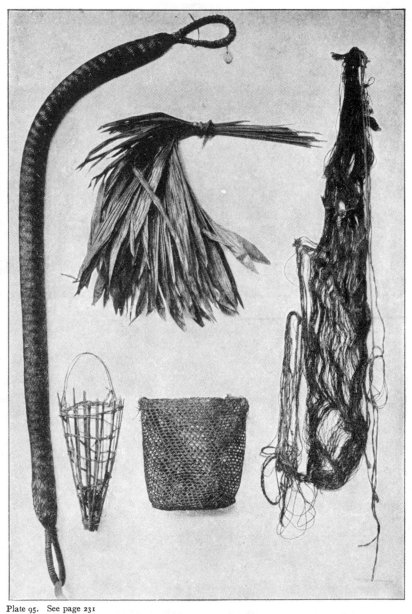

Plate 95.　See page 231

BASKETWORK OF AMAZON TRIBES CONNECTED WITH PREPARING CASSAVA

Collections of U. S. National Museum

the wooden crib. There must have been something refining
about this entire round of activities. In many of the baskets
associated with them the ornamentation is exquisite. The
hunter and the fisherman had scant encouragement to cultivate
the esthetic sense in their employments; but nuts, seeds,
grain, most fruits, and roots are clean. Even berries when
they stain do not soil the outer part of the receptacle, so the
Fraser River tribes adorn the upper portion of the baskets
with beautiful patterns. The lower part is left plain. The
use of baskets in the plant quest was well-nigh universal.
The eastern Indians employed the cane or split ash for their
wicker or twilled baskets. As far as the cane extended, even
to Guiana and Brazil, this is true. The ingenious cassava
strainer belongs to this class.

Plate 95 shows the domestic utensils of the upper Amazon
tribes for various household purposes. Palm leaf, out of
which fiber is made; the fiber itself, used in various forms
of domestic utensils; baskets in two types, twined and crossed
warp weaving. The cassava strainer on the left is in twined
weaving, so that when the weights are taxed the bag is in-
creased in size and the water forced out of the cassava. The
specimen shown was collected for the United States National
Museum by J. B. Steere.

Lewis H. Morgan writes* that in the art of basketwork,
in all its varieties, the Iroquis Indian women also excel.
Their baskets are made with a neatness, ingenuity, and sim-
plicity which deserve the highest praise. Splint is the chief
material, but they likewise use a species of sweet grass, and
also corn husks. Among these various patterns, which are
as diversified as convenience or ingenuity could suggest, the
most perfectly finished is the sieve basket. It is designed for
sifting corn meal, to remove the chit and coarse particles
after the corn has been pounded into flour. The bottom of
the basket is woven in such fine checks that it answers very

* League of the Iroquois, 1851, p. 382, showing twined baskets.

perfectly all the ends of the wire sieve. Another variety of baskets was made of corn husks and flags very closely and ingeniously braided. In their domestic economy the basket answered many purposes. Cat. Nos. 221,161–3, U.S.N.M.

From the historians of the discovery it is learned that basketry was used in connection with the gathering and preparing of food. Bartram mentions the use of a sieve which the Indians of Georgia have for straining a "cooling sort of jelly called conti, made by pounding certain roots in a mortar and adding water." Dumont describes the sieves and winnowing fans of the Indians of Louisiana. The Indian women, he says, make fine sieves with the skins which they take off the canes; they make some with larger holes, which serve as bolters, and others without holes, to be used as winnowing fans. They also make baskets very neatly fashioned, and cradles for holding maize. By comparing this statement with what is said about the California gleaners it will be seen that the Louisiana tribes knew how to sift meal, leaving the coarse particles inside the sieve, and also to separate seeds from chaff, and finally from coarse material, by beating over the edge of a tightly woven basket.

Du Pratz also says that for

sifting the flour of their maiz, and for other uses, the natives make sieves of various finenesses of the splits of cane.

John Smith, speaking of the Indians of Virginia, says they

use a small basket for their Temmes, then pound againe the great, and so separating by dashing their hand in the basket, receive the flowr in a platter of wood scraped to that forme with burning and shels.

Strachey makes the following statement:

Their old wheat they firste steepe a night in hot water, and in the morning pounding yt in a morter, they use a small baskett for the boulter or seaver, and when they have syfted fourth the finest,

they pound againe the great, and so separating yt by dashing their hand in the baskett, receave the flower in a platter of wood, which, blending with water, etc.

There are no gleaning baskets in Arctic and few in northern Canada. Birch, elm, and pine bark usurp the place of textile materials. But all along the southern border there were gleaners and a variety of basket forms in their hands. Maize, wild rice, roots, nuts, and berries were food staples. Checker matting, wicker basketry, and twined bagging supplied the receptacles.

For the basketmaker there are four Alaskas:—Athapascan, and Eskimo, where there is no gleaning or milling; Aleutian, in which the harvest comes from the sea, and the daintiest of twined weaving is made in grass stems; and southeastern Alaska, which shall receive further notice. Storage baskets are attributed to them by early voyagers. Nowadays the ware is small, no piece exceeding half a bushel in capacity. Since seafaring is mixed with hunting and gleaning the fields, the gathering basket leads a busy life. Plates 136–149 represent the types, which, large and small, are chiefly cylindrical in shape. The methods of manufacture and decoration have been described.

In Gerstaecker's Journal is the following account of seed gatherers in California:

While I was standing there, a couple of pretty, young girls came from the woods with flat baskets full of flower seed emitting a peculiar fragrance, which they also prepared for eating. They put some live coals among the seed, and, swinging it and throwing it together to shake the coals and the seed well and bring them to continual and close contact without burning the latter, they roasted it completely, and the mixture smelled so beautiful and refreshing that I tasted a good handful of it, and found it most excellent (p. 375).

Edwin Bryant, in his Rocky Mountain Adventures, gives this description of the acorn harvest:

We soon learned from them that they were a party engaged in gathering acorns, which to these poor Indians are what wheat and maize are to us. They showed us large quantities in their baskets under the trees. When dried and pulverized, the flour of the acorn is made into bread or mush, and is their "staff of life." It is their chief article of subsistence in this section of California. Their luxuries, such as bull beef and horse meat, they obtain by theft, or pay for in labour at exorbitant rates. The acorn of California, from the evergreen oak (*Quercus ilex*), is much larger, more oily, and less bitter than on the Atlantic side of the continent. In fruitful seasons the ground beneath the trees is covered with nuts, and the Indians have the providence, when the produce of the oak is thus plentiful, to provide against a short crop and the famine which must necessarily result to them from it by laying up a supply greater than they will consume in one year (p. 240).

The Hupa Indians, for collecting seeds, according to Professor P. E. Goddard, use the basket in the shape of a common burden basket in closely woven style.* They also made large storage baskets of close-twined work called djelo, the base being of greater diameter than the top.*

Plate 96 represents the harvesting outfit of the Hupa Indians on Hupa Reservation in northwestern California. There is the openwork twined basket for picking the seeds, the carrying basket in openwork with a decorated band at the top for bearing the crop home, the granary basket, which bears significantly on the outside the image of destructive worms that eat the crop after it is harvested. The woman's head has a pad of soft twined work on the forehead, across which the buckskin band of the carrying basket rests. The outfit of the mill consists of a large basket at the bottom for catching the acorn meal and a millstone set in this for grinding, a hopper basket, most elaborately made, resting on the rock to hold the acorns that are being ground. A similar hopper is shown below, both in its form and structure. The pestle for

* Life and Culture of the Hupa. Publications of the University of California, I, 1903, pl. XXII, fig. 2.

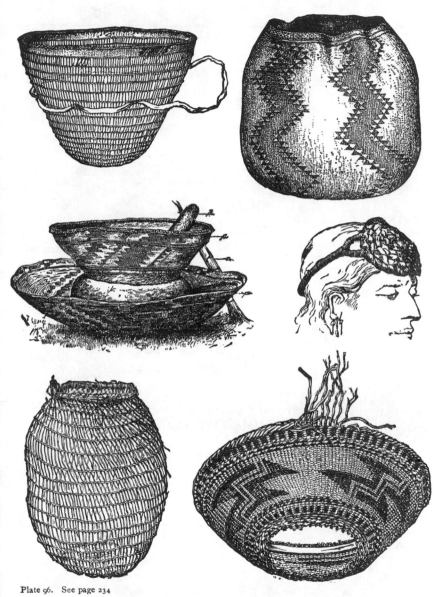

Plate 96. See page 234

HARVESTING AND MILLING OUTFIT FOR ACORNS, HUPAS, CALIFORNIA

Collections of U. S. National Museum

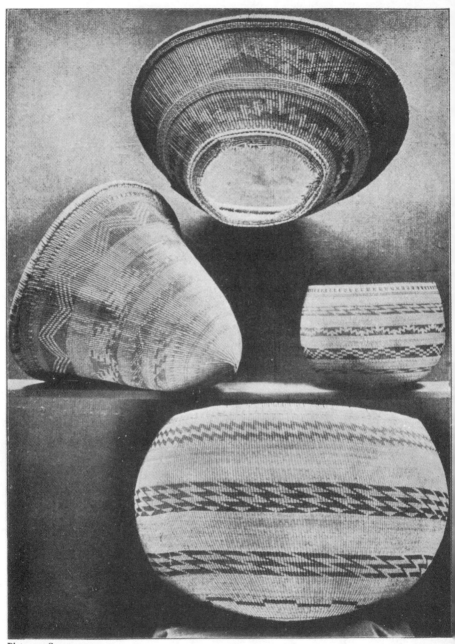

Plate 97. See page 235

POMO TWINED BASKETS FOR HARVESTING, MILLING, AND SERVING, CALIFORNIA

Collection of C. P. Wilcomb

grinding the acorns and the broom for sweeping up the meal complete the paraphernalia. Throughout the entire acorn area implements resembling these will be found.

The outfit for the Pomo acorn mush-maker in Mendocino County, California, is illustrated by V. K. Chesnut* in his paper on Plants Used by the Indians of Mendocino County, California (fig. 71 and Plates 13, 18), issued in 1902 by the Department of Agriculture, Washington.

It consists of eleven pieces: the picking basket for the individual gatherer; the holding basket for receiving the contents of number one; the cone-shaped carrying basket, with headband; the granary basket at the home, holding two or more bushels—many of them have beautiful covers; the basket hopper, open at the bottom to fit on the mortar stone—the work of strengthening these taxes the ingenuity of the weaver; the mat for the meal, to be placed under the millstone; the sifting plaques, in openwork, for coarse separating, and tightly woven, for shaking the waste over the edge; the cooking pot of the closest weaving; the dipper; the eating bowls; and the daintily woven basket hat.

William H. Holmes illustrates at length the acorn harvesting and milling industry in northern California, carrying and hulling the nuts, pounding them in stone mortars, grinding the meal, separating the coarse particles, cleaning the meal by shaking and blowing, leaching in sand and using hot stones for cooking in basket pots.†

Plate 97 is a group of baskets in plain-twined weaving (Bamtush) in the collection of C. P. Wilcomb, of San Francisco. It consists of a conical carrying basket, mill hopper, granary basket, and mush bowl. The carrying basket is in plain-twined work throughout. Even the narrow bands near the top are no exception, for though each twist in the twine

* Contributions to the National Herbarium, VII, pp. 295-408.

† Report of the United States National Museum, 1900, pls. 10-15 and 22.

passes over two warp stems, on the next round the same two are included in the twist above. Casting the eye upward will show that in the upper band next to the border the same motive occurs, but the same pairs of stems are not inclosed in the twist. The effect of this ornament is quite pleasing, as the two bands with intervening space form an endless zigzag pattern. The border of this basket is formed by bending the warp stems down as the foundation of a coiled work, which is strengthened by a hoop of wood. The bands of ornamentation on this and the other baskets in this group are explained under "Symbolism."

The mill hopper is also in plain-twined weaving, strengthened with three narrow bands of tee weaving. The granary basket and the mush bowl are noteworthy, especially on account of the peculiar method of finishing the work by merely cutting off the warp stems.

Plate 98 represents two specimens in the collection of C. P. Wilcomb, both of them from Tulare County, California. The upper figure is a bowl connected with the body in twined weaving. The diameter is 14⅝ inches. The ornamentation is in four bands, the lower broken, the second in chevron pattern, the third human figures, the fourth the standard hourglass pattern. On the margin are spots in black material in groups of fours. The lower figure represents a typical mortar, stone with pestle and hopper, in this case glued to the upper surface of the millstone. The ornamentation on the upper is also the standard band of hexagonal figures. A similar mortar dug up by C. J. Dyer, is in the collection of W. J. Walz, El Paso, Texas.

Gleaning and milling of wokas, seed of the waterlily (*Nymphaea polysepala*) and their relation to basketwork among the Klamath (Lutuamian F.) in southern Oregon are fully illustrated by Coville,* three of whose plates are here repro-

* Coville, F. V., Report of United States National Museum for 1902, pp. 725–739, pls. 7, 11, 13.

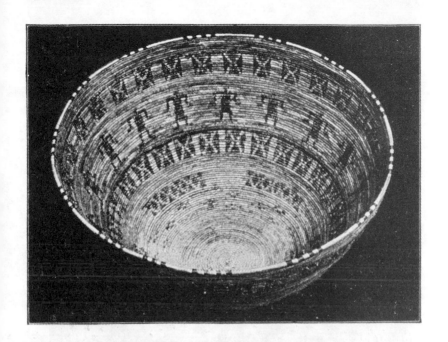

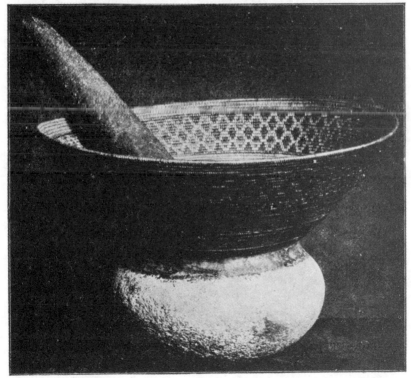

Plate 98. See page 236

YOKUT MUSH BOWL AND COMPLETE MILL, TULARE COUNTY, CALIFORNIA

Collection of C. P. Wilcomb

Plate 99. See page 237 KLAMATH INDIAN OUTFIT FOR GATHERING SEEDS OF THE WOKAS, A WATER-LILY,
SOUTHERN OREGON

After Frederick V. Coville

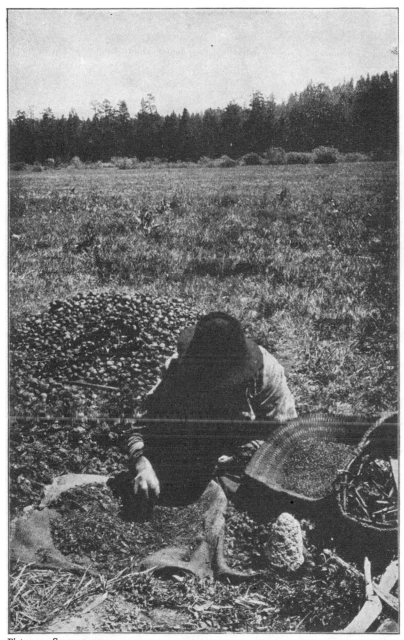

Plate 100. See page 237

KLAMATH INDIAN EXTRACTING WOKAS SEEDS FROM THE PODS, SOUTHERN
OREGON

After Frederick V. Coville

Plate 101. See page 237 Klamath Indian Outfit for Grinding Wokas Seeds, Southern Oregon

After Frederick V. Coville

Plate 102. See page 237 PRIMITIVE MOHAVE STORAGE BASKET, DESERT OF SOUTHERN ARIZONA

Collection of Field Columbian Museum

Plate 103. See page 239

HOPI BASKETRY CASE FOR HOLDING THE BRIDAL COSTUME, N. E. ARIZONA

Collections of U. S. National Museum

duced (Plates 99–101). In the former will be seen the lily-giving waters, the rude canoe of the women, mats in twined weaving for drying roots, and the ubiquitous sack, the receptacle of commerce. Plate 100 associates basketry with the separating process, first and rudest in the line of cleaning mills. The slab or metate and the rubbing stone or muller rests upon a large shallow basket. The stones and the basket, with the woman's strong arms, make up the whole apparatus in what by-and-by will be a roller mill. (See Plate 101.)

Speaking of the Apache Indians and others farther south, Captain John G. Bourke mentions their fanning trays for cleaning the seeds of grasses. Hot stones are placed in them, with the coarse material, and the chaff is burned out. The Captain also mentions that the trays are wetted to keep them from burning. This cannot be a universal practice, because in some of the Ute specimens in the Museum the texture is very much charred.

Hough says that the long and pointed gathering basket of the Havasupai is tied to the belt in front by the woman when gathering mesquite beans, etc. The pointed bottom passes between the legs while the squaw walks around gathering. At the camp the basket is set in a frame. The baskets are made in the spring, when the sap is running.

Plate 102 shows the most primitive form of storage, holding several bushels, used by the Mohave Indians in the desert between Mexico and southern Arizona. It resembles more a bird's nest than a textile preparation. The specimen is in the Field Columbian Museum, Chicago, and to the courtesy of C. L. Owen and G. C. Simms I am indebted for the photograph.

The Mohave and other tribes have curious granaries for storing mesquite beans, corn, etc., near their houses. A platform is constructed on high poles; upon this is placed a round, bottomless basket from 3 to 5 feet in diameter and 2 to 3 feet deep. These are made of arrow-weed stalks tightly interwoven. When filled, the top is sealed with mud to keep out

rain. In specimens examined by Owen and Simms, of the
Field Columbian Museum, several of these nest-like baskets
were clustered on the same platform and a rude fence served
for inclosure.*

In House Building and Furniture

House and furniture were here and there constructed of
basketwork, so the basketmaker became architect and cabinet-
maker. Of the former, the wall may have been constructed
like a huge, coarse basket, with upright stakes for warp and
brush, canes, rushes, or leaves of palm for weft. The roof,
also, especially in its framework, was in some tribes an immense
shallow basket bottom inverted. The rafters were the parallel
or radiating warp and the interlacing vines the openwork woof
into which many kinds of thatch were fitted.

Accessory to the house, whether a woven structure or not,
were fences, awnings, screens, and shelters. They were woven
after the fashion of the walls. In middle America and the
tropical portions of South America, but far more skilfully in the
Philippine Islands and all about the Indo-Pacific, the mat and
light basketry serve for seclusion and decoration among the
houses. Open checkerwork, twilled weaving, wattling, or
twined textile are as effective as they are light and easily put
together. When they were moving about, or in situations
where a compact dwelling wou'd have been burdensome, it
was an affair of only a few moments to imitate the nest-
building birds and throw together a wickiup or leaf shelter of
some kind.

The winter houses of the Pomo Indians were a rude kind
of feathered basketry. They are described by Carl Purdy† as
domes of wickerwork, thatched heavi'y with grass or tule
(page 443, with illustration). The summer houses were of

* For illustration see Newton H. Chittenden, Land of Sunshine, 1901,
p. 202.

† Land of Sunshine, XV, May, 1901.

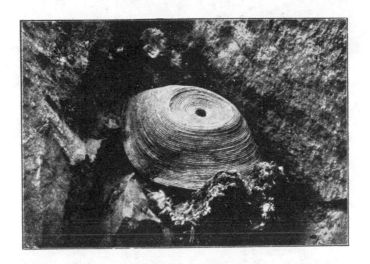

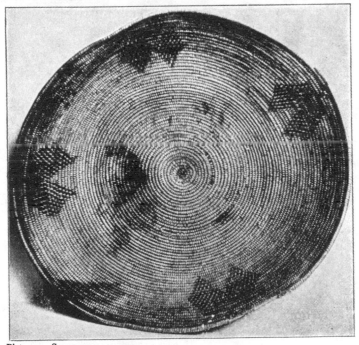

Plate 104. See page 239

ANCIENT MORTUARY BASKETS FROM CAVE IN SOUTHEASTERN UTAH
Collections of Am. Mus. of Nat. Hist., N. Y.

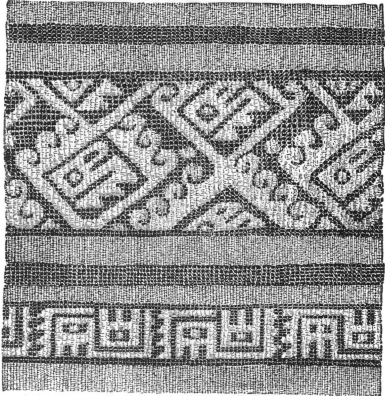

Plate 105. See page 240

ANCIENT PERUVIAN LACEWORK
After W. H. Holmes

wickerwork covered with boughs, and the tribe moved several times a year as acorns, fish, game, or dry quarters were desirable. They solved the problems of transportation by moving themselves about.

Furniture had not the pretentious meaning that it possesses in civilisation. The bed for the Indians was the most desirable luxury. Their chairs were mats of many styles of weaving and many colours. All of them were plicated by hand and were the production of the basketmaker.

But the bed was not always a basket. In the North it was the warmest furs and robes; in many tribes the mat took the place of the robe, and over a wide area the hammock was chair by day and bed at night. In some of these the twine is knotted or netted and the hammock is in no sense a basket. Throughout the Southwest a resting device is formed by the very ancient basketmakers' process of stringing a number of stiff rods together by three or more rows of weaving. (For a Hopi bridal costume case see Plate 103.)

In Mortuary Customs

The basket is intimately associated with Indian life in the "last act." Not only fabrics woven in basketry technic were wrapped about the dead and used to protect the body, but on the sentimental side examples of the finest workmanship were either deposited or burned with their makers. Plate 104 is taken from Pepper's account of the basket-making Indians of Utah, and is interesting as exhibiting the method of burial among the ancient tribes of southeastern Utah in the canyon country. These old people must have lived long in these curious retreats, for on top of their graves are found deposits made by later tribes. The corpse was placed in the hollow of a rock and covered with a rabbit-skin robe made in twined weaving. On top of all was turned upside down a coiled basket. The plate shows the method of administering the blanket and the basket, and the lower figure of the plate declares the type and

style of weaving used by these ancient basketmakers. The foundation is of three-rod type. The four figures on the surface near the margin are like the butterfly design seen on some modern ware, but the symbol is not known. Horatio N. Rust tells of a young Indian girl who was dying of consumption. She wore on her person a small basket of beautiful workmanship, and gave it to a young American, begging him to have her buried in a coffin and the little basket placed within.

Another Indian, Roherio by name, living in the southern California country, tells of his wife, who, when dying, called him to her and said: "Take my basket cap, which I have always worn since I have been your wife, and burn it, with everything that is mine." He obeyed her, and burned two trunkfuls of personal property.

Clarence King describes vividly, in his Mountaineering in the Sierra Nevadas, a cremation scene:

In the opening between the line of huts a low pile of dry logs had been carefully laid, upon which, outstretched and wrapped in her blanket, lay the dead form of "Sally," the old basketmaker, her face covered in careful folds. Upon her heart were the grass-woven water bowl and her latest papoose basket. The flames slowly lapped over, consuming the blanket, and caught the willow papoose basket. When the husband saw this the tears streamed from his eyes; he lifted his hands eloquently, looking up at the sky and uttering heartbroken sobs. All of the Indians intoned in pathetic measure, "Himalaya, Himalaya," looking first at the mound of fire and then out upon the fading sunset.

The desert region of Peru was favourable to the preservation of delicate textiles, and it is in the cemeteries of this region that large quantities of basketry in every style of weaving here described have been found.* (For lace work see Plate 105.)

In Relation to the Potter's Art

Pottery and basketry were in America, especially among the savage tribes, both the work of women. Before answering

* For basketry (coiled and twined) from graves in Peru, see Eleventh Annual Report of the Peabody Museum, pp. 280–292.

the question how far one art was useful to the other, attention must be called to the fact that in eastern United States both prevailed almost universally. In the Arctic, excepting the rude pottery of Alaska on Bering Sea, and on the Pacific from Mount St. Elias to Santa Barbara Islands, the tribes made only basketry. Those of the interior basin and all southward were expert in both.

It was formerly believed that in the eastern division of the United States, especially, pottery was made to a large extent in basketry. Eminent students held this opinion, and there seemed to be abundant evidence of its truth. Cushing figures a basket with clay inside to protect the former in the cooking of seeds and grains.*

Holmes now believes that the extent to which good baskets were used for modeling pottery in this province has been greatly overestimated. There are innumerable examples of basketry and other textile markings on earthenware, and he divides them into five classes:

1. Impressions from the surface of rigid textile forms.

2. Impressions from cloth and nets.

3. From woven textures used over the hand or modelling implement.

4. From cords wrapped about modelling paddles or rocking tools.

5. Impressions of bits of cords or other textile units, singly or in groups, applied for ornament only, and so arranged as to produce textile-like patterns.

In modelling a clay vessel, a basket might be used as a support and pivot. It might assist in shaping the bodies of vessels, assuming to a limited extent the limits of a mould. Also, the mat upon which a plastic form rests will leave impressions that firing will render indelible. The tribes of the Pima

* William H. Holmes: American Anthropologist (N. S.), III, pp. 397–403; also F. H. Cushing, Fourth Annual Report of the Bureau of Ethnology, 1886, pp. 483–493.

linguistic family produce jars and baskets of the same shape; but if a row of Zuñi or Hopi pottery be compared with a row of their basketry, they would not suggest that either one was the predecessor and occasion of the other. Laying aside the inquiry whether the basket was the progenitor of the pot, inasmuch as the same hands often produced both, the former unwittingly rendered itself immortal by its many little helpful attentions to the latter in its formative stage. The pot was afterward fired and worn out and broken into fragments that were buried out of sight. In these last years the archeologist exhumes the shards, washes them carefully, and makes casts of their surfaces in plaster or artist's clay. A glance shows that, though the surfaces of the shards are much worn away by time, the lines in the little cavities are as sharp as when the clay and the basket made each other's acquaintance centuries ago (see Plates 106, 107).

In the shards examined by Eggers and Holmes one fact is preserved that no historian recounts, namely, that twined basketry as varied and beautiful as that of the Aleutian Islanders was made by the tribes in the Mississippi Valley before the fifteenth century.

As a Receptacle

Very few of the Indian tribes of America were so unsettled in life as to be without a home. About such a place accumulated personal property and provisions for the future, large and small. On the Great Plains of the West, receptacles were made of rawhide gaudily painted. On the MacKenzie drainage, bark of the white birch was the material, decorated with quills of the porcupine dyed in many colours. But for holding the bone awl and the sinew thread, the trinkets belonging to dress, the outfits of fisherman and hunter, the baskets and the wallet were well-nigh universal. In the industries and other activities of life in which materials, utensils, apparatus, in a word, things were involved, there were receptacles for holding them. The

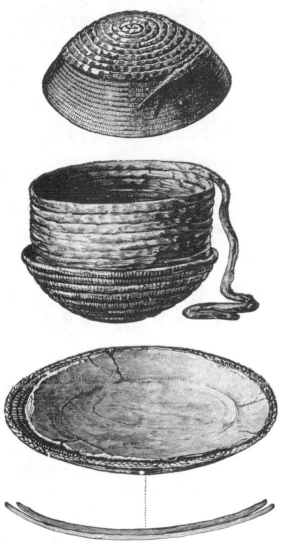

Plate 106. See page 242
RELATIONSHIP BETWEEN BASKETRY AND POTTERY
After F. H. Cushing

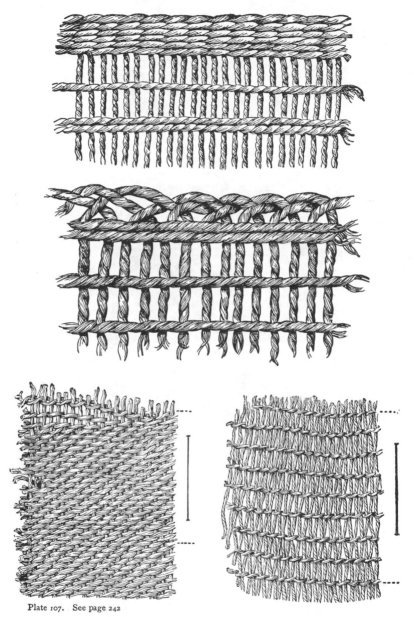

Plate 107. See page 242

TWINED BASKETRY TECHNIC PRESERVED BY POTTERY

After W. H. Holmes

basketmaker herself has a kit of appliances for making her wares.

One of the primary functions of basketry, if not the very first, was to contain or restrain something. The weir, fence, wing of the game drive, wall of the house, besides many smaller objects of the coarsest weave, were invented long before basketry became cooking utensils or works of ceremony. The myriads of Indian baskets sold at railroad stations and summer resorts have gone back to the first principles and are made for the sole purpose of holding.

In the North, the small tools and trinkets of the fur-worker are easily lost in the snow. The work-basket or something in its stead is universal. About Point Barrow the Tinné (Athapascan) Indians make coiled baskets in several styles of weaving. These are traded to the Eskimo. On the Bering seacoast of Alaska rougher trinket cases appear. The Attu makers of dainty wallets in grass, living away out on the Aleutian chain, are quite as skilful in the manufacture of cigar cases, which, by the way, are nothing more than two of their old-fashioned cylinders fitted one into the other and flattened. Receptacles of basketwork, with no other function than just to hold things, are to be found in all the areas of the Western Hemisphere, in all sizes from the granary down to the sheath for an awl, in every one of the technical processes and in every degree of fineness. It is the one function of universal application.

Plate 108 shows an ammunition holder in twined basketry from the Tlinkit Indians of Sitka, Alaska. It is ornamented by false embroidery. The interesting fact concerning this specimen is that as soon as these Indians came in contact with the Russians they began to imitate modern forms of apparatus in textile material. This telescope basket was used by the owner for holding caps, bullets, or other delicate objects for hunting. It also shows that the acculturation of form did not begin recently, but took place as soon as the Indian woman's eye rested upon some novel and attractive form. This specimen

is Catalogue No. 1,156 in the United States National Museum, and was collected by James G. Swan.

Plate 109 represents a woman's work-basket of the Tlinkit Indians, of southeastern Alaska, in twined weaving, ornamented in false embroidery. Doubtless the form is derived from Russian motives, but it is extremely common among the Indians in this locality and is useful in a thousand ways for holding material. This specimen was collected in Sitka, Alaska, by J. J. McLean.

The Fraser River tribes in British Columbia illustrate also what is said about the power of suggestion in modifying form, and even structure, in an art. The bulk of their stalwart baskets are made for cooking and harvesting apparatus. But where the Hudson Bay Company's and Malayo-Pacific packages came into view, another class of baskets appeared, fashioned in their shapes and ornamented over their entire surfaces (see Plates 43 and 44)

In Religion

The one who carried the sacred basket in the Greek religious processions was called the Kanephoros, and it will be remembered that in the consecration of Aaron and his family to the priesthood, among the multitude of paraphernalia was the basket of shew bread.*

In one tribe, at least, of American aborigines—the Hopi of northeastern Arizona—bread consecrated to the service of religion is set before the altar in beautiful plaques of coiled and wicker basketry, on which the emblems of religion are wrought in colours.

By religion is meant beliefs about a spirit world, with all its inhabitants and their relations with mankind; this is creed, and cult, or worship. "The best for the gods" is the talisman in the rudest faiths as in the highest. So it will be found that basketry devoted to religion is worthy of its object.

* Leviticus, viii, 2.

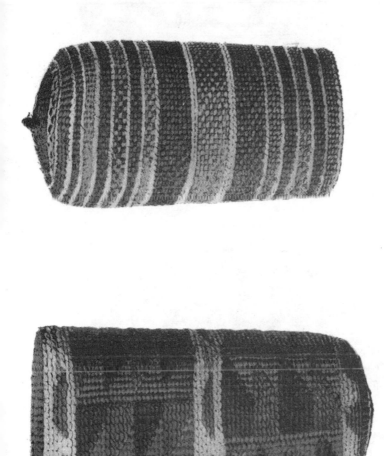
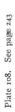

Plate 108. See page 243

TLINKIT TWINED AMMUNITION HOLDER

Adaptation of form to Russian demands; the weaving and patterns are aboriginal

Collected by James G. Swan

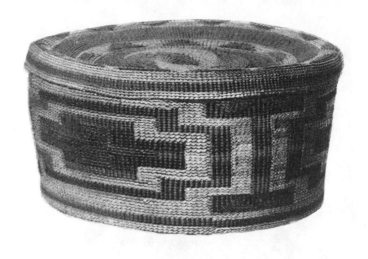

Plate 109. See page 244

TLINKIT WOMAN'S TWINED WORK-BASKET

Ornamented in false embroidery

Collected by J. J. McLean

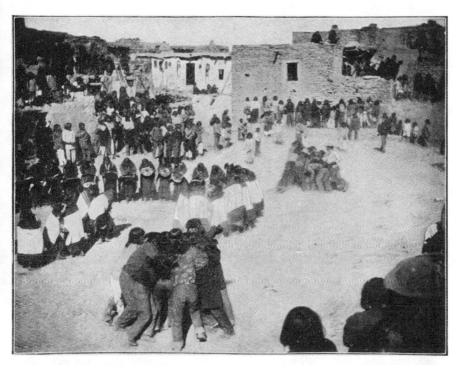

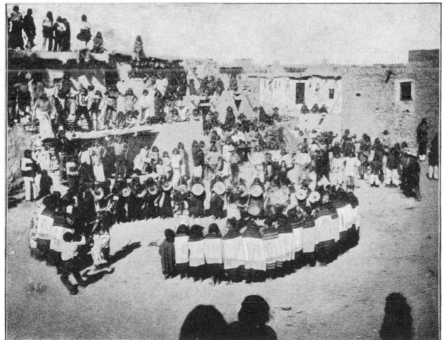

Plate 110 See page 240.

BASKETS IN HOPI CEREMONY

After J. Walter Fewkes

Plate III. See page 247

Baskets Used in Hupa Woodpecker Dance, California

Photographed by A. W. Ericson

In the autumn, during the months of September and October, the Hopi Indians of northeastern Arizona celebrate their basket dances. They have been studied by J. Walter Fewkes and J. G. Owen. The basket dance is a public exhibition, closing a series of secret rites, the whole festival being called *Lalakonti*. It is rather a posturing of the body in rhythm, together with songs, during which baskets are carried by women or thrown as gifts among the assembled spectators.

Those taking part in these dances are in two groups—the basket bearers, or chorus, and the basket throwers, or *Lakone manas*. The only man participating is a priest called the *Lakone taka*.

The costumes of the participants, the method of holding and throwing the baskets, and the struggles of the men for the specimens, are all carefully described by Dr. Fewkes.*

In archeological studies at the Chevlon ruins, about fifteen miles east of Winslow, Arizona, a large amount of basketry was found in the graves. Much of it had the form of plaques like those still used in Oraibi and the Middle Mesa. The inhabitants of the old pueblos at Chaves Pass were also clever basket-makers, and had the same beliefs as their descendants concerning the kinship and close relationships of life between spirit beings and men.

With reference to these basket dances, Dr. Hough says the baskets used are shallow, circular trays, either coiled or wicker, invariably of Hopi manufacture, and all decorated in colours. The designs on the *Lalakonti* baskets are various, and there seems to be a greater use of symbolic figures than in those specimens commonly offered for sale. In some examples the designs are conventionalised merely to the extent of adapting them to the field of the basket and the exigencies of the weaving. In most cases, however, the design is in the last stages of convention and the original motive is lost.

* J. Walter Fewkes, Journal of American Folk-Lore, XII, 1899, pp. 81 to 96

Plate 110 shows the portion of the Hopi *Lalakonti* ceremony in which occur the dance of basket bearers and the struggle for baskets.

The uses of baskets of the plaque type by the Moki may throw light on the reason for their occurrence in the "basket dances." In the household these plaques are devoted to various purposes; ground meal is heaped upon them in high cones by the grinders, or dry food, such as piki bread or dried peaches, is served in them. A basket being difficult and laborious of construction, and high-priced, besides being easily soiled and unsuitable for the uses to which pottery is put, is

FIG. 109.
CEREMONIAL BASKET.
Hupa Indians, California.
Collected by P. H. Ray.

employed in cases of nicety, or, one might say, of luxury. Whenever presents are exchanged, it is proper to carry them on basket trays.

Baskets form an important part of the paraphernalia of the religious fraternities, being used to at least as great an extent as pottery for containing sacred meal, the prayer-stick, offerings, etc. Usually, new plaques are prepared for sacred use upon the altars and in the service of the fraternities, notably the *Lalakonti*. It may be found that plaques are almost entirely of ceremonial import.

Sometimes baskets are placed on the walls of rooms as a decoration. This was observed at Sichomovi, where a frieze

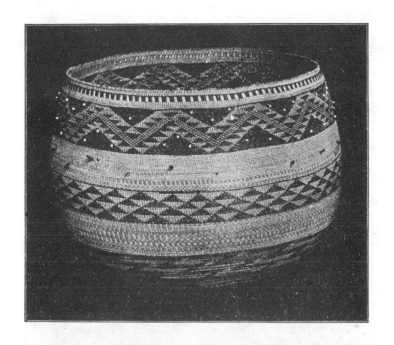

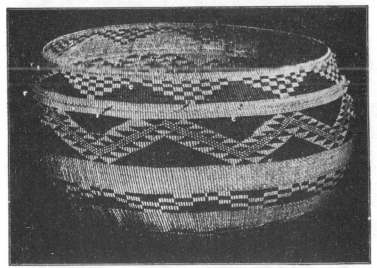

Plate 112. See page 247

GIFT, AND ALSO WEDDING BASKETS OF THE POMO INDIANS, CALIFORNIA

Collection of C. P. Wilcomb

Plate 113. See page 247

POMO WEDDING OR JEWEL BASKETS, ADORNED WITH FEATHERS AND
SHELLS, CALIFORNIA

Collection of C. P. Wilcomb

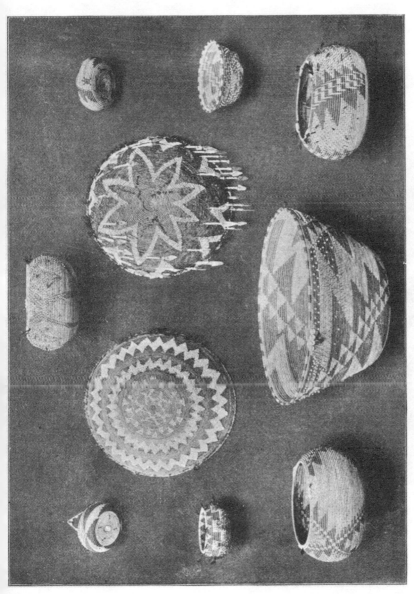

Plate 114. See page 247 POMO WEDDING OR JEWEL BASKETS, ADORNED WITH SHELL
BEADS AND MONEY, CALIFORNIA

Collection of C. P. Wilcomb

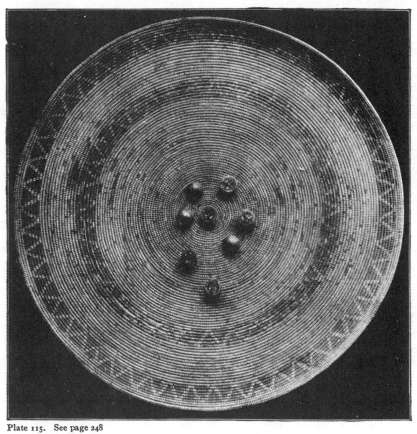

Plate 115. See page 248

YOKUT GAMBLING MAT, WITH DICE MADE OF WALNUTS, TULARE CO., CAL.

Collections of U. S. National Museum

of Coconino baskets decorated a room in the house of Wa lu tha ma.

The use of baskets in religious ceremonies by the Navaho Indians is described in Dr. Matthews's paper, The Mountain Chant, a Navaho Ceremony. (See page 516.) Among the Yaquis of northern Mexico baskets are used for holding palms, which they use in their sacred ceremonies. The Hupa Indians, on the Hupa Reservation, in one of their dances hold in their hands baskets, examples of which were collected by Captain Ray, of the United States Army, and illustrated in the Smithsonian Report for 1886, Plate XI, fig. 45 (see fig. 109).

Professor P. E. Goddard* describes the use of this basket in the ceremony (see Plate III from a photograph by A. W. Ericson).

In Social Life

Baskets played a rôle in the etiquette of the Indians. The Choctaws, in sending a gift of fruit, use a heart-shaped basket to convey a sentiment of sincerity. (See Plate 134.) The wedding basket of the Pomos is an exquisite production in twined-weaving. During a marriage festivity the bride's mother presents her son-in-law with a large, handsome basket, which he must immediately fill with cakes and pine sugar for the guests. It is thereafter known as chi-mó pi-ká, or dowry. On such occasions the artist is incited by a combination of powerful motives to do her best. Among the same Indians the gift basket, presented by the maker as a token of friendship, is a masterpiece not only in fineness, but in the exquisite sentiments of its design. In the National Museum are good examples both of the wedding and of the gift baskets. (See Plates 112–114.)

The Gualala style of gambling, says Powers, prevails all over the State, but the Tulare have another sort, which pertains exclusively to the women. It is a kind of dice throwing, and is called U-chu-us. For a die they take half of a large acorn,

* See Life and Culture of the Hupa, University of California, 1903.

or walnut shell, fill it level with pitch and pounded charcoal, and inlay it with bits of bright-coloured abalone shells. For a dice-table they weave a very large, fine basket-tray, almost flat, and ornamented with devices woven in black or brown, mostly rude imitations of trees and geometrical figures. Four squaws sit around it to play, and a fifth keeps tally with fifteen sticks. There are eight dice, and they scoop them up with their hands and dash them into the basket, counting one when two or five flat surfaces turn up. (See Plates 115, 116.)

The rapidity with which the game goes forward is wonderful, and the players seem totally oblivious to all things in the world besides. After each throw that a player makes, she exclaims *yet-ni* (equivalent to "one-y"), or *wi-a-tak*, or *ko-mai-eh*, which are simply a kind of sing-song or chanting. One old squaw, with scarcely a tooth in her head, one eye gone, her face all withered, but with a lower jaw as of iron, and features denoting extraordinary strength of will—a reckless old gambler, and evidently a teacher of the others—after each throw would grab into the basket and jerk her hand across it, as if by the motion of the air to turn the dice over before they settled, and ejaculate *wi-a-tak*. It was amusing to see the savage energy with which this fierce old hag carried on the game. The others were modest and spoke in low tones, but she seemed to be unaware of the existence of anybody around her.*

The plates show two varieties of the Yokut gambling trays—the flat and the dished. The former is in the National Museum, collected by W. H. Holmes; the latter is in the C. P. Wilcomb collection, collected on the Tule River.

In Trapping

One of the earliest and most primitive uses of basketry textile was in connection with the capture of animals. In a paper on traps, published by the Smithsonian Institution,†

* Contributions to North American Ethnology, III, 1877, pp. 377, 378.
† Report of the Smithsonian Institution, 1901, pp. 461–473.

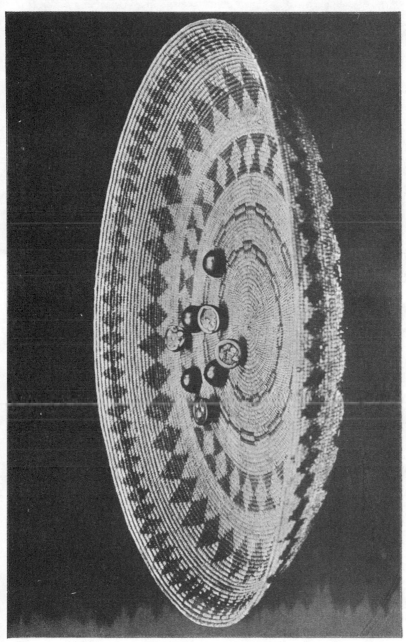

Plate 116. See page 248

GAMBLING MAT AND DICE FROM TULARE COUNTY, CALIFORNIA

Collection of C. P. Wilcomb

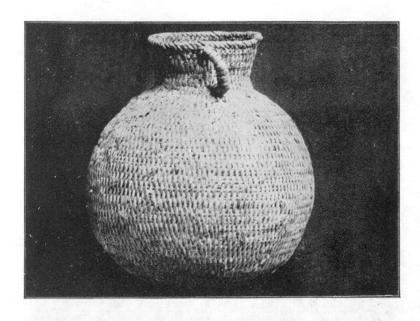

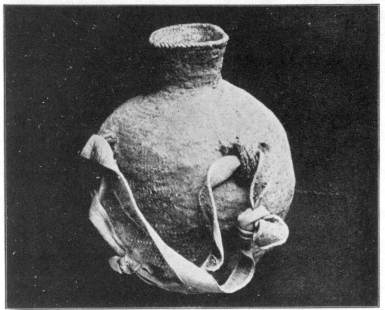

Plate 117. See page 251

PITCHER AND JUG FOR HOLDING AND TRANSPORTING WATER.
PAIUTE INDIANS, NEVADA

Collections of U. S. National Museum

the word *trap* is defined as "an invention for inducing animals to commit self-incarceration, self-arrest, or suicide." The basketry traps are used principally for penning or impounding animals, and not for killing them. In every one of the areas mentioned, coarse wickerwork or twined weaving are used in this function, and there is little doubt that many of the very finest processes of weaving by hand were derived originally from coarse work of this character.

The Pomo Indians make a trap for catching fish from *Juncus effusus*. The interesting feature about these objects is that they are a gross production in brush of the rare Mohave carrying basket, in which the weft is wrapped once about each warp element in passing.

In Carrying Water

Nearly everywhere throughout the Western Hemisphere the Indian was encamped near springs of water, and in his journeys about, for hunting and other purposes, knew always where to obtain it. An exception to this is the arid region of the western portion of the United States.

Among the Shoshonean tribes, and in the pueblos, seeking out, carrying, and storing water were the chief industries, and most of the religious ceremonies and prayers were with reference to rain.

The canteen and the larger carrying jar among the sedentary tribes was of pottery, but with the Utes, Apaches, and other unsettled tribes these vessels were of water-tight basketry, made with round or conical bottom, so that in settling on a level the center of gravity would bring the vessel into an upright position and thereby keep the water from spilling. (Plates 32, 33.)

The transportation and storage of drinking water is one of the functions of pottery. Aquarius, the water-bearer of the sky, is represented with a jar in his hands, and the spirits that haunt the springs in classic mythology are all of them friends

of the potter. The Indians of the Atlantic area were well supplied with water and had vessels of clay. The Eskimo made bottles of sealskin; so did the tribes of the Pacific coast, as far south as the Columbia. But in the Interior Basin of the United States, Indians of the Shoshonean, Athapascan, and Yuman families substitute basketry for pottery in their canteens, jugs, pitchers, and small tanks. These are made in coiled or twined ware, and sealed with pine tar in the north and asphaltum in the south. It is probably owing to the unsettled life of these tribes that they out and out invented this ingenious substitute for fictile ware. There is no lack of clay, for pueblos in the midst of the region are the last strongholds of Keramos in America. And there was in prehistoric times no lack of pottery here, as the supply of charming whole pieces and precious fragments bears witness.

The most interesting connection of hydrotechny with basketry was discovered in a cliff-dwelling three miles north of White River Agency, on the White Mountain Apache Reservation, Arizona, by Charles L. Owen, of the Field Columbian Museum, Chicago. Baskets, without bottoms, were built on the floor of the cavern. The warp was of willow shoots with the leaves on. The weft was in juniper and willow twigs, in twined weaving or wattling. The interstices were filled with puddled clay, to make them useful receptacles for water, which had to be transported from the canyon 300 feet below. An example brought away, No. 68,876, in the Field Columbian Museum, measures 4 feet 10 inches in diameter and is 15 to 20 inches in height. (See Plate 102.)

The occurrence of basketry water receptacles is a good problem in the study of the parallelism of subjective and objective forces which originated and developed special arts in primitive times everywhere. In this particular example, the originators of cement-tightened baskets had good textile material, knew the arts of weaving them, were on the move in desert countries where water sources were far apart, and

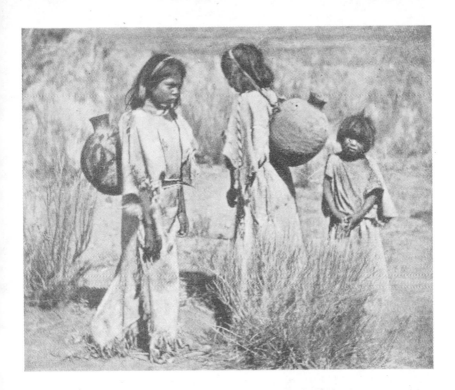

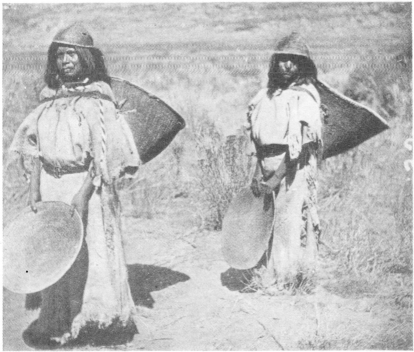

Plate 118. See page 251

PAIUTES, OF NEVADA, CARRYING WATER AND HARVESTING SEED

Photographs and Specimens collected by J. W. Powell

could easily secure the pine sap or the asphaltum for tightening purposes.

Plate 117 illustrates the water jug or pitcher of larger size, called O-oats by the Paiutes. Most of these are in coiled weaving, but even there a variety of technic is shown both in the foundation and in the sewing.

The upper figure is a pitcher-shaped water-carrier with globular body, used also for holding seed. The coiled foundation is of two or more rods, the stitches are wide apart, and overlap in what is called in Pomo, *tsai* work. The border is in oblique coiled sewing, and the handle is an afterthought set on the neck. Its height is 10 inches. This specimen, Cat. No. 11,249 in the National Museum, was collected in southern Utah by Major J. W. Powell.

The lower figure is a much neater specimen, in which the foundation is a single rod, and, in the sewing, the stitches simply interlock with those underneath, giving a very much more regular form to the surface. The border is in oblique coiled sewing. There are lugs on the side for the purpose of carrying, and the head-band is of soft deerskin. This specimen is Cat. No. 11,876 in the U.S.N.M., and also was collected in southern Utah by Major J. W. Powell.

The Powell collection contains a large number of these carrying jars in coiled work. They differ in the form of the body somewhat and in the length and shape of the neck, but in other respects, in structure and function, they are the same.

Plate 118 shows two Paiute girls carrying water in two water-tight jars of basketry, the straps, of soft buckskin, passing over the top of the head. Older persons of the same tribe are shown below, as gleaners, with the carrying bands across the shoulders and breast. The hats, of basketry, on their heads serve many purposes, being gathering baskets and mush bowls in addition to costume. The baskets in their hands are for fanning and roasting the chaff from the seed. (Plate 118.)

ALPHABETICAL LIST OF USES

Armour made of slats and rods woven together.

Awning mats in front of cabins.

Bags for everything: for gathering, carrying, and storing, made in every quality.

Bait holding.

Ball-playing raquets.

Bases for pottery making (primitive wheel); also forms for portion of vessels.

Beds of matting in basketry.

Boiling baskets, for cooking flesh or mush.

Bread, mixing or serving.

Burden baskets in endless varieties.

Burial caskets and deposits.

Cages for insects, birds, etc.; also for children on Sioux travois.

Canoe covers, for cargoes (Swan).

Canteen, for personal water supply.

Cape, poncho, or other garment to cover the shoulders, both in a n i m a l and vegetable fiber.

Carrying basket, an immense class, with infinite variety of form and universal distribution.

Carrying chair, Guatemala and Peru.

Ceremonial objects; trays in rites and before altar, carried in dances, struggled for, etc.

Chef-d'œuvres, to show the best one could do.

Chest for treasures, regalia, and fine costume.

Children's toys; imitations of more serious objects.

Clothing; robes of twine, with or without feathers; hats, jewelry, capes, fringes, petti- c o a t s , leggings, moccasins, and receptacles for these.

Coffins of canes and reeds wattled together.

Cooking baskets, used with hot stones.

Cradles or papoose frames, quite widely distributed.

Creels, all varieties of fishermen's baskets.

Cremation baskets, burned at the woman's grave.

Cult baskets, Hupa basket wand (Ray), Hopi plaque (Fewkes).

Curtain mats for partitions.

Cushions in boat and kaiaks.

Dance baskets, used in ceremonies.

Ditty baskets for small articles of hunters.

Dress. (*See* Clothing.)

Drinking baskets or cups.

Drum, in Navaho ceremony.

Drying tray for fruit, seeds, etc.

Eagle traps and cages.

Etiquette baskets, for giving away on the proper occasion.

Fences of coarse basket technic; hunting fences.

Fine art in basketry.

Fish, holding, transporting, creels, bait baskets.

Fish trap, fish weirs, fykes, etc.

Food-serving baskets.

Foundations for pottery.

Fringes on garments, in refined basket technic.

Furniture in basketry.

Gambling baskets.

Gathering or harvesting.

Gift baskets.

Granary or storage.

Grasshopper baskets, so-called.

Hammocks in basket work.

Harvesting, fan or wand for beating seeds.

Hats for men or for women.

Head-rings, olla rings for carrying.

Hedges, employed chiefly in game drives.

Hoppers, for acorn and other mortars.

Houses, walls, roofs, floors, doors, and other parts.

Inclosures for the beginning of domestication.

Insect cage, for lighting and other purposes.

Jewel baskets, chef-d'œuvres of woman's art.

Jewelry, woven in finest material for ornament.

Leggings in twined weave.

Lined with clay for cooking.

Love baskets.

Marks on pottery.

Meal trays, useful and sacred.

Medicine, associated with sorcery.

Milling outfit, grinding, hoppers, brushes, sieves, etc.

Moccasins or sandals.

Money, mechanism of exchange.

Mortuary baskets of many kinds and functions.

Moulds for pottery.

Mud sandals, Klamath, for going in marshes.

Mush bowls for mixing or serving.

Musical instruments, rattles and drums.

Offerings of food to dead, and mortuary objects.

Paho, or prayer-stick wrappings (ancient graves).

Panniers, with saddles.

Papoose baskets.

Partitions for dwellings.

Patterns for pottery.

Picking baskets, for gathering nuts and fruits.

Pitcher basket, with wide mouth.

Plaques, for meal.

Plates or platters.

Ponchos. (*See* "Capes.")

Pottery. (*See* "Marks on Pottery"; also used to line roasting trays.) (Cushing.)

Prayer basket, Pahos.

Preparing food, mixing mush, bread, etc.

Quivers.

Raquets for ball-playing.

Receptacles of all sorts, for c o o k e d food, d r i e d fish, and all kinds of preserved meats and fruits. The basket-maker h e r s e l f keeps her s p l i n t s and stems in a basket.

Religion, used in services of.

Roasting trays, for parching seeds.

Robes of shredded bark.

Roof of basketry.

Sacred meal trays.

Saddlebags, of late application.

Sails, in both continents.

Seats, at home, in boats, etc.

Seed baskets, harvesting, carrying, and storage.

Seed beater, for harvesting.

Serving food, for single persons or a company.

Sieves, for screening or for shaking.

Skirts, both of common and ceremonial dress.

Sleeping mats.

Storage, fish, berries, pemmican, acorns. All tribes stored some kind of food.

Trade, medium of.

Treasure baskets, those considered treasures.

Trinket and feather storage, also herbs, gum, paint, etc.

Vizors of Katchina masks, made from segments of coiled basketry (Ute type), Hopi.

Washbowl, in ceremonies.

Water bottles, drinking cups, etc., of basketry dipped in pitch.

Water transportation, rafts of cane, mats for sails.

Wedding blanket or cover.

Winnowing baskets for seeds.

Zoötechny, or the arts associated with animal life.

CHAPTER VII

Ethnic Varieties of Basketry

For all arts belonging to humanity have a common bond and are
included, as it were, in the same kinship.—Cicero.

THE technical processes, the decorations, and the symbolism
that may exist in the single basket having been scrutinised,
it is in order to examine the geographic distribution of these
forms in relation to ethnology and environment. Geography
has much to do with human enterprises. It does not furnish
the ingenious mind nor the skilful hand, but it does supply
the materials for their exercise and set bounds in which the
mind and hand soon discover how to reach their best.

America was, in aboriginal times, unequally occupied by
native peoples. On the Atlantic slope in both continents vast
areas were in possession of single linguistic groups, called
families. On the Pacific slope there were also a few influential
families, but the rule was otherwise. Wedged in among the
mountains, wherever there was an inclosure abounding in food
supply, there were crowded what seemed to be shrivelled rem-
nants of once larger peoples, or fragments of disrupted families.

At once arises the query, Did they bring with them and
preserve uncontaminated the stitches and patterns of their
priscan basketry and keep the ancient models unchanged?
It is to be feared that they did not, and that is why the eth-
nologist becomes embarrassed in trying to harmonise ethnology
and technology. There are, notwithstanding, certain general
effects which may be associated with definite peoples.

1. In the eastern region the prevailing families were Algon-
quian, Iroquoian, Muskhogean, Caddoan, and a few remnants
of smaller ones, in some instances numbering at present less

than a hundred persons. The Siouan and other buffalo-hunting tribes on the plains will be slightly noticed because the hide of the slain animals furnished them with receptacles as well as other conveniences of life. The basketmakers in their territory belonged elsewhere.

2. In the Alaskan region an interesting state of affairs existed with reference to the matter here investigated. In the interior of the peninsula are the Athapascan (or Tinné) tribes. Around the coast-line dwell members of the Eskimauan family, having entirely different materials, workmanship, and technical processes. It will be seen later that the Eskimo as a whole are not skilful basketmakers. There has been contact, however, between the two linguistic families. The Aleutian peoples are very different in this art from the Eskimo, their ware being among the most highly admired on the continent. In southeastern Alaska the Koloschan family are found, who are different from the Athapascans in the interior of the peninsula in that they do not make coiled basketry at all. The same is true of the Haida or Skittagetan family, in the Queen Charlotte Islands.

3. In the Fraser-Columbia region, including the drainage of these great rivers, the Salishan family, the Wakashan, the Shahaptian, and the Chinookan are the present basket-making families. As in the Siouan country, so here, a few small fragments or survivals fill in the gaps and waste places, but they contribute little to the technical processes involved. In the discussion of basketry in this province a special characteristic will be brought out.

4. The California region, including also southern Oregon, is the most mixed of all in its ethnology. Many stocks of people whose languages are not known elsewhere, and many fragments of stocks that have a larger existence in other parts of America, are wedged into the mountain valleys and drainages of the streams. Nature has been most lavish here in her materials, and the finest textile plants for making baskets are

to be found in California. The diversity of technic is almost as great as that of language. Few styles of weaving or coiling exist that do not have their representatives among this interminable labyrinth of valleys.

5. The Desert, or Interior region, is occupied in its northern portion by the great Shoshonean family, which extends from the forty-ninth parallel to Costa Rica, pushes its way over the Rocky Mountains into the Mississippi drainage, and across southern California to the Santa Barbara Islands on the Pacific coast, giving and receiving technical suggestions on its way. In the southern portion of this interior region, Athapascan (both Navaho and Apache), Yuman, and Piman tribes are basketmakers.

6. The sixth region includes Middle and South America, not because all the basketry in these regions is on the same plane, but owing to the small collections received from these quarters. A great portion of it is in the torrid zone, where palm leaf and tough cane and reeds await the basketmaker. There will be missing characteristics of the North American tribes, and also local weaves will appear worthy of study.*

Unlike pottery, this fabric is not destroyed by frost, so that wherever textile material could be obtained there was no meteorological reason why the basket should not be forthcoming. The Athapascans of Alaska and northwestern Canada, possessed of both willow and spruceroot, at once developed the coiled ware which their kindred, the Apache, are still making in Arizona.

East of the Rocky Mountains, in the Atlantic drainage of Canada and the United States, at the present time checker

* The author acknowledges that many statements made in this ethnic portion of the work are at second hand and he has been fortunate in being able to consult men of expert information. The Hudson and the Merriam collection, in Washington City, the Benham, Tozier, Emmons, Teit, Long, Whitcomb, McLeod, and others of the west coast, have been placed cheerfully at his disposal. To Mr. C. C Willoughby, Dr. Boas, Mr. Pepper, Dr. Dorsey, Dr. Dixon, Dr. Kroeber, and others mentioned in these pages, he is indebted for constant favours. He hopes that errors will be condoned.

and willow work are practised almost universally; but in the mounds of the Ohio Valley quite well-diffused twined ware is found. The Gulf province afforded excellent cane (*Arundinaria macrosperma, Arundinaria gigantea, Arundinaria tecta*), and here, both in ancient times and in modern, diagonal plaiting of basketry and matting was prevalent in all tribes. The Plains region in its central portion relied chiefly on the hide of animals for its receptacles. But around its borders will be found intrusive processes of manufacture in twined, diagonal, and coiled workmanship.

On its Pacific slope North America is the home of basketry. From Attu, the most westernmost island of the Aleutian chain, to the borders of northern Mexico, is to be found practically every type of this art.

In Middle America, including southern Mexico and the Central American States, pottery was exalted among receptacles, and excellent fibers usurped the function of the coarser pliable materials of basketry.

Owing to differences of climate, rainfall, and other characteristics of environment, the materials for basketry vary greatly from region to region throughout America, and this in spite of all ethnic considerations. Again, the motives for the use of basketry differ from place to place, so much so that peoples of one blood make one ware in this place and another in that. Finally, however, it must never be forgotten that the ideas, utilitarian and artistic, in the minds of the manufacturers themselves, serve to bestow special marks upon the work of different tribes so as to give to them ethnic or national significance under any circumstances. In the following chapters the typical forms of the various families of Indians will be illustrated.

Were there no mixture of tribes, it might be possible to state in every case the maker of each specimen from the technic and the ornamentation, though this opinion must be held with reserve. Throughout the entire continent the practice of

capturing women was common; in each case the stolen ones carried to their homes the processes they had been familiar with in their native tribe. The Twana Indians on Puget Sound practice ten different methods of basket-making; the Pomo Indians have eight processes; the Hopi Indians of Arizona have at least five. It is well known that these tribes belong to synthetic families. In order to comprehend the extent of this relationship between the tribe and the art, the various basket-making groups will be defined and the types of their work illustrated. (See Plates 154, 155.)

The mixing of basketwork from the travelling about of women is well illustrated in the story of Maria Narcissa, told by E. L. McLeod, of Bakersfield, California. Maria was born at San Gabriel Mission and brought up in Tejon Canyon. There she retained the knowledge of her native speech and learned the dialects of the surrounding tribes. She married an American, reared and educated a large family of children, and is still living. On her testimony, tribes from the north as far up as Tule River would come down to Tejon for social and religious purposes, hold great feasts and dances, and gamble on the gaming plaques. Parties came longer journeys from San Fernando, San Gabriel, Ventura, Santa Barbara, and Santa Ynez, and Mr. McLeod finds undoubted evidences of these meetings in the technic and the decorations on basketry. (See Plates 115-116.)

From the Tule River country there came the beautiful flexible work, an improvement on the Fresno ware. But the Tejon basketry excelled, the pieces were better finished, there was more emulation, a greater variety of patterns, showing the influence of both north and south.

There was trading of materials likewise, for you will see fine old pieces from the caves on the Tejon with mission bottoms and Tejon tops, also old specimens from caves in Santa Barbara County which were made in Tejon. The student of basketry suffers another embarrassment in common with the

naturalist, namely, the fact that the place of procuring a specimen is not the same as that of its origin. Finally, a basket may have two or more names that are really synonyms, as Tulare, Yokut, and Mariposan, and, finally, while in a collection like that of Doctor Merriam the student cannot go astray for his tribe, in the myriads of desultory gatherings the owners themselves are never sure of the source.

List of Basket-Making Tribes

The following list includes the names of those tribes known to collectors as makers of any kind of basketry, especially in North America, together with the linguistic families to which they belong, and their locations.

Abenaki, Algonquian family, Maine and Canada.

Aleut, Eskimauan family, Aleutian Islands.

Algonquian family, northern frontier and Canada, many tribes.

Apache, Athapascan family, See Chiricahua, Jicarilla, Mescalero, San Carlos, White Mountain, in Arizona, New Mexico, and Oklahoma.

Apache-Yuma, Yuman family, Palomas, Yuman County, Arizona.

Arapaho, Algonquian family, Shoshoni Agency, Wyoming; and Oklahoma.

Arikara, Caddoan family, Fort Berthold, North Dakota.

Ashochimi, Yukian family, near Healdsburg, California.

Atsuge. See Hat Creek, branch of Pit Rivers.

Attakapa, Attakapan family, southern Louisiana.

Attu Island. See Aleut.

Auk, Koluschan family, Gastineaux Channel, southeastern Alaska.

Basket Makers, Ancient Shoshonean family, Grand Gulch, southeastern Utah.

Bella Coola. See Bilhula. Bella Bella.

Bilhula, Salishan family, northwestern British Columbia.

Cahuilla. See Coahuilla.

Calapooia, or Kalapuya.

Calpella, Kulanapan family, Ukiah, California.

Carriers. See Thompson Indians.

Cayuse, Waiilatpuan family, Umatilla Agency, Oregon.

Chaves Pass Ruin, Hopi pueblo, Arizona.

Chehalis, Salishan family, Chehalis River, Washington.

Chemehuevi, Shoshonean family, southern Arizona and California boundary.

Cherokee, Iroquoian family, North Carolina and Indian Territory

Chetimachas, Chetimachan family, Louisiana. Also written Shetimachas.

Chevlon Ruins, Hopi pueblo, northeastern Arizona.

Chickasaw, Muskhogean family, Indian Territory.

Chilcotin, Athapascan family, Tsilkotinneh or Chilkyotins, distinct from Carriers, British Columbia.

Chilkat, Koluschan family, southeastern Alaska.

Chinook, Chinookan family, southeastern lower Columbia River, Washington.

Chippewa, Algonquian family, northern United States.

Chiricahua Apache, Athapascan family, Arizona and Oklahoma.

Choctaw, Muskhogean family, Louisiana.

Chukchansi, Yokut tribe, Mariposan family, Sierra region, California, between Fresno Creek and San Joaquin River.

Clallam, Salishan family, Washington.

Clatsop, Chinookan family, Clatsop County, Oregon.

Coahuilla, Shoshonean family, Coahuilla, Kawia, Kauvuya, Agua Caliente, Santa Rosa, Cabezon, Torres, Twenty-nine Palms, and Cahuilla reservations, California; also Saboba, southern California.

Cocahebas, Shoshonean family, Burr Valley, California.

Coconinos. See Havasupai, Yuman family.

Cocopa, Yuman family, near Mexican boundary, Arizona, and Lower California.

Comanche, Shoshonean family, Indian Territory.

Concow, Pujunan family, Round Valley, California.

Coos, Kusan family, Coos County, Oregon.

Coquille, Kusan family, Coos County, Oregon.

Couteau. See Thompson Indians.

Cowlitz, Salishan family, Cowlitz River, Washington.

Coyotero Apache, Athapascan family, southern Arizona.

Coyuwee. See Paiutes.

Creeks, Muskhogean family, Southern States and Indian Territory.

Diegueños, Yuman family, San Diego County, California.

Capitan Grande, Sequan, Santa Ysabel, Campo, Cuyamaka, and Morongo reservations.

Diggers, Pujunan family (a popular name applied to vegetarian tribes), California, east of the Sacramento. See Maidu.

Eel Rivers, Athapascan family. See Flonko.

Eskimo. Eskimauan family, Arctic America.

Flathead, Salishan family, misnomer for Salish.

Flonko or Lolonkuh, Athapascan family, Eel River, California.

Fraser River, Salishan family, British Columbia.

Galice Creek, Athapascan family. Siletz reservation, Oregon.

Gallinomero, Kulanapan family, Cloverdale, California.

Garotero, Athapascan family. (Same as Coyotero.)

Gualala, Kulanapan family, Mendocino County, California.

Haeltzuk, Wakashan family, British Columbia.

Haida, Skittagetan family, Southern Alaska, Dall, Prince of Wales Islands, Queen Charlotte Islands, and British Columbia.

Hat Creek, Palaihnihan family, northeastern California, branch of Pit Rivers.

Havasupai, Yuman family, Cataract Canyon, Arizona.

Hoh, Chimakuan family, Neah Bay, Washington.

Homolobi, ancient ruin near Winslow, in Arizona.

Hoochnom, Yukian family, Round Valley, California, Eel River.

Hoonah, Koluschan family, Cross Sound, Alaska.

Hootz ah tar, Kaluschan family, Alaska.

Hopi, Shoshonean or Hopian family, Pueblos, northeastern Arizona. Wrongly Moki.

Hualapai. See Walapai.

Huicholes, Piman family, Zacatecas, etc., Mexico.

Hupa, Athapascan family, Trinity River, California.

Iroquois, Iroquoian family, northern frontier and Canada.

Jicarilla Apache, Athapascan family, northern New Mexico, Jicarilla Agency.

Kabinapo Pomo, Kulanapan family, Clear Lake, California, western part.

Karok, or Cahroc, Quoratean family, Klamath River, California, Lower Salmon River, and down Klamath to a few miles above Waitspeh.

Kaweah, Mariposan family, middle California, not Coahuilla.

Klamath, Lutuamian family, Klamath County, Oregon.

Klikitat, Shahaptian family, Yakima Reservation, Washington, Klikitat County, Oregon.

Kohonino, Yuman family, near the Havasupai.

Kwakiutl, Wakashan family, British Columbia.

Lillooet, Salishan family, western British Columbia.

Little Lakes, Kulanapan family, Round Valley Reservation, California.

Lolonkuh, Athapascan family, Eel River, California.

Luiseño or San Luis Rey Mission, Shoshonean family, Mesa Grande, Potrero, Temecula, Rincon, Los Coyotes, Pauma, and Pala reservations, villages at San Luis Rey, and San Felipe, California.

Lummi, Salishan family, north Puget Sound, Washington.

McCloud or Winnemem, Copehan family, northern California.

Maidu, Pujunan family, east of Sacramento River, California, Sacramento to Honey Lake, from Big Chico Creek to Bear River, California.

Makah, Wakashan family, Cape Flattery, Washington.

Makhelchel, Copehan family, Clear Lake, California.

Mandans, Siouan family, North Dakota.

Maricopa, Yuman family, southern Arizona.

Massawomekes, Iroquoian family, on northern Chesapeake.

Mattoal, Athapascan family, northwestern California.

Mayas, Mayan family, Yucatan and lands adjacent.

Melicite, Algonquian family, Quebec and New Brunswick.

Menomini, Algonquian family, northeast Wisconsin.

Mescalero Apache, Athapascan family, Mescalero Agency, eastern New Mexico.

Mew-as or Mu-was. See Miwok.

Micmac, Algonquian family, Nova Scotia, New Brunswick, and Quebec.

Missions, a great many villages, Shoshonean and Yuman families, southern California.

> Agua Caliente (Shoshonean), a rancheria in western San Diego County.
>
> Augustine (Shoshonean).
>
> Coahuilla, Kawia (Shoshonean).
>
> Comoyei, Yuman family, all Yuma dialects between Lower Colorado River and Pacific Ocean and 32° to 34° north, Comoya, Quemaya, called Diegueños on the coast.
>
> Cuchan, Yuman family, Yumas so called.
>
> Cupania, in Agua Caliente.
>
> Diegueño, Yuman family, in Capitan Grande, Campo,

Missions—(Continued.)

Cuyamaka, Inaja, Sequan, Santa Ysabel, Mesa Grande, San Felipe, Manzanita villages.

Kawia, Shoshonean family. See Coahuilla.

Matayhoa, possibly the Diegueño village of Mataguay, in western part of San Diego County.

Piute, Shoshonean family, at Twenty-nine Palms.

Playanos, Shoshonean family, coast tribes of Coahuilla.

Saboba (School), Shoshonean family, Tahktam village, San Jacinto Valley.

San Felipe, Yuman family, a Diegueño rancheria of this name was seventy miles northeast of San Diego in 1883.

San Fernando, Shoshonean family, related to San Gabriel.

San Gabriel, Shoshonean family, also Kizh dialect, Tobikhar of Loew.

San Juan Capistrano, Shoshonean family, formerly Netela dialect, Gaitchim of Loew, called Juaneños.

San Lucania, Shoshonean family, also Cabezon, Potrero, Pala, Pauma, Rincon, Temecula, Puerto de la Cruz, Puerta Ygnacia, Torris, and Matajaui.

San Luis Rey (de Francis), Shoshonean family, formerly Kizh dialect.

Santa Inez. Same character of baskets as Santa Barbara.

Santa Rosa.

Serraño, Shoshonean family, Morongo, San Manuel, the Serraños or "mountaineers," formerly Tahktam, a division of Tabikhar.

Takhtam (men), Shoshonean family, called Serraños, dialect, Coahuilla.

Tule River, remnant of Tejon.

Yuma, Yuman family, evidently the Cuchan or present Yumas.

Miwok, Moquelumnan family, California, from the Sierra to the San Joaquin River, from Cosumne to the Fresno.

Modoc, Lutuamian family, Klamath Agency, Oregon, east of Shasta, north to Goose Lake Valley.

Mohave, Yuman family, between Fort Mohave and Ehrenberg, Lower Colorado River.

Moki or Hopi pueblos, Shoshonean family, northeastern Arizona.

Monos, Shoshonean family, sierras east of Yosemite, California.

Muckleshoot, Salishan family, Puget Sound, Tulalip Agency, Washington.

Nakum, Pujunan family. See Maidu.

Napa or Suisun or Solano, Copehan family, Sacramento River, California.

Natano, band of Hupa.

Navaho, Athapascan family, southern Utah, New Mexico, and Arizona.

Navarros, Kalanapan, Punta Arenas, California.

Nehalem, Salishan, Oregon.

Newooah (Nu-úah), Shoshonean family, Paiute Mountain, California.

Nez Percé, Shahaptian family, Nez Percé Agency, northern Idaho.

Nims, Shoshonean family, N. fork, San Joaquin River, California.

Nishinam, Pujunan family, Sacramento Valley, California.

Niskwalli, Salishan family, or Nisqualli, Columbia River, Washington.

Nomelaki or Numlaki, Copehan family, Round Valley, California.

Nozis, Yanan family, south of Pit Rivers, California.

Nutka, Wakashan family, West Vancouver Island. See Makah.

Ojibwa, Algonquian family, Michigan.

Opata, Sierra Madre, Sonora and Chihuahua.

Oraibi, Shoshonean family, a Hopi pueblo. (See Hopi).

Paiutes, Shoshonean family, Nevada agencies, Reno, Carson, and Wadsworth on central route of the Southern Pacific Company; Tule River Reservation, Kern River, White River, Poso Creek, Sierras near Walker Pass, eastern Nevada, Pyramid Lake, Schurz, Hawthorne, Virginia City.

Pakanepul, Shoshonean family, South Fork of Kern River, California.

Panamint, Shoshonean family, Death Valley, Inyo County, California.

Papago, Piman family, south of Tucson, Arizona, and Sonora, Mexico.

Patawat, Wishoskan family, Humboldt Bay to Arcata, California.

Patwin, Copehan family, Sacramento River, California.

Pawnee, Caddoan family. See Arikara.

Penobscot, Algonquian family, Old Town, Maine.

Peruvian, Kechuan family, Highlands of Peru.

Pima, Piman family, Gila River, Arizona.

Pit Rivers, Palaihnihan family, Pit River, California.

Pomo, many subdivisions, Kulanapan family, Mendocino and Lake counties, California.

Potter Valley, Kulanapan family, Round Valley, California.

Pueblos: of the Rio Grande, Tanoan, and Keresan families; those of the Zuñian family are in New Mexico; Shoshonean pueblos are in northeastern Arizona.

Puyallup, Salishan family, Puget Sound, Washington.

Queets, Chimakuan family, northwest Washington.

Quileute, Chimakuan family, northwest Washington.

Quinaielt, same as Quinaults, Salishan family, west Washington.

Redwoods, Yukian family, Round Valley Reservation, California.

Rees, or Arikara, Caddoan family, North Dakota.

Rogue Rivers, Athapascan family, Grande Ronde Reservation, Oregon.

Round Valley tribes. See Concow, Little Lakes, Nomelaki, Pit Rivers, Redwoods, Wailaki, and Yuki.

Saboba Mission, Shoshonean, southern California.

Salishan family, great variety of technic and many tribes, Washington and British Columbia.

San Carlos, Apache, Athapascan family, southeastern Arizona.

San Felipe pueblo, Keresan family, Rio Grande River, New Mexico.

Santa Barbara Mission, Moquelumnan family, southwestern California.

Santa Rosa Mission, Yuman family, San Diego County, California.

Santa Ysabel, Yuman family, San Diego County, California.

Seminole, Muskhogean family, Florida.

Shasta, Sastean family, in Shasta and Scott Valley, California.

Shoshoni, Shoshonean family, Great Interior Basin, Montana.

Shushwap, Salishan family, British Columbia.

Sia, Keresan family, New Mexico, a Rio Grande pueblo.

Sikyatki, ruin, ancient Hopi pueblo, northern Arizona.

Siletz, Athapascan family, Siletz Reservation, Oregon.

Sitka, Kaluschan family, Alaska.

Siwash, Chinook jargon for "Savage," general name for Northwest Coast Indians.

Skagit, Salishan family, North Puget Sound.

Skokomish, Salishan family, or Twana, upper Puget Sound, Puyallup Agency, Skokomish Reservation, Skokomish River, Washington.

Snohomish, Salishan family, upper Puget Sound, Tulalip Agency and reservation, northeast of the Skokomish.

Solano. See Napa.

Spokan, Salishan family, Montana and Washington.

Squaxin, Salishan family, Puget Sound.

Suisun. See Napa.

Tahchee, tribe of Yokuts on Tulare Lake.

Tarahumara, Piman family, Sierras of Chihuahua, Mexico.

Tarku, Koluschan family, Tarku Inlet, Alaska.

Tatu, Yukian family, Round Valley, United States Indian Agency, California.

Tejon, Tulares of Tejon Pass, Moquelumnan family.

Thompson Indians, Salishan family, also Couteau or Knife Indians, southern interior of British Columbia, mostly east of Coast Range, in valleys of Fraser, Thompson, and Nicola rivers.

Tillamuk, Salishan family, Tillamook County, Oregon.

Tinné, Athapascan family, name for tribes in Alaska and Canada.

Tlinkit, Koluschan family, southern Alaska.

Tolowa, Athapascan family, Crescent City, California.

Tonto Apache, Athapascan family, southern Arizona.

Towanhoo. See Twana.

Tsinuk or Chinook, Chinookan family, Columbia River, Washington.

Tulalip, Salishan family, Tulalip Reservation, Washington.

Tulares, Moquelumnan family, Tule River, California.

Tule Rivers, Mariposan family, southern California.

Twana, Salishan family, Puget Sound, Washington.

Ukie. See Yuki.

Umatilla, Shahaptian family, Umatilla and Morrow counties, Oregon.

Umpqua, Athapascan, Grande Ronde, Oregon.

Ute, Shoshonean, in Utah under many names.

Viard or Weeyot, Wishoskan family, Eel River, California.

Waiam, Shahaptian family, village rather than tribe, Des Chutes Rivers, Oregon.

Wailaki, Copehan family, Sacramento Valley, California.

Walapai or Hualapai, Yuman family, northwestern Arizona.

WallaWalla, Shahaptian family, Umatilla Agency, Oregon.

Wappo, Yukian family, Alexander Valley, California.

Warm Spring Apaches, Athapascan, Chiricahua, Mexico.

Wasco, Chinookan family, The Dalles, Oregon.

Washo, Washoan family, Reno, Carson, and Wadsworth, on central route of the Southern Pacific Company, western Nevada, Genoa, Gardenville Washoe, Franktown.

White Mountain Apache, Fort Apache Agency, eastern Arizona.

Wikchumni, Yokut tribe, Mariposan family, Kaweah River, California.

Wintun, Copehan family, Sacramento River, California.

Wuksatches, Shoshonean family, north of Kaweah River, California.

Wushqum, Chinookan, Columbia River, Oregon.

Yakima, Shahaptian family, Washington.

Yakutat, Koluschan family, Yakutat Bay, southeast Alaska.

Yamhill, Kalapooian family, Willamette Valley, Oregon.

Yana or Nozi, Yanan family, near Redding, California.

Yaqui, Piman, Sonora, Mexico.

Yoalmani, Yokut tribe, Mariposan family, Tule River Reservation, California.

Yoerkali, Yokut tribe, Mariposan family, Tule River Reservation, California.

Yokaia, Kulanapan family, Ukiah Valley, California.

Yokuts, Mariposan family, mid-California.

Yuki or Ukie, Yukian family, Round Valley, California.

Yurok, Weitspekan family, Klamath River, California.

Zuñi, Zuñian family, western New Mexico.

EASTERN NORTH AMERICA

For thus the tale was told
By a Penobscot woman
As she sat weaving a basket,
A basket or *abaznoda*
Of that sweet-scented grass
Which Indians dearly love.
—CHARLES GODFREY LELAND.

EASTERN North America will include the tribes east of the Rocky Mountains. Many of them are now basketmakers, but archeology is doing excellent service in helping to complete a map of this area in order to determine the distribution of the various technical processes that obtained in aboriginal times. The few types of the art that now survive must not be taken as covering the ground of ancient weaves. The recovery of the latter by the Bureau of American Ethnology, the Peabody Museum, and other explorations, is one of the most wonderful contributions of the spade to the ethnologist. Though basketry was anciently made of grass, hemp fiber, bark, young stalks, and sapwood, and for that reason is the most perishable of human manufactures, under favourable conditions salt mines, nitrous caves, the desert's aridity, metallic earths, and even fire have kindly preserved enough of the delicate textures to reveal the processes of weaving in vogue many centuries ago.

Indian women in the Mississippi Valley used to decorate the outsides of clay vessels by pressing string and basketry products on the soft material before burning. Thus they preserved the record of the art for all time. By applying modeller's clay to these ancient fragments the texture is at once revealed. In *Popular Science Monthly** will be seen account of experiments with these sibylline shards, by George E. Sellers. William H. Holmes simultaneously made larger investigations and published accounts of experiments by him on Mound Builders, and other ancient pottery of this area.† He carefully washed the fragments of their ware and

* Vol. XI, 1877, p. 573.

† Third Annual Report of the Bureau of Ethnology, 1884, pp. 393–425.

made casts of the outer surface. The result was astonishing.
Natural forces had eaten away and greatly obscured the marks
of textiles on the outside surface of the shards, but in the
bottom of the cavities, filled for centuries with earth, the im-
pressions have been carefully preserved, and "the manner in
which the fabric in all its details of plaiting, netting, and
weaving was constructed can be brought out quite as graphic-
ally as though one were examining the surface of the original
vessels." On the surfaces of rocks the paleobotanist discovers
the delicate impressions of leaves. In these indelible lines he
reads the names of species of trees that grew millenniums ago.
So, through these impressions on potsherds, the archeologist
is able to discover lost arts of whose existence all other evi-
dence has perished. (See Plate 107.)

All along our northern frontier and in many parts of Canada
the Iroquois and Chippewa now fabricate baskets from the
ash, birch, linden, and other white woods and the vernal or
sweet grass (*Savastana odorata*). The method of manufacture
is invariably the same; it is the plainest in-and-out checker
and wicker weaving. (See Plates 119 to 121.) The basketry
is far from monotonous, however, for the greatest variety is
secured by difference of form, of colour, of the relative size of
the parts, and of ornamentation. In form the baskets run
the whole gamut, as among the Haida and Makah, guided by
the maker's fancy and the demands of trade. These Indians
all live on the border of civilisation and derive a large revenue
from the sale of their wares. The colours are of native manu-
facture—red, yellow, blue, and green, alternating with the
natural shades of the wood. To begin with the rudest, let us
take a dozen or sixteen strips of paper half an inch wide and
cross them so as to have one half perpendicular to the other
half, woven in checker at the center, and extending to form
the equal arms of a cross. Bend up these arms perpendicular
with the woven checker and pass a continuous splint similar
to the framework round and round in a continuous coil from

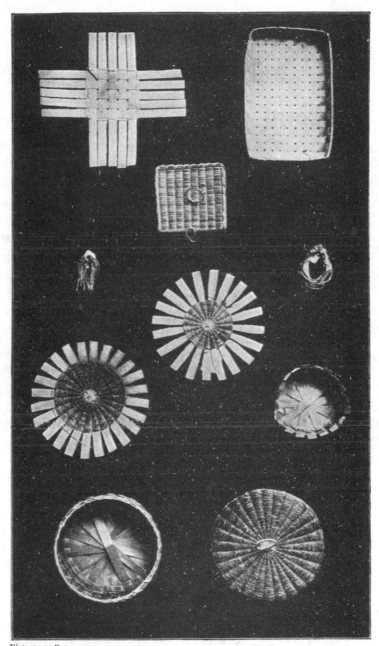

Plate 119. See page 270

ALGONKIN CHECKER AND WICKER BASKETRY, EASTERN CANADA
AND UNITED STATES

Collections of U. S. National Museum

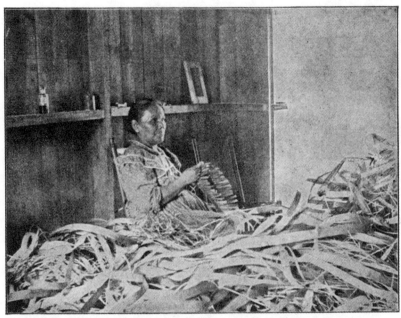

Plate 120. See page 271

CAROLINE MASTA, AN ABÉNAKI WOMAN, OF PIERREVILLE,
CANADA, MAKING CHECKERWORK BASKETS

Photographed by Herbert B. Rowland

bottom to the top. Fit a hoop of wood to the top, bend down the upright splints over this, and sew the whole together with a whipping of splint, and you will have the type basket. (See figs. 9 and 10 on Plate 119.) Now, by varying the width of the splint used to cover the sides, a great difference of appearance is secured. The complete operation among the Menomini was studied out by W. J. Hoffman,* and will be seen in figs. 110 to 114. In the National Museum are baskets made of uniformly cut splints not over one-sixteenth of an inch in width.

Finally, the Algonkin, as well as the Southern Indians, have learned to decorate baskets with a great variety of rolls, looking much like the napkins on the table of a hotel. The weaver

FIG. 110.
ASH LOG FOR MAKING SPLINTS.
Menomini Indians.
After W. J. Hoffman.

draws a splint under the warp stick, gives it a turn up and down, or two turns in different directions, and draws the loose end tightly under the next warp stick but one. This operation is repeated, forming around the basket one or more rows of projecting ornaments. Morgan bears testimony to the skill of the Iroquois women in the art.†

The basket woman at her work sits upon the ground in front of her lodge, or frequently before a little booth or shelter— the first step in the evolution of the artist's studio. The materials which she gathered long ago with much pains, and has been hoarding up, are within easy reach. Her hands and her teeth are both available in her work, aided by only a small supply of tools. A number of Indian women at work will be seen in different connections throughout this paper.

* Fourteenth Annual Report of the Bureau of Ethnology, 1896, p. 260.
† The League of the Iroquois, 1851, pp. vi–55.

Plate 120 shows Caroline Masta, an Abenaki Indian woman from Pierreville, Canada, seated in her humble laboratory at Belmar, New Jersey. Her materials are of black ash (*Fraxinus nigra*) and sweet grass (*Savastana odorata*). The former has been worked out by machinery in Canada, and is piled up around her; the latter is gathered and braided by her relatives, and sent to her all ready for the last step in manufacture. This Indian woman conducts a thriving business, not being able to make up ware as fast as there is demand for it. Specimens of her work are shown in Plate 119, photographed by Herbert B. Rowland.

FIG. 111.
WOODEN MAL-
LET FOR
LOOSENING
SPLINTS.

To illustrate more fully the survival of the old art in the new era, Plate 121 represents three Chippewa women near Saginaw, Michigan, making splint baskets. They are seated no longer in the midst of wretchedness, but in an apple orchard. The clothesline and the receptacles filled with fruit mark the changed life. It will be noticed, also, that the woman on the left is using for her splints a gauge set with metal blades. Indeed, the broad strips lying on the ground were worked out by machinery. Checkerwork and wickerwork are the only forms of technic practised by these Chippewas. It will not be assumed by any one that the improvement in environment has redounded to the benefit of the savage art. The baskets are the common frame ware, and often the best of them bear no comparison in refinement with the work of their most savage sisters on the West coast. Photographed by Harlan I. Smith.

FIG. 112.
BASKETMAK-
ER'S KNIFE
OF NATIVE
WORKMAN-
SHIP.

The acme of northern Algonkin weaving is in twilled

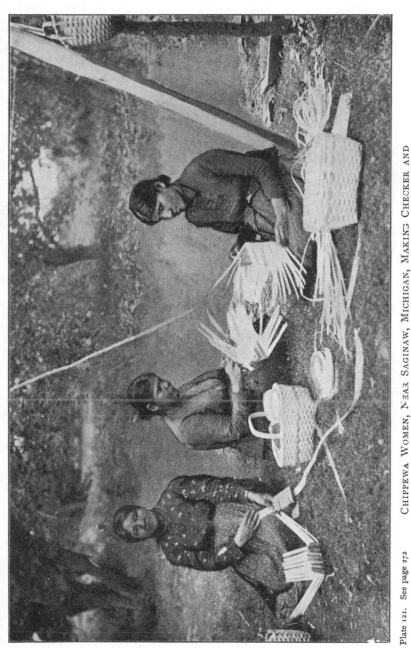

Plate 121.　See page 272　Chippewa Women, Near Saginaw, Michigan, Making Checker and Wicker Baskets

Photographed by Harlan I. Smith

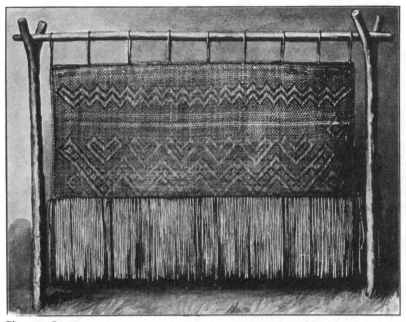

Plate 122. See page 273

TWILLED MATTING FINISHED IN ONE DAY BY A CHIPPEWA
SQUAW OF GRAND MARAIS, MINN.

Photographed by D. D. Gaillard

matting. The operation, technically, is just on the border between free-hand plaiting and loomwork. Plate 122 is a mat plaited by a Chippewa squaw, about fifty years old, at Grand Marais, Minnesota. It is of cedar bast made in strips a quarter of an inch wide, and is in three colours—one the natural tinge of the material and the other two dyed. The interesting features are, first, that the weaving is done from below upward, as in the Haida basketry, and in the work carried on by Virginia Indians in the days of John Smith.

A small rod or stiff cord of bark is suspended by means of eight loops from a pole resting on two forked sticks. This is to give free motion to the woman's hands. Over this the warp strings are suspended freely. The Chilkat blanket weaver, also, as will be seen, has no other machinery. For a few rows

Fig. 113.
COIL OF BASKET STRIPS.

the weaving is simple checkerwork of the plainest kind, and then begins a series of twilled patterns over two and under two. But even this simplest technic so lends itself to charming effects of light and shade that there is not a monotonous square inch on the surface. Another band of plain weaving is followed by zizgag and angular work, inclosing lines and squares, giving birth to a very pleasing effect. Some of the oldest pictures preserved in the early chronicles of the Algonkin Indians, to whom the Chippewa belong, show them weaving in exactly the same fashion.

The mat described above was made for Captain R. D. Gaillard, U. S. A., in a single day, the work beginning at nine o'clock in the morning and the finished product being delivered

two miles away at four o'clock in the afternoon. It is six feet five inches long and four feet five inches wide.

The Menomini Indians of the Algonquian family, living in northern Wisconsin, are quite expert in various forms of basketwork and hand-weaving. Mats are woven from the leaves of rushes, flags or cattails, and cedar bark. They are for roofing temporary structures, such as medicine lodges, for partitions, floor mats and wrappings, and for various purposes in the canoes. The leaves and stems are strung together by means of threads made of basswood fiber. In this they imitate a kind of textile well distributed throughout North America formerly.

Fig 114.
FINISHED WICKER BASKET.

The mats shown on Plates 21, 22, and 23 of Dr. Walter J. Hoffmann's paper* on this tribe are made from the inner bark of the cedar, cut in strips averaging one-half inch in width, in mixed, twilled, and checker weaving, which, combined with the native colour of the material and dyed strips, produce the greatest variety of diaper patterns. They do not differ essentially from Captain Gaillard's mat just described.

The baskets of the Menomini resemble those of the eastern Canadian Indians. A log of elm wood is beaten until the space between the annual layers of growth is destroyed; the thin strips are then pulled off, cut to a uniform width, and scraped as smooth as possible. At present, gauges of steel are used for the purpose. The weaving is done in checker, twilled, and wickerwork. A section of the beaten log, showing the annual layers loosened, the mallet of wood, and the modern

* Fourteenth Annual Report of the Bureau of Ethnology, 1896, p. 260.

knife, resembling the "man's knife" throughout all the northern tribes, are shown in figs. 110 to 112. For the finer kinds of bagging the inner bark of the young sprouts of basswood is employed. It is removed in sheets and boiled in water with a quantity of lye. This softens the fiber and prepares it for the next process, which consists in pulling bunches of the boiled bark forward and backward through a hole in the shoulder blade of the deer. The fiber is twisted into yarn and made into cord or twine by winding on the thigh with the palm of the hand. This advance in the preparation of the textile elements paves the way for twined weaving.

Fig. 1, Plate 123, is an example of hexagonal weaving in a Mackenzie River snow-shoe in which the vertical elements answering to warps are crossed and not interlaced, and the fabric is bound together by the weaving in and out of a single rawhide thong. Fig. 2, on the same plate, illustrates the next step in the weaving, and is suggestive of a feature in the twilled basketry taken from graves in a cemetery at Ancon, Peru, namely, the method by which a bar of the snow-shoe frame enters into the weaving and widens the meshes. Most beautiful effects are produced on the surface of these snow-shoes by the different methods of administering the warp. This has been carefully worked out by John Murdoch in his paper upon the Eskimo of Point Barrow, Alaska,* and is referred to here simply to show how the methods of weaving in basketry are to be seen in other materials for other purposes.

In fig. 3, same plate, the warps at certain points in the manipulation are twisted in pairs about each other, a technical process in vogue throughout middle America, beginning as far north as the Mohave country in southern Arizona. It might be called the first step in lace-making. Fig. 4, same plate, introduces another element of complexity wherein the warp elements, instead of being twisted around each other, are

* Ninth Annual Report of the Bureau of Ethnology, 1892, pp. 342–352.

wrapped once or twice about the weft, so that the primitive lace work is effected both vertically and horizontally.

Charles C. Willoughby, of the Peabody Museum, Cambridge, Massachusetts, is of the opinion that coiled basketry was used among the Ojibwa Indians (Chippewa) on the Great Lakes before contact with the whites, and mentions very old specimens now in the possession of that museum, and others have been seen in private collections. The foundation coils are of sweet grass and about one-quarter of an inch in diameter. In some very old specimens the sewing is done with looped stitches, being continuous from the edge toward the center of the basket, and not following the coils, as is usual. He also finds the following references to old basketwork of the New England Indians. (See Plate 124.) Gookin is quoted, writing in 1674, with the following words:

Several sorts of baskets, great and small, some of them hold four bushels or more, and so on downward to a pint. . . . Some of these baskets are made of rushes and some of bents (coarse grass), others of maize husks, others of a kind of silk grass, others of a kind of wild hemp, and some of bark of trees. Many of these are very neat and artificial, with the portraitures of birds, beasts, fishes, and flowers upon them in colours.

The soldiers under Captain Underhill, after destroying the Pequot fort in Connecticut in 1637, brought back with them "several delightful baskets." Brereton (1602) found baskets of twigs "not unlike our osier." Champlain saw corn stored in "great grass sacks." Josselyn writes, "Baskets, bags and mats, woven with bark of the lime tree and rushes of several kinds, dyed as before, some black, blue, red, yellow." In 1620 the Pilgrims found on a cache at Cape Cod "a great new basket, round and narrow at the top, and containing three or four bushels of shelled corn, with thirty-six goodly ears unshelled." The New England Indians were probably not less expert basketmakers than other tribes to the west and south. Does not the fact that the three distinct forms of weaving—

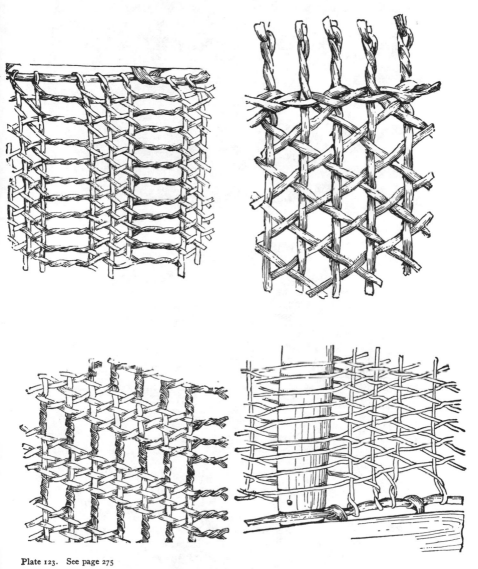

Plate 123. See page 275

HEXAGONAL WEAVING, WITH TWINING, ON A MACKENZIE RIVER SNOW-SHOE
Collections of U. S. National Museum

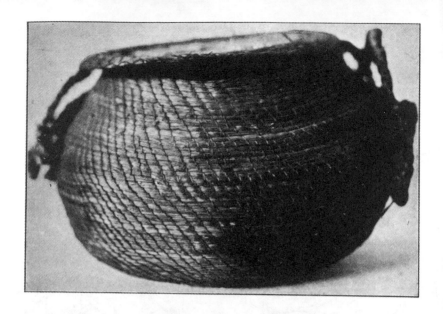

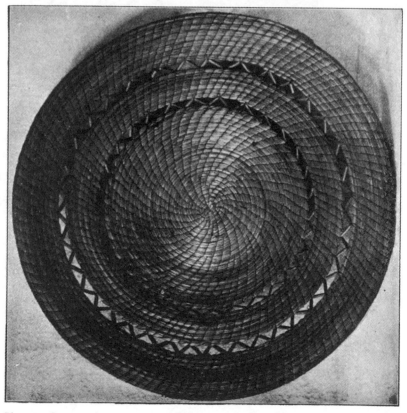

Plate 124. See page 276

COILED BASKETS MADE BY OJIBWA INDIANS ABOUT LAKE SUPERIOR

Photographs by C. C. Willoughby

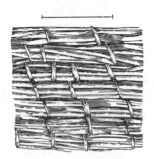
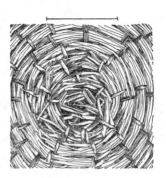

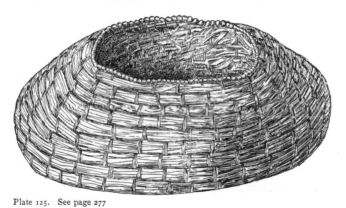

Plate 125. See page 277

COILED BASKETS OF GRASS AND SINEW, FROM ESKIMO ABOUT
CUMBERLAND INLET, EASTERN CANADA

Collections of U. S. National Museum

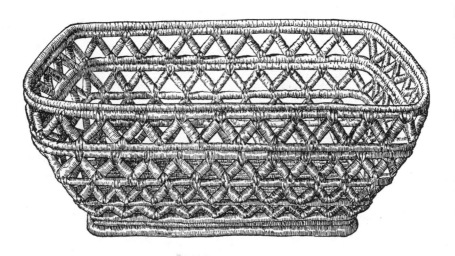

Plate 126. See page 277

OPENWORK COILED BASKET, FROM ESKIMO ABOUT DAVIS INLET, EASTERN
CANADA

Collections of U. S. National Museum

twined, checker, and coiled—still found among the Ojibwas, seem to indicate a survival of these types from prehistoric times all over the great Algonkin area? A few years back this type of coiled work was more in vogue than at present. (C. C. Willoughby.)

The next specimen described will take the reader a long way from the Great Lakes. Plate 125 shows the detail of a flat coiled basket of the Eskimo about Cumberland Inlet, eastern Canada. The foundation likewise contains a bundle of straws, but badly put together and sewed with sinew thread, the stitches being wide apart and caught beneath a few straws of the preceding coil. The bottom is flat, and the walls are drawn in so as to give a compressed shape. This interesting specimen has been many years in the National Museum, and is credited to Captain C. F. Hall, the arctic explorer. It may be compared with others of the same type from the southern Canadian border. Catalogue No. 10,203; height, 1¾ inches. A much later specimen, also from the Eskimo, is shown in the next plate.

Plate 126 is openwork basketry of the Eskimo of Davis Inlet, eastern Canada. The foundation is of straw and the sewing is done in the same material, the stitches merely interlocking. The noteworthy characteristic of the basket is the slight amount of sewing in certain portions. The bottom is not unlike the work of the western Eskimo, and, indeed, is a typical illustration. There is a little splitting of stitches, but probably not designed. On the sides the openwork is produced by wrapping the foundation with straw for one-half an inch and then sewing, as in ordinary coiled work, the angles to the coil below. This may be compared in the wrapping with the openwork coiled basketry of the Kern County Indians in California. (See fig. 196.) Sewing of exactly the same style is to be found in northern Europe, and the suggestion is made that this particular method among the eastern Eskimo is an acculturation. To come nearer home, coiled basketry in

raffia that is taught in the schools is largely in this wrapped and sewed method. The Eskimo of this area were for centuries in contact with Norse settlers. This specimen is 8¼ inches in length, and was collected by L. M. Turner.

Plate 127 gives the profile and inside view of a shallow coiled basket tray of the Comanche Indians, living on the plains east of the Rocky Mountains, used principally in gambling. The foundation is of rods and splints, the sewing with leaf of yucca (*Yucca arkansana*). Especial attention is invited to the furcate stitches, designedly and symmetrically split. This technic relegates the basket to the Ute or Shoshonean area, west of the Rockies. The Comanches belong to the Shoshonean family. Its diameter is nine inches.

In the National Museum are four small, dish-shaped, coiled gambling baskets, Catalogue Nos. 6,342, 8,427, and 153,932, gathered from the Rees or Caddoan Indians, the other one from the Mandans, who are Siouan. These baskets are made from willow, on a two-rod foundation, but roughly assembled and sewed with splints of the same material. The borders are all well done in false braid. No more interesting specimens are to be found in this collection.

There are four other gambling baskets of the same type, but of different material, which are fairly made. The foundation is a single stem of, perhaps, willow, the sewing in the leaves of yucca (*Yucca arkansana*). Catalogue Nos. 152,802, 152,803, 165,246, and 165,765, were gathered from the Cheyenne, Arapaho, and Kiowan Indians in Indian Territory.

Finally, modern pedagogy has found in the long leaves of the Georgia pine a material by means of which poor people may weave a little of the sense of beauty into their lives.

Plate 128 is a covered basket, made near Augusta, Georgia, from the leaves of the pine, by a native Georgia woman, under the instruction and patronage of Mrs. Percy H. Babcock, of Hudson, Ohio. The sewing-material is tough, brown linen thread. The interesting characteristic in this specimen is

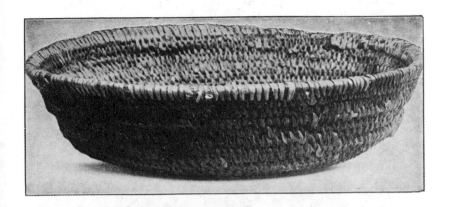

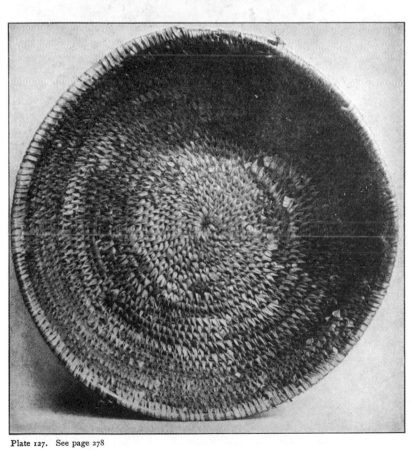

Plate 127. See page 278

COILED GAMBLING BASKET OF THE COMANCHE INDIANS, INDIAN
TERRITORY

Collections of U. S. National Museum

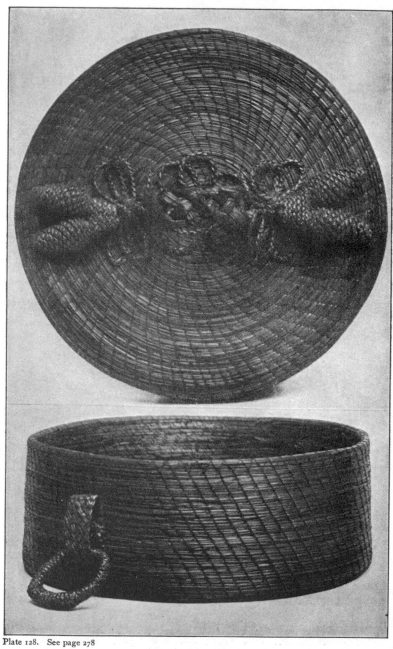

Plate 128. See page 278

COVERED COILED BASKET IN PINE STRAW, MADE BY A NATIVE
GEORGIAN WOMAN

Collections of U. S. National Museum

the undesigned resemblance between the stitching and that on the Hudson Bay Eskimo specimen, as well as the old Chippewa specimen in the Peabody Museum, in Cambridge, Mass.

Coiled work, as was shown in the chapter on weaving, changes to lace work by omitting the hard foundation. In this Eastern region two witnesses, far apart in time, are here to testify to the widespread ancientness of a coiled work now universal in tropical America.

Figs. *a* and *b*, Plate 129, represent the method of weaving in the game bags, or muskemoots, of the Dog Rib and other Athapascan Indians in northwestern Canada, for domestic purposes. These tribes and their relatives in central Alaska use the birch-bark vessels for all sorts of domestic purposes. For transportation they do not make regular baskets, but buckskin wallets, in which a process of coiled weaving now to be described is employed. The sides and borders of the game bags are of dressed skin of moose and reindeer. For the body of the bag the same material is cut into fine string and rolled. This material is called "babiche." It is quite evident that before the introduction of the steel knife this material was much coarser, as may be known not only from the game bags, but also from the snow-shoes. Fig. *b*, a small section from one of the muskemoots, will show how the work is done. The border of the bag on its lower edge is pierced at equal distances for the reception of the first row of weaving. Through these holes the babiche is strung by half stitches, or what is called "button-hole stitch." The work proceeds in the same manner round and round until it is desirable to make a variation in the technical process. In the middle of the drawing it will be seen how this is done. The end of the babiche is carried through a stitch in the row above and twisted one and a half times about itself. As many turns as are desirable can be made, and thus the ornamentation may be varied. This method of coiled work, the first described in the table of methods (page 90), does not occur again among the Indians

until the borders of Mexico are reached, where the tribes in
their carrying nets, and farther south in their wallets and
hammocks, employ precisely the same method of workmanship.
This specimen, Catalogue No. 2,023, with several others in the
United States National Museum from the Dog Rib Indians of
northwestern Canada, was collected by Bernard R. Ross.

Warren K. Moorehead found examples of the muskemoot
weaving in the Hopewell mounds, Ohio. There was nothing
but an easy portage here and there to hinder passage by water
from the mouth of the Mackenzie to the neighborhood of the
Hopewell mounds. Examples in the Peabody Museum, Massa-
chusetts, and in the Field Columbian Museum, Chicago,
prove the identity of technic. (See figs. 115 and 116.)

FIG. 115.
COILED BASKETRY.
Hopewell Mound, Ohio.
After C. C. Willoughby, Peabody Museum.

FIG. 116.
COILED BASKETRY.
Hopewell Mound, Ohio.
After C. C. Willoughby, Peabody Museum

There is a general impression that the baskets of the ordi-
nary soft character described were used by these eastern peoples
in the manufacture of pottery, and were ruthlessly destroyed
in the burning, but Holmes's investigations tend to show that
pliable materials had been almost exclusively employed. In
the Pueblo region the case was quite different, though there
is no evidence of the burning of the basket.

The twined wallets or other fabrics used were removed
before the vessel was burned or even dried. In many cases
handles and ornaments were added after these impressions

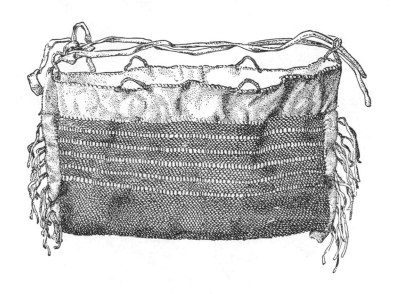

Plate 129. See page 279

COILED AND TWISTED BABICHE IN DOG RIB GAME BAGS,
NORTHWESTERN CANADA

Collections of U. S. National Museum

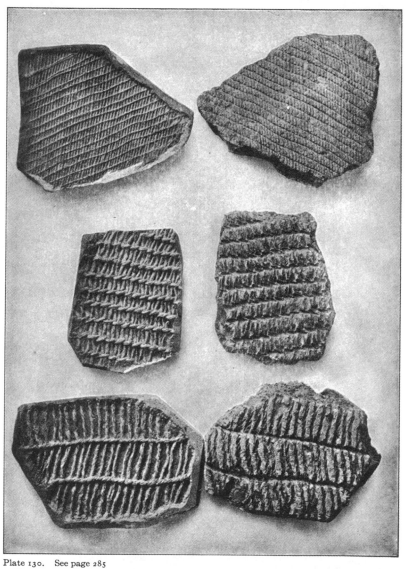

Plate 130. See page 285

CASTS OF POTSHERDS, SHOWING TWINED WEAVING AMONG ANCIENT
MOUND-BUILDERS. AFTER WILLIAM H. HOLMES

were made, also incised designs were executed in the soft clay after the removal of the textile.

It is quite evident that textile impressions were used to enhance the beauty of the vessel, not to support the clay in process of construction.

In many examples, notably the salt vessels of Saline River, Illinois, the fabric was applied after the vessel was finished, inasmuch as the loose threads sag or festoon toward the rim. Simple cord markings arranged to form patterns have been employed on many examples. And in those cases where basketry textile was pressed on the surface, it was not the

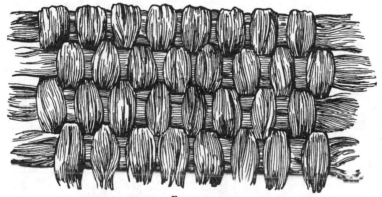

FIG. 117.
WICKERWORK FROM CAVE IN KENTUCKY.
After W. H. Holmes.

common, careless weaving, but the elegant designs, as will be seen in the plates.

The textile markings on pottery, ancient and modern, are of five classes:

1. Impressions on the surface, made by rigid basketry, used in moulding and modelling.

2. Impressions of pliable fabrics on the soft clay.

3. Impressions of woven textures used over the hand or on a modelling or malleating implement.

4. Impressions of cords wrapped about modelling or malleating paddles or rocking tools.

5. Impressions of bits of cords or other textile units, singly or in groups, applied for ornament only, and so arranged as to give textile-like patterns.*

If the reader will turn to the classification of basket-making methods (page 6), it will be noticed that many of these are to be found in the ancient basketware impressed on pottery by the eastern Indians. Referring to Mr. W. H. Holmes's paper, openwork checker weaving is very rare among impressions on clay. Foster illustrates one example on pottery from a mound on Great Miami River, Butler County, Ohio.

FIG. 118.
CHARRED FABRIC FROM MOUND.
After W. H. Holmes.

FIG. 119.
CHARRED FABRIC FROM MOUND.
After W. H. Holmes.

Checkerwork of the close type, on the other hand, was practised in nearly all the Atlantic States, upon the testimony of pottery fragments.

From potsherds found in the State of New York, closely packed checkerwork patterns have been copied. Charred fabrics from mounds in Ohio reveal the coarsest kinds of oblique checker weaving. Holmes illustrates an example in which the oblique work imitates mat plaiting without a frame,

* W. H. Holmes, American Anthropologist (N. S.), III, 1901, pp. 397–403.

worked from a corner. The selvage and the weft cross the texture obliquely.*

Not only checkerwork, but twilled work in cane and in twine, and wickerwork in soft material, have been brought to light by cave explorations in the Western and Southern States. In the Third Annual Report of the Bureau of Ethnology, Holmes figures an example of wickerwork in soft materials, from a cave in Kentucky. (See figs. 117, 118, and 119.)†

To show the distribution of this ancient style of weaving, reference is here made to:

1. Coarse, oblique, checker, twilled work from Ohio, made of twine.

2. In the same volume (fig. 12) is shown a fragment of twilled cane-matting from Petite Anse Island, Louisiana. It has been preserved all these years by salt. (See fig. 126.)

3. Plate 2, in Holmes's report, shows a mat of split cane from a rock shelter on Cliff Creek, Morgan County, Tennessee. It is 6 feet 6 inches by 3 feet 4 inches. The variety of twilled effects and the patterned border leave nothing to be desired.

4. In a mound near Augusta, Georgia, a fragment of twilled matting was found attached to the surface of a bit of copper (Holmes's fig. 11). The interesting feature of this example is that on the side shown the warp passes over one and under four, the weft over four and under one. His fig. 15, from Alabama, is similar, only the formula is three and one.

5. Fig. 14 is from an impression of twilled weaving on a fragment of pottery found in Polk County, Tennessee. Three characteristics of this fragment claim attention. The warp is of fine twine, the weft of coarse yarn; the work is over two, both in warp and weft; the weaving is oblique. The effect

* See Thirteenth Annual Report of the Bureau of Ethnology, 1896, pl. VII, fig. c.

† Thirteenth Annual Report of the Bureau of Ethnology, 1896, pl. VII, figs. c and d.

of this technic is pleasing and unique, the components being
bands of closework alternating with bands of openwork,
made up of sloping elements, giving great variety to unity.

It will be seen that the checker and the twilled work in
ancient eastern North America had about the same distri-
bution as now.

Twined weaving was common throughout the Middle and
Eastern States of the Union in prehistoric times. Fabrics of
this class were employed by the ancient potters in nearly all

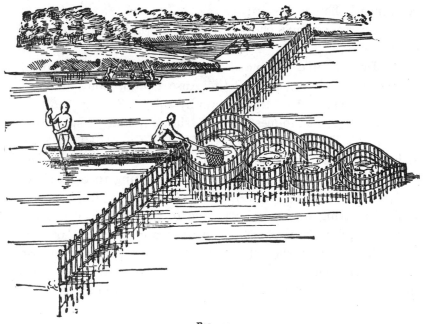

FIG. 120.
TWINED FISH TRAP.
Virginia Indians.
After Thomas Hariot.

of the States. Every variety of twined weaving known to
the modern Indian was practised by the old-time people—
the Mound Builders especially. Holmes figures examples
from pottery in Tennessee, Georgia, Arkansas, Illinois, Missouri,
and Iowa. Even the intricate and delicate forms of twined

weaving described on page 71 as zig-zag or divided warp and crossed warp were well known.

The ancient pottery of the Mississippi Valley furnishes many examples of this, as will be seen in Holmes's papers.*

Traces of wattlework are found in the mounds of the Lower Mississippi Valley, where imprints of the interlaced canes occur in the baked clay plaster, with which the dwellings were finished. In the same connection, John Smith, Butel-Dumont, Du Pratz, Lafitau, and John Lawson are quoted on the use of wattling for houses, inclosures, biers, and burial platforms. A fish trap, with long wings, done in twined wattling, is figured in Hariot, and here reproduced from Holmes. (See fig. 120.)

The illustration shows a warp of stakes driven into the bottom of the stream, close enough together to let the small fry pass through and to offer no impediment to the flow of water. Brush or poles constitute the warp. The rivers of the Atlantic coast teemed with shad, herring, rockfish, sturgeon, and more, in the spring, and it is permissible to infer that twined fish traps were universal there.

Plate 130, thanks to the preserving care of potsherds, introduces the reader to the old basketmakers of no one knows how many centuries ago. From three fragments, selected out of myriads, and shown in the plate on the right hand, the cast on the left being in plaster, one might think himself studying specimens from the Aleutian Islands or the Great Interior Basin. The figure at the bottom is in plain openwork of twined weaving, the material being a soft bast, perhaps of native hemp. Hundreds of wallets indistinguishable in texture from this are now brought from around Bristol Bay Alaska. The figure in the middle is openwork twined weaving

* Prehistoric Textile Fabrics of the United States, Third Annual Report of the Bureau of Ethnology, 1884; Prehistoric Textile Art of Eastern United States, the same subject, Thirteenth Annual Report, 1896; and A Study of the Textile Art, etc., Sixth Annual Report, 1888.

in diagonal pattern. The warp strands are in pairs and flexible, making the interstices triangular, and giving to the weaving the appearance of "faggoting." If the weft were forced close together, the texture would be the common twilled work of the Pacific slope. The upper figures are also twined, but of rarer style, the warp being set diagonally. This figure is worthy of note in two respects. The workmanship in twisting of the threads is superb. One would have to look a long time through a collection of twined weaving of the present day to see threads nearly so fine. Not until the outermost island of the Aleutian chain was reached would the specimen appear. The other characteristic is the sloping warp, a thing of rare occurrence in twined weaving.

A further glance at basketry technic preserved in impressions on pottery and in caves shows plain twined weave, open or closed, with vertical or oblique warp; twilled weaving in twined weft and twined weaving with zigzag warp; three-ply twined weaving, and a style of twined work, which for exhausting possibilities of variety in warp treatment will vie with any modern example. The material is good twine, the warp is administered in groups of sixes, oblique toward the right. The weft is a two-ply twine, which, in crossing the warp, takes in a strand at each half-turn and is twisted tightly in the open spaces. The pattern is varied by bands of close weft in three rows, above and below which the groups of six warp strands are split into threes. Attention is called to Plate 8, in the Thirteenth Bureau Report, where is shown ancient twined work preserved by being wrapped about copper celts.* (See figs. 121-122; also Plate 107.)

Plate 131 represents an open-twined wallet of the Ojibwa Indians (Algonquian family), at Angwassag Village, near St. Charles, Saginaw County, Michigan. The native name is Na Moot, and it is made from the inner bark of the slippery

* Thirteenth Annual Report of the Bureau of Ethnology, 1896, figs. 21-26, and Plates VII and VIII.

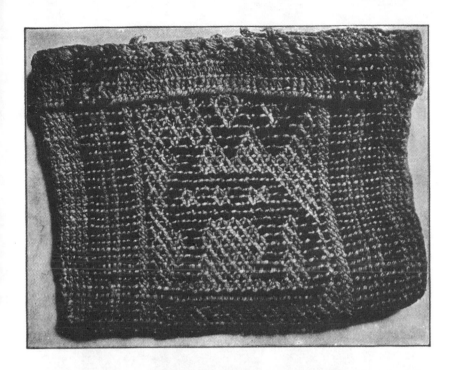

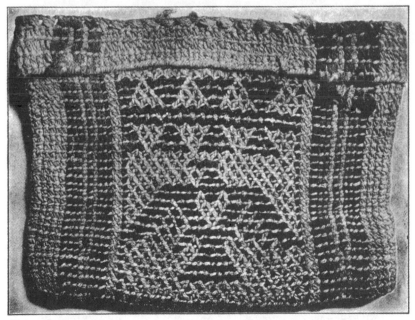

Plate 131. See page 286

OJIBWA TWINED WALLET IN OPEN WEAVING, SAGINAW COUNTY, MICHIGAN

Photographed by William Orchard
Collections of Am. Mus. of Nat. Hist., N. Y.

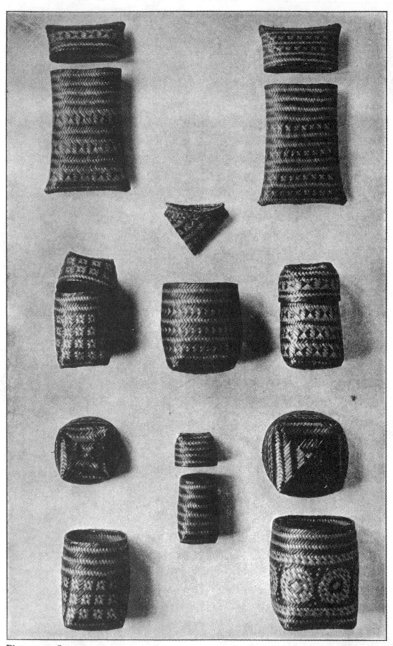

Plate 132. See page 291

TWILLED BASKETRY OF SPLIT CANE, MADE BY THE CHETIMACHAS
OF LOUISIANA

Collections of U. S. National Museum

elm (*Ulmus americana*). Other bags of the same technic in the United States National Museum are from the elm bark associated with red and black yarn. The technic of these

wallets is so interesting in the survival of ancient w e a v e s that they justify a special description. T h e weft is p l a i n twined weaving; all the ornamentation, therefore, is effected b y means of t h e

FIG. 121.
TWINED WEAVE FROM ANCIENT POTTERY.
Tennessee.
After W. H. Holmes.

warp, which is partly vertical, but more of the zigzag type seen in many Aleutian Island wallets. In all of the specimens examined, the warp is made up of twine, partly in the material of the weft and partly in coloured yarns. The diameter of the warp twine, especially the yarns, seems to be greater than the length of the twists in the weft, so that there is a crowding which brings one colour to the front and leaves another colour inside —that is, the figures that are brown on the outside will appear in yarn on the inside and the reverse. To be more explicit, beginning at the lower edge of any one of these wallets, the warp may be in pairs, the elements of which separate and come together

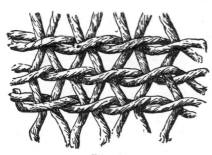

FIG. 122.
TWINED WEAVE FROM ANCIENT
POTTERY.
Tennessee.
After W. H. Holmes.

alternately in the rows of weaving. On the outside of the
bag, two elm-bark warp strands will be included and appear;
in the next half-twine two yarns will be included and show
on the inside of the wallet. After the zigzag process goes on
for a short distance, the weaver changes her plan, omits the
bark or the yarn warp altogether, but continues the twining
process, catching the warp in every other half-turn of the twine.
Again, there will be a row or two of ordinary twined weaving
with straight warp, when she returns to her zigzag method,
covering the entire surface therewith. At the top of the bag,
an inch or less of plain twined weaving, in which the warps
are vertical and included in pairs, brings her to the outer
border, where all the warps are twisted together and turned
back to be fastened off in the texture. In an old example in
the National Museum, long, cut fringes are sewed to the upper
margin and to the sides of the bag.

The photographs of the twined bag shown in Plate 131
were taken by William Orchard, of the American Museum of
Natural History, and presented to the National Museum by
Harlan I. Smith. On one side a mountain lion and on the other
an eagle with geometric figures are shown in black. The
technic of this particular example, from left to right, would be
five vertical rows of plain twined weaving; nine rows of mixed
warp, but plain weaving; a course of braided warp in which
the four elements of two rows of warp are brought together
and included in the twine. On the other side is a similar
administration. The middle portion shows zigzag twined
weaving, figured. Above this is a row of three-ply twined
weaving, as among many of the western tribes; above this,
three rows of plain twined weaving in openwork, including all
the warps. At the top, the warps are twisted and fastened into
the texture. It must be clearly understood that the figures
which show black on the outside—that is, the eagle and the
lion—will be white on the inside, necessarily. The colours
used in the small specimen of the National Museum are the

natural tints of the bark mixed with brown, black, and blue yarns. The National Museum is indebted to Andrew John, a Seneca Indian, of New York, for a number of specimens of modern Iroquoian twined ware from corn husks.

There was a decided lack of coiled basketry in all this vast region. Every kind of hand-woven ware was known. Algonquian, Iroquoian, Siouan, and Muskhogean tribes of the present, and all the cave-dwelling and mound-building ancients, seem, so far as the evidence points, to have known little of coiling.

From this hasty survey of ancient hand-weaving in basketry and the other receptacles, as well as in matting, webbing, sandals, and such products of the textile art as resemble basketry, it is now permissible to examine their modern representatives in the southern portions of the same area.

In the States of North Carolina, South Carolina, Georgia, Florida, Alabama, Mississippi, and Louisiana are many Indians still living, remnants of the Cherokees (Iroquoian), Choctaws, Creeks, Chickasaws, and Seminoles (Muskhogean), and the almost vanished Attakapas and Chetimachas. Some of them were removed fifty years ago into the Indian Territory. Through the lowlands of these States grow the interminable cane-brakes, and from the split cane all these tribes make their basketry. They follow the twilled pattern of weaving. Even now there may be purchased in Mobile, New Orleans, and other Southern cities, little baskets of yellow, red, black, and green cane woven in twill, crossing with the woof two or more warp splints, and managing the checks so as to produce diamonds and various zigzag patterns on the outside. The Choctaws make a basket, oval at the top and pointed below, for presents, averring that this shape imitates the heart, which always accompanies every gift. The handles of their basketry are very clumsily put on, marring greatly the appearance of the otherwise attractive object.

Often in weaving, two thin strips are laid together, the

soft sides inward. The evident motive in doubling the thin
strips is to have both sides of the basket or mat glossy and
smooth. Further on, it
will be noted that in
twined weaving, where
the strands of the weft
are from split roots,
both sides are rendered
s m o o t h by revolving
each strand half a turn
as it passes through be-
tween the warp stems.
(See page 317.)

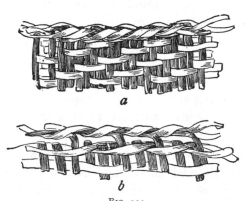

FIG. 123.
DETAIL OF TWILLED BASKETRY BORDER.
Choctaw Indians, Louisiana.
Cat. No. 24,143, U.S.N.M. Collected by Father Roquet.

Figs. 123 and 124
s h o w t h e detail of
twilled basketry among
the Southern tribes, both in the coarser and finer varieties.
In Fig. 123, *a* and *b*, will be seen the border. Each weft
strand crosses four warp
strands. In this example
the warp, however, does
not cover each time the
same number of w e f t
strands; the consequence is
a nearly horizontal diag-
onal effect in the pattern.
To form the border, a few
of the warp filaments are
bent down and inclosed
in a wrapping of the same
material. Underneath this
is a row of twined weav-
ing, which holds in place
those warp elements that
do not enter into the

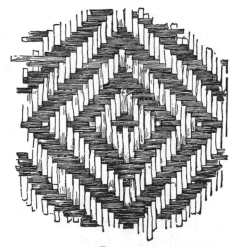

FIG. 124.
BORDER OF TWILLED BASKETRY.
Choctaw Indians, Louisiana.
Cat. No. 24,143, U.S.N.M. Collected by Father
Roquet.

texture. A much neater example of work of this kind is shown in the next figure, where the filaments are more carefully prepared and manipulated and the border more neatly finished, but the technical process is the same. The artistic effect of plain twilled work is shown in this example.

Fig. 124 exhibits the process of crossing in what might be called diaper or figured work. The effect is heightened by dyeing black one set of the filaments, either warp or weft. In that case, the figures stand out most prominently. The entire effect of this sort of weaving, however, is in the endless combination of rectangles, black and white, all having the same width and different lengths.

The basket shown in this dissected weaving is Choctaw, Catalogue No. 24,143, in the United States National Museum, collected by Father Roquet, of New Orleans.

Plates 132-133 represent the twilled basketry of the Chetimacha Indians, Chetimachan family, who have their home on Grande River and the larger part in Charenton, St. Mary's Parish, Louisiana. The name is derived from the Choctaw words, *tchuti*, "cooking vessel," *masha*, "they possess." Mr. Gatschet, in 1881, found about fifty individuals still living. The material of their work is the cane (*Arundinaria tecta*), and all of their weaving is in the twilled style of technic.

Compared with the work of the Choctaw (Plate 134) and their neighbours, the Attakapa (Plate 135), it is more picturesque and attractive, the colours being the original of the cane, red and yellow. Similar work is to be seen in the northern part of South America, especially in Guiana. The interesting feature of the Attakapa weaving is that frequently the specimens have the appearance of being double—that is, both the outside and the inside of the receptacle presenting the smooth surface of the cane. At once the work connects itself with matting found in the caves of Kentucky and Tennessee, and with Yaqui work in Mexico.

Plate 133 represents a fine collection of old Chetimachas in the collection of Mrs. Sidney Bradford, of Avery Island, Louisiana. They should be examined carefully, since they were posed so as to exhibit the technic of the various parts and the variety of symbolism.

Mrs. Bradford has identified the plants with which these Indians dye their basketry, the black being produced from the bark of the walnut (*Juglans nigra*) and the yellow from *Rumex verticellatus*. The red dye comes from the root of a plant, specimens of which are in the National Museum, but are not identified.

Plate 135 shows a small number of twilled basketry, made by the Attakapa Indians, living in Calcasieu Parish, Louisiana. They are the last remnant of an independent linguistic family once spread southward along the Texan coast. The baskets are made from the stems of the cane. The outer tough layer is split off and dyed, if necessary. It is then worked into twilled ware, which by the texture and variety of colors shows elegant designs.

These specimens, Catalogue Nos. 165,735 to 165,739, in the United States National Museum, were collected in Louisiana by Mrs. William Preston Johnston.

The Cherokee make the handsomest clothes-baskets, considering their materials. They divide large swamp canes into long, thin, narrow splinters, which they dye in several colours, and manage the workmanship so well that both the inside and outside are covered with a beautiful variety of pleasing figures; and though for the space of two inches below the upper edge of each basket it is worked into one, through the other parts they are worked asunder, as if they were two joined atop by some strong cement. The weaving begins at the bottom of the inner basket and is finished at the bottom of the outer one (compare page 484). A large nest consists of eight or ten baskets contained one within another. Their dimensions are different, but they usually make the outside

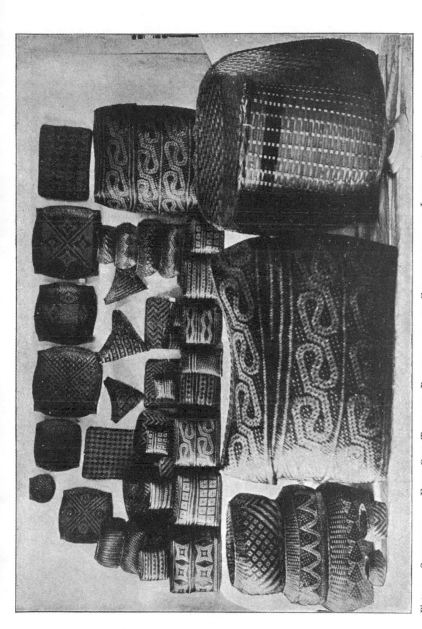

Plate 133. See page 292 Fine Old Twilled Baskets of the Chetimachas of Louisiana

Collections of Mrs. Sidney Bradford

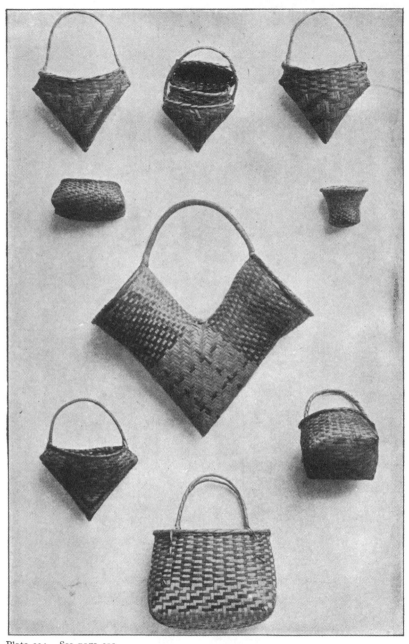

Plate 134. See page 291

TWILLED BASKETS OF SPLIT CANE, MADE BY CHOCTAW INDIANS OF
LOUISIANA

Collection of Mrs. Carolyn G. Benjamin

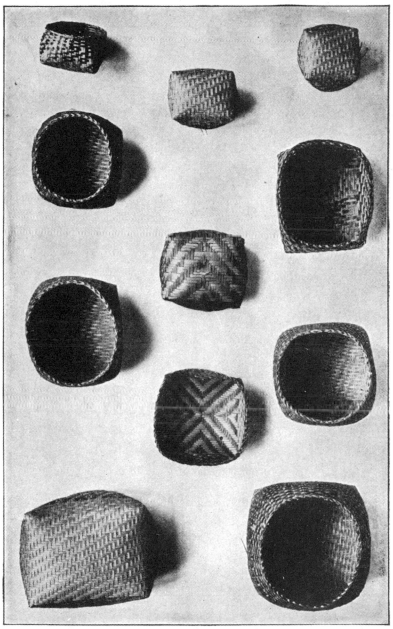

Plate 135. See page 292

TWILLED BASKETS OF CANE, MADE BY ATTAKAPAS, LOUISIANA

Collection of Mrs. William P. Johnston

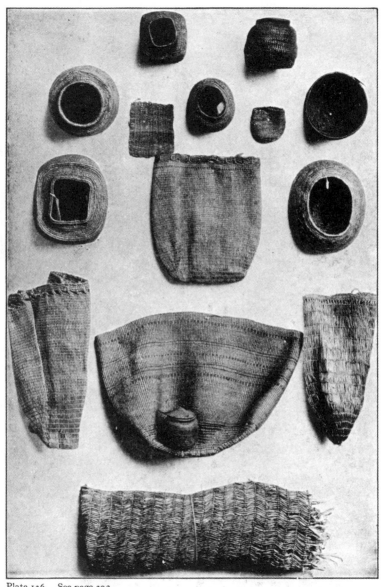

Plate 136. See page 302
Types of Twined and Coiled Basketwork in Alaska
After E. W. Nelson

basket about a foot deep, a foot and a half broad, and almost a yard long.*

A type collection of this ware was made for the National Museum by James Mooney.†

Fig. 125 shows one of the oldest and most beautiful baskets in the National Museum, presented by Doctors Gray and Matthews, of the Army. Four bent poles constitute the framework. Those at the sides are 10 inches apart at the top, 4 at the bottom, and are quite concealed in the structure. The end pair cross these at right angles and descend 6 inches to afford a rest for the load. The carrying strap is of rawhide. The weaving is in twilled work, with diaper patterns made in narrow strips of bark, some having their outer, some their inner surface exposed.

The weaving was done by an Arikara woman in Dakota. Now, these Indians are not Sioux, but belong to the Caddoan family, spread over Louisiana and Texas. It should not be surprising, therefore, to find baskets similar to those of the Cherokees and the Gulf tribes in their hands.

FIG. 125.
TWILLED BASKET.
Arikara Indians.
Cat. No. 84,340, U.S.N.M. Collected by Gray and Matthews.

In close connection with wickerwork and checkerwork is

* James Adair, History of the American Indians, London, 1775, p. 424.
† Nineteenth Annual Report of the Bureau of Ethnology, 1900, p. 176.

twilled or diagonal technic from many localities, especially in the South. An interesting example is illustrated by Holmes.* The two elements, the warp and the weft, are of entirely different material, one a finely spun thread, the other a loose, coarse filament several times wider than the former, and are woven together in the ordinary plan of under two and over two, and yet the difference in the width and tension of the two elements produces a most charming effect, which is not lost, after many thousands of years, in the cast taken from the surface of the fragment. (See page 59.) An example of matting, also illustrated by Holmes, was taken from a piece of pottery found in Alabama. It is worked in the diagonal style, but on one side the warp passes over one and under three, and, consequently, though the matting was destroyed hundreds of years ago, it is certain that on the other side of the fabric the weft made a similar figure, but vertical. (See page 59.)

The caves of Kentucky furnish specimens of ancient textiles, preserved in nitrous earth, and fig. 117 is an illustration of one of these, revealing a wicker type of weaving in soft materials, not found on pottery, however.†

One of the most interesting examples of this ancient work is illustrated by Foster, also taken from a mound on Great Miami River, Ohio. It has a warp of twine, on which the weft is wrapped round and round. (See page 241.) Only one family of Indians, the Yuman, of Arizona, at present employ this technic in making baskets. (Fig. 13; compare fig. 14, in the chapter on processes.)

It is an interesting fact that the Andamanese, living halfway round the world, employ the same method of workmanship on their open fish baskets.

Fig. 126 is from the photograph of a specimen of ancient twilled matting from Petit Anse Island, near Vermillion Bay,

* Third Annual Report of the Bureau of Ethnology, 1884, p. 416, fig. 98.
† Third Annual Report of the Bureau of Ethnology, 1884, p. 403, fig. 67.

coast of Louisiana, presented to the Smithsonian Institution by J. F. Cleu, in May, 1866. Petit Anse Island is the locality of the remarkable mine of rock salt exploited during the civil war, and from which, for a number of years, the Southern States derived a great part of their supply of that article. The salt is almost chemically pure, and apparently inexhaust-

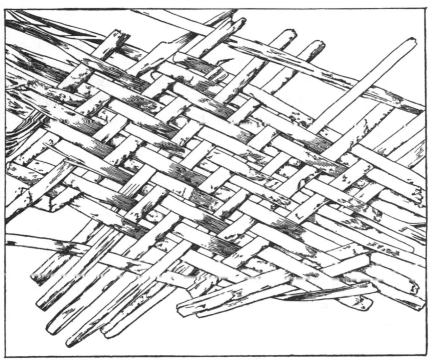

FIG. 126.
ANCIENT TWILLED MATTING.
Petit Anse Island, Louisiana.

ible in quantity, occurring in every part of the island, which is about 5,000 acres in extent, at a depth below the surface of the soil of 15 or 20 feet. The fragment of matting here photographed was found near the surface of the salt. No vast antiquity can be argued on this account, but the specimen is without doubt very old and a relic of the weavers who lived a long time before the discovery of America. The material

consists of the outer bark of the common Southern cane (*Arundinaria tecta*), and has been preserved for so long a period both by its siliceous character and the strongly saline condition of the soil.

THE ALASKAN REGION

There is a charm in the name of such Indian material as spruceroot, wild rye, and cedar bark, but they would be useless to us without the Indian touch.—MARY WHITE.

For convenience of study, a line may be drawn across the map of North America from Dixon Entrance northeastward, so as to have Queen Charlotte Islands and the makers of coiled basketry that are inland to the north of it. The tribes included will be Athapascan, Eskimauan, Koluschan, and Skittagetan. Among the two first named, twined and coiled work, in many styles of weaving, will be found, while the two last named and their northern neighbours, the Aleuts, have avoided coiled basketry altogether. In Plate 136 are gathered types of the peninsula of Alaska—Athapascan, Eskimo, and Aleutian, embracing hard coil, soft coil, closed twined work, open twined work, straight warp, crossed warp, and hemstitch, gathered by E. W. Nelson.

In studying the basketry of this region, the following division, according to tribes and families, will be found convenient:

1. Athapascan (interior of Alaska).
2. Eskimo (around shore).
3. Aleuts (Aleutian Archipelago).
4. Tlinkits (southeastern Alaska).
5. Haidas (Queen Charlotte Islands).

ATHAPASCAN COILED BASKETRY

Perhaps no other family of American tribes has such a variety of contacts with neighbours of different linguistic families and of limitations in environments having little likeness to one another. This northern branch of them, as

will be seen in Father Morice's list,* is in touch along their southern border with Algonquian descendants of Mound Builders on the Ohio, with birch bark workers in northern middle Canada, and with Pacific coast tribes here and there. Some of these were noted in speaking of Region 1, page 279. Further on, other contacts will be shown. The distribution of the family is given by Powell on his linguistic map of North America.†

Here the Athapascans are in touch with Eskimo; indeed, most of the specimens of their ware shown were procured from the former in trade. Their technical methods will be best understood through illustrations.

⅓

FIG. 127.
COILED WORK-BASKET.
Tinné Indians, Alaska.
Cat. No. 89,801, U.S.N.M. Collected by P. H. Ray.

The northern Tinné practice several varieties of technic in their coiled work. The tribes of the interior of Alaska make a very coarse coiled basket, now becoming common. Some of the very old pieces have the button-hole stitch in the sewing. In a collection of them, no two will agree either in shape or composition.

The best of the ware is from near the Mackenzie mouth, where dyed feathers are used for decoration. Some of the oldest specimens in the National Museum, entered in the first catalogue, are coiled basket trays of the Athapascan Indian tribes living at Fort Simpson, at the mouth of the Mackenzie River. Splints of willow and spruce root are employed in the work, and the ornamentation is meager, consisting of stripes on the side, and borders, in quilled work

* Transactions of the Canadian Institute, Toronto, IV, 1894, Pt. I, No. 7

† Seventh Annual Report of the Bureau of Ethnology, Washington. 1891, p. 55.

dyed in different colours. These specimens vary from 6 to 8 inches in diameter, and were gathered by R. MacFarlane, B. R. Ross, and W. L. Hardesty.

Fig. 127 is a coiled basket jar, of the Tinné Indians, near Point Barrow, Alaska. The specimen belongs to the single-rod type, in which one rod, or stem, constitutes the foundation. The sewing is done with split stems of willow, passing over the rod in progress and under the one forming the coil under-

FIG. 128.
COILED WORK-BASKET.
Tinné Indians.
Collected by P. H. Ray.

neath. The illustration here given of this specimen is from Murdoch's paper on the Point Barrow Eskimo.* It is said to have come from Sidaru. The owner declared that it came from the Great River in the south, which Mr. Murdoch interprets to mean the Kowak, flowing into Hotham Inlet. The Eskimo are in the habit of going to this place in order to trade with the Indians, and thus this coiled basket found its way into the possession of the Eskimo at Point Barrow. This figure is 336, on page 326, in Murdoch's paper. Catalogue No. 89,801. Height, about 3 5–16 inches. Collected by P. H. Ray, United States Army.

Catalogue No. 89,802, in the United States National Museum, is a conical work-basket, with a sealskin top, for a drawing-string, to keep the contents from falling out. It is in coiled weaving over a single rod, from Sidaru, northern Alaska, near Point Barrow, collected by Lieutenant P. H. Ray, United States Army. It is similar in technic to No. 89,801. Its height is 4½ inches, and it has been described by Murdoch. (See fig. 128.)

* Ninth Annual Report of the Bureau of American Ethnology, 1892, pp. 326–327.

Catalogue No. 56,564, in the United States National Museum, is an Eskimo woman's work box (Aguma, ama, ipiaru) in coiled basketry, from Point Barrow, Alaska, also collected by Lieutenant Ray. The material is willow and the technic is coiled work of the single-rod type. The neck of the basket is of black, tanned sealskin, and is tied with a string of the same material. Height 1¾ inches. It has been described by Murdoch. (See fig. 129.)

Take an example from another part of Alaska. Fig. 130 is a coiled basket of the Tinné Indians, who are settled on the Lower Yukon River. The founda-

FIG. 129.
COILED WORK-BASKET.
Tinné Indians.
Collected by P. H. Ray.

tion is a single rod of spruceroot, and the sewing is done with splints of the same material. It belongs to the type of coiled work called a single rod (see page 92); the stitches interlock with those underneath and inclose also the rod of that coil. Each stitch, therefore, really incloses two foundations. In the explorations of Dall, Nelson, and Turner, in this long stretch of river bottom, were collected many specimens showing transition between Indian and Eskimo activities.

On the bottom, the basketmaker has taken the greatest pains to split the stitches of each coil with those of the coil beyond, giving to each one, looked at from the center, a bifurcated appearance which is quite ornamental. The same technic will be observed further on in examining the workmanship of the Thompson River Indians, in British Columbia, and by their neighbours, the Chilcotin. The Eskimo woman also in making her coiled basketwork splits the stitches of her coil and sews through them. This process is kept up on the body of this specimen half the way up.

The coils vary considerably in width; the stitches also are not of the same size, so that there is by no means the uniform regularity, either horizontally or vertically, that one observes in the California area. It will be noticed, too, that the top of each stitch is narrowed by reason of the crowding. Over the entire surface of this specimen it is quite impossible to see the foundation rod, because of this crowding of stitches.

This specimen is jar-shaped, and under good conditions

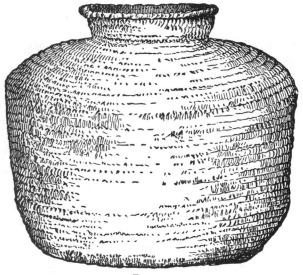

FIG. 130.
COILED WORK-BASKET.
Tinné Indians.
Cat. No. 24,342, U.S.N.M. Collected by Lucien Turner.

would hold water. Catalogue No. 24,342, in the United States National Museum. Collected, with many others, on the Lower Yukon River, by Lucien M. Turner. Diameter, 8½ inches; height, 6¾ inches. The manner of laying the splint foundation, of splitting the stitches, and of finishing off the border in false braid is shown in fig. 131, taken from another example.

It is a long way from middle Alaska to the Hupa Valley,

northern California. The basket here shown is No, 126,520, in the United States National Museum, collected by Captain Ray.* It is introduced to show a coincidence in form between the work of Tinné and Hupa, who speak languages of the same family in regions wide apart. It is twined work. (See fig. 132, and compare figs. 128 and 129.)

ESKIMO BASKETRY

Baskets not only have an infinite variety of functions from village to village, but among each people they have a multitude of uses. From the shore of Norton Sound to the Kuskokwim the women are expert in weaving grass mats, baskets, and bags. Grass mats are used on the sleeping benches and for wrapping around bedding. They are used also as sails for umiaks. They now frequently serve as curtains to partition off the corners of a room or sleeping platform. Small mats are placed also in the manholes of kaiaks as cushions.

FIG. 131.
DETAIL OF COILED BASKET WITH SPLINT FOUNDATION, SPLIT STITCHES, AND BRAIDED BORDER,

The bags are used for storing fish, berries, and other food supplies, or for clothing. Smaller bags and baskets are made for containing small articles used in the house.†

Two types of basketwork are found in close proximity among the Eskimo in the neighbourhood of Norton Sound and Bristol Bay, north and south, the twined and the coiled. In the former (fig. 133) the treatment is precisely the same as in those of Aleutian Islands, to be described, but the Eskimo

* Smithsonian Report, 1886, Pt. I, pl. XV, fig. 67.

† E. W. Nelson, Eighteenth Annual Report of the Bureau of Ethnology, 1900, pl. 74.

wallet is of coarser material and the weaving is far more
rudely done. Quite as interesting as the wallets is the matting.
(See Plate 136.)

At Chuwuk, on the Lower Yukon, Nelson saw a woman
making one of these mats, and watched the process she em-
ployed. A set of three or four straws was twisted and the
ends turned in, for a strand, a number of which were arranged
side by side with their ends fastened along a stick, the primal
loom, forming one end of the mat and hanging down for the

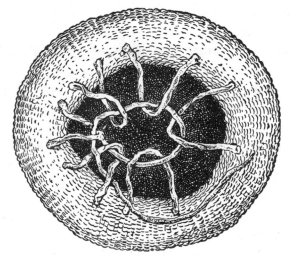

Fig. 132.
TOBACCO BASKET.
Hupa Indians, California.
Collected by P. H. Ray.

warp. Other strands were then used as woof. By a deft
twist of the fingers, it was carried from one side of the mat to
the other, passing above and below a strand of the warp; then
the woof strands were twined around the other strands of the
warp, to repeat the operation. The woof strands were made
continuous by adding straws as necessary, and with each
motion the strands were twisted a little so as to keep them
firmly together. By this simple method a variety of patterns
is produced.

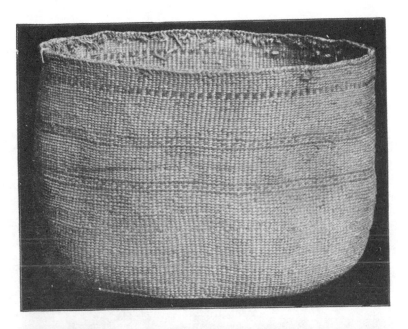

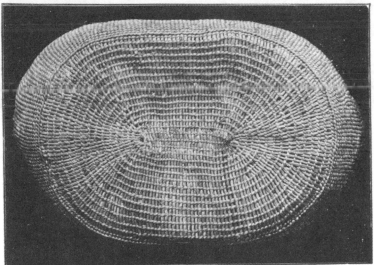

Plate 137. See page 303

TWINED WALLET IN OPENWORK, ESKIMO OF NORTON SOUND,
ALASKA

Collections of U. S. National Museum

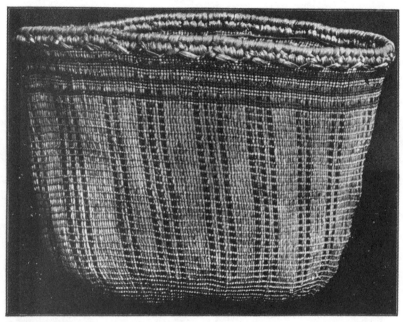

Plate 138. See page 304
Twined Wallet in Openwork, Chukchis, Northeastern Asia
Collections of Am. Mus. of Nat. Hist., N. Y.

Grass bags are started from the bottom where the strands of the warp, consisting of two or more grass stems, are fastened together and extend vertically downward. The woof is formed by a pair of strands of grass, each of which is twisted about itself and both twined with the strands of the warp inclosed in the turns; both are continually twisted as the weaving progresses. In coarsely made bags the strands of the woof are spaced from an inch to two inches apart, and those of the warp at intervals of from a quarter to half an inch. These bags have a conical bottom, which slopes from the center to the sides. At the mouth the ends of the warp are braided to form a continuous edge.*

The lower figures in Nelson's group of Alaskan basketry (Plate 136) show plainly the matting, the closely woven twined wallet, and the openwork. Plates 137 to 145 in this paper are all excellent illustrations of the

FIG. 133
DETAIL OF ESKIMO TWINED WALLET.
Collected by E. W. Nelson.

ware here described. The specimens are in the United States National Museum.

Plate 137 will show better the detail, body and bottom, of one of the twined wallets of the Norton Sound Eskimo. The warp and the twining of the bottom are of a very coarse, rush-like grass. The bottom is in openwork, and oval. In this example the warp is radiating from a median line; in others the strands are laid parallel, so that they form a rectangle. At the boundary line between the bottom and the body of the wallet there is a row of three-strand weaving, the

* Eighteenth Report of the Bureau of Ethnology, 1900, pl. LXXIV.

rows running in opposite directions, as will be seen in the drawing. The body is rush colour; the spotted lines on the cylindrical portion are in black, produced by the insertion of rags and bits of hide. This effect may be varied by mixing two strands of different colour in the twine. The fastening off at the top is done by working the warp strands into a three-strand braid, turning down on the inside of the vessel, and cutting off an end whenever a new warp thread is taken up by the braid. Frequently the last three or four warp straws are not cut off, but braided out to their extremities in order to form a handle for the basket.

In order to show how the warp and weft are administered in this far north region, a square inch of a wallet is represented much enlarged, fig 133. The openwork, producing parallel figures, is effected by leaving spaces between the different lines of twining. The four rows at the top of the drawing are plain, solid, twined weaving; the fifth row from the top is twined in an opposite direction, giving the effect of a three-strand braid between the two rows. It is interesting to find this method of basket-weaving so far north.

The student will notice further on that very much of the elegant use of the warp in ornamentation, so common with the Aleuts, who speak a kindred language and live near-by, is lost. It will be seen, however, that with their rude materials and tools the Eskimo have acquired the art of making a great variety of basketry, showing that they have had a multitude of teachers. This specimen, Catalogue No. 38,872, in the United States National Museum, was collected, with many others, at Norton Sound, by E. W. Nelson.

To furnish a means of comparison between the two sides of Bering Sea, Plate 138 is a twined wallet of the Chukchi people of Kamchatka. The foundation is of straw laid parallel, and the weft is of plain twined weaving, the rows one-half an inch apart. The border is finished off by gathering the ends of the warp into a braid. The decoration on this

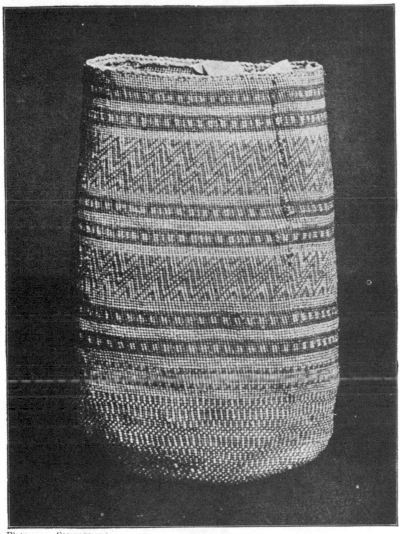

Plate 139. See page 305
CLOSELY TWINED WALLET FROM KAMCHATKA TO COMPARE WITH
ESKIMO WORK
Collections of Am. Mus. of Nat. Hist., N. Y.

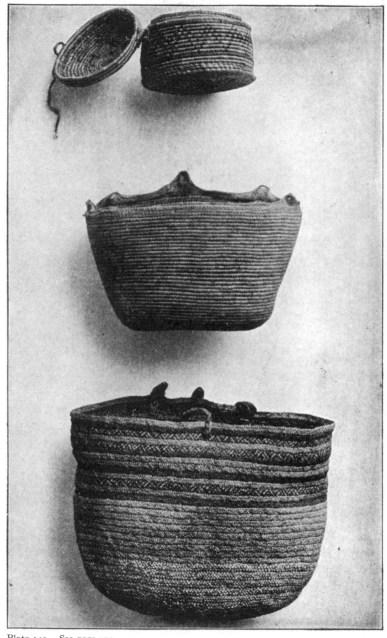

Plate 140. See page 310

COILED BASKETWORK OF CHUKCHIS AND KORYAKS OF KAMCHATKA

Collections of Am. Mus. of Nat. Hist., N. Y.

basket is effected first by colouring warp strands black and grouping them systematically, and also by three narrow bands of black twined weaving near the top. Its height is 12 inches. This specimen, now in the American Museum of Natural History, New York, was collected by the Jesup Expedition.

To pursue the comparison farther into Asiatic territory, Plate 139 is a wallet in twined weaving from Kamchatka, introduced here for comparison with the Chukchi type, just shown. The warp is of coarse hemp cord; the weft or filling is of grass stems in natural colour dyed black. The bottom is ornamented with bands in two colours; in each band there are alternate rows of black and white stitches arranged perpendicularly; in the next band they are oblique, and in the next perpendicular, forming an interminable mass of changing patterns, having a very pleasing effect. The body is covered with alternations of plain and variegated bands in which the white and black are administered in triangles, rectangles, chevrons, and zigzag patterns. The work on this wallet is finely done. The effect of the ornamentation is very attractive—on the top the ends of the warp are bent down and held in place by loops of sinew thread. The work nearest like this will be found quite common on the eastern side of Bering Sea and on the Pacific coast of America. The writer is indebted to Doctor Franz Boas for drawing attention to these similarities.

Its height is 13 inches. This specimen, now in the American Museum of Natural History, New York, was collected by the Jesup Expedition.

The coiled variety of Eskimo basketry, previously mentioned, consists of a bunch of grass sewed in a continuous coil by a whip stitch over the bunch and under a few stems in the coil just beneath, the stitch looping under one of the lower coil. When this kind of work is carefully done, as among the Indians of New Mexico, Arizona, and California,

and in some exquisite examples in bamboo from Siam and in palm leaf from Nubia, beautiful results are reached; but the Eskimo basketmaker does not prepare her foundations evenly, sews carelessly, passing the thread sometimes through the stitches just below and sometimes between them, and does not work her stitches home (fig. 51). It can not be said that she

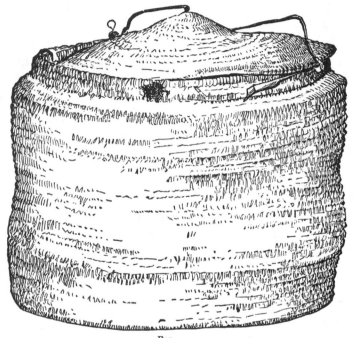

FIG. 134.
COILED BASKET.
Eskimo Indians, Alaska.
Cat. No. 38,469, U.S.N.M. Collected by E. W. Nelson.

has no skill with the needle, for her embroideries in fur, intestines, and quill are excellent. Most of the coiled baskets in the Eskimo collection in the National Museum were gathered by E. W. Nelson, and have a round bit of leather in the bottom to start upon (fig. 135). The shape is either that of the uncovered bandbox or of the ginger jar.* Especial attention should be paid to this form of stitching, as it occurs again in

* Eighteenth Annual Report of the Bureau of Ethnology, 1900, pl. 74.

widely separated regions in a great variety of material and with modifications producing striking effects. (See figs. 134, 135.)

The Eskimo women employ in basket-making a needle made of a bird bone, ground to a point on a stone (fig. 40). Fine tufts of reindeer hair taken from between the hoofs are modernly used in ornamentation, just as the California

FIG. 135.
BOTTOM OF FIG. 134.

women catch the stems of feathers under their stitches as they sew.

Figs. 135 and 136 will illustrate this rude type of coiled basketry of the Eskimo about Norton Sound. It is quite certain that the art of basket-making is not an old one with these people. They have not learned how to begin the work from the center of the foundation, and always leave a circular space, either vacant or to be filled with some other substance.

In the example here shown, a piece of hide 4 inches in diameter and irregular in outline constitutes the starting-point. Holes are punched around the edge of this, as shown in the detail drawing (fig. 136), and the foundation of grass stems and leaves is sewed immediately to this with strips of the same material, not with any regularity or neatness. The basket has a cover, which is also interesting in its leather hinges, fastening, and handle. It must be admitted, however, that under the stimulus and demands of trade, the art is improving. Specimens are at this date brought home that are vastly

better made than any of the old pieces in the National Museum; charming cloud effects are produced in sewing by using straws of different tints.

This specimen, Catalogue No. 38,469, in the United States National Museum, was collected by E. W. Nelson.

FIG. 136.
DETAIL OF ESKIMO COILED BASKET.

Catalogue No. 127,891, in the United States National Museum, is a small jar-shaped coiled basket from the Kowak River region, north of Bering Strait, Alaska, collected by Lieutenant George M. Stoney, United States Navy. The foundation of the coil is a small number of slender grass stems. The sewing is in material of the same kind. The special characteristic of this specimen is that, in the sewing, the grass filament is wrapped once around the foundation and on the next turn is locked in the stitch underneath. This is an economical method of working, but it weakens the basket. The work on this specimen is slovenly done. It has a small piece of leather in the center of the foundation. Height, 1¾ inches. This example is a waif. It comes from the Arctic Ocean area, and most of the pieces in the museum from nearby are Tinné and gotten by the Eskimo in trade. More

curious still is the extra wrap about the foundation every time a stitch is taken. The raffia coiled baskets made in some of the schools are similar.

Catalogue No. 35,962, United States National Museum, is a basket jar of the Eskimo, at Kushunuk, Alaska. The flat bottom is in open twined weaving of grass stems. The sides are in coiled work of the same material, the outline being rectangular, with rounded corners. The notable feature of this piece is the union of two fundamentally different methods of manufacture, the twined and the coiled.

Its height is 4 11–16 inches, and it was collected by E. W. Nelson.

Catalogue No. 36,190, United States National Museum, is a coiled basket jar of the Eskimo on the Lower Yukon. The bottom is a piece of sealskin three inches in diameter. The coiled work on this specimen is unique. A grass foundation is held together by half-hitches, or button-hole stitches, in the same material, close together. There are sixteen rows. The stitches pass over the foundation, lock with the stitches underneath, and in returning make a turn about the standing part. The technic is not half hitch, but, if the foundation were pulled out, would resemble the twisted coils in the Mackenzie River game bags, muskemoots (Plate 129), or the work on the textile from Hopewell mound, Ohio. (See fig. 116.)

Catalogue No. 153,686 in the National Museum is a coiled basket jar of the tribes on the lower Yukon, Alaska. The foundation is a flat piece of hard wood, varying in width, overlaid by a small splint, which gives an uneven line on the outside. The sewing is done with strips of willow rods without bark. The stitches pass over both strips of the foundation and are caught between the two strips of the foundation coil underneath. This is the only specimen of its kind in the museum from Alaska. The use of a broad foundation gives a flat appearance to the surface, something like that of the Mescalero basketry in New Mexico. A handle is attached,

the technic being the same as that of the basket. Height, about
4⅜ inches. Collected by J. Henry Turner.

Catalogue No. 127,482, in the National Museum, is a
coiled basket jar of the Eskimo, Togiak River, emptying into
Bristol Bay, Alaska. The foundation is a piece of sealskin.
The rows of the basket are built up by coiled work, with straw
for foundation and sewing. The peculiar characteristic *
is the neat and regular manner in which the stitches, in passing
outward, split the underlying stitch of the previous coil.
On the surface these stitches pass from top to bottom in
regular vertical lines, resembling feather stitch. The upper
margin is ornamented with a row of birds' feet. Its height is
2⅞ inches, and the specimen was collected by I. Applegate.

Catalogue No. 127,483, United States National Museum,
is a coiled basket jar of the Eskimo on Togiak River. A rude
ornamentation is attempted on the surface near the top by
overlaying the foundation with a band of brown material
underneath the stitches. Much will be said about this device
of overlaying among Indian tribes farther south.

Its height is 2 inches, and it was collected by Mr. Applegate.

The upper figure in Plate 140 is a covered basket in coiled
work of the Chukchi people of Kamchatka. Foundation, a
piece of sealskin; bottom, coarse coiled work in straw, held
together by sewing in sinew thread, the stitches being one-half
inch apart. The body is built up of coiled sewing, similar to
that of the Eskimo of Alaska. Decoration, bands of chevron
pattern in black. Hinge and fastening of sealskin. Top
decorated with six-pointed star. Diameter, 7 inches.

This specimen, now in the American Museum of Natural
History, New York, was collected by the Jesup expedition.
The students of culture will be interested in the results of this
exploration, which settle the question of unity of industries
in the two continents.

* See Report United States National Museum, 1884, pl. IV, showing
furcated stitches.

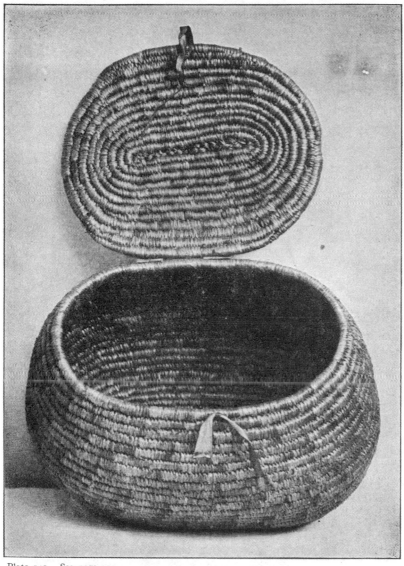

Plate 141. See page 311

ESKIMO BASKET, SHOWING INTERLOCKING COILED WORK, FROM
THE LOWER YUKON, ALASKA

Fred Harvey Collection

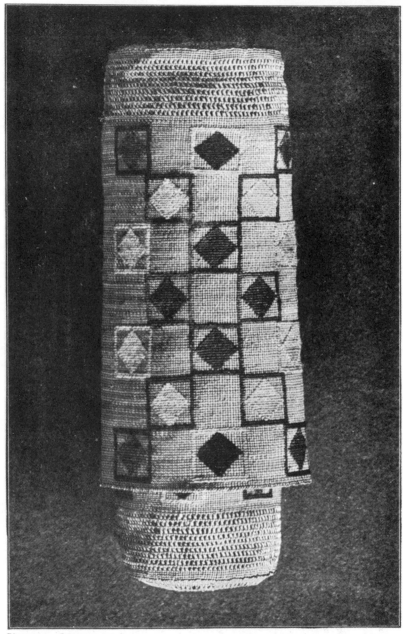

Plate 142. See page 312
TWINED WEAVING IN CLOSE AND IN OPENWORK TWINED WEAVING
ALEUTIAN ISLANDS
Collections of U. S. National Museum

Fig. 2, on Plate 140, is an oblong coiled basket of the Chukchi people of Kamchatka. In the foundation, as in the Eskimo baskets, an oblong piece of sealskin is inserted. The people of the north region do not seem to know how to make the coil beginning which prevails among the Indian tribes.

Around this sealskin the bottom consists of a continuous coil of grass stems held together by wide, open coiled sewing in sinew thread. The body is built up on a grass foundation, with sewing in the same material, resembling precisely the work done by the Eskimo of Port Clarence. Three rows of coiled work at the top are like that at the bottom, and over all is a band of sealskin rawhide with holes here and there for carrying. Its height is 9 inches. This specimen, now in the American Museum of Natural History, New York, was collected by the Jesup expedition.

The bottom figure on Plate 140 is a braided and coiled wallet of the Koryak people of Kamchatka. The foundation is a strip of sealskin. The body is built up in a continuous coil of six-strand braid, as in making hats. The decoration consists of alternating plain with coloured rows of braid. Loops of sealskin on the top serve for fastening and carrying. This is a rare type of basketry in America. Its height is 13 inches.

There is a small specimen in the United States National Museum, obtained by Captain John Rodgers, United States Navy, in 1852–55, made in the same way. As his expedition was on the Arctic coast of Asia, this piece also may have come home from that quarter.

Plate 141 is a covered coiled basket in the collection of Fred Harvey. It is from the Lower Yukon River country and represents one of the best types of Eskimo work. Especial attention is called to the evenness of the stitches, which interlock and at intervals gather in a few of the straws of the foundation. The mottled surface of the basket should also be noted in connection with the delightful effects produced

by simply managing the natural colours of the straw with which the sewing is done. Attention has been directed to the glorification of this technical method by the Mission Indians in California. This specimen represents the very best coiled work that the Eskimo can make.

ALEUTIAN BASKETRY

In 1874, William H. Dall contributed to the United States National Museum several specimens of twined basketry, from Attu and other islands far out in the Aleutian chain. (Catalogue Nos. 19,476–19,480.) There for the first time this exquisite weaving was brought to light. Warp and weft are straws of beach-grass,* and the workmanship will compare favourably with that of any other basketmakers in the world. In the conical wallets, which resemble in outline those of the Eskimo and southeastern Alaskan tribes, the warp straws radiate from the center of the bottom. On the body the twined weft, always the same plain two-strand work, is applied to the warp, so as to give rise to several technical varieties, which may be classified as follows:

1. Plain twined weaving, the weft driven home (Plate 142).

2. Open twined work, there being open spaces between the rows of weaving, but the warp strands are parallel.

3. Crossed warp, in which there are two sets of warp elements, one half inclining to the right, the other half toward the left. The twined weaving binds the decussations, making hexagonal meshes. This type has an interesting distribution on both sides of the Pacific.

4. Divided warp. A pretty effect is produced by these Aleut basketmakers, who split the warp, or divide it, if it consists of straws in pairs, and twine the weft straws around

* *Elymus mollis*, Sitka, Norton Sound, Kotzebue Sound; *Elymus arenarius*, Norton Sound to Point Barrow; *Elymus sibiricus*, Sitka. Rothrock, Smithsonian Report, 1867. For a description of the Eskimo and Aleuts, see W. H. Dall, in the Contributions to North American Ethnology, I, 1877, pp. 7–106.

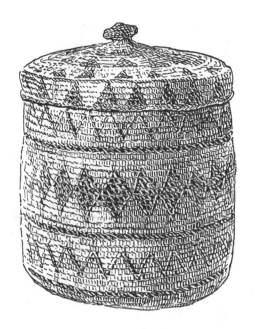

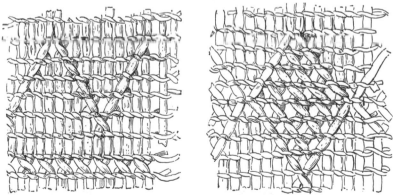

Plate 143. See page 313

DETAIL OF CROSSING WARP STRANDS IN ALEUT BASKET

Collections of U. S. National Museum

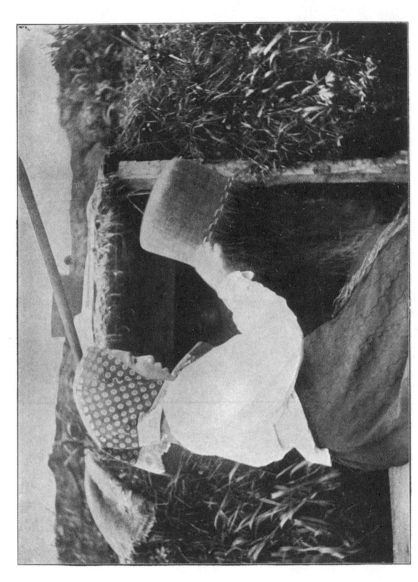

Plate 144. See page 316 Attu Weaver Working Upward on Soft
Warp Suspended

Photographed by C. Gadsden Porcher

two halves of the same straw and next around two half-straws not of the same, but of adjoining stalks. If the warp be of straws by twos, the left-side member of one pair is entwined with the right-hand member of the adjoining pair. On the next round there is an alternation, the straws that belong together being entwined. The result of this is a series of lozenge-shaped openings, or meshes (figs. 16, 17). The general appearance of the surface resembles a form of needle-work called hemstitching. The Aleuts in doubling the warp do not place one element behind another as do the Tlinkits, but alongside. This enables the weaver to convert her technic into some other type in the successive rounds. She may have plain twining, crossed warp, zigzag warp, or hemstitch at any moment.

5. Diverted warp. By this is meant a form of weaving in which certain warp straws are deflected from the perpendicular for a few courses and then brought back or changed to the upright position again. The result of this is a most pleasing effect (Plate 143) and of the greatest variety on the surface. Attention has been previously invited to the similarity of Mound Builders' work in the Mississippi Valley to the playing with the warp of which the Aleuts were so fond. Away down among the mummies of Peru are found relics of weaving of precisely the same sort.

Ornamentation is produced by what looks like darning or whipping one or more rows of coloured grass after the body is formed. It is in effect the false embroidery of the Tlinkits farther south. The worsted patterns are woven into the texture and do not show at all on the inside. (See fig. 16.) Another plan of attaching the ornamentation is very ingenious, but not uncommon. Two strands of coloured straw are twined, and at every turn one of the strands is hooked under a twist on the body of the basket by a kind of "aresene" work or false embroidery with twine. The ornament has a bold relief effect on the outside and is not seen at all on the inside.

The making of the beautiful twined ware is not new in these small islands. Lisiansky * affirms that the Aleuts make baskets called "ishcats," in which they keep all their valuables.

To begin with the eastern tribes, Catalogue No. 2,192, in the United States National Museum, is a twined wallet of the Aleuts (Eskimauan family) on Kadiak Island, Alaska. Native name, Enakhtak. It is made entirely of Topkhnaluk, or wild rye (*Elymus*). The lower stalks are chosen because they have become yellow through want of light. The wallets are woven from the standing grass, generally in July and August, by the women, while engaged in curing salmon. In order to secure uniformity in texture, the broader leaves are split. An ordinary knife is used to cut the grass, but no other apparatus than nimble fingers has to do with the manufacture. The twining is called agankhak. The Kadiak baskets are used chiefly in gathering berries and also in straining a kind of wine made from them. This specimen was collected by Lieutenant G. T. Emmons, United States Navy.

These wallet baskets are woven without ornamentation, except, maybe, a line or so near the mouth, often effected by introducing one or more rows of black rags, the warp strands forming a heavy plaited rope-like border, which permits carriage by means of cords through the openings. In the Kadiak wallets, the Tlinkit border is also imitated where the warp ends are bent down and held by twined weaving.

Catalogue No. 14,978 in the United States National Museum is a typical old Aleut wallet. The cylindrical part is covered with meshes in diamond pattern, shown in fig. 9, Plate 136. The ornamentation on the surface is produced by false embroidery with strands of red, blue, and black worsted. The continuous line between the open stripes is formed by false whipping with a single thread of worsted on the outer stitches of one of the twines of straw. The border is a complicated braid.

* Voyage Round the World, 1803–1806, London, 1814, p. 181.

A square inch of this weave, enlarged (see fig. 17), taken from the part of the texture where the rectangular meshes pass into the lozenge-shaped, will show the peculiar method of separating the warp threads and working the halves alternately to the right and to the left.* In the bottom row the pairs of warp straws are perpendicular and gathered into the twined weaving, so as to produce rectangular spaces. All the rows above this are in the pattern here described. From the Attu Island; collected by William H. Dall.

Plate 142 shows the fine close-twined work done on the extreme western islands of the Aleutian chain. The specimen here described is Catalogue No. 204,588, United States National Museum, the gift of Mrs. Mary L. D. Putnam, of Davenport, Iowa. Its noteworthy features are the crossed warp and the patterns worked in coloured worsted on the surface. The material is beach-grass—some species of *Elymus*. The false embroidery on the surface, there can be no doubt, is borrowed in its method from the Tlinkit Indians of southeastern Alaska. Among the old Aleut wallets, of which there are many in the National Museum, the weaving does not begin to be so fine as on this later ware. It is the same story of progress With the possession of better knowledge, of superior tools, of gauges for sizing the straws, and, above all, of such demands for their products as to stimulate emulation to its highest pitch, the Atka and Attu weavers have reached their climax.

Plate 143 is introduced to show the technic of variety No. 5, diverted warp, combined with variety No. 2, or openwork. Fig. 1 illustrates the general effect of this combination. Attention has been called before to the enigmas awakened by the great variety and exquisite taste of these people, our first possession in the Eastern Hemisphere. In figs. *b* and *c* the detail will be better understood. In fig. *b* the first has parallel warp. In the next row each pair of continuous warp straws are crossed. In the third row they proceed vertically,

* See Report of the United States National Museum, 1884, pl. I, Fig. *b*.

and so do most of them in the fourth row; but here and there
they are crossed again back to the position they occupied in
the second row. These, too, continue in the oblique direction
in the fifth, sixth, seventh, and eighth rows, crossed in each
with a straw of that particular row. In the upper course they
return to the vertical position. The twined weaving is
precisely the same in every case. It does not vary, whether
in the closed or open weaving. No artistic effect is expected
therefrom. In this plate, where the decorative form is
started in the bottom row and begins to widen out, all of the
intersections within the parallelograms are crossed. At the
tenth row, above the upper border of the drawing, the straws
return to their vertical position immediately over the starting-
point. These two are only specimens of the innumerable ways
of producing effects in Aleutian baskets by changes in the
warp.

It will add to the interest in the Attu weaver to see her at
her work. Plate 144, taken by Engineer C. Gadsden Porcher,
of the United States Revenue Marine Service, shows her at the
front door of her barabra, or underground hut. She is essentially
a cave-dweller. The framework of the house may be drift-
wood, wreckage, or timber deposited by ships. Over this,
moss from the tundra is piled, and Nature plants her garden.

It is an error to attribute all of the Aleut basketry to the
women of Attu. Porcher has worked out the types in the
March number of the *Craftsman*,* describing minutely the
grasses, the methods of curing them, and the different weaves
of Attu, Atka, Umniak, and Unalashka.

The first thing that demands notice is that she is weaving
upward—upside-down, a careless first thought would say.
The bottom of her fine wallet is suspended from a pole, most
primitive of warping-beams, stuck into the roof of the barabra.
John Smith's Indians used a limb of a tree (figs. 147 and 148).
The Bristol Bay Eskimo now employ a stick supported on forked

* *The Craftsman*, New York, March, 1904, pp. 575–583.

stakes; so do the Chilkats for their highly prized blankets, and the tribes farther south to make cedar-bark garments. Indeed, the loom is about to be born. With a lens it will be seen that the basketmaker is doing the best work, in which every variety of Aleutian technic is engaged. Her costume shows her to be in the current of world-embracing commerce and thought. The plants about her and the precious work of her fingers, together with the ideas in her retentive mind, ar: survivals from the past.

Tlinkit Basketry

The basketwork of the Tlinkit Indians is superb. Everyone who sees it is struck with its delicacy of workmanship, shape, and ornamentation. Most of the specimens in the National Museum collection are of the bandbox shape, but they can be doubled up flat like a grocer's bag. (Plates 65 and 67.) The material of foundation and weft is the young and tough root of the spruce, split, and used either in the native colour or dyed brown or black. The structure belongs to the twined type before mentioned, and there is such uniformity and fineness in the warp and woof that a water-tight vessel is produced with very thin walls. The warp is double, one splint resting on the other and outside of it. In size, the wallets vary from a diminutive trinket basket to a capacity of nearly a bushel. All sorts of designs in bands, crosses, rhombs, chevrons, triangles, and grecques are produced thus: First, the bottom is woven plain in the colour of the material. In a great many pieces a row of plain weaving alternates with the twined weaving for economy, in which case the woman carries along two rows of work simultaneously. Then, in the building up of the basket, bands of plain colour, red and black, are woven into the structure, having the same colour on both sides.* At the same time, little squares or

* See G. T. Emmons in the Memoirs of the American Museum of Natural History, New York, 1903, This paper is the result of twenty years' work among the Tlinkits by a patient observer, and should be studied with special care.

other plain figures made into designs are added in aresene, or what is here called false embroidery—that is, only half way through—giving the most varied effect on the outside, while the inside shows only the plain colours and the red and black bands. Wild rye straws (*Elymus*) for coarse work, and hair-grass (*Deschampsia*) on fine work are used in this second operation, in plain rich golden colour or dyed, being whipped over and over along the outer threads of the underlying woof. Other grasses for false embroidery are *Panicularia nervata*, *Calamagrostis langsdorffii*, *Cinna latifolia*, and *Bromus sitchensis*. (See Plate 145.)

For borders on Tlinkit and Haida ware see pages 115 to 122, figs. 73–81.

The Tlinkits recognise five styles of weave, not including the fish trap, the false embroidery in grasses and plant stems, and the plaited borders. These are all in twined weaving, the progress of the work being from left to right and the outer woof strand sloping downward. Lieutenant Emmons gives the native name of each as follows:

1. Plain close-twined weaving, Wush tookh á r-kee ("close together work"), which is perfectly water-tight, and is the standard weave of fully three-quarters of all baskets made. It consists of the simple twining of two woof strands around each successive thickness of warp splints. The regular weave produces the vertical, ridge-like appearance in the line of the warp, the polished exterior surface of the root forming the outside or ornamental face of the work.

An openwork work-basket in this plain twined weaving is known as Khart ("a strainer," literally, "will not hold water"). It is used in trying out fish oil and in cooking and straining berries.

2. Twined and checker weaving, Khark gheesút ("between," "in the middle of"), from the introduction of a single woof strand in checker or wicker weaving between the lines of the regular twined stitch. It gives a broken, irregular effect

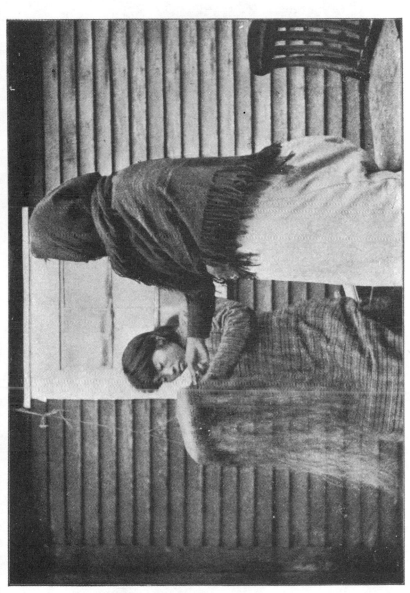

Plate 145. See page 318 ALEUT MANUAL TRAINING SCHOOL, MRS. PHILASET

TEACHING BASKET-WEAVING

Photographed by C. Gadsden Porcher

Plate 146. See page 321 TWINED WALLETS WITH FALSE EMBROIDERY, TLINKIT INDIANS, SOUTHEASTERN ALASKA

Fred Harvey Collection

from the exposure of the warp along the line of the single weft, as well as from the dull, fibrous surface of both of the strands, which are of the coarsest inner sections of the root. This weave is of a later origin; the plain weaving has been borrowed from the mainland and from the more southern people. It is characteristic of the cedar-bark work from Frederick Sound to the Straits of Fuca. It is wanting on the oldest specimens of Yakutat baskets. Its use is confined to the coarser work, such as the plaque-like berry, sewing, and work-baskets of the woman, the bottoms of the baskets and the unexposed tops of the covered baskets. It is in great favour among the Chilkat, who make many large baskets. It is used for economy, both in the quantity and the quality of the material, as one woof strand is saved in every three, and in the more valued exterior root section the saving is one-half. But its disadvantages are loss of strength, rigidity, and closeness of texture, and it does not admit of the embroidery in grasses and plant stems which is the characteristic feature of Tlinkit basketry. (See figs. 140 and 141.)

3. Diagonal twined weaving, Hiktch hee há r-see (rough or uneven, like the skin of the frog's back, from its mottled character), is formed by the simple twining of two woof strands about pairs of warp elements. The weave separates the pairs in each superimposed line of woof, and breaks joints in the units of weave, just as in myriads of Attu and Ute baskets. (See Plates 96 and 143.) It is, in fact, the well-known twilled weaving. This weave was never extensively used among the Tlinkit, except as a skip stitch in conjunction with the ordinary twining (No. 1), whereby a number of geometric figures are produced which form the ornamentation of the Haida hat rim and the Chilkat basket border.

Shuck kuhk (strawberry basket) has erroneously been classed as a type of weave, but it is simply a variation of the regular twined weave, in which the woof strands are of different colours, so that in both the vertical and the horizontal lines

there is produced a variety of effects, supposed to resemble
the seed-covered surface of the wild strawberry. This char-
acter of ornamentation is more commonly found in bands on
the women's work-basket and on mats of basket covers.
The flecking of the surface of twined ware with dark and
light spots is not confined to the Tlinkit, but will be observed
among all Western tribes that have this weave. (See Plate
67).

4. Crossed-warp twined weaving, Wark kus-ká rt ("eye
holes," from the polygonal meshes of the openwork weave),
in which the warp splints are drawn aside from the perpen-
dicular at a fixed angle, the odd numbers trending one way
and the even numbers the other. These cross each other
successively in parallel series, just after which they are inclosed
and held in place by the ordinary twining of two woof strands.
The size of the meshes is regulated by the distance apart of
the spirals of the weave. This type is used for rather long,
flat cases or bags, but more particularly for spoon baskets,
which are fitted with a twisted root handle to hang them to
hooks or pegs on the wall. In later years ornamental baskets
are often made in this weave. .

5. Three-strand twined weaving, Uh ta'hk-ka (twisted).
This gives a longer winding, rope-like appearance to the weave
outside, while on the inside the regular twining stitch in its
ridge-like regularity is seen. It is strengthening as well as
decorative, and is often met with in circles at intervals near
the bottoms of the larger, older baskets, which are required
for the heavier work. It is in general use to-day as a single
line of woof around the outer circumference of the cylinder
basket, where the warp splints are bent upward to form the
sides. Its more important use has been in the construction of
the crown of the hat as well as of the cylindrical ornaments
surmounting it, and other ceremonial head dresses among both
the Haida and the Tlinkit.

The Tlinkits do not seem to have learned, or were forbidden

by economy, in doubling their warp splints, to use strips from the outside of the root and to lay the wrong sides together, so as to have both outer surfaces smooth. This is shown in the mixed twine and checker work on the bottoms of baskets.

Plate 146 is a collection of Tlinkit twined basketry made from the roots of the spruce and decorated in false embroidery with wild rye or hair-grass, either in the natural colour or dyed.

FIG. 137.
TWINED BASKET WALLET.
Tlinkit Indians, Alaska
Collected by J. B. White.

It will be observed that the figures do not appear on the inside of the wallet. Attention is also called to the very fine workmanship on these old specimens, especially upon the large one in the middle. The ornamentation, in its symbolism, has reference to natural features and waterways. The composition of the ornament is in triangle and parallelograms.

Fig. 137, Catalogue No. 21,560, United States National Museum, is a twined basket wallet of the Tlinkit Indians. It is of bandbox shape when spread out, but is here shown as

folded for transportation. The bottom, warp, and twine are very roughly made of spruceroot splints, the former radiating from the center. The boundary of the bottom is a single row of three-strand twine. This method of ornamenting and strengthening their work was used by the Tlinkits, not only at the bottom, but along the sides and near the top. The rest of the body is in stripes done in false embroidery.

Figs. 138 and 139 illustrate the method of making false embroidery employed on the basketry of the Tlinkit Indians.

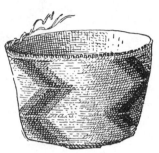

FIG. 138
FALSE EMBROIDERY.
Tlinkit Indians, Alaska.
Collected by J. G. Swan.

As the woman proceeds with her work, she wraps the grass stem once around each strand of the regular twine when it comes outside. On the inside, therefore, there is no appearance of ornament; the figure plainly shows how this work is done, and it might be called a type of three-strand t w i n e d weaving in which one of the elements passes inside the warp. Ornamentation on this ware is also produced by dyeing the filaments of which the basket is made. This specimen is Catalogue No. 20,726, in the United States National Museum, and was collected by James G. Swan.

Fig. 140, from the Tlinkit tribes about Fort Wrangell, in southeastern Alaska, is a carrying wallet for general purposes. It is an interesting and important specimen in that it forms the connecting link between common plain in-and-out weaving and twined work, both plain and twilled (styles 1, 2, 3, and 4 of Emmons), from the tribes immediately north, and the Haidas. The specimen is made of spruceroot, and the rows of weaving are alternately twined and wicker over the entire surface of the wallet excepting the border. In examples already described, this combination of two weaves was seen on the bottoms, for economy, but in this piece the whole surface was

thus covered. The coarser type is shown in fig. 141, from
the Tlinkit Indians, taken from the bottom of basketwork
inclosing a bottle. It will be seen that the first few rounds are
plain twined work; after that the rows are far enough apart
to allow an additional row of wickerwork or beading.

Specimen Catalogue No. 168,163 in the United States
National Museum was collected in southeastern Alaska by
Herbert G. Ogden, and specimen No. 73,755 was collected
in Neah Bay, Washington, by James G. Swan.

Plate 147 represents a group of the Tlinkit Indian basket-
makers. They were named Kolosch by the Russians more
than a hundred years ago, because they wore labrets, or

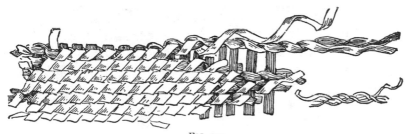

FIG. 139.
DETAIL OF FALSE EMBROIDERY.

plugs in their lips. The woman on the left side of the picture
has a modest one in her lower lip, but specimens in the National
Museum measure as much as three inches in diameter. Owing
to the broken condition of their island home, and the large
ownership of personal property, they are divided into innu-
merable villages or Kwans. The best-known basketmakers
are Chilkats, Hoonahs, Sitkas, Takoos, Tongass, and Yaku-
tats.* It will be noted in looking at the women in the group
that the Tlinkits are a well-fed, vigorous race. The Russians
spoke well of them, not only for their physical qualities, but
for their intelligence.

The group is a study in more respects than in basketry.

* On the Ethnology of the Tribes of the West Coast, see Franz Boas, in
the Proceedings of the British Association for 1884 and following years.

They are all clad in trade goods. As to jewelry, one wears her rings on her fingers, but the chief woman has hers in the septum of her nose. Old forms of basketry are mingled with covered bottles, and the ubiquitous can (Kanastron), formerly a basket, both in Greek and Tlinkit, stands by the side of the genuine article. Before leaving the group, it is worth while to recall that with thrifty tribes new tricks of handicraft are readily borrowed, and too much stress must not be laid on the assumption of identity of race because of identity of art. It is worth while to linger here a moment. The Attu woman

FIG. 140.
CARRYING WALLET.
Tlinkit Indians, Alaska.
Collected by Herbert G. Ogden.

as well as the old-time Algonquian tribes did suspend warp for baskets and matting, but here among the Chilkat is to be seen the pristine loom. It is not surprising when it is re-membered that here the Rocky Mountain goat is at home.

On the main land of the northern Pacific slope the mountain goat (*Oreamnos montanus*) abounds. From the Chilkat Indians about Mount St. Elias southward to the Nez Percés, of Idaho, blankets are woven from the wool. These fabrics are, in their manufacture, the transition from basketry to loomwork. They are in twined weaving. The only shuttles are the skilful fingers of Indian women; the warp hangs down

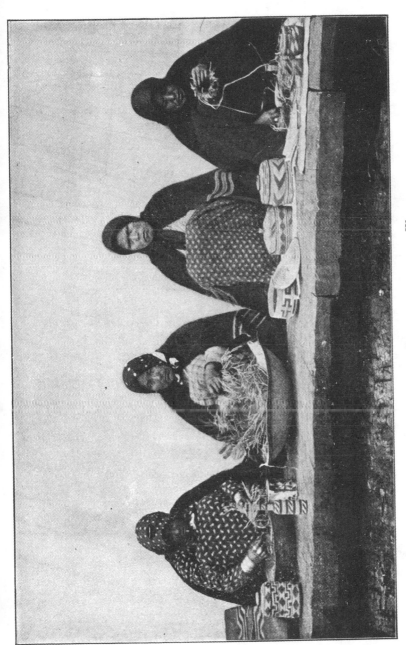

Plate 147. See page 323

GROUP OF TLINKIT BASKET-WEAVERS AT WORK,
SOUTHEASTERN ALASKA

Photograph from G. T. Emmons

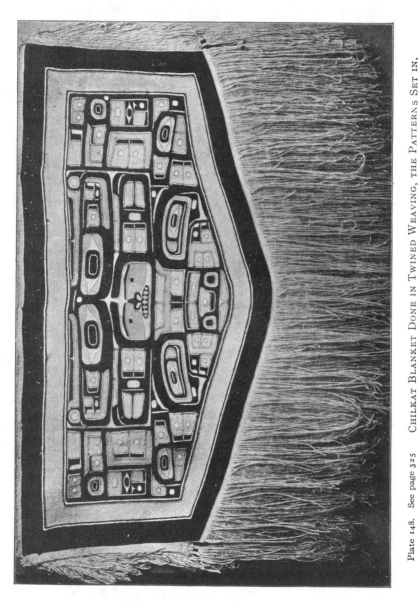

Plate 148. See page 325　Chilkat Blanket Done in Twined Weaving, the Patterns Set in, Southeastern Alaska

Collections of U. S. National Museum

loose from a pole or bar, and the work of twine is upward, precisely as in Haida basketry. (See Plate 148.)

Vernon Bailey says of the material that the winter coat of the mountain goat is a dense piece of long, soft wool, with strong, coarse hairs scattered through it. In spring and early summer, when the wool is being shed and hangs in loose strings on the goat it catches on bushes and rocks and the low branches

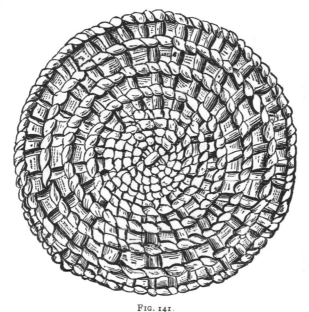

Fig. 141.
TWINED AND WICKER WEAVE.
Tlinkit Indians, Alaska.
Cat. No. 73,755, U.S.N.M. Collected by J. G. Swan.

of timber-line trees. On the slopes above timber line in May and June every bush and tall dry weed will be festooned with tufts of wool that could be picked off in handfuls. In a good goat region the Indians might gather wool enough for a large part of their clothing without the trouble of killing one.

Fig. 142 is a section of a wallet made by the Chilkat Indians. The material is the young root of spruce. It is here introduced to show the effect on the surface of several kinds of weaving

before described. Beginning at the bottom of the drawing there are ten rows of alternate plain twined and checker weaving. At the margin of this lower portion, and also at the upper margin of the drawing, will be found a row of twined work set on the regular twined weaving for strength and ornament. The upper portion of the wallet is a mixture of plain twined work over one warp splint and twilled twine weaving over two warp splints, making a diagonal pattern on the surface. The rope is made of the same material.

FIG. 142.
WALLET.
Chilkat Indians, southeastern Alaska.

HAIDA BASKETRY

The Haida Indians live on Queen Charlotte Archipelago and adjacent islands. Their basketwork is all in twined weaving, and differs from that of the Tlinkits in artistic finish only, owing probably to the demands of trade. Their wallets of spruce are devoid of decoration, save here and there a band in plain black colour; but hats made by these Indians are masterpieces in execution and ornamental weaving. The crown is in three-strand or plain twined weaving of the most delicate workmanship, and the fabric is perfectly water-tight when thoroughly wet. Ornamentation is introduced into the brims by a series of diamond patterns in twilled weave covering the whole surface. This decoration is produced thus: Beginning at a certain point, the weaver includes two warp strands in a

half twist instead of one; then makes two regular twists around single warp strands. The next time she weaves around she repeats the process, but her double twist is one warp stem in advance of or behind its predecessor. A twilled effect of any shape may be thus produced, and rhombs, triangulated fillets, and chevrons be made to appear on either surface. (See figs. 143 and 144.)

The fastening off of the work is done either by bend-

FIG. 143.
HAT IN FINE TWINED WEAVING.
Haida Indians, British Columbia.
Cat. No. 89,033 U.S.N.M. Collected by James G. Swan.

ing down the free ends of the warp and shoving them out of sight under the twists of the web, or a braid of four strands

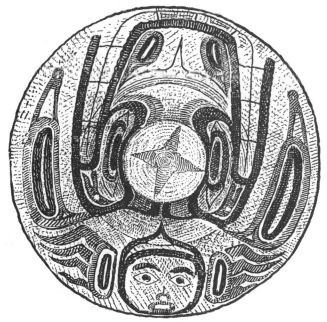

FIG. 144
DETAIL OF FIG. 143.

FIG. 145.
TWINED OPENWORK BASKET.
Haida Indians.
Cat. No. 88,964, U.S.N.M. Collected by James G. Swan.

forms the last row, set on so that the braid shows outside and only one strand at a time shows inside. The ends of the warp splints are then cropped close to the braid or it is held on by a row of plain twining.

Special attention should be paid to the fact that the ornamentation on these hats is painted and not woven (see fig. 143). Not far away, on the mainland, the same motives appear on blankets, woven into the texture. Figs. 143 and 144 show the head, wings, feet, and tail of the duck, laid on in black and red in the conventional manner of ornamentation in vogue among the Haidas and used in the reproduction of their various totems on all of their houses, wood and slate carvings, and the ornamentation of their implements.* Shells, beads, and feathers are often sewed on in profusion.

* A very interesting instance of survival is to be seen in the rag carpets of these Indians. The missionaries have taught the women to save up their rags and to cover their floors with pretty mats. They are allowed to weave them in their own way, however, and the result is constructed on the ancient twined model.

FIG. 146.
DETAIL OF FIG. 145.

Catalogue No. 88,964, collected by J. G. Swan, is a twined openwork basket of spruceroot made by the Haida Indians. This piece of coarse workmanship shows both phases—the open and the close weave in rough inner splints. The handle is a twine of the same material fastened into the weaving while it is in progress. The border is effected by bending down the warp elements at the rim externally and sewing them in place with a row of twined weaving.

A square inch of this specimen taken near the top, where the openwork and the closework come together, is shown. (See figs. 145, 146.)

Fig. 147 shows an unfinished Haida cylindrical basket attached to the stake or frame on which it is woven. In order to explain the process of manufacture, the bottom is in plain twined weaving; at the border where this joins the cylindrical side is a row of three-strand; and four rows of plain twined weaving of the body come next, the unfinished portion exhibiting the warp as it appears before weaving.

Especial attention is here called to the sharpened stake, which has a circular board on top.

FIG. 147.
UNFINISHED BASKET.
Haida Indians.
Collected by James G. Swan.

This is driven into the ground, and the woman seated works upward instead of downward, as in most cases. This specimen, Catalogue No. 89,033 in the United States National Museum, was procured in Queen Charlotte Islands by James G. Swan. It will be remembered that in an ancient drawing showing how the Virginia women made basketry, the woman is seated in precisely the same fashion and is working from below upward. (See fig. 148 and Plate 144.)

FIG. 148.
VIRGINIA INDIAN WOMAN WEAVING
A BASKET.
After W. H. Holmes.

Plate 149 represents old twined wallets of the Haida Indians, Q u e e n Charlotte Islands, B r i t i s h Columbia. The material is splints of spruce, some of which have been dyed simply by immersing in dark-coloured mud. The Haidas used little colour decoration other than black bands in their work, but they have learned the art of producing figures by including more than warp element in the twining. They also know the art of t h r e e - s t r a n d twined work, as will be seen on the upper border of the two larger wallets. The borders are finished off by false embroidery.

Plate 150 represents a company of Haida Indian basketmakers, photographed by J. G. Swan. They are in modern dress, but wear nose-ring and labret common to their tribe, and are also weaving upward.

THE FRASER-COLUMBIA REGION

Basketry is the most expressive vehicle of the tribe's individuality, the embodiment of its mythology and folklore, tradition, poetry, art, and spiritual aspiration.—NELTJE BLANCHAN.

The next general area for study will be the drainage region of the Fraser River and the Columbia River. The families to

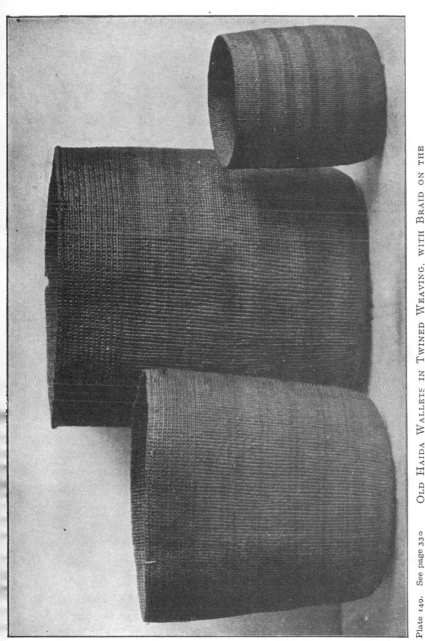

Plate 149. See page 330 Old Haida Wallets in Twined Weaving, with Braid on the
Borders. Queen Charlotte I., B. C.
Fred Harvey Collection

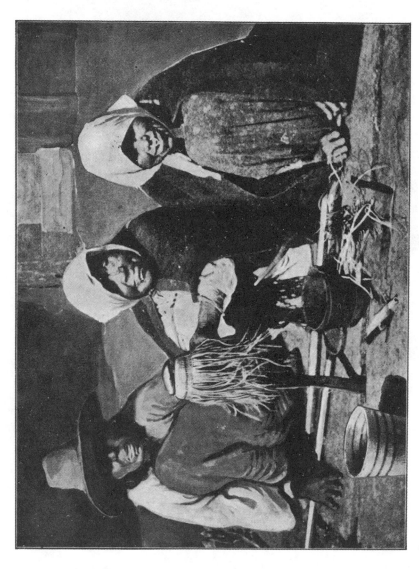

Plate 150. See page 330 Haida Basket-makers, Queen Charlotte I., B. C.,
Showing Upward Weaving

Photograph from J. G. Swan

be visited will be the Chimmeseyan,Wakashan or Aht, Salishan, Shahaptian, and Chinookan. Other smaller groups are scattered around and will be treated at the proper place in the text. The transition from southeastern Alaska to this area is almost imperceptible in some respects, and radical in others. The Tlinkit false embroidery will not disappear, but it will be remanded to a far humbler place. The roots and inner bark of the cedar will occupy the front rank. Coiled and imbricated work, unknown among the Tlinkits and Haidas, will bloom out in British Columbia and Washington. The semiflexible wallet will be replaced by the rigid cooking basket and the soft bags of hemp. The differentiation from the next area south of it will also be marked.

The small Chimmeseyan family, also called Tsimshian and better known as Nass, are the extreme northern of the group. Their basketry is of root and runs largely into the mixed twined checker, and twilled.

Necessarily coming southward from the spruceroot country to the cedar area would have the effect to change much of the basketry from rigid surfaces to flexible and from twined weaving to checker and twilled work. The National Museum possesses no specimens of Chimmeseyan ware of striking individuality.

The Wakashan tribes occupy northern and western Vancouver Island, the coast of British Columbia, and a small point of land in the northwest corner of Washington. They are generally known by the name Aht or Nootka on Vancouver Island, and include Boas's Kwakiutl and the Bella Bella and Haeltzuk on the mainland. In recent years they have been studied by Boas, by Tolmie and Dawson, and by Swan.

A list of authorities will be found given by J. W. Powell* and by Boas.†

In addition to the matting, both checker and twilled,

* Seventh Annual Report of the Bureau of Ethnology, 1891, p. 128.
† Reports to the British Association, 1889–1891.

quite common throughout this region, the Wakashan tribes of
Vancouver Island and Washington make a type of basketry
which is called in this paper the bird cage or wrapped twined
work, in which one element of the weft remains inside of the
basket, and the other element, which is more flexible, is
wrapped about the decussations of the warp and the rigid ele-
ment of the weft. It might also be called the "fish trap" style,
since without doubt the finer basketry is the lineal descendant
of the rude wicker fish trap. Imagine a number of stakes
driven into the ground pretty close together. A horizontal

FIG. 149.
DETAIL OF WRAPPED BASKET.
Clallam Indians.
Collected by J. G. Swan.

pole is laid against them in the
rear, and by the wrapping of a
withe around the pole and each
upright stake diagonally on the
outside and vertically on the
inside, a spiral fastening is pro-
duced. It is shown in the
openwork b a s k e t , Catalogue
No. 23,480, U n i t e d S t a t e s
National Museum, made by a
Clallam Indian. This wrapping
crosses the two fundamentals in
front at an angle and the horizontal frame piece in the rear at
right angles, and the lacing may always run in the same
direction, or the alternate rows in opposite directions, as in
fig. 149. As a matter of fact, in a soft and pliable material this
operation pushes the uprights forward a little, giving to the
fabric an appearance of the lathe work on the back of a watch.
(See fig. 150.)

The Wakashan weaving is not confined to this particular
technic, but, as will be seen in the illustrations here shown
(fig. 151), it is checkerwork on the bottom, three-ply twine
between, separating the checkerwork from the plain twine
commencement of the body. The sides are built up of cedar
bark warp, both vertical and horizontal, and a wrapping of

golden-coloured grass stems. These straws take different coloured dyes readily, and so the Makahs have learned to ornament their baskets with geometric patterns in black, yellow, drab, red, blue, etc. The pattern, therefore, is alike on both sides, although the wrappings are, as in Clallam, Nez Percé, and other specimens, inclined on the outside and vertical on the inside.

This specimen, Catalogue No. 23,346 in the United States National Museum, was collected, with many others (Nos.

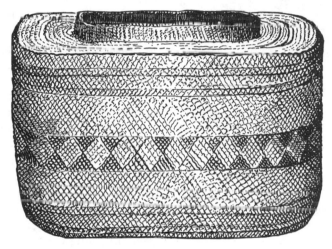

FIG. 150.
WRAPPED TWINED BASKET.
Makah Indians, Cape Flattery
Collected by James G. Swan.

23,343 to 23,368), in Neah Bay, Washington, by James G. Swan. (See figs. 149–151.)

In the Peabody Museum of Harvard University are eight old basket hats, supposed, by C. C. Willoughby, to have originated among the Southern Wakashan tribes, probably the Nutkas. Lewis and Clark described them as "made of cedar bark and bear-grass interwoven in the form of a European hat with small brim. They formed a small article of traffic with the whites, and their manufacture is one of the best exer-

tions of Indian industry." They say that "the only covering for their head is a hat made of bear-grass and the bark of cedar interwoven in a cone form with a knob of the same shape at the top. The colours are generally black and white only, and the designs are squares, triangles, and rude figures of canoes, and seamen harpooning whales." Captain Cook found the same form of head covering worn by the Indians of Nutka Sound. (See Plate 151.)

FIG. 151.
BOTTOM OF MAKAH BASKET.

Mr. Willoughby* describes the hats in the Peabody Museum (Plate 151) as follows:

They are all in twined weaving, and are made principally of cedar bark and grass spires. The construction is double, as shown in the cross-section (fig. 153). Each headpiece consists really of two hats, an inner and an outer one, joined at the rim, the last few pairs of twisted woof elements of the outer hat inclosing also the ends of the warp of the inner. The inner hat, or lining, is coarsely but neatly woven of cedar bark, and only in one specimen is there a knob at the top of the lining corresponding to that of the outer hat. Upon the under side at about three inches from the rim each warp element is doubled upon itself, forming a loop about three-fourths of an inch long. Through these loops is run a strong double cord of Indian hemp. The loops are bound together by twined weaving (fig. 152), and form an inner rim edged with the cord of hemp, which fits the head snugly. To this is fastened the thong which passes beneath the chin of the wearer.

The exterior or outer hat is woven principally of grass spires and cedar bark. In most of the specimens a narrow strip below the knob is made of fine cedar roots. The warp appears to be formed of split roots, and is fine and strong. The grass of the woof was originally an ivory white, the selected cedar bark used in conjunction with it being usually stained a dark brown or black.

* American Naturalist, XXXVII, 1903, pp. 65–68.

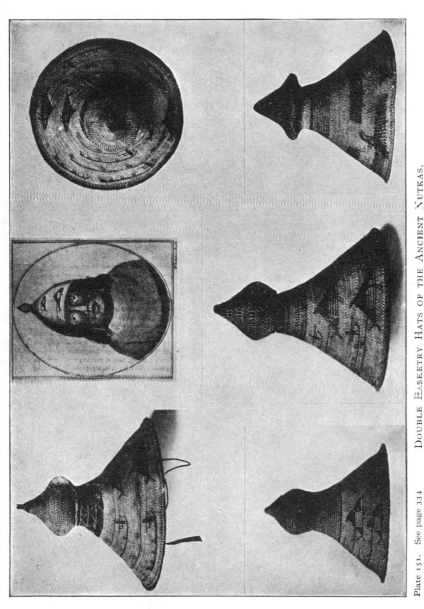

Plate 151. See page 334 Double Basketry Hats of the Ancient Nutkas,
Vancouver I.

Photograph from C. C. Willoughby, Peabody Museum

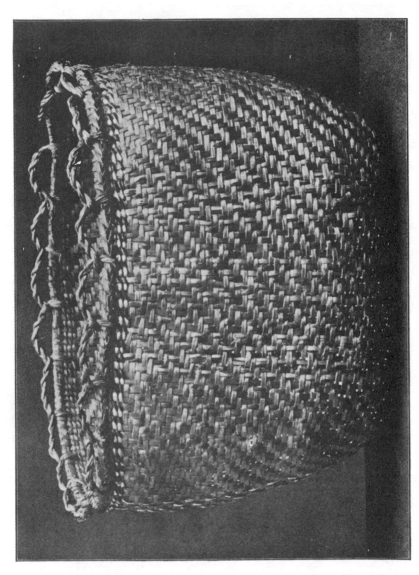

Plate 152. See page 336

Twilled Basket of the Quilleute Indians, Northwest Washington

Collected by C. F. Newcombe for U. S. National Museum

Each strand of the twisted pair of woof elements forming the design is composed of a grass spire overlaying a strip of cedar bark of the same width, the strand thus formed being white upon one side and black upon the other. These double strands are used not only where figures appear, but throughout the groundwork of the design as well. The figures are principally black upon a white ground. In forming them, the strands are simply reversed, the black sides which were concealed beneath the grass spires in the

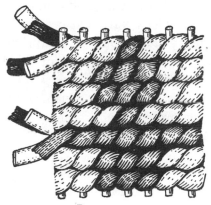

FIG. 152.
DETAIL OF NUTKA HAT.
After C. C. Willoughby, Peabody Museum.

FIG. 153.
CROSS-SECTION OF NUTKA HAT.
After C. C. Willoughby, Peabody Museum.

white background being carried outward. In some of the specimens the knob at the top is woven separately and afterward joined to the hat. (See figs. 152 and 153.)

Comparing the descriptions with the technical processes worked out in this paper, it is evident that the Nutka tribes understood what is called overlaying. It is not the Makah wrapped weaving, nor like the Nez Percé and other Shahaptian weave, but will be found in the Modoc and some Californian tribes as well as abundantly among the Salish (see Plate 155, fig. 5). The double hat is suggestive of the Orient, from which the royal Spanish fleet returned by way of Vancouver every year for two centuries (1570–1770).

The National Museum has a Quilleute (Chimakuan) example of twilled weaving from Vancouver Island, which should be

compared with Clallam ware. It is a large fish-basket made from the split root of a cedar. Attempts at ornamentation are, first, in using alternately the smooth, natural wood and the inner, coarse surface of the splint, also by introducing strips in cedar root with the bark adherent, and finally by laying on the outside of certain strips leaves of bear-grass. With this variety of material, although the basket is as coarse as it can be, the effect is excellent. The finishing off is in three rows of twined weaving, in which black yarn and bear-grass are laid on the fiber to give variety and colour. The upright elements in the weaving are bent down on the inside and held together by a continuous row of button-hole stitches. On the border is a scallop formed by a two-strand rope which passes underneath the border, back, and through itself. Dimensions: Height, 18 inches; width, 24 inches. Collected by C. F. Newcombe. (See Plate 152.)

Plate 153 is a delightful mixture of two extremes in culture. Two Makah or Nutka women are clad in calico, woolen blanket, piano cover, bandana handkerchiefs, etc., not neglecting the latest patent in safety pins. They are seated on a mat of cattail (*Typha latifolia*) stems, sewed together in genuine aboriginal fashion, known before Columbus. And their fingers are following their conservative thoughts as if these cunning weavers had been born centuries ago. They are making from filaments of cedar bark and leaves of squaw-grass the kind of twined weaving called wrapped in this work (figs. 13, 14). The warp is plain, twisted from cedar bark. One element of the weft is of the same material and laid horizontally inside the warp; the other weft element, of squaw-grass (*Xerophyllum tenax*), is wrapped in a continuous coil about the intersections of the other two elements. The photograph is from Capt. D. F. Tozier.

One of the largest families and most diversified, so far as industries are concerned, are the Salishan tribes, east and south of the Wakashan. A small and detached body of them is

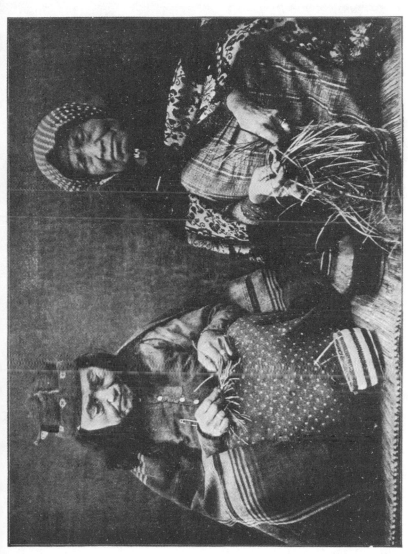

Plate 153. See page 336 Nutka or Makah Women Making Wrapped
Twine Weaving. Neeah Bay, Wash.
Photographed by D. F. Tozier

Plate 154. See page 337

VARIETIES OF TECHNIC PRACTICED BY SALISH WOMEN, WASHINGTON

1
2 3
4 5

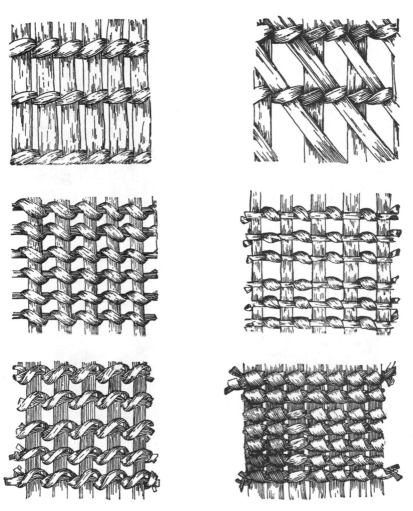

Plate 155. See page 337

VARIETIES OF TECHNIC PRACTICED BY SALISH WOMEN

6 7
8 9
10 11

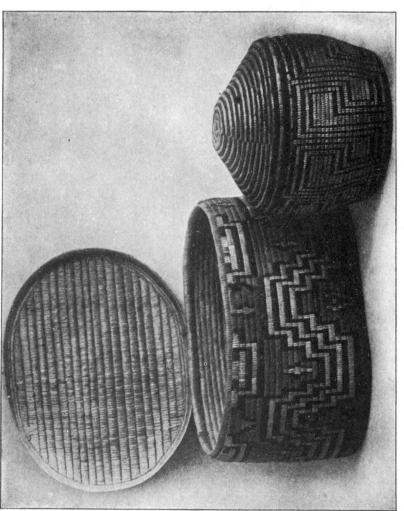

Plate 156. See page 343

COILED AND IMBRICATED BASKETS WITH
COVERS. FRASER RIVER, B. C.

Fred Harvey Collection

to be found on Bentinck Arms, northern British Columbia, hemmed in on the east by Athapascan tribes and on the west by Wakashan tribes. The rest of the family are spread out in British Columbia and Washington, extending from Puget Sound northward, southward, and eastward, across Idaho and even into Montana. A small body of the same family are on the Oregon coast, about the forty-fifth parallel.

Situated, as these tribes are, in the midst of so many other linguistic families, it is not surprising to find a great variety in the types of their basketry. In the plates here shown (Plates 154 and 155), fig. 1 represents plain checker weaving; fig. 2, twilled weaving, in which both warp and weft pass over two; fig. 3, another form of twilled work, in which warp and weft pass alternately over two and under one. Figs. 4 and 5 show the methods of coiled and imbricated sewing in the bottom and on the body of a Thompson River or a so-called Klikitat basket. Especial attention will be called later to these types. Fig. 6 is plain twined weaving in openwork. Fig. 7 is an example of plain twined weaving in openwork over crossed warp of a special character in which every alternate one is vertical and the other inclined. It can be easily seen by looking at the figure that the odd warps are arranged vertically and parallel, every other one turns to the left and is caught, not in the twist just above it, but in the first one beyond. Figs. 8 and 9 show the outside and inside of latticed or bird cage work; fig. 10, a form of twined work in which the tough fiber is overlaid by grass leaves or other colored fiber, adding to the ornamentation but not to the strength; fig. 11, false embroidery, in which the outer element of the twine is wrapped with an additional filament. Myron Eells, who has spent many years among them, and to whom Plates 154 and 155 are to be credited, asserts that styles of weaving peculiar to the stocks near by are practised by a few women of Salishan tribes. This can be accounted for in two ways—women from these outside stocks may have married into the

tribes under consideration, or, as is frequently the case, the Salish women, in order to learn something new, have taken up the methods of their neighbours.

Immediately south of the Haidas and Tlinkits, the bark of the white cedar (*Thuja plicata*) becomes common, the inner portion is quite tenacious, and, since filaments of almost any required width and length may be obtained, checkerwork weaving is in demand for mats, sails, receptacles for all sorts of objects, parts of house furniture, and even of clothing. The figure here shown is a typical example of many hundreds of

Fig. 154.
CHECKERWORK BASKET.
Bilhula Indians, British Columbia.
Collected by James G. Swan.

such baskets to be found in collections. The bottom and sides are in the same type of weaving. By an endless variety of real and proportional width of warp and weft and by colouring some of the strips an indefinite number of patterns may be produced. (See fig. 154.)

In many cedar bark receptacles of this region the two sets of filaments—warp and weft—run diagonally—that is, they are not woven as in a loom, but the maker begins at the corner. Looked at vertically, the surface has a diamond rather than a checker appearance, but from the point of view of the maker the intersections are square. Again, but much more rarely, three sets of filaments are involved, two belonging to the warp and the other one to the weft. The warp elements cross at

right angles or less, and the weft elements run across through the intersections, making a series of rhombs. This same technic is almost universal in Japan.

In addition to the oblique method of weaving the checker patterns in cedar bark, occasional diagonal or twilled weaving is to be seen in the same area.

A large collection of these was gathered by James G. Swan along the coast of British Columbia, and are now for examination in the United States National Museum.

Ornamentation in bark work is effected both by introducing different coloured strands and by varying the width of the warp and the woof threads. In many examples the bottom of the basket is bordered and outlined with one or more rows of the twined or plaited style of weaving to give greater stability and definition to the form. Cedar mats of large size and made with the greatest care enter as extensively into the daily life of the Indians of this vicinity as do the buffalo robes into that of the Dakota Indians.

The Bilhulas made very neat baskets, called "Zeibusqua," as well as hats and water-tight vessels, all of fine cedar roots.

They boil the cedar root until it becomes pliable to be worked by the hand and beaten with sticks, when they pick the fibers apart into threads. The warp is of a different material—sinews of the whale, or dried kelp thread.

They also are expert in weaving the inner bark of the cedar.

It is not astonishing that a material so easily woven should have found its way so extensively in the industries of this stock of Indians. Neither should we wonder that the checker pattern in weaving should first appear on the west coast among the only people possessing a material eminently adapted to this form of manipulation. It is only another example of that beautiful harmony between man and nature which delights the anthropologist at every step of his journey.

Farther south in British Columbia a Salish people demanding careful attention are those formerly called Couteau or Knife

Indians by the Hudson's Bay Company's people. Their home is the southern interior of British Columbia, mostly east of the Coast Range, and is about one hundred miles long and ninety miles wide. Their basketry is described by James Teit, of Spences Bridge, British Columbia.* The basketwork above Lytton is of birch bark, spruce bark, and willow twigs, and the rims are ornamented with stitches made from the bark of *Prunus demissa*. The Indians on the lower division of the Thompson River and on the Upper Fraser make beautiful coiled and imbricated baskets of cedar roots (*Thuja plicata*). This type of basketry is also made by the Chilcotin and Lillooet, and Shushwap, who are said to employ spruceroot.

William Arnott, of North Bend, gives the following Thompson River Indian names for baskets: Tsai, ordinary oblong style; spanach, small oblong and square; spa panach, very small; nikwoeten, round; spanikwoeten, small round; sklokw, very large.

Wallets are made of a twined weaving, the character of which is shown in Teit's fig. 132. Designs on these fabrics are in embroidery or by weaving coloured grasses or bark twine into the fabric, as shown in the same figure. This style of weaving seems to have been acquired recently through intercourse with the Sahaptin.

The Lower Thompson Indians weave mats of strips of cedar bark of the same style as those used by the coast Indians (Teit's fig. 133).

At the present day, rag mats or rugs are often made from scraps of cloth, calico, etc. The patterns on these are mostly the same as those on basketry.

The Thompson Indians also practise twined weaving in coarse bagging and in matting from tule (*Scirpus lacustris*), bulrush (*Scirpus maritimus*), and the twined weft of the bark of *Apocynum cannabinum*. These Indians also know how to

* Memoirs of the American Museum of Natural History, II, 1900, pp. 163–392.

make mats by stringing them. The reed or stick is perforated at two or more places and a cord passed through the holes.

It is interesting to find among them also blankets made from twisted strips of rabbit skin used as weft and held together by twined weaving. Attention is especially called to a method of ornamental overlaying among the Thompson Indians that has not a wide distribution. An ordinary wallet is made of twined work from the fiber of *Apocynum cannabinum* and *Asclepias speciosa*. In the fabric, these do not differ from the world-wide twined weaving, but in the ornamentation a strip of grass or other coloured material—maybe corn husk—is wrapped around the twined work as it proceeds. Comparing this with the Makah wrapped work, the twined weft takes the place of the strip laid behind the vertical warps. The wrapping is precisely the same, but in the Thompson River work the patterns are quite similar on both sides, only the elements are oblique on the outside and vertical on the inside. (See Teit fig. 132.)

The weaving of blankets by basketry processes was formerly an important industry among them. The coast Indians utilised both dog hair and goat hair in their manufacture, but the Thompson Indians seemed to have used the latter only. Sometimes the wool was made whiter or cleaned by mixing a quantity of baked white diatomaceous earth with it and beating the whole with a flat stick. The manner of making the thread is exactly the same as that described by Dr. Boas for the process employed by the Songish. The loom and spindle are also alike, excepting that both disk and shaft of the latter are of wood. The whole process of blanket-making and the implements used are said to be those found among the lower Fraser Indians. Most blankets had a fringe of tassels, 6 to 9 inches in length, along one end. Black bear's hair made into threads, and spun threads of goat's hair dyed either yellow with lichens or red with alder bark, were woven into the blankets in patterns

similar to those used in basketry. The Indians of Spuzzum continue to make these blankets at the present day.

For making nets, threads of the bark of *Apocynum cannabinum* were used. A wooden netting stick (Teit's fig. 134) served for making the meshes of equal size. The meshes were tied with a square knot.

Eells stated that the imbricated basketry is made by the Puyallups, Twanas, Snohomish, Clallam, Skagit, Cowlitz, Chehalis, Nisqualli, Spokan, and Squaxin who are Salish, as well as by the Yakima and Klikitat Indians of middle and western Washington who are Shahaptian. Only women and girls are basketmakers; they use, in securing material, the ordinary root digger. Pieces of the desired length and about the thickness of a finger are buried in the ground to keep them fresh. At the proper time they are taken out and peeled with a sharp stone or knife and hung up to dry. When needed, they are split into long strips by means of the bone awl. The pieces of the desired width and thickness throughout are used for stitching; the others form the foundation of the coil which in the weaving is kept of uniform thickness by adding fresh material. Foundations are also in narrow strips of wood. Mr. Teit makes the important assertion that the stitches of the preceding coil are intentionally split by the awl. Examples of this kind of work are common in collections. On the bottom and back as well as ends of the baskets ornamental strips are often overlaid and decorated by a process here called beading. In many examples, strips of cedar and other woods are used as foundations. The method of ornamentation employed is imbrication, described on page 174, the material for the overlaying being a glossy yellow-white grass.

As soon as enough is known about the geographic distribution of this imbricated type of weaving, a better classification can be made. The following characteristics will suffice as a general guide:

1. *Foundation.*—Either a bundle of splints, somewhat

cylindrical in form, or narrow flat strips of wood usually laid in pairs.

2. *Sewing.*—All done in splints of root; in some baskets the stitch is carefully and systematically bifurcated on the outside, in others it is whole.

3. *Bottom.*—Either a flat spiral, circular or elliptical in outline, as in most of the Washington varieties and in some of the farthest removed of the British Columbia specimens, or a series of straight rows of sewing. The bottoms of many of the baskets of this last type are receding, and even a border is built up outside of the structure of the basket. (Compare Plate 157 with Plate 163.)

4. *General shape.*—Either conical, rectangular, pyramidal, or fanciful.

5. *Decoration.*—Designs covering the whole surface; designs on the upper part of the surface only; and designs around the middle, leaving the top and bottom plain or separately figured. In some, beading is mixed with the imbricated ornament. It may not amount to tribal differences, but some baskets are decorated in front with imbrications, and are plain or beaded on the back and ends. It is impossible with the knowledge at present in hand to make a perfect ethnic chart of this wonderfully varied type of workmanship.

Plate 156 is a covered basket box in imbricated coiled work, from Douglas Harbor, British Columbia, now in the collection of Fred Harvey, Albuquerque, New Mexico. The foundation and sewing are of cedar or spruce root, and the imbrications are in squaw-grass and cedar bark. The noticeable feature in this specimen is the coiled work. In order to diminish the amount of sewing, the basketmaker has thought of the expedient used by the Mescalero Apache Indians of the south, and seen on specimens from other localities, of widening the foundation of the coil. In the Douglas Harbor examples, strips of wood take the place of two or more stems arranged one above another.

Plate 157 represents Thompson River and Fraser River coiled baskets, showing both imbrication and overlaying with grass. The specimens shown in this plate are in the collection of Miss Anne M. Lang, The Dalles, Oregon. They should be examined carefully with respect to the characteristics of foundation, stitch, shape, design, and quality mentioned above.

Fig. 155 is a precious old coiled and imbricated basket. The bottom is made up of fifteen foundation rods laid parallel. Each one of these is overlaid by a strip of bright yellow squaw-

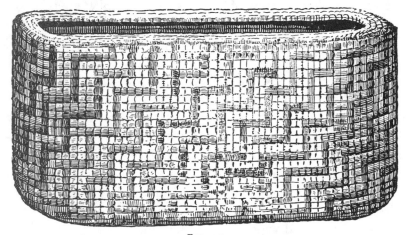

FIG. 155.
COILED AND IMBRICATED BASKET.
Cat. No. 60,235, U.S.N.M. Collected by J. J. McLean.

grass. Thus prepared, these rods are sewed together by coiled stitching, which is split or bifurcated, and some trifurcated in the operation. Again, while the stitching is solid on the inside, those in sight are from one-eighth to one-fourth of an inch apart on the outside, showing that every other stitch is under the straw. On the outside of this rectangular bottom the regular coiled work begins and the body is built up, the stitches all being concealed by what in this treatise is called imbricated ornament, or knife plaiting, carefully described and illustrated elsewhere. In this example the ornamentation

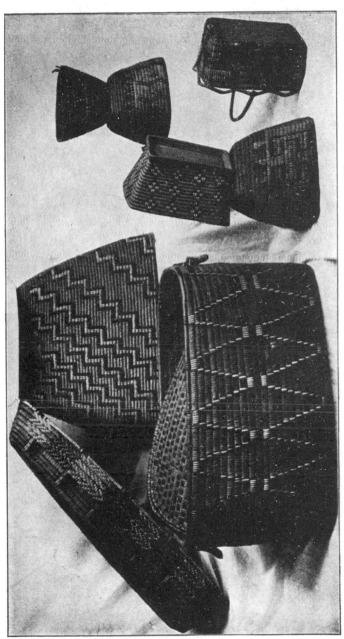

Plate 157. See page 344 Coiled Baskets Imbricated and Beaded. Thompson and Fraser
River Tribes

Collection of Miss Anne M. Lang

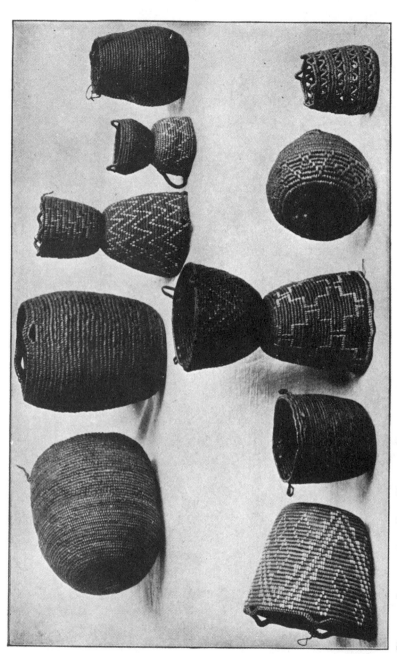

Plate 159. See page 348 OLD KLIKITAT BASKETS, SHOWING LITTLE IMBRICATION. WASHINGTON

Collection of Miss Anne M. Lang

is in squaw-grass, cherry bark and cedar bark dyed black. (See figs. 52–55.)

The foundation of the coiled work is not a single rod, but a bunch of splints made from the cedar root. Catalogue No. 60,235 in the United States National Museum was procured from Sitka Indians, Alaska, by J. J. McLean, to which place it had doubtless drifted in trade from the Fraser River region. Its length is 8½ inches and height 3¾ inches.

Mr. Hill-Tout reports that for boiling their food the N'tlaka pamuq tribe (Salishan family), on the Fraser and the Thompson rivers, always used basket kettles made like their other basketry, from the split roots of the cedar. These roots are sometimes red and black, and very beautiful patterns are made from the two different colours. The red dye was obtained from the bark of the alder tree, and the dark stain was obtained by soaking the roots* in black slime or mud, or from the root of a fern (Franz Boas).

Dr. G. M. Dawson, in his Notes on the Shushwap people of British Columbia, tells us that these baskets were made from roots of the spruce, and Dr. Boas, in his report on the Shushwaps, informs us that the basketry of the Shushwaps and N'tlaka pamuq was always made from the root of the cedar. As the N'tlaka pamuq were preëminent in basket-making, it is possible that the information gained by Mr. Hill-Tout may be accepted as correct, although the cedar (*Thuja*) is not abundant in the Thompson River country.† So skilfully did the women make these baskets that they would hold liquids without trouble. In preparing food, two kettles were used, one containing water for washing off any dirt that might adhere to the heated stones, and the other for holding the food. In boiling salmon for eating, the fish were tied up in birch bark to prevent breaking and falling to pieces.

* According to Dr. Boas, the black dye was obtained from the fern root. It is possible it was gotten in both ways

† Report of the British Association for the Advancement of Science, 1899, p. 511.

The Washington or southern imbricated ware is far more true to the old type than the northern, as will be seen. It may be divided between Salishan and Shahaptian. (Plate 158.)

The Klikitat or Shahaptian basket (Plate 158, fig. 2) is thus made: The foundation consists of the roots of young spruce and cedar trees. They are macerated and split or torn into shreds and soaked for a long time. The materials for the ornamentation are thus prepared. Most of it is of squaw-grass (*Xerophyllum tenax*). It grows on the east side of the Cascade Mountains, and can be gathered only during the late summer, when the snow has melted and the grass has matured. The broad leaves are split into the requisite width, and if they are to retain their natural colour are soaked in water only. To be dyed, they are soaked in mud and charcoal for black, in a dye from willow bark for brown, and a long time in water for yellow. In some cases, cedar bast is dyed black instead of the grass, but it is not so durable; or willow bark takes the place of the grass, but the surface shrivels. With the three elements of the structure around her, the Klikitat basketmaker takes a roll of root splints for the beginning of her foundation, which she wraps at one end for an inch with sewing splint. Doubling this, she begins her over-and-over sewing, splitting, sometimes with exquisite taste and care, the wood of the stitch underneath. The ornamentation covering more or less the surface of every Klikitat basket, called imbricated work, is laid on in the process of manufacture. The woman (1) catches the end of a strip of grass or bark under a stitch, (2) bends the strip forward to cover the stitch, (3) bends it back on itself, leaving about one-eighth of an inch for the next stitch to rest on, (4) makes her stitch, draws it home, and bends the grass strip over and covers it. It is a kind of knife plaiting held down by coiled sewing, and is an invention of this region.*

* Mrs. W. M. Molson, Basketry of the Pacific Coast, Portland, Oregon, 1896.

Plate 158, fig. 1, is an example of the Salishan or older type on the coast of Washington. It is specimen No. 2,612, United States National Museum, collected by Captain Charles Wilkes.

The imbricated basketry of Washington is divided by Mrs. Molson into two classes, by districts. The eastern slope of the Cascade or Yakima district belongs to the arid plateau of eastern Washington, and the basket technic is heavy, staunch, and of good workmanship, though it shows the effect of climate. But the western or Cowlitz River district produced the perfect imbricated basket, with more coils to the inch, more stitches in the same space, and also more beautiful designs.

I am indebted to Mrs. Harriet K. McArthur for copies of the old records relating to the southern imbricated baskets. The most absolutely beautiful and perfect baskets of this type were made on Cowlitz and Lewis rivers in Washington. These places are but a short distance from Portland, over in Washington. No imbricated baskets were ever made south of the Columbia; the finest and best are from west of the Cascade Mountains. The shaping is more graceful, being woven much finer, and the designs are far more intricate. They rarely have the openings around the top for lacing strings. Beautiful ones come from the Skokomish Reservation and from the coast, but they may have reached these remote places through the medium of trade.

Immersion in water, charcoal, and bark dyes is practised. Cherry bark is employed much in British Columbia, and sometimes by the Klikitats, who occasionally put in willow bark, which shrinks and leaves an ugly stitch. The rare ones with colours—not the fine old brown, yellow, and black, but old rose and purple—are valuable because they are rare. The old rose is a berry stain, and the purple is from a root; but they will never rival the old brown in beauty.

The typical coiled and imbricated baskets from west Washington, therefore, may be called the Cowlitz type.

According to Dr. Boas, most of them are made on the Cowlitz River and north to Fraser River. He also bears witness that the split sewing and the interlocking of stitches are both practiced. The term Nisqually is also applied. The Athapascans seem to have dwelt originally in this area, and it is just possible that they carried the coiling everywhere.

The so-called Klikitat baskets are now found on the Yakima Reservation, in Klikitat and Cowlitz counties, along the Columbia River, in the vicinity of The Dalles.

Plate 159 represents old Klikitat baskets, coiled and little imbricated, in the collection of Miss Anne M. Lang, The Dalles, Oregon. At once the difference will be seen between these conical and quite aboriginal forms and those of rectangular shapes farther north in the Fraser and Thompson River countries. The method of ornamentation is the same, but the borders are finished off with considerable skill and taste in braided work. In the National Museum are photographs of excellent old pieces in the Harvey collection in Albuquerque. For the sake of comparison, Plate 160 is inserted to show later and more highly embellished forms.

The baskets made in imitation of a trunk are used for a similar purpose, and not for berries. The Hudson's Bay people and others brought camphor trunks from the Hawaiian Islands, taken there from China. The work is wonderfully good in this as well as in others. The interesting part is that the weavers before this time had made baskets with rounded bottoms, and began, of course, with the coil in the center; but the oblong shape with corners was another matter, so a thin board was covered with cloth to form the bottom, and on the edge of this the bone awl was used to make perforations to fasten the first row on this bottom. Later baskets had an ingeniously woven bottom over a number of narrow slats, and the patient weaver subsequently mastered an oblong coil.

From a report of the Commissioner of Indian Affairs, Governor Isaac L. Stevens, 1854, the following statements

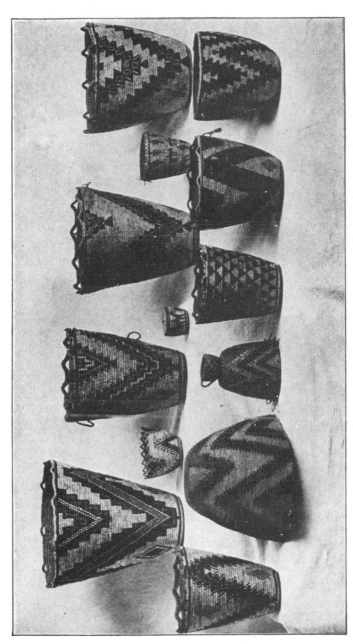

Plate 100. See page 348

IMBRICATED KLIKITAT BASKETS, HIGHLY DECORATED, WASHINGTON

Collection of Miss Anne M. Lang

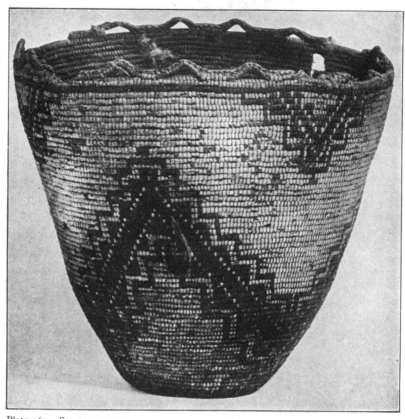

Plate 161. See page 350

IMBRICATED BASKET WITH OPEN BORDER, KLIKITAT INDIANS,
WASHINGTON

Collections of U. S. National Museum

are taken in order to comprehend the migrations of the tribe after whom imbricated ware has been popularly named:

The tribes of the Klikitat and Yakima inhabit properly the valley lying between Mounts St. Helena and Adams, but they have spread over the districts belonging to other tribes, and a band of them is now located as far south as Umpqua.

The Klikitats and Yakimas in all essential peculiarities of character are identical and their intercourse is constant, but the former, though a mountain tribe, are more unsettled in their habits than their brethren. The fact is probably due in the first place to their having been driven from their homes many years ago by the Cayuses, with whom they were at war. They then became acquainted with other parts of the country, as well as with the advantages derived from trade. It was not, however, until about 1839 that they crossed the Columbia, when they overran the Willamette Valley, attracted by the game with which it abounded and which they destroyed in defiance of the weak and indolent Callapooyas. They still boast that they taught the latter tribe to ride and hunt. They manifest a peculiar aptitude for trading.

Under the term Walla Walla (page 223 of Stevens' report) are embraced a number of bands, living usually on the south side of the Columbia and on the Snake River, to a little east of the Palouse.

The Tai-tin-a-pam, a band of the Klikitats already mentioned, living near the head of the Cowlitz, were called by their eastern brethren wild or wood Indians.

From the report of the Commissioner of Indian Affairs for 1858 (page 225), Puget Sound Agency, T. Simmon, agent, is quoted:

There is a portion of the Indians of my district whose homes are high up on the river, principally on the Nisqually, Puyallup, and Snoqualmie. They are nearly related to the Yakimas and Klikitats by blood, and are sometimes called Klikitats.

R. S. Landsdale, agent, White Salmon Agency (page 275), writes:

Many of the Klikitats were removed during the late war from their former homes, west of the Cascade Mountains, to this agency.

The home of the Klikitat Indians, says Mrs. Molson,* was along the waters of the Columbia and its tributaries, from the Cascade Mountains on the west to the Bitter Root Range on the east, and from 46 degrees and 44 minutes North to what is now eastern Washington and northern Idaho. They were not only rovers and marauders, but they went on annual expeditions to trade, carrying dried buffalo meat and robes, and wild hemp, dried and twisted, to exchange for dried salmon and dentalia. They held the gateway between the East and the West, for the river was the only route of communication. South of the Columbia, along the ocean, is an old path known as the "Klikitat trail." They journeyed south by this route, and returned north by the Klamath trail on the eastern side of the Cascades.

Plate 161 is a typical coiled and imbricated berry basket of the Klikitat Indians, from the collection of Mrs. R. S. Shackelford, from whom the following information is received: The inside walls, both foundation and sewing, are from splints of the root of the giant cedar (*Thuja plicata*), collected on the sides of Mount Hood. The ornamentation is the imbricated work described in detail on page 346, the materials being of the white yi or squaw-grass. Cedar and cherry bark are also used, and for colour the yellow dye is procured from the Oregon grape (*Berberis nervosa*), the brown dye from alder bark, and the black from acorns soaked in mud. The meaning of the artistic terraced design is not known. Six months were consumed in making it. Catalogue No. 207,756, United States National Museum. The following story was gathered from a basketmaker by Mrs. Shackelford:

The Spirit told the first weaver to make a basket (tooksi). So she repaired to the forest and pondered over her mission. Gath-

* Basketry of the Pacific Coast, Portland, Oregon, 1896.

ering the plant yi, squaw-grass, elk-grass, pine-grass, and the red cedar roots, noo wi ash (*Thuja plicata*), she began to weave, and after many toilsome days a basket was produced. She carried it to the lake and dipped it full of water, but it leaked, and the Spirit said to her: "It will not do. Weave again a tight basket with a pattern on it." She sat by the water-side, and as she looked into the clear depths of the lake the pattern (chato timus) was revealed to her in the refracted lines, and with new courage she repaired to the depths of the forest and worked until she wrought a basket

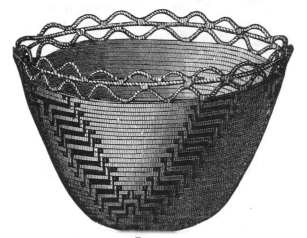

FIG. 156.
IMBRICATED BASKET.
Yakima Indians, Washington.
After W. H. Holmes.

on which the ripples of the lake were shown. Other women have learned the pattern all down the ages, but only very few are now left who can weave a faultless basket and a perfect imitation of chato timus.

The locality where the story was learned is Lummi Island, Bellingham Bay, Washington. The pattern referred to is similar to that shown in fig. 289 of the Sixth Annual Report of the Bureau of Ethnology.

Fig. 156 represents a fine old piece of Yakima coiled and imbricated basket, Catalogue No. 23,872 in the United States National Museum, collected by James H. Wilbur. The foun-

dation and sewing are in split root, probably cedar. The sewing is entirely overlaid and concealed by strips of squaw-grass laid on in the manner explained on page 346. The border is especially interesting, connected structurally with examples from California and Peru (see Plate 248). It is in open coiled work, the foundation being wrapped, bent in a regular sinuous pattern, and sewed down here and there. The design, according to Mrs. Judge Burke, represents a flock of geese migrating. Its height is 7½ inches. (See fig. 159 and Plate 35.)

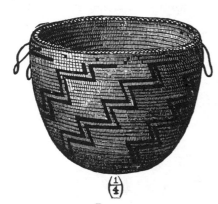

FIG. 157.
IMBRICATED BASKET.
Cowlitz Indians.
Collected by Dr. J. L. Fox, U. S. Navy.

Fig. 157, Catalogue No. 2,137, is an old example of imbricated basketry from Washington, collected by Dr. J. L. Fox, United States Navy, of the Wilkes Exploring Expedition. Such work is now generally called Klikitat, and the Indians of that stock are expert in the use of it; but the exploring expedition did not come in contact with tribes so far in the interior. The Salish Indians on Puget Sound make the same type of work, and it is known that the very best come from the Cowlitz country, so that this is probably a very old piece of Cowlitz basketry in this kind of weaving. The whole surface is covered with imbrication, or knife plaiting, explained on page 346 and illustrated in figs. 52–54.

Catalogue No. 2,614, United States National Museum, shown in Plate 45, is an imbricated basket made by an Indian of Salishan family, in Washington. It is one of the oldest specimens in the National Museum, having been brought home by Captain Charles Wilkes more than sixty years ago. The material of the foundation and sewing is of cedar root.

The surface is covered entirely with imbricated ornamentation, the body colour being produced by strips of squaw-grass. The figures are in cedar bark in natural colour and dyed black by means of charcoal and mud. The golden colour in the straw filaments is produced by longer immersion in water. The most interesting feature in this basket is the bottom, which is

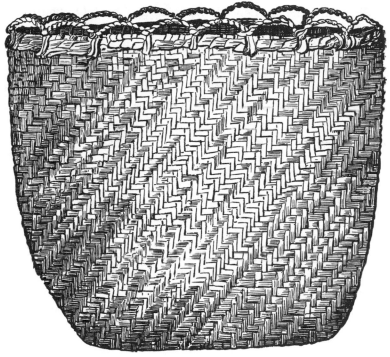

FIG. 158.
TWILLED BASKETWORK
Clallam Indians, Washington.
Collected by J. G. Swan.

formed upon a strip of wood three-fourths of an inch wide and six inches in length. It is very closely wrapped or served with a splint of root. Upon the margin of this the coiled work begins, one round being made in plain stitches. Afterward the patterns are attached immediately to this and extend outward to a black line on the margin, the body of the

basket being completely covered with other figures, the ends
different from the sides. The border is neatly finished off in
false braid. There are about eight rows of coiled work and
from twelve to sixteen stitches to the inch. On the outside
the stitches are regularly split or furcated. Length, 8 inches;
depth, 4¼ inches.

Fig. 158 represents a specimen of twilled work by the
Clallam Indians, and should be compared with Quilleute exam-
ple, Plate 152. It is made of flat splints of white wood, resem-
bling birch. The bottom was woven first, and all of the splints
by being bent upward became the warp of the sides. Twilled
effect is produced by passing each weft splint over two and
under two warp splints. The fastening off of the upper border
is done by bending down the warp splints and holding them
in place by a whipping of the same material. The scallop on
the upper border is formed by looping the middle of two splints
under the rim, twisting both pairs of ends into a twine, passing
one twine through the other, and doubling down to repeat
the process until the whole is finished.

Illustrations of this method of making twilled work are
shown in figs. 94–96, but, as will be seen, innumerable pleas-
ing effects are produced by varying the colour, the number, the
width, and the direction of the splints that are overlapped
in the weaving. Catalogue No. 23,509, in the United States
National Museum, was procured in Washington by James G.
Swan. It is fifteen inches in height.

Myron Eells, long a resident among the Sound tribes of
Salish, has collected for the United States National Museum
at different times many specimens of their basketry. It
was he that first noticed the great diversity that exists in such
small tribes as the Twana, or Towanhoo. They use in their
work a knife for splitting material, and a common awl, for-
merly of bone, in sewing their coiled ware. He has seen a
woman using a small bone for pressing home her weft. This
is rare, for the fingers are usually employed for this purpose.

Fig. 159 is a water-tight basket for cooking, marked Clallam. The foundation is the single flat strip type. Attention is called to the ornamental effect produced in this work by the splitting of the under stitch by the one above it. The noteworthy feature of this type of basket, however, is in the occasional overlaying of a filament of squaw-grass or other material, which seems to be the first step toward imbrication. The

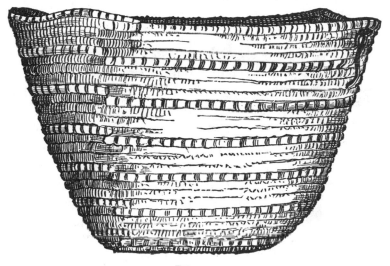

FIG. 159.
WATER-TIGHT BASKET.
Clallam Indians, Washington.
Collected by J. G. Swan.

grass lies over two stitches and is caught under the next stitch, passing under and over as in "beading." In other examples the straw is covered and revealed in the alternate stitches. It can be seen that a great variety of effects is possible in this manipulation.

A square inch from the surface of this specimen enlarged (fig. 160) will show more clearly what has been hitherto described—the interlocking stitches, the furcation of the stitches, and the overlaying with ornamental filaments.

Catalogue No. 23,512, in the United States National

Museum, was procured in Washington State by James G. Swan.

Charles Willoughby, who was agent among the Quinaielt or Quinault Indians in western Washington, makes the following report of their basketry:

"They have the cedar bark for the foundation of basketry, strips of pine root for rigid work, and hemp, rushes, and grass for the weft and ornamentation. The grass used in strengthening the borders of mats, rain cloaks, etc., grows on flat places. It is prepared like flax by soaking in water until the outer portion decays, when it is beaten with sticks until only the fiber remains. The yellow fiber of squaw-grass used by Indians for the outside of baskets is a great source of traffic, as it is only found in this locality. The basket grass is gathered carefully, one blade at a time, to secure that part of the stalk that reaches about six inches under the ground before it meets the root. To prepare the grass for drying, it is woven together at the ends with fibers of cedar bark. It is then spread upon the ground or roofs in the sun. When to be used, it is moistened with water and split with two small knife blades set in a stick in such a manner as to make the strips of the same width, the smaller portion being thrown away. The grass is kept moist with water while being made into baskets. The coloured grasses are now prepared by using aniline dyes. This was formerly done by steeping the roots of plants that yielded a yellow colouring. A red dye was made from the bark of alder, and a paint was made of blue clay." *

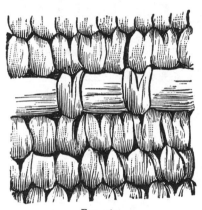

FIG. 160
DETAIL OF FIG. 159.

* Smithsonian Report, 1886, Pt. I, pp. 267–282.

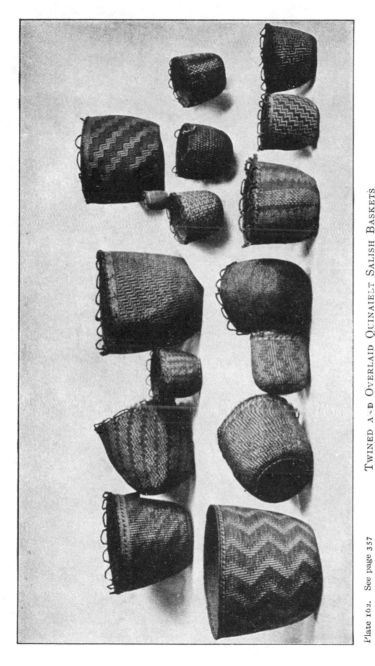

Plate 162. See page 357

TWINED AND OVERLAID QUINAIELT SALISH BASKETS

Collection of Miss Anne M. Lang

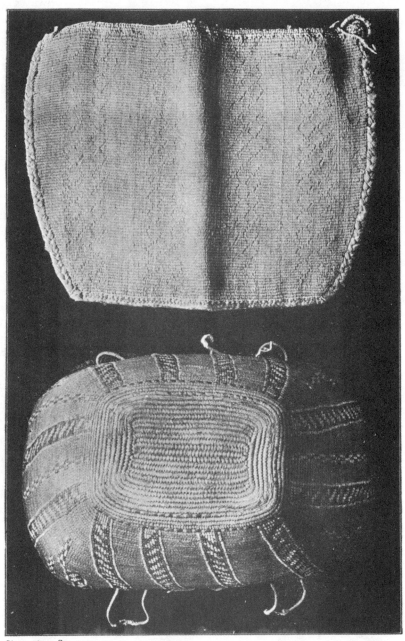

Plate 163. See page 357

TWINED AND IMBRICATED WORK, QUINAIELT AND THOMPSON RIVER
SHOWING DETAIL

Collections of U. S. National Museum

Plate 162 shows a number of Quinaielt baskets in twined and overlaid weave, in the collection of Miss Anne M. Lang.

Plate 163, top figure, is a wallet made from grass stems by the Quinaielt Indians. It is worthy of special study, because the warp is horizontal and the weft vertical. Openwork figures are produced on the surface in a series of chevroned patterns by an ingenious but very simple process. At the point where the open effect is to be produced, the two strands constituting the twine do not make a half-turn, but pass above and below the warp, as in ordinary plain weaving, across one warp strand. In the next round the adjoining pair are similarly treated, and thus figures are produced. At the upper and lower margin two rows of horizontal twined weaving fasten off the ends, which are braided down. On the sides the warp strands are sewed into and concealed in a coarse braid of rushes. Width, 18½ inches; height, 14 inches. Catalogue No. 151,452, in the United States National Museum, was collected in Washington State by Dr. Franz Boas.

Plate 163, bottom figure, is a Thompson River basket in the collection of J. W. Benham. It is introduced here for the purpose of showing how the Indian woman's mind struggled with the problem of starting the bottom of a rectangular coiled basket. It has been said that the Thompson River Indians do not understand this process, but many old Thompsons have coiled bottoms, and this technic is older than the other. The work begins by wrapping a foundation of splints with the split root of spruce or cedar for six or more inches. This is then doubled upon itself, and the sewing begins and proceeds backward and forward, as in plowing, until fifteen rows are made; the coiling then actually starts, the work extending not only along the sides, but across the ends, making a parallelogram, which is extended for ten rows farther outward, at which place the additional ornament begins. So far it is plain coiled work with split stitches; afterward it

becomes a mixture of plain coiled work with upright bands of imbrication. Its height is 13 inches, and its width at bottom is 9½ inches.

The twined baskets of Washington, with little animals around the margin, belong to the Skokomish and other Salishan tribes about Puget Sound. When the tails turn up, the figures are dogs or wolves; when they turn down, they are horses. Especial attention has been called to the varied and tasteful effects produced by the use of the rectangular element.

Plate 164 represents two carrying wallets of the Skokomish Indians living in Washington. The examples shown are done in the style of weaving called here "wrapped twine" (figs. 21 and 22).

Plate 165 shows specimens of carrying baskets made by Salish tribes in Washington; the one in the center is Tillamuk, Catalogue No. 151,149 in the United States National Museum, collected by Dr. Franz Boas. The others, Nos. 2,709 and 23,511, are very old specimens in the National Museum collection, and are credited to the Clallams. The upper one on the plate was brought by the Wilkes Exploring Expedition, secured more than sixty years ago. All of these are in plain, twined weaving with splint of root, probably spruce, made browner by soaking in mud. The ornamentation is false embroidery in squaw-grass. The three methods of forming the border are noteworthy. In the upper specimen, stout cable is formed by "sewing" a small bundle of root splints with the same material. This is sewed here and there to the upper margin of the wallet. The other figures show the margin finished by braiding down; the loops of root were twisted in subsequently. The animals on the margin are horses.

The specimen, Catalogue No. 23,511, which is the lower one on the plate, was collected in Washington by James G. Swan.

Plate 166, upper figure, is an open twined wallet of the Tillamuk Indians, Salishan family, the remnant of which is

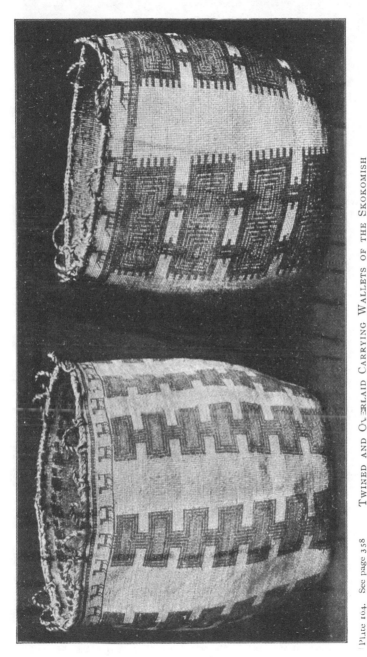

Plate 104. See page 358

TWINED AND OVERLAID CARRYING WALLETS OF THE SKOKOMISH
SALISH INDIANS, WASHINGTON

Collections of U. S. National Museum

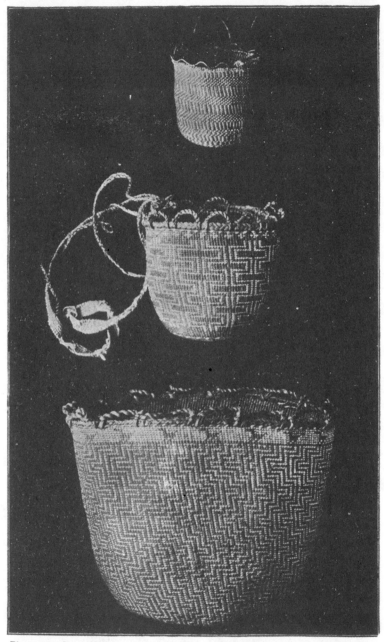

Plate 165. See page 358

TWINED WALLETS OF CLALLAM AND TILLAMUK SALISH, WASHINGTON

Collections of U. S. National Museum

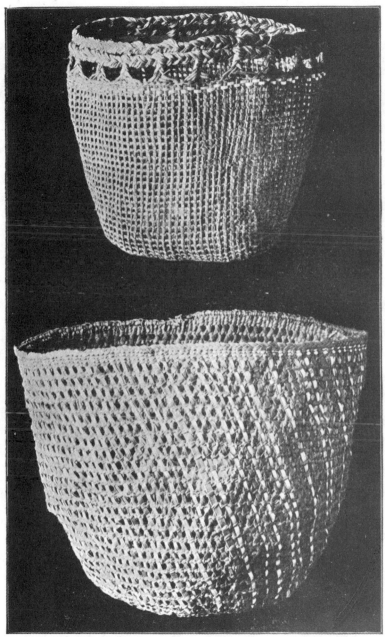

Plate 166. See page 358

OPENWORK TWINED WALLETS, CHINOOK AND TILLAMUK,
WASHINGTON

Collections of U. S. National Museum

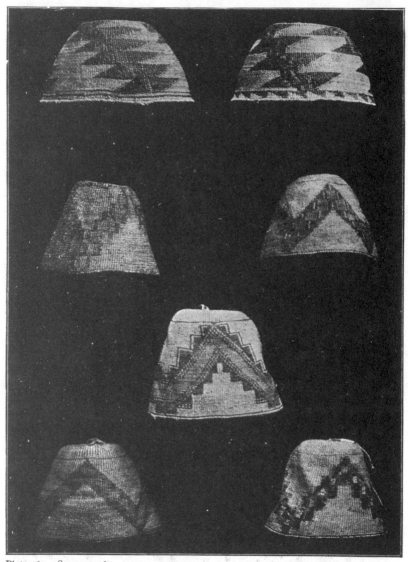

Plate 167. See page 361

WOMEN'S HATS IN TWINED BASKETRY. NEZ PERCÉ
AND MODOC COMPARED

Collections of U. S. National Museum

1 2
3 4
 5
6 7

living at Grande Ronde Agency, Oregon. The bottom of this basket is rather ingenious. The warp splints of the sides pass across the bottom also, and are held together there by courses of twined weaving. At the edges of the end portions of the bottom the splints of the weft become the warp for the body. At the upper border two rows of squaw-grass are beaded in. The braided border around the top is formed by the ends of the warp splints plaited together in a double row, additional material being used if necessary.

The lower figure is an open wallet of the Chinook Indians, Chinookan family, occupying formerly both sides of the Columbia River from the mouth to the Dalles, a distance of 200 miles. According to Lewis and Clark, most of their villages were on the northern bank. To this family also belong the Clatsops and Wascos, to be mentioned later. The wallet illustrated in the plate is made of root in twined weaving with crossed warp. The bottom, or foundation, is a rectangular structure, about four inches square, made of double splints of root securely lashed together. From this central portion the splints spread out and the twined weaving begins. Additional warp elements are added from time to time as the structure widens. A coarse form of ornamentation is produced by overlaying some of the warp elements with squaw-grass. The fastening off of the upper border is peculiar, and on the outside imitates precisely a three-ply braid, but on the inside the structure is at once revealed. A strip of root is laid along the top of the warp elements, and these are brought over in button-hole stitch and tucked behind the strip, and then cut off, making a very rough appearance. It will be noticed that in the weaving of this wallet the half-turns of the twine do not go around the crossings of the warp elements, but just below, so as to include each warp separately. On the outside of the warp splints here and there a strip of grass is regularly overlaid.

Catalogue Nos. 151,447 and 151,448 in the United States National Museum were collected by Dr. Franz Boas.

The Nez Percé Indians of the Shahaptian family, prior to the advent of the whites on the Pacific coast, made heavy and beautiful blankets of the wool of the Rocky Mountain sheep and of the hair of animals killed in the chase, dyed in different colours. The patterns are all geometric, and are, in fact, woven

FIG. 161.
TWINED WALLET.
Nez Percé Indians, Idaho.

mosaics, each figure being inserted separately by twisting two woof threads backward and forward around the warp strands. Scarcely ever does the twine extend in stripes all the way across the blanket in a direct line.

The same Indians at present weave bags from the bast of the Indian hemp (*Apocynum cannabinum*) and from grass stems shredded. The figures are produced by overlaying the regular warp strands with corn husks or coloured grass in false embroidery. In some examples (see fig. 161), the entire surface is covered with geometric figures; in others they are only partially covered. The Nez Percés are in the same family as the Klikitat and Yakima, but they make no imbricated baskets.

Fig. 161 is a twined wallet of the Nez Percés. The body

weaving, both warp and weft, is of Indian hemp. In the proc-
ess of manufacture a sufficient number of warp strands were
joined together in the middle by a row of twined weaving and
probably suspended, the ends hanging down. The weaver
filled this warp with the ordinary twisted work, proceeding
from the bottom to the border. The ornamentation, in corn
husk or other weak material, in the natural colour or dyed, is
laid on externally by what is here called false embroidery.
The process was fully described and illustrated in speaking of
Tlinkit weaving (fig. 139, page 323). This specimen should
be compared with the making of soft
wallets among the Fraser River
tribes, illustrated in Tcith's mono-
graph, where the corn husk, instead
of being wrapped merely around the
outer element of the twine, passes
around both strands, and the figure
appears on the inside of the recep-
tacle, which is not true of the Nez
Percé example.

FIG. 162.
DETAIL OF FIG. 161.

Fig. 162 will show a square inch
of this wallet, the special feature of
which is that while the rows in plain twining seem to be
vertical, they are inclined to the right in the false embroidery.

This specimen, Catalogue No. 9,026 in the United States
National Museum, was collected in Idaho by Dr. Storrer.

Plate 167 is an interesting collection of women's hats.
Figs. 1 and 2 are Modoc twined baskets from the Benjamin
collection, Catalogue Nos. 204,258 and 204,259; height, 5¾
inches. The foundation is of rush. The weaving is in the
same material, the designs being formed by regular overlaying
in step patterns, formed by piling rhomboid figures upon one
another. Strips of bird quill are introduced into these
patterns, having been dyed a bright yellow which gives life
to the figures. It may be repeated that both of these speci-

mens are in plain twined weaving overlaid. All the other figures on the plate are in wrapped twined weaving, as among the Makahs and other tribes of the Fraser-Columbia region.

Figs. 3 and 4 are women's hats of the Nez Percé and Walla Walla Indians, Shahaptian family, Washington, Catalogue Nos. 23,857 and 129,680. The foundation is of hemp. The weft consists of strands of hemp on the inside wrapped around with a filament of squaw-grass. The process of this weaving is explained in figs. 21 and 22. Catalogue No. 23,857, collected by J. B. Monteith, height 5 inches; 129,680, collected by Mrs. Anna McBean, height 5¾ inches.

Fig. 5, Catalogue No. 9,040, United States National Museum, is a woman's hat, called a wedding hat, and assigned to the Cascade Indians. It is doubtless Shahaptian. In every respect it is made like the Nez Percé examples described, being in wrapped twined weaving similar to that of the Makah Indians. Height, 6½ inches; collected by Dr. James T. Ghiselin.

Figs. 6 and 7, 5 inches in height, are women's hats of the Nez Percé Indians, Shahaptian family, collected by F. W. Clark, and No. 23,587, 5 inches in height, collected by J. B. Monteith.

The Cayuse (Waiilatpuan) and Umatilla (Shahaptian) make soft baskets in twined weaving. They are horse Indians and use their wallets for saddle bags. The materials are rushes, wild hemp, corn husks, and worsted. The bottoms and undecorated portions are plain twined work. In the figured parts the husks, split into narrow strips, are administered in four ways—by overlaying, not showing on the inside; by overlaying and twining so as to show on the inside; by false embroidery, wrapped about the weft twine elements on the outside; and by frapping the twined weft as in the Thompson River work (Mrs. McArthur).

The soft wallets illustrated in Plate 168, often called "Sally bags," were made by Wasco Indians, who belong to the Chinookan family. At present they are on the Warm Springs

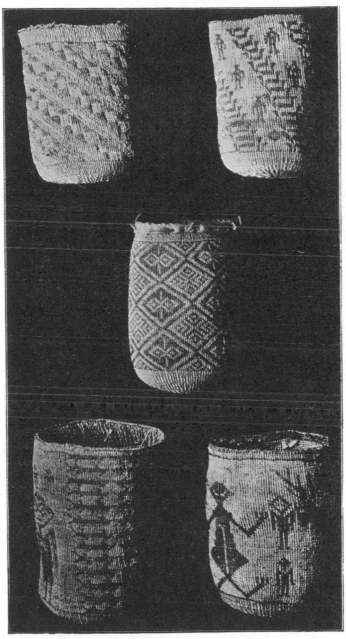

Plate 168. See page 362
WASCO TWINED WALLETS. DESIGNS IN WRAPPED WEAVING
Collections of U. S. National Museum

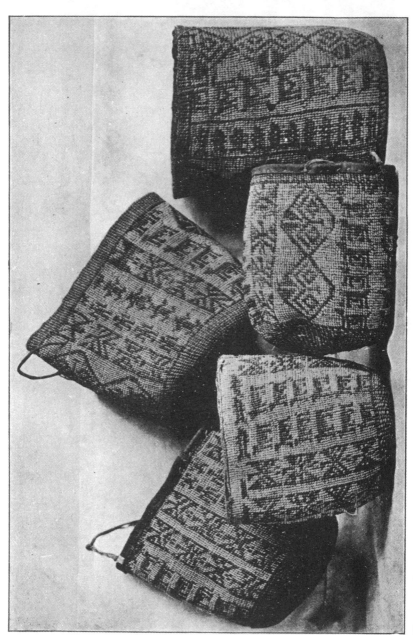

Plate 109. See page 363

Wasco Twined Wallets, Called "Sally Bags"

Fred Harvey Collection

Reservation in Oregon and the Yakima Reservation in Washington. The wallet in the middle of the plate, No. 9,041, was presented to the United States National Museum by Dr. James T. Ghiselin, in 1869; the others were collected by Mrs. R. S. Shackelford and Miss E. T. Houtz. They are all made in plain twined weaving over warp of rushes, the patterns being effected by overlaying the twine of hemp with strips of fiber that in structure resemble corn husks. On the newer specimens the designs are clearly shown, representing man (tillacum), elk (mowitch), sturgeon (pish), duck (culla-culla). By observing the men's faces in the newer specimens it will be easy to detect the idealised faces on the fine old wallet in the middle.

Prof. O. M. Dalton figures* an old Wasco basket wallet, with the image of a man in knee-breeches on the surface. In the National Museum are a number of new wallets bearing this same figure, but the Dalton specimens show that it has been a motive in Wasco weaving for a long period.

Plate 169 represents twined wallets of the Wasco Indians, Oregon, in the Fred Harvey collection. The foundations are in native hemp in plain-twined weaving. On the body of the wallets, birds, beasts, and men are wrought in grass or husks of corn in corners.

Clatsops make flat mats and wallets of cattail rush. The latter, with strap of grass and wool across the shoulders, are excellent for carrying fish. They also construct a sack in open twined work in roots. The fine twined small baskets in three colours are equal to any in Oregon (Mrs. McArthur).

THE CALIFORNIA-OREGON REGION

The human hand is so beautifully formed, it has so fine a sensibility, that sensibility governs its motions so correctly, every effort of the will is answered so instantly, as if the hand were the seat of that will.—Sir CHARLES BELL.

The California-Oregon basketry region has only one definite boundary—the hard coast of the Pacific; on other sides there

* Man (London), I, note 17.

is no sharp ethnic limit. North, East, and South, it is full of turnstiles that move in one direction only. Tribes from far away pushed through them into this region, but if they had desired to turn their backs on abundant game, fish, and vegetal foods, they would have been prevented by the columns in the rear.

The ancient basketmakers of this area knew nearly every type and technical process of the art, both in weaving and coiling. They added at least one new technical process, the Tee weave. In ornamentation, imbrication is wanting as well as false embroidery, but there is quite enough else to make up the deficiency. Within the California-Oregon region there are subregions, and the following list of linguistic families will help to unravel the tangle:

NORTHERN GROUP

Athapascan family: Hupa, lower Trinity River, and Wailaki, western slopes of the Shasta Mountains.

Chimarikan family: On Trinity River.

Copehan family: Wintun under many names, western drainage Sacramento River.

Kalapooian family: The Willamette Plains, western Oregon.

Kulanapan family: Pomo, under many names, in Mendocino and Lake counties.

Kusan family: Coos River and Bay, western Oregon.

Lutuamian family: Klamath and Modoc, Upper Klamath River or Klamath Lake.

Palaihnihan family: Pit Rivers; on Pit River to eastern boundary of the State.

Pujunan family: Concow (Konkau), Maidu, Nockum (Nakum), western drainage of the Sacramento River, south of Palaihnihan.

Quoratean family: Ehnek, Karok, middle Klamath River.

Sastean family: Shastas; middle northern boundary of State.

Takilman family: Lower Rogue River, Oregon.

Weitspekan family: Yurok, weitspek, Lower Klamath River.

Wishoskan family: Wishosk, on Eel River and Humboldt Bay.

Yanan family: Nozis, north of Pujunan.

Yukian family: Ashochimi, Chumaya, Napa, Tatu or Potter Valley, Yuki or Round Valley, in Potter and Round valleys.*

<center>SOUTHERN GROUP</center>

Chumashan family: Santa Barbara, Santa Inez, San Luis Obispo, in Santa Barbara County.

Costanoan family: Mutsun; Pacific slope, west and south of San Francisco.

Esselenian family: Soledad, Eslen, and other missions close by on Monterey Bay.

Mariposan family: Yokut and many smaller tribes, Fresno River. (See Powell.†)

Moquelumnan family· Mu-wä and Olamentke divisions. (See Powell.†)

Salinan family: San Antonio, San Miguel, Monterey County.

Shoshonean family: Chemehuevi, Panamint and others intruded along the eastern border, more and more, from north to south, reaching the Pacific Ocean at the Santa Barbara Islands.

Yuman family: including Cochimi, Cocopas, Cuchan, Diegueños, Havasupai, Maricopa, Mohave, Waicuru, Walapai, and several missions.†

The locations of the linguistic families in California are shown on the map (see fig. 163). A glance indicates how, in a general way, the State is divided into northern and southern portions by a line running from San Francisco Bay to the angle of Nevada, and also in the same manner the subdivision of the northern portion of the State into three vertical sections. A little difference exists between the nomenclature of this map and that of Powell. For instance, the Wintun are Copehan; the Maidu are Pujunan; the Yokut on this map correspond to the Powell Mariposan. With these slight amendments the map will be easily understood and of great importance in locat-

* For classification of these northern tribes on the concept of basketry, consult Roland B. Dixon, Basketry Designs of the Indians of Northern California. Bulletin of the American Museum of Natural History, XVII, pp. 1–32.

† Seventh Annual Report of the Bureau of Ethnology, 1891, p. 1–142.

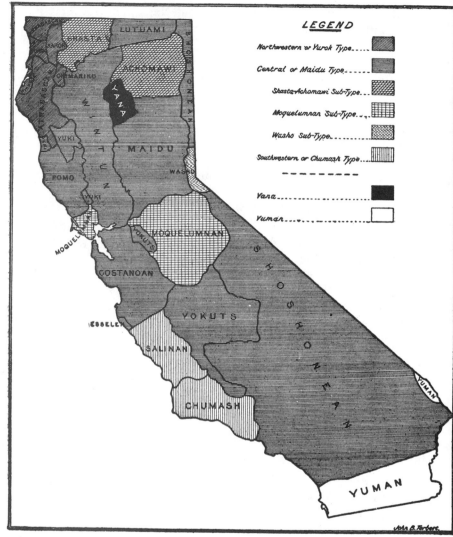

FIG. 163.
LINGUISTIC MAP OF CALIFORNIA.
After Dixon and Kroeber.

ing California basketry. It is interesting to note that, while the Powell map was made long ago from vocabularies only, the Dixon-Kroeber map is based on grammar, and yet the agreements are nearly complete. Especial attention is called to the

vast area occupied by the intruding Shoshonean family from the interior basin.*

The western division of the north California region, including the coast of Oregon as well, may be divided into three locations, each containing different tribes. The most northerly would be Athapascan and adjoining families; the middle division, those tribes associated in Round Valley; and the most southern of all, the Pomo.

The following list of plants carefully prepared by V. K. Chesnut, of the Department of Agriculture,† will apply to the Round Valley and Pomo basketry:

Acer macrophyllum, Pal gun sche (Yuki), maple. The Yukis of California use the bark for their basketry. The Puget Sound Indians employ it in their textiles, and Rothrock says that from the inner bark the tribes of the Pacific slope weave baskets, mats, and hats, waterproof.

Adiantum pedatum. The stems of maidenhair fern attain a length of 1 to 2 feet in the redwood belt of northern California, near the coast. They form the black strands in baskets, and especially basket hats.

Alnus rhombifolia, mountain alder, Un se (Yuki); Juskiat' and Kus (Wailaki); Gashet'l (Pomo). The fresh bark is used by the Yukis, as well as the Hupa and Klamath Indians of California, to colour their basket material.

Apocynum cannabinum, in Mendocino County, California, Indian hemp; Ma (Yuki); Po, in Concow; Masha (Little Lake); and Silimma (Yokaia) yields the common Indian fiber. The inner bark, collected in the fall, is soft and strong for thread, twine, ropes, and nets.

Asclepias eriocarpa, Go to la (Little Lakes); Bo ko (Concow); Machal and Chaak (Yuki), poisonous milkweed. The inner bark is used by the Eel River, Concow, Potter Valley, and Little Lake Indians for strings, nets, and other textiles.

* See Roland B. Dixon and Albert L. Kroeber, The Native Languages of California, American Anthropologist, V, 1903, pp. 1–26.

† Plants used by the Indians of Mendocino County, California. Contributions from the National Herbarium, VII, pp. 295–408, Washington, 1902.

Butneria occidentalis, Sai ka lé (Pomo), spice bush or calycanthus. Both the wood and the bark from fresh shoots are used in basketwork.

Carex, Tsu wish (Pomo), blackroot sedge. Used by the Pomo in their coiled basketry for decorating in black.

Carex sp. The long, tough rootstocks of several and perhaps most of the sedges (saw-grass) in Mendocino County, California, are used by the basketmakers. Great patience is exercised in tracing these from 2 to 5 feet through sand and mud and in preparing the splints. The baskets made from them are called "root baskets." Sedge rootstocks are the most important underground material, and the baskets made from them are the strongest, most durable, and most costly. Special characteristics belong to the different species.

Carex barbarae, Kahum (Pomo for water-tight baskets). The rootstocks furnish the splints for the white or creamy groundwork of most Pomo baskets. They are dug out with clam-shells and sticks aiding the hands and feet.* One end of the stock is grasped by the first and second toes, the clam-shell serves for scraping away the soil, and the stick for prying out stones and loosening the ground. A woman will secure 15 to 20 strands a day. They are placed in water overnight to preserve the flexibility and to soften the scaly bark, which is removed in the morning by the women. The end of the stick is chewed until the bark is separated. The wood is then held by the teeth, the other end of the stock is held taut by the first and second toes, and the bark is scraped away, leaving a tough white or tan-coloured strand about one-half the original thickness. · These are done up in small coils and carried by the women to the camp. Mr. Coville draws attention to a bit of primitive agriculture in this connection. The Pomo women insist that the toughest and finest roots can be obtained only at certain spots. Unconsciously, they have been making this true by means of their digging sticks and clam-shells, during all the years loosening the ground and removing weeds.

Carex sp., Ta tet el (Wailaki), sea-grass or sedge. The roots and leaves used in basketry, especially for hats and cheap semi-flexible baskets.

Ceanothus integerrimus. The Concow squaws gather the young and flexible shoots of the California lilac, Hibi, for the warp of their baskets.

Cercis occidentalis. The bark and the wood from sprouts of

* J. W. Hudson, Overland Monthly, XXI, 1893, pp. 561–578.

the redbud, Cha-ba, in Yuki; Mula, in Little Lake; Kala-a-kala, in Yokaia; and Dop or Talk, in Concow, are used in finer baskets as foundation, as weft in twined ware, and as sewing-material in coiled work. The Indians produce a variety of results in *Cercis*. The stems are sometimes cut in winter and early spring to insure material for the next fall. The colour of the bark is then slightly red, which may be darkened by exposure to smoke and blackened by soaking in dirty water, in water and ashes, or in a decoction of oak bark to which scraps of iron have been added. The bark to be used in sewing coiled baskets is separated by steaming. In twined basketry some of the white wood is left adhering to the bark, in which case designs in two colours are produced, since the willow and carex are both much darker.

Corylus californica. The slender stems of the Hazelnut, Olman, in Yuki; Gom he ni, in Concow; Ch' ki, in Wailaki; Cha ba, in Little Lake, are commonly used in place of willows in Round Valley for coarse sieves and fish traps and as warp in saw-grass baskets. A baby-carrying basket at Ukiah was made from the same material. The Calapooias make the finest openwork twined basketry of hazel sticks.

The Coos and Rogue River ware resembles the Shasta, the latter produce excellent work in hazel stems (Mrs. McArthur). (See Plates 4 and 172.)

Covillea tridentata, Tah sun up (Paiutes), creosote wood. It is one of the commonest industrial plants in southern California, Arizona, and southern Utah. The gum is used by the Apaches for cement. It is also used to produce a greenish-yellow dye. Owing to the odour emitted when heated, the plant is called creosote wood.

Gymnogramma triangularis, Gold-back fern. Common on open brushy hillsides throughout Mendocino County. As in the case of the five-fingered fern, this plant grows much more thriftily near the coast. The stems are also used there in the making of baskets.

Juncus effusus. The stalks of wire-grass, Lolum, in Yuki; Cha-ba, by the Potter Valley, Little Lake, and Yokaia Pomos; and Sito by the Wailaki, are used in Mendocino County for making temporary baskets. With them also children are initiated into the art of basket-making, and rackets used in gathering pinole seed as well as fish traps are woven.

Lonicera interrupta, Hai wat (Yuki), honeysuckle. The Yukis employ the flexible stems slightly for hoops in basket borders.

Philadelphus gordonianus, Ka kuss (Wailaki); Shon a hi (Little Lakes); Hawn li (Yukis), arrow-wood. A species of syringa or mock-orange. The pithy stems are valued on account of their lightness for the manufacture of baskets used by women for carrying babies.

Pinus sabiniana, Pol cum ol (Yuki), nut or digger pine. Used for basketry. The more pliable wood from the root is the chief source of material for making large V-shaped baskets, which Little Lake Indians use for carrying acorns. The root is warmed in hot, damp ashes, and the strands are split off before cooling. They are brittle when dry, but after being soaked in water they are easily manipulated in the more simply woven baskets. They are not sufficiently pliable, as sedge roots are, to be used like thread in wrapping round and round a horizontal withe.

Pseudotsuga mucronata. The smaller roots of the Douglas spruce, Nu, in Yuki language, are used in fine Pomo baskets. They are found in sections 8 to 10 feet long, uniform in thickness, and about the diameter of a lead pencil (quoting Hudson).

Pteridium aquilinum, Bis (Calpella Pomo); Bebi (Little Lakes); Sulala (Concows); Dos (Nomelakkis); Ma orda-git (Yokaias), the bracken fern. The hard wood is easily split into flat splints, which are sometimes used by the coast Indians for the black strands of their cheaper baskets. They are much less frequently used for this purpose by the Indians of Round Valley and Ukiah. Because susceptible of a fine polish, they are far weaker and more brittle than the saw-grass roots which compose the weft of their choicest baskets. The black colour is imparted by burying in mud.

Quercus lobata, Ky am (Yuki), white oak, acorn. The bark is used to a very slight extent by the Concows to blacken strands of the redbud for use in basketry. Rusty iron is added to the water extract of the bark to produce a black solution, in which the strands are allowed to remain for some time.

Rhus diversiloba. For dyeing the splints with which some Pomo baskets are sewed. Dr. Hudson is quoted as saying that an intense black is produced by applying to them the fresh juice of poison-oak in Pomo, Matuyaho; in Wailaki, Kots ta. The slender stems are also worked into the foundation of coiled basketry. *Rhus aromatica,* says Purdy, was formerly used by tribes eastward from Ukiah, as redbud is used by Pomos.

Salix argyrophylla. The silver-leaved willow, Bam Kal é, in Pomo; Kalalno, in Yokaia, is considered the best for coarse baskets.

It is common along Russian River, in California. It is not found at Round Valley, so these Indians would carry back small supplies of the slender stems when they returned from hop-picking near Ukiah. The roots are also highly valued in making certain baskets.

Scripus sp. The most valuable of the sedges for basket splints in Mendocino County is an unidentified species of the bulrush, *Scirpus* sp., Tsuwish, in Pomo. It is an article of commerce. Being rare near Ukiah, it is purchased at a cent a root from plants collected by Clear Lake Indians and in parts of Sonoma County or along the seacoast. The rootstocks, about one-fourth of an inch in diameter, consist of three distinct tissues—the outer, brown, like parchment; the middle; and the heart, a tough, woody structure. The outer surface of this woody tissue, which makes up the great bulk of the black fiber in the finest Pomo baskets, is slightly ribbed, and varies from light brown to nearly jet black. The interior is more or less white. Some of the dark splints are used just as they are, while others are blackened with the juice of poison-oak, *Rhus diversiloba*, or by burying them with charcoal, ashes, and earth for about eighty hours.

A detailed account of the manipulation of these rootstocks at Round Valley is given.*

Smilax californica, the only species of smilax in California, does not occur in Mendocino County, but is common along the headwaters of the Upper Sacramento. The fine, long trailing limbs are exceedingly strong, and are used to some extent in Round Valley and perhaps at Ukiah for basket-making. The Indians say that the strands have a brownish-black colour.

Tumion californicum. Splints from the roots of the California nutmeg, Kahe in the Yokaia language and Ku'-bi in Pomo, are said to be used by the Pomo in some of their fine baskets.

Vitis californica. She in (Pomo); Mot mo mam (Yuki); Kop (Numlaki); wild grape. The native wild grape of the region climbs over trees in canyons and in damp places to a height of thirty feet or more. The smaller, woody parts of the vine are extremely flexible, and are very considerably used by the tribes for the rims of their large carrying baskets. It is gathered at almost any time, soaked in water and hot ashes, after which the bark is removed and the wood split into a couple of strands, which, although very coarse, are used substantially as thread. The tribes of California make ropes and various household articles from the vine.

* Plants used by the Indians of Mendocino, California, p. 317.

As a connecting link between the Salish and other basketry north of the Klamath River and the true California types, there is here shown the figure of an old piece of basketry brought from Oregon more than sixty years ago (fig. 164). It is the ordinary coiled weave of the west coast, covered with red and white feathers. The latter are caught by their stems under the stitches as the work progresses, just as in the Pomo and other California tribes of to-day. It is interesting to find this type of work so far north. It points to the fact that many of the gaps which occur in this study could have been easily

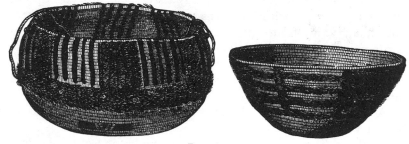

FIG. 164.
OLD FEATHERED BASKETS FROM OREGON.
Collected by Dr. J. L. Fox, U. S. Navy.

filled when the Indians were in their native situations. Holmes has other figures in the same type of basketry, only the feather work is combined with the ornamentation in the weaving on the surface. Attention is called again to the fact that the imbricated ware stopped short at the Columbia River. In it the plaits of grass or bark overlie one another just as feathers do in this feather work, and the stem of the feather is doubled under the stitches in the same way. To be especially noted are the groups of vertical stripes on the margin and the chevroned design at the bottom. Whether there was genetic relationship between the two remains to be studied out. The specimen Catalogue No. 2,138 in the United States National Museum was collected by Dr. J. L. Fox, United States Navy, of the Wilkes Exploring Expedition.

The Pacific slope branch of the Athapascan family is found in the northwestern corner of California and far northward into Oregon. The Hupa Reservation in 1864 was made to include a number of bands scattered around Trinity River, the names of which may be found in the Smithsonian Report for 1886, Part I. As late as 1850 the Hupa are said to have lived in pristine simplicity. Autumn supplied the all-important acorn, large quantities of which were collected and kept in store for use during the winter and spring. The vegetable food is gathered chiefly by the women. The outfit of the primitive gleaner, miller, and cook was principally in basket-work. While no edible root or food was despised, the oak furnished the chief breadstuff. The acorns were gathered in an osier hamper about 16 inches high and 20 inches in diameter, made in twined weaving. It was used by the women in carrying loads, supported by a band across the forehead. Filled with acorns, this hamper was placed on the back and held in position by means of a carrying pad, consisting of a disk of mat 5 by 4 inches. About the middle of October the Indians beat the acorns from the trees with long poles and carry them home in these baskets. The squaws remove the hull by giving it a slight tap with a pestle. The nuts are then dried and beaten to powder in a mill having a basket hopper. The flour is soaked in a hollow scooped in the sand, cooked into a kind of mush in baskets by means of hot stones, and baked into bread.

If the harvest was of seeds instead of acorns, they were winnowed in another basket of close twined weaving which the good woman had not failed to decorate with graceful patterns, following that unconquerable artistic instinct which is the heritage of all the peoples who breathe the air of the Pacific Ocean. Under the heading of uses, a multitude of functions for the Hupa basket will be described in detail.*

* The Ray Collection from Hupa Valley, Smithsonian Report, 1886, pp. 205–239.

Dr. W. L. Jepson has determined for Dr P E. Goddard the materials used by Hupa in baskets. The burden basket, the baby basket, and the salmon plate are made entirely of the shoots of hazel, *Corylus rostrata* var. *californica*, Hupa name mûk-kai-kit-loi. These shoots form the foundation or warp of all other basketry except the finest hats and the covered bottles. For these, shoots of willow are used, of which *Salix sessilifolia* and *S. fluviatilis* var. *argyrophylla* are indicated. These willows are not common in Hupa Valley. The warp stems, while slimmer than those from the hazel, are said not to be so durable. They are fastened at the commencement of the basket and at the beginning of the body by rounds twined with the root of certain deciduous trees. This material is called indiscriminately "kût." The roots of the more common willow, as well as the two mentioned, are used, besides the root of *Alnus oregana*, *Vitis californica*, and *Populus trichocarpa*. The principal weft of all close-woven baskets is composed of the root of *Coniferæ*. Of the trees growing in or near the Hupa reservation, the roots of *Pinus ponderosa*, *P. sabiniana*, and *P. lambertiana* are used. The selection of the species and of the individual trees depends on their readiness to split properly. These roots are roasted in the ground. Besides these, the Hupa import, from the coast, material from *Sequoia sempervirens* and *Picea sitchensis*. These root materials are called "xai." The root of the wild grape, *Vitis californica*, is used in place of the coniferous roots in fine hats for the woof. For decorative work the leaves of *Xerophyllum tenax* serve for white, and the stems of *Adiantum pedatum* for black. A reddish-brown is obtained by dyeing the inner part of the stem of *Woodwardia tradicans* with the bark of *Alnus oregana*. The primitive method of dyeing was to chew the bark and draw the splint through the mouth just before introducing it into the woof. The alder dye is now sometimes applied by steeping in a dish, but the results are said to be not so certain. Yellow is obtained by dipping the leaves

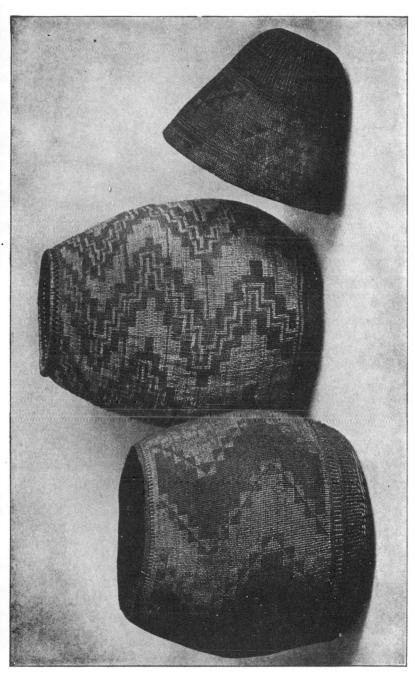

Plate 170. See page 375

Hupa Granary Baskets, Twined and Overlaid
Fred Harvey Collection

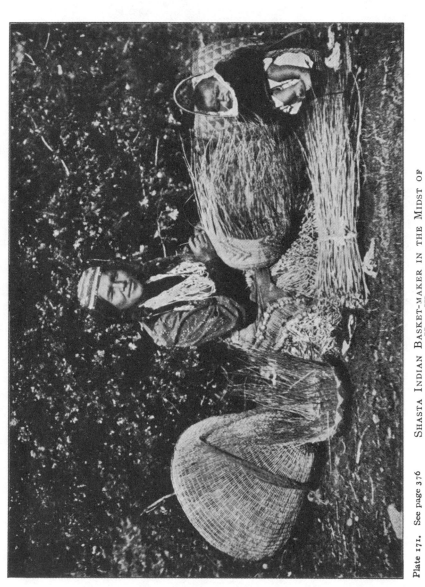

Plate 171. See page 376 SHASTA INDIAN BASKET-MAKER IN THE MIDST OF
HER WORK

Photographed by John Daggett

of *Xerophyllum tenax* into a decoction of *Evernia vulpina*. The setting of this dye is difficult, and many women do not use the yellow in basket-making. Porcupine quills are dyed with this lichen, giving a brighter effect. Their use is not common. A few women are now employing the Oregon grape for dyeing the Xerophyllum leaves. Baskets are sometimes collected for Hupa work which are made by the Tolowa, in Del Norte County. These have a steel·gray colour obtained by dyeing the root of the tideland spruce with rusty iron. The root and iron are buried in the damp ground for some time.*

Plate 170 represents three granary baskets of the Hupa Indians in the Harvey collection. The figure shown on the right is used as a cover for the granary. These baskets furnish excellent examples of form and decoration, as well as technical processes, among this Athapascan group. It has been mentioned before that we have here an example of acculturation through women of an art created by the conservative sex. If a number of Hupa men of Athapascan stock broke into this area and took to themselves wives of the country, the weaving processes would not be changed, so that in any one of these baskets will be found, beginning at the bottom, three-strand twined weaving; above that, two-strand plain twined weaving, and over the surface, decoration in overlaying. On the granary baskets the triangular and rectangular elementary forms are worked into vertical stripes, the basis of which is the bent line, or zigzag, forming the ornamentation, while the leaves of grass alternate with the foundation colour by laying a strip of the former on the latter and exposing it or turning it under at will. Dr. Goddard, in his paper published by the University of California, gives the following symbolism:

* Goddard, Pliny Earle, The Life and Culture of the Hupa. Publications of the University of California. American Archæology and Ethnology, I, No. 1, 88 pp., 30 pls., September, 1903; also No. 2, Hupa Texts, 290 pp., March, 1904.

The isosceles triangle the Hupa calls "rattlesnake's nose" (Lūwminchūw); right-angled triangles made with a horizontal line meeting a vertical line are called "sharp and slanting" (ches-Linalwiltchwel). Oblique-angled parallelograms are very frequently used. The name given them is "set on top of one another" (niLkutdasaan). Another design, which lacks beauty on account of its jagged appearance, is called "grizzly bear his hand" (mikyowe mila). Another figure is called "frog his hand" (ttchwa mila). A third design has angles projecting upward with the vertical lines on the outside of the figure and the oblique lines sloping inward and downward. This pattern is called "swallow's tail" (teshechmikye) or "points sticking up" (chaxcheuñeL).

When the isosceles triangles (called Lūwminchūw) are grouped one above another they are called Lūwminchūw niLkutdasaan ("snake's nose piled up"). When these figures come back to back so as to form diamonds alternating with the background, they are called Lokyomenkonch ("sturgeon's back"). When the figure apex is superimposed on a trapezoid the name cha is given to the design. These figures are nearly always so connected as to encircle the basket, when the name LenaLdauw is given to it, signifying "it encircles." A design which seems to be the trapezoids superimposed is called LekyuwineL ("they come together.") The conception of the design seems to be that of the second variety of triangles back to back. A series of rectangular parallelograms superimposed so that each higher one projects to the right of the one below it, the whole being bordered by a double line conforming to the outline, is called kowitselminat ("worm goes round" or "worm's stairway"). The oblique-angled parallelograms in pairs, with the upper one at the right, are the designs most frequently found on the hats. They are found in series on the storage baskets (djelo). Usually even numbers are employed, preserving the symmetry of the zone. Designs in red often have horizontal lines in black. Oblique lines in white often run across the design. When such lines run through the oblique-angled parallelogram they are called niLkutdasaan mikiteweso ("one-on-the-other its scratches").

In his monograph on Hupa Texts, Doctor Goddard gives the Formula of Medicine for making baskets.

Plate 171 represents a Shasta basketmaker in northern California, wearing one of the beautiful twined basket hats,

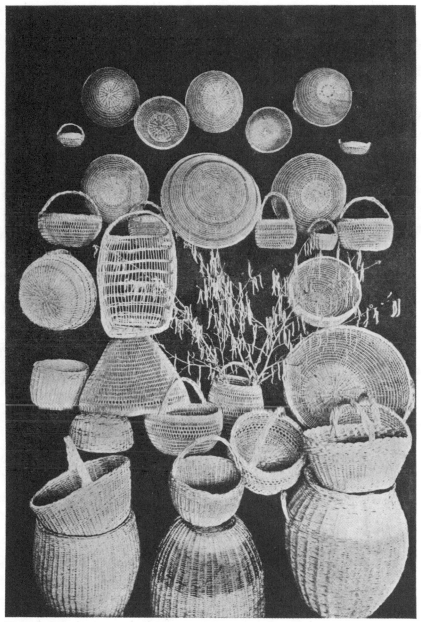

Plate 172. See page 377

BASKETS MADE FROM HAZEL STEMS

Collection of Mrs. Harriet K. McArthur

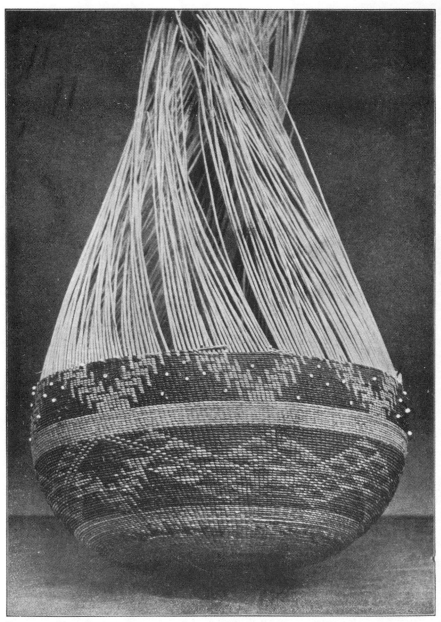

Plate 173. See page 383

UNFINISHED POMO BASKET, IN TEE WEAVE, SHOWING TECHNIC

Collections of U. S. National Museum

so called among this tribe. She also has about her, as a gar-
ment, a deerskin decorated with long fringes of false braid in
straw, the work done in a single strand.

From Governor Daggett comes the information that the
California Indians about him make the frame of the coiled
baskets of hazel twigs skinned (*Corylus californica*). The
weaving is done with split pine root. The ornamental patterns
are produced by sour-grass, maidenhair fern and bird quills
obtained in trade. The white splint is dyed by being chewed
in the woman's mouth together with alder bark, thus making
a kind of animated vat of herself. For the conical carrying
basket, the Shasta Indian name is as tim num. Papoose
basket, locks too; soup cooking basket, sal am poki; soup eat-
ing basket, pas tarrum; large storehouse, sip nook; cover to
same, ash roos; mortar basket with hole in bottom, kraam
num; acorn sifter, a flat disk, ten na bra; acorn bowl, moo roch.

Mrs. Harriet K. McArthur has in her collection also a large
number of Shasta, Rogue River, and Calapooia baskets, made
in open twined work from stems of the hazel. (See Plate 172.)

South of the Hupa Indians is the Round Valley Reserva-
tion with the following-named tribes: Concow (Pujunan);
Little Lakes (Kulanapan); Redwoods and Yukies (Yukian);
Wailakis (Copehan); Pit Rivers (Palaihnihan), and the
Nomelakis (Copehan or Wintun family). A moment's thought
will show why it is that varieties in basket types come from
this reservation. The Indian tribes of the neighbourhood are
mixed with those of the Sacramento Valley and Maidu or
Pujunan people east of the Sierras. With biological mixture
there has been corresponding fertilisation of ideas.

N. J. Purcell, for a long time agent among the Round
Valley Indians, describes the gathering basket as coarse
meshed and roughly constructed. He has sent to the National
Museum an example made by the Little Lake tribe. It is
woven of sticks with the bark on, and is very quickly made.
It has a buckskin string attached about the center, by which

it is carried. It is used for gathering acorns, nuts, grain, etc. When filled, this basket is emptied into a large carrying basket, this being repeated until the larger basket is full.

The large carrying basket is always put in some convenient place and a smaller one is used in gathering nuts or grain. Several of the other tribes there use the same basket, though it seems to have originated among the Little Lake Indians. The willow of which it is composed is of the ordinary kind which is seen along nearly all the creeks in the East, and is equally plentiful here.

The sticks are generally used while green, though they are frequently gathered in quantities, allowed to dry, then soaked in water as they are required for use.

The carrying sack is made like an ordinary hunting bag and about the size. It is manufactured by the Concow Indians only. The buckskin string attached is thrown across the shoulder, allowing the sack to swing by the side, as we carry the hunting bag. The material of which it is made is from a weedlike plant that grows from three to five feet high, found in but one place in this country. At the foot of Black Butte, about 7,000 feet above sea level, it grows in great quantities. This plant, bo-coak, bears a large white flower, which is filled with seed and has quite an agreeable odour. The leaves are large and long, tapering at the points. In winter the stalks die and become hard and dry, and are gathered in great quantities by the Indians. The bark is carefully taken off and the material from which the twine is made is stripped from the inside of the bark. This is as white as cotton and seems much superior in strength. In making his twine, the Indian seats himself, after first removing his trousers, takes enough of this flax to twist into about the size of No. 10 cotton in his left hand, lays it across the fleshy part of his right leg, licks the palm of his right hand, places it upon the flax, and twists it. In this way they make twine of all sizes, from that of the coarse sewing thread to that of a half-inch rope.

In early times all the sewing they did was with this thread, using a sharpened bone for a needle. The larger size twine was for making fish nets, bird nets, carrying sacks, snaring deer, etc.

The mortar basket is used for pounding acorns, grain, all kinds of nuts, and seeds. It is made of tough roots of the fir, which are usually gathered in spring or winter, when the ground is soft. Roots of the small saplings are preferred, being tougher than those of the old tree. The size of the roots gathered varies from one-half to one and a half inches. These are buried under hot ashes and are allowed to remain thus for an hour. They are then taken out, not burned, but very hot. This steaming process toughens them and makes them split more easily, besides seasoning them to some extent. The squaw takes this hot root in both hands, seizes it near the end with her front teeth, throws her head back and her hands forward, and the root is split exactly in the center in less than half a minute.

The two halves are again split in like manner, and so on until the pieces are about twice as large as required. The craftswoman is now more careful, and the last piece is some- times started with a sharp rock or knife, but usually with the teeth. One end of the splint is caught in the right hand, the other being kept between the teeth. The thumb and fore- finger of the left hand are clinched tightly on the stick below the mouth. The head and right hand are now pulled slowly from each other. As the operation proceeds, the finger and thumb of the left hand are slowly slipped down in front of the split part. Thus this last piece is divided accurately in the middle. The splints are not used at once, but are tied up in large circular coils and allowed to season, which, however, does not take long, as they are thin and the heating process hastens the operation. Being now prepared to make a basket, the woman uncoils the splints and throws them into a pan or basket of water, which renders them pliable and easy to be worked. The ribs of the basket are willow switches with the

bark scraped off. In beginning the basket, two of the splints are taken from the water and attached to one of the ribs with a kind of wrapped knot, so fastened as to allow one splint to stand toward the weaver and one directly from her. Another rib is now set close to the first one, and the splints are reversed—that is, the outside one is pulled toward the weaver and the inside one is put from her; this forms a half-turn around each side of a rib, the splints crossing or twining between the ribs. The same weave is used in the construction of the whole basket. Around the extreme top of this basket is a half-inch stick, usually wrapped or stitched on with small vines split in the center. The dark red material used occasionally in this basket (*Cercis occidentalis*) is found in the mountains, and is an undergrowth never attaining a size larger than one's ankle. The Indians call it "mo-lay." It bears a red blossom and small, slender switches, which are of a dark red colour, which grow up at the bottom of the larger bush. These are split open in the middle in the same way as the fir root, save that they are not heated. The stitches represent half the size of the stick, as it is split only once. The wood with bark off is snow white.

Mr. Purcell, in describing a pretty little basket of grass root covered with red feathers, made by the Little Lake Indians, says every mother in this tribe presents one of these baskets to her child when it is about seven years of age, with the admonition to take care of the gift. They have a superstition that if the basket is lost some evil will befall the child. It is impossible to obtain one of these from the Little Lakes, the specimen mentioned having been secured in the Concow tribe.

Under the name of Pomo are included a great number of tribes or little bands, thirty, according to Hudson, Purdy, and Wilcomb—sometimes one in a valley, sometimes more— clustered in the region where the headwaters of the Eel and Russian rivers interlace, along the latter and around the estuaries of the coast. In disposition the Pomo are quite differ-

ent from the Yuki and their congeners, being simple, friendly, peaceable, and inoffensive. They are also much less cunning and avaricious and less quickly imitative of the whites than the lively tribes on the Klamath, to whom they are inferior in intellect. As to their physique, there prevail on the Russian River essentially the same types as that seen in the Sacramento Valley. When first occupied by the European, the valleys inhabited by the Pomo teemed with wild grasses and the streams were hedged in with carex and willow. The native grasses have almost disappeared, while the carices have given place in the lowlands to hops and alfalfa. Many ranchers forbid an Indian to dig on their lands, thus limiting the weaving material supply to outlying canyons or compelling a substitution of inferior quality. Sometimes an indifferent worker will use but one character of material in a basket; for instance, the redbud shoots for warp and the two contrasting sides of the cortex for pattern. This method, called bi-to'-i, effects looseness of weft and warp, incongruity of colours, and instability of the vessel, and is strongly condemned by an expert. Some weavers will conscientiously refuse to work rather than substitute hai (woody material) for ma-yem' (roots). The following notes by J. W. Hudson accompanied his collection to the National Museum:

Vegetal materials for Pomo basketry

Indian name.	Scientific name.	Common name.	Parts used.
Ka-hum'.........	*Carex barbaræ*........	California sedge.......	Prepared root.
Tsu-wish'........	*Carex*...............	Black-rooted sedge	Dyed root.
Shi-kŏ'	*Salix sitchensis*.......	Sitka willow..........	Prepared root.
Băm..............	*Salix sessifolia*	Hinds's willow........	Prepared stems.
Ma-ló-ma-ló......	*Salix nigra*...........	Prepared inner bark.
Ka-lĭ'-she........	*Pinus sabiniana*.......	Nut pine.............	Split root.
Ka-wă'	*Pseudotsuga taxifolia* ...	Douglas spruce........	Root.
Bĭs..............	*Pteridium aquilinum* ...	Brake or bracken......	Prepared root.
Mu-lé............	*Cercis occidentalis*......	Redbud	Bark of shoots.
Pshû-bă'.........	*Corylus californica*	Beaked hazel	Stems.
Băm-tú	*Vitis californica*........	Grape	Vine.
Ma-shă'..........	*Linum californicum*	California flax........	Prepared stems.

Wilcomb finds black designs sewed in tule root and fern roots also.

Animal materials for Pomo basketry

Indian name.	Scientific name.	Common name.	Parts used.
Ká-ya	*Saxidomus gracilis*		Prepared shell.
Ká-ya	*Cardium corbis*		Prepared shell.
Tĕm	*Haliotis*		Prepared shell.
Ka-tăte'	*Melanerpes formicivorus.*	Woodpecker	Throat and scalp feathers
Ju-shĭl'	*Sturnella magna*	Meadow lark	Breast feathers.
Chi-ká-ka	*Lophortyx californicus*	Crested quail	Crest.
Ka-yán'	*Anas boschus*	Mallard	Scalp feathers.
Tsă-wá-lû	*Cyanura stelleri*	California jay	Neck feathers.
Ba-chí-a	*Colaptes cafer*	Mexican woodpecker	Quill splittings.
Shaí-i	*Aquila chrysaetos*	Golden eagle	Tail and pinions.
Tsu-lí-a	*Agelaius gubernador*	Tricoloured blackbird	Elbow feathers.
Kai-yó-o	*Icterus bullockii*	Bullock's oriole	Neck and breast.
Pö *	*Magnesite*	Magnesite	Burned, prepared cylinders.

* Mineral.

Ka-hum' is split into strings or flat splints and kept wet during the process of construction. Colour, light tan or white. Used in sewing coiled basketry.

Tsu-wish' is buried in ashes for about eighty hours, thus dyeing to shades of black; then split into splints like Ka-hum'.

Shi-kó, split into splints. Whole stems are used for fish weirs; colour, cream.

Bam. 1. Young shoots decorticated and polished for foundation of coiled basketry; colour, straw.

2. Splittings from bark of young shoots.

3. Splittings of young shoots.

Ma-lo-ma-lo. Inner bark strips; colour, dark tan.

Ka-li-she. Split root; colour, buff.

Ka-wa. Split root, trimmed limbs; colour, gray

Bis. Chewed and cleansed root, split; colour, black.

Mu-lé. Bark of shoots, split into tape with a bit of wood adhering; colour, burnt sienna. Used in sewing coiled basketry.

Pshu-ba. Trimmed stems.

Bam-tu. Vine, used rough or decorticated.

Ma-sha. Crushed, hackled, and combed.

Ka-ya. Manufactured from clam-shells; current among the Indians as "Indian silver." Monetic base.

Po. Magnesite, mined in Lake County, California. Heated dull red, then tempered in hot water. Knapped and scoured into cylinders.

Bored. Current as Indian gold. Monetic base.

All prepared vegetals turn dark with age, and especially by the smoke from the open fires in Indian huts.

Tsu-wish ranks first in value; a bunch equals 100 Ka-ya. A bunch of Ka-hum' equals 65 Ka-ya; Mu-le, 20 Ka-ya.

Plate 173 illustrates a coiled basket of the Pomo Indians left unfinished to show the workmanship. The foundation is in the style called Tee weaving, twined work, described and illustrated on page 77 and in fig. 27. These structural features are clearly set forth in the plate. In the foreground the vertical and the horizontal warp, as well as the twined weft, appear in their true association. The body sewing is done with white splints of me lé or redbud (*Cercis occidentalis*); the figures, representing mountains, are wrought with brown splints of cercis. It is ten inches in diameter, collected by J. W. Hudson, and is Catalogue No. 200,013 in the United States National Museum.

In feather work, each feather is plucked from the prepared skin of the bird and neatly caught under a stitch, which is then drawn tight. They are used either to heighten the colour without aiding the design or the design is in the feathers and not in the stitches. For the former, quail plumes and the red feathers from the woodpecker's head are employed. The red feathers are placed regularly but thinly on the stitches of the upper half of the basket, and the quail plumes scattered, or below three rows of shell disks (kaia) on the upper edge of the basket. In the feather basket proper there are two varieties called "tapica" and "epica." The tapica is the so-called sun basket; but Purdy insists that the word means "red basket." The oldest specimens are saucer-shaped, covered with red feathers, decorated with pendants of kaia and abalone and with circles of shell money. The use of other feathers than

red is a charming innovation. The Ballo kai Pomo name for feather baskets in any other shape is "epica." When the Pomo use shell disks (kaia) to decorate coiled basketry, a thread is carried along under the stitches and the disks threaded on as needed. Beads are usually applied in the same way, but in some examples they are threaded on the sewing filaments. (Carl Purdy.)

There is no more interesting group of Indians in America than the Pomo with respect to the variety of technical processes in basketry. They not only understand many of the processes common among other tribes, but have introduced one or two types of manipulation peculiar to themselves. The following classification, prepared by J. W. Hudson and Carl Purdy, shows the variety of basketwork made by them:

TWINED WORK (TSHAMA)

1. Pshukan (Shakan, Purdy), coarse twined work of shuba or hazel.
2. Pshutsin, wrapped weft, happily called backstitching by Hudson.
3. Bamtush, plain twined weaving.
4. Shuset, twine over two warp rods, twilled.
5. Sheetsin, three-strand braid or twine.
6. Lit, Makah style, wrapped weft twined (figs. 20, 21).
7. Tee, twined weaving over lattice foundation.

COILED WORK (SHIBU)

8. Shailo, foundation of splints.
9. Tsai, foundation of one rod.
10. Baumko, two-stem foundation laid vertically.
11. Bamshibu, foundation of three rods.
12. Bamteck, four-stem foundation.
13. Tsawam, the half-hitch work on cradles.

Purdy adds ringed and sewed; each circle of foundation complete. These names are from Yokaia, Upper Yokaia, Calpella, and Potter Valley. The word for basket in Potter

is Pika; at Upper Lake, Sitol; at Lower Lake, Kolob; at Cache Creek, Kawah.

1. Pshû-kăn' (fish weir) in its simplest form is the binding of a row of upright warp rods by means of pairs of hazel or willow shoots, passing them horizontally with a half twist in each space. Undressed material is the rule, but in more delicate household vessels the wood is decorticated, even polished. Hazel (Shu ba, the fisherman) was the original material. It is nothing more than a very coarse open twined work, passing now and then into three-strand twine. (See fig. 20.)

2. Pshutsin, a very substantial means of framing a large, heavy structure, such as granaries, sheathing for thatch, game fences, etc. It is in effect wrapped twined weaving, seen also in Mohave carrying frames and Andaman baskets. From the periphery a strand of grapevine loosely encircles two ribs, passing to the left over four ribs, then backward, catching two or more and repeating gradually, back two, forward four, inward to the center or apex. A second vine catches a rib at the bottom of the roof, passing to the left over four ribs, encircling two, thence zigzags parallel with No. 1 to the top. This is repeated till spaces are covered. Pshutsin effects in house building a coarse mesh at the foundation, but gradually closed in at the apex, where most needed. In granaries and cages the conditions are reversed, but the effect is the same. Fences require an additional top vine. (See fig. 13.)

3. Bamtush (Bamtu, grapevine), plain twined weaving. Coloured patterns and esthetic art were here born, the brown bark of the vine contrasting with the pale yellow of the inner vine splittings. The grape has long since been discarded for stronger and more polished material. Bamtush is the strongest weave, and is used in carrying baskets, acorn baskets, and very large, heavy mush baskets. There is a warp of willow or other stems radiating from the bottom. On this the weft is laid in pairs, the two splints being twisted a half turn in

passing a warp stem. The effect is that of ribbed cloth or corduroy. The ornamentation is usually in bands. (See fig. 15.)

4. Shuset is twining over two warps and alternating from round to round, and affords the amplest opportunity for artistic display. It is called twilled twined work, and its surface is the smoothest of Pomo leaves; the patterns are bold and clear and cover the whole area. It is the only weave whose designs are not woven through. It has also the mode of delicate structure. It is used in large acorn baskets, also in mush baskets, being strong, smooth, and moderately close. Some fine gift baskets are also in this weave, and it seems to be susceptible of much more elaborate ornamentation than the plain twined work. The word Shuset, says Hudson, is understood only as far south as Ukiah City, the Yokaia term for diagonal twine being Bam tsai. (See fig. 20.)

5. Sheetsin is a style of three-strand twined weaving in which at each third of a turn one weft filament is carried behind a warp stem. It will be seen at once that when the bundle of weft filaments has made a whole revolution, each one of them will have been carried behind the warp. On the inside, this basketry does not differ in appearance from common twined weaving, but on the outside each weft element passes over three warp stems and under one.

There is a peculiar type of Sheetsin used chiefly to start the foundations of twined baskets. It is a three-strand weft in which a braid is formed instead of a twine, one of its elements passing over each warp, the other two remaining outside. On the inside the effect is that of plain twined weaving, while on the outside the effect is diagonal. (See fig. 28.)

6. Lit is a style of twined weaving in which one of the elements remains on the inside of the basket and the other is wrapped around the checks formed by the crossing of this horizontal element with the vertical warps. The Makah Indians of Cape Flattery employ this technic almost exclu-

sively, but Hudson says the Kulanapan tribes used it only to give variety to a surface in which plain twine and Shuset are used. On the same authority, this word Lit is known among all the Pomo tribes, even among the Tsawalu Pomo, near Guernerville. (See figs. 21 and 22.)

7. Tee (intricate) is a double structure, a Bamtush reinforced by horizontal warp across the outside of the vertical. On the inside this ware is indistinguishable from plain twined work. Its characteristics are great strength, the closest mesh, and a pattern dim and impressional. It is the most difficult and highest priced of the Tshama weaves. The openwork basket trays in Tee weave are called by Dr. Hudson psher kom, or fish plate. (See fig. 27.)

The name Shi bu, or Tschibu, applies, says Purdy, in reality to only the three-stick coiled baskets. The full name is Bam shi bu or Bamsibu—sticks three. No branch of the Pomo uses it except for three-stick baskets, and only the Calpella, Kalshe, and Ballo bai Pomo use it at all as a basket name. One-stick baskets in Calpella, Kalshe, and Ballo bai Pomo are bam cha, stick one, or tishais. The filaments of Pomo shibu coiled basketry are shaved down to uniform width and thickness with the greatest care.

Those who are studying the technic of basketry will find great possibilities in the three-strand weaving, including: (1) 3-strand twine, braid and sennit, in each of which all three strands do the same work; (2) the Thompson weave, in which one strand is wrapped about the other two twined; (3) Tee twine in which two are twined about the other one.

8. Shailo, suggested by the spiral rib of Tee, was constructed of a spiral coil of fir-root fibers bound to its adjacent coil below by a single strand of the same material catching in the lower coil fibers or the tops of its lacings. This method, the Protean Shibu, developed and considered by other California Indians, notably Yokut, as the acme of art, has long since been discarded by the Pomo as inadequate to the de-

mands of even close weaving and pattern. However, it proved the coil to be practicable, and from it evolved Tsai.

9. In the Tsai (bam-cha, one rib) or single-rod coiled basketry the foundation is a single willow shoot of uniform thickness throughout, seasoned and smoothed, spiralling from base to rim, and sewed down with narrow splints of various materials Two rods are inclosed in each stitch which passes beneath the foundation of the previous turn, the stitches interlocking. This structure is quite light and elegant, permitting the most delicate treatment, both in stitch and pattern. Specimens frequently average sixty stitches to the linear inch. (See fig. 46.)

10. Baumko is the Pomo name for coiled basketry on a foundation of two stems, one above the other. It is an economical method of work, for it widens the coil and to that extent diminishes the amount of sewing. (See fig. 47 and compare Mescalero, page 467.)

11. Bamshibu or bamtsuwu (tsu-ba, three) consists of a three-rod warp or coil bound down by its lacings, catching in the lacings and one stem of the next lower coil. This is justly regarded by the Pomo as the highest type of basket art. Its materials require the most careful tests of evenness, pliability, and colour. The legitimate function of treble ribs, besides solidity, is their adaptability for retaining the bulbs of feathers, and was doubtless created by an incentive for this rich ornamentation. Comparison with other styles of work reveals the fact that by reason of fine material and pressing together of the stitches the sewing conceals the foundation, while in the varieties before mentioned the latter is visible between the stitches. (See fig. 50.)

12. Bamteck is scarcely to be looked upon as a separate style of weaving. It is simply a variety of No. 11. The manipulation of the stitches is precisely the same in both.

13. Tsawam. This is an application of the backward and forward braiding or false braiding found on the margins

of many baskets and described in the proper place in this work. The rods of the cradle are held together by a coarse cotton string obtained from the traders, and was formerly made of splint Carried across the warp rods, the weft material passes forward four, backward two, right; forward four, backward two, left—and so, alternately backward to the right or left, forms a very neat braid on one side of the basket and what looks like two rows of twined weaving on the other.

The making of a fine coiled basket requires an infinite amount of patience. The rootstocks, carefully gathered during the summer and early autumn, are split into fine strands for direct use. At Round Valley the process is as follows: The rootstocks, denuded of their outer coverings, are thoroughly soaked in warm water, and one end of a root is divided through the center, by means of the finger nails, into three parts. One of these parts is held firmly between the teeth, while by means of the fingers the whole root is carefully and very evenly split into three sections. Each of these sections is again separated into three parts in the same manner, and the same process is carried out until the strands are as fine as may be desired, the value of the basket depending in great measure upon the fineness of the strands used as well as on the general beauty of the finished fabric. These strands are used not like those from the pine root in twined work, but for thread for sewing coiled ware. In beginning the basket, three very pliant stems are so selected that when placed together their combined cross-sections will be nearly circular. The use of three "sticks" instead of one, as is sometimes the case in less costly baskets, gives much more elasticity and greater strength to the basket. The strand is wrapped tightly about one end of the compound withe, and as the wrapping progresses the wand is bent into a minute circle; the central hole is filled in by stitching over and over again, and with this as a basis the little plaque is gradually built up by coiling. The general shape and plan of the basket must necessarily be carried in

mind, for there is no skeleton to serve as a guide. Infinite care must therefore be exercised, not only in preserving the symmetry of shape, but also of the designs which are worked in with the black and white strands. It requires many months, sometimes years, of leisure work to complete a first-class bas-

FIG. 165.
TINY COILED BASKET.
Pomo Indians.
Collected by C. P. Wilcomb.

ket. Some of the very best are more or less individual in their shape and pattern. (Chesnut.)

Fig. 165 is a coiled basket of the Pomo Indians (Kulanapan family) in a style of sewing called Bamshibu. The foundation consists of three stems or rods. The stitches pass over the foundation and interlock with those underneath, giving

FIG. 166.
TINY COILED BASKET.
Pomo Indians.
Collected by C. P. Wilcomb.

a ribbed appearance to the fabric. This tiny object is a little over one-half an inch in diameter, and passes easily through a lady's finger ring. In the foundation, the uniform width of the coil and of the stitches, and the neatness of the sewing, it would be difficult to find a more charming piece of Indian handiwork.

Fig. 166 is a coiled basket of the Pomo Indians in a style of weaving called Tsai, in which a single rod is used for the

foundation, the stitches passing both over the rod of the course in progress and under the rod of the foundation of the course beneath. These small pieces represent fairly the best Pomo workmanship.

These two baskets are in the collection of C. P. Wilcomb, curator of the Golden Gate Park Museum, San Francisco, California, and were made under his supervision.

Fig. 167 is a coiled basket of the Hoochnom Indians, Yukian family. It is made in a style of coiled weaving called

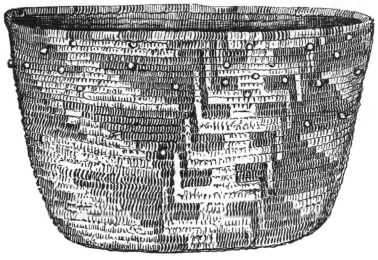

FIG. 167.
COILED BASKET.
Hoochnom Indians, California.
Cat. No. 21,371 U.S.N.M Collected by Stephen Powers.

rod and welt. In this method one or two small rods or stems of uniform thickness constitute the body or foundation of the coil. Over this is laid a thin filament or strip of material, and the stitches of each coil pass over the foundation, under the splint, and interlock. The work of the Hoochnom Indians is of excellent character, the coils being of about the same width, and the number of stitches to the inch uniform. In the example here shown, the coils are one-eighth of an inch in diameter, and there are twenty stitches to the inch. The

ornamentation appears to be the usual California combination of mountain and coil plume. The use of light and dark filaments and the alternation of triangles and rectangles on the two sides of the open space form a very attractive ornament. The use of shell disks improves the appearance of

FIG. 168.
DETAIL OF FIG. 167.

the object. Feathers are also employed on some specimens from this locality.

A square inch shown in fig. 168 illustrates more definitely the description here given.

This specimen, Catalogue No. 21,371 in the United States National Museum, was procured in Eel River, California, by Stephen Powers.

Leaving the West Coast peoples, the next group of basketmakers will be found in the Oregon tribes belonging to the Lutuamian family, namely, the Klamath and Modocs, and the Shastas, also various bands of Wintun belonging to the Copehan family. The basketwork of this middle region is largely twined work with overlaying. The designs have been studied by Roland B. Dixon, and will be found illustrated in Plates 18 to 24 in his paper on the basket designs of northern California.* In the work here mentioned it is interesting to find that the movement has been eastward, for quite a number of these specimens figured as Maidu are very surely made under the influence of tribes here mentioned.

The Klamath Indians have their home upon the Little and Upper Klamath Lake, Klamath Marsh, and Sprague River, Oregon. Their name in their own language is E-ukskik-

* Bulletin of the American Museum of Natural History, XVII, pp. 1–32.

ni (Klamath Lake people). The Modoc are termed by the Klamath, Modokni (southern people).*

Fig. 169 is a twined flexible basket of the Klamath Indians. The body is in plain twined weaving; the three elevated bands on the outside are in three-ply twined weaving, the effect being that of hoops placed on wooden vessels for the purpose

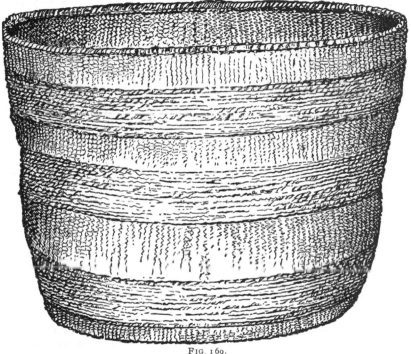

FIG. 169.
TWINED BASKET BOWL.
Klamath Indians, Oregon.
Cat. No. 24,124, U.S.N.M. Collected by L. S. Dyar.

of strengthening them, and is very pleasing. By choosing straws or stems of different plants for these three-ply bands the artistic impression is heightened. By twining dark and light coloured straws in the texture, and by varying the number of monochrome or dichrome twines, charming effects in endless variety may be produced.

* J. W. Powell, Indian Linguistic Families, Seventh Annual Report of the Bureau of Ethnology, Washington, 1891, pp. 1–142.

A square inch shown in fig. 170 makes clear the manner in which the plain twined and three ply twine may be combined, and also that of using different coloured materials. The rows in both cases, however, are monochrome. If the alter-nate meshes were dark and light, the beauty would be enhanced. The using of dichrome twine is rather limited to this particular area—northern California and southern Oregon.

This specimen, Catalogue No. 24,124 in the United States National Museum, was procured in Oregon by L. S. Dyar.

The following names for baskets were collected from the Hot Spring Valley Indians, Modoc County, California.

INDIAN NAME	BASKETWORK
Doch jäm' ä	Papoose basket.
Po lu' lu	Boat-shaped, used to hold trinkets and small articles.
Bä po' kä	Storage basket, also used for cooking; indeed, applied to any basket where the top curves in toward the center.
Shute' pä	Soft plaque used for gambling and winnowing.
Tä w y'ä	Hard plaque used for gambling and winnow-ing.
Clowä'	Coarse basket with hole in bottom for grind-ing meal.
De le' mä che	Cone-shaped burden basket.
Shu' wä	Squaw's cap.
Da lu' ti ä	Coiled weave. A coiled weave storage basket is called dalutia bapoka and is greatly prized, also the plaques in dalutia weave.

Plate 174 represents two Klamath Indian baskets in the collection of Dr. C. Hart Merriam. The interesting feature in them is that the entire structure is in three-strand twined work. The border resembles closely one of the simplest among the Tlinkits, namely, the warp strands are turned down and held in place by a row of twined weaving. All the Indians of this area practise the three-strand work, but do not cover the whole basket with it This weave is reserved

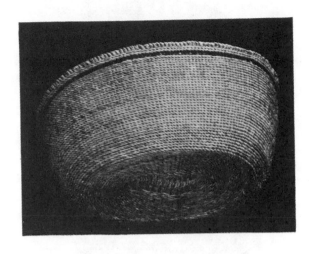

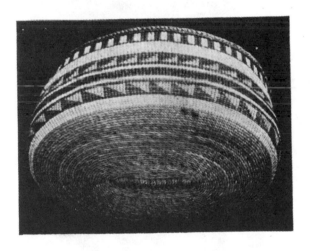

Plate 174. See page 394

THREE-STRAND TWINED BASKETS, KLAMATH INDIANS,
OREGON

Collection of C. Hart Merriam

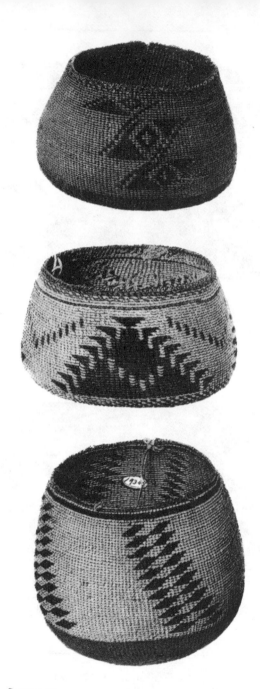

Plate 175. See page 395

PIT RIVER TWINED BASKETS

Decorations in overlaying ; shows wolf's eye, lizard's foot, and flying geese designs

Collected by L. Stone and H. F. Liston

for strengthening weak places and for ornament. It has the disadvantage of being wasteful of material.

South of the Klamath and Modoc tribes, and closely associated with them, live the Shasta Indians (Sastean family, formerly on the Klamath River from Bogus Creek to Scott River; on the Shasta River, Little Shasta and Yuka Creek; and in Scott Valley, to which has been added the Upper Salmon and a part of Rogue River in Oregon), Stephen Powers commends the strength and beauty of the Shasta women. With their basket hats fitting tight to their round heads and walking with a grenadier stride, they present quite an Amazonian appearance.* The specimens of Shasta Indian baskets in the United States National Museum are not to be distinguished fundamentally from those just described. They are in twined weaving

FIG. 170.
DETAIL OF FIG. 169

with overlaying in straw. Their special marks are in the designs or symbols.†

Plate 175, top figure, represents a twined basket of the Pit River Indians. In Dixon's paper precisely the same sym-

* Powers, Contributions to North American Ethnology, III, chapter XXVI.

† Shastas, Rogue Rivers, and Calapooia tribes on Grand Ronde and Siletz Reservations, Oregon, make excellent openwork twined baskets from hazel (*Corylus californica*) sticks cut in May, peeled. Those cut in autumn are toasted, then soaked and peeled. Charming effects are produced in the seasoning of the wood. Rarely stems dyed black by soaking them in mud are used in weaving. Besides the old-time plaques, baby frames, and conical burden baskets, the latest willow ware is being freely imitated in hazel for all domestic and industrial uses.—Mrs. Harriet McArthur. (See Plate 172.)

bols are seen on a basket labelled Yanan (Plate 25). The
warp and weft on the bottom are of some kind of rush. The
weft on the body is in stems of the squaw-grass. There are
twelve twists and twenty rows of twined weaving to the inch.
The colour of the body is a beautiful old gold produced by age.
The ornamentation is in three sets of three rhombs, each done
in black material—perhaps fern stems. Crosses and diamond
patterns are employed to decorate the centers. The margin
is formed by braiding down the unused warp stems. Height
is 3¼ inches; diameter, 5¼ inches. Catalogue No. 19,283.
Collected by Livingston Stone.

The middle figure is said to have been made by the Pit
River Indians, the warp and bottom being in soft rushes.
The weft of the body is in strips of rushes over which thin
filaments of squaw-grass have been wound. The delicate fig-
ures are in black fern stems. Design: lizard's feet, three in
number, with festoons of short lines between. The border is
formed by braiding down the ends of the warp and holding
them in place by a row of twined weaving. This is a very
common method of treatment throughout this country. Its
height is 3 inches and diameter 5½ inches. Catalogue No.
204,910, United States National Museum. Collected by
Harry F. Liston.

The lower figure represents a basket from the McCloud
River Indians, Copehan family. The warp is in small rods,
perhaps of hazel. The weft is in twisted root of dark brown
colour. The first few rows of twining, and here and there
another row around the bottom, are in three-strand, the rest
in double twining. The body is in the same brown material
wrapped with squaw-grass, the figures showing on both sides.
The ornamentation consists of four rows of double rhombs
in black fern and one single row. Around the bottom is a
double row in two colours. The border is finished in one row
of three-strand twined weaving, the ends of the warp showing.
Its height is 4½ inches and its diameter 5 inches. Catalogue

No. 19,349, United States National Museum. Collected by Livingston Stone.

Fig. 171 is a carrying basket of the McCloud River Indians, Copehan family. The tribes of this family are described by Powers under the general name of Wintun. Those living on the McCloud Fork are named Winnemen, the meaning of which term is North River. The similarity of the McCloud

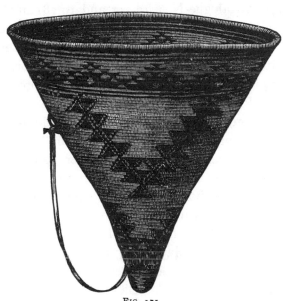

FIG. 171.
CARRYING BASKET.
McCloud River Indians, California.
Cat. No. 19,290, U.S.N.M. Collected by Livingston Stone.

River basketry with that of the Pit River people will be apparent. The technic, poorly shown, is in twined weaving with a foundation of stems. The noticeable feature is the overlaying of the filaments with grass stems or fern stems to produce the ornamentation. The strength of the basket is in the weaving. The bottom is cup-shaped, and for three or four inches is in three-strand twined weaving. The rest of the workmanship is in the ordinary two-strand twine. In order to strengthen the basket, a coil of rods is sewed around

the bottom for about a foot. The border is a strong hoop attached to the warp stems by bending down the latter and sewing them in place with splints, forming a single row of coiled work. The overlaying passes to the inside, so that the figures are the same without and within the basket. On the body, the rhomboid figures forming triangular ornaments are named in Mr. Dixon's paper, "leaves strung along."

Plate 176, Catalogue Nos. 19,297 and 19,281 in the United States National Museum, are labelled McCloud River Indian baskets. They were collected by the superintendent of the United States fish-hatching establishment in northern California many years ago, and doubtless were procured from the McCloud River Indians.

The upper figure is an example of two-coloured design in plain twined weaving produced by simply hiding every alternate twist of the weft strands. The lower figure is made in the same fashion with broken bands in two colours, brown and yellow, but the border is finished off by bending down the warp stems and sewing with thread.

Plates 177–178 show the work of the Hat Creek Indians, Pakamalli, who live on Hat Creek, a branch of Pit River in northeastern California. They belong to the Palaihnihan family, which Mr. Gatschet believes to be related to the Sastean tribes. Dixon (1902) places the basketry of these tribes in his northeastern group of California tribes associated with the Klamath and Modoc (Lutuamian), Shastas (Sastean), Pit Rivers (Palaihnihan), Yana (Yanan), Wintun (Copehan), and Maidu (Pujunan). Powers* characterises the Hat Creek Indians as the most warlike in all the Pit River Basin, and the one most dreaded by the timid aborigines of the Sacramento Valley. These specimens are in the collection of H. E. Williams.

The eastern portion of northern California, as before mentioned, is largely divided between the Palaihnihan, Yanan,

* Contributions to North American Ethnology, III, 1877, p. 274.

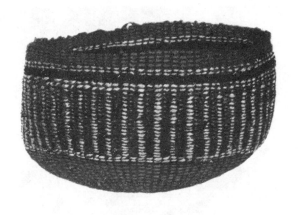

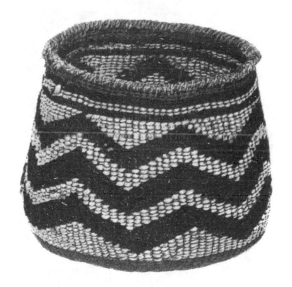

Plate 176. See page 398

McCloud (Wintun) Twined Baskets

Showing how the patterns may be concealed or revealed at pleasure on the wrong side

Collected by Livingston Stone

Plate 177. See page 398 Twined Basketry of the Hat Creek Indians, with Designs
in Overlaying. Northern California

Collection of H. E. Williams

Plate 178. See page 398 TWINED BASKETRY OF THE HAT CREEK INDIANS, WITH DESIGNS
IN OVERLAYING. NORTHERN CALIFORNIA.

Collection of H. E. Williams

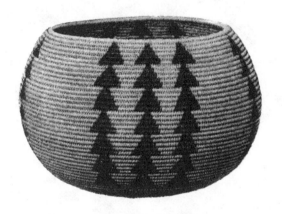

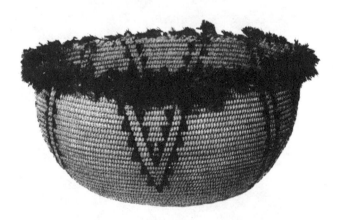

Plate 179. See page 401

WASHOE COILED BASKET BOWLS

Remarkable for dainty ornamentation and faultless workmanship

Collected by E. Mead and J. W. Hudson

and Pujunan linguistic families. It might be easily supposed by one who had no knowledge on the subject whatever that the coiled basketry of the interior basin would obtrude itself here, and either push backward the tribes making twined work, or at least the latter would be forced to a very subordinate position. Dr. Roland B. Dixon has published in the American Anthropologist, but more extensively in the Bulletin of the American Museum of Natural History,* the result of accurate studies in the basketry of the eastern tribes. The most extensive researches of Dr. Dixon are on the basketry of the Maidu Indians, described by Powers. On Powell's linguistic map these Indians are assigned to the Pujunan family. Their country lies east of the Sacramento River, and extends as far as the Nevada line, stretching north and south from the southern line of Lassen and Tehama counties to the Consumne River. A number of examples of Maidu basketry have already been described, and illustrated in Plates 56 and 57. The specimens are in the United States National Museum.

The body is either in splints of willow or other wood and a species of root. At the time of this writing, Mr. Coville was not quite sure as to the species employed. The designs on the body of the basket are in the splints of *Cercis occidentalis*, the bark and young shoots remaining in place. An inspection of a number of Maidu baskets together leaves the impression of distinct individuality. They belong to the three-rod variety of coiled weaving, and the sewing passes over the foundation, under one of the rods of the foundation beneath, the stitches interlocking. Frequently on the inside they split, which enables the sewer to give each stitch on the outer surface a vertical position. The material used in the sewing is hard, and is not driven home tight, each stitch being wide below and narrow above. After a study of one of these specimens, its colours and patterns, the investigator will have no trouble afterward in identifying a Maidu basket.

* Vol. XVII, pp. 1–32.

Dr. Dixon, who has given most attention to the lore in Maidu baskets, divides the symbols into three classes, namely, natural designs, plant designs, and those representing natural or artificial objects. His plates 1 to 17 are devoted exclusively to Maidu basketry. Among them will be seen a few in twined weaving, principally conical burden baskets. A comparison of these among themselves, and also those of the Pit River Indians and tribes living in the Sacramento Valley, indicate acculturation of some kind, borrowing ideas, or maybe women, ideas, and all. A number of Maidu baskets in the United States National Museum were collected by W. H. Holmes.

A suggestion might be made in this connection that the so-called feather design on the Dixon baskets* may be those on arrows, which in some California tribes are notched. This is only a suggestion. One of Dixon's most intricate feather patterns has narrow lines between, resembling the letter H, which might be either the rib of the feathers or the owner's mark on the shaftment of the arrow. The association of this notched half-feather design with the symbol for arrow points would be in harmony with this view. No other artificial object enters so profoundly into Indian art, gaming, lore, and ceremony.

On the map of California, covering a small spot at the angle of the eastern border, are the Washo Indians (Washoan family). They extend into the parts of Nevada adjoining, occupying the mountain region in the extreme western portion of the State about Washoe and Tahoe lakes and the towns of Carson and Virginia City. They formerly extended farther east and south, but were driven back by the Paiute, who conquered them and reduced them to complete subjection. Their basketry is the same general type as the Maidu, just north, but in execution it is far above. The material is willow splint, Tah-buk; the brown or reddish tint is that

* American Anthropologist, April-June, 1900, pp. 266–276.

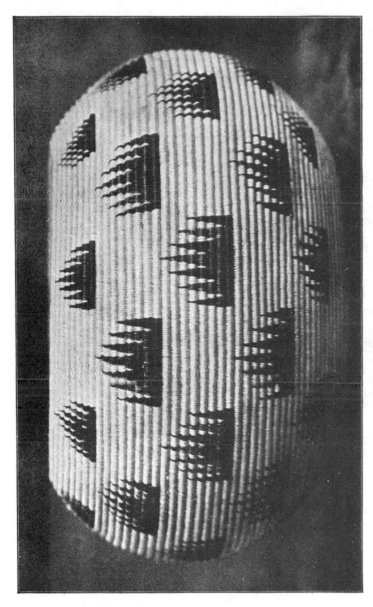

Plate 180. See page 401

FINE COILED BASKET OF THE WASHOES, NEVADA
DESIGN REPRESENTING SUNRISE

Collection of A. Cohn

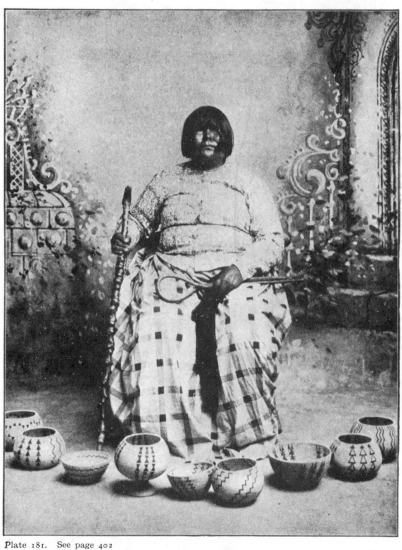

Plate 181. See page 402

DATSOLALEE, THE WASHOE BASKET-MAKER, NEVADA

Photograph from Mrs. A. Cohn

of the bark of the mountain birch (*Cercis occidentalis*), Tag-goo-let, and the black is from the root of a mountain brake (*Pteridium aquilinum*), mes-sa-wag-a-see, all of lasting quality, and they acquire with age a richness that makes them incomparable. The sewing is faultless. Stitch after stitch, over and over, increases in width and length with the swelling and shrinking of the basket, like a harmony in music. The form of the specimen is charming, and the ornamentation ideal. The recognition of worth in the Washo basketmaker is encouraging, for the price of a few pieces reaches into thousands of dollars. The author heartily acknowledges the aid of Mrs. A. Cohn, of Carson City, Nevada, for information about the Washos and for photographs.

The tiny Washo offering or gift basket, when used to propitiate the harvest spirit, is filled with choicest grain or seeds or acorns from the last crop, to insure a future good harvest. One or two of the large storing or household baskets will hold the winter supply of grain or nuts. The flat cradles are for the papooses. If the child's father is a famous brave or chief, the basket is covered with buckskin and gaily decorated with beads, trinkets, tasselled fringes, or feathers. The ornamentation of the little sheltering cover for the head tells the sex of the occupant.*

Plate 179 represents three basket bowls in the United States National Museum labelled Washo. They all show the characteristics of uniformity and plain ornamentation referred to. The lowest in the series has also a margin of feather-work which allies it with the type of the tribes farther west. Catalogue Nos. 204,846, 36,244, 35,435, United States National Museum.

Plate 180 is one of the best specimens in Mrs. A. Cohn's collection. The symbol on the surface is a series of points meaning "clear skies, good weather." Mrs. Cohn finds variations in these, the number of points ranging from three to

* Clara MacNaughton, Out West, XVIII, 1903, p. 438.

seven. In some examples they are contiguous; in others, separated by narrow spaces.

Plate 181 is a picture of Datsolallee, the maker of the finest specimens of Washo basketry. She is holding in her left hand the bowed stick in the shape of a racquet, with which hot stones are stirred about in the basket of mush, while cooking. The symbols shown on the various baskets at her feet represent men, women, snakes, arrows, wind, weather symptoms, morning, and migrating.

Plate 182, upper figure, shows a basket bowl of the Washo Indians, collected by Eugene Mead. The foundation is the three-rod style in willow. The sewing is done in splints of the same material. The ornamentation on the bottom is a many-pointed star in brown cercis. On the body there are three circles made up of isosceles triangles in the same. Two of the rows on the body of the basket are so arranged as to have a narrow belt of white between them, the points of one being downward and the other upward. This form of ornamentation is suggestive of the patterns on the sewed coils of the Navaho basket bowls. The border is plain coiled sewing. Its diameter is 8¾ inches, and height 3½ inches.

Plate 182, lower figure, is a basket bowl, Catalogue No. 204,852, United States National Museum, coiled work from Inyo County, California, tribe not positively known. There are four sets of ornamentation on the side in step pattern in threes, done in sewing splints dyed black. The most interesting feature of the basket is the border, which is in false braid, made of a single splint wrapped over the upper foundation, forward, under, and back, over again and down beneath the two foundation rows, making a figure 8.

The southern portion of the Oregon-California basket area is bounded on the west by the Pacific Ocean, and there was little encouragement to venture beyond the shore line except in San Francisco Bay and around the Santa Barbara Islands. On the north of it are the Maidu, Wintun, and the Yuki

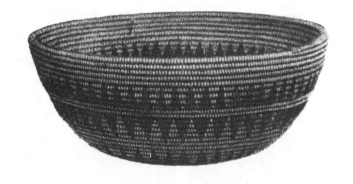

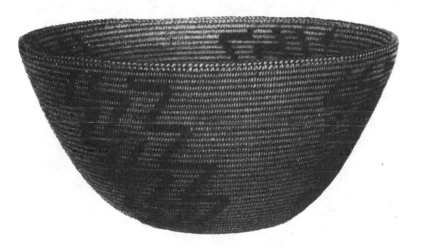

Plate 182. See page 402

EASTERN CALIFORNIAN COILED BASKETS
Unclassed, bearing Washoe motifs
Collected by Eugene Mead

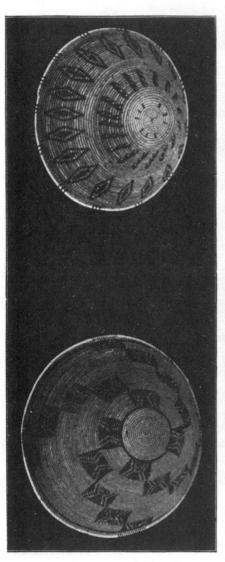
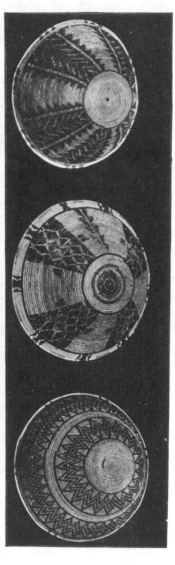

Plate 183. See page 409 COILED BOWLS OF THE PANAMINT SHOSHONEAN INDIANS, CALIFORNIA

Collection of C. Hart Merriam

1 2
3 4
5

tribes. On the south, and forming a part of the subarea itself, are the Missions, some of which belong to the Yuman family, the southern boundary of the area. The great Shoshonean family has pushed across the drainage of the interior basin to the coast of Santa Barbara. This southern region is a long rectangle inclined toward the west. Its axis would be a meridian through diagonal corners. The eastern portion is Shoshonean territory. The western portion belongs to the following linguistic families: Moquelumnan, Costanoan, Mariposan, Esselenan, Salinan, and Chumashan. Along the median line of this subarea are Mono, Fresno, Inyo, Tulare, and Kern counties another basketry Caucasus or Babel (See fig. 163.)

Those who have made collections from this part of California will bear witness that the exchanging of baskets and of women who make baskets from tribe to tribe has rendered it almost impossible to identify forms ethnically. Here blood and speech and industry are apt to be confounded. At least, it is too early in the investigation to be positive on the subject.

Another difficulty arises in this study from the fact that language groups, tribal names, and county names are also mixed up. For instance, a basket may be called Tulare because it was purchased in that county of California, having no reference to the Indian tribe. A specimen made by the same woman will bear the name of the tribe of which she is a member. Still another one of her productions might be called from the group of languages to which her own belongs. At present, the confusion extends beyond form and design to the substances and technical processes. The author acknowledges his obligations to E. L. McLeod, of Bakersfield; C. P. Wilcomb, of San Francisco; and Dr. C. Hart Merriam, of Washington, for the information here given. Each of these has given most careful study to this cosmopolitan basket region. Dr. Merriam has

devotéd special attention to the plants used and to the ethnic determination.*

Of this ware, Dr. Merriam says that most of the coiled baskets made by the Indians inhabiting the lower slopes of the Sierra from Fresno River south to the Kern are celebrated for excellence of workmanship, beauty of form, elegance of design, and richness of material, which differ in tone and texture from that used by the tribes north and south of the region indicated. When fresh, its colour is brownish buff; with age it becomes darker and richer. By careful selection a handsome dappled effect is produced. It is made from the root of a marsh plant which the Indians travel long distances to procure, identified by Miss Alice Eastwood, botanist of the California Academy of Sciences, as *Cladium mariscus*. The foundation consists of a bundle of stems of a yellow grass, *Epicampes rigens*. The black in the design is the root of the "bracken" or "brake fern," *Pteridium aquilinum*. The red is usually split branches of the redbud, *Cercis occidentalis*, with the bark on, gathered after the fall rains, when the bark is red. The tribes making the *Cladium* baskets are the Nims, Chukchansis, Cocahebas, Wuksatches, Wikchumnis, Tulares, and perhaps one or two others. Besides these, the root is sometimes used by certain squaws of the Muwa tribe living north of the Fresno and by the Pakanepull and Newooah tribes living south of the Kern; but among these its use is exceptional.

Another material which has proven a stumbling block to collectors is the red of the design in the handsome baskets made by the Kern Valley, Newooah and Panamint Shoshone Indians. This material is often called cactus root. It is the unpeeled root of the tree yucca (*Yucca arborescens*), which grows in the higher parts of the Mohave Desert, pushes over Walker Pass, and reaches down into the upper part of the valley of South Fork of the Kern. The so-called Tejon Indians

* It is too early to complete a plant synonymy for the Inyo-Kern and Tulare basketry. The list of Coville (pp. 19 to 43 of this work) and the following paragraphs from Merriam will be helpful.

obtain it in Antelope Valley, at the extreme west end of the Mohave Desert. The yucca root varies considerably in depth of colour, so that by careful selection some of the Indian women produce beautiful shaded effects and definite pattern contrasts.

Some of the Panamint Shoshones inhabiting the desolate desert region between Owens Lake and Death Valley use, either in combination with the yucca root or independently, the bright red shafts of the wing and tail feathers of a wood-pecker—the red-shafted flicker, *Colaptes cafer collaris*. These same Indians use two widely different materials for their black designs—the split seed pods of the devil's horn, *Mar-tynia*, and the root of a marsh bulrush, *Scirpus*. The *Mar-tynia* is a relatively coarse material, and when properly selected yields a dead black. The *Scirpus* root is a fine, delicate mate-rial, which, by burying in wet ashes, is made to assume sev-eral shades or tones, from blackish brown to purplish black, or even lustrous black.

In parts of the Colorado Desert in southeastern California the Coahuilla Indians use split strands from the leaf of the desert palm (*Neowashingtonia filamentosa*) as a surface mate-rial for their coiled baskets. The design is usually black or orange-brown, and is a rush (*Juncus*).*

The following list gives the families of the tribes in Tulare, Kern, and Inyo counties using the plants named in the first part of this description: 1. Chukchancys (Mariposan); 2. Cocahebas (Shoshonean), 3. Muwa (Moquelumnan); 4. Newooah (Shoshonean); 5. Nims (Shoshonean); 6. Pakanepull (Shoshonean); 7. Tulares (part of Olamentke div., Moquelumnan); 8. Wiktchumnes, Wikchumni (Mari-posan); 9. Wuksatches, Wiksachi (Mariposan).

The elements of ornamentation are lines direct and crooked, in shapes as varied as the margins of leaves, and they might without affectation receive the same names—dentate, serrate,

* C. Hart Merriam, Science, May 23, 1903; but more especially of June 17, 1904, where this most difficult ethnic tangle is straightened out.

sinuous, etc. These simple lines are combined in parallels, herring-bone, chevrons, crenelations, and many more patterns. The triangle, the rectangle, the rhomb, and the polygon are used in great variety. Out of these elements the designs on this basketry are separate, concentric, or radial.

The separate designs are, after all, subservient to the others. Very little of this ware shows entirely free and scattered patterns. The plume or L-shape, the white and coloured rectangles associated, the groups of marks on the border, and chiefly the rectangles in two colours with hour-glass middle are most common.

Concentric designs are narrow or wide bands, whose middle portion is decorated with crooked lines and geometric figures in endless variety of combinations. Most of the bands have entire margins, but projecting margins are not unknown. The most noteworthy is Merriam's "butterfly flight design." (See Plate 194.)

The radial designs are straight or spiral. The composition of each ray is a study in itself. But a glance at a large number of baskets from this central region shows the predominance of the cuneate motive. These truncated wedges spring out of a central, circular pattern and widen toward the margin. Their surfaces and their margins are seldom entire. The spiral designs are also frequently wedge-shaped, but the manner of their composition is of the greatest interest. Lurking in them all is the stepped motive in which herring-bone or jagged lines and simple geometric figures follow one another by echelon. This on a roundish surface gives spirals of any amount of curvature. By widening and lengthening the rectangular elements the wedge-shaped interspaces are filled with the spiral pattern, and the whole surface is covered with a single design. This charming decoration is peculiar to the Santa Barbara baskets. (See Plate 49.) In outward form, the baskets of the area here considered vary from round, flat gambling mats, through trays and bowls of various depths

and hats of conical shape, to narrow-mouthed vases, or "bottle-necks," as they are called. Some of these are low and broad and closely resemble the best of ancient Arizona pottery.

The basketry of the Panamint Indians (Shoshonean) living in Death Valley, Inyo County, says Coville, is made by the squaws at the cost of a great deal of time, care, and skill. The materials are very simple. They consist of the year-old shoots of some species of tough willow, splints from *Salix lasiandra*, the year-old shoots of the aromatic sumac, *Rhus trilobata*, the long, black, slender, flexible horns on the mature pods of the unicorn plant, *Martynia louisiana*, locally known as devil horns, and the long, red roots of the tree yucca, *Yucca arborescens*. These materials give three types of colour—that of the willow and the sumac, the black of the devil horns, and the red of the yucca roots. This last material, although it has a strong fiber and a pretty red colour, is rarely used, for it is too thick to pack closely, and the resulting fabric is full of interstices.

Sumac and willow are prepared for use in the same way by the Panamint Indians. The bark is removed from the fresh shoots by biting it loose at the end and tearing it off. The woody portion is scraped to remove bud protuberances and other inequalities of the surface and is then allowed to dry. These slender stems serve as foundation. The sewing-material is prepared from the same plants. A squaw selects a fresh shoot, breaks off the too slender upper portion, and bites one end so that it starts to split into three nearly equal parts. Holding one of these in her teeth and one in either hand, she pulls them apart, guiding the splitting with her fingers so dexterously that the whole shoot is divided into three equal, even portions. Taking one of these, by a similar process she splits off the pith and the adjacent less flexible tissue from the inner face and the bark from the outer, leaving a pliant, strong, flat strip of young willow or sumac wood. Both stems and splints may be dried and kept for months, and probably even for sev-

eral years, but before being used they are always soaked in water.

The pack baskets, and some, at least, of the water baskets, are made of these splints and rods in twined work. The women begin at the bottom with two layers of rods superimposed and fastened by their middles at right angles. The free ends are bent upward, and in and out between them the strands are woven, new warp rods being inserted as the basket widens. An attempt at ornamentation is frequently made by retaining the bark on some of the strands or by staining them and by slightly varying the weave. A squaw commonly occupies an entire month constructing one such basket.

Starting from a central point to make a coiled basket, a bundle of two or three grass stems and one very slender rod is wrapped with a willow splint. At the proper point the foundation is drawn more tightly, so that the remainder of the spiral forms the sides of the basket. The wall has the thickness, therefore, of one of these bundles, and is composed of a continuous ascending spiral. The willow rod furnishes a strong hold for the stitches, and the punctures are made with an iron awl. When such an instrument can not be obtained, an admirable equivalent is substituted in the form of a stout, horny cactus spine from the devil's pincushion, *Echinocactus polycephalus*, set in a head of hard pitch. The grass stems, when the stitches are drawn tightly, make a perfect packing, and the basket when finished is water-tight.

The pack baskets of the Panamint Indians have the form of a funnel, from $1\frac{1}{2}$ to $2\frac{1}{2}$ feet high and not quite so broad. The loaded basket is held against the back between the shoulders, either by the hands grasping its rim, or by leather or rope thongs passed around the forehead, the body meanwhile bent forward.

The plaques are small, flat, circular pieces of closely sewed coiled work, usually 9 to 12 inches in diameter. They are flexible, and sometimes slightly saucer-shaped, and are used

not only as plates and pans, but also as substitutes for sieves. The material to be sifted, composed of ground seeds, is placed upon the plate and the chaff winnowed out.

The pot basket of the Panamints is in coiled work, and has the shape of a rather deep bowl with curved sides and a deep bottom, and has a capacity of about three pints. The squaw uses it as a general measure, as a bowl for dry food and for soup, and often, when in the sunshine, as a hat. Most of their starchy food is roasted dry by mixing seeds, before they are ground, with hot coals and stirring them in the basket. This process is still largely used.

The water basket has a capacity of two or three gallons. Its outline is that of an urn with a narrow neck and a rounded, conical bottom. The entire inner surface, and frequently the outside, is coated with pitch. Woven into the shoulder of the basket on one side are two loops of horsehair, or other strong material, to which is attached a thong. In carrying, this thong is passed around the forehead, while the basket is rested on the back between the shoulders.

All the Shoshonean types of weaving, all their forms of baskets, and most of the patterns on them, are ancient. The canyon walls of the upper tributaries of the Colorado are honeycombed with cliff and cave dwellings. From them came inexhaustible treasures of basketwork.*

In the collection of Dr. C. Hart Merriam in Washington City there are most excellent examples of the Panamint (Shoshonean) Indian basketwork in which the ornamentation has been a matter of especial study. Plate 183 illustrates five examples from Dr. Merriam's collection, which I am allowed here to reproduce. Before speaking of them, it will be at once noticed that these Indians, whose most numerous kindred are in the Interior Basin, have been in contact with well-known California tribes and have been subjected to their influence. (See also Plate 185.)

* See F. V. Coville's account of the Panamint Indians of Death Valley, California, American Anthropologist, V, 1892, pp. 351–361.

Fig. 1 will be recognised at once in its relationship with the Tulare tribes. The ornamentation consists of four cycloidal radii made up of rectangles in black, arranged in stepped patterns. Each one of these rectangles is ornamented with two double chevron patterns, called hour-glass designs by Dr. Dixon. In some examples the colour is mixed red and black. Collections of short and parallel lines on the border terminate the patterns.

Fig. 2, another Panamint bowl, has the center ornamented with groups of small rectangles in threes. The first band near the bottom has for decoration a design which resembles a barbed harpoon head with unilateral prongs. The principal band on the body is decorated with a series of rhombs in black, containing white and black designs within. In some of the Californian eastern tribes this design represents the eye, but until the symbol is surely known, denotive names are better. The border is decorated with groups of short marks in threes.

Fig. 3 is a bowl with plain center, excepting a short owner's mark, so-called, and on the body are two bands, each one decorated with a threefold chevroned pattern. It will be noted that the offsets in the three boundary lines of the designs are exactly in line with the finishing off at the upper border. This feature is often mentioned by basket collectors among other tribes.

Fig. 4 is another Panamint bowl, the interior decorated with plain rings in black. From the bottom project four equidistant wedge-shaped designs decorated on the surface with rhombs in white. On the border, the pattern shown in fig. 1 appears rectangular in form, with eight single chevroned designs on the surface. One of the patterns is abbreviated, and between the two wedge-shaped designs on the right side of the figure is an arrow motive which may represent arrowheads strung or the feather of the arrow notched.

Fig. 5 is another Panamint bowl, with five wedge-shaped designs on the body, proceeding from a dark ring bordering the bottom. Each design has outside edges bordered in white,

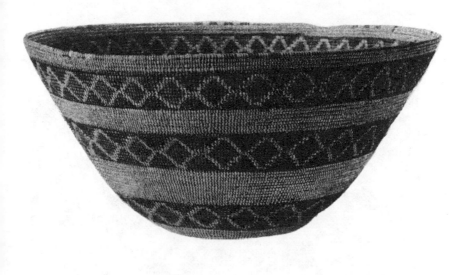

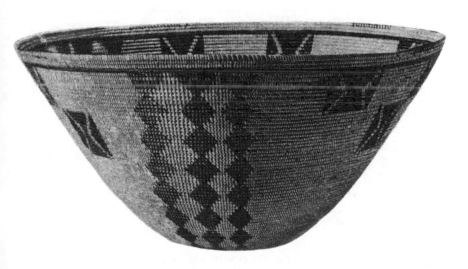

Plate 184. See page 411

TULARE AND KERN BOWLS

Showing the force of natural colours in ornamentations

Collected by J. W. Hudson and Eugene Mead

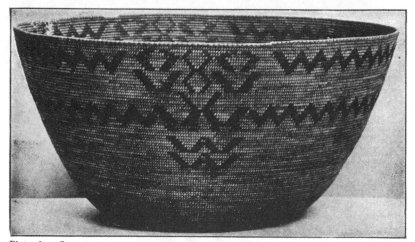

Plate 185. See page 412

TEJON BOTTLE-NECK AND YOKUT BOWL, FRESNO TYPE, CALIFORNIA

Collection of E. L. McLeod and Collection of U. S. National Museum

with serrate edges in brown and straight venations in white on the middle portion. The little groups of marks in threes on the border have nothing to do with the radiate pattern.

Plate 184 is introduced here for the purpose of showing how the colours mentioned in the foregoing pages are used in giving variety and beauty to the surface of the ware in this area. The yellow golden colour is that of the usual sewing-material. The black is produced by the use of martynia. The red is from the *Yucca arborescens*. In the ordinary photographic plate the effect of these colours is lost, but in the illustrations here given the full effect is brought out. Attention is called also in the lower figure to the union of two methods of sewing. In the figured stripe in the middle, open sewing is shown, while on the rest of the body the stitches are packed close together. It has Kern Valley or Panamint designs. On the upper bowl they are Yokut.

The following information concerning the basket tangle in this area is from Mr. C. P. Wilcomb, of the Memorial Museum, San Francisco. The Inyo and the Kern (Inyo-Kern) basketry are virtually indistinguishable; the tribes are Paiute (Shoshonean). The Tulare County basketry is that of the Yokuts, and is identical with that of the Yokuts of Fresno County and of the Monache or Monos (Shoshoneans inhabiting the headwaters of the San Joaquin and Kings rivers). The Monache and the Fresno work are somewhat coarser than that of the Tulare tribes, but in materials and shapes are identical. The Kern tribes are mostly on upper Kern River in the vicinity of Kernville.

The Tulare-Fresno foundation is made of grass stems (*Sporobolus vilfa* or *Epicampes rigens*). The Inyo-Kern foundation is of willow (*Salix lasiandra*), or sometimes of the root of sumac (*Rhus trilobata*). For the Tulare sewing, roots of slough grass (*Cyperus virens* or *Cladium mariscus*) are used, while in the Kern, willow is usually employed. For the red of their patterns the Tulare-Fresno women employ the redbud

(*Cercis occidentalis*), which is coarser than the root of the *Yucca arborescens*, used for the same purpose by the Inyo-Kern and Panamint. The Yucca root is of light yellowish-red like willow bark, but is sometimes as dark as cercis. In some of the burden baskets and winnowing trays, willow bark is used for red. The Paiutes do not use redbud. For black, the Tulare-Fresno women use the common fern root (*Pteridium aquilinum*), while in Inyo-Kern and Panamint the heart of the tule root (*Scirpus nevadensis*) and martynia are employed. In Inyo-Kern ware, quail tips and red wool are rarely used on baskets as they are on Tulare; but small private marks and symbols are wrought with split pink quills from the woodpecker known as redshafted flicker. The Tulare make many large bowl-shaped baskets. In Inyo they are small, if of this shape.

Plate 185 will emphasise the difference hinted at in the foregoing text between the coarser and finer weaving in the same area. The upper figure in the plate is a Tejon bottle-necked jar in the collection of E. L. McLeod, of Bakersfield. The ornamentation is the striped pattern well known among the different tribes in this area. The foundation is laid up rather wide for the size of the basket, and the sewing far apart, the stitches not being crowded home. Compare this with the specimen which follows:

Fig. 2, Catalogue No. 204,851, United States National Museum, is a fine coiled basket bowl collected by Eugene Mead. The foundation is of the three-stem type. The sewing is in splints of *Cladium*. The ornamentation is in the black fern root (*Pteridium aquilinum*). There are nine rows of sewing and thirteen stitches to the inch, but the most remarkable feature in this large bowl is that the three-rod foundation and the sewing together make a fabric not more than an eighth of an inch in thickness. The designs are two serrated lines in black. On either side is a combination of symbolic figures which almost resemble letters of the alphabet. There is no exact

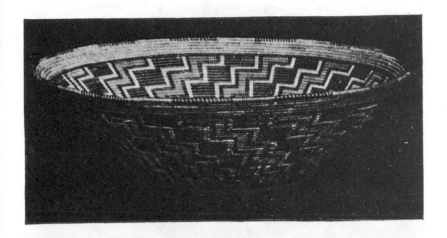

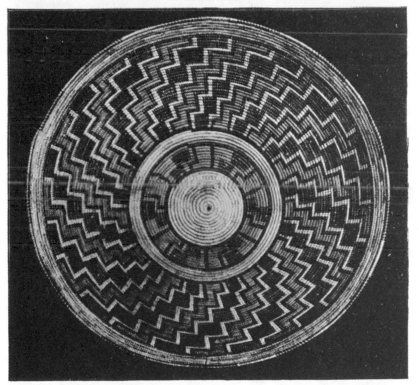

Plate 186. See page 413

YOKUT COILED BASKET BOWL, WITH STEPPED DESIGNS RADIATING,
TULARE COUNTY, CAL.

Collection of C. P. Wilcomb

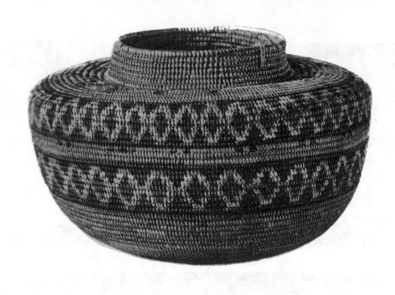

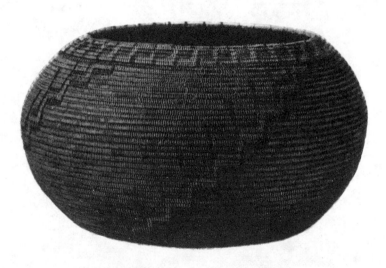

Plate 187. See page 413

TULARE COILED JAR

Compared with an old and precious mission basket with key-pattern border and stepped designs

Collected by Stephen Powers and Gavin and Leonard

history of this basket. It is pronounced to be the Fresno type of Yokut basket. It is an intrusive form among the Owens Valley Paiutes, captured by them on a raid into the interior side of the Sierras a long time ago. Its height is 7¾ inches, and diameter 15 inches.

Plate 186, one of the interesting specimens in Mr. Wilcomb's collection, is an Inyo basket, made in Inyo County by a Tulare squaw. It is 13 inches in diameter. The ornamentation outside the plain centre is radial in two bands of stepped patterns, the inner band of six, the outer of thirteen. Each one of the latter having five parallel elements, there are with the interspaces seventy-eight elementary stepped designs in the band. The border is the oft recurring bunch of coloured stitches in groups.

Plate 187 represents baskets in the collections of Stephen Powers and Miss E. F. Hubby. The upper one is Tulare, and an examination shows the difference between the open and rather coarse texture of the Tulare basket and the very much more refined type of the Santa Ynez basket below. Besides the faultless sewing and the truly charming design, another characteristic worthy of observation is the use the weaver has made of small differences of shade in the splints for sewing, giving a clouded effect to the surface.

From the Tule River country, says E. L. McLeod, we have the fine flexible work, an improvement on their more northern sisters in Fresno. But the women of the Tejon and adjacent mountain tribes certainly excelled in their basketwork. Their choice ware is much more beautifully finished, their patterns much more numerous, and here is where they show the influence of both north and south in the number and diversity of their patterns; also in the trading of materials. Old baskets have been taken from the caves where the bottom was Mission and the top beautiful, fine Tejon; also examples brought from caves in Santa Barbara County that were made over in the Tejon, as the stitch, texture, and all general

appearance go to show that they were carried about by the Indians with them.

An excellent example of moving about of basketmakers is given by McLeod. A woman was born at San Gabriel Mission, where she was baptised as Maria Narcissa, and is now about seventy years old. She was brought to the Tejon Canyon while a young child about nine years old, and she still remembers much of the language and customs of her native people. Her uncle Sabastian was General Fremont's guide into the San Joaquin Valley through the Tejon Pass. Maria Narcissa not only learned the language of her adopted people, but many of the dialects of the surrounding tribes. Between forty and fifty years ago she was taken as wife by a young American of English-German parentage. They were the parents of a large family of children, and gave them all as good an education as possible, especially the eldest daughter.

She was not able to give much light on the general family relation. The tribes from the north as far up as Tule River used to come down to the Tejon for some purpose, either religious or social. She tells of gaming baskets and great feasts and dances, where they used to play games of chance. But by far the longest travel was from San Fernando, San Gabriel, Ventura, Santa Barbara, and Santa Ynez. Many came thence every year to the Tejon, and unquestionable evidence in the meeting of all these streams exists in their basketwork.

In a translation from Costans (1769)* occurs this account of the Santa Barbara basketmakers:

These are [the Indian women] who make the trays and vases of rushes, to which they give a thousand different forms and graceful patterns, according to the uses to which they are destined, whether it be for eating, drinking, guarding their seeds, or other ends, for these people do not know the use of earthenware as those of San Diego use it. . . .

The large vessels, which hold water, are of a very strong weave

* Land of Sunshine, XV, 1901, p. 39.

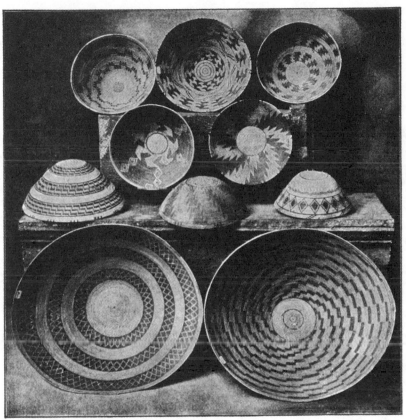

Plate 188. See page 415

COILED BASKETS OF KERN AND TULARE COUNTIES, CAL.,
FOR STUDY IN DESIGNS

Collection of E. L. McLeod

1 2 3
4 5
6 7 8
9 10

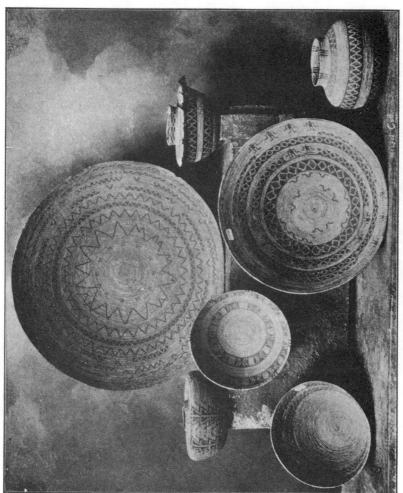

Plate 189.　See page 416　Coiled Baskets from Tulare Co., Cal.,
Showing Characteristic Patterns

Collection of E. L. McLeod

1
2　3　4
5　6　7

of rushes [junco], pitched within, and they give them the same form as our tinigas [water jars].

Plates 188 to 195 are taken from baskets in the McLeod collection, and cover the subjects of form and design in the Inyo-Kern and Tulare-Fresno area. They furnish an excellent opportunity of seeing how far a few simple geometric elements combine in kaleidoscopic effects in the hands of the skilful Indian woman. Some of these specimens are of exceeding delicacy, and it is a matter of wonder how so many little stems of uniform diameter could be gathered together. Gauges are out of the question.

Plate 188, fig. 1, crenelated and chevroned designs; colour, cream, black, and red; diameter, 12 inches; depth, 9 inches.

Fig. 2 is a very different pattern, resembling a pine tree; colour, two shades of brown, black, and cream; diameter, 13 inches; depth, 10 inches.

Fig. 3, diameter, 11½ inches; depth, 8½ inches; 24 stitches to the inch; very rich shades of brown, mottled, cream, and black. Pattern very peculiar; so flexible that it has been bent together; a most beautiful specimen.

Fig. 4, diameter, 11¼ inches; depth, 7¼ inches; 15 stitches to the inch; body, brown; design, black and cream; very rare.

Fig. 5, diameter, 11½ inches; depth, 7 inches; 22 stitches to the inch; colour, red, black, and cream.

Fig. 6, diameter, 13½ inches; depth, 9½ inches; 24 stitches to the inch; colour, cream, and two shades of brown.

Fig. 7, diameter, 11½ inches; depth, 7½ inches; 18 stitches to the inch; colour, red, black, and cream; very old; used for cooking grubs.

Fig. 8, diameter, 10 inches; depth, 7 inches; 20 stitches to the inch; colour, black, brown, red, and cream.

Fig. 9, diameter, 21½ inches; depth, 15 inches; 12 stitches to the inch; colour, cream and brown. Very effective; splints even, well made, but not closely woven; the spirals are built up by elongating the little rectangles.

Plate 189, Tulare baskets, fig. 1, diameter, 22 inches; depth, 13 inches; 30 stitches to the inch; wood mottled, dark and light brown, and red. One of the very old style of flexible gambling baskets. It would be possible to bend it together. The variety of effects here shown by the mere use of the broken line must be noted.

Fig. 2, bottle, diameter, 8½ inches; depth, 3¾ inches; diameter of neck, 2¾ inches; 17 stitches to the inch; colour, black and red; wood dark with age.

Fig. 3, diameter, 9 inches; depth, 5½ inches; 22 stitches to the inch; colour, brown, red, and white.

Fig. 4, diameter, 8 inches; depth, 4½ inches; neck, 3¾ inches; 22 stitches to the inch; colour, cream, red, and brown. Red wool and quail plumes.

Fig. 5, diameter, 9 inches; depth, 6 inches; 14 stitches to the inch; colour, black and natural wood; very old. The white woman from whom Mr. McLeod purchased this basket had owned it for fifty years.

Fig. 6, diameter, 15 inches; depth, 9 inches; 14 stitches to the inch; colour, brown, red, and mottled wood.

Fig. 7, diameter, 8 inches; depth, 8 inches; 22 stitches to the inch.

Plate 190, group of baskets from Tejon, Kern County. Fig. 1, diameter, 13 inches; depth, 7½ inches; 18 stitches to the inch; colour, cream, black, red, and brown.

Fig. 2, mortar basket; diameter, 17 inches; depth, 8 inches; colour, cream.

Fig. 3, diameter, 12½ inches; depth, 7 inches; 24 stitches to the inch; colour, black, brown, red, and cream; very old and fine specimen.

Fig. 4, diameter, 7 inches; depth, 3¾ inches; 20 stitches to the inch; colour, black, brown, cream, and with spots of yellowhammer quill.

Fig. 5, diameter, 4½ inches; depth, 3½ inches; 30 stitches

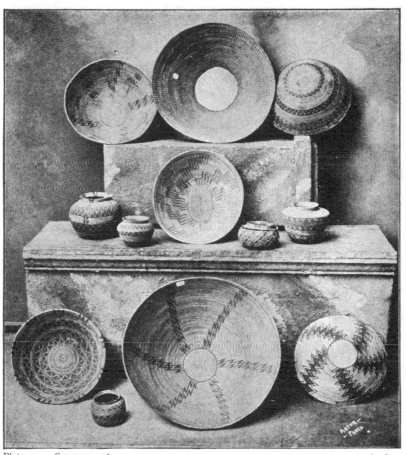

Plate 190. See page 416

GROUP OF COILED BASKETS, CHIEFLY TEJON,
KERN COUNTY, CAL.

Collection of E L. McLeod

1	2	3		
4	5	6	7	8
9	10	11	12	

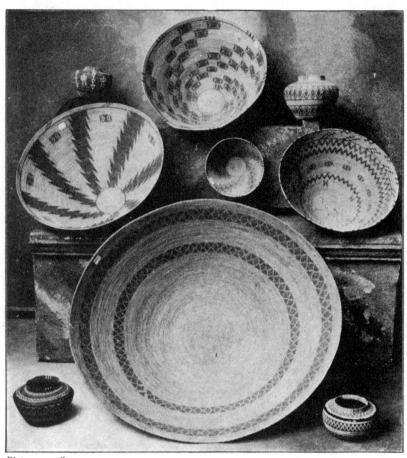

Plate 191. See page 417

COILED BASKETS, KERN AND TULARE TYPES,
CALIFORNIA

Collection of E. L. McLeod

1 2 3
4 5 6
7 8 9

to the inch; colour, cream and brown; very old and most beautifully made.

Fig. 6, oblong; length, 13 inches; width, 12 inches; depth, 6 inches; 18 stitches to the inch; colour, brown and cream. A very peculiar basket, as the pattern is so allied to those of Arizona and New Mexico.

Fig. 7, diameter, 5 inches; height, 3 inches; 24 stitches to the inch; colour, dark wood, cream, brown, and white, with dots and rim of red wool. This was a birth-gift basket, being presented filled with silver coins to an Indian woman, from whom it was purchased at the birth of one of her daughters, who is now forty years old. The giver was Sabastian, General Fremont's guide.

Fig. 8, diameter, 6½ inches; height, 5¼ inches; 21 stitches to the inch; colour, black and cream; very old.

Fig. 9, diameter, 12 inches; circumference, 38 inches; depth, 7½ inches; 15 stitches to the inch; colour, black, brown, cream, and mottled wood.

Fig. 10, oblong; length, 4 inches; width, 3 inches; height, 3 inches; 22 stitches to the inch; colour, cream and brown.

Fig. 11, diameter, 20 inches; depth, 12 inches; 24 stitches to the inch; colour, cream; pattern, black.

Plate 191, baskets from Kern and Tulare counties. Fig. 1, Kern County; diameter, 18 inches; depth, 12 inches; 17 stitches to the inch; colour, cream, brown, and red. A very dark basket. The vertical row of triangles and the human figures must be observed.

Fig. 2, diameter, 8½ inches; depth, 6 inches; diameter of neck, 3¾ inches; 22 stitches to the inch; very fine in weave, shape, and finish; colour, rich cream, black, and red; very old; made at Tejon.

Fig. 3, diameter, 6 inches; depth, 4½ inches; neck diameter, 2¼ inches; 17 stitches to the inch; made at Tejon. Top is brown; bottom and patterns are white with black markings. This design is the "Sachem dancing about the funeral

baskets." Such examples are strung on poles erected at their burial places.

Fig. 4, diameter, 15½ inches; depth, 9 inches; 18 stitches to the inch; colour, cream and three shades of brown.

Fig. 5, Kern County squaw cap; diameter, 8 inches; depth, 5 inches; 26 stitches to the inch; colour, cream, black, and red.

Fig. 6, Kern County basket; diameter, 20 inches; depth, 12½ inches; colour, cream, brown, red, and black.

Fig. 7, Tulare basket; diameter, 30 inches; depth, 17 inches; 14 stitches to the inch; colour, dark wood, red, and black. Braided edge; very beautifully woven and finished. The thread is regular but wide. The squaw was one year in making it.

Fig. 8, diameter, 7¾ inches; depth, 5 inches; diameter of neck, 4 inches; 20 stitches to the inch; made in Kern County; colours, body in brown; pattern, in black and white.

Fig. 9, Tulare basket; diameter, 7 inches; depth, 4 inches; 30 stitches to the inch; colour, wood, black, red, white, dark brown, and red wool; a beauty.

Plate 192, group of baskets from South Fork Caliente Creek and Paiute Mountain (McLeod's Plate 11).

Basket No. 1, diameter, 24 inches; depth, 15½ inches; stitches, 14; colours, cream, black, red, brown. The noteworthy features are the simple, undecorated crenelations. Compare fig. 9.

No. 2, diameter, 21 inches; depth, 15½ inches; stitches, 17; colour, body, mottled wood shades; pattern, cream, black, and dark red. This is a very choice specimen. The design is one that they use when they make a basket for a special friendship gift, and is highly prized. The owner was five years in getting the squaw to part with this basket.

No. 3, described on another plate.

No. 4, diameter, 18 inches; depth, 13½ inches; stitches, 17; colour, body, wood shades; pattern, cream, black, red; a very beautiful basket.

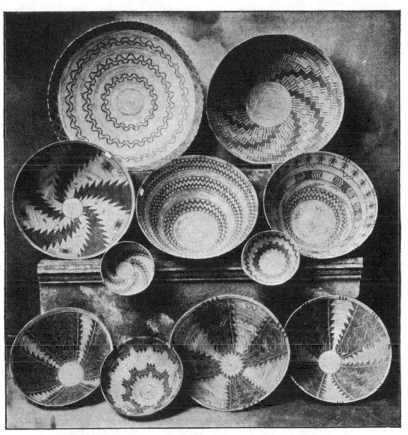

Plate 192. See page 418

COILED BASKETS FROM CALIENTO CREEK AND PAIUTE
MOUNTAIN, CAL. BOTTOM ROW CHIEFLY
PANAMINT SHOSHONEAN

Collection of E. L. McLeod

1 2
3 4 5
 6 7
8 9 10 11

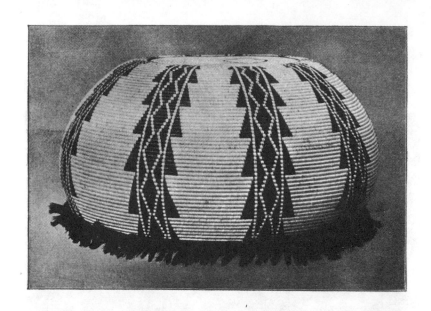

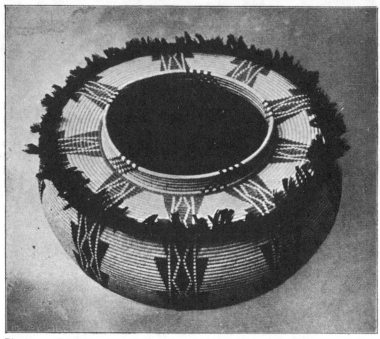

Plate 193. See page 419

BOTTLE-NECK COILED BOWL, TRIMMED WITH FEATHERS,
KERN COUNTY, CAL.

No. 5, described on another plate.

No. 6, diameter, 7½ inches; depth, 6½ inches; stitches, 19; colour, cream, red, and black; a very fine squaw cap.

No. 7, diameter, 8 inches; depth, 6 inches; stitches, 17; colour, cream, black, and brown.

No. 8, diameter, 15½ inches; depth, 11½ inches; stitches, 14; colour, cream, red, and an unusual amount of black. This design, with some, is the tail of the rattlesnake, and with others the arrowhead. The administration of radial patterns is a striking feature in this plate. The forms of the radii, but chiefly the varied markings on them, are most effective.

No. 9, described on another plate.

No. 10, diameter, 11½ inches; depth, 9 inches; stitches, 22; colour, black, brown, and cream, with yellow-hammer quills; a very odd shape and good pattern.

No. 11, diameter, 15 inches; depth, 11 inches; stitches, 15; colour, rich red, brown, black, and cream. A very striking example and unusual for so much dark colour.

Plate 193 is a fine coiled basket of the Kern County Indians, who belong to the Shoshonean family. It was made in Canebrake Canyon by the last old basketmaker of the tribe, who was swept away in a flood in August, 1901. The decorative patterns are ideal. Nine vertical stripes in black and red, with stepped borders and diamond figures on the interior, rise from the plain bottom and extend to the lower edge of the rim. The latter has its own fine-checkered, sloping designs, with no relation to the decoration on the body. Circumference, 29 inches; diameter, 9 inches; height, 5 inches; stitches to the inch, 32; colours, red, black, and cream. A design of quail plumes is shown on the border.

Plate 194 is a coiled bottle-neck from Canebrake Canyon, Kern River, Kern County. Diameter, 9 inches; height, 6 inches; stitches to the inch, 24; colour, cream, black, and brown. This and Plate 193 were both made by the same squaw, who was supposed to be about eighty-five years of age,

and was the last really good weaver in Kern County. The ornamentation on this basket consists in a band of dentate figures on the bottom and three bands of crenelated ornament on the body and top. The dentate figures also occur on the outer projection of the crenelles on the body. Dr. Merriam has found this pattern symbolising the spasmodic flight of a butterfly. Below the border of the lower band are rhombs in pairs, and there are five checker oblique patterns about the rim.

Plate 195, McLeod collection, is a Kern County basket from Paiute Mountain, called by him the apostolic basket, from the human figures on the top. Diameter, 15 inches; height, 12 inches; stitches to the inch, 28; colours, red, brown, black, and cream. The owner speaks of this as the most beautiful specimen in his collection. The woman was three years at work on it, and it is at least sixty years old. The ornamentation consists of discrete figures of five rectangles, thirteen men on the upper part, but chiefly of seven radial patterns ascending to the mouth. Each is made up of a continuous series of rectangular figures touching and by echelon. This pattern will be seen frequently, and the specimen may be taken as a type of that particular design.

Fig. 172 is a grasshopper basket of the Wikchumni Indians (Mariposan family), in a style of technic which may be called interrupted coiled work. The foundation is a small bundle of stems or shreds. The sewing consists in wrapping the foundation from five to ten times with the splint, and then catching this under one or two turns of the coil below in the form of stitches, the only bond which holds the fabric together being these few stitches. Another example of this sort of interrupted work in North America is shown in Plate 126, illustrating basketry from the Eskimo of Hudson Bay.

The existence of this type of basketry in a restricted area among the Mariposan family raises interesting questions about the cause of its occurrence here. The ornamentation consists

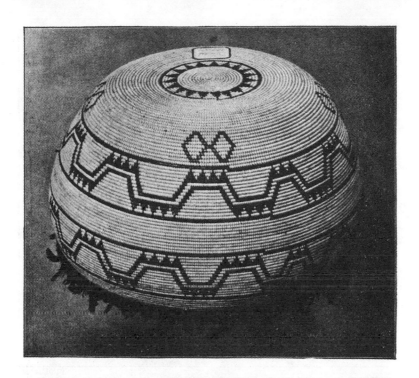

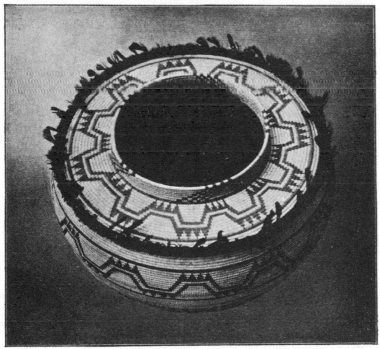

Plate 194. See page 419
BOTTLE-NECK COILED BOWL, WITH BUTTERFLY FLIGHT DESIGN,
KERN COUNTY, CAL.

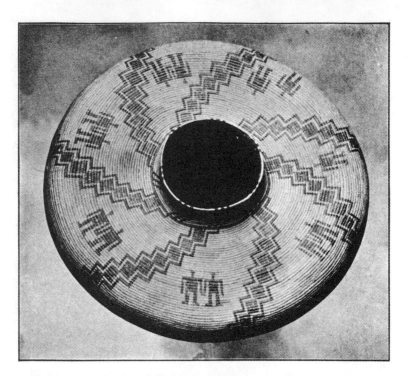

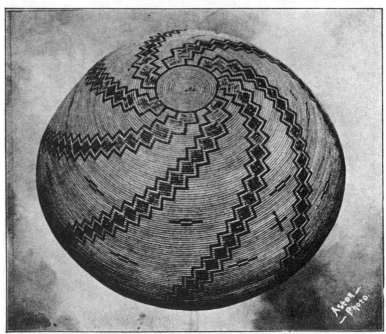

Plate 195. See page 420

APOSTLE BASKET, FLAT TOP BOTTLE-NECK, KERN COUNTY, CAL.

Collection of E. L. McLeod

in rows, hour-glass patterns, and figures resembling the letters of the alphabet, done in brown material, like cercis or fern stems.

The detail of this interrupted work is well shown in fig. 173, where the wrapping is plainly illustrated, and also the methods of joining. By bring-ing the stitches one over another, geomet-rical p a t t e r n s are produced. A s t h e w o r k widens, new rows are introduced, as will be seen in the principal figure.

T h i s specimen, C a t a l o g u e N o. 215,586 in the United States National Mu-seum, is a gift from C. P. Wilcomb, of California.

Mr. McLeod, who has the largest collec-tion of the grasshop-per baskets, says of them that they have

FIG. 172.
GRASSHOPPER BASKET.
Wikchumi Indians, California.
Cat. No. 215,586, U.S.N.M.

no such function. They are all made by two families, the Butterbread and the Williams, living in Kelsey Canyon, Kern County, California. The sewing and wrapping are faultless. The ornamentation is chiefly in plain lines and rectangles. On one of them, fig. 10, the chevroned design is attempted with doubtful success, but figs. 2 and 3 have the stepped radial patterns well carried out, and on fig. 9 the human conventional figure is cleverly executed. (See Plate 196.)

Mission Indian basketmakers belong to the Shoshonean

and Yuman families. They receive their several names from
the Franciscan missions of southern California, into which they
were gathered, and where their tribal identity was lost. In
the present state of knowledge it is not possible to distinguish
the linguistic family of each by the shape, technic, or designs
of basketry. In Powell's Indian linguistic families the Yuman
tribes include the Coconino or Havasupai, Cocopas, Yuman
proper, Diegueños, Maricopas, Mohave, Seri, Guaicum, and

Walapai. These tribes occu-
pied the peninsula of lower
California, and are also mixed
with other tribes in southern
California, and across the
Colorado into Mexico and
southward into Mexico.

The material of Mission
Indian baskets differs accord-
ing to locality. A rush, prob-
ably several species, is used
for the s e w i n g . The best

FIG. 173.
DETAIL OF FIG. 172.

known to Mr. Coville is *Juncus lesnerii*, the Techahet
Indians using it almost exclusively. This plant is collected
and dried, and what are often thought to be brushes
by strangers are merely bunches of this rush prepared for
the weaver's use. A tall, thin grass, *Vilfa rigens*, is used
as the body of the coil, about which pieces of the *Juncus* are
wound. Such of the latter as are intended for ornamentation
are dyed black by steeping in water with portions of *Sueda
diffusa;* and a rich yellowish brown is produced in a like man-
ner from the plants *Dalea emoryi* and *Dalea polyadenia*. The
bottoms of large baskets are often strengthened by the intro-
duction of twigs of *Rhus aromatica* or three-leaf sumac. Dr.
Merriam finds that latterly the leaf of a palm (*Neowashing-
tonia filamentosa*) is used for sewing. The work resembles
that done in raffia.

In beginning a basket, a central foundation is made and the rush wound about it and coiled, fastened by fibers passing through holes made for the purpose with a pointed bone or metal awl. This is the commonest method employed.

To assist the student in understanding the relationship of arts in southern California, the following account of tribes from Dr. Barrows will be helpful. The Indian tribes south of Santa Inez Mountains on the coast and San Joaquin Valley in the interior fall into three divisions: (1) Tribes of Santa Barbara channels and islands covering the coast of Ventura County; (2) Serraños; (3) Coahuillas.

The Serraños live on a small reservation at San Bernardino and on the Morongo Reservation in the San Gorgonio pass in southern California. They are called Takhtam by Loew.

The Coahuillas live in the Colorado Desert and the San Jacinto Mountains. The word is also spelled Kauvuyah by Gatschet after Loew. Dr. Barrows thinks this to be only the German spelling for Coahuilla (pronounced Kau-vü-yah).

With them he joins by speech the Indians of the missions northward, making a Coahuillian linguistic family; perhaps it were better a subfamily.

Coahuillian subfamily

1. Coahuillas. Colorado Desert and San Jacinto Mountains.
2. Gaitchim. Oscar Loew's name for Netela.
3. Kechi. Missions of San Luis Rey.
4. Kizh. San Gabriel Mission.
5. Luiseños. (*See* Kechi.)
6. San Fernando Mission.
7. Serraños.
8. Takhtam or Takhtem, Loew's name for Serraños.
9. Temeculas. At Pechanga, eight miles north from Luiseños.
10. Tobikhar. Loew's name for Kizh.

Barrows narrates that the Coahuilla basketry and that of the Diegueños as well as Luiseños is of the one California type, namely, coiled ware, and fragments of similar technic have

been found by Schumacher in the graves of the Santa Barbara channel. He quotes Humboldt to the effect that the Indians presented the Spaniards "with vases curiously wrought of stalks of rushes and covered with a very thin layer of asphaltum that renders them impenetrable to water." Lumps of the material are said to have been put into the basket with hot stones and shaken with a rotary motion to distribute it. The foundation of the coil is a bunch of grass, su-ul (*Vilfa rigens*); the sewing - material varies according to the colour desired. The three-leaf sumac (*Rhus trilobata*) gives a light straw colour; these are dyed black in a wash made from the berry stain of the elder, hun kwat (*Sambucus*). The other sewing-material is a bulrush or reed grass (*Juncus lesnerii*, or *Juncus robustus*). The scape and leaves are 2 to 4 feet high or more, stout, and pungent. A supply of these is gathered by the basketmaker and cut into suitable lengths. The woman then with her hands and teeth splits the scape carefully into three equal portions. Near its base the rush is of a deep red, lightening in colour upward, passing through several shades of light brown, and ending at the top in a brownish yellow. For dyeing black, ngaial (*Sueda diffusa*) is also employed, and Dr. Palmer also mentions a dahlia (D. *polyadenia*) as furnishing a yellowish-brown dye.

The Techahet use the reed grass (*Juncus robustus*) or the *Rhus trilobata*, and the tall, thin grass (*Vilfa rigens*) in a dried state for making basketry, the first two for binding material, the latter for the body. The reed grass is split and some of it dyed, usually brown. The basket is begun at the center of the bottom, the thickness of the coil of grass depending upon the size of the basket to be made. A bone pricker is used. The coil is begun by laying one end of the filament upon the bunch of grass and taking a few wraps about it to hold it down. This is bent double, and the sewing progresses by catching the filament over the bunch of grass through the coil of the sewing filament made at the last turn.

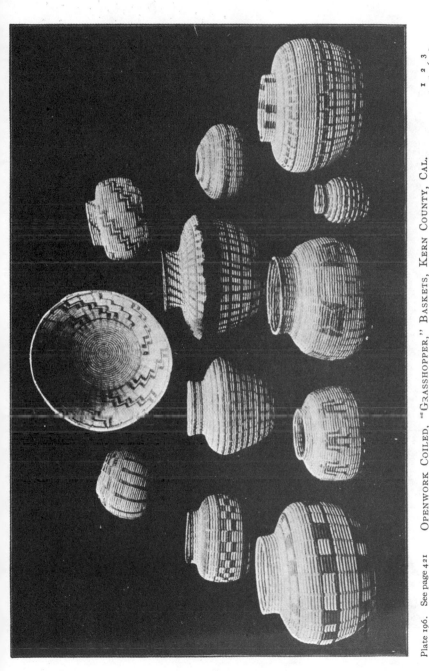

Plate 196. See page 421 OPENWORK COILED, "GRASSHOPPER," BASKETS, KERN COUNTY, CAL.

Collection of E. L. McLeod

1 2 3
4 5 6 7
8 9 10 11 12

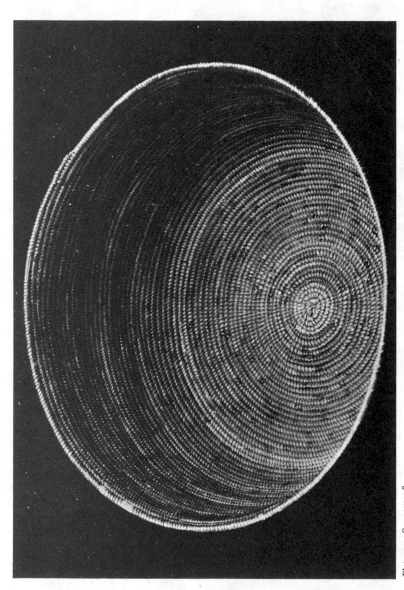

Plate 197. See page 428

MISSION INDIAN COILED BOWL, SHOWING CHARMING SHADES OF THE MATERIAL.

Collected by Horatio N. Rust

Basket-making among the Coahuillas belongs to the old women. They sit flat on the ground, with the feet thrust out in front. The deft artist holds her work in her lap; at her right lies the grass for the foundation; on her left, soaking in a pot of water, her variously coloured splints. Her only tool is her awl, "wish," anciently of bone; or a cactus spine set in a piece of asphaltum; but now a nail serves the purpose, one end pointed, the other in a handle of manzanita wood. The sewing-materials are named according to colours —the scapes of *juncas* se il; the red portion, i i ul; dyed black they are se-il-tu-iksh. Splints from sumac are se-lit, and the grass of the foundation su-ul. No model or pattern is ever used. The border is finished by simply cutting the sewing-material close on the inner side. The most common form, se-whal-lal, of the Coahuilla basket has a flat bottom and gently flaring sides, a depth of from 4 to 7 inches, and a width of from 13 to 20 inches. These are for holding foods, including seeds, grains, and fruits, household utensils, and basket materials. Small, globular baskets, with bulging sides and rather wide mouths, 5 to 10 inches in diameter, are called te-vin-ze-mal. They are the prettiest and the most carefully ornamented, and are used to hold trinkets and sewing-materials. The deep packing baskets, se-kwa-vel-em, are about eighteen inches deep and are used for carrying loads. Rawhide strings, ka wi ve, are tied to the opposite edges to pass around the forehead, but usually the basket is sustained in a net. They are used not only for food gathering, but on the threshing floor for storing foods. The chi-pat-mal is a round, almost flat basket, 16 to 18 inches in diameter and one or more inches deep, used for harvesting. The woman beats it full of grass seeds or fills it with elder berries or cactus fruit, and transfers the contents to the packing basket on her back. It makes a good tray, platter, fruit dish, or receptacle for meal, and is exclusively the winnower.

The basket hat, yu-ma-wal, shaped like a truncated cone,

is worn by women especially to protect the head from the carrying band. It serves also for a water dipper or mixing pan. The chi-pa-cha-kish, holding about two quarts, is an openwork basket of network, made from the unsplit, flattened scapes of the se-il, or Juncus. They are often provided with a bail, and hung up in the house or ramada to hold fruit or vegetables.*

Fig. 174 is a coiled basket of the Coahuilla (Shoshonean family). The foundation coil is of stems of grass; the sewing is in

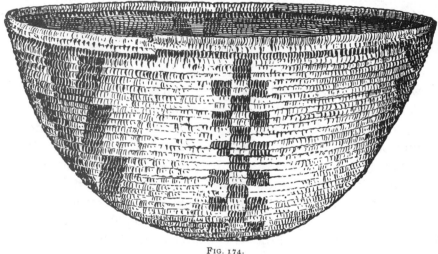

FIG. 174.
COILED BOWL.
Coahuilla Indians, California.
Cat. No. 21,787, U.S.N.M. Collected by Edward Palmer.

splints of sumac (*Rhus trilobata*). The ornamentation is in stems of rush dyed black with sea-blite (*Dondia suffrutescens*).

No special study has been made of the meaning in the designs upon the Coahuilla basketry. It is impossible, therefore, to guess what the combinations of parallelograms may mean. From the point of view of elementary forms in design, it is interesting to note what diversities of effects may be pro-

* David Prescott Barrows, The Ethno-Botany of the Coahuilla Indians of Southern California, Chicago, 1900. Chapter IV (quoting Paul Schumacher, Humboldt, Hugo Reid, and Edward Palmer).

duced by variations in the form and composition of simple geometric patterns. Five of the figures on the example here shown are built up of rhomboidal elements, and a single one is the composition of rectangles in quincunxes.

Fig. 175 is a view of the inside of the bowl, showing the ornamentation. A square inch of coil foundation, made up of straws or small filaments, is shown in fig. 176. This speci-

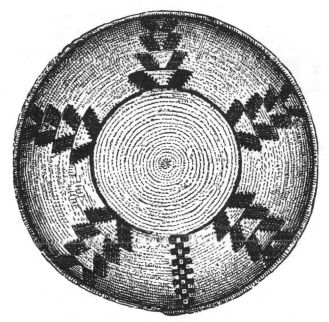

FIG. 175
INSIDE VIEW OF FIG. 174.

men, Catalogue No. 21,787 in the United States National Museum, was procured in southern California by Edward Palmer.

Fig. 177 is an inside view of another specimen from the Coahuilla, made of the same material. It is possible that some of the specimens from this tribe are sewed with splints of willow. It is difficult in the dried form to distinguish the two materials. The pretty, attractive design on this speci-

men is simplicity itself. Small triangles are arranged in two rows, half of them joining outward and the other half inward from the base, forming a continuous circle. One row is so suggested with reference to the other that the white space between forms a continuous chevron. It is a little difficult to say whether the whole meaning of such a result from simple processes was in the mind of the basketmaker. While not wishing to deprive her of all the credit due to her for this

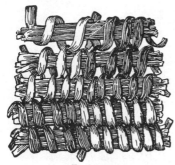

FIG. 176.
SQUARE INCH OF FIG. 174.

beautiful work, one can scarcely refrain from thinking that the total effect was not comprehended by the artist.

This specimen, Catalogue No. 21,786 in the United States National Museum, was collected in southern California by Edward Palmer.

Plate 197 is a plain Mission bowl in the Rust collection, United States National Museum. Its shape, foundation, and sewing are all typical. The general shading and the spots on the surface were achieved by using different parts of the straw.

Plate 198, of the same collection, also illustrates typical Mission ware. The designs are not exclusively of the region. In the right-hand pile several colours are introduced, and they are instructive as showing the artist's struggles to unite natural shades in the material with geometric designs in coiled textile. The top basket in this row is made of desert palm (*Neowashingtonia filamentosa*), described first by C. Hart Merriam (p. 405), and the sewing is in highly coloured materials. Palmer long ago told us that the Coahuilla Indians used sea-blite and Parosela in dyeing the rushes used in basketry. It is just possible that those who are looking for materials for basket-making may find the desert palm serviceable.

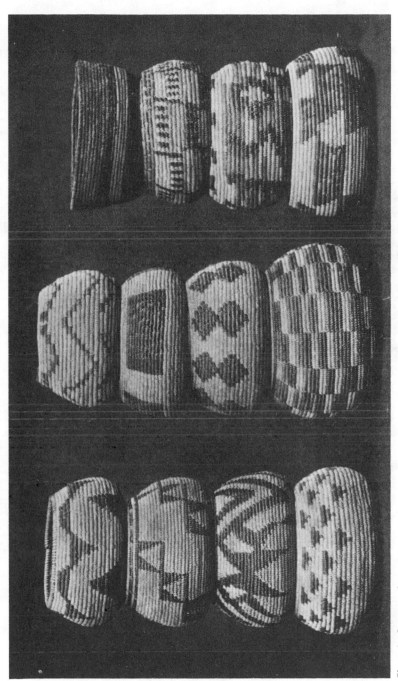

Plate 198. See page 428

Mission Indian Designs on Basketry, Original and Borrowed

Collected by Horatio N. Rust

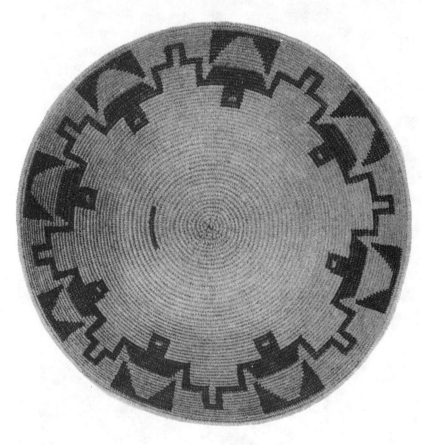

Plate 199. See page 429

MISSION INDIAN COILED BOWL

Designs dyed with sea-blite and in natural colours. The stripe near the middle said to be the owner's mark

Collection of George Wharton James

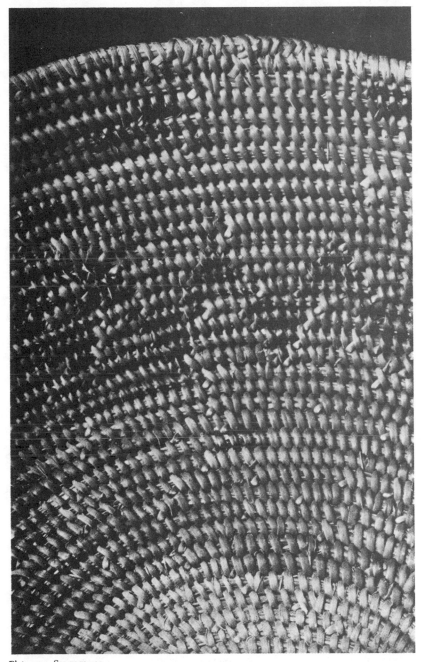

Plate 200. See page 429

DETAIL OF MISSION INDIAN COILED BOWL, COILING, DECORATING, BORDERING,
AND FASTENING OFF

Detail of Plate 197

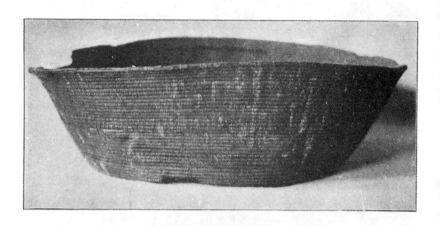

Plate 201. See page 429
ANCIENT COILED BOWLS, FROM SAN MARTIN MOUNTAIN, CAL., IN
PEABODY MUSEUM

Photographed by C. C. Willoughby

Plate 199 is a coiled bowl made by the Mission Indians of California, illustrating the technic with splint foundation. The sewing of the Mission baskets is sometimes in bulrush and at others in splints. The dark mark near the center is said to be the signature of the maker. The colours in the orna-

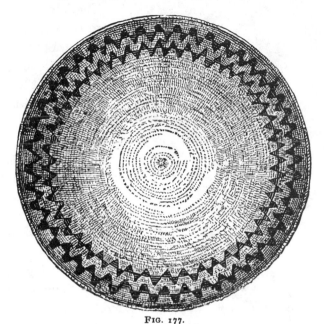

FIG. 177.
COILED BOWL.
Coahuilla Indians, California.
Cat. No. 21,786, U.S.N.M. Collected by Edward Palmer.

ment around the border are produced by sewing dyed or natural material of different shades.

Plate 200 is introduced to make plain the intimate struc-ture of this species of coiling with short stems of soft rushes over grass foundation. The methods of inserting figures, bordering, and fastening off are evident in the illustration.

Plate 201, from photographs by C. C. Willoughby, presents two very ancient tray-shaped baskets or plaques from the cave in San Martin Mountains, Los Angeles County, California, which were collected by Stephen Bowers. The Catalogue No.

is 39,245, in the Peabody Museum, Cambridge, Massachusetts. (See also Plate 202.)

The upper figure is a fine old example of coiled weaving in the three-rod type, the stitch interlocking with the upper element.

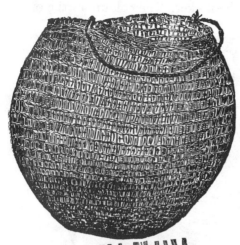

The lower figure is an example of the same kind of coiling, but the surface has been covered with asphalt, so that the texture is almost totally obliterated.

Twined weaving is not so common as coiled work in southern California. One could scarcely conceive a more primitive specimen, however, than is shown in fig. 178, from the Diegueños Indians (Yuman family) living about San Diego, California. The specimen is a basket for cactus fruit. The warp is gathered singly or in

FIG. 178.
TWINED BASKET.
Diegueños Indians.
Cat. No. 19,742, U.S.N.M. Collected by
Edward Palmer.

pairs in the twists of the weft. Old specimens of twined weaving from the region, on the contrary, are finely wrought.

Plate 203 represents a sack in twined weaving, collected at Mesa Grande, on the Mission Indian Reservation, in southern California, by Mrs. Watkins, the Government teacher there, and sent to the National Museum by Miss Constance Goddard DuBois. The dark threads are said by Mrs. Watkins to be made from the inner bark of *Asclepias vestita,* and the lighter threads, in which the decorative bands are worked, from

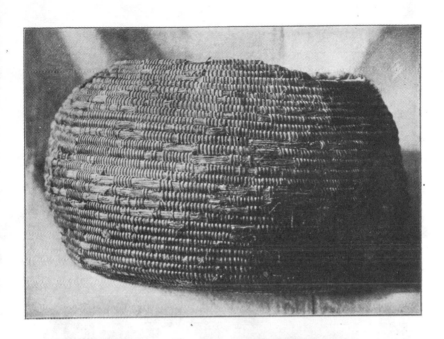

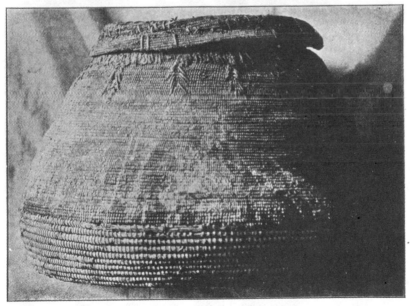

Plate 202. See page 430

ANCIENT COILED BASKETS, FROM SAN MARTIN MOUNTAIN, CAL., IN PEABODY
MUSEUM

Photographed by C. C. Willoughby

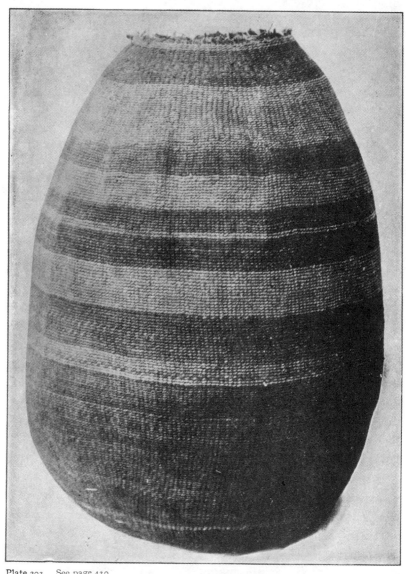

Plate 203. See page 430

RARE OLD TWINED SACK, MESA GRANDE MISSION, CAL.

Collections of U. S. National Museum

Asclepias ascicularis. It is a very ancient piece, the only one that had been seen in those parts. Narciso Lachapa, whose father owned it, says it was old when he was a boy.

The majority of baskets from the Mission region are in coiled weaving. A few examples of twined weaving from this area have been seen in collections, but none equalling this in size and beauty. Its height is 29 inches. Miss DuBois adds that the Mission Indians in the more remote regions wear basket hats, most of them in twined weaving, and others of an older type in coiled stitch. There is an old tale that "two sisters went on the mountain and found little sticks which they wove into baby baskets. They put the babies in and made pillows for their heads. Then the elder sister, who was a witch doctor, held up her hand to the North and received a roughly made basket, which she put on the elder baby's head. Then she held up her hand to the South and received a fine basket, which she put upon the younger baby's head."

THE INTERIOR BASIN REGION

Not the hands, but reason, teaches mankind arts; but the hands are the instruments of arts, as the lyre is of the musician and the forceps are of the mechanic.—GALEN.

Leaving now the Pacific slope, we may examine the basketry of the Great Interior Basin, bounded on the east by the Siouan, Kiowan, and Caddoan families beyond the Rocky Mountains. The Siouan tribes, together with the western Algonquian and other tribes wedged in among them, borrow coiled gambling baskets and substitute the convenient buffalo hide for textiles; but the Caddoan (see figs. 124 and 125) were excellent workers in twilled weaving.

On the north, this basketry area merges into the Fraser-Columbian group, Salishan and Shahaptian tribes chiefly, who are especially skilful in twined work of peculiar types. The soft hat in wrapped twined work, and almost all of the twined wallet overlaid, predominate with the Shahaptian, but the Salish have a wide range of technic.

On the west there is no sharp boundary line, as will be soon shown, the Interior Basin region and the Oregon-California fitting into and invading each other as shore and water line on an irregular coast. This will be especially noticeable with coiled work, the three-rod foundation of California being adopted by some Ute tribes.

The same is true of the southern boundary, the linguistic families dovetailing into those of Mexico. The Apache cross the boundary southward, the Yuman and Piman tribes also reaching northward and excelling in coiled ware with fine grass foundation.

The tribal or ethnic groups in this area are chiefly the Shoshonean and the Athapascan. The first named is a vast linguistic family reaching from near the forty-ninth parallel to Costa Rica; the latter, quite as widespread, extending between 30° and 70° north. Care must again be taken to separate the classific concept of language from that of blood kinship or of arts. Where people live contiguous and have the same speech, their blood becomes mingled as a matter of course. Arts will also be communicated. Especially is this true of the one here considered, being a woman's craft. The Athapascan occupies the southern portion of the Basin, and the Pueblos are most of them in northern Arizona and New Mexico.

SHOSHONEAN AND PUEBLO BASKETRY

By far the largest part of the Interior Basin is Shoshonean. The tribes also spread out far to the north in the drainage of the Snake River; have pushed themselves across the Rocky Mountains on the southeast into the drainage of the Gulf of Mexico, and on the western side occupied a large part of southern California, as was shown. The basket-making tribes are the Shoshoni in Idaho; the Ute, with many subdivisions, in Colorado and Utah; the Paiute in western Nevada and California adjoining. As before intimated, both exclusions and inclusions of the term are undefined.

This great stock of Indians employs both structures, the woven and the coiled. The twined weave of all kinds is used in conoidal basket hats, baskets, jars and bottles, roasting trays, and wands. The coiled and whipped structure is used in pitched water bottles, trays, and bowls. The hat is a conical basket made of splints, the warp radiating from the apex, the woof splints being carried around and twined in pairs, generally in diagonal weave. The woof is not so thoroughly driven home as in softer and more pliant material, but remains open so as to have the appearance of the osier weaving of the East. Simple ornamentation is produced by using one or more rows of red or black splints in elementary geometric patterns.

Roasting trays are shaped like a scoop rimmed with a large twig. The warp is made of parallel twigs laid close together and held in place by diagonal twining. The Shoshonean tribes place seeds of wild plants, with hot stones, in these trays, and thus roast them. Some specimens are much charred on the upper side. (In the Ute country could be seen Indian women gathering seeds in conical baskets, beating the heads of the plants with a spoon-shaped wand toward the basket held in the left hand, with its mouth just under the plants.) These baskets are constructed in every respect like the conoidal hats, and the fans are made of twigs coarsely woven on the same pattern.

The water bottles of the Shoshonean tribes, on the other hand, belong to the coiled and whipped structure. As before mentioned, this style can be made coarse or fine, according to the material, the size of the coil, and of the outer thread. These bottles differ in shape—one class has round bottoms, another long, pointed bottoms; one has wide mouths, another small mouths; one class has a little osier handle on the side of the mouth, like a pitcher; but the majority have one or two loops of wood, horsehair, or osier fastened on one side for carrying. All of them are quite heavy, having been dipped in pitch. The same form is found among the Apache, the Hopi, and the

Rio Grande pueblos, but it is not improbable that they were obtained from the Ute. These bottle-shaped baskets are used for small granaries as well—to hold seeds and keep them away from vermin.

The basket trays of the Ute do not differ essentially in general style from those of the Gila River or California tribes, but they are much coarser. Among the coiled basket trays in the collection accredited to the Ute are indeed two styles, but one of them resembles so much those of their Apache neighbours

FIG. 179.
WOMAN'S HAT.
Ute Indians, Utah.
Cat. No. 11,838. Collected by J. W. Powell.

on the south as to raise the suspicion that they were obtained by barter.

The typical styles here mentioned, as well as interesting variations, will be best understood from examples.

The National Museum has a rare old collection of Ute or Shoshonean material, of which A. H. Thompson writes that of the baskets and other articles of Indian manufacture gathered by the Powell expeditions between 1870 and 1875, the greater part, probably nine-tenths, was secured from the Kaivavits at Kaibab and the Shivwits about St. George, southern Utah, and the Moapas about St. Thomas, southeastern Nevada.

These clans all belong to the Paiute nation. (The articles secured from the Ute were from the Gosiute about Deep Creek in western Utah and the Uinta Ute on the Uinta Reservation.) Much of the clothing (buckskin and rabbit fur) and many of the baskets were made by the Indians working under the direction, or rather observation, of Mrs. E. P. Thompson, the endeavour being to have the work done by the methods employed before the coming of the whites and by the older people of the clans.

FIG. 180.
HARVESTING FAN.
Paiute Indians, Utah.
Cat. No. 11,823, U.S.N.M. Collected by J. W. Powell.

Fig. 179 is a hat of a Ute Indian woman, in diagonal twined work. The warp stems converge at the top, and additional ones are added as the texture widens. The weft splints are twined so as to include the vertical warp twigs in pairs. On the next round the warp elements are again inclosed in pairs, but not in corresponding ones to those of the row underneath. The lines of the weft elements ascend diagonally, and a twilled effect is produced on the surface. This form of twining must not be confounded with three-ply twine around the border, which has a somewhat similar appearance, but is so close that the warp stems do not show. The border of this Ute basket is ingeniously made. First, the projecting warp elements are bent and whipped in place with splints, to form the body of the rim; on the top of this the weaver sews an ornamental false

braid, catching the splint into the bent warp stems underneath. The ornamentation on the outside is produced by three-strand monochrome or dichrome weaving. The Utes are skilful in various methods of technic, but the materials in which they work are coarse and rigid, giving a rough appearance to the surface. The hats are used also as receptacles, so that the terms top and bottom are only relative to function.

Fig. 180 is a harvesting fan of the Paiutes, made of small stems, split or whole, and bound together with various fibers,

FIG. 181.
HARVESTING FANS.
Paiute Indians, Utah.
Collected by J. W. Powell.

the manual portion being wrapped with softer material. This very coarse specimen is represented in other tribes, especially on the western side of the Sierras, by finely woven, spoon-shaped harvesting wands. It is Catalogue No. 11,823 in the United States National Museum, collected in Utah by J. W. Powell.

Fig. 181 is a pair of harvesting fans of the Paiute Indians in southern Utah. A bundle of rods is fastened together to form the grip of the fan; the other ends of these rods are then spread out, and afterward brought together to a point, at

the same time bent downward in spoon form for a warp. These are held in place by a continuous twined weaving backward and forward, the rows being at irregular intervals. Near the end, the points are held together by compact twined weaving. The border is made by coiled work built up on a pair of strong rods. These interesting objects are not confined, as will be seen, to the Ute Indians, but all the tribes in California, Nevada, and Arizona that depend upon the smaller seeds for their sustenance have the same method of beating the ripe grass into a conical carrying basket. The fans of this type, perhaps, form the very earliest harvesting device.

Associated with the harvesting fan is the gathering and carrying basket and the roasting or winnowing tray.

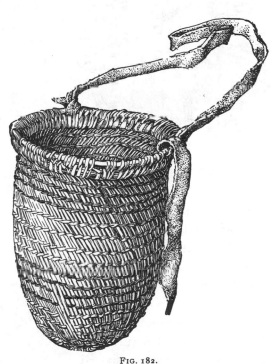

FIG. 182.
GATHERING BASKET.
Paiute Indians, Utah.
Cat. No. 14,688, U.S.N.M. Collected by J. W. Powell.

Catalogue Nos. 11,817 and 11,822 in the United States National Museum, procured in Utah by J. W. Powell.

Figs. 182 to 184 illustrate a gathering basket of the Paiute Indians. The first, fig. 182, represents the entire structure, which is at basis open twined work. The noticeable feature about this piece is the treatment of the warp, which, instead

of rising perpendicularly from the bottom to the top, is twisted to the left, each radial element of the warp making about one-fourth of a turn from the vertical. Again, the technic

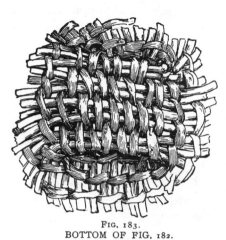

is diagonal weaving in twined work. The diverting of the warp from the vertical is not common in twined weaving, but occurs quite frequently in this area and among the Shoshonean family.

Fig. 183 gives a good notion of the way in which the bottom is started. Four pairs of warp stems constitute the base. These are held in place by very coarse

FIG. 183.
BOTTOM OF FIG. 182.

twined weaving. The ends of the stems are bent to become the warp of the body. The upper border of the basket shows how the warp stems are bent down to the left; a bundle of splints laid on top and sewed as in coiled weaving (fig. 184). On the top of this a stout rod is sewed by another turn of the same process, so that both coiled work and twined work are to be seen in this coarse bit of everyday ware.

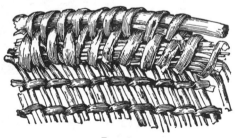

FIG. 184.
BORDER OF FIG. 182.

This specimen, Catalogue No. 14,688 in the United States National Museum, was collected in Utah by J. W. Powell.

Fig. 185 is a harvesting and carrying basket of the Paiutes in diagonal twined weaving, precisely as in fig. 179, representing a Ute woman's hat, and fig. 180, the fanning tray.

The bottom is covered with hide to protect it, and on the body is fastened a head band used in carrying. The ornamentation on many Ute specimens seems to have been effected by charring, since the figures do not appear on the inside at all.

The Ute Indians make use of many kinds of seeds in their dietary. The women go out into the plains with this carrying basket and the fan, illustrated in Fig. 181. The apex of

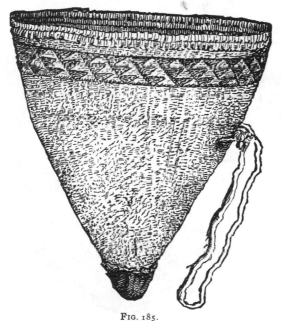

FIG. 185.
CARRYING BASKET.
Paiute Indians, Utah.
Cat. No. 14,667, U.S.N.M. Collected by J. W. Powell.

the carrying basket is rested on the ground, and the seeds are beaten into it by means of the gathering fan. When the basket is full, the woman places the band across her forehead, rests the receptacle on her back, and trudges home with her load.

Catalogue Nos. 14,667 to 14,746 in the United States National Museum were procured in Utah by J. W. Powell.

Fig. 186 is called a roasting or fanning tray of the Paiutes,

being used for the purpose of separating the chaff from the
seeds which have been gathered, either by blowing or roasting.
The warp is a lot of twigs spread out like a fan. The weaving
begins at the inner or manual end, which is the bottom of the
illustration, with short curves, and progresses by ever widen-
ing rows to the outer margin. The rim is produced by a
double row of coiled and whipped work. The whole surface

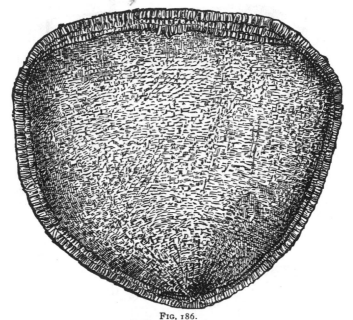

FIG. 186.
ROASTING TRAY.
Paiute Indians, Utah.
Cat. No. 11,857. U.S.N.M. Collected by J. W. Powell.

is very rough by reason of the nature of the material which
these people living in a desert region have to use.

This specimen, Catalogue No. 11,857 in the United States
National Museum, was collected in Utah by J. W. Powell.

Fig. 187 is a coiled seed jar of the Paiute Indians. It
belongs to the type of coiled work called two-rod—that is, the
foundation of the coil work consists of two stems, one above
the other. The stitches pass around these two and under

one of the foundation underneath and interlock. Baskets of this kind are frequently dipped into hot gum or pitch of some kind, varying in different localities. The peculiar effect of this sort of weaving is to hide one of the rods in the foundation and to reveal the other. Frequently, the upper one in each pair is smaller, and by driving the stitches close home a tolerably close and very enduring structure is the result.

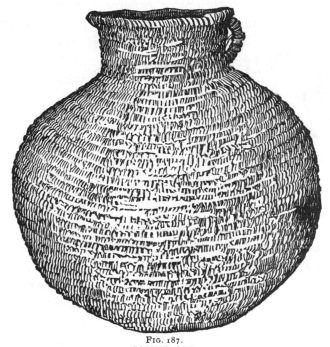

FIG. 187.
COILED JAR.
Paiute Indians, Utah.
Cat. No. 11,262, U.S.N.M. Collected by J. W. Powell.

Pottery was made by the ancient Utes, but is not now common. The basket bottle is much more useful and enduring. A square inch from the surface of this bottle is shown in fig. 188.

Catalogue No. 11,262 in the United States National Museum was collected by J. W. Powell, together with Nos. 11,249 to 11,261.

Plate 204 presents two figures from different localities, but having essentially the same form, structure, and function. That on the left, Catalogue No. 19,029 in the United States National Museum, is a fine old water jar made by a Coyuwee Paiute woman, Pyramid Lake, Nevada; secured by Stephen Powers. It is a model of uniformity in technic. The twilled weaving in twined technic is laid up as regularly as brickwork. There is no attempt at ornament, either in colour or variety in weaving. The pine gum is applied so carefully

FIG. 188.
SQUARE INCH OF FIG. 187.

that it does not hide, but emphasises, the workmanship. The lugs are of braided horsehair. Its height is fifteen inches.

The right-hand figure, No. 2,610, is labelled "Pueblo Indians," but it was evidently made by a Ute woman. The pitch has worn off sufficiently to reveal the process of making the other. Note, first, the twilled weaving in openwork.

The twists of the weft each include two of the warp stems. On the next round the same two are not included; they are separated, to be joined again in the next row above. Now, if the woman had pressed her weft close home, she would have produced exactly the same effect as may be seen on the left-hand figure, a close twill. Observe, however, that at the widest part of the body she has introduced one round of three-strand twine. Two rows of the same form the lower boundary of the neck, which is done carelessly in plain weaving. Collected by W. L. Hardesty.

Nordenskjöld found in the cliff dwellings of the southwestern United States:

1. Checkerwork in heavy, coarse sandals.
2. Wickerwork. This may be seen also in Hopi basketry.

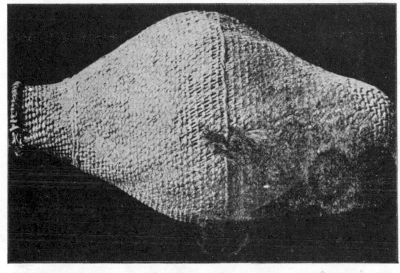

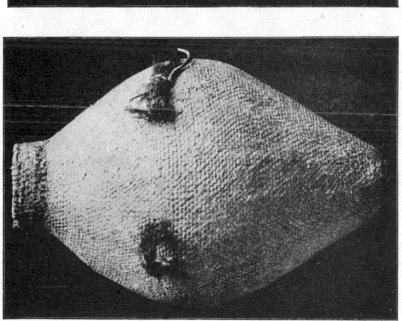

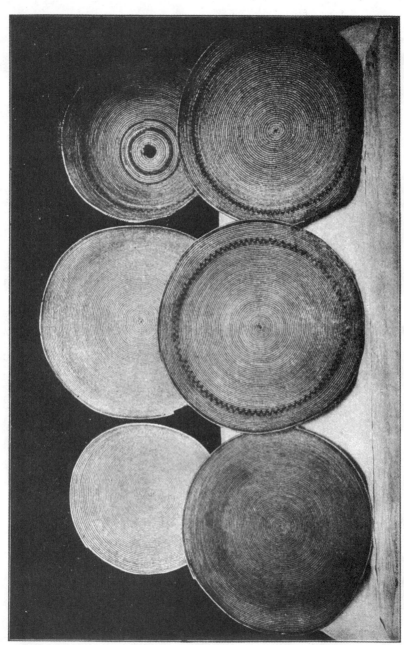

Plate 205. See page 444 COILED BASKETRY OF ANCIENT BASKET-MAKERS, CAVES OF
SOUTHEASTERN UTAH

Collections of Am. Mus. of Nat. Hist., N. Y.

3. Diagonal or twilled weaving, common in Hopi pueblo especially.

4. Matting of rod strung on twine. Apaches and Hopi now use it. (See fig. 103.)

5. Braiding in the flat and in the round.

6. Twined weaving in many forms.

7. Three-rod coil foundation (Bam-shi-bu).

8. Coiled network, the spirals twisted on themselves. (Compare Muskemoot, Plate 102.)

9. Sandals with knots of various patterns in the lacing.

In a paper by Dr. George II. Pepper,* attention is called to a cliff people formerly living in Grand Gulch region of southeastern Utah called the "Basketmakers." They are shown to have worn beautiful robes of feathers and of rabbit skins woven, and sandals of yucca fiber squared in front, and to have had little or no pottery. They fought with "atlatls" rather than bows, and hunted with the Hopi rabbit stick. Most interesting of all, they lived in caves, but not in stone houses. In some of the caves the houses of the Cliff-dwellers have been found overlying the remains of the earlier Basketmakers. The bodies of the dead were doubled up, placed at the bottom of potholes or granaries, some of which were lined with baked clay, covered with robes and finally with baskets, either several small ones or one large carrying basket. The last-named feature is said to have been almost invariably in evidence, and it is to this that attention is here given. The material is willow, the designs on the baskets being in splints of black or a peculiar dull red. The bottoms of the carrying baskets were reinforced with heavy yucca cord. The borders were finished with the ordinary coiled stitch, but in some the last inch or two are finished off with false braid or herring-bone.

One example of Dr. Pepper's, called openwork or sifter basket, has a single rod foundation, and the wrapping at one

* The Ancient Basket Makers of Southeastern Utah, Guide Leaflet No. 6 of the American Museum of Natural History, New York, 1902.

turn passes around the foundation only; at the next it is drawn under the rod in the coil below, and returning is wrapped about itself or "the standing part," as the sailors say. The ordinary Japanese lunch baskets, Samoan basketwork, and those from the Strait of Magellan are on the same plan. But it is certainly a rare sight in this part of the world.

Plates 205 and 206 are from the Pepper collection of coiled basketry from the caves of the ancient Basketmakers. The particular specimens will be described under separate photographs of each one, but the group shows both the forms and functions of the material gathered at this interesting locality in southeastern Utah.

Plate 207 is a coiled tray, having as design two circles of figures resembling aquatic birds floating on the water. This is an excellent opportunity to speculate about the relation of this desert region with prayers to the water god.

Plate 208 is another coiled tray from the cave-dwellers, with an ornamental design, showing two sinuous rings in black.

Plate 209 contains two bowls apparently with the three-rod coil, such as is now common among the best basketmakers of California. The ornamentation is also suggestive of the same locality. On the upper figure are four radial designs triangular in outline, two having their bases at the bottom and two on the outer border, each pattern made up of fringe-work of triangles, reminding one of the strings of arrowhead patterns mentioned by Dr. Dixon in his pamphlet on the Maidu. The lower figure is similarly constructed in coiled weaving, the ornamentation being in circular patterns; the bottom is plain; then follow narrow rings in black, a broad ring in white, a broad band with seven triangular rays, a narrow band in black, and a broad band in the natural colour of the wood.

Plate 210 is interesting as showing the function of the baskets which were found in the Utah cave. All of them have relation to food. They are in twilled and coiled weav-

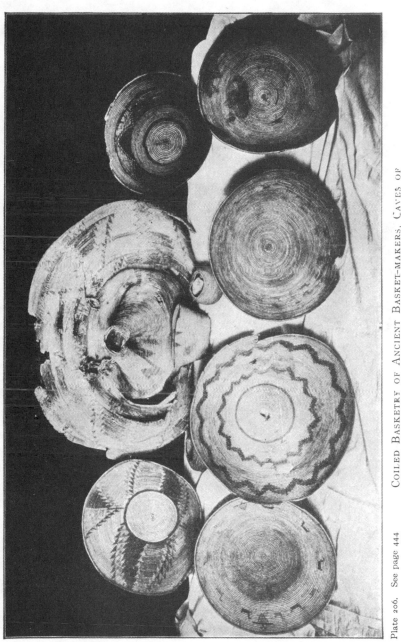

Plate 206. See page 444 COILED BASKETRY OF ANCIENT BASKET-MAKERS. CAVES OF
SOUTHEASTERN UTAH

Collections of Am. Mus. of Nat. Hist., N. Y.

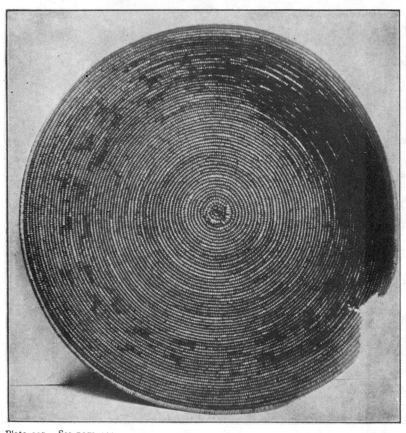

Plate 207. See page 444

COILED PLAQUE OF THE ANCIENT BASKET-MAKERS, CLIFFS OF
SOUTHEASTERN UTAH

Collections of Am. Mus. of Nat. Hist., N. Y.

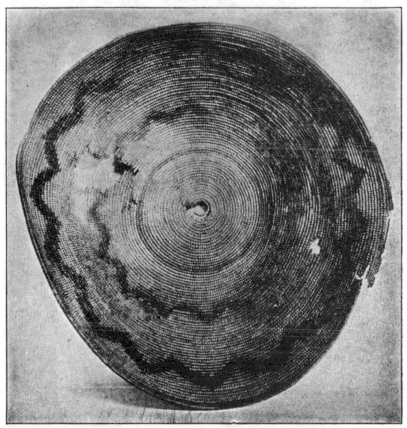

Plate 205. See page 444

COILED BOWL OF THE ANCIENT BASKET-MAKERS, CLIFFS OF
SOUTHEASTERN UTAH

Collections of Am. Mus. of Nat. Hist., N. Y.

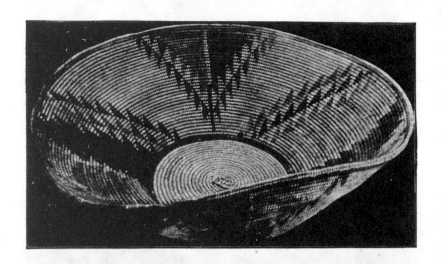

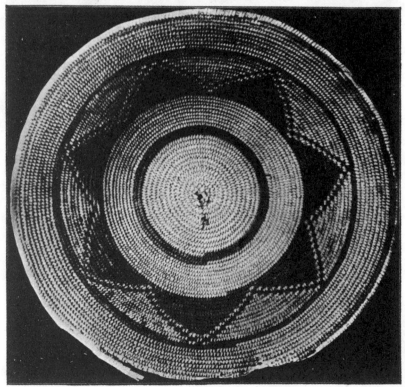

Plate 209. See page 444

COILED BOWLS OF THE ANCIENT BASKET-MAKERS, CLIFFS OF
SOUTHEASTERN UTAH

Collections of Am. Mus. of Nat. Hist., N. Y.

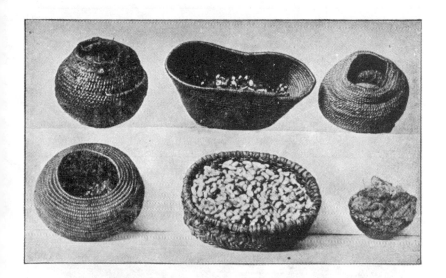

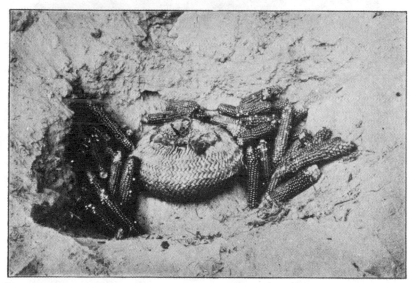

Plate 210. See page 444

FOOD VESSELS OF THE ANCIENT BASKET-MAKERS, CLIFFS OF SOUTHEASTERN UTAH

Collections of Am. Mus. of Nat. Hist., N. Y.

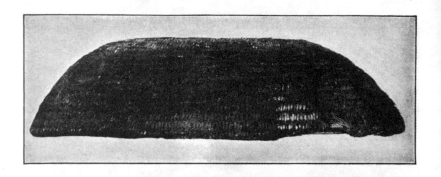

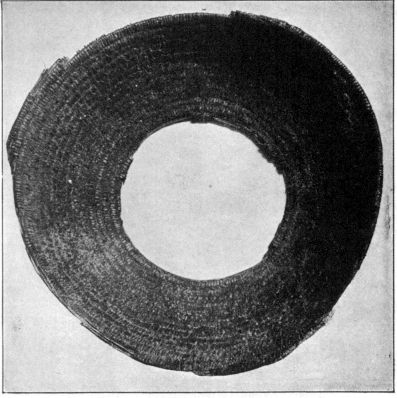

Plate 211. See page 445

HOPPER FOR MORTAR, ANCIENT BASKET-MAKERS OF CLIFFS IN
SOUTHEASTERN UTAH

Collections of Am. Mus. of Nat. Hist., N. Y.

ing, and show how in ancient times the basket entered into the service of these agricultural Indians.

Plate 211 shows a mortar basket of the ancient basket-makers in coiled weaving on splint foundation. It is not possible to determine the material of the stitches. It is 13 inches in diameter and 3½ inches deep. The interior is coated with meal, and the surface of the sewing is worn through from long use. Mortar baskets are common among the California tribes, both in twined weaving and in coiled work. A specimen quite similar to the one here shown in the United States National Museum has a coiled basket top, cemented to the shallow mortar stone underneath by means of pitch. The specimens are in the collection of the American Museum of Natural History.

Pepper describes four varieties of sandals among the ancient Cliff-dwellers—thin soles in twilled weaving from narrow leaves of yucca; those made of broad leaves split; a padded variety made from the same leaves shredded; and an exceedingly fine kind, of spun fiber and worked into elegant patterns. In these last the warp is in two or more layers or plies, so that the body is thick and durable. He quotes Richard Wetherill to the effect that while the chamber-building Cliff-dwellers wove the sandal with pointed toes and a jog or step a few inches from the toe, those of the Basketmakers were square in front. McLoyd and Graham assert that square-toed sandals were made by the people that inhabited the underground rooms, since they are found only with mummies of that race. No square-toed sandals are found in caves where remains of the Basket Makers do not exist. From their variety of weaving in soft materials, the Cliff-dwellers are to be traced to Mexico for their origin.

The term Pueblo basketmaker is far from specific. It applies to women of all the settled villages in New Mexico and Arizona, from Taos on the Rio Grande, in the former, to the Hopi in the latter. The peoples belong to the Tañoan and

Keresan families on the Rio Grande, to the Zuñian in western New Mexico, and the Hopean or Shoshonean in Arizona.*

Far back in time those structures whose ruins furnish inexhaustible supplies of pottery and some textiles have also to tell the tale as to the ancient types of basketry. At the present moment, great confusion exists concerning the ethnic significance of basketry found in the pueblos. Beautiful old pieces, about which there is little information, came twenty years or more ago from these villages. James Stevenson wrote then that the women of the villages were fond of securing in trade and hoarding rare forms and weaves. The best that can be now done is to classify Pueblo basketry as follows:

(1) What the women are actually making and old material precisely like it.

(2) Specimens dug from sites of old pueblos and carefully labelled.

(3) Old materials stored up in the modern pueblos, handed down from the past, whose authorship is not known.

If all this material could be assembled, a variety of technical processes would be revealed, some of them common over wide areas and a few characteristic of the pueblo culture. The following weaves are among the list:

(1) Checker weaving, rare.

(2) Wicker weaving, coarse and fine.

(3) Twilled work, in hard stems and in yucca.

(4) Twined work of many kinds on old baskets. Thought to be intrusive.

(5) Coiled work with foundation of stems, splints, grass, and shredded leaves.

The fine wicker and the thick coiled plaques are peculiar. The great variety mentioned is quite as much between pueblos as between these and tribes outside. The Hopi are note-

* For a list of pueblos, see Seventh Annual Report of the Bureau of Ethnology, under the words Keresan, Shoshonean, Tañoan, and Zuñian; for ruins, see bibliography under Fewkes, Hough, Keam, Mindeleff.

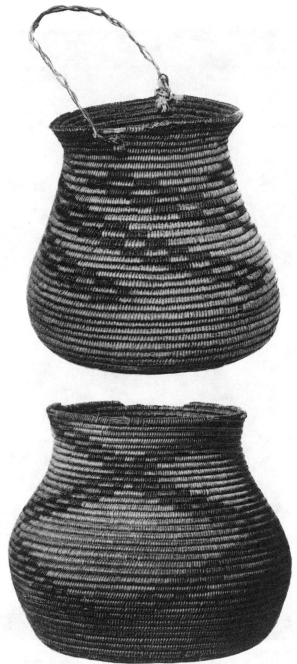

Plate 212. See page 447

Sia Ancient Coiled Baskets

They are among the rarest of baskets, and are like those which have been found
in the cliff house ruins

Collected by James Stevenson

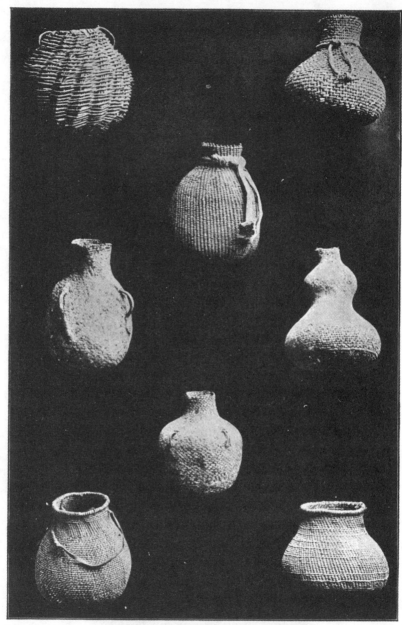

Plate 213. See page 448

OLD WICKER AND TWINED BASKETS FROM THE
PUEBLO OF ZUNI, NEW MEXICO

Collections of U. S. National Museum

1 2
3
4 5
6
7 8

worthy in this regard, having in their hands the making of the two unique kinds of weave in their sacred meal plaques. A better insight into these differences will be gained by an examination of specimens.

Plate 212 represents two ancient coiled basket jars collected at the pueblo of Sia, on the Jemez River, a tributary of the Rio Grande in New Mexico. The Indians of this pueblo belong to the Keresan family. The characteristics to be observed and studied on these specimens are the following: The foundation is of splints, the sewing is done with willow or rhus, and the stitches are just barely carried around a small portion of the foundation underneath, where they are interlocked. Note also that the ornamentation—an ascending spiral—is in one case a rhombic figure and in the other is built up of little rectangles formed by counting stitches, which may be few or many, as the curve on the body of the basket expands or contracts. This mingling of very simple elementary forms is capable of an infinite variety in treatment.

The attention of the student is especially called to the margins of these baskets, which appear to be in a three-strand plait; but they are really done in a single splint which passes backward over the foundation, then under and forward, inclosing the rod underneath, forming a figure 8, and the multiplication of this produces on the surface the braided appearance. For detail, see page 126, fig. 87. Catalogue Nos. 134,214, 134,215. Collected by James Stevenson.

Although there may be seen at the pueblo of Zuñi all sorts of baskets, the most of them include pitched bottles for water, coiled and whipped trays, Hopi coiled and water basket trays; but it is not to be understood that they were necessarily made there. The only work made by the Zuñi nowadays is their small, rough peach baskets of twigs and wickerwork, hardly worthy of notice except for their ugliness and simplicity. Those who are familiar with this interesting tribe of Indians say that trading is a passion with them, and that through

their agricultural products and their refined loomwork they are able to gratify among the surrounding tribes this taste for old basketry, examples of which are stored away, and brought out on special occasions.

Plate 213 shows some old so-called Zuñi ware, collected for the Bureau of American Ethnology by James Stevenson, in New Mexico, long ago.

Fig. 1 is a wicker basket of globular form. The warp consists of a number of stems of *Chrysothamnus* laid flat. The weft of the same material is in wickerwork, the border being fastened down in coiled sewing with yucca leaf. Handle, a rawhide thong. Used by these Indians in gathering fruit and other food substances. Height, 8 inches. Cat. No. 68,603, U.S.N.M.

Fig. 2 is a jar-shaped basket of *Chrysothamnus* (*Bigelovia*) splints. The warp is radiating at the bottom and parallel on the body; the whole basket is made in twilled style of twined weaving over two. The border is not finished off. The handle is a rawhide thong around the neck. This is a very coarse specimen of twined work. The height is 8 inches. Cat. No. 68,480, U.S.N.M.

Fig. 3 is a rare and interesting specimen of a twined basket jar. The bottom has radiating warp and is in coarse twilled weaving, but the body from the bottom to the upper margin is plain, twined weaving, without variation. There is not in the National Museum collection from this Pueblo region another basket in which the whole body is treated in this monotonous manner. Its height is 8½ inches. Cat. No. 68,513, U.S.N.M.

Fig. 4 is a water-tight jar from the Zuñi Indians. The whole surface of the object is in the twilled type of twined weaving and well saturated in pitch. The characteristic features are the lugs of wood on the side for the carrying strap, and flattening of the surface between these lugs, as in a canteen. This is partially shown in the photographs, but is quite

apparent on the jar itself. Its height is 9 inches. Cat. No. 68,515, U.S.N.M.

Fig. 5 is a water-tight basket jar, constricted in the middle for the attachment of a carrying strap. The whole surface is in coarse twilled weaving in two-strand twine with the exception of one row between the bottom and the body, which is in three-strand. The constriction of the body is said to be an imitation of a custom of tying rag around the young gourd so as to stop its growth, which results in a modification useful for holding the carrying strap. Its height is 9 inches. Cat. No. 68,541, U.S.N.M.

Fig. 6 is a water-tight basket jar, from the Zuñi Indians, symmetrical in outline. It is in the twilled type of twined weaving, with wooden lugs on the side and no flattening of surface between them. Its height is 7½ inches. Cat. No. 68,502, U.S.N.M.

Fig. 7 is a gathering basket from the Zuñi Indians. The weaving on the bottom and the body is in the twilled type of twined work; the neck, on the contrary, has about an inch of plain twined weaving, and is finished off with four rows of three-strand twine. The border is in coiled sewing of yucca. This specimen, like the preceding, is made from the stems of *Chrysothamnus*. Its height is 7½ inches. Cat. No. 68,491, U.S.N.M.

Fig. 8 is a gathering basket from the Zuñi Indians. The bottom is in twilled twined work; the body is in plain twined work relieved at varying distances with single rows of three-ply weaving; border finished off with coiled work in yucca. Its height is 6 inches.

The Zuñi pueblos in western New Mexico lie in the very heart of the desert region. On the east are the Rio Grande pueblos, on the northwest the Hopi, and far to the south the Gila River. Besides the settled communities long inhabiting this region, the Navaho and Apache are close at hand on every side, and the Utes not far away. There is no surprise, there-

fore, in finding on the same plate illustrations of wickerwork, twined work in its many varieties of plain twilled and three-strand work, and all of these at times on the same piece of basketry.

Plate 214 shows a rare lot of old coiled baskets, chiefly from Zuñi and Sia, in New Mexico, collected under the direction of Major J. W. Powell, by James Stevenson, of the Bureau of American Ethnology. They appear to be of the three-rod variety, though splints may take the place of rods in some of them. They are catalogued as follows, in the order named:

Top row—

1. No. 68,471, Zuñi, James Stevenson; length, 9½ inches.
2. No. 68,550, Zuñi, James Stevenson; height, 4¼ inches.
3. No. 68,474, Zuñi, James Stevenson; height, 7 inches.
4. No. 68,472, Zuñi, James Stevenson; height, 4¾ inches.
5. No. 42,140, Zuñi, James Stevenson; height, 4¼ inches.

Bottom row—

1. No. 68,489, Zuñi, James Stevenson; height, 4¾ inches.
2. No. 166,800, Apache, James Mooney; height, 8¾ inches.
3. No. 134,215, Sia, James Stevenson; diameter, 11½ inches.
4. No. 134,214, Sia, James Stevenson; height, 12 inches.
5. No. 42,168, Zuñi, James Stevenson; height, 4 inches.

A jar-shaped coiled basket attributed by the collector to the Zuñi Indians is shown in fig. 189. It is a very beautiful and smooth piece of coiled ware, to which justice is not done by the drawing. In regularity of stitch, symmetrical shape, and ornamentation it is almost without fault. It belongs to the class of technic termed in this treatise rod and welt. The foundation consists of a single rod, over which is laid a thin splint, perhaps of the same material. The stitch passes over rod and welt in the row that is in progress of manufacture, and not only locks with the stitch underneath, but in each case takes up the welt. This forms an excellent packing. The stitches are crowded so closely together that in the original

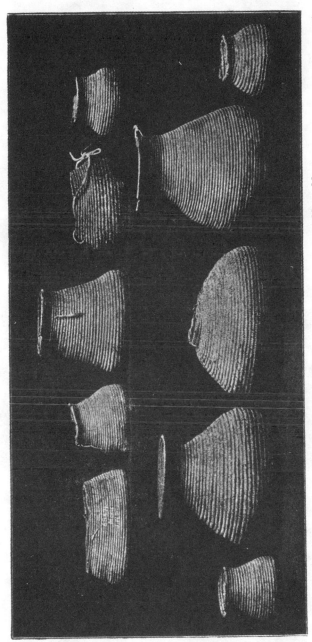

Plate 214. See page 450. OLD COILED BASKETS, PUEBLOS OF ZUNI AND SIA, NEW MEXICO

Collections of U. S. National Museum

| 1 | 2 | 3 | 4 | 5 |
| 6 | 7 | 8 | 9 | 10 |

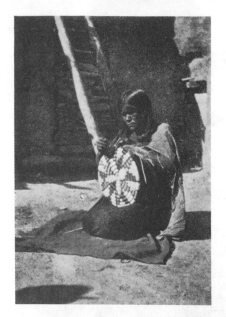
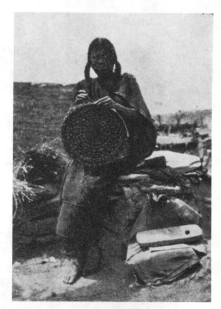
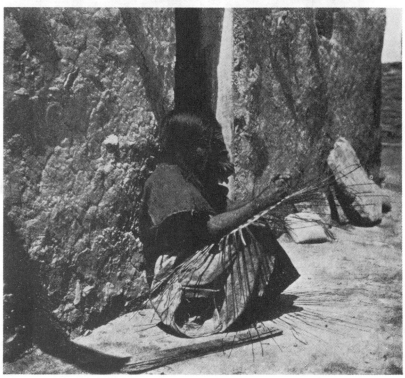

Plate 215. See page 453

HOPI WOMEN MAKING WICKER AND COILED BASKET TRAYS

Photographed by W. H. Simpson

those of the different rows lie practically one over the other, with a slight inclination from the perpendicular. On the bottom, not shown here, it has a circle in black from which radiate six spiral rays. On the body, the ornamentation is as shown

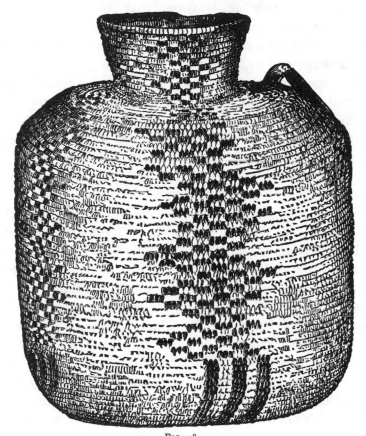

FIG. 189.
COILED BASKET JAR.
Zuñi Indians, New Mexico.
Cat. No. 68,546, U.S.N.M. Collected by J. W. Powell

in the figure. It is made from the pod of *Martynia louisiana*. On the shoulder, two lugs of leather are sewed for the purpose of carrying the jar, being intended, doubtless, for the transportation of food or water. It is customary to attribute such ware to the Apache Indians, although in the National

Museum there are quite a number of very old coiled jars of this type and fine workmanship purporting to come from the Zuñi Indians. This specimen was gotten by Major Powell, one of the most careful collectors, so that there is no doubt as to the location. It is possible, however, that the Zuñi, since they are potters, may have acquired this coiled specimen in traffic. The detail of this texture, both in its sewing and ornamentation, is illustrated in fig. 48, also by Cushing.*

This specimen, Catalogue No. 68,546 in the United States National Museum, was procured in New Mexico by James Stevenson. Its width is 9 inches and depth 10 inches.

The Hopi pueblo settlement, called also Moki, in the ancient province of Tusayan, is made up of the following-named villages, in order from east to west: Walpi, Hā'no or Tĕ'wa, Sichōmōvi, Shipaulovi, Mŭshŏngŭnŭvi, Shumōpavi, and Oraibi. Here in these seven old towns are made all kinds of basketwork. From Dr. Walter Hough the following information is received: The thick North-African-like coiled plaques are from Mŭshŏngŭnŭvi Shipaulovi, and Shumōpavi, all on the middle mesa, and nowhere else in the Western Hemisphere. The material for the foundation is stems of Takashu (*Hilaria jamesii*), gathered in October. The sewing is done with narrow strips from the leaves of Mohu (*Yucca glauca*) in the natural colour of the outside or the interior, or nowadays dyed in aniline colours. Formerly vegetal dyes were employed, red brown Ohaushi (*Thelesperma gracile*); dark blue from seeds of Akaushi (*Helianthus petiolaris*); yellow from Asapzrani (*Carthamus tinctorius*); green or blue, rarely seen on old baskets; but from Mrs. Hough comes the delightful information that the Hopi make a native blue dye from the beans which they raise for food. The following are their terms for basketry:

Apa, blanket mat. (Anciently made in checker weaving.)
Chu ku pö eta, also Chu ku böt se buh, Havasupai.
Shio eñ ya puh, Oraibi wicker tray.

* Fourth Annual Report of the Bureau of Ethnology, 1886, p. 486.

Du tsi ye, or Du tsai ya, sifting basket.

Hō a pūh, carrying basket (wicker over frame of bent sticks crossed).

Kŏm che, awl of bone.

Hush tush shum pi, or Ko tuc, basket for parched corn.

Kwakū ütshpi (hay cover), twined mat for kiva hatch.

Pek ech be, piki tray (food tray).

Pö eta, basket plaque (coiled).

Se boch be (Oraibi basket).

Tümni, flat basket in Soyalana rites.

Wiko zhro, pitched bottle.

Plate 215 represents Hopi women making coiled and wicker baskets. Photographed by W. H. Simpson. Figured and coloured examples of their ware are shown in Plates 16, 27, 30, 47, 85, 93, and 216.

Wicker baskets are made at the Hopi pueblo, Oraibi. The radiating framework is of slender shoots of sübi, *Rhus trilobata*. The interwoven element is of branches of hanoshivapi, *Chrysothamnus graveolens*, also called *Bigelovia*, carefully smoothed and dyed, as in the coiled baskets, red brown, red, yellow, dark blue, purple, green, blue, and white, the latter with kaolin.

The white of the background is applied after the basket is finished. The edge of the basket is finished with a winding of yucca over the several rods of rhus bent down after the basket has reached the size required. This edge is often painted with red ocher (Hough). The framework consists of two cross sets of twigs, four or more in a bar of the cross. These are firmly held together at their intersection by weaving. They are then spread out radially, the space being from time to time supplemented by additional stems. The worker provides herself with bunches of white, yellow, orange, purple, black, blue, and green twigs only a few inches in length. These she proceeds to weave into patterns of the greatest beauty, even imitating cloud effects seen on Japanese screens, using long or short twigs as the occasion

demands, hiding the ends between the ribs and the filling of the preceding coils. (See Plate 216.)

The variety of ornament created with these poor appliances is marvellous. In no other tribe of Indians and in no other type of basketry are more striking effects realised. It seems almost as if the women had set themselves the problem of producing with the least pliable materials the most versatile of effects, in which are embodied the symbols of an intricate ritual, in all grades of symbolism from the pictograph to the mere conventional mathematical form. Both, however, represent the same ideas. It will be easily seen that the figures on the back and front do not exactly conform, the corresponding square on the back being always one space to the right or left of the same in front.

Attention is called at this point to the ornamental beginning of the wicker plaque, or sacred meal baskets. In the chapter on structure, attention is directed to the methods of holding the central warp stems together before bending them apart radially. Two methods are resorted to. On one, half a dozen or more stems are laid side by side and wrapped together by a process shown in fig. 38, after Miss White. The same number of stems are similarly joined and laid under this at right angles, the whole twelve being bound together by one or two rows of wicker weaving. From this central point, the twelve or more wrapped stems are bent apart at equal distances and the regular wicker weaving proceeds. At a certain distance outward, new warp stems are added between each pair of those already in use, and from this circle the weaving proceeds to the margin.

With the same number of warp stems, quite a different process is sometimes employed, by which the two sets of the upper and lower are held together in pairs by wicker weaving, and at an inch from the center the whole series are bound together as before and widening and weaving proceed in the same manner.

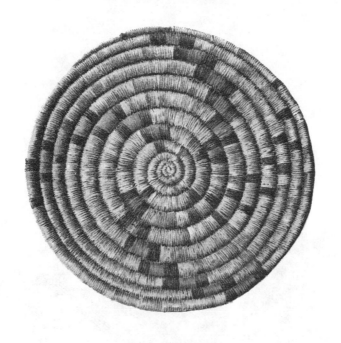

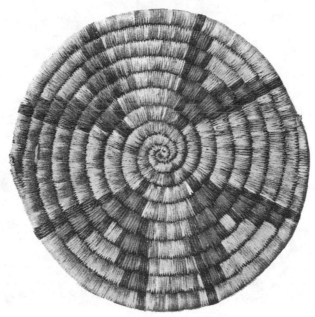

Plate 216. See page 454

HOPI SACRED COILED PLAQUES

In which the symbols are reduced to the lowest terms

Collected by James Mooney

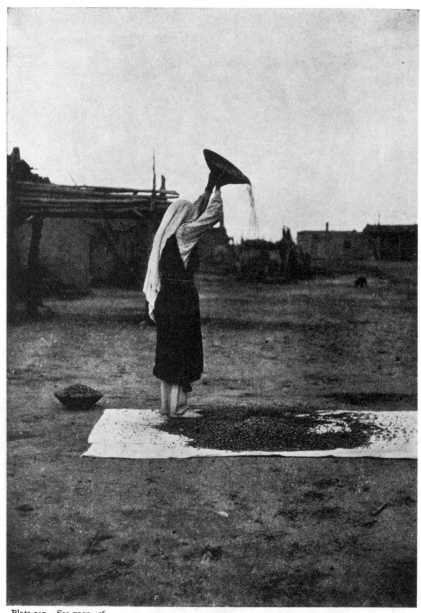

Plate 217. See page 456

TEWAN PUEBLO WOMAN, ON THE RIO GRANDE, WINNOWING SEEDS

Photographed by A. C. Vroman

Fig. 190 is a coarse wicker tray of the Hopi Indians of north-eastern Arizona, and is introduced for the purpose of illustrating the method in which the much finer work on the sacred meal trays is done. Here may be seen the plan of starting out with a few stems crossing each other at right angles for warp; the method of hiding the large end of the weft stems to become a portion of the warp, and the method of adding new

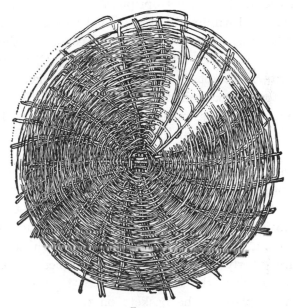

FIG. 190.
COARSE WICKERWORK.
Hopi Indians, Arizona.

warp stems as they are needed. Especial attention is called to the way in which several stems for weft are introduced at the same time and worked along in sets or series. The common method of working out the twill would be to introduce a weft stem, carry it as far as it would go, and then insert a new one; but in this case the series of half a dozen stems are all worked at the same time. Compare description of a Mexican wicker basket, on page 484.

The modern twilled basketry is as rough as it can be. The

same is true of the flat mats used about the dwellings; in fact, the mat and the basket are identical in weaving. The basket is formed by bending the mat over the edge of a hoop and sewing down with a row of twined weaving.

Plate 217, in the graceful pose of the actor, reminds one of the vestal Tuccia. In this picture she is a pueblo woman of the Tewan family, living on the Rio Grande and cousin to the people of the most eastern Hopi pueblo. She is a survival of the gleaners and winnowers of primeval times. Interest here centers in her baskets, one of which is a receptacle, the other a primitive fanning mill. Photographed by A. C. Vroman.

The twined ware of the Hopi are a few baskets and other domestic utensils, made in the same manner as the Ute hats, but there is enough dissimilarity of form to give the Hopi the credit of inventing this peculiar style. (See Plate 218, figs. 4 and 7.)

Plate 218 shows a collection from Oraibi, the westernmost of the Hopi pueblos in northeastern Arizona, gathered by Colonel James Stevenson and Cosmos Mindeleff. The three types of work always in mind when Oraibi and the pueblos of the adjoining mesa are mentioned, to wit, twilled, thick coils, and wicker, are utterly wanting in these examples. The cosmopolitan character of the Hopi is attested by the varieties of technic in the plate. The baskets on the upper row are as follows, from left to right:

1. Water-tight coiled jar, with foundation of rods, sewing material of willow splints, the stitches interlocking, but not taking in any of the foundation below. Catalogue No. 42,109 in the United States National Museum. Height, 7½ inches. The lugs on the side are of horsehair.

2. An old flat coiled dish, No. 41,227, said to have come from Zuñi, in western New Mexico; 7¼ inches in diameter.

3. A delightful old gathering basket, No. 42,126, from Oraibi. It is of the three-rod coiled variety, and might be taken for the original elegant Pomo Bamtsuwu. Each stitch

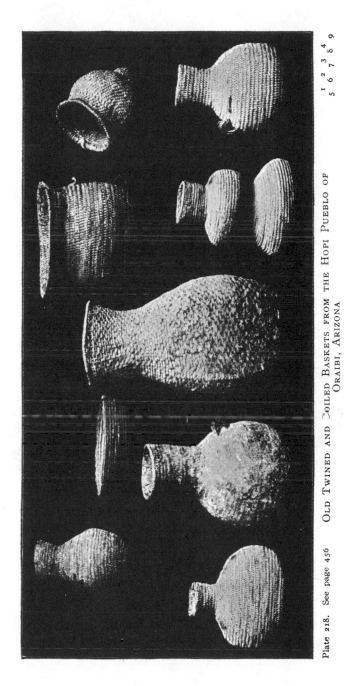

Plate 218. See page 456 Old Twined and Coiled Baskets from the Hopi Pueblo of
Oraibi, Arizona

Collections of U. S. National Museum

1 2 3 4
5 6 7 8 9

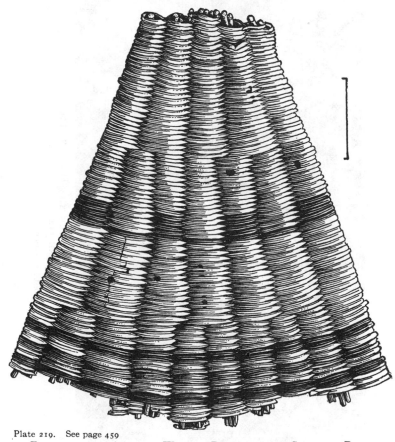

Plate 219. See page 459

FRAGMENT OF ANCIENT WICKER BASKET FROM CHEVLON PASS,
ARIZONA. AFTER J. WALTER FEWKES

passes over three rods of the current foundation and under the upper rod of the coil underneath, illustrated in fig. G on page 89. Its height is 7¼ inches.

4. A gathering basket in twilled twined technic. On the bottom is a projection whose function is not known. Notice on the shoulder three rows of twined work over two warps. The difference between this and twilled work is that the weft elements embrace the same pairs of warps and are superposed. The border is finished off with a neat herring-bone stitch. Catalogue No. 83,977, United States National Museum. Its height is 6 inches.

The old pieces on the lower row are equally interesting.

1. A globose coiled jar in three-rod foundation. The workmanship is coarse, but the form is suggestive of old pottery. This specimen is No. 84,596, United States National Museum, and is 7 inches in height.

2. A water jar in three-rod coil, modern, with lugs of horsehair on the side for carrying. The border is fastened off with a kind of sewing here called false braid. The material for making the vessel water-tight is pine resin. Catalogue No. 42,107, United States National Museum. Its height is 10 inches.

3. This interesting piece of water-tight twilled twined work is strengthened by an interior framework similar to that seen often in the large Zuñi packing baskets for donkeys, and suggests the possibility of transporting water in the same fashion. The weaving is rude, but all the better for holding pitch. The border, however, is neatly done in false braid. Catalogue No. 68,506, United States National Museum. Its height is 15 inches.

4. The water jar constricted in the middle might with propriety be called a canteen. Frequently the savages in this arid region tie a bandage around a young gourd, which afterwards takes the shape here shown. The foundation of the coil is more like that of Apache, the stitches interlocking. Indeed,

the piece is labelled "old Apache" by the collector. It is numbered 40,109 and is 8¼ inches high.

5. A water jar or pitcher in three-rod coil. It should be compared with No. 1 in the same row, secured in Oraibi by the same collector. It is Catalogue No. 84,596, United States National Museum. Its height is 8½ inches.

Fig. 191 is an ancient miniature gaming wheel, used frequently in the ceremonials of the modern Pueblo Indians.

Fig. 191.
ANCIENT BASKETRY GAMING WHEEL.
Pueblo Indians, New Mexico.
Collected by James Stevenson.

Then, as now, the hoop of wood was made and a series of half-hitches passed around the inner side, done in yucca fiber. This process was repeated upon the loops thus constituted until the center of the wheel was reached. It is in effect a kind of coiled work in which the foundation is absent. Collected by James Stevenson.

Dr. J. Walter Fewkes was so fortunate as to recover from the Chevlon ruin, fifteen miles from Winslow, and in sight of

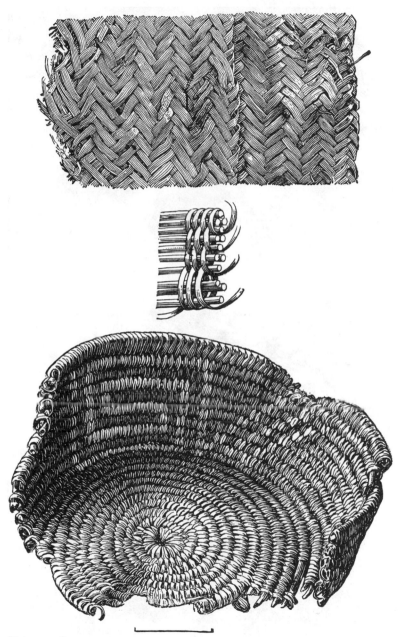

Plate 220. See page 459

FRAGMENTS OF TWILLED AND COILED BASKETRY, CHEVLON PASS,
ARIZONA. AFTER J. WALTER FEWKES

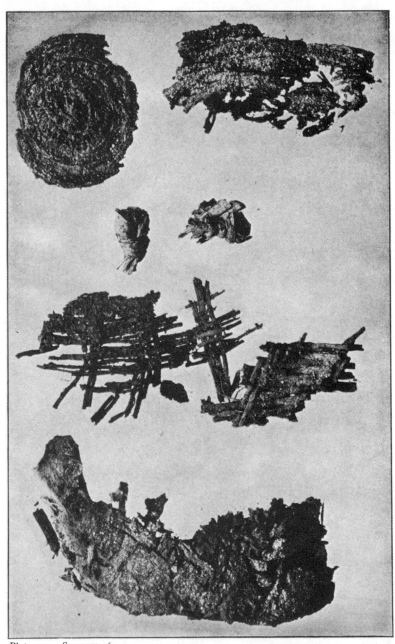

Plate 221. See page 460
ANCIENT WICKER AND COILED BASKETRY FROM RUINS IN ARIZONA
AFTER WALTER HOUGH

the station Hardy on the Santa Fé Railroad, fragments of ancient basketry shown in the accompanying plates. The custom of burying baskets with the dead is still preserved in the Tusayan towns, and from the specimens here figured it has been inherited from ancient times. Baskets, says Fewkes, are not now made at the east mesa, and the craft is confined to the middle mesa and Oraibi.

The wicker baskets from several graves at Chevlon were identical with those made to-day in the pueblo of Oraibi. Some of these specimens were painted on the surface a green colour with malachite, or blue with azurite. In other exam ples, the small stems had been stained before they were woven. Plate 219 represents a segment from a wicker basket made from the stems of *Chrysothamnus graveolens*. The warp consists of small bundles of stems; the weft, of the same material barked and smoothed down, in some places dyed. The interesting feature of the specimen is the increasing of the number of warp elements as the basket enlarges. At first in the drawing there are five bundles of stems; about two inches lower the number is increased to seven; and near the bottom, by the introduction of new stems, ten warp elements are provided for. As in the modern basketry, in this ancient example the weft is soaked and woven in that condition and pressed home so effectually that the warp is invisible.

In Plate 220, fig. 1, is shown a specimen of ancient matting in twilled weaving. The work is done in split yucca leaves, just as to-day, and in certain places the figure shows where the leaf was stripped from the stalk. Examining the thousands of mats and soft baskets from the same pueblo reveals the identical method of doing the twilled work, but in a great many of the modern examples regular diaper patterns are introduced. In the same plate (fig. 3) is an ancient example of coiled basketry having foundation of three stems or rods. By referring to the California basketry it will be seen that this foundation is the same. This makes a very smooth surface, easily dis-

tinguishable from the rugose condition of Apache basket built on a single rod.*

These specimens are Catalogue Nos. 157,912, 157,915, 157,918 in the United States National Museum, and were procured at Chevlon, Arizona, by Dr. J. Walter Fewkes.

Plates 221, 222 illustrate the forms and uses of basketry in the pueblos of northeastern Arizona before the coming of the whites. The explorations of Dr. J. Walter Fewkes in Sikyatki and Awatobi, and the Museum-Gates expedition in 1901 to examine two ruins on the Jettyto Wash, a few miles from Keams Canyon, have brought to light wicker, twilled, and coiled basketry. The wickerwork is precisely identical with the little wicker trays or plaques made in the pueblo of Oraibi and used in religious ceremonies there. The twilled work is the matting of to-day, and the coiled resembles that of the Utes or Pimas rather than that of the Apache, having a foundation not of rods, but of fine material. The uses of basketry must have been in all respects as among the Hopis of our day, but Plate 223 shows the connection of such material with the care of the dead (Catalogue No. 213,074). The plate illustrates the fact that coarse wicker matting was placed in the bottom of the grave; on this was laid a matting of yucca fiber, and on this was deposited the body. In the dressing of the hair, then, as now, a plaited cord of human hair was employed. A description of its discovery appears in Dr. Hough's paper, Archeological Field Work in Northeastern Arizona.

Judging from the artifacts secured by the Museum-Gates expedition, these pueblos belong to the type of Awatobi and Sikyatki, and, as far as appearances go, may have been contemporaneous. Dr. Fewkes regards Sikyatki as one of the most ancient pueblos of the Hopi group. It is well known that Awatobi was inhabited up to the year 1700, but there is no historical reference to the pueblos from which these specimens were derived, and there is no evidence of the Iron Age in them.

* Smithsonian Report, 1896, pls. XXXII and XXXIII, after Fewkes.

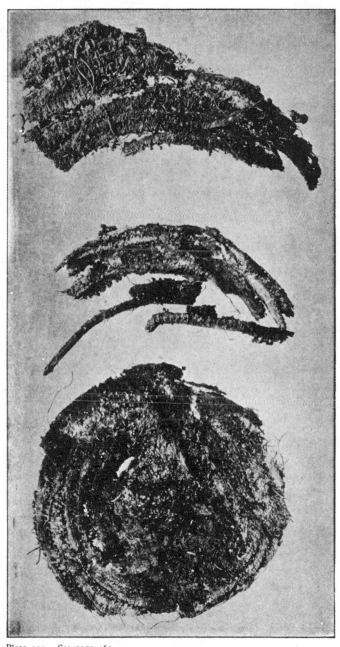

Plate 222. See page 460

ANCIENT COILED WARE FROM RUINS IN ARIZONA
AFTER WALTER HOUGH

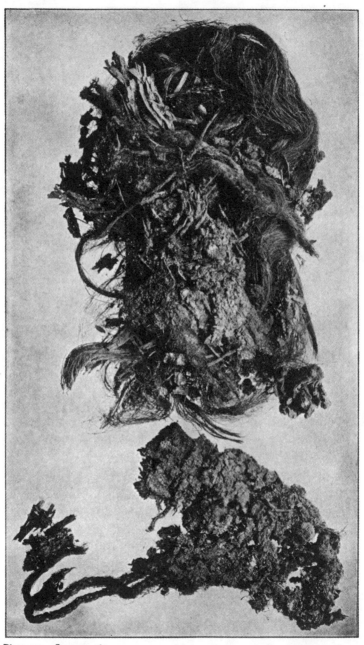

Plate 223. See page 460

ANCIENT COILED AND BRAIDED WARE, IN MORTUARY
USES, ARIZONA. AFTER WALTER HOUGH

It seems probable, however, that they date before the year
1700, but just how much anterior it is not possible at present
to say.*

ATHAPASCAN BASKETRY

A summary of Athapascan basketry in its ethnic areas
would indicate the following:

The northern Athapascans in the interior of Alaska and in
the Mackenzie drainage make coiled basketry in a variety of
types, the material being willow and root of the conifers.
The Pacific coast group, living formerly in Washington, Oregon,
and northwestern California, near the sea, of which the Hupas
are the best known, excel in twined work with decoration in
overlaying, but these tribes have not the versatility of the
Pomo, farther south. All the weaving is of one variety, well
known in the region.

The southern Athapascans, under many names, practice
both coiled and twined basketry. They base their coiled work
on hard stems, and sew them with splints of cottonwood,
mulberry, sumac, and willow, or strips of yucca. They also
used agave fiber.

The mescal plant (*Agave americana*), says Bourke, is to the
Apache what the palm is to the East. It is baked in ovens
for victuals, and its juice is fermented to make a drink. For
the basketmaker the thorns are good needles, the fibers ex-
cellent thread material, and the flower stalk forms the frame
of the carrying outfit.

The Apaches or southern Athapascan basketmakers were
formerly spread over eastern Arizona, western New Mexico,
and in Texas along the Rio Grande, as will be seen in Powell's
linguistic map.† They were gathered on reservations by

* Archeological Field Work in Northeastern Arizona. The Museum-
Gates expedition of 1901. Walter Hough, Report of the United States
National Museum, 1901, pp. 279-358.

† Seventh Annual Report of the Bureau of Ethnology, 1891, pocket.

General Nelson A. Miles. Scattered bands are to be found here and there. Mr. James mentions one near Short Horn Mountains and in the neighbourhood of Palomas and Agua Caliente, comprising about thirty families of basketmakers. The collector or student must not be surprised, therefore, if in the hands of Apaches is seen work of other tribes. Indeed, he will frequently see the women borrowing materials, structures, forms, and even designs from outside. A large and varied collection of Apache ware is exhibited in the Free Museum, of Phoenix, Arizona, collected by Messrs. Benham.

On the authority of Mrs. J. S. Newman there are five tribes on the Apache Reservation, and a few scattered members of other tribes, but five only are basketmakers. Of these, the Tonto should rank first, making chiefly ollas, which require more skill than plaques or bowl shapes, and their work is invariably even and good. Their specimens are nearly always marked with the arrow-point, the pattern running vertically from the center. Their proficiency is accounted for in the fact that the land allowed them on the Gila River is the least productive of any on the reservation, hence their dependence on basket-making for a living.

The center or beginning of either Apache coiled bowl or olla is always wrapped with black (devil claw), and the rim finished with the same stitch as that used throughout the body of the work, both or either colours being used.

Plate 224 shows a number of Apache coiled bowls belonging to the collection of J. W. Benham. The foundation is in whole stem and the sewing done with splints of white wood and martynia. A comparison of these ten pieces reveals tolerably well the genius of Apache decorations. There are discrete figures of men and beasts; also both radial and concentric designs; and in the crenelated (fig. 10) and fretted motives (figs. 5 and 9) suggestions arise which point to the Tulare area. The Apache, naturally a wanderer, has picked up here a little and there a little of design.

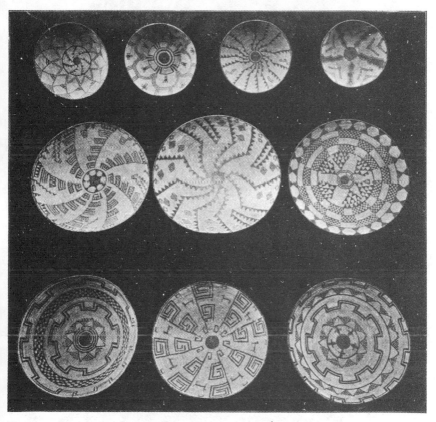

Plate 224. See page 462 COILED BASKETRY OF THE APACHE,
SHOWING BORROWED DESIGNS,
ARIZONA

Collection of J. W. Benham

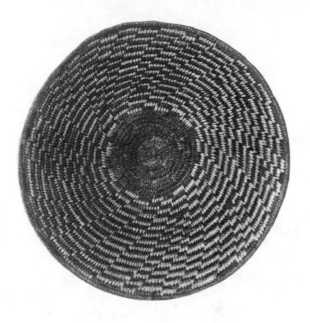

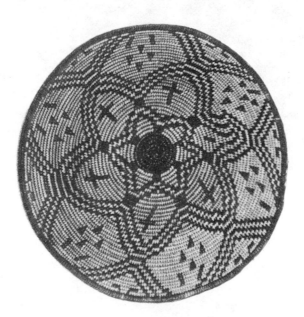

Plate 225. See page 463

APACHE COILED BOWLS

The design of the upper bowl represents the sunflower; the lower bowl is a modern design
of excellent conception, but inaccurately worked out in one place

Collected by Walter Hough

The White Mountain Apaches are clustered around Camp Apache, the agency, and on two of the large creeks running south from the Mogollon mesa. The art of basket-making is not actively practised at present, the younger members of the tribe finding it difficult to learn, and saying that it injures their hands. Some of the old women, however, retain the ancient skill, and even superior work may be secured from the reservation. It may be said that the carrying baskets and the pitched water bottles are as frequently made as ever and are in constant use, whereas the finer bowls, which were formerly common, as among the Pueblo tribes, for storing meal, etc., are growing rarer every year and command high prices.

The baskets shown in Plate 225, Catalogue Nos. 213,262 and 213,268, United States National Museum, were secured at the agency in the summer of 1901.

Fig. 1 is a small, well-woven bowl, the design representing the sunflower.

The second figure is a modern basket with geometrical pattern, which in certain portions is quite inaccurately worked out. On the whole, the design is excellent.

Plate 226 represents coiled basket bowls of the White Mountain Apache. The foundation of the upper figure is of willow, the sewing in splints of white wood and martynia in alternate rows, which are divided into four sections by V-shaped ornaments, effected by changing the direction of the lines in black.

The lower figure is the same material, foundation of rods, sewing in white and black, coarsely done, stitches scarcely touching. The whole surface is covered with rhomboidal figures, produced by crossing of four sets of lines in pairs, passing in cycloidal curves from the bottom to the margin. Catalogue Nos. 213,264 and 213,265.

The specimens were collected by Doctor Walter Hough, on White Mountain Apache Reservation, 100 miles south of Holbrook, Arizona.

The symbol is that of the martynia hooks, the sharp points having been allowed to project from the inner surface in certain areas.

The shoots for basket material are gathered in the spring, tied in bundles, and put away in the houses for future use, sometimes with the bark on, at others without. When the basketmaker is ready, the osiers are soaked thoroughly in water; the stems are employed whole for the foundation of the coil, and the sewing is done only with the outer layer, the inner portions being peeled off and the splints scraped. One end is held in the mouth, the other in the left hand, while the steel knife, formerly the stone knife, is used in the right hand.

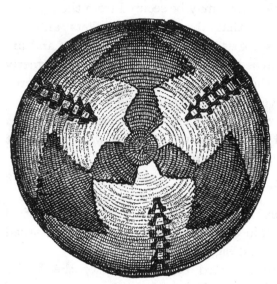

Fig. 192.
COILED BOWL.
Coyotero Indians, Arizona.
Collected by H. W. Read.

The ornamentation on all this basketry is in *Martynia louisiana*, or devil horns (Tagate), the design itself often being the figure of the plant. The awl used in the sewing is called by the White Mountain Indian, tsatl; the coiled bowl, tsa; the spindle-shaped water jar, tose; the carrying basket of twined work, ta tsa; the gathering scoop, pen al té; and the shoots of wood, tsin.

Fig. 192 shows the ornamentation on a coiled basket bowl of the Coyotero, on the San Carlos Agency, in southern Arizona. The parts are in three; the smaller design is made up

of a combination of little squares and triangles, the larger design being more complicated in its elements, with its three vase-shaped parts, which terminate in the dark circle of the center. The meaning of this design is unknown.

This specimen, Catalogue No. 4,428 in the United States

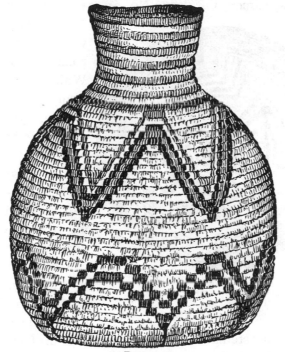

Fig. 193.
BASKET JAR.
Apache Indians.
Collected by J. B. White.

National Museum, was collected on the Gila River, Arizona, by H. W. Read.

Fig. 193 is an old bottle-shaped coiled basket, made, according to Dr. Hough, long ago by the Mescalero Apache, before they adopted the present wide variety. The foundation of the coil consists of a rigid stem overlaid with soft fiber. The stitching passes over the foundation of the coil, under the packing of the coil underneath. The sewing is done with

splints of willow or cottonwood. The ornamentation con-
sists of six rows of coiling in brown material on the neck, a
row of black material on the shoulder, with two rows of chev-
rons on the body. The latest Apache has only black and white
in decoration; red and brown are old and rare.

This specimen, Catalogue No. 21,494 in the United States

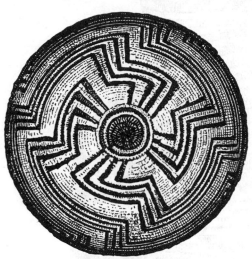

National Museum,
was collected in Ari-
zona by Dr. J. B.
White, United States
Army.

Fig. 194 is a design
on a coiled basket bowl
of the Apache. The
foundation of the bowl
is the rod-and-splint
pattern, and the sew-
ing passes over it, un-
der the splints of the
coil below, the stitches
interlocking. The de-
sign is in *Martynia
louisiana*. The ap-

FIG. 194.
COILED BASKET BOWL.
Apache Indians.
Collected by J. B. White.

parently unsystematic ornamentation is, in fact, perfectly
regular. Four lines of black stitching, of the same
lengths in each of four groups, proceed from a black ring
around the center. From the ends of these lines the sewing
is to the left in regular curves. The four radiating lines are
repeated, and then the curved lines until the border is reached.
The suggestion of lightning or the limbs of some insect has
been made, but the design has not been explained by any
basketmaker.

This specimen, Catalogue No. 21,493 in the United States
National Museum, was collected in Arizona by Dr. J. B. White,
United States Army.

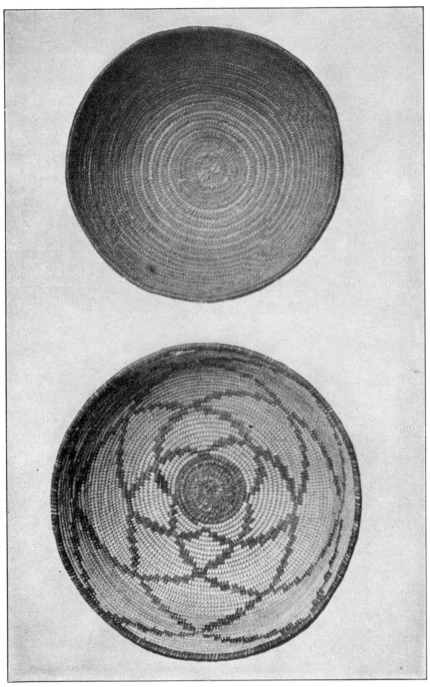

Plate 226. See page 463

COILED BOWLS OF THE WHITE MOUNTAIN APACHE, ARIZONA

Collections of U. S. National Museum

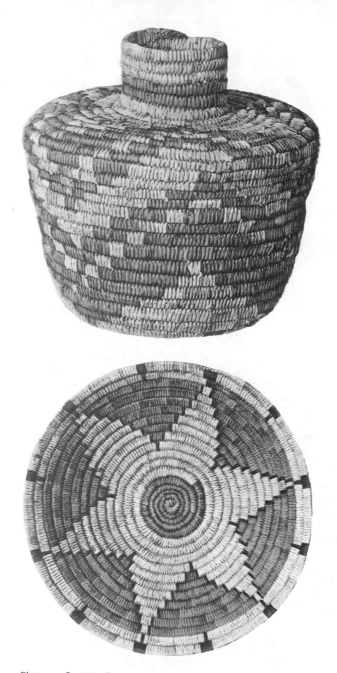

Plate 227. See page 467

Mescalero Coiled Baskets

Showing a surprising adaptation of the shades of the material to form an artistic design, shown in the upper figure. The lower figure is a conventional design which also shows careful selection of materials.

Collected by Walter Hough

Plate 227 represents a jar and a plaque by the Mescalero Apache Indians of New Mexico, collected by Dr. Walter Hough, Catalogue Nos. 204,651 and 204,646 in the United States National Museum. Especial attention is directed to the width of the coils in these baskets. It will be remembered

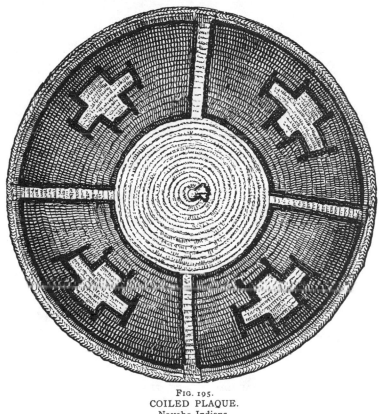

FIG. 195.
COILED PLAQUE.
Navaho Indians.

that the Fraser River tribes in British Columbia obtained an economical result of widening coils by the introduction of narrow strips of wood instead of roots or bundles of grass for the foundation. These Apache Indians have also discovered that using two or more rods, one lying on the top of the other, will give the same result. The stitches in yucca also, instead of passing underneath a rod in the coil below, are simply inter-

locked with the stitches underneath. The ornamentation is
produced by different colours of the same substance. The
outside of the leaf is green in different shades, but the inside of
the split leaf is white. By exposing the inside or the outside
the angular ornamentation results. In such wide foundation

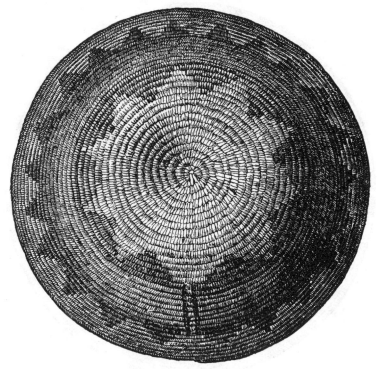

FIG. 196.
SACRED BASKET TRAY.
Navaho Indians.
Collected by Governor Arny.

the designs must be very simple. The dark lines in the lower
figure are produced by using the small roots of the same plant
in sewing. This fiber is very much more brittle than the leaf.
Comparing these two examples with the plaques of the Hopi
Indians demonstrates better than any other figures yet em-
ployed the limitations of the basketmaker in the very ele-
ments of ornamentation. Each separate part of the mosaic

is a long stitch, set vertically in the jar and radially on the plaque or bowl. From this the basketmaker can not escape.

Fig. 195 is labelled a coiled plaque of the Navaho. In this example the foundation is a single rod. The body colour of the bowl is that of the wood. The ornamentation is in splints of rhus dyed mahogany brown and black, and consists of four quadrants, in each of which is a cross-shaped figure. The boundary of the space is black, filled in with brown. The figure is in the colour of the wood and has a black border. In the sewing, the stitches simply interlock with those underneath. The border of the spec-
imen is worthy of study, being what is called elsewhere false braid. The Apaches, on the contrary, make borders in plain coil. Catalogue No. 16,510 in the United States National Museum was collected in 1873 by Governor Arny, of New Mexico.

<center>Fig. 197.
BORDER OF FIG 196</center>

Plate 228 is a collection of Navaho sacred basket drums belonging to C. P. Wilcomb. Baskets attributed to the Navaho are extremly uniform in every respect. On the author-ity of Dr. Washington Matthews, the sewing-material is splints of sumac (*Rhus aromatica*). Some Indians told Dr. Hough that a species of willow growing along the washes is some-times used. The stitches in the sewing simply interlock, and there is no attempt made to pass into the foundation of the coil underneath. The borders are in false braid passing by a figure "8" movement under the foundation and over the outer margin. In the ancient days a Navaho woman invented this pretty border. She was seated under a juniper tree fin-ishing her work in the old, plain way, when the god Hastse-yath threw a small spray of juniper into her basket. Happy

thought! She imitated the fold of the leaves on the border and the invention was complete (Matthews).

The decoration also of the Navaho baskets is in designs taking the form of bands for their sacred drums (fig. 196) and of crosses (fig. 195) for their sacred meal baskets. The coloured bands on the drums are founded on a central stripe which may be light or dark, and from the borders project variously notched or angular figures. The one characteristic to which attention is always directed in this ware is the break in the band. It is mentioned elsewhere on the authority of Matthews that a line drawn from the center of the basket through this open pathway will end at the point where the basket was finished off, and when it is used as a drum this is the point where the hand of the medicine man must be placed in the plaque, the radial line pointing eastward. Another interpretation of this, which can not here be proven, is that this break in the ornamentation has something to do with the passing backward and forward of the spirit of the basket, as in the Pueblo pottery decoration.* (See figs. 196 and 197.)

Dr. Ales Hrdlicka writes that the Hualapai and Havasupai, although associated with the Yuman family linguistically, are decidedly one with the Apaches in physical characteristics.

Their basketry, therefore, will have to be compared to that of the Apaches, and not that of the Mission Indians of southern California, who are Yuman. The foundation is a solid stem with a welt. The sewing is done with splints of willow, and also now with those made from the young and tender suckers from the cottonwood tree, from 2 to 3 feet in length.

The Hualapai baskets are made in white or green fiber and ornamented with two kinds of red or with black fibers. Dyes are very rarely used. The green fiber is from a bush called Ke-the-é, growing in the mountains; the brownish-red

* See Washington Matthews, The Night Chant, a Navaho Ceremony. Memoirs of the American Museum of Natural History, VI, pp. 1–332, New York, 1902.

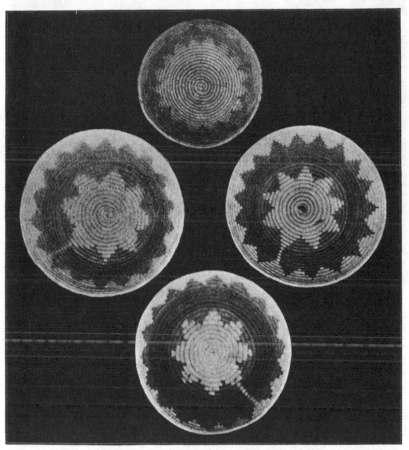

Plate 228. See page 469

CEREMONIAL BASKETS OF THE NAVAHO, ARIZONA

Photograph from Mrs. I. H. Kirkpatrick

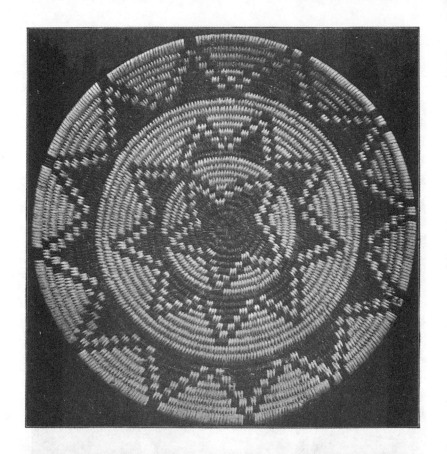

Plate 229. See page 471
COILED BASKET OF THE KOHONINO, ARIZONA, SHOWING METHOD
OF FINISHING OFF
Collection of A. Hrdlicka

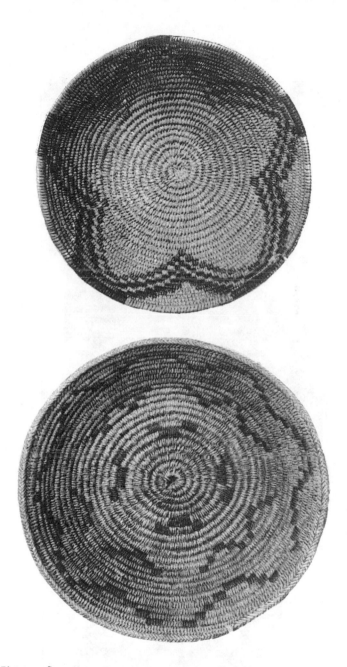

Plate 230. See page 471

HAVASUPAI COILED BOWLS

Old Havasupai basketwork was bartered with the Hopi, who valued them as heirlooms, though often they may be found in use around the mealing troughs, or filled high with meal and placed on a shelf.

Collected by Walter Hough

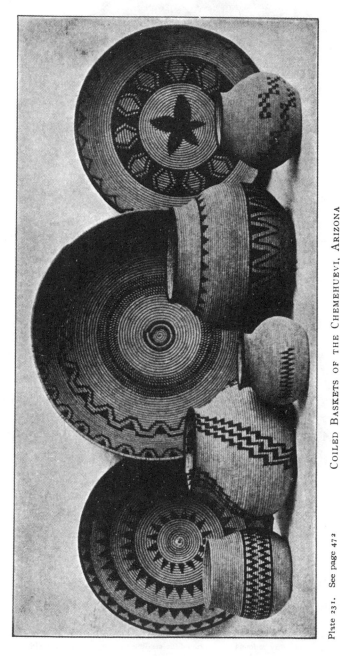

Plate 231. See page 472

COILED BASKETS OF THE CHEMEHUEVI, ARIZONA

Collections of U. S. National Museum

fibers are roots (Mi-s'-ma) of a yucca-like plant called M'-nat; the black fiber is from the martynia. A brighter red fiber is from the root of the Ma-k'-tu-na, a small plant growing in the mountains. The white ribs and splints are from reeds known as Ke-he-é, or K'-he-e-he-vak, the former also occasionally from reeds called Ma-tha-ki.

The Hualapai make five varieties of baskets. They are:

1. A shallow, undecorated plaque, for general household purposes. It also serves for parching seeds. It is nearly always lined with pitch on the inside, which protects it from charcoal.

2. A large cone-shaped carrying basket, called Ka-thak. This variety is almost always decorated with narrow bands or isolated geometric figures in black or brown. The weaving is better than on No. 1, but is not water-tight.

3. The third variety, both for household use and in better style, with more decoration, made for sale, is flat-bottomed, with globular or cylindrical body, slightly narrowing in its upper third, and in some places flaring a little at the border.

4. The fourth variety is the water bottles, of various shapes, most often globose in body and tapering into a narrow neck. Covered inside and outside with brownish pitch.

5. A much better made and more profusely decorated variety is in the form of a small, shallow plaque.

Plate 229 represents a Kohonino (Yuman) coiled basket. While the coiling is going on, the ends of the splints are left projecting. They are trimmed off all at once, when the sewing is finished.

Plate 230, fig. 2, represents a Havasupai coiled basket bowl. The foundation is of rods and splints of willow, and the sewing is the same. The most interesting feature is the border. It is false braid in which two rows of the coil are involved. A single splint passes down and includes both foundations, up, over, and under the upper foundation only, then back and under both to the point of beginning. This is an

old specimen that had been in the possession of a family for many years. From the Sichomovi (Hopi) Pueblo, made by the Havasupai (Yuman) Indians, collected by Dr. Walter Hough.

The Apache-Yuma basketmakers at Palomas, Arizona, sit in front of their brush and straw shelters the same as the Pimas, hold the right side of the plaque or bowl inward, and work their sewing toward the left hand. (G. C. Simms, Field Columbian Museum.)

The Mohave Indians (Yuman family) do not make baskets, but obtain them from other tribes, and examples will be found in every house. They obtain their rabbit-skin robes, done in twined weaving, from Paiutes (Shoshonean family) and Walapai (Yuman family). The Mohaves make constant use of the wrapped weaving. (See page 67 and Plate 17.)

The Chemehuevi are Shoshonean linguistically, and are now located on the Colorado River Agency, Arizona. They make coiled baskets. The foundation is a rod, and the sewing is done with willow or other splints, maybe cottonwood. The black figures are from the pods of martynia. Only two colours are used; frequently, however, feathers are introduced under the stitches. They are the most tastefully made and the most beautiful baskets in that whole region. Catalogue No. 211,028 is a Chemehuevi plaque in the National Museum, collected by Captain Paul B. Carter, U.S.A. The ornamentation consists of a black center and two bands done in martynia pod. The surface is covered with a network of rhombs. Plate 231 is a collection of Chemehuevi plaques and jars in coiled weaving now in the United States National Museum. Especial attention is called to the purely geometric figures on the surface, star, toothed lines, rhombs in bands, crenelated and serrated lines in great variety. In the central figure the middle band recalls the design, a modification of which becomes the well-known flying butterfly pattern. (See Plate 195.)

The tribes of the Piman family are in two groups, the

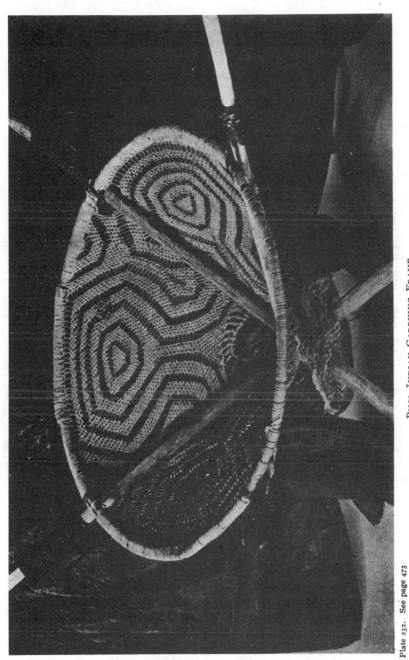

Plate 232. See page 473

PIMA INDIAN CARRYING FRAME
Collected by Frank Russell

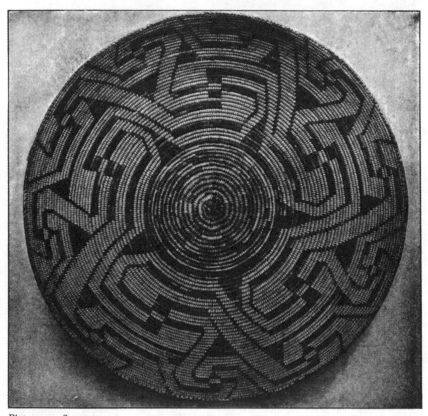

Plate 233. See page 478
OLD COILED BOWL OF THE PIMAS, ARIZONA. DESIGNS IN COMPLEX
FRETWORK

Collection of C. E. Rumsey

northern, including Opata, Papago, and Pima proper; and
the southern, including Cahita, Cora, Tarahumara, and Tepe-
huana, wholly confined to Mexico. By many scholars the
Piman family would be made part of the great Uto-Aztecan.

The Piman basketry is unmistakable. The foundation
is of split cattail stems (*Typha latifolia*), and the sewing is with
willow (*Salix nigra*) and pods of
martynia, but the stitches are so fine
and the work so uniform that the
surface is not rugose, but smooth.
The Pima decoration is the exuber-
ance of fretwork. In the National
Museum are many old pieces brought
home by Army officers. Edward
Palmer also collected many, and
recently Dr. Frank Russell has en-
riched the collections with material
which will be the subject of a special
monograph. Coiled work without
foundation finds application among
the Pima in the network which sup-
ports their gourd receptacles. (See
fig. 198.)

It has been said that basket-mak-
ing was introduced among the Pima
100 years ago, when the Maricopa
sought shelter among them from the slaughter of the Yuma.
At that time the Pima made pottery only. On the other
hand, the Maricopa allowed basket-making to fall into disuse,
and now make pottery only. The Mohave, Pima, and Papago
make matting in twilled work, and also carrying frames
covered with rude coiled lace. (See Plate 232.) A
beautiful example of the last named is in the National
Museum, collected for the Bureau of American Ethnology by
Frank Russell.

They had no pails or vessels of wood, but were not slow to invent. They, therefore, took willows, which grow in abundance along the river, and a reed, and stripped the bark, then very adroitly split these with their teeth and wove them so closely together as to hold water. This they accomplished by means of needles or thorns of cactus, of which there are over one hundred varieties in this territory. They used these baskets while digging small ditches, the women filling them with earth and carrying them up the bank.*

Catalogue No. 76,033, United States National Museum (see fig. 100), is a carrying basket (child's) of the Pima Indians, a pyramidal bag netted of the fiber of the agave; at the vertex is an opening 3 inches in diameter. The base is attached to a hoop by a string of agave fiber, with which the hoop is served; the bag is decorated with fretted work painted black and red. Two stems of the *Cereus giganteus*, 34½ inches long and ½ inch in diameter, are passed from the outside of the hoop to the inside of the bag, 10 inches apart, thence down till they pass through the opening in the vertex; at this point they cross each other at an acute angle and extend 7½ inches beyond; two other stems, 14 inches long, are passed into the bag, in front, in the same way, 9 inches apart, and their ends stop at the crossing of the other sticks; at this point the four are firmly lashed together and the margin of the bag at the vertex opening is fastened to the sticks.

Where the sticks enter the bag the hoop is tied to them by a cord of black horsehair; these also serve to tie the load in the basket. Near the bottom, a small brace of wood is passed through the meshes of the bag and in front of the sticks on either side, to give it additional strength. A piece of matting of split reeds, 16 by 7 inches, is attached to the back of the basket to protect the body of the carrier.

A strong cord of twisted agave fiber, 3 feet long, is looped around the vertex; the ends passed along the posterior sticks, outside the bag, are fastened to the sticks by a loop of fiber.

* Isaac T. Whittemore, Among the Pimas, p. 53, Albany, N. Y., 1893.

Above, the ends are attached to the forehead band, woven from the softened fiber of the *Yucca baccata;* it is double, and 7 inches long and 2 inches wide. The staff is of wood 21 inches long and ½ inch in diameter, painted red, ornamented at upper end with buckskin strings, and served with agave twine; the upper end is notched. The staff is also used to support the basket in an upright position when it is unslung. (See figs. 100 and 106.) Width above, transverse, 13 inches; antero-posterior, 11 inches; depth behind, 11½ inches; front, 7¼ inches. Collected by Edward Palmer. This peculiar l a c e w o r k e x i s t s also among Maricopas, Papagos, and Coras.

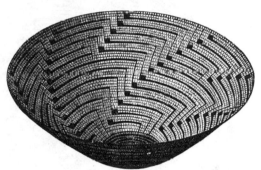

FIG. 199.
COILED BOWL.
Pima Indians.
Collected by Edward Palmer.

Fig. 199 is a coiled bowl of the Pimas. The f o u n d a t i o n is made of grass stems or cattail, and the sewing is done with narrow and uniform splints of cottonwood or willow, the black figures being worked in with martynia. The puzzling and intricate ornamentation is reducible to a few most simple elements, and easy of construction. Four series of vertical lines start from the black bottom. At uniform distances from the beginning, all the way out to the rim, horizontal lines proceed to the left, terminating in small black squares. It can easily be seen that, while the vertical lines are narrow and depend upon the width of the stitches, the horizontal lines must necessarily be as wide as the rows of sewing. About two-thirds of the way from the beginning a new set of zigzags is started, and this is continued to the outer margin.

This specimen, Catalogue No. 9,376 in the United States

National Museum, was procured in Arizona by Edward Palmer, and is figured by Holmes.*

Fig. 200 is a coiled basket bowl of the Pima Indians. The foundation is of shredded material and the sewing is in splints of willow. The decoration is in three series, as follows: Bot-

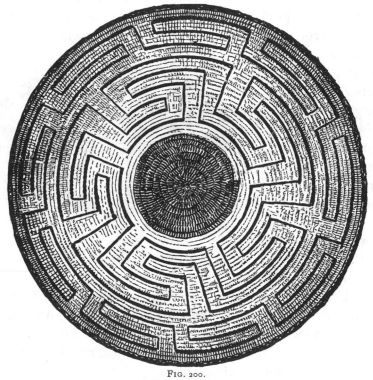

Fig. 200.
COILED BOWL.
Pima Indians.
Collected by Edward Palmer.

tom, solid black; the main portion of the body is a double row of fretwork in single lines of black; on the upper margin is a single row of fretwork. The up-and-down-lines in this work are partly perpendicular and partly sloping to adjust themselves to the widening of the basket. On the extreme

* Sixth Annual Report of the Bureau of Ethnology, 1888, p. 220, fig. 322.

edge, as a finish to the basket, is a false braid in black martynia.

Fig. 201 is a coiled basket bowl of the Pima Indians. The foundation is in shredded material of rush, the sewing in willow and martynia. The ornamentation consists of a black

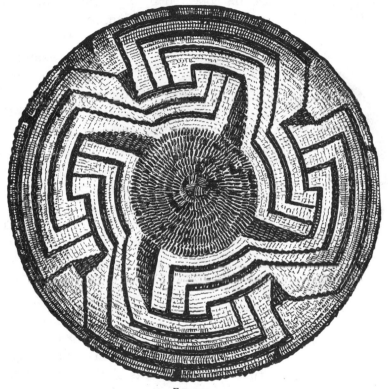

FIG. 201.
COILED BOWL.
Pima Indians.
Collected by Edward Palmer.

bottom, out of which rise four right-angle triangles, to which is attached a curious fretwork made up of L-shaped elements. There are a number of smaller right-angle triangles worked into the figures at various points, showing that this is a constant idea in the mind of the manufacturer. Diameter, 12¼ inches; height, 4¾ inches.

This specimen, Catalogue No. 76,040 in the United States National Museum, was collected, with many others, in Arizona, by Edward Palmer. Plate 233 is a piece of the same type from the collection of C. E. Rumsey.

Plate 234 represents two Pima basket bowls in the United States National Museum, collected by Dr. Frank Russell, of the Bureau of Ethnology. The foundation, sewing, and bor-

FIG. 202.
COILED BOWL.
Pima Indians.
Collected by Edward Palmer.

der are the same as in other examples. This plate is introduced for the purpose of showing how the basketmaker works out a series of concentric figures whose elements are straight lines mixed with segments of circles. The lower figure is based on a circle in black from which four points project. The concentric rings are based upon this fundamental figure

absolutely. From the points, segments of circles increase in length as they proceed outward. From the concave quarter of the central figure circular segments decrease in length as they proceed outward, and the ends of these two sets of segments are connected by ragged straight lines. Finally, the spaces at the four quarters on the rim are filled with small triangles in black. Could anything be more artistic than this association of the simplest elements in basket-weaving?

The upper figure is on the same sort of foundation, only concentric segments alternate with series of rectangles arranged

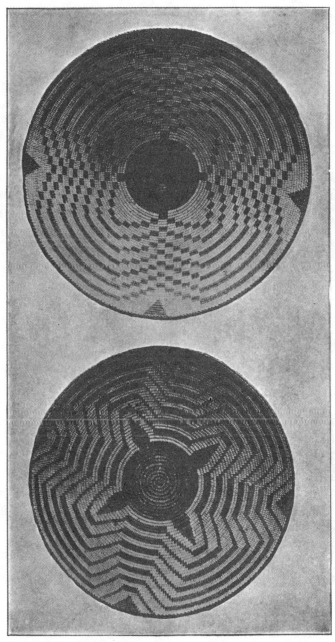

Plate 234. See page 478
COILED BOWLS OF THE PIMAS, ARIZONA
Collections of U. S. National Museum

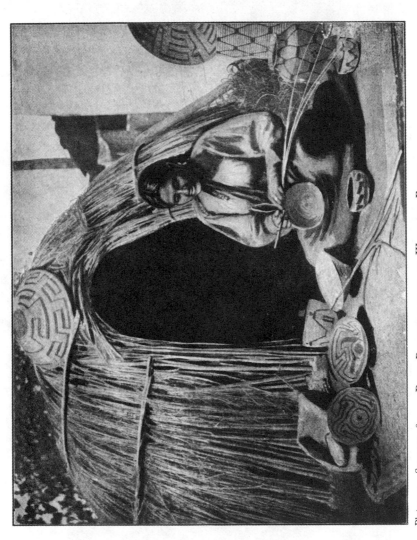

Plate 235. See page 480 PIMA BASKET-MAKER AT WORK IN FRONT
OF HER DWELLING, ARIZONA

Photographed by J. W. Benham

in checker patterns. These rectangles are all the same size, and are based on the four quarters projecting from the black circle. The widening of the pattern is all accomplished by the lengthening of the circular segments.*

Fig. 202 is a coiled basket bowl of the Pima Indians, Piman family, in southern Arizona. The foundation of the coil is

FIG. 203.
COILED GRANARY.
Pima Indians.
Collected by Edward Palmer.

in stems of finely shredded fiber of cattail (*Typha latifolia*). The sewing is in splints of willow, the stitches passing over the foundation and interlocking with those underneath. The sewing material is somewhat rigid, so that the stitches are not pressed home and the foundation shows between. Many of

* Frank Russell, Annual Report of the Bureau of Ethnology (in preparation).

the stitches are split is the sewing, but it does not appear that it is systematically done for the purpose of ornamentation, as is the case with the Salish and Klikitat tribes of the farther north. The designs are in splints of martynia pod. The elements of decoration are in threes, and doubtless have symbolic meanings, but these are not known. Diameter, 11¼ inches; height, 3½ inches.

This specimen, Catalogue No. 5,548 in the United States National Museum, was collected in Arizona by the veteran explorer, Edward Palmer.

Fig. 203 is a small granary of the Pima Indians, Piman family, in coiled work. The foundation is a bundle of wheat straw averaging about half an inch in diameter. The sewing is done in willow bark, the strips varying in width from a quarter to half an inch. No attempt is made to crowd the sewing-material so as to hide the foundation; indeed, this would be impossible because of the width of the willow bark. The effect on the surface is to produce almost perpendicular lines from the center to the border. New rows are added as the coils enlarge.

The Pima Indians live partly on vegetable diet, the fruit of the mesquit and of other plants, and they use the granary baskets on platforms for the purpose of keeping the dried material out of the way of rodents.

To make the detail structure more clear, a square inch is given in fig. 57.

This specimen, Catalogue No. 76,046 in the United States National Museum, was collected in Arizona by Edward Palmer.

Plate 235 represents a Pima basketmaker. The Piman family have been supposed to be the connecting link between the Shoshonean of the Great Interior Basin and the Aztec or Nahuatl family of Mexico. In their present situation, however, they are cut off from the northern Shoshonean by the extension of the Yuman family.

MIDDLE AND SOUTH AMERICA

This genius (Clotho) led the souls first to cloths, and drew
them within the revolution of the spindle impelled by the hand.—
PLATO'S REPUBLIC

On the border line between the Republic of Mexico and
the United States is a transition between the standard forms
which have hitherto been studied and the more open
types of lacework and loomwork. Coiled basketry of
well-known varieties continues on southward, both in
the lowlands and in the mountainous regions, to within
a few miles of the City of Mexico. Variations from these
types are also in evidence, both coiled and twined, the
former predominating. Foundations of grass more than
an inch thick are built into immense baskets for carry-
ing, and also into granaries for holding the crops of
seeds and nuts, the sewing being done with wide strips
of bark, wood, and leaves. Taking these coarse baskets
for a motive, smaller and finer ones are done in better
material, but still the stitches are half an inch apart.
There is no occasion for surprise in this, since the linguistic
families which are represented in Arizona, New Mexico, and
California are also continued into the Republic of Mexico.
In this area the student is clearly "within the revolution of
the spindle." In addition to the coiled work just mentioned
will be found coiling of the hammock type, and, interesting
to know, the Chippewa on Lake Superior and the Loucheux
type on the Mackenzie River are here reproduced in the carry-
ing basket (see fig. 106). Starting out from very plain,
coarse varieties of this work, it passes on into the lacework
and netted burden baskets of the Pima, Papago, and Mohave.
(See Plate 232.) The figures wrought into the lacework bas-
kets are the same as are to be seen in the labyrinthian pat-
terns on the basket bowls of the Pima. Quite as interesting
as any of these types, the wrapped weaving before described

is found in burden baskets of the Yuma tribes.* It must be recalled at this point, however, that Hudson mentions the same style of workmanship among the Pomo Indians for roof building and traps, and W. H. Holmes brought from California a framework for carrying birds in which the rods are held in place by a similar wrapping. There is also in the National Museum an old coarse mortar basket made of sticks which are bound together in the same way. A great deal of twilled and wicker work comes from the neighbourhood of the City of Mexico and from Central America, and a species of coiled sewing which exists sporadically all the way from the Arctic Ocean to the Strait of Magellan. The stitch, in addition to passing around the foundations to hold them together, also makes a wrap about the standing part between the coils. Modern coiled ware in great quantities is made up from agave fiber of fine quality, but it resembles African work more than American. A variety of forms and uses exists in baskets in Mexico; among others, the immense hats. The Caribs on the Mosquito coast of Nicaragua are said to have plaited a pretty water-tight basket of reeds, called "patapee," but these people had been in touch with natives of Africa, who knew how to make water-tight baskets from the time of Moses, at least. The Tlaxcala Indians used twined weaving in making slings. Types of work just mentioned continue on into the Central American States. No account is here made of the fine weaving and needlework, in which typical and extraordinary patterns are wrought, because they are across the boundary line, and are no longer in the family of basketry made merely by hand without machinery.

Twined basketry and matting are preserved in the Peabody Museum from prehistoric burial caves in Coahuila,

* To bring together the net-like fiber of this area, the following list will be helpful: (1) The common coil without foundation is universal; (2) The wrapped work, Diegueños, Coahuillas, Mohaves, and other Yuman tribes; (3) Lace work—Pimas, Papagos, Maricopas, and Coras; (4) Netted or knotted carrying receptacles, Mohaves.

Plate 236.　See page 483　COVERED PLUME BASKET, TARAHUMARA INDIANS,
MEXICO

Collections of U. S. National Museum

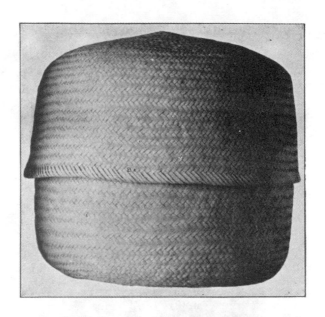

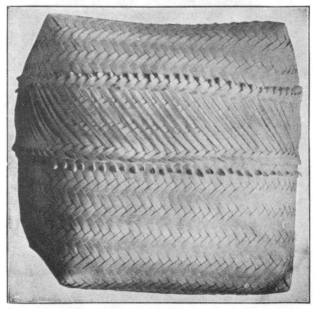

Plate 237. See page 483
YAQUI COVERED BASKETS IN DOUBLE TWILLED
WEAVING, SONORA, MEX.
From negatives in Am. Mus. of Nat. Hist., N. Y.

Mexico; among the Tlaxcala Indians (Nahuatlan family) in Central Mexico; from prehistoric graves at Ancon, Peru, and Arica, Chile; from graves at Pisaqua, Chile; from the Guatos Indians (Tapuyan family), in southern Brazil, and from the Cadioes Indians (Guaycuruan family), on the Paragua River. (C. C. Willoughby.)

Plate 236, United States National Museum, was brought by Frank Russell from Tarahumara Indians of northern Mexico. It is in the form of the so-called "telescope trunk," and old specimens of the National Museum were collected many years ago by Edward Palmer. The material is a kind of rush, and the weaving is in twilled work. Such baskets are employed for holding all sorts of useful articles, but especially in connection with religious practices they are the depository of charms and fetish objects.

The Yaquis, of Sonora, Mexico, says Palmer, split the stems of *Arundinaria* for basketry by pounding them carefully with stones. The reeds divide along the lines of least resistance into splints of varying width, which are assorted and used in different textures. They now manufacture to order floor mats, porch screens, and the like, and sell them in Guaymas.

Dr. Hrdlicka spent much time among the Yaquis and brought a varied collection of their basketry to the American Museum of Natural History. They make several varieties, all in twilled weaving. The coarsest are for household use, and have no covers. They are usually quadrilateral, and measure up to twenty-four inches in length. Examples of much finer quality serve for the holding of small objects. These are made in several forms, probably the rarest being cylindrical and covered, never exceeding eighteen inches in diameter. Plate 237 shows two of the specimens mentioned above. They are in narrow splints of the yucca palm of Sonora, and the weaving is double. The work was begun at the bottom, built up to the border, and the process reversed so as to make

another fine basket outside and closely adhering to the first. A more common variety, of better form, is found in many sizes up to twelve inches in height or diameter. They are not double throughout, but a broad decorative band, made of a second layer of fibers, is added to the outside of the body and of the cover. Double baskets are also made in bottle shape, of various sizes, with covers. They are doubtless made for sale. Dr. Hrdlicka obtained a number from Yaqui captives—women confined at Guadalajara. Charming decorative effects are produced on them by the fineness of the filaments, the regularity of the technic, and variations in the twilled weaving. The Yaqui hats are broad-brimmed, with semiglobular tops, all in twilled weaving, and some are of fine quality. They are, in most examples, double, and similar to the *bottles* in the variations of technic.

The Huichole Indians, living in the State of Salisco, Mexico, belong to the Aztecan branch of the great Shoshonean family. They have been described, among others, by Lumholtz, and are living in a state of native simplicity. The few baskets that they make are in twilled weaving, with covers, and are 18 inches or less in length, 4 to 6 in width, and the same in height. Used chiefly to hold ceremonial objects. Similar baskets are woven by the Tarahumara (Piman), State of Chihuahua, and also by the Tepehuanos (Piman) in Durango. These low, tray-shaped, rectangular baskets, with covers, are the common packing cases among these tribes of northern Mexico mentioned. (Hrdlicka.)

A wicker basket from Santa Maria del Rio, fourteen leagues south of San Luis Potosi, Mexico, is Catalogue No. 76,925, United States National Museum, made from the prepared stems of willow. The weaving is not after the fashion of the common market basket, but its parts are worked spirally in such manner that the smaller ends of the stems terminate in a braided band around the top of the body. (Compare fig. 190.) This arrangement reminds one of Dr. Matthews's

Study in Butts and Tips.* The warp consists of groups of fine stems arranged in fours. As the bottom is oblong, five of the groups pass straight across it widthwise, while at the ends others radiate from the foci of the ellipse. The weft of the bottom is formed by means of fourteen stems, seven of which run in one direction and seven in the other, the smaller ends being fastened off on the border. The body is built up in the same way. In the ordinary wicker basket a stem is woven among the warps, and when the end is reached another stem takes its place, and so on; but in this example all the weft stems of the body begin at the very bottom and are wound in a spiral up to the upper margin. At this border, the warp stems arc all bent to the right for an inch and a half and then turned back again, being intertwined in a sort of openwork diagonal weaving. To form the handle, seven stems on each side are thrust between the weft, and these bundles are wrapped about each other to form the twisted handle, the smaller ends being deflected so that the ends of the stems which form the body and the ends of the handle and the stems of the body are all woven together to form the braid work at the top. Collected by Edward Palmer.

H. Ling Roth, in his paper on the aborigines of Hispaniola,† says that, although none of the histories make reference to the island in which baskets were manufactured, nor even to the material out of which they are made, there is occasional mention of them, proving that formerly, as now, the Caribs and their tribes knew how to weave basketwork. The Spaniards, both in Hispaniola and Cuba, on several occasions found men's heads cut off and sewed up with great care in small baskets. He quotes Benzoni in speaking of a feast in which baskets were adorned with roses and various flowers. Columbus found baskets, in Guadeloupe, full of men's bones.

* American Anthropologist, Washington, V, 1892, pp. 345-350.
† Journal of the Anthropological Institute of Great Britain and Ireland, XVI, p. 283.

A glance at the map of northern South America shows how easy it is to pass from the Windward Islands up the Orinoco and over the drainage of the Rio Negro, down to the Amazon. On this central position it is not difficult to make communication with the highlands of middle Brazil, Bolivia, eastern Peru, and Ecuador, and to pass from the Xingu River to Paraguay is easy. This explanation will clear the way for the collection of baskets now to be described.

The seventieth parallel from Greenwich may be used to divide South America into east and west basketry sub-areas. The West Indies will be counted with the eastern portions. The few widespread linguistic families serve as a bond to hold the tribes in mind. At the extreme north, the Carib and the Arawak are conspicuous; the Tupi-Guarani and the Geez answer for Brazil; over the Amazon watershed, the La Plata areas, the Gran Chaco tribes follow. Patagonia and Fuegia complete the series. Over a large portion of this eastern region the types of weaving practised in the southern States of the Union prevail. On the western side of the continent, in the Andean valleys, the basketry is more varied and interesting, as the description and illustrations will show. The information which follows is far from complete. The little said will serve at least as a starting point, and show that, aboriginally and technically, there was only one America.

Plate 238 shows an Indian woman standing in front of the agave plant—a fitting combination, since in Mexico, Central America, and northern portions of South America the agave is to the native population an enduring friend. In modern industries it has not lost its influence. The lechiguilla, ixtl, sisal, and other standard fibers are therefrom. In old times it was the substance from which receptacles, clothing, parts of household utensils and conveniences, and many other useful things were made. The figure standing in front of the plant might be called the Clotho of the agave, whose

Plate 238. See page 486

INDIAN BASKET-MAKER STANDING IN FRONT OF HER PLANT,
VENEZUELA

Photograph from R. Bartleman

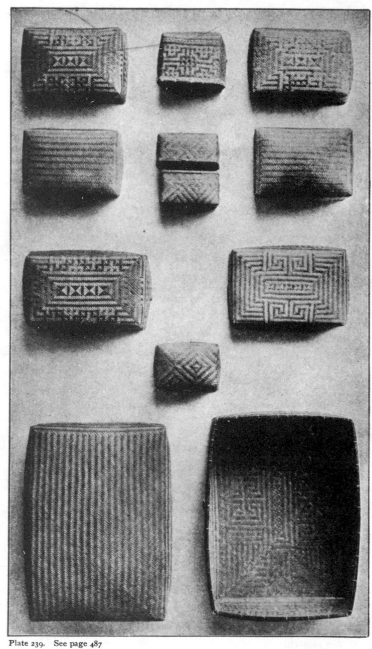

Plate 239. See page 487

TWILLED BASKETRY OF THE ARAWAK INDIANS, BRITISH GUIANA

Collected by R. Figyelmesey, for U. S. National Museum

skilful fingers will turn the ideal plant into many supplies of wants.

Baskets from British Guiana are like those described by E. F. im Thurn in his work entitled Among the Indians of British Guiana. The specimens in the National Museum are all of the twilled pattern, wrought from a brown vegetable fiber that shows the same on both sides. This twill is used with good effect in the diagonally woven cassava strainers, widely distributed, which may be contracted in length by a corresponding increase of width. When the cassava is packed into this strainer the latter is suspended and a great weight fastened to the bottom. The same device is used among us by country housewives in making curds. There is an entire lack of gaudy dyes in the Guiana baskets, the only colours being the natural hue of the wood and a jet-black varnish. The gorgeous plumage of the birds replaces the dyes in ornamentation. (See Plate 239.)

The material used for basketwork among the Indians of Guiana is the split stem of a kind of maranta (*Ischnosiphon*) called iturite by the Indians. For rough work, other species of iturite are used, and for the roughest of all the unsplit stems of certain creepers, especially one called by the Indians mamamoorie (*Carludovica plumierii*).

The so-called pegalls (packalls) are generally square. The basket and lid are the same shape; the latter, being larger, slips over the former and entirely covers it. Many Caribs make their pegalls of an oblong shape, with gracefully curved lines, and adorn them with long strings of thick, white cotton on which are knots of coloured feathers. Sometimes the true Caribs make the pegall and lid double, and between the two layers of basketwork certain leaves (*Ischnosiphon*) are inserted to make the whole waterproof. Here is another example of double weaving noted in several parts of North America.

Another basket, shaped like a slipper, is the suriana, for carrying heavy loads. This useful form has a wide distribu-

tion, being seen in Guatemala. The "quake," another basket, is used for storing provisions. It also serves as a cage. It is made of open wickerwork, with a rounded bottom. Most of the baskets are manufactured in the same way and of the same material. The Nikari karus, living on the Brazilian borders, make their pegalls of the leaves of the palm (*Orbigna*), very rare in British Guiana. These are square or oblong.*

Plates 240 and 241 are from photographs presented by the distinguished ethnologist, Dr. Carl von den Steinen. They represent carrying baskets from eastern Brazil in the collection of the Berlin Ethnographic Museum. In order to bring the structure into comparison, baskets of the same functions were selected. The following descriptions, aided by the photographs, will make plain the structure.

Plate 240, fig. 1, is a carrying basket (hasiri) of the Jamamadi Indians, living on the Rio Purus, in the collection of Paul Ehrenreich. The warp is crossed, and the weft passes through the warp in regular order, so as to produce hexagonal openings. The border is formed by simply turning over the ends of the warp and weaving them backward. The head strap is a wide strip of inner bark. Prof. J. B. Steere collected for the United States National Museum a fine specimen of this same type of weaving of the Jamamadi, resembling, in fact, fig. 2 of this plate. (See Plate 95, fig. 5.)

Fig. 2 is a carrying basket (shibati) of the Hypurina Indians, living on the Rio Purus, collected by Paul Ehrenreich. The warp is crossed and the weaving is done as in fig. 1, but there are twice as many weft splints, the hexagonal spaces being crossed by them. The border is formed of a hoop of wood. Strips are attached to the side of the basket for strength, and string loops at the top for attachment of the head band, which is in tough inner bark of a tree, as in No. 1.

Fig. 3 is a carrying basket (koho) from the Paressi Indians,

* E. F. im Thurn, Among the Indians of British Guiana, p. 282, London, 1883.

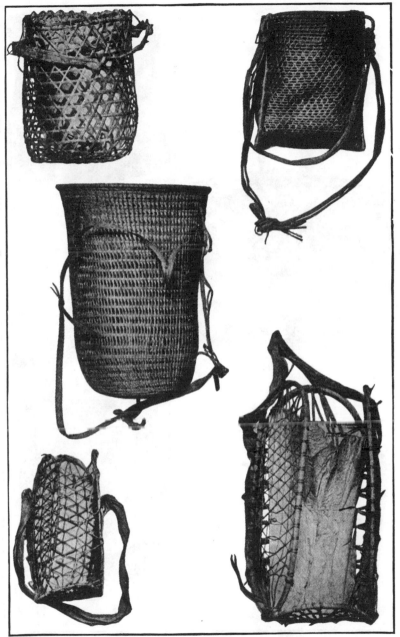

Plate 240. See page 488

I 2
3
4 5

DIFFERENT FORMS OF CARRYING BASKETS
OF BRAZILIAN TRIBES

Photograph from Carl von den Steinen, Berlin Museum of Ethnography

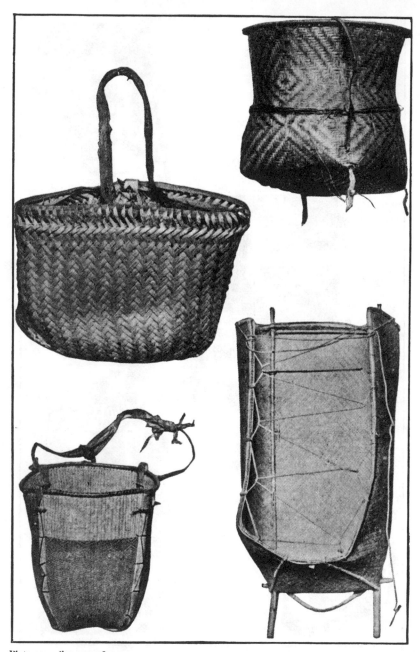

Plate 241. See page 489

DIFFERENT FORMS OF CARRYING BASKETS
OF BRAZILIAN TRIBES

Photograph from Carl von den Steinen, Berlin Museum of Ethnography

1
2
3 4

on the upper Tapajoz River, Brazil, in the collection of Dr. Carl von den Steinen. This is an elegant piece of work and worthy of study. One-half of the warp elements are vertical and the other inclined. The weft passes through the interstices formed by the crossed warp in twos and threes. At the top, a hoop is used for strengthening, the warp turned back and held firm by a single row of three-strand weaving. On the sides, a rope is attached to the weft elements for loops, and the head band is made, as in the other specimens, from the tough inner bark of a tree.

Fig. 4 is a child's carrying basket (mayaku) of the Bakairi Indians, on the upper Xingu River, Brazil, and fig. 5, an example for adults by the same tribe, from the collection of Dr. von den Steinen. They are made of four elongated hoops of wood. One furnishes the bed or bottom of the frame, two others the sides, and the smaller one the end. Those who are accustomed to studying utensils used in transportation will recognise in these two frames African forms. They are not basketwork, either of them, in the strict sense of the word, since the webbing which fills up the hoops is true network of string; the crossings form regular knots. In both examples the head band is of bast or the inner bark of a tree, and in the larger the binding of the bottom is in the same material.

Plate 241, fig. 1, is a carrying basket (kodrabo) of the Bororo' Indians, on the Rio São Lourenço, Brazil, in the collection of Dr. von den Steinen. It is in palm leaf, in regular twilled weaving common throughout the world. The interesting portion, not to be overlooked, is the border, which is the midrib of the palm leaf, with the leaflets attached. The carrying band, or head band, as in other examples, is in tough inner bark of a tree.

Fig. 2 is a carrying basket of the Kabischi Indians, on the upper Xingu River, in the collection of Hermann Meyer, found in an abandoned camp. The weaving is in twilled work, forming rhomboidal patterns on the surface. The top of the

basket is round, and strengthened with a hoop. The bottom is square, held in shape by sticks, and carried by means of a head band of bark.

Fig. 3 is a carrying basket of the Kaingua Indians, on the Rio Alto Paraná, collected by Rohde Ambrosetti in southern Brazil. It is an elaborate specimen, built on a framework, with a round hoop at the top and two oxbow-shaped pieces of wood crossing under the bottom to give shape to the body. The upper part of the surface is in wickerwork. A band around the middle in twilled weaving is ornamented with rhomboidal patterns, and the lower part is also covered with wickerwork. The head band is in tough bark.

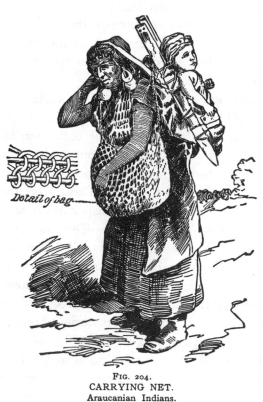

Detail of bag

FIG. 204.
CARRYING NET.
Araucanian Indians.

Fig. 4 is a carrying basket (apoi) made by the Warrau Indians, on the Rio Orinoco-Cuyuni in Guiana. The framework and covering are interesting on account of the distribution of this peculiar form, which may be found as far north as Guatemala and around the Caribbean Sea. The work is in twilled weaving, and the border is formed by strips of wood sewed to the upper edge. The head band is in two-strand rope.

Nieuhoff describes the Brazilian basketry of his day.*

The baskets of the Indians of southern Brazil are made of palm-tree leaves. They call them patigua. They have also some made of reed or of cane. These are with one general name called karamemoa. They make also large broad baskets of reeds and branches twisted together. These they call panaku, and are chiefly used for the carrying of the mandioka root. In their journeys they always make use of the patigua, but the panaku is used by the slaves and negroes in the Receif for the convenience of carriage.

The Guatos Indians in southern Brazil employ twined weaving in the manufacture of mantles, and the Cadricios Indians on the Paragua River make grass bags in the same technic.

The figure of an Araucanian woman acting as both freight

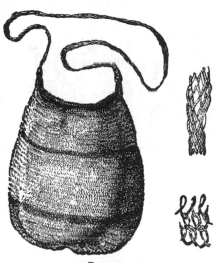

FIG. 205.
CARRYING NET.
Chiriqui, Columbia.

and passenger carrier is introduced from De Schryver† to show the extension of the button-hole stitch technic southward. The insertion of a foundation in coiled work is not common farther north, but will be again noted at the very extremity of the continent. (See fig. 204.) The basketry of South America reaches its southern limit in the Fuegian coiled ware with slight foundation and sewing in button-hole stitches, illustrated in Fig. 59.

Coming over to the western side of the continent, fig.

* Voyages in Brazil, in Churchill, II, p. 132.
† Simon de Schryver, Royaume d'Araucanie-Patagonie, 1887.

205 is a coiled carrying bag from Chiriqui, Colombia, and is
a type of an enormous amount of ware to be found in Middle
America, North America, and South America. It is repre-
sented in fig. 42, and is called in this monograph coiled work
without foundation. It will be seen, by looking at the detail,
that the twine constituting the fabric interlocks with the
stitch underneath and makes a complete revolution, catching
the next stitch, and so on. Without definite information on

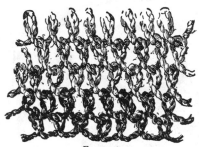

FIG. 206.
DETAIL OF FIG. 205.

the subject, it is believed that
in making these bags some
sort of a gauge is used by the
weaver—a small stick, which
may be slipped along as the
work proceeds.

The detail is shown in fig.
206, and especial attention is
called to the ornamental effect
of using a two-ply twine and
the additional decorative feature of having the twines in
different colours.

The fibers of the Middle Americans and Mexicans are of
the best kind and texture, and are used in hammocks and
for the most exacting labour in transportation.

An interesting example of the friendly coöperation between
the best material and the best workmen is to be found in the
Republic of Ecuador in the manufacture of the so-called
Panama hat. In August, 1900, Consul Perry M. de Leon,
of Guyaquil, gave the following account of it: The Manavi
(Panama) hat was first made in the province of Manavi,
Ecuador, about 275 years ago, by a native named Francisco
Delgado. The present centers of the industry are Monte
Cristi and Jipijapi in the province of Manavi, and Santa Elena
and Cuenca in the provinces of Guayas and Azuay, respec-
tively. They came to be known as Panama hats years ago,
when that city was a distributing center. Those who are

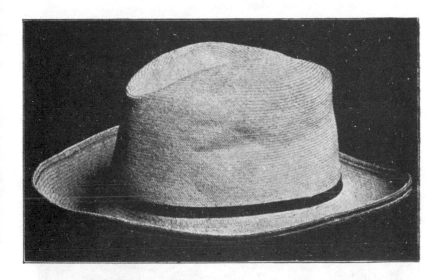

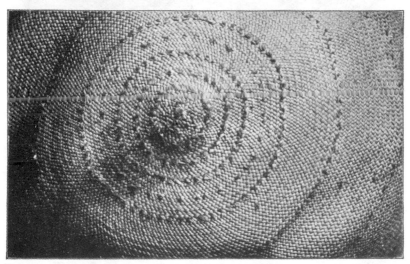

Plate 242. See page 493

ECUADOR, OR PANAMA. HAT OF PALM LEAF IN CHECKER WEAVING

Collection of S. O. Richey

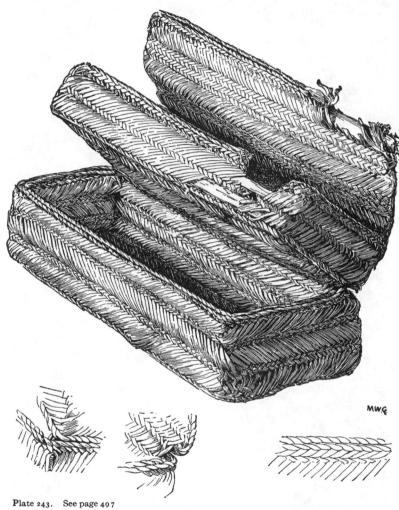

Plate 243. See page 497
ANCIENT WORK-BASKET OF PERUVIAN SPINNER IN FINE WOOL
Collections of U. S. National Museum

familiar with them can tell by the method of beginning the weaving at the center of the crown the locality where the work is done. In Ecuador, Colombia, and Central America the hat is known to the natives as the Jipijapi (pronounced hipi-hapi), but as they are made elsewhere in Ecuador, principally in the province of Manavi, and as the name is easy to pronounce, it might take the place of the present misleading appellation. (See Plate 242.)

They are made from a native species of palm (*Carludovica palmata*), cultivated in the provinces of Manavi and Guayas, and known as "paja toquilla." In appearance it resembles very much the saw palmetto, and is fan-like in shape. Low-lying wet land is selected and the seed planted in rows during the rainy season. When the plant attains a height of 4½ or 5 feet it is cut just before ripening. The leaves are boiled in hot water, and after being thoroughly sun-dried are assorted and ready for use.

The material is first carefully selected, dampened to make it pliable, then very finely divided into requisite widths, the little finger and thumb nail being used for the purpose. The very finest specimens are prepared from delicate leaves that need no splitting or stiffening. The plaiting begins at the apex of the crown, and is continued in circular form until the hat is finished. The story that they are made under water by candle light is untrue. The work is carried on while the atmosphere is humid, from about midnight to seven o'clock in the morning. At night the hat is hung out in the open air so that the dew may fall upon it, and it is then in condition to be worked the next day. If the strand breaks, it can be replaced and so plaited as not to affect the work nor be visible to the naked eye. The ingenious woman uses her knee for a head-block. It requires from three to five months daily labour of three hours a day to make one of the finest hats. The business in its highest development is really an art, requiring patience, fine sight, and special skill—qualifications few of

the natives possess. The plaiting completed, the hat is washed in clean, cold water, coated with a thin solution of gum, and polished with dry powdered sulphur. They are so pliable that they can be rolled up without injury and put in one's pocket. They will last for years, and can be repeatedly cleaned.

Natives of both sexes and all ages are engaged at odd times, the business being a side issue. Children make from raw, undressed straw about two of the common hats a day.

The specimen here shown is in the collection of Dr. S. O. Richey, of Washington City, and has twenty or more crossings to the linear inch. The hats vary from the ordinary form having eighteen crossings or checks to the finest quality, which have twice as many. In the market they are sold at from $10 to $150. The most costly specimens are those in which there is not a break in the straw, mismatched colour, or a knot showing in the work.

During the nineteenth century the cemeteries of Peru yielded the greatest abundance of relics and remains. Among the former were a mixed variety of textiles, which were types of basketry hereafter to be described. The climate of Peru is arid, and the land almost a desert like that of Arizona or Egypt. The frail products of the textile industry that might have perished utterly in North America almost everywhere have here all been preserved. Fine specimens of old Peruvian work are to be seen in all the leading museums of the world. The Field Columbian Museum, in Chicago, is especially rich in productions of this kind, gathered through the agency of the World's Columbian Exposition in 1893.

In the Peabody Museum and in the United States National Museum also are fine old collections brought home fifty years ago by earlier travellers and explorers in South America, and in this Peruvian basketware are to be seen not only great varieties in form and exhaustive treatment of native technical processes, but adaptations to uses without number, extending literally from the cradle to the grave.

The name Peru has for the ethnologist a long perspective in time, reaching through many centuries; in elevation it covers the range of habitable areas from reeking sea-coasts to heights barely endurable by man. In coast line it stretches through fifteen degrees of south latitude (5° to 20°). Only in width is it restricted to the narrow watershed of the Andes and a slight portion of the incline on the eastern side, reaching down to the forest line. The most celebrated of the explorations in this area have been by Reiss, Stübel, and Kappel.*

The authors figure the following-named types of basketry:

1. Checkerwork: In this connection should be noted a kind of openwork in which the warps are set at an angle of 45 degrees, running in two directions, forming diamond-shaped spaces. A weft passes around among these warps so as to divide the diamond-shaped spaces into triangles. Such weaving is seen in many specimens of the North Pacific area; even the Aleutian Islanders practise it. It has been already described and figured in von den Steinen's plates for the eastern area.

2. Wickerwork, in Colombia and Uruguay.

3. Diagonal or twilled work, widely diffused.

4. Twined work has been recovered from prehistoric graves at Ancon, Peru, in matting, both coarse and fine, and on baskets; from prehistoric graves at Arica, Chile, in the structure of small wallets of basketry; and from graves at Pisagua, Chile, in baskets. On other styles of manufacture a row or two intrude themselves.

5. Coiled work without foundation is universally distributed. With foundation of fine splints it occurs also, as will be seen.†

In the plates of these authors the following-named technical processes will be seen:

Plate 8, fig. 1, wickerwork basket from Bogota, Colombia.

* Kultur und Industrie Südamerikanischer Völker, Berlin, 1889.

† Compare Nos. 13,039 and 13,096 in Eleventh Annual Report of the Peabody Museum, p. 280, fig. 3; p. 292, fig. 18.

Fig. 2, crossed warp, open weaving, from Pasto, Colombia.

Fig. 3, diagonal weaving from Pasto, Colombia.

Fig. 4, twilled weaving from Panama.

Fig. 5, wicker from Andaqui, Colombia.

Figs. 6 and 7, diagonal weaving from Otavalio, Colombia.

Fig. 8, twilled weaving from Bogota, Colombia.

Fig. 9, coiled basketry from Copacabana, Bolivia.

Fig. 10, diagonal weaving from Quito, Ecuador.

Figs. 11 and 12, twilled weaving from Rio de Janeiro, Brazil.

Fig. 13, coarse, diagonal weaving from Guallabamba, Ecuador.

Fig. 14, open coiled basket box from Bogota, Colombia.

Fig. 15, plaited fans from Cocamilla Indians, Peru.

Fig. 16, diagonal weaving, fan, Papayan, Colombia.

Fig. 17, checker, oblique weaving, from Cocamilla Indians, Peru.

Fig. 18, wicker strainer for maté, from Cerro Largo, Uruguay.

Fig. 19, diagonal weaving, tray, from Brazil.

Figs. 207 to 211 are twilled basketry, found deposited with the dead in a cemetery at Ancon, Peru. They are made of rushes, and exhibit a great variety of forms, as may be seen by examining the drawings on the cover of fig. 207. Across the middle are two rows of ordinary over-two twilled weaving, seen also in detail in fig. 208. A noticeable feature on other specimens, however, to which attention is drawn by Holmes,* and to which he gives the name diagonal combination, is the production of triangular figures. The weaver, in going from right to left, produces the effect of right-angle triangles, but in returning so regulates the decussations of the fibers as to give to the pairs of triangles of the two rows a common hypothenuse. The effect of this combination is magical, leaving the impression of high relief. (Fig. 209.)

* W. H. Holmes, A Study in the Textile Art, Sixth Annual Report of the Bureau of American Ethnology, p. 206, figs. 297–299.

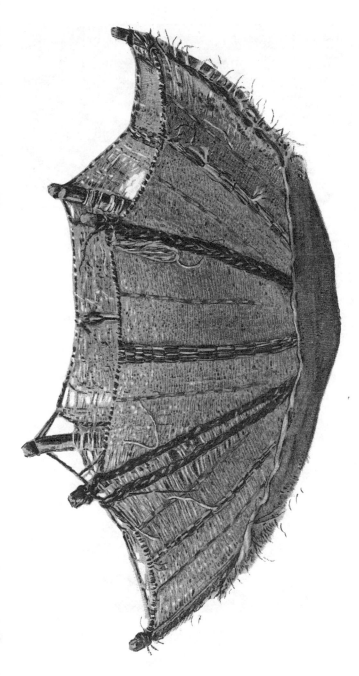

Plate 244. See page 497

PERUVIAN ANCIENT CARRYING FRAME

In wrapped and twined weaving, from a grave in Iquique

Field Columbian Museum

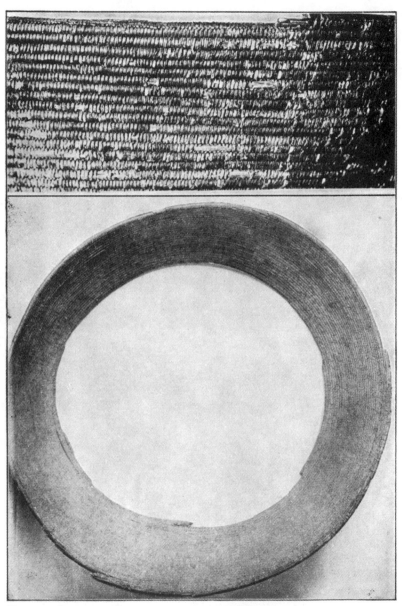

Plate 245. See page 499

FRAGMENT OF ANCIENT COILED BASKET, FOUND IN COPPER MINE, CHILE

Exhibited in Buffalo Exposition

But the most charming effects in these Peruvian work-baskets are brought about by the use of narrow strips of wood, over which the plaiting takes place and by which broad bands of twilled work are produced. This result is manifest in figs. 210 and 211.

Another characteristic of this Peruvian work is the hinging of the cover of the basket as part of the weaving. In Plate 243, evidently the work-basket of an ancient spinner in Vicuña

FIG. 207.
ANCIENT PERUVIAN WORK-BASKET.
After W. H. Holmes.

wool, there is a single cover, but it will be seen that the modern compartment trunk has been anticipated, the basket being in three divisions, the middle one forming the cover of the lower one. The detail of the hinge as a part of the texture may be seen in the small drawings at the bottom of the plate.

Plate 244 is a twined carrying frame, from the graves of Iquique, southern Peru. The framework consists of three sticks, bent in the shape of an oxbow, crossing each other at the bottom so as to give to the top the form of an oblique hexagon. The ends are held in place by a stout cord of hair, in natural brown colour. The warp of this basket is formed by winding a white string round and round these sticks on the

outside, the turns about one-eighth of an inch apart, from the
bottom to the top. The weft is a series of vertical rows of
twined weaving, in some places close together, and in others

FIG. 208.
DETAIL OF FIG. 207.
After W. H. Holmes.

FIG. 209.
DETAIL OF A PERUVIAN BASKET.
After W. H. Holmes.

wide apart, for ornamental effect. The vertical stripes seen
on the surface are in green, red, black, and white twine, each
block including two or more warp strands. By using two
colours in the twine the patterns are variegated on the surface,
first the white and then the coloured strand

coming in-
to view.
By compar-
ing these
s p e cimens
with the
one from
the Arikara
Indians,

FIG. 210.
DETAIL OF A PERU-
VIAN BASKET.

FIG. 211.
DETAIL OF A PERUVIAN BASKET.

fig. 125, it will be seen that, in the latter, two of the bows
projected downward and formed the bottom, on which
the basket rests. But in this case no such protection is
afforded. The woman has sewed a coarse piece of woven
stuff along the bottom as a protection for the more delicate
threads. The specimen is in the Field Columbian Museum,
Chicago, and the coloured plate was furnished by Doctor
George A. Dorsey.

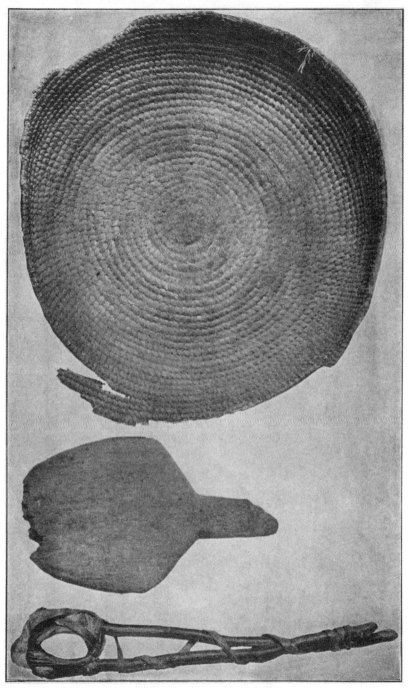

Plate 246. See page 499

ANCIENT COILED BASKET FROM COPPER MINE IN CHILE

Exhibited in Buffalo Exposition

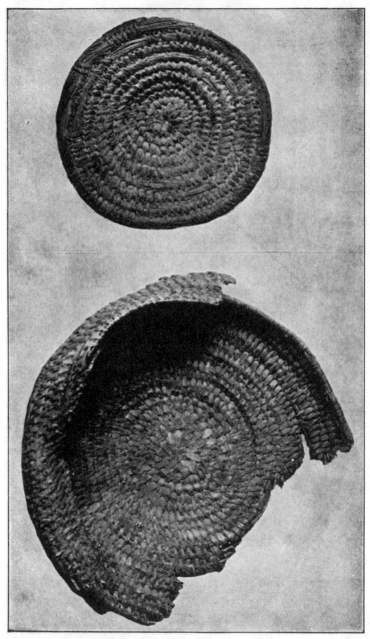

Plate 247. See page 499
ANCIENT COILED BASKETS FROM COPPER MINE IN CHILE
Exhibited in Buffalo Exposition

Fig. 212 is a fragment of a coiled basket from a copper mine in the district of Chuquicamata, in the desert of Atacama, Chile. It was found, together with other industrial implements, associated with the body of a woman, who undoubtedly met her death on the spot. From the dislocated backbone and the small stones embedded in the skin it is supposed that she was buried by a caving in of the works. The basket, of which this is a fragment, was in every respect similar to the

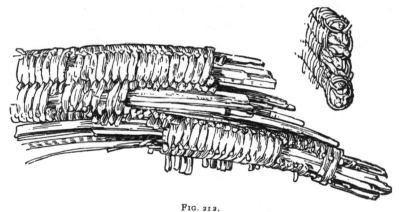

FIG. 212.
ANCIENT COILED BASKET FROM CHILE.

Pima ware in southern Arizona. This fragment bears such remarkable similarity to Pima workmanship that J. W. Benham, of Arizona, who is most familiar with it, was struck with the Chilean example, and wondered whether it were possible that the Pima Indians and the maker of this specimen could have been under the same instructors.

Plates 245 to 247 are also specimens of coiled work, exhibited at the Pan-American Exposition, with the mummy from Chile; the foundation of the coil of shredded material and the sewing also in soft splints. The stitches pass over the foundation, and are not only interlocking, but take up a portion of the foundation in its base below. These should be compared with the specimens from northern Mexico, in the Peabody Museum, described by C. C. Willoughby.

Plate 248 is the side and bottom view of a coiled basket from Peru. The style is entirely modern, but it is introduced here to show two features in technic, well wrought out in the northern continent. The foundation and the sewing are both in a brilliant-coloured straw, species unknown. Sewing is reduced to the minimum, most of the foundation being neatly wrapped, or served with the sewing-material. The stitches on the body are bifurcated most neatly, and, coming one above the other, give the impression of herring-bone work done vertically. Finding this openwork coil and furcate stitches in Eskimo land, California, and Peru, would tempt one to see the same invention arising independently in regions wide apart; but, omitting the unlimited going about in pre-Columbian times, during hundreds of years the sovereigns of Spain, France, England, and for a century Russia, mixed the native tribes and their industries. Catalogue No. 150,844, United States National Museum.

The two areas of South America, eastern and western, unite in the Strait of Magellan. There are three linguistic families of Indians, among whom two types of basketry are found belonging to the coiled variety. They are made by women of *Juncus magellanicus*. Descriptions and figures of the stitches involved will be found in the Revue d'Ethnographie.* See also Lovisto.† The rim is made of wood, veya or tshelia. The specimens in the United States National Museum are all of one variety, the sewing being in the button-hole stitch, so called, and in openwork. Nothing of the kind exists in the neighbourhood, so that it is within the limits of possibility that the style of technic was introduced.

In summing up what has been said on basketry in the Western Hemisphere, it would seem that nearly all the types and processes known throughout the world are to be seen here.

* Paris, IV, p. 517.
† Guida Cora's Cosmos, October, 1884, pl. v.

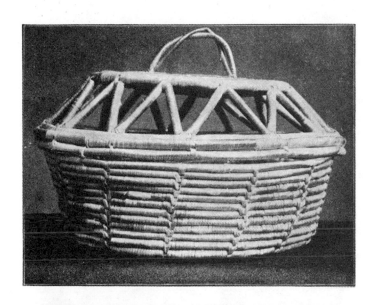

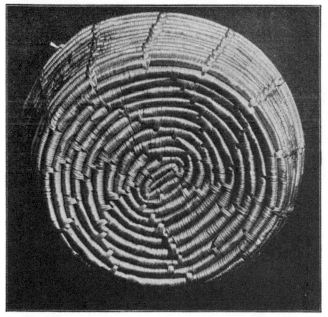

Plate 248. See page 500

MODERN COILED BASKET IN OPENWORK, PERU

Collections of U. S. National Museum

CHAPTER VIII

COLLECTORS AND COLLECTIONS

As David and the Sibyl say.—THOMAS OF CELANO

BASKETRY and pottery are the sibylline leaves on which are written the thoughts and lore of our Indians. Already much has gone beyond recovery; it is for this reason that a good word is here spoken for those lovers of art who have spent time and means in redeeming the more perishable of the two treasures from destruction. Pottery may be broken, but its fragments endure and bear witness. Not so basketry; made of the most perishable portions of plants, it can endure only when in contact with preservative materials, or partly reduced to ashes, or deposited in caves and other dry places; or finally, their technic, but not their story, may be saved by impressions left on pottery.

The following instructions are published for the great number of persons who are interested in the collection and preservation of American basketry. Besides the esthetic elements involved and the pride of saving the best examples of a rapidly vanishing industry, there is a vast deal of culture study which ought not to be neglected.

In every collection, public or private, there are opportunities for special investigation that should not be in the possession of a single individual only. If all who are gathering baskets would preserve such information as they may be able to obtain, the bringing together of the results of all this study would be a monument for our American aboriginal women.

As pointed out in former chapters, knowledge concerning basketry seems to be illimitable, the technician, the artist,

and the student of folk-lore finding equal pleasure in the acquisition. To begin with the manufacture, a correct knowledge of the materials includes the name of the tribe and their location, the name of the different kinds of weaving in the native tongue, and chiefly the native name, the common name, and the scientific name of every plant or animal substance or mineral involved. The reason for this is that in order to know whether an art is indigenous or acquired, it is necessary to compare the names for definite things with those used by other tribes for the same things. Not to discourage the collector, however, it must be said that this is merely an ideal toward which we ought to work.

The following label of a specimen in the Hudson basketry collection, United States National Museum, will serve as a model to guide the collector in saving information about his specimens:

BASKET JAR of the Pomo Indians (Kulanapan family). Made from the prepared root of Kahum, or California sedge (*Carex barbarae*), throat and scalp feathers of Katátch, or woodpecker (*Melanerpes formicivorus*), breast feathers of Jucil, or meadow lark (*Sturnella neglecta*), scalp feathers of Kayán, or mallard (*Anas borchas*), plumes of Tchikáka, or crested quail (*Lophortyx californicus*), neck feathers of Tsawálu, or jay (*Cyanura stelleri*), and Káya, or prepared clam-shell (*Saxidomus gracilis*), in a style of coiled sewing called Tsai, in which a single rod constitutes the basis. The sewing passes over this rod, under the preceding one, and locks in the stitch immediately underneath. Ornamentation, a row of shell disks around the margin and another row serving as a handle.

Diameter, 5 inches.

RUSSIAN RIVER, CALIFORNIA, 1896. No. 203,415.

FROM THE BUREAU OF AMERICAN ETHNOLOGY, COLLECTED BY DR. J. W. HUDSON.

For the artistic collector, there is a very important mission, to know and to foster the aboriginal patterns and motives in decoration. Many of the shapes and designs in basketry are spurious. Besides the trashy imitations of letters and common things on basketry, which mislead no one, there is an unfortunate habit springing up of getting women of one tribe to imitate the designs of another tribe. This works confusion in two ways. It confounds the student of folk-lore absolutely, and, if there be any truth in the belief that in all art the material

and the motive have in the ages adapted themselves to each other "like perfect music unto perfect words," the attempt to put Apache ornaments on Pima or Wasco on Klikitat is discordant.

PRESERVATION OF BASKETS

The art of a people must be judged by what they need not do and yet accomplish.—A. C. HADDON.

Textiles are among the most fragile and perishable of human industrial products. Insects and rust, heat and cold, too much and too little moisture, the common accidents of life, are hastening our pretty baskets to their dissolution. Therefore, how to prolong the life of a basket is a living question with all basket lovers, and the answer will be easier if the causes of destruction are known. The three enemies of baskets are moth and rust and human fingers. By the moth are meant all destructive animals; by rust, natural decay; and in the last agency must be classed the myriad ways by which our fellow-creatures purloin and destroy our treasures. E. S. Morse tells us that the Japanese do not make of their houses bazaars for the ostentatious display of art objects, but they put them away in silk bags, to bring forth when they wish to delight their friends. Those collections that have been made with a view to permanence should be kept so that they will suffer least from damage. The dust may be blown from the specimens with bellows. Those containing remnants of vegetable matter, berries, food, etc., should be carefully scrubbed with soap and water, and rubbed down with a very small portion of oil and dryer. Above all, they should be poisoned with a weak solution of corrosive sublimate or arsenic dissolved in alcohol. A card catalogue giving the legend and history of each piece would add much to the value of the collection.

A list of collections of rarities in American basketry is here appended, by no means complete, but it will aid the student

who wishes to prosecute his investigations further to find the material. First of all, in the great museums there are permanently in store priceless examples of basketry, and in addition many costly collections belonging to private individuals have thus rendered a great service to this writer. It is interesting to read over the names of the men and women who long ago contributed to the great museums precious examples of uncontaminated Indian art.

AMERICAN MUSEUM OF NATURAL HISTORY OF NEW YORK. The best assemblages of American basketry are the Emmons collection from Alaska; the Teit from the Chilcotin and the Thompson Indians (Jesup expedition); the Farrand from the Quinaielt (Jesup expedition); the Farrand from the Klikitat and Oregon (gift of Mr. Henry Villard); the Dixon from northern California (Huntingdon expedition); the Briggs collection from California (gift of Mr. George Foster Peabody); the Apache collection (gift of Mr. Andrew E. Douglass); the Pepper, of ceremonial baskets of the ancient cliff-dwellers (Hyde Expedition); baskets from the Chukchi Peninsula collected by Messrs. Jochelson and Bogoras (Jesup expedition).

If we should include birch-bark baskets, one might also mention the Stone collection from Mackenzie Basin; and the Berthold Laufer collection from the Amur River (Jesup expedition). The basketry collection has been brought together for decoration, not for technic.

ANKENY, Mrs. LEVI, Walla Walla, Washington. Salish basketry.

BARRETT, S. A., Ukiah, California. All Pomo. About 150 pieces.

BENHAM, J. W., Phœnix, Arizona. Large and rich collection of Apache ollas, rare Pimas, and other basketry from the Southwest.

BENJAMIN, Mrs. CAROLYN G., Washington City. General collection. Good in Chetimachas.

BINGHAM, Mrs. J. E., 338 Katharine Street, Walla Walla, Washington.

BISHOP, Mrs. THOMAS T., 2309 Washington Street, San Francisco, California. Miscellaneous.

BOGGS, Mrs. A. G., Redding, California. Principally Hat Creeks, of Shasta County, and Pit Rivers, of Modoc County. Some 200.

BRADFORD, Mrs. SIDNEY, Avery Island, Louisiana. Fine old Chetimachas.

BRIGGS, C. F., San Francisco, California. Miscellaneous. Very choice examples. Northwest coast, Pomos, Mariposan, and few fine Mission.

BRITTIN, L. H., Edgewater, New Jersey. Old Tlinkit baskets.

BRIZARD, BROUSSE, Arcata, California. Large Hupa material with illustrated catalogue.

BUCHANAN, CHARLES MILTON, Tulalip Agency, Tulalip, Washington. Good Salish collection.

BUGBEE, Mrs. SUMNER W., Pasadena, California, Miscellaneous.

BURDICK, J. W., Albany, New York. Rare Tulares.

BURGESS, JOHN D., Tucson, Arizona. Pima, Maricopa, and Apache examples.

CARPENTER, Mrs. HELEN M., Ukiah, California. Pomos.

CARROLL, ANDREW W., DE LA CŒUR, Ardglass, Ireland. Good California types.

CHICAGO UNIVERSITY. Especially Mexican. See Frederick Starr.

CINCINNATI MUSEUM OF FINE ART. General collection.

COHN, A., charming specimens of Washoe baskets, Nevada.

COLE, Mrs., Pasadena, California. General collection.

COOK, Mrs. J. B., Yosemite Valley, California. About seventy-five examples of Mono, Washoe, and Mariposan tribes.

COVERT, FRANK M., New York. Good in Arizona basketry.

COVILLE, FREDERICK V. Fine collection from the west coast to illustrate the plants used.

CROSS, Mrs. EDWARD, Salem, Oregon.

CURTIS, WILLIAM CONWAY, Norwalk, Connecticut. The Klikitat and other basketry of Washington.

DAGGETT, JOHN, Black Bear, Siskiyou County, California. Fine collection of Yurok and Karok material. Klamath and Salmon rivers, northern California. At present on deposit in the Memorial Museum, Golden Gate Park, San Francisco, California.

DAVENPORT ACADEMY MUSEUM, Iowa. Miscellaneous collection.

DEISHER, H. K., 50 Noble Street, Kutztown, Pennsylvania. Pomos and Wintuns, and a few good Maidus.

DESSEZ, Miss HENRIETTA LOUISE, Washington City. California and Interior Basin.

EATON, the Misses, Boston, Massachusetts. Very precious old California baskets.

EMMONS, G. T., Princeton, New Jersey. Excellent old Tlinkits.

ERICSON, A. W., Arcata, California. Photographs of basket-makers and baskets.

FEENEY, Miss KATHARINE, 1570 Filbert Street, Oakland, California. A fine miscellaneous collection.

FIELD COLUMBIAN MUSEUM OF CHICAGO has rich collections of basketry from all the north Pacific coast families, and especially old and beautiful specimens of Tlinkit twined ware, the gift of Mr. E. E. Ayer; from the Columbian Basin fifty Nez Percés twined wallets, many of them large and choice, and some of considerable age; sixty coiled and imbricated baskets of the Klikitats of various sizes. The last-mentioned two collections were made by Mr. E. E. Miller. From various parts of California, the Field Columbian possesses many choice baskets, and is especially rich in examples from tribes of the Kulanapan, Mariposan, and Moquelumnan families. These were gathered chiefly by Dr. J. W. Hudson, but many choice examples were the gift of Mr. E. E. Ayer. The same generous benefactor added to his gift large collections from the White Mountain and Mescalero Apaches; and from the Pimas, made by George A. Dorsey, Charles L. Owen, and S. C. Sims, typical series from special tribes. Dr. Dorsey's Ute collection should be mentioned, and also that from the Klamath tribe, numbering over 200 specimens and comprising all their forms, technical processes, and designs.

FROHMAN, Mrs. J., Portland, Oregon. West Coast basketry and matting.

GARDNER, Mrs. GEORGE S., Laurel, Mississippi. Tribes of Indian Territory, Georgia, and Louisiana. Also a fair series of Pacific coast work—Alaska, British Columbia, Washington, California, and Arizona.

GRAY, Mrs. WILLIAM, Salem, Oregon.

GREBLE, Mrs. MARY D., Pasadena, California. Rare old southern California pieces.

HALL, ROBERT C., Pittsburg, Pennsylvania. Miscellaneous. Good Pomos and Tulares.

HAMILTON, Miss HENRIETTA, Seattle, Washington. Large and choice collections from Alaska to California. Mostly in the Fred Harvey series.

HARBAUGH, Mrs. H. W., Colton, California. Choice California specimens.

HARVEY, FRED, Albuquerque, New Mexico. Large and rare collection from all the West coast region.

HEARST, Mrs. PHEBE A., Berkeley, California. Miscellaneous. Very large collection. Rich in Pomos and central California tribes. The collection is in the University of California, and exhaustive studies are being made under her generous patronage.

HUBBY, Miss ELLA F., Pasadena, California. Excellent general Pacific coast collection.

HUDSON, Mrs. GRACE, Ukiah, California. Fine Pomos. Dr. J. W. Hudson's two large collections from these tribes are in Washington and Chicago.

HYDE EXPLORING EXPEDITION, New York. Collection of basketry from the Southwest. Encourages the making of baskets and aids in the sale of them.

IDE, Mrs. ESTHER C., Seymour Street, Syracuse, New York. Miscellaneous. Good Pomos and Tulares.

JACKSON, Col. JAMES, Salem, Oregon.

JAMES, GEORGE WHARTON, Pasadena, California. Especially good in examples from California Missions.

JOHNSTON, Mrs. WILLIAM P., New Orleans, Louisiana. Chetimaches, Choctaws, and Attakapas.

JONES, PHILIP MILLS, State University, Berkeley, California.

KEPLER, JOSEPH, Inwood on the Hudson. General collection.

KIRKPATRICK, Mrs. I. H., Adrian, Michigan. Fine Navahos.

LANDSBERG, FREDERICK, Victoria, British Columbia. General collection.

LANG, Miss ANNE M., The Dalles, Oregon. Collection of imbricated basketry. Large and rare.

LOOSLY, Mrs. JOHN, 9 Pine Street, San Francisco, California. Miscellaneous.

LOWE, Mrs. T. S. C., Pasadena, California. Fine, large collection. Rich in Pomos and central California tribes.

LYNCH, Mrs. JAY, Fort Simcoe, Washington. General collection of west coast baskets.

MABLEY, Miss KATE, Detroit, Michigan.

McARTHUR, Mrs. H. K., 739 Glisan Street, Portland, Oregon. Collection from Washington and Oregon.

MacGREGOR, JOHN, Hope Station, British Columbia. Thompson River basketry.

McKEE, Miss BELLE, Salem, Oregon.

McLeod, E. L., Bakersfield, California. Large collection of baskets of Kern and Inyo tribes. A few Tulares.

McNeil, Mrs. W. H., 1022 North Nineteenth Street, St. Joseph, Missouri. Miscellaneous.

Mallett, J. H., Jr., San Francisco, California. A few fine Pomos and tribes in east-central California.

Masters, Mrs. W. U., Pasadena, California.

Mastic, George H., Alameda, California. Large collection of Pomo baskets. A few good examples of Mariposan and Yokuts.

Merriam, C. Hart, Washington City. About 1,000 examples of Western basketry, personally selected and card catalogued. A model collection.

Mills, Mrs. Anson G., Washington City. Select general collection.

Mitchell, John S., San Francisco, California. Miscellaneous. Good examples from Northwest coast and from Arizona.

Mitchell, Susman, Visalia, California. Excellent work of different tribes in Tulare and Kern counties, California.

Molson, Mrs. W. Markland, Montreal, Canada. Washington and Oregon basketry.

Montgomery, Mrs. J. B., Portland, Oregon.

Moseley, Mrs. William H., New Haven, Connecticut. Collection on exhibition at the Peabody Museum of Yale.

National Museum.—The Museum is rich in collections of American basketry made to show all forms of technic and also to exhibit handiwork from tribes in the six areas. Beginning at the north, the collections of Ray from Point Barrow ; of McFarlane and Ross at the Mackenzie mouth; the rich treasures gathered by Nelson in western Alaska; those of Dall, Turner, Appelgate, and Fisher farther south; and the Tlinkit ware selected by McLean, Swan, and Emmons amply illustrate the technical processes in that area.

Going southward, the Salish and other Fraser-Columbia basketry includes, among others, Wilkes, Swan, Eells, Shackelford, Emmons, and Willoughby collections.

The largest collections from California were made by Purcell, Ray, Stone, Powers, Hudson, Henshaw, Curtin in the north; by Holmes, Merriam, Rust, and Mead in the south.

The collections of basketry from the Interior Basin are the largest of all, being gathered by Palmer, Powell, Cushing,

Stevenson, Holmes, Fewkes, Hough, Mooney, and Russell, and officers connected with the numerous surveys. Much of this is very old. From farther south, from Middle and South America, the Museum is indebted to explorers and officers of various departments of the Government for typical material, the latest gathered on the Amazon by J. B. Steere.

NEWMAN, Mrs. H. W., San Carlos, Arizona. White Mountain Apache.

NICHOLSON, Miss GRACE, Pasadena, California. Choice old Californian specimens.

O'HARA, Miss, San Francisco, California. Good pieces of Old Missions.

OWEN, Mrs. WILLIAM, Sepacuite, Panos, Alta Vera Paz, Guatemala. Fine collection of Guatemala work.

PEABODY MUSEUM OF ARCHÆOLOGY AND ETHNOLOGY, Harvard University, Cambridge, Massachusetts. Collections which ought not to be neglected by the special student. Among these should be mentioned that of Mrs. George B. Linder, of Boston, rich in California material; that of Mrs. Mary Hemenway, devoted especially to the pueblo tribes of Arizona, the Hopi, being the collection made by Thomas Keam many years ago. Dr. Edward Palmer contributed to this series also material from southern California, especially from the caves. This series contains the outfit of a society, since the baskets were accompanied also by head dresses and musical instruments.

PICHER, Miss ANNIE B., Pasadena, California. General collection, well selected.

PLATT, Mrs. ORVILLE H., Meriden, Connecticut. General collection.

PLIMPTON, F. S., San Diego, California. Miscellaneous. Very choice. Fine Pomos. Good examples of work of different tribes throughout northern, central, and southern California.

POWER, Mrs. E. B., San Francisco, California. Choice Maidus.

PURDY, CARL W., Ukiah, California. Well-selected collection of Pomos.

ROBERTS, Mrs. ERNEST W., Chelsea, Massachusetts. General collection; fine old California.

ROSENBERG, Mrs. ANNA M., 1605 East Madison Street, Seattle, Washington. Some fine Pomos. Few good examples of Tulare and Kern tribes.

ROST, Mrs. H., Portland, Oregon.

RUMSEY, C. E., 110 Indiana Avenue, Riverside, California. Excellent collection from the Southwest; selected for instruction.

RUSSELL, Mrs. GEORGE F., Portland, Oregon.

RUST, HORATIO N., Pasadena, California. Good, in work of the Missions.

SEQUOYA LEAGUE, The. A corporation whose design is "to make better Indians." One of its objects is to revive, encourage, and provide market for such aboriginal industries as can be made profitable.

SHACKELFORD, Mrs. R. S., The Dalles, Oregon. Excellent Klikitats and Wascos.

SHARPE, Miss ELIZABETH M., Wilkesbarre, Pennsylvania. General collection.

SMITH, Mrs. EMILY A., 2226 Jackson Street, San Francisco, California. Miscellaneous. A number of exceptionally fine Pomos, including several solidly feathered. Also some choice examples from Tulare, Kern, and Inyo counties, the Missions, Alaska and British Columbia, etc.

SPIEGELBERG, A. F., Santa Fe, New Mexico. Large collection of basketry from southwestern United States.

STANFORD, Mrs. JANE L. (Mrs. Leland). In her museum at Palo Alto is a good collection of Tulare baskets. Also fair representation of the Klamath River material. The latter collected by John Daggett.

STARR, FREDERICK, University of Chicago, Chicago, Illinois. Collection of basketry from southern Mexico.

STEVENS, Mrs. FREDERICK H., Buffalo, New York.

STONE, Mrs. B. W., San Francisco, California. Miscellaneous collection. Very good specimens from various tribes of central California.

TAPLEY, Mrs. LOUIS, Salem, Oregon.

TEIT, JAMES, Spences Bridge, British Columbia. Good in Thompson River. Largely in American Museum of Natural History, New York.

TEVIS, Mrs. WILLIAM, Bakersfield, California. Large collection of baskets of Kern, Inyo, and Tulare tribes. A number of very fine and rare pieces. Many old examples.

TOZIER, D. F. A very large and choice collection from southeastern Alaska, British Columbia, and Washington. On exhibition in Tacoma, Washington.

TUTTLE, E. O., 28 State Street, Boston, Massachusetts. Miscellaneous. Some good Pomos and Tulares.

UNIVERSITY OF CALIFORNIA is conducting an exhaustive survey of the State, both in archæology and ethnology, under the patronage of Mrs. Phebe A. Hearst.

UNIVERSITY OF PENNSYLVANIA has a large series of basketry, sandals, and other textile material from the cliff-dwellers of Mancos Canyon, given by Mrs. Phebe A. Hearst.

VROMAN, A. C., Pasadena, California. Fine old Pima and Apache baskets.

WADLEIGH, W. J., Hope Station, British Columbia. Klikitats.

WANAMAKER, JOHN, Philadelphia, Pennsylvania. Miscellaneous.

WHITMORE, Mrs. W. L., Salem, Oregon.

WILCOMB, C. P., Memorial Museum, Golden Gate Park, San Francisco, California. Large and choice collection of California basketry, well identified and labelled.

WILLIAMS, H. E., Cassel, California. Fine collection of Hat Creek baskets.

CHAPTER IX

Bibliography

And let her works praise her in the gates.—King Lemuel

The following list of publications will help to follow up this study in special lines. A great awakening of interest in the processes of savage industries as the foundation of all modern machine work has stimulated the production of excellent books and papers on basketry. At the moment of going to press, the author of this general treatise learns of several. Doctor P. E. Goddard, of the University of California, was so good as to lend his proof on the Hupas; Frank Russell on the Pimas had not appeared; Emmons on the Tlinkit, and Dixon and Kroeber's further studies on California basketry, were not in print.

Anderson, Ada Woodruff. Last Industry of a Passing Race. Harper's Bazaar, November 11, 1899.

B., T. F. Lessons in Basket Weaving. The Papoose. New York, February and May, 1903.

Bancroft, H. H. Native Races of the Pacific States. New York, D. Appleton & Company, 5 vols., 8vo. Index references to basketry, weaving, and kindred topics.

Barrows, David Prescott. The Ethno-botany of the Coahuilla Indians of Southern California. Chicago, 1900. The University Press, 82 pp., 8vo.

Basket, The. A quarterly journal. Vol. 1, 1903. Pasadena, California. Edited by George Wharton James. Organ of The Basket Fraternity.

Blanchan, Neltje. What the Basket Means to the Indian. Everybody's Magazine, V, 1901, pp. 561–570, illustrated.

Boas, Franz. The Decorative Art of the Indians of the North Pacific Coast. Bulletin American Museum of Natural His-

tory, New York, IX, 1897, 54 pp. See also the author's papers in Reports of British Association, 1889–1891.

BUREAU OF AMERICAN ETHNOLOGY. Reports, bulletins, and miscellaneous publications abound in papers discussing basketry and related matters, 1879–1903.

CARPENTER, H. M. How Indian Baskets are Made. The Cosmopolitan, October, 1900.

CARR, JEANNIE C. Among the Basketmakers, California. Illustrated Magazine, October, 1892.

CHANNING, GRACE ELLERY. The Baskets of Anita. Scribner's Magazine, August, 1890.

CHESNUT, V. K. Plants Used by the Indians of Mendocino County, California. Washington, 1902. Contributions to the National Herbarium, VII, pp. 295–408.

CHITTENDEN, NEWTON H. Among the Cocopahs. Land of Sunshine, Los Angeles, California, 1901, pp. 196–210, illustrated.

COLES, CLAUDIA STUART. Aboriginal Basketry in the United States. The House Beautiful, February, 1900.

COVILLE, FREDERICK V. The Panamint Indians of California. American Anthropologist, V, 1892, pp. 351–361. Washington.

————. Directions for Collecting Specimens and Information Illustrating the Aboriginal Uses of Plants, Bulletin No. 39, Part J, United States National Museum.

————. Wokas—Primitive Food of the Klamath Indians. Report of the United States National Museum for 1902.

CUSHING, FRANK HAMILTON. Pottery Affected by Environment. Fourth Annual Report of the Bureau of Ethnology, 1882, pp. 482–521, 64 figs.

DELLENBAUGH, F. S. The North Americans of Yesterday. New York, 1901.

DIXON, ROLAND B. Basketry Designs of the Maidu Indians of California. American Anthropologist, June, 1900.

————. Basketry Designs of the Indians of Northern California. (The Huntingdon California Expedition.) Bulletin, American Museum of Natural History, New York, XVII, pp. 1–32, 37 plates.

————, and ALFRED L. KROEBER. The Native Languages of California. American Anthropologist, Washington, N. S., V, 1903, pp. 1–26, 8 figs.

Dodge, Charles Richards. Report on the Leaf Fibers of the United States. Department of Agriculture, Washington, 1893. Fiber Investigations—Report No. 5.

Doubleday, Mrs. F. N. Indian Industrial Development. The Outlook, January 12, 1901.

Dubois, Constance Goddard. Manzanita Basketry, a Revival. The Papoose, June, 1903, pp. 21–27.

Emmons, G. T. The Basketry of the Tlingit. Memoirs, American Museum of Natural History, New York, 1903, III, Pt. 2, 18 pls. and text figures.

Farrand, Livingston. Basketry Designs of the Salish Indians. Memoirs, American Museum of Natural History, New York, 1900, II, Pt. 5, 6 pp., 3 pls., 15 figs.

Fewkes, J. Walter. A Contribution to Ethno-botany of Tusa-yan. American Anthropologist, Washington, 1896, IX, pp. 14–22.

———. Hopi Basket Dances. Journal of American Folk-lore, April–June, 1899.

———. The Snake Ceremonial at Walpi. Journal of American Ethnology and Archæology, IV.

Firth, Annie. Cane Basket Work, 1 and 2 series. London.

Goddard, P. E. Life and Culture of the Hupas. Publications of the University of California. First volume of the series on American Archæology and Ethnology, Berkeley, California. Vol. 1, No. 1, 88 pp., 30 pl.; also No. 2, Hupa Texts, 290 pp. September, 1903–March, 1904.

Harshberger, J. W. Purposes of Ethno-botany. Botanical Gazette, XXI, No. 3.

Harvard, Victor. The Food Plants of the North American Indians. Bulletin, Torrey Botanical Club, XXII, No. 2, February; No. 3, March, 1895.

———. Drink Plants of the North American Indians. Bulletin, Torrey Botanical Club, XXIII, No. 2, February, 1896.

Hoffman, Walter James. The Menomini Indians. Fourteenth Annual Report of the Bureau of Ethnology, Washington, 1896, pp. 3–328, pls. I.–XXIII, 54 figs.

Holmes, William Henry. Prehistoric Textile Fabrics of the United States Derived from Impressions on Pottery. Third Annual Report of the Bureau of Ethnology, Pt. 1, 1884, pp. 397–425, 1 pl., 55 figs.; also Volume XIII, 43 pp., 9 pls., 28 figs.

———. A Study of the Textile Art in its Relation to the Develop-

ment of Form and Ornament. Sixth Annual Report of the
Bureau of Ethnology, Washington, 1888, pp. 189–252, figs.
286 to 358.

———. Anthropological Studies in California. Report of the
United States National Museum, 1900, pp. 155–187.

HOUGH, MYRTLE ZUCK (Mrs. Walter). Plant names of the South-
western United States. The Plant World, Washington, 1900,
III, p. 137.

HOUGH, WALTER. Primitive American Armour. Report of the
United States National Museum, 1893, pp. 625–651.

———. The Hopi in Relation to Their Plant Environment.
American Anthropologist, X, February, 1897.

———. Environmental Interrelations in Arizona. American
Anthropologist, Washington, XI, 1898, pp. 133–155.

HUDSON, J. W. Pomo Basket Makers. Overland Monthly, San
Francisco, June, 1893.

HUMBOLDT, ALEXANDER VON. Essay on New Spain. II, p. 297,
note on California basketry.

IM THURN, E. F. Among the Indians of British Guiana. London,
1895, p. 278.

JAMES, GEORGE WHARTON. Symbolism in Indian Basketry. The
Traveller, San Francisco, August, 1899.

———. Poems in Indian Baskets. The Evening Lamp, Chicago,
September 8, 1900.

———. Indian Basketry. Pasadena, 1901, privately printed.
238 pp., 300 ills., 8vo. Third edition, 1903.

———. The Art of Indian Basketry. The Southern Workman,
August, 1901, 10 pp., 8 figs.

———. Basket Makers of California at Work. Sunset, San
Francisco, California, November, 1901, 12 pp., 13 figs.

KNAPP, ELIZABETH SANBORN. Raffia and Reed Weaving.
Springfield, Massachusetts, 1903.

KROEBER, ALFRED L., The Arapaho. Bulletin, American Mu-
seum Natural History, New York, 1902, XVIII, pp. 1–150.
Also other papers on symbolism.

LUMHOLZ, CARL. Symbolism of the Huichol Indians, Memoirs,
American Museum Natural History, New York, III. Pt. 1.

McGEE, W J The Seri Indians. Seventeenth Annual Report
of the Bureau of Ethnology, 1892, 336 pp., 56 pls., 42 figs.

MACNAUGHTON, CLARA. Nevada Indian Baskets and Their
Makers. Out West, Los Angeles, April and May, 1903.

MASON, OTIS T. Basketwork of the North American Aborigines. Report United States National Museum, 1884, pp. 291–300, pls. I–XIV.

———. The Ray Collection from the Hupa Reservation. Smithsonian Report, 1886, pp. 205–239, 26 plates.

———. Primitive Travel and Transportation. Report United States National Museum, 1894.

———. Woman's Share in Primitive Culture. New York, 1894.

———. Types of American Basketry. Scientific American, New York, July 28, 1900.

———. The Technique of Aboriginal American Basketry. American Anthropologist, N. S., III, 1901, pp. 109–128, Washington, January–March, 1901.

———. Directions for Collectors of American Basketry. Part P., Bulletin 39, United States National Museum, Washington, 1902, pp. 1–31, 44 figs.

MATTHEWS, WASHINGTON. Navaho Weavers. Third Annual Report of the Bureau of Ethnology, 1881, pp. 371–391, 3 pls., 15 figs.

———. A Study in Butts and Tips. American Anthropologist, Washington, October, 1892.

———. The Basket Drum. American Anthropologist, Washington, 1894, VII.

———. The Night Chant: A Navaho Ceremony. Memoirs of the American Museum Natural History, New York, 1902, VI.

MERRIAM, C. HART. Some Little - Known Basket Materials. Science, XVII, 1903, p. 826. See also Doctor Merriam's article in the same journal, on Distribution of Indian Tribes in the Southern Sierra and Adjacent Parts of the San Joaquin Valley, California, pp. 912–917, June 17, 1904.

MINDELEFF, COSMOS. Aboriginal Remains in Verde Valley. Thirteenth Annual Report of the Bureau of Ethnology, 1896, pp. 176–261, 40 pls., 26 figs.

MOLSON, Mrs. W. MARKLAND. Basketry of the Pacific Coast. Portland, Oregon, 1896.

MURDOCH, JOHN. Ethnological Results of the Point Barrow Expedition. Ninth Annual Report of the Bureau of Ethnology, Washington, 1892.

NELSON, E. W. The Eskimo About Bering Strait. Eighteenth Annual Report of the Bureau of Ethnology, Washington. 1899.

NORDENSKJÖLD, G. The Cliff-Dwellers of the Mesa Verde. Stockholm, 1894.

OUT WEST, formerly THE LAND OF SUNSHINE, Los Angeles, California. Monthly journal, edited by Charles F. Lummis.

PALMER, EDWARD. Plants used by the Indians of the United States. American Naturalist, XII, p. 653.

PAPOOSE, THE. Monthly journal published by the Benham Exploring Expedition. New York, 1903.

PEPPER, GEORGE H. The Ancient Basket Makers of Southeastern Utah. Journal American Museum of Natural History, II, Guide leaflet No. 6, New York, 1902.

PERCIVAL, OLIVE M. The Lost Art of Indian Basketry. Demorest's Family Magazine, February, 1897.

PORCHER, C. GADSDEN. Aleut Basketry. The Craftsman, New York, March, 1904, pp. 575–583.

POWERS, STEPHEN. Aboriginal Botany. Proceedings, California Academy of Sciences. V.

———. The Indians of California. Contributions to North American Ethnology, Washington, III, 1877.

PURDY, CARL. The Pomo Indian Baskets and Their Makers. Land of Sunshine and Out West, Los Angeles, California. A series of illustrated papers of great value running through Volumes XV and XVI, 1901, 1902, in that journal, with many illustrations, and also in pamphlet form.

REID, HUGO. The California Farmer, 1861. Old files for early references.

SCHMIDT, MAX. Ableitung südamerikanischer Geflechtmuster aus der Technik des Flechtens, Ztschr. f. Ethnol., 1904, pp. 490-512, 40 figs.

SCHUMACHER, PAUL. In Archæology of the United States Geological Survey West of the One Hundreth Meridian, VII, pp. 239–250.

SCIDMORE, ELIZA RUHAMAH. Indian Baskets. Harper's Bazaar, September 1, 1894.

SELLERS, GEORGE E. Markings on Pottery, of Salt Springs, Illinois. Popular Science Monthly, New York, XI, p. 573.

SHACKELFORD, R. S. The Wasco Sally Bag. Sunset, San Francisco, January, 1904, p. 258.

STARR, FREDERICK. Notes on the Ethnography of Southern Mexico. Proceedings, Davenport Academy of Sciences, IX, 1902.

STEARNS, MARY WATROUS. A School Without Books. Battle Creek, Michigan, 1902.

STEPHEN, A. M. The Navajo. American Anthropologist, October, 1893.

STEVENSON, JAMES. Illustrated Catalogues of Collections. Second and Third Annual Reports of the Bureau of Ethnology, Washington, 1879–1881.

TEIT, JAMES. The Thompson Indians of British Columbia. Memoirs of the American Museum of Natural History, II, Pt. 4, New York, 1900, 391 pp., 7 pls., 197 figs.

WEST, ARTHUR B. University Club, Denver, Colorado. Basketry photographs.

WHITE, MARY. How to Make Baskets. New York, 1902, 194 pp., ill.; also More Baskets and How to Make Them. New York, 1903.

WILKIE, HARRIET CUSHMAN. American Basketry. The Modern Priscilla, Boston, June, 1902.

WILLOUGHBY, C. C. Hats from the Nutka Sound Region. American Naturalist, Boston, 1903, pp. 65–68, 1 pl.

INDEX

PAGE

Abenaki Indian basketmaker... 272
 basketry borders......... 107
Accessories used in basketry... 55
Acorn harvest, description of.. 234
 mush maker, Pomo, outfit
 of.................. 235
Adornment and dress, use of
 basketry in.............. 223
Aht basketry.............. 331
Alaskan Eskimo, basket making
 by.................. 51
 basketry................ 303
 coiled baskets........·94, 311
Alaskan region, basketry of.... 296
 basket-making tribes and
 families.............. 256
Alaskas, four basket-making... 233
Aleut basket making.......... 143
 symbolism.............. 188
Aleutian basketry............ 312
 ornamentation.......... 314
 twined..............314, 315
Algonkin Indian basketry, deco-
 ration.............. 171
 symbolism.............. 170
Algonkin weaving, northern
 twilled matting............ 273
Amazon tribes, upper, domestic
 utensils................. 231
Amazonian basket decorations
 in checker................ 144
American basketry, aboriginal.
 (See Basketry.)
 list of collections in....... 501
Ancient Basket Makers........ 444
 cave baskets..............429
 Pueblo coiled basketry.... 450
Andamanese, open fish baskets. 294
Apache Indian basketry....461, 463
 carrying baskets.......... 219
 coiled work.............. 92
 dyes.................. 169
 water-tight vessel........ 72
Arabian Nights, quotation from vi
Arapaho Indian gambling bas-
 kets.................. 278
 symbolism 179
Araucanian Indian basketry... 491
Arawak Indian basketry....... 487
Arikara Indian twilled basket.. 293

PAGE

Arizona, ancient forms and uses
 of basketry in.............. 460
Arnott, William, information
 from..................... 340
Athapascan basketry......296, 461
 family, Pacific slope branch 373
 Indian game bags......... 279
 snowshoe detail.......... 275
 tribes, central Alaska, bas-
 ket making of.......... 51
Attakapa Indian twilled bas-
 kets.................. 292
Attu basketmaker............ 316
 weavers.................. 68
 color, how obtained by.. 51
Awl, bone, basketmaker's...... 50
 for coiled basketry.......86, 87

Bakairi Indian carrying basket. 489
Bam shi bu coiled basketry....97, 98
Bamtush coiled basketry...... 69
Barrows, D. P., tribes in south-
 ern California............. 423
Basket armor of tribes on Pa-
 cific coast.............. 222
 boat.................. 219
 bottles, Paiute............ 251
 dance.................. 245
 derivation of the word. v
 Greek word for.......... vii
 hat.................... 223
 jar, Pomo, water-tight.... 55
 Makers................. 443
 coiled basketry......443, 444
 making (see Basketry)... 44
 art of, degenerating..... 8
 canes for.............. 51
 characteristics to be ob-
 served in............ 7
 harvesting materials for.44, 45
 knives................. 50
 mechanism............. 48
 preparing materials for.44, 47
 processes of manufacture
 in.................44, 54
 sweet grass in.......... 50
 tribes, list of.......... 260
Basketmakers, moving about of, 414
 tools of................. 53

PAGE

Basketry (*See* Basket making.)
aboriginal American....... v
accessories used in........ 55
Alaskan region........... 296
Aleutian................. 312
alphabetical list of uses.... 252
American, list of collections. 501
Athapascan.............. 461
bibliography of........... 512
borders on............... 105
California-Oregon region... 363
checkerwork in........... 56
coiled.................. 84
 and lace work, transition. 86
 Athapascan............ 296
 kinds of.............. 6
coiled work without foundation................. 88
collectors and collections.. 501
coloring matters for, in ancient times............ 48
cooking-pots of........... 228
decoration of............ 17
definition of............. 3
designs in decorating...... 153
diagonal twined weaving in. 71
differentiated from loom products.............. 5
network............... 5
dyes for coloring, how obtained................. 17
Eastern North American region................ 269
Eskimo.................. 301
ethnic varieties of........ 255
fireproof................ 17
form and structure in.... 133
foundation used in........ 53
Fraser-Columbia region. 256, 330
Fuegian coiled........... 103
furcate stitches in coiled.... 85
grass-coil foundation in.... 101
Haida................... 326
imbricated............... 99
Interior Basin region...... 431
lattice-twined weaving in.. 75
leaves of plants used in.... 47
lists of plants used in, prepared by F. V. Coville
and V. K. Chesnut....19, 367
materials for............. 17
Middle and South American region.............. 481
mosaic effects in.......... 141
ornamentation on........ 131
 through color......... 161
paints for coloring, how obtained............... 17
papoose frames of........ 221

PAGE

plain twined weaving in... 69
plants used in............ 19
preparation of materials for. 47
preserved by pottery...269, 286
regions in which it may be compared 5
rod and welt foundation... 95
roots used in............. 45
Shoshonean and Pueblo... 432
simple interlocking coils... 90
single-rod foundation..... 92
splint foundation......... 99
stems used in............ 46
subdivisions under which it may be studied........ 4
symbolism.............. 178
technic in, types of........ 6
 preserved in impressions on pottery and in caves 285
tee-twined weaving....... 76
three-rod foundation...... 97
 strand braid.......... 80
 twined weaving.....78, 79
Tlinkit.................. 317
tools used in............. 54
twilled work in.......... 58
twined, Tlinkit........... 55
twined work............. 67
two-rod and splint foundations................ 96
 foundation............ 94
uses of.................. 213
 as a receptacle........ 242
 in carrying water....... 249
 defense and war....... 222
 dress and adornment.. 223
 fine art and culture... 225
 gleaning and milling.. 230
 house-building and furniture.............. 238
 manufacture of pottery.............. 280
 mortuary customs.... 239
 preparing and serving food................ 228
 relation to the potter's art.............. 240
 religion.............. 244
 social life............ 247
 the carrying industry. 217
 trapping............. 248
Ute Indian, for mortuary purposes............... vi
varieties of forms in...... 5
vocabulary of............ 10
water-tight.............18, 104
wickerwork.............. 62
woven..................6, 56
wrapped twined weaving in....................65, 67

PAGE

Beading on basketry.......... 172
 twined work, Klamath In-
 dians.................... 172
Beads, featherwork, etc., in or-
 namentation................ 175
Benham, J. W., collections men-
 tioned.................161, 499
Bible, quotation from, regarding
 baskets.................... vi
Bibliography of basketry...... 512
Bilhula Indian basketry....... 339
Birch-bark trays, border on.... 128
Bird-cage twine.............. 73
Blanket twill in basketry...... 60
Boas, Franz, on Thompson
 River basketry............. 341
Bone awl for coiled basketry..86, 87
Border of checker work........ 106
 coided work.............. 123
 twilled work.............. 107
 twined work.............. 110
 wicker work.............. 107
Borders on basketry.......... 105
Bororó Indian carrying-basket.. 489
Bowl forms in baskets........ 138
Braid, three-strand.......... 80
Brazilian basketry.........488–491
British Columbia, imbricated
 basket work of............ 90
 Guiana basketry......... 487
Bryant, Edwin, description of
 acorn harvest by........... 234
Burial caves, prehistoric, twined
 basketry and matting....... 482

Caddoan Indian coiled gambling
 baskets.................. 287
 twilled weaving.......... 431
Cadricios Indian basketry...... 491
Caliente Creek Indian baskets.. 418
California Indian coiled baskets. 377
 linguistic families in, loca-
 tion of................ 364
 northern, eastern portion,
 linguistic families........398
California-Oregon basket region,
 basket making and types
 in256, 363
 coiled work............. 430
 families 402
 tribes, account of...... 423
 twined weaving........ 430
Canes for basket making...... 51
Carib basketry 482
 pegalls.................. 487
Carrying basket, Klamath
 Indian 81
 frame and net............ 89
 industry, use of basketry
 in 217

PAGE

Carrying sack, Concow Indians. 378
Cassava strainer............. 231
Cave explorations, basketry
 brought to light by....... 283
Cayuse Indian soft baskets in
 twined weaving.......... 362
Central Eskimo coiled bas-
 kets.................277, 278
Ceremonial basket, Hupa..... 247
Ceyal Pomo basketry, border of. 113
Checkerwork, basketry in..... 56
 border of 106
 decoration in 144
 distribution of........... 284
Chemehuevi Indian basketry... 472
Cherokee Indian clothes baskets. 292
 colors, natural sources of.. 51
Chesnut V. K., information
 from.................. 18
 list of plants used in bas-
 ketry 367
 plants used by aborigines.. 19
Chetimacha Indian twilled bas-
 ketry 291
Chevlon, wicker baskets from
 graves at.............. 459
Cheyenne Indian gambling
 baskets................. 278
Chilean coiled basketry, ancient. 499
Chilkat Indian blanket weaver. 273
 ceremonial blanket....... 324
 border 130
 symbolism 180
Chimmesoyan family, basketry
 of 331
Chinook Indian basketry..359, 362
Chippewa Indian basketry and
 matting, Michigan...270–272
Chiriqui carrying net.......... 492
Choctaw Indian twilled baskets. 291
Chukchi coiled baskets........ 311
 twined wallet............. 304
Cladium, baskets of, tribes mak-
 ing 404
Clallam Indian basketry...... 332
 twilled basket work...... 354
 twined baskets.......... 358
 water-tight basket....... 355
Clatsop Indian basketry...... 363
Cliff Dwellers, ancient, sandals
 of 445
Coahuilla Indian basketry..423–428
 coiled................. 405
Coconino basketry dyes....... 170
Cohn, Mrs. A., information
 on Washoes............. 401
Coiled basketry.............. 84
 and lace work, transition
 between.............. 86
 Athapascan 296

PAGE

Coiled bone awl for85, 87
 by whom made........... .. 52
 decoration, mosaic elements
 in148, 149
 form and designs......... 87
 how made.............. 52
 kinds of................ 6
 needlework approached in. 5
 size.................... 87
 varieties 87
Coiled ware, ancient, in Arizona. 460
 symbolism on............ 187
 tool employed in manufac-
 ture of 7
Coiled work, borders on........ 123
 changes to lace work...... 279
 interrupted style of....... 420
 without foundation 89
Collectors and collections, bas-
 ketry 501
Color. (See Dyes.)
 Attu basketry............ 51
 Cherokee Indian basketry,
 etc.................... 51
 Makah Indian basketry... 53
 ornamentation through.
 (See Ornamentation.)
Coloring, list of plants used in.. 177
 matters for basketry, an-
 cient times 48
Colors having significance with
 the Pomo............... 202
Columbia-Fraser region, bas-
 ketry in..............256, 330
Comanche Indian coiled tray... 278
Complex patterns in decorating
 basketry................ 160
Concow Indian carrying sack... 378
Cooking pots of basketry...... 228
Couteau Indian basketry (see
 Thompson)...........339, 340
Coville, Frederick V., plants
 used in basketry.......... 19
 plants used in coloring.... 177
 thanks due 7
Cowlitz Indian imbricated bas-
 ket.................... 352
 type of imbricated basketry 347
Coyotero Indian coiled bowl... 464
Culture and fine art, use of bas-
 ketry in............... 225
Cushing, F. H., on fireproofing
 basketry 17

Daggett, John, information
 from.................. 377
Dall, William H., on Aleutian
 baskets................ 312
Dance baskets, Hopi sacred.... 245
Decoration, basketry.......17, 131

PAGE

Decoration, complex patterns in 160
 designs in............... 153
 lines in ornament........ 154
 mosaic elements in....... 141
 polygonal elements in..... 159
 rhomboidal figures in..... 157
 squares or rectangles in... 155
 triangles in.............. 158
Defense and war, use of basketry
 in 222
de Leon, Perry M., on the Pa-
 nama hat................ 492
Desert, or Interior region, bas-
 ket-making families...... 257
Designs in decoration. (See
 Decoration.)
 Maidu (Pujunan)......... 207
 Moquelumnan 207
 Nozi (Yanan) 207
 Pit River (Palaihnihan)... 207
 Pomo (Kulanapan)....... 205
 Wintun (Copehan)........ 206
Diagonal or twilled technic in
 basketry................ 294
 twined weaving.......... 71
Diaper or figured work, processes
 of crossing............. 291
 twilled work in two colors.. 145
Diegueños Indian basketry.... 423
 twined basket............. 430
Dish forms in baskets......... 137
Dixon, Roland B., basketry
 types of northern Cali-
 fornia.................. 206
 on Maidu basketry symbols. 400
 symbolism............200, 207
Dog Rib Indian game bag..... 279
Dorsey, George A., on Peruvian
 basketry............... 498
Dress and adornment, use of
 basketry in 223
Du Pratz, quoted............ 232
Dyeing in ornamentation of bas-
 ketry 167
Dyes. (See Color.)
 how obtained............ 17
 Menomini Indian 50

Eastern North American bas-
 ketry255, 269
Eastwood, Miss Alice, plant
 identified by 404
Ecuador twilled weaving...... 492
Eells, Myron, information
 from................337, 342
Egyptians, baskets used by.... vii
Emmons, G. T., identifications
 made by................ 189
 on basketry borders....115, 116
Eskimo basketry............. 301

PAGE

Eskimo coiled................ 305
 grass bags in............ 303
 symbolism on............ 188
 twined, basket-making pro-
 cess 143
Eskimo women, basket making. 307
Ethnic symbolism............. 187
 varieties of basketry...... 255

False embroidery............. 55
 ornamentation.............. 172
Fanning trays, basketry....... 237
Farrand, Livingston, symbolism
 on Salish basketry...... 193
Feather work in ornamentation
 of basketry 175
Fine art and culture, use of bas-
 ketry in 225
Fireproof, basketry rendered... 17
Flat forms of baskets 137
Food, use of basketry in prepar-
 ing and serving........ 228
Form and structure in basketry 133
Foundations for basketry...... 52
 weaving baskets, manner of
 laying.................. 82
Fraser-Columbia region, bas-
 ketry of............256, 330
Fresno type of work........... 411
Fuegian coiled basketry...... 103
Furcate stitches in coiled bas-
 ketry 85
Furniture and house - building,
 use of basketry in...... 238

Gambling trays, basket....247, 248
Gerstaecker's Journal, quotation
 from................. 233
Gift basket, Pomo............. 247
Gleaning and milling, use of bas-
 ketry in............... 230
Goddard, P. E., quoted on Hupa
 basketry.............. 376
Gookin, quoted 276
Grass-coil foundation in coiled
 work 101
Grasshopper baskets, so-called 92, 421
Great Interior Basin basketry
 region................. 431
Guatos Indian basketry....... 491
Guiana Indian basket work.... 487

Haida basketry 326
 color designs not woven in. 330
Haida Indian basketmakers.... 330
 hats118, 223, 326
 position in weaving....... 68
 symbolism............179, 191
 twined basketry borders 115, 122
 wallets of spruce.......... 326

PAGE

Harvesting materials for basket
 making.............44, 45
 outfit, Hupa Indian...... 234
Hat Creek Indian basketry.... 398
Havasupai Indian basket ren-
 dered fireproof.......... 17
 basketmaker............. 471
 basketry................ 470
 basketry dyes............ 170
 detail of border on basket.. 127
Hazel stalks, used by Oregon
 tribes.................. 53
Hoffman, Walter J., quoted.49, 274
Holmes, William H., on æsthetic
 effects................. 164
 basketry in relation to pot-
 ter's art 240
 form.................... 5, 6
 ornamentation 7
Hoochnom Indian coiled basket. 391
Hopi Indian basket dances.... 245
 basketry................ 452
 in carrying industry.... 219
 bridal costume case...... 239
 coarse wickerwork 455
 coiled basket border....... 125
 plaques 102
 meal trays............229, 454
 ornamentation on 454
 symbolism............179, 210
 twilled basketry, modern.. 455
 twined ware 456
 weaving, type of........ 84
 wicker plaque............ 454
Hot Spring Valley Indian names
 for baskets 394
Hough, Walter, on basket
 dances................. 245
 colors in Hopi basketry.... 453
 Hopi basket work........ 452
 materials of Navaho bas-
 ketry 469
House building and furniture,
 use of basketry in...... 238
Hrdlicka, Ales, on Havasupai &
 Hualapai............... 470
Hualapai Indian basket work.. 470
Hudson, J. W., classification of
 Pomo basket work...... 384
 interpretations of symbols
 by................... 202
 notes by, on Pomo bas-
 ketry.............381, 382
Huichole Indian basketry...... 484
Hupa Indian basketry........ 219
 materials used in........ 374
 overlaying in weaving..... 170
 plants used in............ 367
 symbolism on............ 375
 twined weaving in......113, 375

PAGE

Hupa Indian baskets for carry-
in 219
ceremony................ 247
collecting seeds........... 234
cradles.................. 221
food service............. 373
harvesting outfit......... 234
storage................. 234
Hypurina Indian carrying bas-
ket..................... 488

Imbricated basketry.......... 100
Athapascan, Salish, and
Shahaptian............. 342
ornamentation on........ 175
Implements used by basket-
makers................... 53
Interior Basin region, basket-
making families........ 257
basketry of............. 431
ethnic groups........... 432
Interlocking coils, simple...... 90
Interrupted coiled work....... 420
Inyo basketry.............412, 413
plants.................. 405
Inyo county, coiled work from.. 402
-Kern basketry........411, 412
Iquique, graves of, carrying
frame from............... 497
Iroquois Indian basket work.231, 270
Israelites, baskets used by...... vii

Jamamadi Indian carrying bas-
ket..................... 488
James, George Wharton, quoted. 132
Jar forms in baskets........... 139
Jepson, W. L., information from. 374
Jewel basket of Pomo......... 177

Kabischi Indian carrying bas-
ket..................... 489
Kadiak Eskimo baskets....... 314
Kaingua Indian carrying basket. 490
Kamchatkan twined wallet.... 304
Katchinas or Hopi sacred bas-
kets.................... 185
Kentucky, caves of, ancient tex-
tiles preserved in.......... 294
Kern and Tulare coiled bas-
kets....................406, 421
King, Clarence, quoted........ 240
Kiowa Indian gambling baskets. 278
symbolism............... 179
Klamath Indian basketry orna-
mentation 147
beading on twined work... 172
mud shoe............... 46
three-strand baskets...... 394
tribes.................. 392
twined basketry.......... 393

PAGE

Klamath River Indian basketry,
overlaying............. 171
Klikitat baskets, so-called,
where found........... 348
imbricated basketry, mod-
ern and old forms in.... 348
imbricated coil work, how
made...............100, 346
Indians, Mrs. Molson on
the................... 350
Knife Indian basketry......339, 340
Knives used in basket making.. 50
Kroeber, A. L., quoted....187, 366

Label, basketry.............. 502
Lace work and coiled basketry,
transition between.......... 86
Lake Dwellers, baskets of...... v
Lang, Miss Anne M., collection
of..................... 348
Lattice-twined weaving....... 75
Leaves of plants used in bas-
ketry.................. 47
twilled work............. 58
Lillooet style of basketry...... 96
Lines in basketry ornament.... 154
Linguistic families in California,
location of............. 365
northern and southern
groups..........364, 365
Little Lake Indian baskets..377, 380
Louisiana Indian baskets...232, 292
Lower Thompson Indian mats.. 340
Luiseños Indian basketry...... 423

McCloud River Indian basketry. 396
border.................. 114
Mackenzie River snowshoe..... 275
McLeod, E. L., collection of.... 412
Maidu Indian basketry, symbols
of..................... 400
designs................. 207
Makah Indian basketmakers... 336
basketry, ornamentation
on.................332–334
colors, how obtained...... 53
mats.................. 220
Manavi or Panama hat........ 492
Mandan coiled gambling bas-
kets.................... 278
Manufacture, processes of, in
basket making............44, 54
Maricopa Indian basket boat... 219
making................. 473
Markings on pottery, textile,
classes of................. 281
Massawomeke basket shields or
armor................... 223
Materials for basket making,
harvesting...............44, 45

PAGE

Materials for preparing 47
Materials for basketry......... 17
Matthews, Washington, on dyes. 169
 Navaho basketry......469, 470
Matting, ancient, in twilled
 weaving.................... 459
Meal trays, Hopi Indian....... 229
Mechanism in basket making... 48
Menomini Indian basketry..... 274
 dyes..................... 50
Merriam, C. Hart, studies in
 California basketry..403, 409
 type collection of basketry. 7
Mescalero Apache Indian basket
 work................. 91
 baskets..........465, 467
Mexican fibers............... 492
Middle American basketry fi-
 bers.................. 492
 symbols,.............210-212
Middle and South American bas-
 ketry region............257, 481
Milling and gleaning, uses of bas-
 ketry in................ 230
Mission Indian basket-
 makers..................421-431
Modoc Indian baskets......... 392
 women's hats............. 361
Mohave Indian baskets........ 237
Moki (see Hopi).............. 452
Molson, Mrs., on Klikitat In-
 dians.................... 350
Monache basket work......... 411
Moquelumnan designs........ 207
Moravian basketry border..... 110
Mortuary baskets, ancient..... 239
 customs, use of basketry in. 239
Mosaic effects in basketry...... 142
 elements in decorating bas-
 ketry.................. 141
Mounting the loom........... 60
Mud shoe of Klamath Indians.. 46
Murdoch, John, on Eskimo bas-
 ketry................... 298
Muskemoots, or hunting bags,
 weaving in.............. 280

Nass Indian basketry......... 331
Natural materials in ornament-
 ing basketry.............. 163
Navaho Indian basket plaque.. 227
 basketry.............469, 470
 baskets for religious cere-
 monies................. 247
 dyes.................... 169
Nelson, E. W., on Alaskan bas-
 ket making.............. 303
New England Indians, old bas-
 ket work of............. 276
 Mexico, Zuñi pueblos...... 449

PAGE

Nez Percé Indian basketry..360, 361
 blankets................. 360
Nikari karu Indian pegalls or
 packalls.................. 488
Nootka basketry............. 331
Nozi (Yanan) Indian designs... 207
Nutka Indian basketry.....333-335
 overlaying............... 335

Ohio, ancient basketry from
 mound in.............. 294
 charred fabrics from...... 282
Ojibwa Indian coiled basketry.. 276
 symbolism............... 179
 twined wallet............ 286
Openwork weaving........... 92
Oraibi Indian, ancient baskets
 of.....................453, 456
Oregon-California basket region,
 basketry of.............363, 402
Oregon, old feathered baskets
 from................... 372
 tribes, hazel stalks in bas-
 ketry................... 53
Ornamentation, dyeing in bas-
 ketry................... 167
 false embroidery on bas-
 ketry................... 172
 feather-work, beads, etc.,
 on basketry............. 175
 imbrication on basketry... 174
 natural materials of, in bas-
 ketry................... 163
 on basketry............. 131
 overlaying in basketry.... 170
 through color on basketry. 161
Owen, C. L., basketry used in
 storage.................. 237

Paints for coloring baskets..... 17
Paiute Indian basket bottles... 251
 basketry.............436-441
 coloring in..........412, 413
 simple coil border........ 124
 twined basket, border on.. 114
Palmer, Edward, reference to.20, 473
Panama hat, so-called........ 492
Panamint Indian basketry..407-412
Papago Indian basket making.. 472
 carrying frame........... 220
Paressi Indian carrying basket.. 488
Pegalls, or carrying baskets.... 487
Pepper, George H., on the an-
 cient basket makers........ 444
Peru, Ancon, cemeteries of, bas-
 ketry found in......495, 496
 desert region of, preserva-
 tive of textiles......... 240
 southern, twined carrying-
 frame.................. 497

PAGE

Peruvian basketry.........494, 495
 modern coiled basketry.... 500
 workbasket, ancient, from. 497
Pima basketmaker............ 480
 Indian basket boat....... 219
 basketry............472–480
 carrying frame........ 153
 child's carrying basket.. 474
Pit River Indian basketry..395, 396
 designs................. 207
Plants, leaves of, used in bas-
 ketry................. 47
 used in basketry, by F. V.
 Coville............. 19
 list prepared by V. K.
 Chesnut............. 367
 coloring, list of........... 177
Polygonal elements in decora-
 tion of basketry........... 159
Pomo Indian acorn mush maker,
 outfit................. 235
 basketry.............380, 390
 borders............... 111
 classification of........ 384
 materials for, list....381, 382
 plants used in.......... 367
 symbols............202–204
 colors having significance
 with................. 202
 gift basket.............. 247
 milling baskets........... 235
Potsherds from State of New
 York.................. 282
 showing textile impressions. 285
Potter's art, use of basketry in
 relation to................ 240
Pottery, basketry preserved
 by.................269, 286
 textile markings on....... 281
Powell, J. W., collections...... 434
Preparing materials for basket
 making..................44, 47
Preservation of baskets........ 503
Processes in basket making...44, 54
Pueblo and Shoshonean bas-
 ketry................. 432
 basketmaker............. 445
 basketry, ancient..450, 457, 460
 symbolism............. 209
Purdy, Carl, classification of
 Pomo basket work...... 384
 interpretations of Pomo
 symbols.............. 205
 on unspoiled art in north-
 western California...... 9
 vocabulary of symbols on
 Pomo basketry......... 204

Quinaielt Indian basketry..... 356
 wallet.................. 111

PAGE

Ray, P. H., collections of bas-
 ketry.................... 296
Receptacle, use of basketry as a. 242
Rectangles or squares in decora-
 tion of basketry............ 155
Ree Indian coiled gambling bas-
 kets...................... 278
Regions, basketry, in America.. 4, 5
Religion, use of basketry in.... 244
Rhomboidal figures in decora-
 tion of basketry............ 157
Rod and welt foundation in
 coiled work................. 95
Roots, use of, in basketry.....45, 46
Roth, H. Ling, information from 485
Round Valley basketry, plants
 used in................. 367
 fine coiled basket, making
 of..................... 389
 Indian basketry.........377, 378
Rust, Horatio N., on mortuary
 baskets.................... 240

Salish imbricated ware........ 342
 of British Columbia....... 150
 Washington........... 180
 symbolism.............. 193
Salish Indian basketry, borders
 on....................... 111
 designs on..............179, 180
 types of...............335, 337
San Martin Mountains, Califor-
 nia, ancient cave baskets..... 429
Sandals, basket makers'....... 445
 basketry................. 223
Santa Barbara basketmakers.. 414
 baskets, decoration....... 406
Shackelford, Mrs. R. S., informa-
 tion from.................. 350
Shahaptian Indian basketry.346, 360
Shapes of baskets..........135, 139
Shards, facts preserved by..... 242
Shasta Indian basketry........ 395
Shoshonean and Pueblo bas-
 ketry.................... 432
 basketry................. 409
Shushwap Indian basketry.... 345
Sia Indian coiled basket, border
 of...................... 126
 pueblo of, basketry....... 447
Sieve basket 232
Sikyatki basketry 460
Simmon, T., quotation from
 report of.................. 349
Simms, G. C., on Apache-Yuma
 basketry.................. 472
Single-rod foundation 92
Sioux, symbolism of.......... 179
Skokomish Indians, twined wal-
 lets of.................... 358

PAGE

Smith, Harlan I., on twined bas-
 ketry in the eastern region... 288
Smith, John, quoted.......... 232
Social life, use of basketry in... 247
South America, basketry of,
 southern limit............ 491
 symbolism on.........210, 211
South America, basketry sub-
 areas...................... 486
South and Middle America,
 basketry of.............257, 481
Southern Indian basketry, deco-
 ration on.................. 271
Splint and two-rod foundations. 96
 foundation................. 99
Squares or rectangles in decora-
 tion of basketry............ 155
Steinen, Carl von den, on Bra-
 zilian baskets.............. 488
Stems, use of, in basketry...... 46
Stevens, Isaac L., quotation
 from...................... 348
Stevenson, James, quoted...... 446
Storage basket, Mohave....... 237
Strachey, quoted 232
Structure and form in basketry. 133
Subdivisions of American bas-
 ketry 4
Sun basket, Yuki Indian........ 200
Sweet grass for basket making.. 50
Symbolism, basketry.......... 178
 classes of objects and phe-
 nomena represented 180
 ethnic 187
 identifications of 189
Symbolism, on Hupa bas-
 ketry375, 376
 Maidu basketry........199, 400
 Pomo basketry............ 204
Symbolism, points of view from
 which it may be studied. 183
 Professor Farrand's plates. 193
 technic of, illustrated..... 205

Tarahumara Indian basketry.. 484
Techahet Indian basket mak-
 ing422, 424
Technic in basketry, types of.. 6
Tee-twined weaving.......... 76
Teit, James, on Thompson
 River Indians..........193, 340
Tejon basket work............. 413
 coiled baskets............. 416
Tepeguanos Indian basketry.. 484
Textile markings on pottery,
 classes of.................. 281
Thompson, A. H., information
 as to Ute material.......... 434
Thompson River Indian bas-
 ketry340, 341

Thompson River Indian bas-
 ketry, false embroidery
 on.................... 174
 ornamentation on 175
Thompson River Indians, list of
 symbols on baskets of...... 193
Thompson River Indians, weav-
 ing of blankets by basketry
 processes.................. 341
Three-rod foundation in coiled
 work.................... 97
 strand braid............. 80
 strand twined weaving....78, 80
Tillamuk Indian twined wallet.. 358
Tinné Indian basketry........
 128, 130, 298, 300
Tlaxcala Indian basketry ...482, 483
Tlinkit Indian basket-makers...
 54, 68, 323
 basketry................. 317
 borders......115, 117, 118, 122
 false embroidery in..... 322
 styles of weaves in 318
 symbolism..........179, 189
Tonto Indian Basketry......... 462
Tools used by basket makers..54, 55
Tozier, D. F., on Makah weavers 336
Trapping, use of basketry in..... 248
Triangles in decoration of bas-
 ketry 158
Tribes, basket making, list of.. 260
Tsimshian Indian basketry..... 331
Tulare and Kern basketry..403, 420
 decoration on 151, 411
Twana Indians, implements used
 by in basket making........ 53
Twill, or tweel weaving......58-61
Twilled basketry, canes for.... 51
 Southern tribes, detail of.. 290
Twilled matting, ancient,
 Petit Anse Island....294, 295
 or diagonal technic, in
 basketry...........293, 294
 ware, ancient, in Arizona.. 460
 weaving, borders on...... 107
 decoration of145, 146
 how produced........60, 61
 in ancient eastern North
 America............. 284
Twined basket, Tlinkit Indian,
 process of making...... 55
Twined basketry terms....... 110
 baskets, false embroidery
 in 174
 baskets, plain twined
 weave, decoration on..146, 147
Twined wallet, Ojibwa Indians. 286
Twined weaving, border on..... 110
 decoration.........145, 146
 diagonal................. 71

PAGE

Twined weaving, different structures in.......... 69
Hopi Indian type......... 84
lattice 75
plain 69
position of weaver........ 68
prehistoric, where common. 284
symbolism............... 186
three-strand 78
wrapped...............72, 73
Two-rod and splint foundation in coiled basketry..........94, 96

Umatilla Indian baskets, twined weaving................... 362
Upper Yukon River, birch-bark tray, border 129
Uses of basketry............. 213
Ute Indian basketry.......... 434
mortuary uses of vi
Ute Indian water-tight vessel..71, 72

Varieties of basketry, ethnic.... 255
Vocabulary of basketry........ 10

Wakashan Indian basketry...331, 332
Walapai Indian basketry....470, 471
dyes.................... 170
Walla Walla Indian women's hats 362
War and defense, use of basketry in 222
Warrau Indian carrying basket . 490
Wasco Indian twined wallets.. 363
Washington, imbricated basketry of90, 347
or southern imbricated ware................. 346
Washoe Indian basketry....400, 401
Water, use of basketry in carrying 249
Water-tight basketry......18, 104
vessels, in basketry......71, 72
Wattled work, traces of........ 285
Weaving baskets, laying foundation for................... 82
Weaving, plain..............59, 60
tools used in54
Wedding basket, Pomo....... 247

PAGE

White Mountain Apache basket making.................463, 464
Whittemore, Isaac T., quoted.. 474
Wickerwork, basketry.......135, 136
ancient, Arizona.......458, 459
border of 46
decoration............145, 146
from cave in Kentucky 294
in soft materials.......... 283
symbolism on 185
Wikchumni Indian grasshopper basket 420
Wilcomb, C. P., information from..................... 411
Wilkie, Miss Harriet C., information from................. 51
Willoughby, C. C., on ancient ware, San Martin Mountains, California 429
coiled ware in the eastern region 276
old Nutka hats.......333–335
Willoughby, Charles, report by as to Quinaielt basketry..... 356
Wintun Indian basketry...... 397
designs on basketry...... 206
Woven basketry.............. 56
kinds of 6
Wrapped twined weaving..... 72
work, basketry 65

Yakima Indian imbricated basket 351
Yakutat Bay basket weavers.. 168
Yanan or Nozi basketry207, 398
Yaqui Indian basketry......483, 484
in ceremonies............. 247
Yuki Indian sun basket.....200, 201
Yukon River birch tray, border on....................... 128
Yuman Indian tribes, basketry of 430

Zuñi Indian basketry, ancient 447–449
coiled basket jar.......... 450
wickerwork, border on.107–109
wrapped border........113, 114